The Desire of My Eyes

The
Desire of My Eyes

The Life and Work
of John Ruskin

Wolfgang Kemp
Translated by Jan van Heurck

"There is no Wealth but Life."
Unto This Last

HarperCollins
An Imprint of HarperCollins*Publishers*

First published in Great Britain in 1991
by HarperCollins Publishers,
77/85 Fulham Palace Road,
Hammersmith, London W6 8JB

9 8 7 6 5 4 3 2 1

Originally published in German as *John Ruskin: Leben und Werk, 1819-1900*
Copyright © Wolfgang Kemp and Carl Hanser Verlag, München, 1983

The Author asserts the moral right to be
identified as the author of this work

First published in this English translation in the United States by
Farrar Straus & Giroux Ltd, New York, 1990
Translation copyright © Jan van Heurck and Farrar Straus & Giroux, 1990
This translation has been made possible in part through a grant from
the Wheatland Foundation, New York.

British Library Cataloguing in Publication Data

Kemp, Wolfgang, *1946-*
The desire of my eyes: the life and work of John Ruskin.
1. English literature. Ruskin, John 1819-1900
I. Title II. John Ruskin 1819-1900, Leben und werk.
English
828.809

ISBN 0 00 215166 9

Printed in Great Britain by Butler & Tanner Ltd, Frome and London

Contents

Preface / ix

One / 1
The Little Phenomenon
1819–1842

Two / 65
The Graduate of Oxford
1842–1845

Three / 131
A Mad Man or a Wise
1845–1853

Four / 205
The Luther of the Arts
1853–1860

Five / 267
Savage Ruskin
1860–1870

Six / 327
The Professor
1870–1878

Contents

Seven / 393
The Only Real Seer
1878–1890

Eight / 457
The Old Man of Coniston
1889–1900

Notes / 491

Index / 515

List of Illustrations

John Ruskin, Age 3½, 1822 / 2
James Northcote

Merton College, Oxford, 1838 / 54
John Ruskin

John Ruskin, Age 24, 1843 / 66
George Richmond

Trees on Mountain Slope, 1845 / 127
John Ruskin

Detail of San Michele, Lucca, 1845 / 149
John Ruskin

The South Façade of St. Mark's, Venice, 1851 / 159
John Ruskin

Studies of the Ca d'Oro, Venice, c. 1849 / 163
John Ruskin

John Ruskin, Age 34, 1853–54 / 206
John Everett Millais

Gneiss Rock, 1853 / 210
John Ruskin

Cascade de la Folie, Chamonix, c. 1849–56 / 252
John Ruskin

William Bell Scott, John Ruskin, and Dante Gabriel Rossetti,
1863 / 268
William Downey

Rose La Touche, 1874 / 284
John Ruskin

Self-portrait, c. 1873 / 328
John Ruskin

Street in Venice, 1876–77 / 335
John Ruskin

John Ruskin, Age 60, 1879 / 394
Hubert von Herkomer

San Martino in Lucca, 1882 / 431
John Ruskin

John Ruskin and Henry Acland, 1893 / 458
Angie Acland

Preface

This book will now appear in English translation before a public for whom it was not first intended. At the time of its German publication in 1983, John Ruskin's writings were virtually unobtainable in Germany except for some thirty pages in anthologies. No independent works by him or about him were available. At that same time, a harassed American critic was complaining to his readers that 3,527 pages by and about Ruskin had been published in English over a six-month period in 1982.

I thus found myself in an altogether different position from my British and American counterparts, who were publishing such a storm of books on Ruskin that they had been accused of churning up "The Storm-Cloud of the Late Twentieth Century." My original intentions were to introduce Ruskin to a German audience, arouse interest, and, above all, let Ruskin speak for himself. Of course I am gratified, and proud, that the book is now to appear in Ruskin's own language. But I have a hint for my new public regarding the differences between my book and its English and American cousins, and why English-speaking readers may find its perusal worthwhile.

It was my plan that this study of Ruskin should serve as the jumping-off point for a study of the nineteenth century in England. For this reason, the reader will find general information about the century's social, scientific, economic, and artistic developments. Each chapter contains an "excursion"—often disguised—into the broader context of Ruskin's life. This approach may, I hope, help to overcome *morbus Ruskinianus*, that specific malady from which

Preface

Ruskin's critics and biographers are often said to suffer—a sort of tunnel vision which allows them to see Ruskin only and nothing of what is alongside or around him. John D. Rosenberg attempted something similar in 1961, in his book *The Darkening Glass*. My aim was to write a "Rosenberg" for our time—a time in which Ruskin's teachings are needed more urgently than ever.

A travel grant given to me by the Deutsche Forschungsgemeinschaft greatly assisted my work on this book. As an Arts Council Lecturer at the University of California at Los Angeles, I had access to Ruskin's papers at various American libraries and universities. I would like to thank both these institutions for their support.

I am grateful to James S. Dearden, curator of the Ruskin Galleries, Bembridge, Isle of Wight, for answering so many of my questions; and to Michael Krüger of Hanser Verlag, my publisher in Munich, who bestowed such long and patient care on this book.

I also want to express my regret at the death of Christoph Schlotterer of Hanser Verlag, who arranged my contacts with Farrar, Straus and Giroux. Finally, I am most of all indebted to my translator, Jan van Heurck, for her share in what I would like to think of as an inspired co-authorship.

W.K.

One
The Little Phenomenon
1819–1842

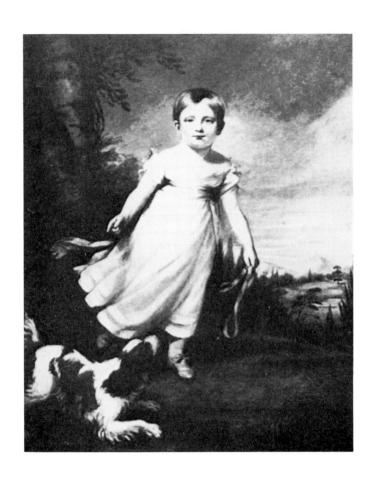

James Northcote, John Ruskin, Age 3½, *1822. Oil on canvas.*
National Portrait Gallery, London

I

The English academic painter James Northcote had turned out scores of commissions like this. A wine merchant from the City of London had asked him to do a portrait of his son, who had just turned three and a half. The year was 1822. Northcote, now seventy-seven, must have seemed the ideal artist to paint the child, as he could still lend an aristocratic flair to the hackneyed genre. A pupil of Joshua Reynolds, he never tired of reapplying the same formulas which in the eighteenth century had made English portraiture the model for the world—relaxed, unconstrained, even sprightly poses; an absence of pomp in costuming and decor; a nature scene in the background—and he clung to the conventions all the more with his middle-class clients. Northcote liked to pose children as "nature sprites" or "sylphids." He had the formula down pat, so the child's role was little more than that of a photographer's model who sticks his head through an empty hole in the canvas to have his picture snapped above a prepainted body. Such is our first portrait of John Ruskin.

"I am represented as running in a field at the edge of a wood"— half floating, half arrested: the same suspended lunge achieved by duchesses and actresses in the paintings of Reynolds. The child's light white garment flutters as a small dog bounds along beside him. The animation is studied, recaptured by the composition; and the child's face, intently seeking the viewer, remains aloof. The face is still rounded, unformed, but already we see the beginnings of Ruskin's long skull, framed by an abundance of fine, pale blond hair. The features are so clear-cut as to have an academic look, but

future portraits will show that the artist was faithful to his model. A flaring curve runs from the eyebrows to the nostrils, indented halfway down the face to make the bridge of the nose appear more delicate and the lower part of the nose broader and fleshier.

A good likeness, the artist must have thought, once he had transferred these dominant features of the face onto the canvas. For the rest, he stuck to the routine pattern. As he put in a poetic blur of landscape and filled one corner with an indeterminate species of tree, he had no way of knowing that the child he was painting would one day be acclaimed, by contemporaries and by later generations alike, the keenest observer of nature born in his century, an art critic unrivaled in his alertness to the detail of trees and mountains. Northcote knew none of this, and yet possibly he was the first to see a clue to Ruskin's future. After the child had sat for him for ten minutes, he asked the painter why his carpet had holes in it. "My formed habit of serenity was greatly pleasing to the old painter; for I sat contentedly motionless, counting the holes in his carpet, or watching him squeeze his paint out of its bladders,—a beautiful operation, indeed, to my thinking;—but I do not remember taking any interest in Mr. Northcote's application of the pigments to the canvas; my ideas of delightful art, in that respect, involving indispensably the possession of a large pot, filled with paint of the brightest green, and of a brush which would come out of it soppy."

Northcote followed up this commissioned portrait with a second, privately designed work for which he also used the child Ruskin as a model. It is a small genre piece, a scene from classical antiquity, in which a russet-colored satyr is removing a thorn from the foot of an Apollonian nature sprite against a background of grazing sheep—a schematized Arcadia. Northcote painted the nature boy with a part in his hair, neatly stroked into place only moments before by his mother. Below the hair is a woebegone little face, and below that, the body of a nude from the Sistine Chapel. Everything in this picture is false, formulaic, geared to produce cheap effects. Not one of its themes or sentiments would have any future in Ruskin's life: not classicism or Michelangelo,

not mythological dress-up or lower orders of spirits soothing his troubled senses. In fact, neither the gentility of Northcote's portrait nor its hackneyed appeal to antique models is in any sense a prefiguration. Both are hallmarks of the eighteenth century. But there is also something nineteenth-century about it, insofar as the artifices no longer work. Art critics were already pointing out that the dryads and naiads churned out by painters of the day had lost all point except as nude studies. Nevertheless, two more decades would go by before the adult Ruskin formally declared them passé and called on artists to devote themselves directly to the nude, and to study real trees and sky. Meanwhile, Ruskin's parents must have been quite pleased with Northcote's portraits, because they went on to commission portraits of themselves.

Ruskin's mother and father were first cousins. Ruskin senior had grown up in Scotland, and his wife in southern England. Neither came from a prosperous or distinguished background. John James Ruskin was the son of a small tradesman, and Margaret Ruskin's family ran a pub. The cousins met when Margaret traveled to Edinburgh to serve as helper and companion to her aunt, John James's mother. The two women grew close and soon fastened on a common object of love and concern, John James. The threesome had scant illusions about the fourth member of their household, its father and head, John Thomas Ruskin, who involved himself in reckless and unrealistic business deals in his drive for success. Briefly he achieved his life's goal when he rose from small retailer to merchant; but after that he was only able to maintain his position by fraud. Finally, in 1817, John Thomas died by suicide, in a fit of depression, after two years of mental disorder. He left a heavy burden to his only son, now in his early thirties and already afflicted with a mild form of his father's mental illness: some £5,000 worth of debt from his embezzlements, and a lifelong dread of ending up in the same state of despair and instability.

John James went to London at age sixteen in search of work. He was well educated, which in different circumstances might have earned him something better than a job as a merchant's assistant (indeed, in 1804, he commissioned a portrait of himself holding a

book which undoubtedly is not just a business ledger) but his family could not afford to give him long-term professional training. Also, Britain at that time was isolated from the Continent by Napoleon and foreign trade was almost at a standstill. The political situation made it difficult for a young Briton to establish himself in the business world, and John James was hard pressed to find even a minor position in a London firm. For seven years, he worked in a colonial trading company for only £100 a year. He kept to a grueling schedule, working seven days a week until eight o'clock at night, except for two evenings, when he would work until eleven. By the age of twenty-three, he had managed to earn a central post in a large shipping office. Then, after nine years without a vacation, he fell gravely ill, and it took months of nursing by his mother and cousin to bring him back to health. In 1814 he transferred to a small wine-importing house where he became the sole active partner, and from then on he was in business for himself. Describing his career in later years, he claimed that he had visited every town in England, most in Scotland, and a number in Ireland as a sales representative for his company, until he had increased business from a mere twenty barrels a year to three thousand, making the firm of Ruskin, Telford and Domecq the leading sherry importer in Britain. "There must be brought an unconquerabel *Will* & Power to Seize upon that which a hundred Competitors are Striving to Keep from you," he wrote, describing the two forces behind his business success. Will and power—not the gambler's instinct, the sudden stroke of luck, the "good nose" on which his father apparently had staked his hopes. John James carried on his business as if it were a paid office, a duty for which he was publicly accountable, with fixed hours of work, set assignments, and concrete goals to achieve. Later his son, when writing his works of social theory, had the same scrupulous attitude that his time was not his own but belonged to the public.

Like many self-made men of the nineteenth century, John James first learned responsibility by having to care for his family. The year 1808 brought the bankruptcy of his father's business and installed young John James as head of the household. He had always

adored his mother and now was closer to her than ever. His new responsibilities probably intensified his sense of duty and his serious attitude to life, and it is in keeping with this gravity that he became engaged to his cousin Margaret the following year, in 1809. By choosing to marry his cousin, he was marrying all that was familiar to him from his own mother; his mother, in fact, used to call her niece "the half of myself."

When young Margaret left the provincial town of Croydon in southern England and moved to Edinburgh to live with her aunt, she was following a well-beaten path, in the sense that she had been reared with no other prospects than a busy and pious life in the bosom of her family. But in Edinburgh she was unexpectedly exposed to influences which broadened her horizons. The Scottish capital, known then as the Athens of the North, was teeming with the theological, philosophical, and scientific speculations thrown up by a circle that included such luminaries as Thomas Reid, Dugald Stewart, and Adam Smith; and not even a simple young woman with little formal education could remain untouched by them. Indeed, the remarkable thing about the enlightened Scottish school of philosophers is that it attracted the lively interest of the general populace, despite the climate of religious stricture and intolerance emanating from the Scottish Church.

The national church of Scotland, of which the Ruskins were members, was committed to the basic Calvinist beliefs in predestination and the depravity of human nature—beliefs which made no allowance for aesthetic enjoyment or for the delights of independent study. This was all the more true at a time when the Scottish Church was embroiled in minor wars of religion against forces both within and without. But although Ruskin's parents always remained loyal to the principles of Scottish orthodoxy, they nevertheless persisted in reading contemporary authors (even authors as depraved as Byron), socializing with artists, taking long and expensive trips, and enjoying the luxuries appropriate to their class.

Yet religion was more to them than a matter of duty or social propriety. If that had been all, then John James and Margaret could

have found a simpler and socially more attractive denomination when they moved south to London, which was home to a broad spectrum of English churches. There was, for example, the High Anglican Church, whose style of worship filled the need of many rising men of the nineteenth century for ornamental richness and religious fervor, without placing strict demands on their mode of life. Instead, the Ruskins chose an evangelical sect, the closest thing they could find in England to the national church of Scotland. This seemingly contradictory behavior cannot be dismissed simply as a case of individual eccentricity. Foreign observers regarded such behavior as hypocrisy and a British national trait. The nineteenth-century German historian Heinrich von Treitschke wrote: "We find there [in Britain] a rigid adherence to traditional dogma rivalling that of the Jews, side by side with a popular morality—long potently embodied in the bold, practical egotism of that nation—which . . . at bottom has always judged moral matters by the advantage to be derived." Treitschke tried to explain this dualism—British "Protestant strictness" versus British "worldliness"—by emphasizing the need of the middle class to find security and meaning amid the unpredictable bustle that they themselves had unleashed. But, in the Ruskins' case at least, other factors also played a part. John Ruskin's family home was highly religious and yet not narrowly or conventionally opposed to everything new in art, literature, and science. This openness was in part due to the great value which his parents attached to the work of mental craftsmen; and this in turn was traceable to the fact that they, too, had risen in the world by their own talents and efforts. They would happily have admired the English upper class and other governing institutions had they seen in them anything to admire; but the intellectual vacuum in the south led them to follow the Scottish model, and to cherish the achievements of those who, like themselves, had worked their way up without name and rank.

Like many middle-class townspeople of their day, they were impressed by the fame that writers, painters, scientists, and preachers had been able to achieve since 1800. It cannot have escaped the notice of Ruskin senior that, on the day in 1814 when Byron's

Corsair went on sale in London, whole streets of the business district were blocked by the crowds clamoring to buy it, and that the publisher, John Murray, reported the sale of ten thousand copies on this single day. And yet, at the same time, John Ruskin's parents must have felt the writer's profession to be a particularly hazardous and stressful one. To see one's name in print; to face critics like those who, in Edinburgh, were just then honing their craft into a fine art; and to influence public affairs—these seemed enterprises even riskier than the intrigues of the business world. All their lives, Ruskin's parents grew anxious each time one of his books was published and faced public scrutiny, whereas the author himself was inclined rather to view the process as a disruption of his work on new projects.

In Edinburgh, and later in Perth, Margaret read a great deal: the Bible with her aunt, numerous other religious and philosophical works, and fine literature. (She would one day pack into her son's traveling luggage curious treatises that betray her liking for a semi-philosophical type of devotional writing.) During her long years in Scotland, she occupied herself with "self-improvement" and preparation for marital life, while she carried on her chief duty of helping her aunt in these times of trouble. Apparently, Margaret seldom wanted anything for herself, but she did firmly expect that her vigil would one day end in marriage to her cousin and in their joint independence. This was the goal she waited and even fought for, resisting, with her modest resources, the opposition of her uncle and aunt, who desired a more brilliant match for their only son than their impoverished niece from Croydon. This same pattern of events was to repeat itself, a generation later, between Effie Gray and John Ruskin's parents.

No one knows whether John James himself felt indecisive about marrying his cousin, and whether this partly explains the length of their engagement—from 1809 to 1818. Later their son John commented on the subject in a passage that he wrote for his autobiography *Praeterita* and then omitted: "Very certainly, had there been what is rightly called 'love' on both sides it [the long engagement] would have been impossible, and as things were, it was

by my present judgment, unwise, and even wrong." We need not be overly swayed by this remark. The son always felt that his mother had been the loving partner in his parents' marriage, and assumed that his father treated his mother as he treated him: rationally and controllingly. Yet the letters exchanged by John James and Margaret after the birth of their son do not bear out this assumption, and even suggest the opposite. The long engagement—incomprehensible to us now, like much of the behavior both of the parents and of their son—was probably the result of their firm middle-class willingness to sacrifice present happiness in order to advance John James's London career, and their devotion to their aging parents in Scotland, who needed increasing amounts of care. There is no way of telling how the tale of the long-suffering lovers might have ended, had it not been for the dramatic events of 1817, the year which saw the deaths of all their surviving parents—Margaret's mother and John James's mother and father—and so altered their circumstances that the couple were able to marry in February 1818.

They moved to London at once, and one year later, on February 8, 1819, their only son, John Ruskin, was born in their new home at No. 54, Hunter Street. By this time Margaret was thirty-eight, John James thirty-three. If we consider the years of struggle that preceded their marriage, and the fact that in those days it was unusual for a mother of comparatively advanced age to give birth to a healthy child, we may more readily understand the parents' exaggerated anxieties about their son. For Margaret especially, her child represented the confirmation and fulfillment of decades of hope when hope was all but gone. She formed her own interpretation of the great event. Looking to the Bible for precedents, she felt that she was a second Hannah whose years of prayer for a child had been answered by God, and who dedicated her child to him in return: "For this child I prayed; and the Lord hath given me my petition which I asked of Him: therefore also I have lent him to the Lord; as long as he liveth he shall be lent to the Lord" (I Sam. 1:27–28). But Hannah-Margaret's vow went unfulfilled: John Ruskin did not become a clergyman. Instead, he ended up a prophet

like Hannah's son Samuel—to the discomfiture of his mother, who lived long enough to see it happen.

2

Historians have long regarded 1819 as a pivotal year in British history, when the kingdom came closer to revolution than in any year since, except 1848. A political battle was fought and lost then, which became known as "Peterloo": a working-class crowd had assembled at St. Peter's Fields, Manchester, to demonstrate for repeal of the Corn Laws and for the fundamental reform of Parliament, only to be brutally dispersed by the army and the police, who left eleven dead and four hundred wounded. Shelley, in his sonnet "England in 1819," described the Peterloo massacre as a moral Waterloo committed by a corrupt nobility opposed to reform:

> An old, mad, blind, despised, and dying king,—
> Princes, the dregs of their dull race, who flow
> Through public scorn—mud from a muddy spring;
> Rulers, who neither see, nor feel, nor know,
> But leech-like to their fainting country cling,
> Till they drop, blind in blood, without a blow;
> A people starved and stabbed in the untilled field,—
> An army, which liberticide and prey
> Makes as a two-edged sword to all who wield—
> Golden and sanguine laws which tempt and slay,—
> Religion Christless, Godless—a book sealed;
> A Senate,—Time's worst statute unrepealed,—
> Are graves, from which a glorious Phantom may
> Burst, to illumine our tempestuous day.

The meaning of the last lines, especially the phrase "glorious Phantom," has often been debated. Biographers of Queen Victoria and of John Ruskin, both of whom were born in this fateful year

of 1819, have refrained from claiming that the prophecy refers to either one. And as it turned out, what rose from the graves of 1819 was neither something so dim as a will-o'-the-wisp nor so bright as a beacon. Peterloo was the Waterloo of the workers and of the reform-minded middle class: it meant their neutralization as a political force. On the Continent, 1819 was the year of the Carlsbad Decrees repressing civil liberties in the German states, while at the same time the Restoration further entrenched itself in France. On the other hand, 1819 was also the year of the first law to reform working conditions in Britain. Working hours were reduced for child laborers, and employers were prohibited from hiring children under the age of nine. This paved the way for a series of small-scale but essential reforms effected by political means, not by violence and counterviolence, which culminated in 1846–47 in the repeal of the Corn Laws and the restriction to a ten-hour workday for women and children.

John Ruskin was born into an English middle class, most of whom, during his adolescent years, shared Shelley's opinion of the authorities, yet went on faithfully supporting the monarchy and the aristocracy. In fact, the middle class was excluded from governmental functions until the first franchise reform was enacted by Parliament in 1832. But the ongoing debates about reform, and the occasional piece of reform legislation, perpetuated the illusion that their interests, too, were being represented. And the fact that virtually no restrictions were placed on their own characteristic activities in trade, manufacturing, and intellectual life convinced them that there was no need for them to take a more active stand. John James had recognized that he had a job to do in England, and tackled it with a will. His success, and the success of many others of his generation, confirmed his view that, while one might defer to the upper classes, one did not necessarily have to share their politics in the narrower sense. Party politics and the formation of government and foreign policy could safely be left to the small governing class, as long as a man was free to manage his own affairs, for they were what really counted.

The son born to the Ruskins in that momentous year of 1819

would not begin to interest himself in politics until relatively late in life, and where politics were concerned, he always remained a product of his class. His excursions into current affairs looked amateurish, and his indifference to party conflict naïve, for he continued to believe that only the most basic things—the relationship of man to nature and the relationship of man to man, within the discipline of work and faith—deserved the name of politics or the total dedication of the politician.

The following passage—Ruskin senior's comment on the marriage of Queen Victoria to Prince Albert, from a letter he wrote to his wife in February 1840—reflects, in its seemingly contradictory tones, the static political platform of the English middle class, and as it shows us the father, equally it reveals the character of his son: "We are a King & Queen loving people but they must keep up their own dignity & keep the higher classes around them—else we may grow tired of paying for pomp. She the Queen is but a silly child & seems to have no Character. I wish the Boy [Prince Albert] may grow into something better. It is a poor prospect for the Country. We must look to our domestic Circles & our own neighbourhood & let politics alone. I am exceedingly well off under any sort of Queen & I shall make no attempt at revolution or disturbing the Government."

In 1819 the Ruskins' priority was to look to their "domestic Circles," and they do not give the impression of feeling overtaxed by the demands of their newly won independence and domesticity. They stayed in their first home, a narrow four-story row house, for only four years, before moving to a villa surrounded by extensive grounds in Herne Hill, south of London—an area that had not yet been overtaken by the metropolis. They lived here for nineteen years, until 1842, when they moved to nearby Denmark Hill, to an even larger villa with even larger grounds—a property with extensive greenery in the garden and surrounding landscape, big enough to maintain and occupy the little family and a fairly large retinue of servants. This was the house where John James and Margaret died many years later.

At Herne Hill, remote from the noise and dirt of the city, on

elevated ground with a panoramic view, Ruskin's parents began a way of life which they were never called on to give up, which they never changed in any basic respect, and which their son later faithfully copied. The Ruskins were not of farming stock, but they set out to grow their own food as if it were the most natural thing in the world. They had milking cows, and vegetables and fruit in abundance. Ruskin's mother tended the flowers and decorative plants, and the head gardener, of whom there were several over the years, was always of central importance in the household. (Years later, before undertaking one of his social-reform projects, John Ruskin would as a rule send his gardener to evaluate the situation first.)

In establishing this kind of self-contained village economy, the Ruskins were not so much imitating an aristocratic life-style as trying to realize the ideal of autarky—economic self-sufficiency. The 1820s saw the publication of William Cobbett's popular pamphlets on self-sufficient farming. These pamphlets were aimed at a different, less wealthy audience than the Ruskins, but the family seems to have taken up his basic ideas: don't give up your natural means of subsistence, don't trust in the monetarization of labor and exchange, resist the destruction of nature and custom. Cobbett was, at least at times, a radical Tory—today we might call him a cultural conservative—and the same must be said of both John James and his son. After all, John Ruskin later began his autobiography with the sentence: "I am, and my father was before me, a violent Tory of the old school;—Walter Scott's school, that is to say, and Homer's." The political platform of the radical Tory found its tersest expression in the words of William Blake, in his famous poem "The New Jerusalem" from the Preface to *Milton* which ends:

> I will not cease from Mental Fight,
> Nor shall my Sword sleep in my hand
> Till we have built Jerusalem
> In England's green & pleasant Land.

Cobbett was the man who led this struggle during Ruskin's youth: a radical who wrote gardening manuals and cookbooks, who had traveled all over Britain on horseback, a nature conservationist, a politician who made his stand in an England that was a garden— and from there fought like a champion.

John James, as a radical Tory, felt that the good life was life close to nature, and that this must go hand in hand with resistance to progress. Admittedly, he ran a flourishing business in the City of London, but he did not belong to that segment of the middle class which sets store by innovation. As a merchant of the old school who maintained personal contact with his customers and never sold any but the best and purest of products, he was a figure representing stability, not progress. He never took to that symbol of the new age, the railroad: "These Railroads are the most thorough nuisances that ever a Country was infested with." He hated the way that the railroads changed business practice through the stocks and lending system used to finance them, and when he made his annual business trips, it filled him with sadness and despair to see the drastic transformations taking place in England and the English. He was gratified to have a son who voiced more resoundingly than any other man of his time concerns that the father was probably not in a position to express even to the circle of his clients and colleagues.

But it caused him a great deal of anxiety, and alienated the two men, when Ruskin junior went a step further and began to interpret the railroad, industrial machinery, and the new conduct of finance as mere symptoms of a deeper-lying malady, and to prescribe a cure that would have undermined his father's economic foundation along with the other instances of modern blight. For, after all, how could John James have risen from obscurity to become the largest sherry dealer in England, without the new wealth, and without the improvements in communications and transport? Thus, the autarky at Herne Hill, and later at Denmark Hill, was less a new feudal state established by a socially and commercially successful merchant than a tangible symbol of middle-class insecurity and defensiveness. And the symbol lay under siege from all directions.

It was threatened by a possible working-class revolution, the kind which had at last begun to look possible after the violent events of 1819. From another side came the threat that the incompetent policies of the ruling class might lead to the abrupt ruin of trade, in which case the little Ruskin estate might offer a remnant of security. Finally, it acted as a bulwark against those destructive tendencies which were being unleashed by John James's own entrepreneurial class.

The independent state in the hills above London did not limit itself to the production of milk and apples. It was also the center of gravity for a little family who enjoyed each other's company and were developing a characteristic pattern of life. In addition, ill health necessitated a comfortable domestic refuge. His mother remained sickly for years after John's birth, and his father suffered periodic relapses after his serious bout of illness in 1813. John James dreaded the business trips, often lasting for months, that exposed him to heat, cold, rain, and dust, the laziness of waiters and coach drivers, and the foolish chatter of customers. At night in his hotel room he would write letters to Margaret, often one a day: long, unhappy, nearly illegible monologues, expressing his weariness and disgust. It is important to read these letters because they correct the image of John James as the tough, dour, and dogmatic old curmudgeon, an image which for a long time Ruskin's biographers tended to paint. His letters show him to have been a deeply insecure man with a strong urge to unburden his feelings, and also given to self-accusation: "I know my utter Selfishness & I mourn over it but I mend not in it. Myself only have I all my Life Studied." And

I have a sort of a Schoolmaster within that seems to scorn his pupil that can neither lead me nor whip me forward[,] that goads & soothes & flatters & reprimands but all in vain. I feel I shrink I wince but am in two hours your senseless monster again, an amazing thick coating of Clay has this Carcase of mine—the Spirit shines through it as a Candle through a Horn Lantern—it is all but a total darkness— Some

are made of fine China clay & are clear & transparent— I am composed of absolute mud, incapable of shaping or moulding into anything tolerable or decent. In truth I can put myself into no form that will endure for a single day.

Amazing confessions to come from the pen of Britain's most successful sherry merchant! His two driving motors, "*Will* & Power," have switched off, and doubt undermines that self-confidence, that strong sense of identity, which we automatically attribute to every entrepreneur of his day.

At the same time, we must recognize that self-criticism of this kind *can* be merely a perfunctory exercise, a reflex of duty and convention. No article of faith lay closer to the heart of a Scots Presbyterian than the doctrine of his own worthlessness and depravity. And even in the nineteenth century it was still common practice in Scotland to denounce oneself before the congregation. Young John Ruskin had the same proclivities as his father, and many of his later snippets of self-analysis sound like variations on themes set by John James. In *Praeterita*, he wrote of himself at twenty-three: "I was a mere piece of potter's clay, of fine texture, and could not only be shaped into anything, but could take the stamp of anything, and that with precision."

Thus, father and son alike complain that the stuff of which they are made refuses to take on independent form; that is, an identity. But whereas the father expects *himself* to supply his form ("I can put myself into no form") and despairs of his inability to do so, the son sees at least one positive feature in his protean nature: it lets him absorb impressions from outside and reproduce them accurately. Already we have a statement of what set the son apart from the father, and of what set John Ruskin apart from most of his contemporaries: he saw salvation neither in a well-rounded ego nor in a superego anchored in the world beyond, but rather in the world of things, reality, what in the quoted passage he calls "anything"—which demanded to be perceived and assimilated with precision. The realization of reality ranks before self-realization.

And there is yet another notable difference, if we compare the

parallel quotations of father and son. The father reveals his inner life to only one person, a trusted confidante, whereas the son speaks to everyone who will listen or read. The father found a way out of his cyclically recurring depression by resuming his role as a hard-boiled businessman, and consoled himself with the thought that no man with a wife, a child, and sound business sense could be a total reprobate after all, whereas the son publicized his self-doubt and introspection yet found no release.

Although John Ruskin never threw away his parents' extensive correspondence, we cannot say with any certainty when, if ever, he understood the implications of the letters which John James and Margaret exchanged. Many things in their letters prefigure the themes of his own life and work. This does not necessarily mean that his parents directly influenced him in his behavior in relationships, that he deliberately imitated them, or that he inherited their traits. It was simply that this son who lived with his parents until they died absorbed as a matter of course all aspects of their marital relationship: their mutual solicitude, the serious attention they gave to each other's moods and ailments, the exaggerated devotion stemming from low self-esteem, their anticipation of each other's wishes, their awareness of areas where each was vulnerable or touchy—in short, all the things that tend to stimulate inner life and emphasize its importance.

Yet we should note again that the parents had cause for real concern, especially where their child was concerned. The annual adult mortality rate in Britain at this time was 2.5 percent, meaning that the average adult could expect to live to the age of forty; but the mortality rate for infants in the first year of life was over 16 percent. Consequently—as J.F.C. Harrison comments in his book *Early Victorian Britain*—"the ordinary Victorian family was intimately acquainted with death in a way which is rare today. To ensure two surviving children a married couple could expect to have five or six births." Those who feel, when they read the family correspondence, that the Ruskins fretted and fussed too much should pay more heed to those many passages which tell of the deaths of relatives and friends. To cite just one example, Jessie,

John James's sister, bore ten children and lost six of them during her lifetime. Ruskin's parents were comparatively lucky that their only child outlived them, and almost inevitably, they paid for their good luck by the compulsion to overprotect him.

3

Ruskin expressed widely differing opinions of his parents and of the way they brought him up. "I should have to accuse my own folly bitterly; but not less, as far as I can judge, that of the fondest, faithfullest, most devoted, most mistaken parents that ever child was blest with, or ruined by." And: "In all these particulars, I think the treatment, or accidental conditions, of my childhood, entirely right, for a child of my temperament." The glaring contradiction between these two remarks mirrors that of many other passages and is fundamental to Victorian attitudes in general. The Victorians felt ambivalent about children. Adults who as children were harshly disciplined and at the same time idolized regarded their own children as angels but also as sensual beings with dangerous proclivities. The nineteenth century brought major social advances, and the claim that the Victorian Age invented childhood is undoubtedly true, and yet the most heinous crimes were committed against children in this period. The view that every cultural achievement is counterbalanced by, and closely linked to, a new manifestation of barbarism is certainly borne out in this case. For example, in L. Walther's essay "Invention of Childhood," we read a description of middle-class Victorian family life which says that this was a time when "children were much favored while they were much denied. It was during Victoria's reign that the Christmas tree was introduced to England, that penny and halfpenny and farthing toys became popularly available, that the children's book trade reached previously unparalleled heights in volume and quality. It was also the age in which the early isolation of children from their parents—through the growth of the nursery and Nanny traditions—became established and acceptable in middle class homes; and the child for

whom new games and amusements were being created was also painfully familiar with the cane, the strap, and the riding whip as disciplinary methods."

John James, certainly, did not succumb to the nineteenth-century fashion for discovering poetry and magic in even the most unhappy childhood, and stated curtly: "I have not one pleasing association of my childhood or youth to help me." His son, on the other hand, described the narrow landscape of his childhood as a Garden of Eden, a paradise, albeit a paradise ruled by far stricter laws than the first Eden: for he was forbidden to eat not just one of its abundant fruits but *all* of them—or so he claimed. Nothing could state more succinctly the essence of a middle-class Victorian childhood.

John Ruskin did not accuse his parents of beating him, or of using the customary brutal techniques employed to teach children that kettles are hot and that fingers stuck in doors tend to get pinched. It was rare for Ruskin or for any other Victorian to question the value of punishment or the need to curb a child's early pleasures and passions. No, his main reason for criticizing his parents was that they tried, out of concern for his welfare and from puritanical motives, to bring him up in artificial poverty. "My mother's general principles of first treatment were, to guard me with steady watchfulness from all avoidable pain or danger; and, for the rest, to let me amuse myself as I liked, provided I was neither fretful nor troublesome. But the law was, that I should find my own amusement. No toys of any kind were at first allowed." Dolls given him by a sympathetic aunt were taken away at once, he recalls, and for years his only playthings were a bunch of keys, a cart, and a ball. He was never allowed sweets, pets, playmates, physically strenuous games, or any of the other normal pleasures of childhood. This secluded upbringing, he thought, profoundly affected his life. He claimed to have had "nothing to love," "nothing to endure," and no power to make his own decisions. "I had no companions to quarrel with, neither; nobody to assist, and nobody to thank." "Danger or pain of any kind I knew not: my strength was never exercised, my patience never tried, and my

courage never fortified." "My judgment of right and wrong, and powers of independent action, were left entirely undeveloped; because the bridle and blinkers were never taken off me."

By the time he wrote these remarks, Ruskin was an old man who did not like himself and whose life had gone awry in many ways—not exactly the most reliable of informants. Indeed, recent studies have revealed that his autobiography is riddled with factual errors. A close reading of *Praeterita* shows something wrong in Ruskin's portrait of himself as a young Robinson Crusoe living alone on a green island and never allowed to do what he wants. To cite a few simple facts: the dog bounding along beside the child in Northcote's painting is no fancy of the artist, for there were always dogs in the Ruskin household (one of which once bit John on the upper lip, leaving permanent scars). Nor did Ruskin grow up without the company of other children. The servants' children were there, and often the children of relatives; and John's parents, concerned for his happiness or his proper upbringing, took a young relative, a little girl named Mary, into their home, where they treated her like a daughter. Moreover—fruitless as it may be to try to reconstruct the exact contents of Ruskin's nursery—his father's household expense ledgers show that the elder Ruskins tended rather to refuse their son too little than too much. And what message is conveyed by the following excerpt from a letter which his mother wrote to his absent father, describing young John's third birthday?

John never spent such a birthday you know how bridget loves him she even put a stop to cleaning that the servants might enjoy themselves and every one of the children brought him something he was particularly cheerful himself too and at night he made me feel more joy in him than I think I have felt in any one of his doings or sayings since his birth he had heard me speak to his Aunt of the storm you had been in you know how he listens I was obliged to repeat it all to him again when I did his little heart filled and he said I want my papa home from the wind & the rain I told him

you were out of it now and he cheered up no more was said about it all day but at night when he said his prayers—without even a hint being given or a word said he said "pray God bring my papa home away from the wind & the rain will that do Ann[?]"— is he not a dear lamb[?]

This and many similar documents of the period reflect a shift in attitudes, a growing sensitivity among parents and adults generally to the special qualities and rights of children. Children have always studied the behavior of adults; but only late in history, and under certain specialized conditions, have adults begun to pay attention to the feelings of children. The most important of the required preconditions was the formation of the middle-class nuclear family. In the Ruskins' case, the nuclear family existed in a particularly pure form, so it is no wonder that by 1820 we find them already exhibiting behavioral traits which were not to become the norm until the twentieth century: celebrating a child's birthday, for instance, to the extent of allowing it to dominate all the activities of the household; or writing down things a child said, and collecting specimens of any other medium in which he expressed himself. (Thanks to his parents' habit of dutifully amassing evidence of everything he said or did, we still have a large number of Ruskin's childhood drawings and letters, and of course his juvenilia, the early literary compositions which he began to churn out at the age of seven as if he could not help himself, and which would fill a thick volume if brought to print.) Moreover, Ruskin's parents staged activities and diversions quite suitable for a child: surprises, outings, visits from relatives, and family trips on which they were often accompanied by John's nanny, the same who had cared for Ruskin senior when he was a child.

In short, Ruskin's childhood was not as unstimulating as he remembers it, and there is no evidence of a lack of parental affection or of puritanical strictness. His mother, admittedly, was older than most mothers and perhaps less given to physical contact with the child than was normal. But, on the other hand, both parents under-

went a kind of regression to his level and then kept pace with his development, albeit always maintaining the sober and edifying manner that was all they knew. Both parents worked their way through English literature and scientific journals with their son, while the boy sat every evening in a little recess in the drawing room, like "an Idol in a niche," listening as his father read aloud. When he showed an interest in pictures, his parents brought him panel reproductions and then original artworks. They were equally cooperative when he turned to natural history. Not only did John James and Margaret quietly supply everything his childish curiosity desired, but in a sense they joined him in his studies, accompanying this perceptual giant into a school of their own making, which they refurnished again and again, so that it always brimmed over with equipment and objects of study.

This disparity between Ruskin's memory of his childhood and its reality does not necessarily imply that he was mistaken in his judgment or in assigning blame to his parents. It is certainly possible for a person to be wrong about the facts but right about the general picture. His parents brought up their child as best they knew—that is, they followed the best available model. They raised him at home and gave him an upper-class education, but blended it with more stringent middle-class values such as devotion to religion, the zeal for knowledge, the taste for art. The child never lacked possessions and stimulation, company and interesting experiences. But—and it is here that his criticisms seem justified—everything with which he came into contact was selected for him, weighed and measured, given the parental seal of approval.

Once grown to adulthood—though still looked after by his parents—John Ruskin developed a theory of education quite different from the one he had experienced, and different, too, from the type of state education which was then coming into vogue. His chapter on "The Two Boyhoods," from Volume Five of *Modern Painters* (1860)—famous for its contrasting descriptions of Giorgione's childhood in Venice and Turner's childhood in London—secretly states what Ruskin felt was missing from his own childhood:

Born half-way between the mountains and the sea—that young George of Castelfranco—of the Brave Castle:—Stout George they called him, George of Georges, so goodly a boy he was—Giorgione.

Have you ever thought what a world his eyes opened on—fair, searching eyes of youth? What a world of mighty life, from those mountain roots to the shore;—of loveliest life, when he went down, yet so young, to the marble city—and became himself as a fiery heart to it?

A city of marble, did I say? nay, rather a golden city, paved with emerald. For truly, every pinnacle and turret glanced or glowed, overlaid with gold, or bossed with jasper. . . . A wonderful piece of world. Rather, itself a world. It lay along the face of the waters, no larger, as its captains saw it from their masts at evening, than a bar of sunset that could not pass away; but for its power, it must have seemed to them as if they were sailing in the expanse of heaven, and this a great planet, whose orient edge widened through ether. . . . As not the flower, so neither the thorn nor the thistle, could grow in the glancing fields. Ethereal strength of the Alps, dreamlike, vanishing in high procession beyond the Torcellan shore; blue islands of Paduan hills, poised in the golden west. Above, free winds and fiery clouds ranging at their will;—brightness out of the north, and balm from the south, and the stars of the evening and morning clear in the limitless light of arched heaven and circling sea.

Such was Giorgione's school—such Titian's home.

Near the south-west corner of Covent Garden, a square brick pit or well is formed by a close-set block of houses, to the back windows of which it admits a few rays of light. Access to the bottom of it is obtained out of Maiden Lane, through a low archway and an iron gate; and if you stand long enough under the archway to accustom your eyes to the darkness you may see on the left hand a narrow door, which formerly gave quiet access to a respectable barber's shop, of which the front window, looking into Maiden Lane, is still

extant, filled, in this year (1860), with a row of bottles, con-
nected, in some defunct manner, with a brewer's business.
A more fashionable neighbourhood, it is said, eighty years
ago than now—never certainly a cheerful one—wherein a boy
being born on St. George's day, 1775, began soon after to
take interest in the world of Covent Garden, and put to service
such spectacles of life as it afforded.

No knights to be seen there, nor, I imagine, many beautiful
ladies. . . . [Instead,] dusty sunbeams up or down the street
on summer mornings; deep furrowed cabbage-leaves at the
greengrocer's; magnificence of oranges in wheelbarrows
round the corner; and Thames' shore within three minutes'
race.

Profoundly different though their circumstances may have been,
with regard to their natural and human environments, the boy
Giorgione and the boy Turner had one thing in common: the
unregulated variety, the raw impact of their surroundings. Their
world was unprocessed, both in the sensory impressions they re-
ceived and in the rough-and-tumble conduct of their lives. Turner,
for instance, was a Huckleberry Finn type who spent all day hang-
ing around the river, whose playroom was the harbor and the
marketplace, whose first teachers were prostitutes and seamen.
Ruskin describes him as a child not unlike Sam Weller in Dickens's
Pickwick Papers, whose father tells Pickwick: "I took a good deal
o' pains with his eddication, sir; let him run in the streets when
he was wery young, and shift for his-self. It's the only way to
make a boy sharp, sir." Ruskin had great appreciation for this kind
of unstructured, practical upbringing—not only because of his af-
fection for Turner but because, as he wrote in another volume, "It
is not the going without education at all that we have most to
dread." His parents must have shuddered to read such remarks.
They would never have dreamed of letting their child out onto the
street to play unsupervised with youngsters his own age, or of
accepting the resultant escapades, pranks, and brawls as normal
childhood behavior.

However, Ruskin rejected the idea that children could be pre-pared for life by exposing them to the kind of Darwinistic free-for-all popularized in the 1857 novel *Tom Brown's School Days*, written by fellow Oxonian Thomas Hughes. He also opposed any national program of education which would universalize the kind of circumscribed training that he felt he had suffered in his own childhood. Whereas the Swiss educational theorist Johann Pesta-lozzi said that middle-class children should not be taken into the woods because the trees there "are not arranged in systematic order, in an unbroken sequence," Ruskin preferred children to learn out-side the schoolhouse. And while the educational psychologists of his century were recommending that classroom walls be solidly whitewashed, Ruskin pictured them painted in bright colors and crowded with things to look at. From his first major writings to the last, his autobiography, Ruskin's thought was dominated by the idea of richness, of abundance; and his theory of education is no exception. His own childhood was a pattern of instruction devised by wealthy parents and by no means without its charms. What it lacked—and what Ruskin believed to be an indispensable part of the concept of "wealth"—was the element of the uncon-trolled, the adventurous and accidental. His final judgment of his own education—"that it was at once too formal and too luxuri-ous"—seems to get to the heart of the matter more directly than complaints about sensory impoverishment, loneliness, and re-jection.

4

Nothing very exciting happened in the Garden of Eden at Herne Hill during the years when Ruskin was growing from a little "idol" into a "little phenomenon." "I never had heard my father's or mother's voice once raised in any question with each other; nor seen an angry, or even slightly hurt or offended, glance in the eyes of either. I had never heard a servant scolded; nor even suddenly, passionately, or in any severe manner, blamed. I had never seen a moment's trouble or disorder in any household matter; nor any-

thing whatever either done in a hurry, or undone in due time."

Young John's schooling was all carried on at home. At the age of four he began to read and write, and soon the mornings were formally assigned to schoolwork. His mother read the Bible with him and gave him whole chapters to memorize. He pursued drawing, or rather copying, without any guidance or prompting. He studied Latin systematically, with the aid of a dictionary and a grammar; he learned geography from books filled with beautiful illustrations. Mathematics was comparatively neglected. Besides all this, he went far beyond the normal home-teaching curriculum in his reading matter and devoured everything his father read aloud in the evenings and every book that was bought for him. This literature included a great deal of popular science: geology, meteorology, astronomy. At the age of seven, John began to disgorge all he had been fed by writing his first poems, dialogues, scientific treatises, plays, and novels. His poetical writings became his main occupation. When his father was away, John preferred to compose something for him rather than to write him a letter. On March 4, 1829, his mother wrote to her husband, apologizing for the brief note sent him by their son: "He has commenced writing a novel & a Sermon."

Contrary to Ruskin's later claims that it was his mother who kept him at his rhyming and so spoiled him, his parents' letters tell us that his mother tried to curb his authorial drive. It was his father who started dreaming of having a writer as a son and who gave John various sorts of encouragement, even awarding him a shilling for each page produced. Once, when his mother begged him to do something else for a while, John replied: "Well Mamma as you think I had better put this aside for awhile I will but then you must give me some subject for an Epic." So mother and son went out to the post office, but no sooner had they returned than the son sat down at the table and started writing again. His mother renewed her reproaches, whereupon he answered: "Why Mamma in the forenoon you almost put me out of heart about it and I thought I would give it up but I have so much to say it does not give me the least labour and is so delightful and pleasant to me

that I really cannot give it up." "What in this case do you think should be done[?]" the mother then asked the father. "I cannot think." In his fanatical zeal to turn everything into grist for his poetic mill, John even wrote a poem about the fight he had with his mother when she told him to go to bed just as he was trying to squeeze in one last poem.

The works of the child author range from epic poems "On the Universe" and "On Happiness" to one entitled "Want of a Subject." Many themes seem to prefigure Ruskin's later work, and there is also much which later disappears altogether—for example, an interest in modern machinery. (His first poem was an ode to the steam engine!) But his thematic interests appear to have been outweighed by a concern for poetic form. Ruskin was experimenting with the uses of language and applying his findings to a vast range of subjects, not just the so-called poetic. His gradual mastery of the medium gave him a sense that the world—both the prosaic elements of everyday family life and the abstract elements of the sciences—was controllable. He acquired a feeling of competence that stayed with him all his life.

Objective and subjective factors combined to enhance his self-confidence. In the early nineteenth century, the sciences—even in their most advanced form—still lent themselves to poetic depiction, as we see from English poet Erasmus Darwin's didactic poem "The Temple of Nature, or the Origin of Society" (1803). Goethe's *Theory of Colors* (1810 ff) shows that the reverse was also true, that science could still profit from aesthetic insights. That non-professionals could still advance science through playful experiment is further documented by the work of the independently wealthy Joseph Nicéphore Niepce, who in 1816 began experiments which would eventually lead to the invention of photography. This was a time when an individual could still be competent in a variety of fields. Henry Fox Talbot, for example, another pioneer of photography, also made a name for himself as a mathematician, philologist, mythologist, and chemist. The sciences were steeped in myth, especially Christian myth—a matter to be discussed at greater length later in this chapter.

All this does not mean that a seven-year-old boy could hold his own with adult scientists; but the world of science did not seem to him hostile and impenetrable. Its variety and charm could be conveyed by word and picture, and it was empirical, tangible. This made it possible for the boy to imitate at least its outward forms and then little by little to grasp its inner meaning. When he came to write his autobiography, Ruskin quoted a sample of his early writings, well suited to illustrate these points. He chose an excerpt from a work he wrote at age seven. This "book," an imitation of the popular dialogues of Jeremiah Joyce and Maria Edgeworth, was handwritten in an imitation of type, a clear indication that Ruskin was already entertaining thoughts about publishing his work. Indeed, the "little boy" had only four years to wait before he would see one of his poems in print.

Here is the end of the first (and only) volume of *Harry and Lucy*, as Ruskin himself published it in *Praeterita*:

Harry knew very well-
what it was and went
on with his drawing but
Lucy soon called him aw-
ay and bid him observe
a great black cloud from-
the north which seemed ra
ther electrical. Harry ran

for an electrical apparatus which
his father had given him and the-
cloud electrified his apparatus positively
after that another cloud came which
electrified his apparatus negatively
and then a long train of smaller
ones but before this cloud came
a great cloud of dust rose from
the ground and followed the pos
itive cloud and at length seemed
to come in contact with it and
when the other cloud came
a flash of lightning was seen
to dart through the cloud of
dust upon which the negative
cloud spread very much and
dissolved in rain which pres
ently cleared the sky
After this phenomenon was over
and also the surprise Harry began
to wonder how electricity
could get where there was
so much water but he soon-
observed a rainbow and a-
rising mist under it which
his fancy soon transform
ed into a female form. He
then remembered the witch of
the waters at the Alps who
was raised from them by-
takeing some water in the-
hand and throwing it into
the air pronouncing some
unintelligable words. And
though it was a tale it-
affected Harry now when
he saw in the clouds some-
 end of Harry thing
 and Lucy like it.

In *Praeterita*, Ruskin explained what he felt was the significance of this curious scientific fantasy; namely:

> That the adaptation of materials for my story out of Joyce's *Scientific Dialogues* and *Manfred*, is an extremely perfect type of the interwoven temper of my mind, at the beginning of days just as much as at their end—which has always made foolish scientific readers doubt my books because there was love of beauty in them, and foolish æsthetic readers doubt my books because there was love of science in them. [Also,] that the extremely reasonable method of final judgment, upon which I found my claim to the sensible reader's respect for these dipartite writings, cannot be better illustrated than by this proof, that, even at seven years old, no tale, however seductive, could "affect" Harry, until he had seen—in the clouds, or elsewhere—"something like it."

The subject matter of *Harry and Lucy* is also symptomatic of Ruskin's future development. Clouds, dark and otherwise, always fascinated Ruskin—indeed, they haunted him—right into his old age. One of his very last works was called *The Storm-Cloud of the Nineteenth Century*. By then, however, he no longer envisioned witches in the clouds. Instead, after carrying out detailed observations of the overcast sky, he thought he could read there a prefiguration of Apocalypse, of the end of the world. *Coeli Enarrant* (*The Heavens Tell*) was the title he gave to a collection of his texts on clouds. To read what nature had to say about man, to keep open the bridges between the human world and the world of inanimate objects, and between art and the sciences: that was Ruskin's life's work, the task to which he devoted himself, through changing circumstances, from childhood on.

Very likely, the reason he took such a lively interest in clouds as a boy was that they would not submit to the confined, pinned-down world of Herne Hill. They were a faraway, unconstrained reality. True, they also brought other realities with them: fog, smog, dirt, and gloom, all of which the Ruskins had been at pains

to shut out of Herne Hill—all things which, even then, were largely attributable to the environmental pollution of the London metropolis. At ten, Ruskin wrote a poem "On the Appearance of a Sudden Cloud of Yellow Fog Covering Everything with Darkness," an accurate and dramatic description of this blight upon the climate, albeit without an explanation of the causes:

It low'red upon the earth,—it lay
A champion in the face of day:
It darkened all the air around,
It let not free a single sound:
A leaf stirred not: the trees stood still;
The wind obeyed the darkness' will;
Not a thing moved; 'twas like the night. . . .

5

In the summer of 1835, the Ruskin family went on a six-month tour of France, Switzerland, and Italy. John packed into his luggage a cyanometer for measuring the intensity of blue of the sky, a notebook for recording geological observations, a sketch pad, a square rule and a large foot rule to help him copy the architecture correctly, a diary, and of course enough paper to write a poetic rendition of his trip. "I determined that the events and sentiments of this journey should be described in a poetic diary in the style of *Don Juan*, artfully combined with that of *Childe Harold*."

He prepared for the journey by studying Saussure's *Voyages dans les Alpes*, William Brockendon's *Illustrations of the Passes of the Alps*, and Robert Jameson's *System of Mineralogy*, as well as by non-stop digestion of all poetic descriptions of the area—led of course by the aforementioned works of Byron. Samuel Rogers's *Italy*, and the poems of Wordsworth, Shelley, and Coleridge, served as poetical travel guides in the absence of a proper British guidebook. These writings were supplemented by pictorial works like Samuel Prout's *Sketches in Flanders and Germany*.

The trip to the Continent which the Ruskins took in 1835 set a pattern for their many subsequent journeys together and for those that John would make on his own, although it was not their first joint tour. Starting when John was three, they had begun to travel around the Lake District and Scotland, and mother and son often accompanied the father on his business trips, crisscrossing the whole of Britain. Then, cautiously, they extended the radius of their tours onto the Continent: first to Paris, then across the Alps to Genoa. In 1835, their route crossed France and Switzerland to Italy, and concentrated on Chamonix and Venice. This route became canonical: Ruskin, who spent approximately half his life in travel, was to follow it twenty-six times in his life, with minor variations and abbreviations. "A traveller I am / And all my tale is of myself," Wordsworth wrote, and the lines apply equally well to Ruskin—provided that one deletes the word "myself" and substitutes "the things I see."

Like Byron, Wordsworth, Shelley, Samuel Rogers, and indeed the majority of English authors of the early nineteenth century, Ruskin wrote travel books. His titles alone make that clear: *The Stones of Venice, Verona and Its Rivers, Mornings in Florence, The Bible of Amiens*. Others of his main works—*Modern Painters* and *Fors Clavigera*, to name only two—brim over with descriptions of his journeys or observations he gathered while abroad. The title of a late work, *On the Old Road*, might serve as a motto for almost the whole of his life.

Ruskin's traveling skills were acquired in "the olden days of travelling, now to return no more"; that is, before the coming of the railroad.

In the olden days of travelling, now to return no more, in which distance could not be vanquished without toil, but in which that toil was rewarded, partly by the power of deliberate survey of the countries through which the journey lay, and partly by the happiness of the evening hours, when from the top of the last hill he had surmounted, the traveller beheld the quiet village where he was to rest, scattered among the

meadows beside its valley stream; or, from the long hoped for turn in the dusty perspective of the causeway, saw, for the first time, the towers of some famed city, faint in the rays of sunset—hours of peaceful and thoughtful pleasure, for which the rush of the arrival in the railway station is perhaps not always, or to all men, an equivalent.

After some unhappy experiences traveling by public mail coach, the Ruskins extended to the Continent the same practice they had formed in England: they hired or bought their own coach. This was more expensive, and it increased their party from four or five—the parents, John, Mary, and usually the nurse—to seven or eight, by adding two postilions and a courier. But this style of travel had such advantages that they soon felt it was indispensable.

To all these conditions of luxury and felicity, can the modern steam-puffed tourist conceive the added ruling and culminating one—that we were never in a hurry? coupled with the correlative power of always starting at the hour we chose, and that if we weren't ready, the horses would wait? As a rule, we breakfasted at our own home time—eight; the horses were pawing and neighing at the door (under the archway, I should have said) by nine. Between nine and three,—reckoning seven miles an hour, including stoppages, for minimum pace,—we had done our forty to fifty miles of journey, sate down to dinner at four,—and I had two hours of delicious exploring by myself in the evening; ordered in punctually at seven to tea, and finishing my sketches till half-past nine,—bed-time.

Later, when Ruskin traveled without his parents, he would sometimes journey by rail, but he used coaches whenever possible. "Going by railroad I do not consider as travelling at all; it is merely 'being sent' to a place, and very little different from becoming a parcel." By the 1870s, stagecoaches were used only for short-distance travel; but Ruskin had a large traveling coach built es-

pecially for him and, when he traveled in it, attracted as much attention as if he were riding in a steam-driven automobile.

The Ruskins felt that owning their own transport was not merely a luxury and a convenience but a necessity: for their son was the kind of person who felt compelled to stop to examine a particular landscape which he had seen in a painting by Turner or Samuel Prout; who wanted to leave the main road to study an interesting geological formation; and who, above all, needed time and more time to record new or familiar sights in elaborate drawings.

What is the proper title for a person who travels equipped like the young Ruskin, who pursues such an active itinerary, who returns home laden with poems, drawings, geological samples, and scientific notes: material enough to occupy him until his next journey? We might, I suggest, call him a studying traveler or a poet-observer, a type distinct from all earlier and later species of traveler: different, that is, from the traveling aristocrat and the curiosity hunter, from the traveling scientist or artist, and also from the tourist or cultural sightseer of our own day.

The Ruskins were middle-class travelers at a time before middle-class people began to travel in any significant number; while traveling, they moved in a sort of social vacuum. The upper classes had always been fond of travel and had their own characteristic behavior patterns, their own destinations and interests. Business travelers, too, had their own routes and habits, as John James knew better than anyone. When the Ruskins went on their study tours, the father would always ask for the second-best hotel rooms because he felt that this was in keeping with his median social status. Although he wanted something better than the quarters used by traveling salesmen and other commercial travelers, he did not want to stay in the best rooms, lest one of his many noble clients turned up unexpectedly and wanted the best for himself. For the same reason, he never sent his courier ahead to prepare a change of horses for his coach, because he regarded a mounted courier as another privilege of the nobility.

What distinguished travelers like the Ruskins from all other travelers of the past or their own time was their social isolation,

their anonymity. For the traveling aristocrat or the curiosity hunter, and even for scientists and artists, travel was fundamentally a matter of making contact with other people. The Ruskins, exemplifying the priorities of the new studying traveler, focused on *things*.

Since the seventeenth century, people had toured Europe with a long list of names and addresses, to which they added whenever they could. The nobility had their far-flung network of relatives and contacts, duty calls to pay on the local gentry, and special "watering places." The middle class had their own smaller network, made up of business correspondents and trading partners. They, too, carried letters of recommendation and kept lists of suggested contacts among the local persons of influence; and they could always turn to other members of their own class, who held senior positions at public institutions like libraries, art galleries, universities, and academies. To most people, traveling meant moving as fast as they could through long, boring stretches of wilderness so as to arrive at an island of civilization, where they would then settle down for a while, making and receiving visits. The Ruskins, on the other hand, avoided the fashionable spots and were likely to stop almost anywhere along the road. They spent no more time with the locals than was necessary to arrange their travels and, unless they accidentally ran into someone they knew, were always alone wherever they went.

During the family's early trips through England, the father's business concerns forced him to steer for the houses of the gentry, but later they were free to keep to themselves. They never even made arrangements to be shown private art collections or other notable sights that were privately owned. As dutiful members of the middle class, they stuck to what was open to the public: the few state- and community-run museums; the churches; nature's monuments and anything else that could be seen out-of-doors. A typical feature of the Ruskins' traveling style was the way they always kept their distance, and this trait had far-reaching effects on John Ruskin's future work. For instance, one reason that he devoted so much attention to the features of Catholic churches,

despite his unfamiliarity with and dislike of the Catholic religion, was simply that, of all the architectural monuments of Europe, Catholic churches were the most accessible to the traveler. Although he was extraordinarily sensitive to everything which could be grasped by the eye, his deeply engrained stance as an outsider partly explains why he did not acquire an adequate understanding of the functional aspects of art and especially of architecture: because to understand these things fully he would have had to talk to people and ask questions. It also explains why he always viewed art as an inferior adjunct of nature, not only because nature was his first love but also because it could be experienced without constraints. Nature left him free to enjoy what—in describing the trip of 1835—he called his "entire delight," which was "observing without being myself noticed,—if I could have been invisible, all the better."

Ruskin tried to refine himself into a "pure eye," an organ without any body attached, without social and historical obligations. But nimbly and freely as it may play over surfaces, such an organ is incapable of penetrating them. The eye is, literally, defenseless. It has to get along without the aid of property, convention, the counsel of experts. Seventeenth- and eighteenth-century travelers reflected the mechanistic world view of their time, in that everywhere they went they had one main question on their minds: How does it work? Whatever they saw, natural or man-made, they wanted to know what lay behind or inside it, what made it tick. They preferred watching the pressure derrick of a well to seeing the jet of water shoot up; they wanted to observe the hoisting machinery backstage at the theater, rather than the gods rising toward heaven on stage. And the key to all the machinery, they thought—and to works of art as well, for weren't these, too, half composed of tricks and gadgets?—was *people*. To study things meant to find out about the inventor or artist: how things were made or acquired and incidents or anecdotes connected with them.

The new nineteenth-century traveler pursued an opposite course. He had his own form of information gathering, which was to approach the object alone and without constraints, in the "free-

dom" of nature, or in an art collection open to the public, and there to concentrate wholly on its outward aspect, on the "impersonal" data it supplied—an isolated observer of an isolated phenomenon. Ruskin was one of the first true representatives of this type. He cared nothing for the opinions of guides, either in the flesh or in books. The only things he considered valid were his own analyses and his own visual composition of chosen objects.

But at the moment it is only 1835, and Ruskin has not yet had a chance to realize and defend his methodology. So far, he is simply filling in the blanks, following the lead of people around him. "My father liked a view from his [hotel] windows, and reasonably said, 'Why should we travel to see less than we may?'—so that meant first floor *front*." Concentration on the outward aspect brought the risk of being dominated by the outward charm. That was the risk John ran, unwittingly, in these apprentice years. The possible reward lay in the chance that, through sight, he might progress to insight.

The Ruskins, as we have said, gravitated mainly to places devoid of the cultural and social attractions sought by the old-style traveler. In a sense, they filled in the gaps between other people's destinations, and journeyed to empty places on the map. They were long-term guests not on the Riviera but in the Chamonix Valley, years before it became a tourist center. They valued Lucca more than Florence and spent much more time in Abbéville than in Paris:

> About the moment in the forenoon when the modern fashionable traveller, intent on Paris, Nice, and Monaco, and started by the morning mail from Charing Cross, has a little recovered himself from the qualms of his crossing, and the irritation of fighting for seats at Boulogne, and begins to look at his watch to see how near he is to the buffet of Amiens, he is apt to be baulked and worried by the train's useless stop at one inconsiderable station, lettered ABBEVILLE. As the carriage gets in motion again, he may see, if he cares to lift his eyes for an instant from his newspaper, two square towers, with a curiously attached bit of traceried arch, dominant over

the poplars and osiers of the marshy level he is traversing. Such glimpse is probably all he will ever wish to get of them; and I scarcely know how far I can make even the most sympathetic reader understand their power over my own life.

It is permissible, even essential at this point, to mention the resemblance between the towers of St. Riquier in Abbéville and the bell tower of St. Hilaire in Combray: for, dear as the former were to Ruskin, the latter was equally dear to Proust, who said of his bell tower that it lent to all the town's activities, times, and spectacles their aspect, their culmination, and their blessing; and moreover, that it was able like nothing else to connect him with what was deepest in his life. (See Part I, "Combray," Chap. 2 of *Du côté de chez Swann.*) We need to note this connection here, because it was Proust who translated Ruskin into French, and because Abbéville and Combray fulfilled a similar function in the lives of the two men as a home away from home.

We may, for a moment, wonder why the cautious denizens of Herne Hill were willing to expose themselves each year to the rigors and hazards of a long journey. We may even wonder how, in the light of these many journeys, Ruskin can ever have felt that his childhood lacked excitement and stimulation. The answer to both questions is that the Ruskins' traveling style was such that in a sense they never left home. Indeed, for the middle class, travel meant arranging things so that they were always at home wherever they went. The Ruskins had their own special route, their own favorite lodgings, their own private destinations, their favorite views, "their" couriers and mountain guides; and all these things remained unchanged over a period of decades. "The reader must pardon my relating so much as I think he may care to hear of this journey of 1835, rather as what *used* to happen, than as limitable to that date; for it is extremely difficult for me now to separate the circumstances of any one journey from those of subsequent days, in which we stayed at the same inns, with variation only from the blue room to the green, saw the same sights, and rejoiced the more in every pleasure—that it was not new."

This passage makes clear another marked difference between the Ruskins and traditional travelers. Byron had described travel as life's most powerful excitement besides ambition, as something whose purpose was heightened sensation, an intensification of the sense of being alive. Thus, his Childe Harold is said to seek change at any cost, even death. But the Ruskins, when they traveled, were searching not for the new but for the old. Their journeys were homecomings. They derived from travel superimposed images of the same things, enriched each time by the change of perspective. To them, changes were a source of sadness rather than of pleasure and diversion. In 1833, Ruskin had noticed the unusual blue of the Rhône in Geneva, and the following year he published some brief remarks about it in Loudon's *Magazine of Natural History*. In 1835, when he returned to Geneva, he then filled his diary with fresh observations on the color of the river and referred to it in his rhymed account of his journey. He went on writing about the same subject year after year, and his final work, his autobiography, contains a celebrated and often-quoted passage about the Rhône's remarkable blue.

Ruskin commented frequently on his affection for the familiar. He referred to Geneva as a second home, a second center of his life, and it was there that he entered this passage in his diary on June 5, 1841, at the age of twenty-one: "I have been very happy all day, seeking out all my well known old haunts. There has been much building about the place, but still it is the same about the Hotel des Etr[anger]s, and the gravelly walk and old wooden seats are precisely what they were . . . and I felt six years younger." Earlier he had written: "I never can enjoy any place till I come to it the second time." And: "I believe the only part of a journey really enjoyable to be the first six weeks, when every feeling is fresh, and the dread of losing what we love is lost in the delirium of its possession."

The aim of the middle-class traveler is to turn what is no one's property into his own internal possession. Ruskin's compulsive need to view the same sights again and again results from his dread of not seeing adequately, of not having really seen what he saw,

and so losing it. Thus, we have the following lament, which seems so extreme for a man who has hardly begun his life:

> I was tormented with vague desires of possessing all the beauty that I saw, of keeping every outline and colour in my mind, and pained at the knowledge that I must forget it all; that in a year or two, I shall have no more of that landscape left about me than a confused impression of cupola and pine. The present glory is of no use to me; it hurts me from my fear of leaving it and losing it.

Ruskin lived by two main strategies. One was to convert the *déjà-vu*, the already seen, into the *déjà-vécu*, the already lived, and to recharge himself over and over from the same objects and scenes. The other was to develop techniques of assimilating and incorporating what he saw so as to conserve "the present glory" without killing it off. His concentration on seeing meant concentrated seeing, repetitive, patient percipience, the inward expansion of the zone of vision.

"There was always more in the world than men could see, walked they ever so slowly; they will see it no better for going fast." This was the central message broadcast by the adult Ruskin, the message instilled in him by his travel experiences as a child and a young man. And yet he seems to have felt this way from the very start, as we can see by the following short excerpt from his childhood work *Harry and Lucy*, describing the attractions of a family outing:

> such a fine day that they all got out and walked a good way they had intended to walk very quick but they did not for they were attracted by such variety of objects such as the white major convolvolus in the hedges the black & white broad beans the butterfly like pea's the sparkling rivulets and winding rivers all combined their forces to make them walk slowly.

The late-eighteenth-century cults of the picturesque and the sublime vastly expanded the range of what was considered aesthetically appealing, so that people now went out of their way to look at sights which previously they would have ignored. The Ruskins, too, benefited from this enrichment of the visible. "A very few years,—within the hundred,—before [I was born], no child could have been born to care for mountains, or for the men that lived among them, in that way. Till Rousseau's time, there had been no 'sentimental' love of nature; and till Scott's, no such apprehensive love of 'all sorts and conditions of men.' " Nor, we may add, until the time of William Gilpin, a leader of the cult of the picturesque, did people take any aesthetic interest in Tudor nooks, low-slung peasant cottages, and stunted willow trees.

In the seventeenth and eighteenth centuries, a traveler—assuming that he was not simply out for pleasure and adventure—would collect data on the great theme of man's power and dominion over nature. In a foreign country, he would want to know about its machines, its technical skills and memorabilia, and its methods for maintaining civic order. This type of traveler was then replaced by others, who wanted to see nature that had never been subjugated by man, or human creations that had since been abandoned, and so could be aesthetically ingested by a solitary observer. To stand awestruck before the snow-covered peaks of the Alps, or to derive aesthetic enjoyment from a decaying thatched roof, presupposed that one would ignore the significance these objects might hold for the non-spectator. Much later, Ruskin wrote that the charms we find "in a completely picturesque object, as an old cottage or mill . . . are introduced, by various circumstances not essential to it, but, on the whole, generally somewhat detrimental to it as cottage or mill." What attracts us in the sublime and the picturesque, Ruskin says, are "parasitical" rather than intrinsic qualities stemming from "merely outward delightfulness" and from the fact that they stimulate a flow of associations. These are not—as is the case with the beautiful—qualities or values in themselves but, as Hazlitt says, are "interesting only by the force of circumstances and imagination." The picturesque and the sublime can be enjoyed

if you neither can nor wish to own the object itself: if you confine yourself to traveling and looking.

The young Ruskin had cut his teeth on the poets of the picturesque and the sublime. Undecided whether he preferred Byron's mocking version or the metaphysical direction of the Lake Poets, he experimented with both manners in thousands of lines of verse. Here are just five, in Wordsworth pastiche:

> Give me a broken rock, a little moss, . . .
> for I would dream
> Of greater things associated with these,—
> Would see a mighty river in my stream,
> And, in my rock, a mountain clothed with trees.

In his drawings, the youthful Ruskin imitated Samuel Prout, who drew townscapes and architectural scenes. Like the Ruskins, Prout admired the decaying crannies of Continental cities, bits of rustic architecture, and everyday life in historic settings. His style was extremely mannered and thus easily copied. Embracing the principle that the main quality of the picturesque is the marred or broken, he never drew a straight line in his life but reproduced everything with cracked and jagged contours. To judge by Prout's pictures, there was not a single undamaged building left in all of nineteenth-century Europe, and nothing remained of the grand architectural designs of bygone ages except ruins surrounded by a rusticated race physically and spiritually dwarfed by the monuments of their forebears.

In Britain, however, there seemed to be more of the new all the time—"the world is more and more," Tennyson wrote in 1836. From this vantage point, the crumbling Continent looked like an undiscovered vacuum just waiting to reveal itself to the trained eye of the New Traveler and be filled up with his wealth of associations. Prout's attitude to the small cities of Europe was mirrored by Hazlitt's, in this succinct evocation of the "enchanting" city of Ferrara: "You are in a dream, in the heart of a romance; you enjoy the most perfect solitude, that of a city which was once filled with

'the busy hum of men,' and of which the tremulous fragments at every step strike the sense and call up reflection."

The traveler in search of the picturesque had his own way of experiencing Italy. A sine qua non was that he must ignore the "official" ruins of Roman antiquity and devote himself to his everyday surroundings and to the random blend of culture, nature, and the life of the common people.

Describing his 1840 sojourn in Rome, Ruskin wrote that he "proceeded to sketch what I could find in Rome to represent in my own way, bringing in primarily,—by way of defiance to Raphael, Titian, and the Apollo Belvidere all in one,—a careful study of old clothes hanging out of old windows in the Jews' quarter." A diary entry points up his views about the importance of picturesque detail:

So completely is this place picturesque, down to its doorknockers, and so entirely does that picturesqueness depend, not on any important lines or real beauty of object, but upon the little bits of contrasted feeling—the old clothes hanging out of a marble architrave, that architrave smashed at one side and built into a piece of Roman frieze, which moulders away the next instant into a patch of broken brickwork— projecting over a mouldering wooden window, supported in its turn on a bit of grey entablature, with a vestige of inscription; but all to be studied closely before it can be felt or even seen: and I am persuaded, quite lost to the eyes of all but a few artists.

Thus, Ruskin subscribed almost word-for-word to the view expressed by aficionados of the picturesque, in their dictum—a line from Cicero: *Quam multa vident pictores in umbris et eminentia, quae nos non videmus.* ("How many things do the painters see in light and shadow that we see not.")

The picturesque was an education for the young Ruskin. It taught him to see what other people tended to overlook. He learned that there is something to see everywhere, even in the common-

place and the trivial. He learned to build up a visual impression by putting together the details, rather than turning at once to the grand, ready-made structures. In all these respects—and in one other—he remained faithful to the picturesque in the years to come. Picturesque artists like Prout, and authors like William Hazlitt, looked at history in its present form; they were not interested in idealizing or reconstructing the past. On the contrary, what they valued most was what Ruskin called, in the just-cited passage, "bits of contrasted feeling," the blend of past and present—in other words, some old clothes hanging out of a marble architrave. It is in this sense that Ruskin praises his model Prout for his "ideal appreciation of the present active and vital being of the cities." It may sound strange to hear him say this, considering that Prout always chose to depict scenes of ruin and decay. And yet Ruskin is right: life amid ruins is still life. In Prout's work, culture is changing into nature, and that moment of transition creates the special form of vitality, of which the "hunter of the picturesque" can never get enough. Ruskin, too, was loyal to the actual—not the ideal—aspect of what he saw. The school of the picturesque drew him toward material, phenomenal things, and away from books, archives, data, and numbers. In an age dominated by the historical sciences, it was no small decision to commit oneself to present time.

On the other hand, Ruskin never developed into a "slave to the picturesque," as Hazlitt described himself. Quite the contrary, he has every claim to be considered its first critic. With the ferocity that only the apostate can muster, he writes that the "lower picturesque ideal is eminently a *heartless* one" and that "the lover of it seems to go forth into the world in a temper as merciless as its rocks." We have already noted that the picturesque had its negative sides and potential hazards, particularly in its concentration on outward appearances. Without doubt, Ruskin succumbed to all its temptations in his youth, being innocently led astray both by great models and by the conditioning influences of his own background. Yet he was able to marshal some resistance even at a young age, as his 1835 geological studies show; and later, after undergoing a

period of hostility toward the picturesque, he created a new blend in which he was able to reaffirm its positive features.

Ruskin's main objection to the picturesque was a moral one: those who fell prey to its charms lost touch with the human reality of the people they observed. However, at the age of fifteen or twenty he could not yet be expected to know this. From his point of view, the peril that threatened him had to do with the possibility that he might see nothing more than "merely outward delight-fulness" and patterns that often were accidental; and that his perceptions might inspire him to mental associations which were remote from reality. For, paradoxical as it may sound, these two contrary tendencies—the cult of the concrete and the cult of the abstract—came together in the cult of the picturesque and the sublime. The humble, the accidental, the uncivilized, the unrefined, were made more valuable by the sophisticated attractions they now held for the trained eye. But beyond the concrete attraction, devotees of the picturesque always went on to show links to grander, more abstract values. Matter underwent continual transformation, or was penetrated by something more subtle. "Give me a broken rock, a little moss" was never enough: the poet then wanted to see a mountain in the rock. And if he started out with a mountain—Mont Blanc, for instance, which the Romantic poets regarded as the quintessence of the sublime—he would come up with still more rarefied associations. Byron, after his stay in Chamonix in 1816, wrote: "to me / High mountains are a feeling." Coleridge, in "Hymn Before Sun-Rise, in the Vale of Chamouni," celebrated Mont Blanc in these words:

> O dread and silent Mount! I gazed upon thee,
> Till thou, still present to the bodily sense,
> Didst vanish from my thought: entranced in prayer
> I worshipped the Invisible alone.

As thought and emotion ascend heavenward, the mountain itself gradually joins in:

Rise, O ever rise,
Rise like a cloud of incense from the Earth!

And Wordsworth, it seems, would have preferred his idea of
Mont Blanc to the actual view of it, for he complains of having
"a soulless image on the eye / Which had usurp'd upon a living
thought / That never more could be." Not until he reaches the
Simplon Pass do the mountains appear to him "Characters of the
great Apocalypse, / The types and symbols of Eternity." Hazlitt
put the same experience into prose: "You stand, as it were, in the
presence of the Spirit of the Universe, before the majesty of Nature.
. . . The mind hovers over mysteries deeper than the abysses at
our feet; its speculations soar to a height beyond the visible forms
it sees around it."

When Ruskin took his turn to extol the mountain, he, too, felt
compelled to change his "mountain clothed with trees" into some-
thing more:

That burning altar in the morning sky;
And the strong pines their utmost ridges rear,
Moved like an host, in angel-guided fear
And sudden faith. So stands the Providence
Of God around us; mystery of Love!

It is not my intention here to discuss the caprices of the Romantic
experience of nature. I wish simply to point to a single paradox:
that poets who used the sublime and the picturesque to unlock
new spheres of reality ended by exchanging these newly won real-
ities for suprasensory, imaginative experiences. Hazlitt—as was so
often the case—expressed this most clearly: "Let us leave the real-
ities to shift for themselves," he wrote when his picturesque ex-
pectations were disappointed by the reality—"and think only of
those bright tracts that have been reclaimed for us by the fancy,
where the perfume, the sound, the vision, and the joy still linger,
like the soft light of evening skies!"

But Ruskin, even as a young man, was disinclined to be so

broad-minded. By 1835, the "realities" had gained considerable ground against the "associations, recollections, fancies." Ruskin describes his 1835 tour as an equal blend of science and emotion. For, though the Ruskins wanted to feel what Byron had felt, they also wanted to observe what Saussure, the great Alpine geologist, had observed, or at least John did. An early poem shows that mountains may in fact "tell" him the same sort of thing they told other writers of Romantic nature poetry: they may be a message from God, a presentiment of infinity, an emblem of the beauty of earthly things and of man's inadequacy. On the other hand, mountains might equally well tell him something else, as we see from the following passage picked at random from the diary describing his 1835 tour of the Continent:

> *July 14th.* MARTIGNY. Very fine. The rocks which you pass immediately after leaving St. Gingoulph are exceedingly remarkable. The first are composed of calcareous tuffa, and are moistened by a hundred dripping streamlets, which deposit their carbonate of lime in beautiful translucent brown stalactites, which in some places coat the original rock entirely; some in the progress of formation, instead of being soft and crumbling like lumps of brown sugar, as some stalactites are, were flexible, something like a rather tough paste. The rocks which are below this tuffa break out soon afterwards—iron-stone veined with quartz—in thin layers, divided by lamina of indurated blue clay rendering the rock easily separable. In one piece I found a quartz vein pierced through by a long cylindrical hole, quite filled with blue clay.

Here, Ruskin is a geologist who fills a whole book with similarly exact observations; here, he is faithful to appearances. He can, of course, still find beauty in what he observes; but he does not yield to the compulsion to admire the Alps simply because of their ruined look—"a ruined universe"—which made English travelers find them so picturesque, so "rustic." ("Rural" was the epithet that Byron heard from an English lady in Chamonix.)

Nor does Ruskin immediately start seeing the stalactites as the handiwork of God. His self-taught geology was an experimental science demanding prolonged and many-sided examination of an object. The same was true of meteorology, which Ruskin pursued with equal zeal. Both sciences—of the earth and of the sky—lent themselves to study by the layman, who could enrich them by careful observation. Jameson's *System of Mineralogy*, which Ruskin used to guide his geological studies, promised readers that the author had classified his minerals according to their external qualities, so that no knowledge of chemistry was required to pursue their study.

Ruskin also praised Saussure because "I found Saussure had gone to the Alps, as I desired to go myself, only to *look* at them, and describe them as they were, loving them heartily—loving them, the positive Alps, more than himself, or than science, or than any theories of science." Thus, the young amateur of outward delights and outward information focused on two vast but distinct realms of study: the field of the accidental and the field of characteristic features. But different though they were, the two had one thing in common: they were accessible not to analytical but only empirical effort. His empiricism was to be Ruskin's most enduring and valuable quality. In his youth, he quite naturally found it hard to discern the common factor in his many divergent interests. It was not that he actually experienced the diversity as stressful, but he did feel a need to separate "science" from "feeling." He did not long to sacrifice one to the other as the young are wont to do, but he did want to be able to tell them apart. So, on March 31, 1840, he wrote: "I have determined to keep one part of diary for intellect and another for feeling."

6

His feeling side was not destined solely to compose poetic verses about his observations of nature. His emotional needs went deeper than that. The Garden of Eden at Herne Hill, where one was not

allowed to touch the fruit, was now visited by Eve—but, alas, only visited.

In 1833 the Ruskins had visited their Spanish sherry supplier, Pedro Domecq, in Paris. Domecq, the Spanish partner in Ruskin's firm of Ruskin, Telford and Domecq, was married to an English-woman and had five daughters. In Paris, young John encountered a social world totally different from his own. The Domecqs were nobility: wealthy, urbane, Catholic, ostentatiously fond of luxury; a large family with branches in many nations. They were exactly the sort of people for whom John James always gave up the best rooms in the hotel and who, when they traveled, gravitated toward the fashionable resorts which the Ruskins strenuously avoided. Their daughters attended fine convent schools where they acquired all the social graces: "They were the first well-bred and well-dressed girls I had ever seen—or at least spoken to." John naturally was obliged to be attentive when they wanted to play, dance, and chat with him; but he was very impressed by the skilled conversation of the youngest daughter. He must have found it odd to hear her rave about the Domecq home on the Champs-Elysées and say that she thought all Paris was a paradise.

And then, in 1836, four of the Domecq girls came to visit the Ruskins in London. "A most curious galaxy, or southern cross, of unconceived stars, floating on a sudden into my obscure firmament of London suburb." Ruskin's own account of the visit is unsurpassable, and deserves quoting, because the other sources do not show that it is in any way inaccurate:

How my parents could allow their young novice to be cast into the fiery furnace of the outer world in this helpless manner the reader may wonder. . . . Virtually convent-bred more closely than the maids themselves, without a single sisterly or cousinly affection for refuge or lightning rod, and having no athletic skill or pleasure to check my dreaming, I was thrown, bound hand and foot, in my unaccomplished simplicity, into the fiery furnace, or fiery cross, of these four girls,—who of course reduced me to a mere heap of white

ashes in four days. Four days, at the most, it took to reduce me to ashes, but the *Mercredi des cendres* lasted four years.

Anything more comic in the externals of it, anything more tragic in the essence, could not have been invented by the skilfullest designer in either kind. . . . Clotilde (Adèle Clotilde in full, but her sisters called her Clotilde, after the queen-saint, and I Adèle, because it rhymed to shell, spell, and knell) was only made more resplendent by the circlet of her sisters' beauty; while my own shyness and unpresentableness were farther stiffened, or rather sanded, by a patriotic and Protestant conceit, which was tempered neither by politeness nor sympathy; so that, while in company I sate jealously miserable like a stock fish (in truth, I imagine, looking like nothing so much as a skate in an aquarium trying to get up the glass), on any blessed occasion of tête-à-tête I endeavoured to entertain my Spanish-born, Paris-bred, and Catholic-hearted mistress with my own views upon the subjects of the Spanish Armada, the Battle of Waterloo, and the doctrine of Transubstantiation.

Ruskin wooed Adèle with all the means at his command: he wrote her long letters in laughable French; he wrote a blood-and-thunder tale for her about an Italian bandit, which was actually published; he wrote poems, which were also published. All of this amused Adèle, but less than a fashionable outing or a ball. His courtship was so romantically vague that, although she might suspect, she could not know for certain that the young Englishman had fallen in love with her. John knew, but what he did not know was what to do about it: "I had neither the resolution to win Adèle, the courage to do without her, the sense to consider what was at last to come of it all, or the grace to think how disagreeable I was making myself at the time to everybody about me."

So alert to their son's every mood, his parents recognized the change in him but initially thought it was due to a passing infatuation. Then, as the affair dragged on, they concluded that the infatuation was an illness which they must quietly wait for him to

get over. John stood no serious chance of actually being able to marry Adèle. The daughters of the Domecqs were meant for the sons of the European nobility, and the parents on both sides would have regarded the difference in religion as an insurmountable barrier. Eventually, the girls transferred to an English boarding school, which enabled John to see Adèle a number of times over the next few years; but there was no change in their basic situation. Adèle showed no wish to commit herself, and John elevated her to heavenly rank both in his thoughts and in his verses. He had found his "ideal beloved" and was unhappy and preoccupied. His new feelings are best expressed in two lines of poetry which unfortunately do not represent his best work as a poet:

> Nature has lost her spirit stirring spell
> She has no voice, to murmur of Adèle.

Actually, things were not quite so bad. The years 1836 to 1840 may have been overshadowed by Adèle, but they did not grind to a halt on her account. "Nature's spirit stirring spell" worked on as indomitably as before and, in fact, was the real inspiration behind Ruskin's student years at Oxford. There were also new trips, new works of art to delight in—Ruskin lost interest in Prout as the universe of Turner opened up for him. These other interests and distractions do not dispel Ruskin's claim to deep and serious emotion; but they show he was not as helpless in dealing with it as he may have thought. On the other hand, there is also something rather ominous in the plight of a young man who is reduced to inventing rhymes on his mistress's name, and who knows that his first unrequited love has the sanction of a school of poetry and thought which views love as, by nature, unrequitable.

John Ruskin went through a period of academic tutoring, brief attendances at private schools, and courses at King's College, London, to fill some of the gaps in his unconventional education, before beginning his studies at Oxford at the start of 1837. His mother took stock at this watershed in her son's life and wrote in a letter to her absent husband: "Our child has entered his nineteenth year

without having by his conduct occasioned a moments serious uneasiness to either of us, and as we have the Divine assurance following the commandment, train up a child in the way he should go, & when he is old he will not depart from it, so I think I may venture to prophesy that his future conduct will not differ from the past."

But Margaret cannot have been as confident of her son's well-being as she claims, or she would not have moved to Oxford for the duration of his studies to watch over him—an action that can hardly have helped Ruskin's position at the university. Many years later, in *Praeterita*, he commented that he thought it was very much to his credit that he had never felt his mother's presence to be embarrassing. Thirty years before Ruskin enrolled at Oxford, Byron, then a student at Cambridge, wrote the following in a letter to a friend who had suggested that Byron's mother might be coming to visit him: "You hinted a probability of her appearance at Trinity; the instant I hear of her arrival, I quit Cambridge, though *Rustication* [temporary suspension] or *Expulsion* be the consequence."

"Oxbridge" undoubtedly made a more suitable setting for a dandy like Byron than for the studious, knowledge-hungry John Ruskin. Byron had pointed out in 1805 that "College improves in every thing but Learning[:] nobody here seems to look into an author ancient or modern if they can avoid it. The Muses poor Devils, are totally neglected." What had been true then was still true in 1837, especially for students from high-born or wealthy families. They could afford to cut themselves off from the ordinary students, the commoners, and from ordered study activities.

John James, of course, had spared no expense to ensure that his son was registered at Oxford as a "gentleman commoner." This did not mean that he would get a different or better standard of education, but merely that he would not be required to take an entrance examination, would be entitled to better lodgings and food, and would rub shoulders with the nobility. His dinner companions, next-door neighbors, and daily associates were young noblemen, a fact which deeply gratified his parents but does not

John Ruskin, Merton College, Oxford, *1838. Pencil.*
Education Trust, Brantwood, Coniston

appear to have meant much to John himself. He had gone to Oxford to study, whereas the students of noble birth thought of their three years' stay as an opportunity for amusement. As a result, John had to fight a clique of young playboys to defend his right to study, while at the same time defending himself against his parents' reproaches that he was cutting himself off from the other students and losing out on the chance to form contacts with men of rank. Despite the close eye his parents kept on him, they appeared not to understand the conflict into which they had plunged him. Later, Ruskin reprimanded them for it:

> You and my mother used to be delighted when I associated with men like Lords March & Ward—men who had their drawers filled with pictures of naked bawds—who walked openly with their harlots in the sweet country lanes—men who swore, who diced, who drank, who knew *nothing* except the names of racehorses—who had no feelings but those of brutes—whose conversation at the very hall dinner table would have made prostitutes blush for them—and villains rebuke them—men who if they could, would have robbed me of my money at the gambling table—and laughed at me if I had fallen into their vices—& died of them.

In a different letter, Ruskin tells how one day, when he had no classes, he used the free time to make drawings of his college, Christ Church, while two of his aristocratic fellow students spent the day racing each other on horseback along the road from Oxford to London and back again. Six hours later, just as he was packing up his drawing pencils, the two returned: first the winner, and hard on his trail the loser, who was now on foot after having ridden one horse to death and broken the legs of a second.

In spite of this often sharp contrast between Ruskin and his classmates, at no other time in his life did he conduct himself as adroitly as during his studies at Oxford, and in no other setting was he as successful at human relations. He parried with ease the constant interruptions, pranks, and tactless intrusions of the young

rogues. He would take part in their drinking bouts when it seemed called for, and proved he could hold his liquor, like the good wine dealer's son he was. He shared out his allowance as evenly as possible, and clearly he was well liked, for otherwise the young lords would not have made such persistent efforts to win over a bookish, middle-class student. He sought the company and friendship of the few like-minded young men at Oxford, who were equally fond of him. A twenty-year-old who had traveled extensively and was proficient in many fields, and who had files and drawers filled with the amazing objects he had collected, was a rare find even at Oxford, and he was soon admitted to scientific societies and invited to the dinner tables and evening gatherings of various faculty members. He accepted good-naturedly the indifference or outright rebuffs of the majority of the dons, like the classics lecturers who tended their field like the Holy Grail and soon realized that Ruskin was not interested.

John managed to let his mother and his cousin Mary share in his life, as if it were the most natural thing in the world for them to be in Oxford. His mother, seeing how coolly he took the teasing of the young lords, wrote to her husband that she was pleased to see that John did not take himself too seriously—which was quite true. Ruskin walked with the sure-footedness of a sleepwalker through this murky compound of scholarly study, which had the mores of a feudal manor. And yet he was not really asleep but had a clearer idea what he was doing than almost everyone around him.

Ruskin's problem during his Oxford years was not his social life but his studies. The undergraduate curriculum consisted of classics, mathematics, and theology—the latter including its subsidiary branches, ethics and philosophy. None of these subjects had ever been of much interest to Ruskin, and none was ever to play a significant role in his life. He worked very diligently, sometimes to the satisfaction and more often to the surprise of his tutors, who looked with scorn on his earlier patchwork education. But his heart was not in it, and he profited no more from his official

course of studies than he would have from any thorough training in the humanities.

It is no accident that he began to write his first major work of art criticism the moment he started at Oxford, to divert himself from the university's deficiencies. *The Poetry of Architecture* was a series of reflections on the aesthetic aspects of architecture, which began to appear in the *Architectural Magazine* in 1838 and led to other small pieces as well. Oxford could teach him nothing about this kind of trade literature. There was no Professor of Fine Art at Oxford at this time; the first—Ruskin himself—would not arrive until thirty-two years later.

The only university offering which aroused his enthusiasm was the Newdigate Prize, an annual award for the best poem by an Oxford student. Three times he submitted a poem laden with erudition and metaphors, and the third time he won, read his poem aloud to an audience of two thousand, and was introduced to William Wordsworth. The Newdigate Prize was just about the best reference a poet could have to launch himself on a career as a writer of occasional verse and sentimental album poetry. Of course, this support and encouragement came rather belatedly for Ruskin, who by this time was already a regularly published poet. His work had been appearing since 1835 in *Friendship's Offering*, an annual anthology of lyric poetry put out by William Henry Harrison. But although a number of people took pains to ensure that the New-digate Prize would go to Ruskin in his final year at Oxford, no one had any illusions about his being a great poet. Even his father, who admitted that he normally tended to overvalue his son's achievements, did not want publishers to advertise John's other writings by listing him as the "Winner of the Newdigate Prize." "As we can no longer pass him off as The *little phenomenon* I am afraid of letting the Kindness of Friends, usher him into the world of Literature as any great phenomenon." All the same, John James did continue to "indulge a hope that he may, if spared, become a full grown poet." The phrase "if spared"—neither pampered with praise nor intimidated by harsh criticism—shows the antiquated

view that Ruskin's parents, and also literary Oxford, held about what goes into the making of a poet. The only truly readable verses that Ruskin wrote are his love poems; that is, work reflecting an experience which did not "spare" him.

Some years earlier, Wordsworth had written disparagingly of his years of study at Cambridge: "I had melancholy thoughts . . . / And, more than all, a strangeness in my mind, / A feeling that I was not for that hour, / Nor for that place." Ruskin was saved the need to say the same by the fortunate fact that at Christ Church there was one faculty member at least who encouraged his private researches in a field which interested him. He was William Buckland, canon of Christ Church and lecturer in geology and mineralogy. Through Buckland, Ruskin stayed in touch with developments in geology. As a member of the Geological Society, a frequent visitor to the British Museum, and a collector and researcher in his own right, Ruskin would most likely have made good progress in his geological studies, even if he had stayed at home in London. But his encounters with one or two teachers within a university setting enabled him to develop a professional method from what might otherwise have remained no more than a hobbyist's urge to collect.

Geology was the key science of the age. The future of other disciplines—history, theology, biology, anthropology—all depended on the pronouncements of geology—pronouncements which in the 1830s, when Ruskin began to approach the field's great issues, had yet to be made. Chief among the unsolved problems, and the most ticklish of them all, was whether the Biblical account of the Creation could be reconciled with the most recent discoveries in geology and paleontology.

Some thirty years earlier, the French comparative anatomist Cuvier had studied fossil remains from the Paris basin and drawn certain conclusions based on them which had not yet been digested by the theologians. Cuvier had reconstructed whole species of long-extinct creatures. Fossil findings seemed to contradict the Old Testament, which appeared to say that only six thousand years had elapsed since the creation of the world, and which also indicated

that God never allowed any species to perish, or brought any new ones into existence. Although Cuvier himself had managed to wangle his way out of the dispute, he had lent impetus to the science of stratigraphic geology, a field which then made rapid strides, especially in Britain. More and more unknown creatures were emerging from the dark of time, deeper and deeper strata were being quarried, and people were asking with growing urgency whether the Book of Books could stand comparison with the Book of Nature.

Scientists with a Christian orientation—and that meant most of them—came up with an idea which temporarily relieved the strain. Assuming that the extinct species really were once alive, then they must have lived before man's expulsion from Paradise. Paradise being timeless, many aeons of natural history could have come and gone before the expulsion. But this explanation raised other tricky questions. Was it possible for a species to die out in Paradise? Did death even exist then?

This explanatory model and the accompanying theological conflict were under debate when Ruskin arrived at Oxford. Characteristically, Ruskin immediately embroiled himself and his family in the problem. His geology lecturer, William Buckland, had his own thesis: the extinct animals *did* live in Paradise, and they ceased to exist by eating each other up—but this could not actually be called dying. Margaret Ruskin's comment on this was: "The question is a very puzzling one—it is a great mercy that neither our welfare here nor our happiness hereafter depend on our solving it—it would I think be wise in the Dr. and his compeers I think if they would let the Bible alone, until they had gained sure knowledge on the subject." John James, who was fretting over the problem on one of his sales trips, wrote (before hearing Buckland's suggested solution): "The monsters as we must let them live by Geologists Chronology—ceased to live by the power of Deity but in a way yet not called dying."

Their son took a different tack and argued in a number of pamphlets more scientifically than the scientists. The laws of metabolism stated quite simply that plant life is dependent on the

disintegration of animal life, and animal life on the disintegration of plant life. Therefore, he said, to speak of life and growth was to speak of death and destruction at the same moment. The same laws must have applied in the Garden of Eden, whose greenery was destined to turn into flesh; destruction was already there. Thus, while everyone else was trying to argue that death, by definition, could not have existed in Paradise, Ruskin took the positive position: death is a precondition of life. The theme of decay seemed not to shock the young theorist, who, after all, had been brought up to appreciate decay as picturesque.

The second part of his answer also had an individual stamp. One must not take the Biblical account of Creation too literally, in its statements about history, for it is an Eastern allegory. We know what we are, Ruskin said, and we also know what we shall be; but only God knows what we *were*. This was an amazing remark coming from a student of geology, a science just on the brink of redefining both the nature and the dimensions of time. It was amazing, too, because it was written in a century dominated by reflections about history and by attempts to recapture it. Faced by the question What can we know? Ruskin replies: the present and the future, but not the past. In other words, he has reversed the perspective of his century. He has begun to establish the spot from which he will view the world: the present moment. He turns to nature in its eternal wealth of phenomena; and to art, that most contemporary vehicle of history, which is only too ready to sacrifice information to appearance. So far, he remains unimpressed by the rubble of past epochs, styles, and individuals, by the laws of becoming and passing away, by the laws of action. He wants to devote his life's work to the present.

But this was a bad moment to make that choice. The century of historicism became an age of revolutionary change. As far as art and nature were concerned, the present tense was shifting to the past so fast that, to investigate the present, a man had to straddle the world with one leg in the past and the other in the future: a historian and a prophet at the same time. This was, in fact, the normal posture of a Victorian "sage" like Carlyle. But no one felt

it was such a bone-wrenching contortion as Ruskin did, who had focused all his senses onto the present. Nor did anyone pay a more bitter price than he did for risking a reply to the question: What can we know? When the now became unbearable, he swung back and forth between a past and a future which alike rejected him, and in the end he was left with nothing but that which he had wanted to leave up to God: the knowledge of what had been.

The nineteenth-century speculations on Genesis and geology had a lasting effect on Ruskin in that he avoided such speculations in the future, clearly realizing how hard it was to combine the offices of priest and scientist. William Buckland came into conflict with orthodox theologians at Oxford. And the geologist Sir Charles Lyell, who unlike Buckland was not a clergyman, had to give up his professorship at King's College, London, because of his geological theories. The prospects for future geologists were far from appealing. Ruskin had had enough of authority at home; he was not the sort who could function creatively within a system of dogma.

But from his involvement in this controversy, and particularly from Buckland's example, came something which would stand him in good stead in his future work. In his youth, Ruskin had picked up as a matter of course the classical scientific skills of collecting, defining, and classifying. Now he learned that the model scientist, the paleontologist, must be able to do more: by looking at the present, he must be able to extrapolate, reconstruct, prophesy about the past. His true sphere of operations is not the neatly filled specimen case but the insignificant detail which in itself hardly warrants collection and classification. An eye attuned to microscopic detail, however, the eye that could "see a world in a grain of sand," could infer from a present trace the living whole of the past. As Cuvier wrote, "Today it suffices to see the print of a cloven hoof, to conclude that the animal which left the mark was a ruminant. This conclusion moreover is as certain as any in physics or ethics. This one print is enough to tell the observer the shape of the teeth, the jawbones, the vertebrae, of all the legbones, thighbones, shoulder and pelvic bones of the animal which walked by."

Buckland operated on this same basis. He was a keen-eyed reader of fossil imprints. The first to study the fossil traces of rain and hail, he drew conclusions from them about the climate of prehistoric times. By examining the eyes of trilobites, he calculated the intensity of light that penetrated prehistoric seas. This method aimed to bring the fragments of the past back to life. It was, in fact, the classical method of inductive reasoning, which took relics of the past and theoretically completed them so as to give them life. They were not placed in any new order but were projected back into the old one. The starting point for the chain of reasoning was the individual fact, not any overall system of classification.

This method must have greatly appealed to Ruskin, because it validated his empirical turn of mind and his devotion to detail. At the same time, it stimulated him to go beyond recording, identifying, and collecting, to the mental work of reconstruction and to the exercise of his scientific imagination. Moreover, it gave him the capability—although he seemed unaware of it at the time—to lay a common basis for his investigation of the works of nature and the works of man.

Ruskin also profited personally from his contact with Buckland. This was the first natural historian with whom he developed a close relationship, and the eccentric cleric taught him that a man can be many things besides a scientist, and that he is nothing if he is a scientist only. Buckland was anarchic in his life-style, fond of wild parties, as well as an obsessive collector: by profession a priest, teacher, scientist, and writer all rolled into one. He refused to separate his activities as researcher and university lecturer from the rest of his life. Ruskin was often invited to his home and saw how Buckland and his friends would do mathematical-probability calculations while gambling, then later use stilts to walk around the library. On another occasion, they sent a young lady to an evening party wearing a live snake for a necklace. We owe it to Buckland's influence that our young gentleman commoner never turned into a scholastic, a specialist, a rigidly systematic thinker.

Ruskin's first stint at Oxford finished abruptly, in an emotional and physical crisis. On December 28, 1839, he wrote in his diary:

"I have lost her." Adèle had left England to marry a French baron in Paris. Shortly after their wedding in March 1840, Ruskin started coughing up blood, was removed from the university, and spent two years recuperating from his illness, which seems not to have been the dreaded consumption after all. Recovery was slow but complete. Ruskin spent ten months in Southern Europe, although this time he could not be as active, or undertake as many projects, as in past sojourns abroad. The shadow of his illness and the shadow of Adèle fell "on the old road." His diary "celebrated" a season of gloom. But his notebooks continued to fill up with notes, and his portfolios with sketches and watercolors.

Finally, in May 1842, with his health reasonably restored, he was able to complete his bachelor's degree at Oxford. Again he faced the question of what to do with his life: "What should I be, or do?" His father, Ruskin claimed later, had higher expectations of his son than of himself, and had already made up his mind that "I should enter at college into the best society, take all the prizes every year, and a double first [highest honors] to finish with; marry Lady Clara Vere de Vere [a Tennyson character]; write poetry as good as Byron's, only pious; preach sermons as good as Bossuet's, only Protestant; be made, at forty, Bishop of Winchester, and at fifty, Primate of England."

His mother, who had promised him to God when he was born, seemed more accepting of his scientific inclinations and would have been satisfied, Ruskin thought, if he had become a combination naturalist and country parson like Gilbert White of Selborne.

While he was ill, Ruskin had given much thought to the question of choosing a profession. He did not simply avoid the issue because it made him uncomfortable, as he claimed later in *Praeterita*. He thought, but his thoughts produced nothing concrete, except a negative determination not to become a clergyman as his parents wished. Unable to make an immediate decision, he set out on a trip with his parents—to Switzerland.

Two
The Graduate of Oxford
1842–1845

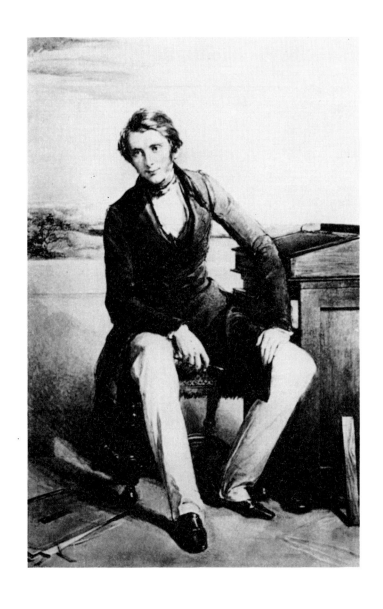

George Richmond, John Ruskin, Age 24, *1843. Watercolor.*
Present whereabouts unknown

Our second portrait of John Ruskin was painted in February 1843, when he had just turned twenty-four. This time the artist was George Richmond, a painter who, unlike James Northcote, does not seem to have gone in for classical disguises and poetic raptures. "He painted a charming water-colour of me sitting at a picturesque desk in the open air, in a crimson waistcoat and white trousers, with a magnificent port-crayon in my hand, and Mont Blanc, conventionalized to Raphaelesque grace, in the distance."

This is a contemporary portrait which shows us more of the prosy details than we may care to know. Only four years after the invention of photography, this watercolor already contains the ugly machine-made furniture which will soon become standard equipment in every portrait studio. Not much time is left before Ruskin will start to speak of the deadly modernity of contemporary furniture. A notable feature of Richmond's portrait is the contrast between the stiff joints of the stool legs and the effortless elegance of the figure and clothing.

The clothing is still pre-Victorian, still brightly colored rather than somber. It accentuates rather than conceals the functions of the body: look at the slashed sleeve cuffs of the frock coat, for instance. In this portrait, neither Ruskin nor his times have yet achieved their own characteristic style. Within a few years, the conventions of Victorian attire will be fixed, and Ruskin himself will have settled on a style of dress which would last him the rest of his life.

The young man in Richmond's portrait has turned away from

his desk and toward us. But his gaze does not meet ours directly. Instead, it falls down and to the left, focused on nothing in particular. The perfect oval of the face wears a soft and dreamy expression. Only the agile energy of the body below it tells us that there is more here than the handsome, art-loving son of wealthy parents. No doubt the painter was right—just as Northcote had been in the first portrait—to show the clear-cut features lit up with the youth and security that only wealth can afford.

Ruskin, when he looked back at his youth from old age, saw himself in much the same terms that Richmond did. "What should I be, or do? . . . I had not the least love of adventure, but liked to have comfortable rooms always ordered, and a three-course dinner ready by four o'clock." So, if his thoughtful expression in the portrait betokens more than a sheltered life, it might imply sensitivity, a romantic disposition, even personal troubles—but not the "universal pain" which later reduced his features and gave them their characteristic stamp. Taking the image as a whole—the vague, soft face, combined with the quasi-professional bearing of a body which is relaxed only for the moment—we see the quite accurate portrait of a young man who is skilled in general without yet being skilled at life.

Other details stand out which also merit comment: the desk, and especially the background. There was nothing unusual about portraits with their subject in the role of an amateur draftsman. In the eighteenth century, the nobility and even royalty commissioned portraits of themselves holding drawing crayons and cases. But never before had a sketcher been represented seated at a desk. The desk is a telling addition, which can no longer be reckoned as the paraphernalia of a nobleman enjoying a leisure-time pursuit. But when we look closer, it is difficult to tell what sort of desk it really is. It looks impractical for use when sitting—where would the legs go?—and too low to use standing up. Is it suitable for a draftsman and watercolorist, or would it be better used by a writer? Both could work on the sloping surface of the desktop; but this surface is a bit cramped for someone trying to draw. There seems to be some extra chalk there, but nothing else that gives us any clue to

the desk's purpose: no manuscript, no drawing pad. Is this perhaps a piece of practical, multipurpose convertible furniture with a detachable top—some kind of travel desk, for example?

We are not the only ones who have been confused. The painting was first shown at a Royal Academy exhibition where it appeared under the title "John Rusken [*sic!*] Jr., Esq." But, after that, it was always known as "The Author of *Modern Painters*," as if the figure had impressed viewers more by his writerly than by his draftsmanly qualities.

Ruskin had been friendly with George Richmond since their first meeting in Rome in 1840. Richmond was one of Ruskin's many drawing instructors, and although he did not like the direction which Ruskin's work was taking in 1842–43, he must have seen that his pupil's talents far outstripped those of the ordinary dilettante and amateur draftsman. It also could not have escaped his notice that Ruskin had already emerged as a writer on art and a lyric poet. He may even have known that by this time his young acquaintance had all but finished his first book. So it was not convention or flattery which moved Richmond to depict Ruskin as a draftsman, and quite suitably, he also showed the association between Ruskin the artist and Ruskin the author.

What Richmond cannot have known yet was that this union of working artist and reasoning critic, of theory and practice, would set the pattern for the whole of Ruskin's life. Only three months after the portrait's completion, Volume One of Ruskin's *Modern Painters* was published, and its Preface announced to the world: "Whatever I have asserted throughout the work, I have endeavoured to ground altogether on demonstrations which must stand or fall by their own strength, and which ought to involve no more reference to authority or character than a demonstration in Euclid. Yet it is proper for the public to know that the writer is no mere theorist, but has been devoted from his youth to the laborious study of practical art."

The background scenery is a particularly notable feature of Richmond's portrait. Later, in *Praeterita*, Ruskin wrote that Richmond had painted him "sitting . . . in the open air," as if seated on a

terrace somewhere in Switzerland, with Mont Blanc in the distance. But what kind of terrace can suitably be furnished with a writing desk? The background landscape is so vague—"conventionalized to Raphaelesque grace"—that it might just as easily be an indoor wall painting, which would make this a studio portrait, inside a closed room with a desk in it. This ambiguity of locale is more meaningful than the artist can have realized. He knew of course that Ruskin's main interest, as a practicing artist, was in depicting landscape. He may already have learned that Ruskin's first book—the manuscript of which perhaps lay inside the writing desk—was a treatise on landscape painting. But no one, not even Ruskin's friends, dreamed that he had just created a new language and a new theoretical framework for looking at art as nature and at nature as art: a vision involving science, firsthand experiment, and practical artistic skills.

Thus, we have a revised reading of Richmond's painting: its subject is John Ruskin, a mediator between art and nature. He has turned away from his work as a writer/draftsman, not toward the landscape but toward the observer. This implies more than that he has finished his work. He is now open to the public, his public is becoming important. This author is not playing the role of a good Romantic, absorbing himself in nature. He is gazing into infinity; but the infinity does not lie in the inauthentic studio landscape behind him. It is somewhere out in front, where we are.

Richmond's portrait is less conventional, more reflective of real circumstances, than has hitherto been realized. The three-year-old John, we know, demanded the blue mountains of Scotland as a background to his first portrait, and the twenty-four-year-old John would hardly have kept silent about the landscape which he wanted in his adult portrait. So we must consider why George Richmond painted Mont Blanc on the horizon, when he could just as easily have painted a snow scene in London, for it was now the end of February, in a winter of very heavy snowfall. Why did he not paint the view from Ruskin's home in Denmark Hill, looking out on the hills of Norwood, or onto the Thames valley that stretched away toward Windsor?

The three Ruskins had been on tour through France and Switzerland from May to August of the previous year. Their main destination was Chamonix at the foot of Mont Blanc, where John wanted to carry out geological studies. But there was another reason for the trip. For several years the Ruskins had been on good terms with the painter William Turner. Even before they met him, they were buying his watercolors on a regular basis. In 1843 Ruskin senior purchased eight new watercolors costing almost £500.

Turner, now fifty-seven, continued to win major art prizes and had amassed a sizable fortune, but even so he could not qualify as a truly successful artist. Art critics and the public at large did not understand his later works and greeted them with undisguised hostility. His "Snow Storm: Peace and War," exhibited in 1842, showed a wild storm at sea, and the critics denounced it as a "mass of soapsuds and whitewash." One evening when he had been invited to the Ruskins' home, Turner fumed at his detractors: " 'Soapsuds and whitewash!' What would they have? I wonder what they think the sea's like? I wish they'd been in it." He was alluding to the celebrated story that he had personally lived through the terrible snowstorm in the Channel on which his painting was allegedly based. He claimed to have spent four hours lashed to the mast, exposed to the raging elements like a modern Ulysses, but, unlike Ulysses, with his eyes and ears open, observing the details. The artist's heroic feat undoubtedly made a deep impression on the young Ruskin, not only because it was a real adventure but also because it bore out his growing conviction that all the things which interested him—clouds, rocks, trees—could be grasped only by direct observation, and not through reading, analysis, or the teachings of others.

Ruskin felt impelled to defend Turner publicly. He had already written a brief apologia in 1836, replying to a devastating attack by critics. This piece was presented to the artist, but, at his request, it was not published: Turner liked to complain about art critics but did not want the matter exaggerated in public. Ruskin senior also tried to curb his son's excessive zeal. In 1842, when young John wrote that he was starving for some Turner paintings, he received

the brutally complacent reply: "Awful ideas starving to look on Turner. I like him after Roast & pudding & a few Glasses of Sherry which too many Turners would soon abridge us of."

That same year, Turner hired out his services on a kind of subscription basis, preparing fifteen rough sketches of Swiss landscapes and promising to turn each into a finished painting if a member of the public would first commission him to do it. The sketches were put on display by an art dealer, whereupon the Ruskins ordered two. Closer inspection showed that the landscape scenes were not imaginative compositions but were copied directly from nature; so the Ruskins hurried off to the Alps to get a look at the originals before Turner finished the copies. The artist himself did not start for the Alps until later that summer, by which time his clients were already on their way home. But he caught up with them all the same, or at least news of him did. Arriving to pick up his mail in Geneva, John found some newspaper items critical of Turner's most recent works: "This gentleman has on former occasions chosen to paint with cream, or chocolate, yolk of egg, or currant jelly,—here he uses his whole array of kitchen stuff."

Ruskin was furious. "It put me in a rage," he recalled one year later, "and that forenoon . . . I determined to write a pamphlet and blow the critics out of the water. On Monday we went to Chamonix, and on Tuesday I got up at four in the morning, expecting to have finished my pamphlet by eight." In fact, it would take him eighteen years to finish his "pamphlet," which became a five-volume work some 2,500 pages long and made its author as famous as the painter it was written to defend.

To think that the whole thing had started that Tuesday morning in Chamonix at the foot of Mont Blanc! William Blake, of course, had written:

> Great things are done when Men & Mountains meet;
> This is not done by Jostling in the Street.

So it seems completely appropriate that in February 1843, when Richmond was painting his portrait in London and the first volume

of the "pamphlet" was all but finished, Ruskin should elect to have Mont Blanc painted into the background.

Ruskin's diary entry for February 24, 1843, says: "In at Richmond's and had a pleasant sitting. He says my chief aim in art is infinity, which I think a clever guess, if it be a guess. Called at Turner's. . . . Insisted on my taking a glass of wine, but I wouldn't. Excessively goodnatured today. Heaven grant he may not be mortally offended with the work!"

But why should Turner have been "mortally offended" by *Modern Painters*, by Ruskin's scheme to restore the artist's reputation? This question leads us to the core of Ruskin's work as a writer. A dependent son, he became independent by writing. This was true from the start—certainly by the time he had finished the first volume of *Modern Painters*—and remained so until his very last book. When he thought he was right, he ignored the social consequences, threw caution to the winds, was unswayed by tactical considerations. But the heroes he celebrated in his books discovered that he could be as hard on them as he was on himself. *Modern Painters* was far from flattering in its view of Turner's early works, and sharply censored his painting techniques: "No *picture* of Turner's is seen in perfection a month after it is painted."

Probably Turner was not offended by such strictures but accepted them as a necessary counterbalance to Ruskin's extravagant eulogies of the artist as the Angel of the Apocalypse, a prophet of God, a mighty spirit, and the greatest landscape painter of all time. But the way Ruskin publicly dismissed artists, and whole schools, which Turner and his generation thought of as the supreme models of landscape art must have angered him. Turner cannot have been happy to have his honor avenged at the expense of Claude Lorrain, Nicolas Poussin, Salvatore Rosa, Canaletto, and the entire Dutch School. He was in many respects a cautious man who had experienced the hazardous life of the freelance artist when he was young, and who on that account valued the great masters, the traditional loyalty to fellow artists, and the established institutions of his craft. Perhaps he could not get along with the critics, but at least he wanted to stand up for other artists. He would not have conceded

2

The twenty-four-year-old Ruskin sent off his book—which bore no other mark of authorship than the phrase "A Graduate of Oxford"—to Byron's publisher, John Murray, who rejected it. He donned the mantle of art critic with the same nonchalance that he had shown in mixing with nobly born students at Oxford and with the leading scientific lights of his age. One who at the age of eighteen had presented meteorologists with a treatise on the basic principles of their science—"Remarks on the Present State of Meteorological Science"—had no need to feel daunted by art critics whose ignorance and lack of principle he had seen demonstrated time and again: "For many a year we have heard nothing with respect to the works of Turner but accusations of their want of *truth*. To every observation on their power, sublimity, or beauty, there has been but one reply: They are not like nature. I therefore took my opponents on their own ground, and demonstrated, by thorough investigation of actual facts, that Turner *is* like nature, and paints more of nature than any man who ever lived."

This was the task Ruskin set himself, as formulated in the intricate title of the first edition: *Modern Painters: Their Superiority in the Art of Landscape Painting to all the Ancient Masters, proved by examples of the True, the Beautiful, and the Intellectual, from the Works of Modern Artists, especially from those of J.M.W. Turner, Esq., R.A., by a Graduate of Oxford.* He restated his aim even more explicitly later in the volume: "I shall endeavour, therefore, in the present portion of the work, to enter with care and impartiality into the investigation of the claims of the schools of ancient and modern landscape to faithfulness in representing nature. I shall pay no regard whatsoever to what may be thought beautiful, or sublime, or imaginative. I shall look only for truth; bare, clear, downright

statement of facts; showing in each particular, as far as I am able, what the truth of nature is, and then seeking for the plain expression of it, and for that alone."

A man bent on such a feat needs a wider background and training than the art critic or art historian normally commands. But, remarkably, Ruskin does not explicitly acknowledge this need in his prefaces to the first and second editions of Volume One (1843 and 1844), where he lays out his tools and intentions as neatly as a set of medical instruments. He does say that he is not inexperienced in the practical side of art, and claims familiarity with all the major art galleries between London and Naples (a gross exaggeration!). But not until Volume Three does he outline the full range of his operations:

> For the labour of a critic who sincerely desires to be just, extends into more fields than it is possible for any single hand to furrow straightly. He has to take *some* note of many physical sciences; of optics, geometry, geology, botany, and anatomy; he must acquaint himself with the works of all great artists, and with the temper and history of the times in which they lived; he must be a fair metaphysician, and a careful observer of the phenomena of natural scenery.

This résumé lists all the elements of Ruskin's agenda, expanded for the 1850s, but still headed by the need for cooperation between the sciences and the arts.

In the same volume he decries the ignorance and narrow mentality of his fellow art critics:

> Ask a connoisseur who has scampered over all Europe, the shape of the leaf of an elm, and the chances are ninety to one that he cannot tell you; and yet he will be voluble of criticism on every painted landscape from Dresden to Madrid, and pretend to tell you whether they are like nature or not. Ask an enthusiastic chatterer in the Sistine Chapel how many ribs he has, and you get no answer: but it is odds that you do not

get out of the door without his informing you that he considers such and such a figure badly drawn.

Ruskin felt that he was unusually well equipped when it came to judging the scientific aspects of art. He had studied nature before he studied art, and at age twenty-four he could claim genuine authority:

I should not have spoken so audaciously, had I not been able to trace, in my education, some grounds for supposing that I might in deed and in truth judge more justly of him [Turner] than others can. I mean, my having been taken to mountain scenery when a mere child, and allowed, at a time when boys are usually learning their grammar, to ramble on the shores of Como and Lucerne; and my having since, regardless of all that usually occupies the energies of the traveller,—art, antiquities, or people,—devoted myself to pure, wild, solitary, natural scenery; with a most unfortunate effect, of course, as far as general or human knowledge is concerned, but with most beneficial effect on that peculiar sensibility to the beautiful in all things that God has made, which it is my present aim to render more universal.

Ruskin, provisionally, was not concerned with the beautiful and exceptional in nature, but with its widespread and commonplace aspects. He sought to emulate Wordsworth in disclosing that everyday life produces paradises and Elysian groves in abundance. In his chapter on the sky, Ruskin wrote: "The noblest scenes of the earth can be seen and known but by few; it is not intended that man should live always in the midst of them . . . but the sky is for all." Nature's claims are not confined to its special achievements. "God is not in the earthquake, nor in the fire, but in the still, small voice. . . . It is in quiet and subdued passages of unobtrusive majesty, the deep, and the calm, and the perpetual; that which must be sought ere it is seen, and loved ere it is understood; things which the angels work out for us daily, and yet vary eter-

nally: which are never wanting, and never repeated; which are to be found always, yet each found but once. . . . These are what the artist of highest aim must study."

This passage shows, already assembled, all the elements of Ruskin's concept of nature, as well as those features which distinguish it from other views of nature prevalent at the time. Moreover, it tells us something about the origin of Ruskin's attitude. Clearly, he is deeply indebted to the literature and art of the picturesque, which had undertaken to ennoble the commonplace; and from the champions of the picturesque he has derived some of his urge to educate the observer. The first task must always be to sensitize the viewer to the aesthetic qualities of what is commonly deemed ordinary. So Ruskin writes, in the same passage quoted above: "Who, among the whole chattering crowd, can tell me of the forms and the precipices of the chain of tall white mountains that girded the horizon at noon yesterday? Who saw the narrow sunbeam that came out of the south and smote upon their summits until they melted and mouldered away in a dust of blue rain? Who saw the dance of the dead clouds when the sunlight left them last night, and the west wind blew them before it like withered leaves? All has passed, unregretted as unseen."

Ruskin is thus in deep sympathy with the attitudes and aims of the theorists of the picturesque, with one fundamental exception. He is not looking for nature phenomena which will make attractive pictures and which can then be lifted out of nature and allowed to usurp its place. One reason that we ignore clouds, he says, is that we have looked at too many pictures of clouds and so are under the illusion that we already know what they are like. "If we could examine the conception formed in the minds of most educated persons when we talk of clouds, it would frequently be found composed of fragments of blue and white reminiscences of the old masters."

The shorthand imagery used in landscape painting prevents us from seeing into the depths of nature. But neither are these depths visible to the scientist who tries to dissect nature. The nineteenth-century concept of nature as an assemblage of data, as the product

of mechanical and chemical processes on a micrological scale, has something in common with Ruskin's view, particularly with respect to his interest in precise detail; and yet he saw this concept as no more "true" than the theory of the picturesque, in its attempt to frame and to layer. "True" perception, he believed, aimed not at the tangible but at the intangible aspects of objects, and to living nature returned a living response. His concern was not with art or science as such, and most certainly not with the quasi-artistic or quasi-scientific in nature, but rather with the way we assimilate experience, the way we process our lives. His interest was that single all-important dimension of nature which he called infinity, or sometimes diversity or wealth. Once again, it is fitting to quote Blake: "If the doors of perception were cleansed every thing would appear to man as it is, infinite."

The idea of *plenitudo*, of the divine fullness and multiplicity of the world, goes back to Plato, whom Ruskin read extensively. It reappeared among the English Neo-Platonists like Richard Hooker (who figures in *Modern Painters*), and it became an abiding element in European intellectual history. Around 1800, the emphasis was on wealth in the sense of variety, on plenitude as the product of perpetual evolution and creativity. This is the aspect that interested Ruskin, not the other nineteenth-century interpretation of "infinity" as the principle of the sublime, as that which surpassed human understanding due to its sheer magnitude or extraordinariness. For Ruskin, infinity was within. It was revealed by changing one's perspective, and thus there was no phenomenon where it could not be studied. Once again, we see his interest focusing on the everyday: he domesticated the object of study.

"Infinity" was the common denominator of all nature's phenomena, which in turn was split into infinite numerators. There were infinite numbers of different cloud formations; infinite combinations of light, clouds, and weather in the sky; and the sky itself was infinitely deep. The trees had infinitely many leaves, the leaves infinitely many indentations and veins; no leaf was like any other, no leaf had the identical coloring at any two points. Every landscape stretched into infinity; infinite nuances were to be

found at its every degree of depth. An infinite variety of reflections played over the water's surface; there were infinite numbers of waves, and each wave in turn took on infinite forms as it moved along. Nature, in all its appearances, exhibited depth. An attentive gaze would reveal in every object the most varied facets and subtle gradations of motion and form. To perceive this was a science in itself, a science prior to aesthetics and to any kind of theoretical exercise. Eventually Ruskin gave it a name: the "science of aspects." He described it this way, in the third volume of *Modern Painters*: "For there is a science of the aspects of things, as well as of their nature; and it is as much a fact to be noted in their constitution, that they produce such and such an effect upon the eye or heart . . . as that they are made up of certain atoms or vibrations of matter."

De singularibus non est scientia ("Science is not made up of particular cases") is the basic principle of the "science of facts." Or, to restate it in a positive form, the duty of science is to determine what is necessarily and absolutely true always, everywhere, and in every case. The "science of aspects," on the other hand, had the duty to act as a "commentator on infinity," to reflect life's actual wealth, and so to concentrate on "individual or particular truths" and on "rare truths" rather than on "general" or "frequent truths"—that is, on description, not diagnosis. Its champions aimed to be counted among those rare mortals who, Carlyle had said, were permanently endowed with the blessing of having no system.

<div align="center">3</div>

Ruskin was not the first to try to look at nature in this way. Leonardo and Goethe had also been unsystematic scientists investigating an unsystematic nature. Goethe practiced and preached the need to preserve the individuality of both man and nature in scientific study. In the human observer, individuality was invested in the variety of his senses, his polyperceptivity; and in nature, it

lay in the undivided range and complexity of its phenomena. Of the multitude of Goethe's remarks on this subject, it is sufficient to quote two which must have daunted lovers of scientific systems, and which surely would have appealed to Ruskin. Concerning man's role in the study of nature, Goethe reports: "Thus my studies of nature are based on the pure foundation of experience," and concerning the object of study he says: "No living thing is a single object but is a multiplicity of objects. Even if to us it appears to be an individual, it is actually an assemblage of living and independent entities which are identical in concept and overall construction, but which as phenomena can be alike or similar, or unlike or dissimilar."

There is another point of agreement between Goethe and Ruskin. Both had a lifelong detestation of studying nature through slides and prepared samples, and of allowing mechanical aids and devices to come between man and nature—of putting nature onto the "rack" in the laboratory. "At the center lies the particular case, that which is suited to be grasped by the senses, on which I depend," Goethe said. He did not like to use a microscope or a telescope; and Ruskin did not even like eyeglasses. From childhood on, he regularly recorded in his diary all details concerning his eyesight. Late in life, when he was plagued by recurrent attacks of mania, he felt more afraid that he might lose his eyesight than his mind. One of the last positive entries he made in his diary was the following: "I see everything far and near, down to the blue lines on this paper and up to the snow lines on the Old Man . . . as few men at my age."

In the England of their day, Coleridge and Wordsworth were the poets, and Turner and Constable the painters, who resisted a dissecting attitude toward nature and who campaigned for what Coleridge called "distinction without division." Wordsworth—to whom *Modern Painters* is indebted for infinitely more than its opening quotation from *The Excursion*—asks, in a passage from "The Ruined Cottage" (1795) which he later deleted: "For was it meant / That we should pore, and dwindle as we pore . . . / On solitary objects, still beheld / In disconnection dead and spiritless, / And

still dividing and dividing still, / Break down all grandeur?" "Let us rise / From this oblivious sleep," the poet cries and calls for a revitalizing interchange between ourselves and the object-world: "Thus disciplined / All things shall live in us and we shall live / In all things that surround us."

But, in this instance, Wordsworth rarely practiced what he preached. It was his sister, Dorothy, who used to fill her diaries with subtle observations of nature and then passed on this wealth of detail to her brother. Probably she was the "he" of this passage which Wordsworth quoted in his *Guide to the Lake District*:

I will content myself with one instance of the colouring produced by snow, which may not be uninteresting to painters. It is extracted from the memorandum-book of a friend; and for its accuracy I can speak, having been an eye-witness of the appearance. "I observed," says he "the beautiful effect of the drifted snow upon the mountains, and the perfect *tone* of colour. From the top of the mountains downwards a rich olive was produced by the powdery snow and the grass, which olive was warmed with a little brown, and in this way harmoniously combined, by insensible gradations, with the white. The drifting took away the monotony of snow; and the whole vale of Grasmere, seen from the terrace walk in Easedale, was as varied, perhaps more so, than even in the pomp of autumn. In the distance was Loughrigg-Fell, the basin-wall of the lake: this, from the summit downward, was a rich orange-olive; then the lake of a bright olive-green, nearly the same tint as the snow-powdered mountain tops and high slopes in Easedale; and lastly, the church, with its firs, forming the centre of the view. Next to the church came nine distinguishable hills, six of them with woody sides turned towards us, all of them oak-copses with their bright red leaves and snow-powdered twigs; these hills—so variously situated in relation to each other, and to the view in general, so variously powdered, some only enough to give the herbage a rich brown tint, one intensely white and lighting

up all the others—were yet so placed, as in the most inob-
trusive manner to harmonise by contrast with a perfect naked,
snowless bleak summit in the far distance."

Ruskin must have been familiar with this interpolation in Words-
worth's *Guide*. He had toured the Lake District with his parents
in the summers of 1824, 1826, 1830, 1837, and 1838; and although
he admired another of the region's poets, Robert Southey, more
than he did Wordsworth, he must have consulted the *Guide* on his
tours. Wordsworth points out that the description may interest
painters, and in fact can be said to offer suggestions for picturesque
touches, especially at the end, where the sublimely monolithic
mountain is contrasted with the drift of the low hills. But some
of the observations go beyond the picturesque to something more.
The remarkable color effects of the snow and the way in which
the hills relate to each other *and* to the whole give us a multifaceted
perspective which makes us resist the urge to isolate and to em-
phasize one feature at the expense of the others. Moreover—this
is the most surprising and important feature—whereas travel guides
normally are written with the aim of allowing everyone to repro-
duce the journey described, Wordsworth's journey is unique. It
begins at a particular place and time—in the winter, when the
fewest tourists were roaming the district—which make it unre-
peatable. The "science of aspects" claimed the validity of individual
moments.

If ever a researcher took an empirical approach to the study of
nature, it was J.M.W. Turner. Before him lay the mobile surface
of the water, overhead a cloud-covered sky with bursts of sun
breaking through at intervals; multicolored objects went swim-
ming past in the water, while at the back of his mind were stored
the inadequate laws of optics and perspective.

Turner, a lecturer on perspective at London's Royal Academy,
and also an amateur fisherman who could spend hours, even days,
at the seaside and on riverbanks and lakeshores, remained an avid
student of reflections all his life; indeed, he referred to this as "the
peculiar study of our lives." This keen observer published his ob-

servations in his paintings. His written notations about the ephemeral world of reflections remained largely private, except for the occasional remark which he interpolated into his Academy lectures.

Turner, and later Ruskin, used the phenomena of light as a rapid entry into nature's infinity. One author has described his lectures as "a reverie on the indefinite transmission and dispersal of light by an infinite series of reflections from an endless variety of surfaces and materials, each contributing its own colour that mingles with every other, penetrating ultimately to every recess, reflected everywhere, 'plane to plane, so that darkness or total shade cannot take place while any angle of light reflected or refracted can reach an opposite plane.' Turner's axiom, in fact, amounted to a whole view of the world. . . . 'We must consider every part as receiving and emitting rays to every surrounding surface.' " Turner told his audience that the "more minute investigation" of reflections "may in the end discover positive axioms" which would ensure their discoverer a name "that must be honoured as long as the English School"—"or as long as reflexies," he added—"exists."

But Turner's art students cannot have been exactly enthralled by the sort of practical experiments in which he expected them to join. For example, he demonstrated how light was filtered through glass balls filled to varying levels with colored liquids; he placed polished metallic spheres side by side to show how the room was reflected on each sphere and how this reflection in turn was passed on to the next sphere; and he pointed out the behavior of reflections on uneven surfaces. For, contrary to the hope expressed in the passage just cited, Turner was not really interested in "positive axioms." As he wrote in another passage, certain natural phenomena, such as reflections, "evade every attempt to reduce them to anything like rule or practicality. What seems one day to be governed by one cause is destroyed the next by a different atmosphere."

A quarter of a century later, Ruskin would voice the same opinion. The painter, he wrote, would benefit little from a knowledge of all the laws of optics, unless he also had a large stock of personal observations at his disposal: "Thousands of exquisite effects take place in nature, utterly inexplicable, and which can be believed

only while they are seen; the combinations and applications of the above laws [of optics] are so varied and complicated that no knowledge or labour could, if applied analytically, keep pace with them."

Nature in motion, especially bodies of water, made for ideal observation posts, where the difficulties of applying the laws of optics became palpable to the senses. The laws of optics functioned on the premise that the reflecting surface was smooth and opaque. But water, nature's mirror, is subject to all gradation of movement. Calm water, of course, is transparent and thus forms "a surface whose reflective power is dependent on the angle at which the rays to be reflected fall. The smaller this angle, the greater are the number of rays reflected. Now, according to the number of rays reflected is the force of the image of objects above, and according to the number of rays transmitted is the perceptibility of objects below, the water. Hence the visible transparency and reflected power of water are in inverse ratio." So far, Ruskin is merely repeating things known by virtue of optics; but once water is set in motion, increasing the number of factors, things grow more complex. Jack Lindsay, in one of his books on Turner, tells us that the artist meditated on " 'a white body floating down a river [the Dee].' Though its whole surface was light against the water on which a dim cloud was reflected, 'yet the reflection of the white body had not any light or dark reflection, but on the contrary had its reflection dark.' " Turner also noted: " 'Reflections not only appear darker but longer than the object which occasions them, and if the ripple or hollow of the wave is long enough to make an angle with the eye it is on these undulating lines that the object reflects, and transmits all perpendicular objects lower than the spectator. But in receding lines, as well as objects, rules seem to lose their power.' " Twenty-five years later, Ruskin would write his own description of this same phenomenon, while he was in Venice:

[May 17th, 1846. 4 P.M.] Looking east . . . the water is [calm] and reflects the sky and vessels; with this peculiarity, the sky which is pale blue is of the same kind of blue a little deeper in the water: the vessels' hulls, which are black, are reflected

in pale sea green, the natural colour of the water under sun-
light, which, however, comes dark against the blue of the
reflected sky; while the orange masts of the vessels, wet with
a recent shower, are reflected without change of colour, only
not quite so bright as above. One ship has a white, another
a red stripe—of these the water takes no notice. What is
curious, a boat passes across with white and dark figures—
the water reflects the dark in green and misses out all the
white; this is chiefly owing to the dark images being opposed
to the bright reflected sky.

On looking at the apparent shadow of a boat near me, I
find that a boat swinging near the quay casts an apparent
shadow on the rippled water. This appearance I find to be
owing altogether to the increased *reflective* power of the water
in the shaded space; for the farther sides of the ripples therein
take the pale grey of the cloud, hardly darker than the bright
green.

This passage is taken from Ruskin's diaries, where he recorded
hundreds of pages of precise notes. He later transferred it, almost
exactly as it stands, to the first volume of *Modern Painters*, to il-
lustrate the personal and ad hoc character of optical science. It seems
certain that when he wrote these observations he knew nothing
whatsoever about Turner's handwritten notes on the same subject;
and for this reason it is especially interesting to see how master
and pupil wrestled with the identical problems at an interval of
more than two decades.

And why does the rippling water reproduce only the vertical
lines and not the foreshortened, slanting ones? Ruskin says: "Rip-
pled water, of which we can see the farther side of the waves, will
reflect a perpendicular line clearly, a bit of its length being given
on the side of each wave, and easily joined by the eye. But if the
line slope, its reflection will be excessively confused and disjointed;
and if horizontal, nearly invisible. It was this circumstance which
prevented the red and white stripe of the ships at Venice . . . from
being visible."

It is a pity that Ruskin did not devote more attention to Turner's rival John Constable, both as an artist and as a theorist. Constable was a keen observer of everyday nature, as committed as Turner to the study of the "transitional," and, like Turner, had done what Ruskin called his "service of clouds," noting the varied reflections made by light on water and damp vegetation, and devoting himself to the scrutiny of everything that had to do with the sky and the atmosphere. Like Ruskin, he despised the mannered treatment of nature in art, because such "handling" was alien to nature. He both preached and practiced working directly from life, because, he said, perfection must be sought in the original source, which was nature. The study of bygone excellence would lead to an eclectic style, but only the study of nature could lead to an original style. "The world is wide; no two days are alike, nor even two hours; neither were there ever two leaves of a tree alike since the creation of the world."

Strictly speaking, Ruskin ought to have been won over by ideas which so closely paralleled Turner's and his own; but his judgments not infrequently seem eccentric. One possible explanation is that ignoring Constable was Ruskin's way of showing that Turner had no equal among the landscape painters of his day; but, to be fair, Ruskin also differed with Constable on some material points. Constable, who had even more difficulty than Turner in conveying his art to the public, seemingly could not tolerate the insecurity of staking out a position halfway between a fact-based scientific approach and an art based purely on imagination. Feeling that he was not the imaginative type, he opted for science, as Leonardo had done before him. Consequently, we find remarks like this among his writings: "In such an age as this, painting should be *understood*, not looked on with blind wonder, nor considered only as a poetic aspiration, but as a pursuit, *legitimate, scientific,* and *mechanical.*" This classification of painting would not have sat well with either Turner or Ruskin. Nor would either man have chosen—much though they both admired Gilbert White's book on *The Natural History and Antiquities of Selborne*—to underline precisely the same lines from it that Constable did: "System can by no means be thrown aside. Without system, the field of nature would be a

pathless wilderness; but system should be subservient to, not the main object of, our pursuit." For both Turner and Ruskin were preaching a third way, a median path between science and imaginative art.

Ruskin distinguished between a "science of aspects" and the established "science of facts." The same distinction was present in Turner, who contrasted what he called the "science of vision" with a method which he described but did not name and which we might call the "art of vision." This term would not imply vision in a vacuum but rather a mode of perception that, instead of renouncing anything, is nourished on the relation between subject and object. Ruskin puts it this way: "Science deals exclusively with things as they are in themselves; and art exclusively with things as they affect the human sense and human soul."

<center>4</center>

When we start looking for indications as to how the young Ruskin thought about art, we always run across the famous lines from the last chapter of Volume One of *Modern Painters*, where he gives advice to young artists: "Go to Nature in all singleness of heart, and walk with her laboriously and trustingly, having no other thoughts but how best to penetrate her meaning, and remember her instruction; rejecting nothing, selecting nothing, and scorning nothing; believing all things to be right and good, and rejoicing always in the truth." The phrase "rejecting nothing, selecting nothing, and scorning nothing" has often been interpreted as a defense of naturalism, of a purely mimetic art. But those who quote it out of context overlook the fact that Ruskin was advising the beginning painter, and also that he was deliberately exaggerating, because he was trying to put across ideas which were not generally accepted. The sentence does not imply that, beyond the initial stages, art is or even could be mere imitation of nature.

Traditional theorists like Sir Joshua Reynolds, while not recommending the imitation of nature as the proper approach to art,

had regarded it as at least a legitimate method. Ruskin quotes Reynolds's remark: "This imitation being merely mechanical, in which the slowest intellect is always sure to succeed best." Victorian art theory, now partially imbued with science, held the contrary view that, while copying nature was recommended, it was ultimately impossible. For example, one of Ruskin's drawing masters, J. D. Harding, wrote in his 1845 classic, *The Principles and Practice of Art*:

> It is not within the reach of Art to give an identical imitation of any one object, and less still of all which constitute a landscape. Can all the leaves of trees, and all the branches, in form and variety, be given? Impossible.— All the blades of grass and all the herbage? Impossible.— All the endless forms of water in motion? Impossible. All the buildings constituting the city, and all the windows and doors in them? Impossible.— Is there any one thing, a constituent, properly so called, of a landscape, which can be imitated *tale quale*? There is not:— "Impossible" is written in distinct characters over all.

Similarly, Ruskin's view of developed art is that it is an imitation of the inimitable. He often stressed that nature's nuances, vibrations, ever-shifting states and varieties cannot be translated perfectly into the materials of painting. This did not mean that the artist was free to use conventional abbreviations in depicting his subject. Instead, he had always to strive to represent infinity with his finite means, keeping in mind the actual properties of objects and the laws governing their appearance. Painting must always suggest the depth and variety which it could never actually fathom:

> To form a judgment of the truth of painting, perhaps the very first thing we should look for, whether in one thing or another,—foliage, or clouds, or waves,—should be the expression of *infinity* always and everywhere, in all parts and divisions of parts. For we may be quite sure that what is not infinite cannot be true. It does not, indeed, follow that what

is infinite is always true, but it cannot be altogether false; for this simple reason, that it is impossible for mortal mind to compose an infinity of any kind for itself, or to form an idea of perpetual variation, and to avoid all repetition, merely by its own combining resources. The moment that we trust to ourselves, we repeat ourselves, and therefore the moment we see in a work of any kind whatsoever the expression of infinity, we may be certain that the workman has gone to nature for it; while, on the other hand, the moment we see repetition, or want of infinity, we may be certain that the workman has *not* gone to nature for it.

To the many definitions of man which already exist, we may, if we choose, add that of the young Ruskin: man—including the artist—is a being who repeats himself. But the world around man is geared to variety and infinity. From the tension between the two springs the great task of our lives: to emulate the outside world by the realization—that is, the perception *and* the achievement—of variety.

Ruskin later extended this idea into the social and political realm. But in 1843 it was useful to him mainly as a criterion for telling good from bad art, and for contrasting the new with the old style of landscape painting. The passage just cited continues as follows:

For instance, in the picture of Salvator[e Rosa] before noticed, No. 220 in the Dulwich Gallery, as we see at once that the two masses of cloud absolutely repeat each other in every one of their forms, and that each is composed of about twelve white sweeps of the brush, all forming the same curve, and all of the same length; and as we can count these, and measure their common diameter, and, by stating the same to anybody else, convey to him a full and perfect idea and knowledge of that sky in all its parts and proportions,—as we can do this, we may be absolutely certain, without reference to the real sky, or to any other part of nature, without even knowing what the white things were intended for, that they cannot

possibly resemble *anything*; that whatever they were meant for, they can be nothing but a violent contradiction of all nature's principles and forms. When, on the other hand, we take up such a sky as that of Turner's Rouen seen from St. Catherine's Hill, in the Rivers of France [collection], and find, in the first place, that he has given us a distance over the hills in the horizon, into which when we are tired of penetrating, we must turn and come back again, there being not the remotest chance of getting to the end of it; and when we see that from this measureless distance up to the zenith, the whole sky is one ocean of alternate waves of cloud and light, so blended together that the eye cannot rest on any one without being guided to the next, and so to a hundred more, till it is lost over and over again in every wreath; that if it divides the sky into quarters of inches, and tries to count or comprehend the component parts of any single one of those divisions, it is still as utterly defied and defeated by the part as by the whole; that there is not one line out of the millions there which repeats another, not one which is unconnected with another, not one which does not in itself convey histories of distance and space, and suggest new and changeful form; then we may be all but certain, though these forms are too mysterious and too delicate for us to analyze, though all is so crowded and so connected that it is impossible to test any single part by particular laws, yet without any such tests we may be sure that this infinity can only be based on truth, that it *must* be nature, because man could not have originated it, and that every form must be faithful, because none is like another.

In Ruskin's view, the old masters violated the principle of infinity in their landscape art in two respects. First, they did not show regard for the variety of phenomena but were content with a few formulaic images representing foliage, water, sky, etc. And when they did represent variety, they tended to make the detail overly distinct and so mistakenly allowed it to dominate the pic-

ture. It is difficult, Ruskin says, to retain respect for the old masters if, for example, one compares their systems of skies with what nature produces "for a single day or hour, when she is really at work in any of her nobler spheres of action."

Stand upon the peak of some isolated mountain at daybreak, when the night mists first rise from off the plains, and watch their white and lake-like fields, as they float in level bays and winding gulfs about the islanded summits of the lower hills, untouched yet by more than dawn, colder and more quiet than a windless sea under the moon of midnight; watch when the first sunbeam is sent upon the silver channels, how the foam of their undulating surface parts and passes away, and down under their depths the glittering city and green pasture lie like Atlantis, between the white paths of winding rivers; the flakes of light falling every moment faster and broader among the starry spires, as the wreathed surges break and vanish above them, and the confused crests and ridges of the dark hills shorten their grey shadows upon the plain. Has Claude [Lorrain] given this? Wait a little longer, and you shall see those scattered mists rallying in the ravines, and floating up towards you, along the winding valleys, till they crouch in quiet masses, iridescent with the morning light, upon the broad breasts of the higher hills, whose leagues of massy undulation will melt back and back into that robe of material light, until they fade away, lost in its lustre, to appear again above, in the serene heaven, like a wild, bright, impossible dream, foundationless and inaccessible, their very bases vanishing in the unsubstantial and mocking blue of the deep lake below. Has Claude given this? Wait yet a little longer, and you shall see those mists gather themselves into white towers, and stand like fortresses along the promontories, massy and motionless, only piled with every instant higher and higher into the sky, and casting longer shadows athwart the rocks; and out of the pale blue of the horizon you will see forming and advancing a troop of narrow, dark, pointed vapours,

which will cover the sky, inch by inch, with their grey network, and take the light off the landscape with an eclipse which will stop the singing of the birds and the motion of the leaves, together; and then you will see horizontal bars of black shadow forming under them, and lurid wreaths create themselves, you know not how, along the shoulders of the hills; you never see them form, but when you look back to a place which was clear an instant ago, there is a cloud on it, hanging by the precipices, as a hawk pauses over his prey. Has Claude given this? And then you will hear the sudden rush of the awakened wind, and you will see those watch-towers of vapour swept away from their foundations, and waving curtains of opaque rain let down to the valleys, swinging from the burdened clouds in black bending fringes, or pacing in pale columns along the lake level, grazing its surface into foam as they go.

And so the passage continues or, rather, rolls on. Five times, before it ends—five times, in the span from dawn to dark and back to dawn again—Claude Lorrain must suffer the sonorous question: "Has Claude given this?" Only through terse footnotes does the reader learn that this prose portrait of nature's changeable face is actually based on ten paintings by Turner—five of which are surreptitiously described in the above excerpt.

The outrageous feature of *Modern Painters* was not that a twenty-four-year-old had accused the "divine Claude" of making mistakes, or of lacking inspiration, in his depiction of trees, clouds, and water, but rather in the fact that—as everyone finally recognized—the unknown author, with his treasure-house of experience and his gifts of language, could find nothing to sink his teeth into, and nothing to inspire him, in the mild skies and radiant backgrounds of Claude Lorrain—whereas he found abundant material in the British tradition of imagistic poetry, and in the literature of the picturesque. No reader, scanning Ruskin's grand descriptive passages—his "purple passages"—can feel the slightest doubt whose side he is on. Not that of the "intellectual" Poussin, nor of the

"undisciplined" Salvatore Rosa, nor of the "tender" Claude. Ruskin thought only two artists worth their salt: nature and Turner. Whenever he wants to berate the great triumvirate of landscape painters, or some other old master, his "science of aspects" turns into a "poetry of aspects" and his censure to a rapture—as we see in the following passage, where he speaks of the old masters' second violation of the principle of infinity; namely, the unnatural vacuousness of their depiction of space:

Take, for instance, the street in the centre of the really great landscape of Poussin (great in feeling at least) marked 260 in the Dulwich Gallery. The houses are dead square masses with a light side and a dark side, and black touches for windows. There is no suggestion of anything in any of the spaces; the light wall is dead grey, the dark wall dead grey, and the windows dead black. How differently would nature have treated us! She would have let us see the Indian corn hanging on the walls, and the image of the Virgin at the angles, and the sharp, broken, broad shadows of the tiled eaves, and the deep-ribbed tiles with the doves upon them, and the carved Roman capital built into the wall, and the white and blue stripes of the mattresses stuffed out of the windows, and the flapping corners of the mat blinds. All would have been there; not as such, not like the corn, or blinds or tiles, not to be comprehended or understood, but a confusion of yellow and black spots and strokes, carried far too fine for the eye to follow, microscopic in its minuteness, and filling every atom and part of space with mystery, out of which would have arranged itself the general impression of truth and life.

Now, Ruskin's punch line: "And thus nature is never distinct and never vacant, she is always mysterious, but always abundant; you always see something, but you never see all."

If it is true that nature knows no repetition and that it exhibits regularity only in isolated cases, while its normal state is a blend of every conceivable type of effect, then the artist can do his job

only by sticking close to his model in nature; and the critic, whose job it is to verify the truth of the artwork, ought properly to stand by the artist's side as he works, or at least to follow in his footsteps later on, to see the same thing that he saw. Ruskin followed Turner's trail through Europe before starting work on *Modern Painters*, and later he revisited hundreds of the scenes which Turner had painted, where he actively reconstructed Turner's works by a process of looking, drawing, and writing. Landscape painting, he believed, meant assigning the viewer to a specific time and space: "The painter . . . places the spectator where he stands himself; he sets him before the landscape and leaves him." Art criticism, which ideally was a comparative and empirical science, had no choice but to operate in the same way. Instead of carrying on an abstract dialogue between elevated criteria and works of art which might or might not fulfill them, the critic had to begin again each time he confronted a new work; and each time he had to draw on his own experience to understand it.

Moreover, the critic needed readers whose minds and senses were as alert as his own. Starting with his first major book, Ruskin always presupposed an active and responsive reader: not a "dear" or "gentle reader" who would consent to be led by the hand, but a collaborator prepared to work at the tasks assigned him, willing to take a stand, and never weary of poring over details alongside the author. It was the critic's job to make repeatable the experience of a painting which was not physically present and of a nature scene which had been present only once. In fact, when the painting itself failed to reconstruct adequately the "truth" of nature, the critic had to do it instead, without any prompting from an artwork. In other words, he had to be prepared, if necessary, to do everything himself.

Let us look at an actual example of how Ruskin believes the critic should function. He starts off as follows: "There is, in the first room of the National Gallery, a landscape attributed to Gaspar Poussin, called sometimes Aricia, sometimes Le or La Riccia, according to the fancy of catalogue printers." In Ruskin's day, one

did not begin with a description of the work itself but with a statement of where it was to be found; for paintings were not widely available but were unique and confined to a particular location. And for Ruskin, even more than for other critics, it was important to place the reader and the work, because his judgments were based less on general principles than on the possibility of reconstructing the specific time, place, and circumstances in which a nature scene was perceived.

So he goes on: "Whether it can be supposed to resemble the ancient Aricia, now La Riccia, close to Albano, I will not take upon me to determine, seeing that most of the towns of these old masters are quite as like one place as another." Already we have encountered our first disappointment: in spite of this concreteness about names and places, it turns out that we are not really dealing with anything concrete after all.

"At any rate, it is a town on a hill, wooded with two-and-thirty bushes, of very uniform size, and possessing about the same number of leaves each." The deadpan prose, paradoxically, produces uneasiness. Even a reader unacquainted with Ruskin's theories about infinity must suspect, after reading this sentence, that all is not well with a picture in which you feel you can count the bushes and leaves.

"These bushes are all painted in with one dull opaque brown, becoming very slightly greenish towards the lights, and discover in one place a bit of rock, which of course would in nature have been cool and grey beside the lustrous hues of foliage, and which, therefore, being moreover completely in shade, is consistently and scientifically painted of a very clear, pretty, and positive brick red, the only thing like colour in the picture." This chapter of *Modern Painters* happens to be about color, the "truth of colour." The dominant hue of the old-style landscape painting was, we are told, brown, or greenish-brown. Even modern painters like Turner and Constable were hounded with advice that they should aim for an overall brownish effect resembling the color of a Cremona violin. Such a subdued portrait of woods and fields naturally cried out for

a patch of contrasting color, and this is why the rock, which in the real world would be drowned out by bright green foliage, has been painted brick-red.

For a moment, Ruskin adopts a sympathetic tone, pretending to condone the rules of this school of painting; but he does so only to expand the irony as he goes on to describe the next feature: "The foreground is a piece of road which, in order to make allowance for its greater nearness, for its being completely in light, and, it may be presumed, for the quantity of vegetation usually present on carriage-roads, is given in a very cool green grey; and the truth of the picture is completed by a number of dots in the sky on the right, with a stalk to them, of a sober and similar brown." The reviewer, apparently conforming to the artist's intentions, seems within his rights when, at the end, he describes details of the work as if they were not objects from nature but merely artistic constructs: "a number of dots with a stalk to them" is enough to make his point.

So far, his total description amounts to only four sentences. He has not expressed any explicit judgment or sprung excitedly to the defense of any rules of art; Ruskin the critic has been cool and concealed.

But now he moves on. "Not long ago, I was slowly descending this very bit of carriage-road, the first turn after you leave Albano." He introduces this scene from nature as concretely as, before, he introduced the scene from art, fixing it in time and place. Earlier, he raised doubts about whether the work of art was meant to be a topographical portrait. Now all doubt is forgotten, because he can consult the reality itself. And only when reality is directly present does this critic really bring his guns to bear.

Suddenly the disagreeably factual, hypotactic style begins to vibrate. There is an alternation of stressed and unstressed syllables. On come the rolling parataxes which are the hallmark of Ruskin's "purple passages." It is a sentence that you must *hear* rather than read: "It had been wild weather when I left Rome, and all across the Campagna the clouds were sweeping in sulphurous blue, with a clap of thunder or two, and breaking gleams of sun along the

Claudian aqueduct lighting up the infinity of its arches like the bridge of chaos." The lines have assonantal rhyme and can be scanned like poetry; but the most powerful element is the surging rhythm with its sequence of varied stresses. Twice, Ruskin gives us details about the weather; twice the word "and" signals us to look upward, to take in a sweeping view of the landscape. Then we are jacked up even further by hyperbole and metaphor ("infinity of arches," "bridge of chaos") which would have been completely out of place ten lines before.

And yet all this is only a warm–up exercise, an advance scouting party, a sentence like a long, fine-jointed antenna feeling its way forward—to this: "But as I climbed the long slope of the Alban Mount, the storm swept finally to the north, and the noble outline of the domes of Albano, and graceful darkness of its ilex grove, rose against pure streaks of alternate blue and amber; the upper sky gradually flushing through the last fragments of rain-cloud in deep palpitating azure, half æther and half dew. The noonday sun came slanting down the rocky slopes of La Riccia, and their masses of entangled and tall foliage, whose autumnal tints were mixed with the wet verdure of a thousand evergreens, were penetrated with it as with rain."

And now at last he is getting down to his real subject, color, only to say that the category does not apply: "I cannot call it colour, it was conflagration. Purple, and crimson, and scarlet, like the curtains of God's tabernacle, the rejoicing trees sank into the valley in showers of light, every separate leaf quivering with buoyant and burning life; each, as it turned to reflect or to transmit the sunbeam, first a torch and then an emerald."

So, even foliage can look red, and only those determined to keep it greenish-brown forever and ever are reduced to hunting around for something to make a contrast. The laws of local color break down when both the color and the locale start to swing. Now there is nothing left to hold back the sonorous language as it sweeps forward, into infinity, until it reaches the horizon: "Far up into the recesses of the valley, the green vistas arched like the hollows of mighty waves of some crystalline sea, with the arbutus

flowers dashed along their flanks for foam, and silver flakes of orange spray tossed into the air around them, breaking over the grey walls of rock into a thousand separate stars, fading and kindling alternately as the weak wind lifted and let them fall. Every blade of grass burned like the golden floor of heaven, opening in sudden gleams as the foliage broke and closed above it, as sheet-lightning opens in a cloud at sunset; the motionless masses of dark rock—dark though flushed with scarlet lichen, casting their quiet shadows across its restless radiance, the fountain underneath them filling its marble hollow with blue mist and fitful sound; and over all, the multitudinous bars of amber and rose, the sacred clouds that have no darkness, and only exist to illumine, were seen in fathomless intervals between the solemn and orbed repose of the stone pines, passing to lose themselves in the last, white, blinding lustre of the measureless line where the Campagna melted into the blaze of the sea."

Who could blame the word-drunk author for claiming that nature's portrait is beyond the resources of art to duplicate—even beyond the resources of Turner? "Not in his most daring and dazzling efforts could Turner himself come near it." We see that this critic has not found the approach to suit his material: he keeps complaining that the available terms, rules, and norms are insufficient. For his prose has captured nature itself—or at least more of it than the works he is examining. In fact, this is another novel element which the anonymous young author introduced to his task in the year 1843: he put forward the idea that criticism is an act of substitution. Or, to borrow a notion from William Blake, he treated criticism as imitation, imitation as criticism. He did not evaluate, he demonstrated. For him, criticism was something that consumed itself, the work of art under discussion, and all other works of art, so that the resultant upsurge of energy might elevate him to his proper subject, which was nature. Only the concrete experience mattered now; and only language, which made the experience repeatable, could make it concrete.

Of course, it is not enough for a critic, his readers, and the viewers of a work of art simply to return to the spot where nature

originally enacted its spectacle. To be sure, this is one prerequisite, at least for the critic; for Walter Pater spoke the truth for his whole century when he pronounced: "Modern thought is distinguished from ancient by its cultivation of the 'relative' spirit in place of the 'absolute.' . . . To the modern spirit nothing is, or can be rightly known, except relatively and under conditions." But Ruskin is pursuing a task of absorption and reabsorption, which requires something more than to be accurately placed in space and time.

We have already quoted Ruskin's definition of what the landscape painter does: "The painter only places the spectator where he stands himself; he sets him before the landscape and leaves him." But Ruskin goes on to say that the painter must also "guide the spectator's mind" so as "to inform him of the thoughts and feelings with which these [objects] were regarded by the artist himself. . . . In attaining the second end, the artist not only *places* the spectator, but *talks* to him; makes him a sharer in his own strong feelings and quick thoughts." Art speaks to many senses and emotions; it is expression as well as information. Consequently, the critic, the second spectator on the scene, has as one of his duties the obligation to describe the work in a way which arouses sympathy and kindred emotions.

There can be little doubt that Ruskin achieved this in his word-painting of the landscape around Ariccia. Twentieth-century readers, overfed by now on the opulent style of later writers on art, may feel that the passage could do with a general toning-down. Ecstatic realism has become very alien to us. Yet close inspection reveals that the hymn never strays from the point, that it never tries to ascend to some higher level of emotion or idea. Our last view of the horizon *is* the real horizon: the infinity of the finite, a transcendence of the sensory, not of the suprasensory. Ruskin moves the reader by moving everything. His prose, seemingly so dry at the start, is falling in cascades by the end. The author experiences the landscape peripatetically, by walking around it, rather than "taking in the view" from a fixed vantage point like his predecessors, the *vedutisti* or view hunters of the eighteenth and early nineteenth centuries; so he, too, is in motion. And finally the

landscape itself is pulsating, under the twin effects of weather and light.

What this author tells his reader is not a nature story with a moral at the end: it is nature *as* a story, as a narratable event. The English Romantics had aimed to temporalize space, to make it possible to experience the infinite in time. The moral lay in the process, that is, in "sharing" in the "strong feelings and quick thoughts," not in the feelings and thoughts themselves. As in the "science of aspects," the key to life is to perceive it in a living way.

I will now quote a celebrated text in its entirety, without interruption or comment, to show how successfully Ruskin was able to "narrate" pictures so that the painting and its model became indistinguishable inside his pictorial narration. This passage is the description of Turner's seascape *The Slave Ship* (1840), which at that time was privately owned by the Ruskin family and which now is in the Boston Museum of Fine Arts. Ruskin's footnote to the text explains that the ship he describes "is a slaver, throwing her slaves overboard. The near sea is encumbered with corpses."

It is a sunset on the Atlantic, after prolonged storm; but the storm is partially lulled, and the torn and streaming rain-clouds are moving in scarlet lines to lose themselves in the hollow of the night. The whole surface of sea included in the picture is divided into two ridges of enormous swell, not high, nor local, but a low broad heaving of the whole ocean, like the lifting of its bosom by deep-drawn breath after the torture of the storm. Between these two ridges the fire of the sunset falls along the trough of the sea, dyeing it with an awful but glorious light, the intense and lurid splendour which burns like gold, and bathes like blood. Along this fiery path and valley, the tossing waves by which the swell of the sea is restlessly divided, lift themselves in dark, indefinite, fantastic forms, each casting a faint and ghastly shadow behind it along the illumined foam. They do not rise everywhere, but three or four together in wild groups, fitfully and furiously, as the under strength of the swell compels or per-

mits them; leaving between them treacherous spaces of level and whirling water, now lighted with green and lamp-like fire, now flashing back the gold of the declining sun, now fearfully dyed from above with the undistinguishable images of the burning clouds, which fall upon them in flakes of crimson and scarlet, and give to the reckless waves the added motion of their own fiery flying. Purple and blue, the lurid shadows of the hollow breakers are cast upon the mist of night, which gathers cold and low, advancing like the shadow of death upon the guilty ship as it labours amidst the lightning of the sea, its thin masts written upon the sky in lines of blood, girded with condemnation in that fearful hue which signs the sky with horror, and mixes its flaming flood with the sunlight, and, cast far along the desolate heave of the sepulchral waves, incarnadines the multitudinous sea.

Ruskin founded a new literary genre with texts of this kind, a genre which is often referred to as "literature of art." It differed from older forms in that it was not writing *on* art, composed with a moralistic interest beyond art; nor was it writing that tried to resemble art (*Ut pictura poesis, ut poesis pictura*) using media other than paint. One might say that the literature of art sprang from a twofold personal experience: the experience of the painting and the experience of what the painting depicted. Its aim was to re-create this personal experience, conferring meaning in the process.

It is essential to stress these distinctions because recent interpreters of Ruskin, following the prevailing academic trend to trace everything back to earlier sources, have viewed him as firmly entrenched in the venerable tradition of scriptural exegesis and moral didacticism based on the study of types, the interpretation of symbols, and the poetic association of ideas. Anyone at all familiar with Ruskin must be aware that he was in fact steeped in this kind of evangelical hermeneutical tradition, that he grew up in it and drew on its resources throughout his life. On the other hand, it would be a mistake to regard his mature work as merely the product of an evangelical upbringing and of early exposure to

reading matter rich in didactic imagery. To do so would leave us unable to account for two things: the dramatic shifts and upheavals of his life and thought, which produced several distinct phases and which are inconsistent with the idea of a firmly rooted tradition, as well as the fact that he was perceived as a seminal figure by other writers on art who took him as a model. If Ruskin only faithfully carried on a tradition, it is hard to see why we should study him at all. But the fact is that the great contributors to the genre of the literature of art—Swinburne, Pater, Proust, to name but a few—plus a host of minor authors like George Moore and Philip Hamerton, all drew their inspiration from Ruskin, starting with the first volume of *Modern Painters*, published in 1843. Pater's *Studies in the History of the Renaissance*, published thirty years later, was not the ground-breaking work that some have thought it.

Granted, in Volume Two of *Modern Painters*, Ruskin does give us a description which abides by all the conventions of typological exegesis: "The ruined house is the Jewish dispensation; that obscurely arising in the dawning of the sky is the Christian; but the corner-stone of the old building remains, though the builders' tools lie idle beside it, and the stone which the builders refused is become the Headstone of the Corner." If Ruskin had done all his analyses in this method and style, he would today be as forgotten as, for instance, Anna Jameson, the diligent exegete who interpreted the iconography of Christian paintings for her Protestant countrymen around this same time.

But, for every passage like the one just quoted, Ruskin's first volume has a hundred others like those about Ariccia or *The Slave Ship*—passages which show nature's one supreme truth to be the truth of infinity, which must also be the goal of art, and which will not exchange this truth for the set truths of any language of pictorial symbolism.

Charlotte Brontë wrote, after reading *Modern Painters*: "I feel now as if I had been walking blindfold—this book seems to give me new eyes." Ruskin's book taught a different way of seeing and writing about nature and art. As *Britannia* magazine expressed it, Ruskin had outdone "the whole body of cognoscenti,

dilettanti, and all haranguers, essayists, and critics." Moreover, he had also outdone himself, by overcoming his comfortable roots in the literary tradition of the English art world. In the 630 pages of Volume One of *Modern Painters*, I counted only eleven quotations from the poets—a remarkably small number for the first book by a well-read author. He had abandoned that lazy shuttling back and forth among the arts, that meshing of cultural media, practiced by art critics who do not know what to do with pictures as pictures.

Ruskin's liberation from allegory meant a liberation from Turner, too. *The Slave Ship* itself makes it clear why this had happened. Turner belonged, consciously and devotedly, to that older, traditional school of artists who went in for allegorical painting weighed down with literary trappings; and he approved a flagrantly allegorical interpretation of his works. When he drew a burst of light around Wycliffe's birthplace, he explained that it was "the light of the glorious Reformation," and the geese fluttering in the foreground were "the old superstitions which the genius of the Reformation is driving away." He challenged Ruskin to explain the hidden meaning of a detail in his painting of Napoleon, and when the baffled Ruskin finally confessed that he could not, Turner still refused to give him the slightest clue. He liked to accompany his paintings with poems, composed either by himself or by others. These verses revealed both his respect for the art of literature, which, socially, ranked higher than painting, and his great personal love of poetry.

Turner attached the following lines, composed by himself, to his painting of the slave ship, whose correct and unabridged title was *Slavers Throwing Overboard the Dead and the Dying—Typhoon Coming On*:

> Aloft all hands, strike the top-masts and belay.
> You angry setting sun and fierce-edged clouds
> Declare the Typhoon's coming.
> Before it sweep your decks, throw overboard
> The dead and dying—ne'er heed their chains.

Hope, Hope, fallacious Hope!
Where is thy market now?

Turner drew the inspiration for his painting and his verse caption partly from reality and partly from literature. On occasion, slave ships do appear to have thrown the dead and wounded overboard during storms at sea, because the insurance companies would pay compensation only for slaves lost to the wind and waves, not for those who died of injury or illness while on board.

The setting of this cruel scene—the blood-red sunset at sea— was also a familiar feature of Romantic poetry, where it figured as a motif of guilt and high tragedy. One of Turner's favorite poets, the eighteenth-century Scot James Thomson, had described a typhoon in his poem "Summer." A storm, "a mingled mass / Of roaring winds and flame and rushing floods," destroys a slave ship, delivering both seamen and their human cargo to the sharks ("one death involves / Tyrants and slaves"; "he [the shark] dyes the purple seas / With gore, and riots in the vengeful meal").

The contemporary political debate about slavery also played a role in Turner's work. His painting was first exhibited in London in 1840, the same year that Prince Albert delivered his first public address as Consort at a meeting of the Anti-Slavery League, and there is every reason to see Turner's ship and shipwreck as part of the long and still vital tradition in which a ship stands for the ship of state. The painting may well have been meant as a critical social allegory, as scholars have often supposed. The question which Turner asks in his poem—"fallacious Hope! / Where is thy market now?"—thus refers not to the commercial failure of the slavers' enterprise but, in an extended sense, to the moral bankruptcy of a trade that deals in human beings. Even more specifically, *The Slave Ship* is a critique of a whole economy which will buy and sell anything, which has turned the profit motive into the ultimate bond between people—a bond which, as we see in the painting, is all too easily severed.

Fifteen years later, Ruskin would have been only too happy to interpret Turner's painting in exactly this way. But in the year

1843, when he was writing *Modern Painters*, he chose to install his description of *The Slave Ship* at the end of the section on the "Truth of Water," because it represented for him the completion of "the perfect system of all truth, which we have shown to be formed by Turner's works." He consigns the narrative element of the work to a footnote. The theme, he says, is "the power, majesty, and deathfulness of the open, deep, illimitable sea"—whereas, for Ruskin, the essential feature is not the theme but "its daring conception . . . based on the purest truth, and wrought out with the concentrated knowledge of a life."

Ruskin offers no proof of this painting's truth, as he does for that of other works, by bringing in his own observations or citing the laws of nature. The "purple passage," which replaces the literary element of art with literature itself, is the only experimental test he applies to this great work. It is as if—to borrow Turner's ship metaphor—the ship of Ruskin's prose can only set sail in full rig, can only lift off from the sandbar of technical discussion and float into the open sea when it encounters a work of "truth." A tremor passes through the vessel, a tensing and relaxing, and suddenly it heaves its way into a vast organic rhythm which unites everything under the laws of its own motion. The rhythm fuses together the two focal points of the experience, the painting and its model in nature, and these in turn with the perceptions of the first and second spectator, the artist and the critic, and all these with the form and the content. Granted, Ruskin's prose seascape is, like Turner's original, a *paysage moralisé*; but it is not just a landscape with a moral. It communicates its message only in that moment when all its elements have merged into a living whole. The message will go on being transmitted only so long as the image continues to be experienced. Its communicability depends on the intensity of response, and not on its intelligibility in the conventional sense.

5

All art theorists before Ruskin accepted that art had to imitate nature, but they asserted the principle only to qualify it. Normative aesthetics began with the postulate of mimesis, but its history since then had been a series of escape clauses. For an ever-changing variety of reasons, the theorists had maintained that great painting could be produced without real absorption in the model in nature. They always stressed factors other than the primary relation of art to nature—the need for consistency, for instance. Paintings had to harmonize with the demands of place, time, theme, and audience, and they had to be internally consistent as well, so that the part was attuned to the whole, the colors to each other, and the formal aspects to the content.

In *Modern Painters*, Ruskin said of the great artists of the past that they "worked entirely on conventional principles, not representing what they saw, but what they thought would make a handsome picture." To be sure, they were right to do so, for the use of conventions and the demand for harmony had enabled them to produce works which were not merely "handsome" but substantial in every way; and this was true of landscape paintings along with the rest. Yet Ruskin was right, too: it was important to recognize the great role which convention had played in representing nature—especially if, like Ruskin, you believed that there was a close link between the way people perceived art and the way they perceived other things, and if you cared at least as much about the model in nature as about the picture that was based on it.

In our own time, aesthetic theory has bypassed Ruskin and sanctioned the view that styles are relative, that fidelity to nature is not the primary objective in art. The emphasis now is not on accurate differentiation but on the total effect. Art has been released from its foundations in society and nature, with the result that it must now be interpreted on its own terms. We have long since accepted it as self-evident that all styles and all stylistic epochs are equal in the sight of God. Fidelity to nature may no longer serve as a standard for judging an artwork. Today, anyone who criticized

Claude Lorrain for making all his leaves look alike would be dismissed as a philistine. Of course, there are solid theoretical reasons why it would be wrong to find fault with his leaves. The worrying thing is that, having been told that we must not criticize his lack of realism, we have at the same time lost our ability to recognize a realistic leaf when we see one. Like Ruskin's fellow critics, today's aestheticians have nothing specific to say about Claude's trees, because they can no longer tell the difference between a conventionalized elm and a true elm. They get around the problem by announcing at the start that the difference doesn't matter. And whatever has happened to diagonal lines? Are they as eager to show their reflections in the water as they were in the days of Canaletto and Belotto? Sometimes it seems as if scrapping the mimetic principle in art criticism—and in art itself—had less to do with separating art from history and science than with relieving everyone of an unpleasant chore.

It is no coincidence that we owe this improvement in our thinking to the second generation of art historians who followed in the wake of pioneers like Ruskin, Burckhardt, and Viollet-le-Duc. This second generation brought the first specialist art historians, the first for whom this was their exclusive profession: academically trained and incapable of absorbing detail because recent advances in the technology of image-making, such as the invention of photography, relieved them of the need to do their own drawing. Not one of the founders of academic art history has left us a body of carefully observed and composed drawings numbering into the thousands, as Ruskin did.

But even Ruskin, the champion of the devoted study of nature, had his escape clause. For a man of his years and a Victorian, Ruskin had amazingly advanced views of the requirements and potentials of the painter's medium and of the perceptual apparatus of the viewer. He was among the first to point out the physiological limitations of our perception of nature and art, and the limited physical range of pigment and canvas, compared to the palette of nature. He considered it as important for a painter to follow the laws of nature as to work in accord with the requirements of his

medium and of human perception. While these two demands were not identical, Ruskin, as a late Romantic, regarded both as integral to the artist's identity: "The laws of nature he knows; these are to him no restraint. They are his own nature." From here, it is only a step to the following, perhaps surprising conclusion: "But if a painter has inventive power he is to treat his subject in a totally different way; giving not the actual facts of it, but the impression it made on his mind."

This idea can, of course, be traced all the way back to Plato; but the immediate model was Wordsworth, who had written in the expanded preface to an 1815 edition of his poems: "The appropriate business of poetry . . . is to treat of things not as they *are*, but as they *appear*; not as they exist in themselves, but as they *seem* to exist to the *senses*, and to the *passions*."

Some years later, when Ruskin was writing his second major work, *The Stones of Venice*, he again underlined this distinction, and made an important addition, which in part is familiar to us from his thoughts about the science of aspects: "Science deals exclusively with things as they are in themselves; and art exclusively with things as they affect the human sense and human soul. . . . Both, observe, are equally concerned with truth; the one with truth of aspect, the other with truth of essence. Art does not represent things falsely, but truly as they appear to mankind. Science studies the relations of things to each other: but art studies only their relations to man: and it requires of everything which is submitted to it imperatively this, and only this,—what that thing is to the human eyes and human heart, what it has to say to men, and what it can become to them."

In our discussion of the science of aspects, we saw that this science, and its applied form, art, represented a way of making experience accessible—experience which was totally dependent on the perceptual alertness of the individual observer. Now Ruskin is telling us that the very limitations of art may be viewed positively, in that art may serve as a special filtration process for extracting the human meaning of all we observe. Nature is passed through the medium of art, and through the senses, and thereby becomes

communicable. Art, as Coleridge said, is "the mediatress between, and reconciler of, nature and man. . . . It is, therefore, the power of humanizing nature." And Wordsworth described the poet as "a man speaking to men." Now, thirty years later, Ruskin has taken up these ultra-Romantic views of poetry and applied them to visual art, at the same time giving them a scientific foundation.

Ruskin tells us that reflections in water show us better than anything else what nature is and what man can grasp of it: "Go to the edge of a pond on a perfectly calm day, at some place where there is duckweed floating on the surface, not thick, but a leaf here and there. Now, you may either see in the water the reflection of the sky, or you may see the duckweed; but you cannot, by any effort, see both together." The eye is forced to focus either on the nearby leaves floating on the water's surface or on the brilliant reflection of the faraway sky. If it concentrates on the reflection, then the leaves become indistinct patches floating across it; if it rests on the shape and internal veining of the leaves, then the sky seems no more than a meaningless swaying mass of bright and dark reflexes. Nature offers both, but man can grasp only one at a time; and above all, he can *reproduce* only one, when he is acting as an artist. He will tend to depict a scene as people "normally" perceive it; that is, he will choose to paint what is at the surface of the water, where our eyes tend to focus because it is from there that we expect to derive the most important information. As a result, objects at the surface, and also the shadows of low nearby objects such as projecting fence posts, will have a solid and clear-cut reflection, while the reflections of high clouds and trees will look indistinct and patchy.

A similar problem arises when we try to look at a simple land-scape, which unfolds in several successive layers as it recedes to-ward the horizon. We cannot get a clear and distinct view of objects in the foreground and in the background at the same time. The critical zone is the first five hundred yards from our eye, Ruskin says in *Modern Painters*. It is impossible for us to see two objects at the same moment if one is ten yards away and the other five hundred; this requires a shift of focus. But if one object is five

hundred yards away, and the other five miles beyond it, we *can* focus on both at the same time. "The consequence of this is, practically, that in a real landscape, we can see the whole of what would be called the middle distance and distance together, with facility and clearness. . . . And therefore, if in a painting our foreground is anything, our distance must be nothing, and *vice versâ*; for if we represent our near and distant objects as giving both at once that distinct image to the eye . . . we violate one of the most essential principles of nature; we represent that as seen at once which can only be seen by two separate acts of seeing, and tell a falsehood as gross as if we had represented four sides of a cubic object visible together."

This apparently foolproof chain of reasoning actually conceals a hidden assumption, a personal aesthetic imperative that is as peremptory and aggressive as the older imperatives ordering the artist to imitate the works of classical antiquity or of Raphael. Ruskin is demanding that the image depicted must conform to the image seen—an idea which belongs entirely to the nineteenth century. Before then, the rule had been that pictures gave you something to see; now they were supposed to do your seeing for you.

So fundamental was this change that it may be called the second anthropological turning point in art history: the second major attempt to adjust art to the human organism. In the fifteenth century, painters had begun to follow the guidelines of perspective, taking into account factors like the viewer's distance from the work, and using horizontal and vertical lines to define a vantage point, so as to improve the way the viewer relates to the picture. This was a geometrical, mechanical, and optical solution to the problems of perception. Its terms were so general that the painter was more or less free to treat objects as he liked, providing only that he maintained a consistent perspective. It would hardly have occurred to anyone to ask a picture to do what belonged to the eye itself. The purpose of a painting was to occupy the eyes and the mind, to stimulate or even tax them, to set off perceptual and reflective processes on a variety of levels. But now, in the nineteenth century, the geometric model of perception was replaced

by a physiological model. The bundle of optical rays was supplanted by an internal apparatus with built-in limitations, and with built-in mechanisms which were capable of compensating for these limitations. Painting had to take both into account.

This change of focus came out of vigorous research in the field of optics, which began in the second half of the eighteenth century. Scientists in the nineteenth century were familiar with the ancient scientific principle that we cannot really understand nature's "machines" until we have developed technological duplicates. In an age which had invented the camera lucida, the stereoscope, the photocamera, and the electrical telegraph, it became possible to rethink the physiology of the human eye and its mechanism of nerves. It was almost inevitable that Britain—the home of such outstanding scientists as the three Herschels, Count Rumford, Thomas Young, David Brewster, William Hyde Wollaston, Henry Fox Talbot, and the Wedgwoods—would see a lively exchange of ideas between science and art. For example, by the turn of the century, Thomas Young had published his *Observations on Vision* (1793) and *Mechanism of the Eye* (1800), giving a precise description and explanation of all the essential functions of the eye. Young's interpretation of the accommodation of the eye—although it was later discarded—was the first plausible theory of how the eye automatically adjusts to seeing at different distances. He accurately defined the area of acute vision on the retina; he measured the pupil's range in motion or at rest; and he devised the first precise optometer to test individual eye performance. All his studies showed that even healthy eyes which needed no correction varied widely in their ways of seeing and that, consequently, the eye was not a mechanical construct but a highly individual sense.

Young became known as the father of physiological optics, and Turner very likely profited from Young's discoveries when he began to study scientific literature on the eye to prepare his lectures at the Royal Academy. As a Professor of Perspective (his actual title), and as an artist, he eagerly read every new contribution to the linear–geometric analysis of objects, the physiology of perception, color optics, and the imponderables of reflection. Even so,

he never really mastered traditional perspective and, Ruskin said, never painted a picture in which the perspective was really correct.

In a lecture which he probably delivered in 1811, Turner informed his audience: "The eye must take in all objects upon a Parabolic curve for in looking into space the eye cannot but receive what is within the limits of extended sight, which must form a circle to the eye." This was a central tenet of his art theory, although it does not make much sense, expressed in these words. Turner was a poor lecturer, tending to muddle his arguments and continually drawing connections between things which were unrelated—as he does here. Actually, he is trying to say two things. First, the retina, which receives the image of objects, is curved—or as Turner says elsewhere, "circular"—if you look at it in cross section. Second, the eye's field of vision is also circular; but for a separate set of reasons.

Very likely, Turner was also aware of a third major factor in the functioning of the eye, to which we have already alluded: its inability to focus with equal sharpness on more than one point at a time. In any case, some of his remarks show that he realized the general nature of the problem. Again, he seems essentially to be discussing the curvature of vertical and horizontal lines as projected onto the retina; but we can interpret one phrase to mean that, given the curvature of the retina, the point of optimum resolution is necessarily very limited. We do not know if Turner also discussed in his lectures the fact that the eye, which sees one point sharply while the surrounding points are more or less blurred, also has to adjust its focus to shift back and forth between objects at varying distances. His paintings suggest a more than subconscious handling of this physiological phenomenon.

Ruskin brings out this point about Turner very neatly: "Turner introduced a new era in landscape art, by showing that the foreground might be sunk for the distance, and that it was possible to express immediate proximity to the spectator, without giving anything like completeness to the forms of the near objects. This, observe, is not done by slurred or soft lines (always the sign of vice in art), but by a decisive imperfection, a firm, but partial

assertion of form, which the eye feels indeed to be close home to it, and yet cannot rest upon, nor cling to, nor entirely understand, and from which it is driven away of necessity to those parts of distance on which it is intended to repose."

Turner appears to have introduced this bold innovation in a matter-of-fact, almost systematic way. But his preoccupation with resolution of depth was outweighed by an interest, repeatedly expressed in his statements of theory, in the spherical structure of the eye and its circular field of vision. The painter who had begun by modeling his work on Claude Lorrain's reliable scroll composition, with a stage left, a stage right, and a shallow arc in between, eventually set the lower half of his canvas into motion. The curving arcs of the foreground, middle ground, and background started to swing toward each other like hammocks, with their ends rising higher and higher, until they toppled over and the whole painting began to whirl like a vortex. *Hannibal and His Army Crossing the Alps*, painted in 1812, one year after Turner's first Academy lectures, and *Light and Colour (Goethe's Theory)*, painted in 1843, represent the extreme of Turner's turbulent, inward-sucking spirals. Between the two lie innumerable works in which curved horizons, segments of landscape, and cloud formations have the shape of a shallow ellipse or a spherical lens. The best-known examples of these are Turner's panoramic Petworth landscapes (circa 1828). Not only do the edges of the terrace bend upward in these landscapes, but all objects obey a mysterious law of gravity which seems to have set the whole scene revolving inside a shallow plate. Only the center remains at rest, so that here the sun's rays cut a clear triangular pattern. These pictures are eye-shaped, not cutouts viewed straight through the visual pyramid, but subtly curved bowl shapes.

The delicate harmonization of eye and picture is apparent even in Turner's most unassuming works, his book illustrations. His illustrations are almost all vignettes, that is, small round or oval pictures with blurred rather than defined edges: not mere cutouts but developed compositions whose rounded detail seems to grow from inside.

If we assume that Turner himself did not at some time make a clear statement on the subject in one of his unrecorded lectures, then the first person to explain why the rounded form of the vignette was so satisfying—and incidentally to explain the new paradigm of painting at the same time—was a twenty-year-old art critic who, back in 1839, had a piece published in Loudon's *Architectural Magazine*. The young man wrote under the pseudonym Kata Phusin ("According to Nature"), but his real name was John Ruskin, and he called his paper "On the Proper Shapes of Pictures and Engraving."

> The truth is, however, that, strictly speaking, only one *point* can be clearly and distinctly seen by the fixed eye, at a given moment; and all other points included in the vision, are indistinct exactly in proportion to their distance from this central point; and when this distance has increased till the line connecting the two points subtends thirty degrees, the receding point becomes invisible. This distance of thirty degrees, therefore, may be considered as the limit of sight. . . . Consequently the limit will not be a harsh line, but, on the contrary, will be soft and unfelt by the eye.

But it is very rare that we fix the eye on a single point, Ruskin says. Instead of "confining the attention to the central point, [we normally prefer to] distribute it . . . over the whole field of vision." This general distribution then produces a circle whose diameter subtends sixty degrees and whose center is opposite the eye. If we assume Ruskin to be right in his main premise, that paintings or printed engravings ought to be "a substitute for the natural limit of sight," then their format must reflect the spherical structure of human vision, and the artist must choose whether to exceed or fall short of our visual limitations. The circle shape is the most "scientifically true," Ruskin says, but it results in a distortion of perspective lines. Turner did not shrink from this distortion in his own work. But Ruskin, for reasons too elaborate to discuss here, ends by rejecting the circle in favor of the ellipse, as the ideal shape

for a painting—a figure which, of course, comes much closer to the conventional rectangle. The important thing is that Ruskin recommends a reduction in the sharpness of detail along the edges and suggests that the corners of the rectangle—the points where it extends beyond the ideal ellipse—should be blurred and filled in with rounded brushstrokes, "indicating the form of the ellipse." Everything must work to ensure that, when viewed from an appropriate distance away, the lines of the edge should coincide with the limits of sight: because the failure to achieve this coincidence produces an unharmonious effect.

For the same reasons, Ruskin recommends use of the vignette for book illustrations, which can never be viewed from far enough away, for a rectangle to produce the illusion of an ellipse. The vignette, he says, is a figure "by whose indeterminate edge the eye is made to feel that it is a part of a picture, not a perfect one, which it is contemplating. All harshness is thus avoided; and we feel as if we might see more if we chose, beyond the dreamy and undecided limit, but have no desire to move the eye from its indicated place of rest."

We hardly need to add that Ruskin praised Turner as the great master of the vignette. After all, as Ruskin tells us in his autobiographical recollections for 1832, Turner's vignette illustrations to Rogers's *Italy* (1830) "determined the main tenor of my life."

Reading this article on the "proper shapes of pictures and engravings," written when Ruskin was only twenty, we might conclude that in future years the budding art critic would produce a scientifically based aesthetics, a "psychophysical" art theory in the style of Continental theorists like Fechner, Helmholtz, or Claudet, who several decades later worked out ideas originally posed by the English. Ruskin's arguments are so mathematically and philosophically stringent that they seem to belong to the second half of the nineteenth century, the age of facts. Indeed, one is tempted to conclude that the older Romantic and classical schools of art appreciation, and the elegant, chatty, essayistic tone of the usual art critic, were doomed not to survive much longer.

And yet we know that time did not bear out this supposition.

Instead, Ruskin raised the literature of nature and art to a high art form and helped to preserve the ideas of the early nineteenth century—the ideas of Wordsworth and Turner—so that they continued to flourish down to the start of the modern age. The times called for *Modern Painters* to criticize enthusiasm, but instead it turned out to be enthusiastic criticism. Whenever Ruskin argued scientifically, it was always in response to a Romantic idea, and to pursue a Romantic science: the "science of aspects." His determination to make a painting a substitute for the image in nature was merely the logical consequence of axioms put forward by virtually every representative of English Romanticism.

Blake had said, "As the Eye, Such the Object"; and Wordsworth's "high argument" had been the interaction between the object seen and the eye that sees: "A balance, an ennobling interchange / Of action from within and from without, / The excellence, pure spirit, and best power / Both of the object seen, and eye that sees." Wordsworth's, too, was the remarkable dictum that it is the poet's habit to view man and nature as "essentially adapted to each other." The idea of adaptation also plays a role in Ruskin's thought, whenever his concern is for art as deriving from the faculties of the eye.

But, unlike Wordsworth, Ruskin did not regard the adaptation, the harmony between man and nature, as "essential," but rather considered that it had still to be created and that it was art's task to do so. Traditionally, the history of art had often reflected art's divorce from nature rather than the reverse; and recent social and cultural developments had multiplied the barriers to achieving Wordsworth's "balance" and "ennobling interchange."

The Romantics had been well aware of the threats to this ideal. Among the threats they included not only the growth of science and industry but also what Coleridge called the "despotism of the eye"; that is, the tendency to enslavement to the outward, sensory aspects of nature. Wordsworth warned that the eye, "The most despotic of our senses gain'd / Such strength in me as often held my mind / In absolute dominion." Thus, an "inward eye" was the necessary complement to the "outward eye," and the Roman-

tics' highest goal was the eventual "triumph of vision over optics."

But at this point Ruskin parted company with the Romantics. He upheld to the last the paramount importance of the "outward eye." It was art's task to enable the beholder to experience the possibilities of perception, to teach him to see. The artist leaves the spectator "more than delighted,—ennobled and instructed, under the sense of having not only beheld a new scene, but of having held communion with a new mind, and having been endowed for a time with the keen perception and the impetuous emotions of a nobler and more penetrating intelligence." Therefore, the artist's duty is to offer a model of perception, a perception that seizes nature directly: "Nothing must come between Nature and the artist's sight." Granted, Ruskin does not deny the role of emotion: "The whole function of the artist in the world is to be a seeing and feeling creature." But this definition is a kind of traditional formula which he tacks on, while his real emphasis is always on the artist's other function: "The whole value of that witness [i.e., art] depends on its being *eye*-witness; the whole genuineness, acceptableness, and dominion of it depend on the personal assurance of the man who utters it. All its victory depends on the veracity of the one preceding, 'Vidi.' "

Ruskin calls on the artist—and through him on the spectator— "to be an instrument of such tenderness and sensitiveness, that no shadow, no hue, no line, no instantaneous and evanescent expression of the visible things around him, nor any of the emotions which they are capable of conveying to the spirit which has been given him, shall either be left unrecorded, or fade from the book of record." But, as later chapters will show, this kind of urgent, biased appeal always signaled that Ruskin—consciously or unconsciously—felt the principle in question to be under threat; and this response to it was more the symptom of a problem than a step toward its solution.

Ruskin wanted to safeguard the communication between nature and man. Knowing the limitations both of art and of human perception, he wanted to drop the boundaries between them so as to communicate as directly as possible with nature in its unbounded

form, filtered only through the one medium of the artist's eye. Seeing as communication, as communion with nature: that was not the same thing as seeing for seeing's sake or seeing as a mode of self-perception and self-validation for the perceiver. But inherent in Ruskin's idea was the risk—to which he sometimes succumbed—of confusing intensity with purity, and of divorcing sensory stimulation from the stimuli which caused it: "Everything that you can see in the world around you, presents itself to your eyes only as an arrangement of patches of different colours variously shaded. . . . The perception of solid Form is entirely a matter of experience. We *see* nothing but flat colours; and it is only by a series of experiments that we find out that a stain of black or grey indicates the dark side of a solid substance, or that a faint hue indicates that the object in which it appears is far away. The whole technical power of painting depends on our recovery of what may be called the *innocence of the eye;* that is to say, of a sort of childish perception of these flat stains of colour, merely as such, without consciousness of what they signify,—as a blind man would see them if suddenly gifted with sight."

This passage is a fairly late one, taken from Ruskin's highly successful text on the techniques of draftsmanship, *The Elements of Drawing*, published in 1857. It does not, by any means, mark the end point of a development which had been going on continuously since 1839. I have quoted it simply because it shows, in an especially pure form, one possibility which was latent in Ruskin's theories from the start but which he never raised to the rank of an absolute. Like his much-quoted appeal to young artists to study nature's model, "rejecting nothing, choosing nothing, scorning nothing," these lines from *The Elements of Drawing* are aimed at the beginner, the novice in aesthetic perception and practice. But, of course, this did not stop Ruskin's readers from fragmenting his thought and quoting him out of context.

For example, supporters of Ludwig Feuerbach's view that "the truth of art" was equivalent to the "truth of the senses" cited Ruskin to back up their arguments. By a circuitous path, the message of *The Elements of Drawing* even reached the French Impressionists,

who, more than any other school of painters, based their art on the equation that the Image Depicted equals the Image Seen. And yet Ruskin himself later rejected Impressionism and became embroiled in a lawsuit against the greatest Impressionist painter in England, the American James Whistler. For Ruskin always held aloof from any purely physiological aesthetics. For him, the "truth of art" was more than the "truth of the senses"; it was the truth of nature—of the inner nature of man and the outward nature of the creation. Or, more precisely, it was the truth of the relationship between man and nature.

<div style="text-align: center">6</div>

In *Praeterita*, we find several not especially informative remarks about Volume One of *Modern Painters*, which, as we have noted, was written in 1842–43. The year 1842, coincidentally, was a key year in Ruskin's life for a different reason as well. It was then that he had his encounter with the aspen tree in the woods at Fontainebleau; it was the time of his conversion to nature.

The Victorians, when reviewing their lives, had a great fondness for interspersing them with dramatic conversion episodes, thus adding spice and direction. Originally a Romantic tradition, the conversion episode was perpetuated by the Victorians, like so many other Romantic motifs. But they overused and overloaded it, distorting and to some extent devaluing it in the process. The conversion experience always tended to follow the same pattern. Personal distress, coupled with distress at the course of modern society, would cast the person into a deep depression, a state of emotional and physical ill-being, and great loneliness. This loss of the primordial unity of man and nature, and of man and society, would then reach crisis point, whereupon a sudden inspiration, or an unexpected encounter with some new concept of life, would bring change: not a restoration of the former unity, but insight into how to restructure its elements.

Thomas Carlyle, in his semi-autobiographical novel *Sartor Re-*

sartus (1833), gave us a hard-to-match account of one such "spiritual rebirth." The book's anti-hero, Professor Teufelsdröckh, was, in his youth, denied "all that the young heart might desire and pray for," including friendship, love, professional duty and recognition, and any possibility of converting his "excellent Passivity" into "useful, reasonable Activity." Hopelessness, religious doubt, and fears of human contact have robbed him of life and vitality. "The fearful Unbelief is unbelief in yourself," he says; and this has driven him aimlessly through the world, until the moment of his conversion:

> Full of such humour, and perhaps the miserablest man in the whole French Capital or Suburbs, was I, one sultry Dog-day, after much perambulation, toiling along the dirty little *Rue Saint-Thomas de l'Enfer*, among civic rubbish enough, in a close atmosphere, and over pavements hot as Nebuchadnez-zar's Furnace; whereby doubtless my spirits were little cheered; when, all at once, there rose a Thought in me, and I asked myself: "What *art* thou afraid of? . . . What is the sum-total of the worst that lies before thee? Death? Well, Death. . . . Let it come, then; I will meet it and defy it!" And as I so thought, there rushed like a stream of fire over my whole soul; and I shook base Fear away from me forever. I was strong, of unknown strength; a spirit, almost a god. Ever from that time, the temper of my misery was changed. . . .
>
> Thus had the EVERLASTING NO (*das ewige Nein*) pealed au-thoritatively through all the recesses of my Being, of my ME; and then was it that my whole ME stood up, in native God-created majesty, and with emphasis recorded its Protest. . . . The Everlasting No had said: "Behold, thou art fatherless, outcast, and the Universe is mine (the Devil's)"; to which my whole Me now made answer: "*I* am not thine, but Free, and forever hate thee!"
>
> It is from this hour that I incline to date my Spiritual New-birth, or Baphometic Fire-baptism; perhaps I directly there-upon began to be a Man.

This conversion episode climaxes in a tumult of exalted phrases from transcendental philosophy. But how does Ruskin's account of his own rebirth compare with it?

On their way to Switzerland in 1842, the Ruskins, including their son, who was still sick and feverish after losing Adèle, stayed at an inn in Fontainebleau not far from Paris. John left the inn "in an extremely languid and woe-begone condition," and struck out on a cart road

> among some young trees, where there was nothing to see but the blue sky through thin branches, [and] lay down on the bank by the roadside to see if I could sleep. But I couldn't, and the branches against the blue sky began to interest me, motionless as the branches of a tree of Jesse on a painted window.
>
> Feeling gradually somewhat livelier, and that I wasn't going to die this time, and be buried in the sand, though I couldn't for the present walk any farther, I took out my book, and began to draw a little aspen tree, on the other side of the cart-road, carefully. . . .
>
> Languidly, but not idly, I began to draw it; and as I drew, the languor passed away: the beautiful lines insisted on being traced,—without weariness. More and more beautiful they became, as each rose out of the rest, and took its place in the air. With wonder increasing every instant, I saw that they "composed" themselves, by finer laws than any known of men. At last, the tree was there, and everything that I had thought before about trees, nowhere. . . .
>
> That all the trees of the wood (for I saw surely that my little aspen was only one of their millions) should be beautiful—more than Gothic tracery, more than Greek vase-imagery, more than the daintiest embroiderers of the East could embroider, or the artfullest painters of the West could limn,—this was indeed an end to all former thoughts with me, an insight into a new silvan world.
>
> Not silvan only. The woods, which I had only looked on

as wilderness, fulfilled I then saw, in their beauty, the same laws which guided the clouds, divided the light, and balanced the wave. "He hath made everything beautiful, in his time," became for me thenceforward the interpretation of the bond between the human mind and all visible things; and I returned along the wood-road feeling that it had led me far;—Farther than ever fancy had reached, or theodolite measured.

This epiphany in the woods at Fontainebleau, though far-reaching in its consequences, is undramatic in its form. The account is modeled, in both its images and its message, on an experience which Wordsworth reports having had in his youth. Wordsworth, now an old man, tells Miss Fenwick about the image of a tree which he described in "An Evening Walk." This tree, he recalls, was silhouetted against the evening sky. "I recollect distinctly the very spot where this first struck me. It was in the way between Hawkshead and Ambleside, and gave me extreme pleasure. The moment was important in my poetical history; for I date from it my consciousness of the infinite variety of natural appearances which had been unnoticed by the poets of any age or country, so far as I was acquainted with them; and I made a resolution to supply, in some degree, the deficiency. I could not have been at that time above 14 years of age."

Wordsworth claimed, concerning his poem "An Evening Walk," that "there is not an image in it which I have not observed; and now, in my seventy-third year, I recollect the time and place where most of them were noticed." Ruskin, who was sixty-seven when he wrote the above-quoted passage from *Praeterita*, could have claimed the same. As for those critics who theorize that the Fontainebleau episode was fictitious, or that the author read meaning into it after the fact, Ruskin might well have pointed out to them that there are, in Wordsworth's phrase, certain "spots of time" which can never be forgotten and which, although they have a perfectly ordinary appearance from the outside, have the power to transform the individual. Actually, the most convincing evidence for the authenticity of the conversion at Fontainebleau may

well be the fact that it seems rather ordinary. Revelations based on props as unspectacular as an aspen tree or a madeleine cake cannot be invented but, at most, rediscovered. And the fact that there may be literary prototypes for an experience does not mean that it cannot be real. Ruskin had read a great deal of Wordsworth, and Proust had read a great deal of Ruskin, so both were prepared to experience an epiphany in the commonplace; indeed, they even expected it.

The message which Ruskin received from the trees was more or less identical to what they told Wordsworth—up to a point. Both Wordsworth and Ruskin discovered the infinite variety of natural phenomena; both discovered, as Wordsworth put it in *The Prelude*, that "Our destiny, our nature, and our home / Is with infinitude, and only there"—in the infinitude of the finite, that is. Both discovered "the bond between the human mind and all visible things," and both found themselves in finding nature—as we see in the familiar lines from Wordsworth's "Tintern Abbey" (1798):

> And I have felt
> A presence that disturbs me with the joy
> Of elevated thoughts; a sense sublime
> Of something far more deeply interfused,
> Whose dwelling is the light of setting suns,
> And the round ocean, and the living air,
> And the blue sky, and in the mind of man;
> A motion and a spirit, that impels
> All thinking things, all objects of all thought,
> And rolls through all things.

But here Wordsworth and Ruskin diverge. The Romantic poet may choose to gaze into the inner being of things, as he has just described, but Ruskin prefers to study the common laws that govern all organic life. Whereas Wordsworth aims ultimately at mystical vision, Ruskin feels called to work on *Modern Painters*, the exposition of the laws of his "science of aspects." Wordsworth finds a goal and fulfillment in experience itself—what Rossetti

called "the moment's monument"—while Ruskin's experiences merely spur him on to other tasks. His tree vision turned into a chapter on the truth of trees which tells us all we could wish to know about trees, both painted and real.

And yet Ruskin and Wordsworth are in agreement again in the practical conclusion they draw from their revelations: that they are determined to write or draw to "supply the deficiency." Wordsworth overcomes his "wise passiveness" to write, and Ruskin overcomes the condition of being "potter's clay" that can "take the stamp of anything" to do his work. In fact, perhaps the only way that we can understand what really happened in the woods at Fontainebleau is to remember that, whatever it was, Ruskin experienced it *while he was drawing.* This alone makes clear the sense in which it could have converted him into a "prophet of nature." Because, after all, the Ruskin we know had long been an ardent student of natural science. But his "chrysalid days" ended when he realized that "I had virtually lost all my time since I was twelve years old, because no one had ever told me to draw what was really there!"

Ruskin had been taught a language of drawing which quickly enabled him to produce beautiful pictures. But then he began to realize "what was really there," and that the reality surpassed all art: "my little aspen was . . . beautiful . . . more than the daintiest embroiderers of the East could embroider, or the artfullest painters of the West could limn,—this was indeed an end to all former thoughts with me."

Actually, this realization had first dawned on him earlier in 1842, when he was out walking near his parents' home and noticed "a bit of ivy" which seemed to him "not ill 'composed' " and which challenged him to draw an exact copy. But the first time that he came close to making a realistic copy of a natural object would seem to have been in the woods at Fontainebleau, when he began in a trancelike state to record what the aspen tree dictated to him.

Without doubt, a moment like this is memorable. When you learn any skill, you must at some point cross the threshold from practice to real mastery. The note you strike sounds pure for the

first time, and the body rings out in unison with it. Ecstasy like this makes you forget all the hard work which preceded it, and you will go on feeling its glow through later setbacks and dry spells.

Many famous drawing students have reported the sense of joy they experienced the first time that their efforts proved truly successful. Equally notable are the "near misses," one of which is described by Goethe in his *Poetry and Truth*:

> I wandered on the right bank of the river, which glided along in the sunshine partly concealed by a luxuriant bush of willows at some distance below me. Then the old desire arose in me again of being able to imitate such objects worthily. By chance I had a handsome pocket knife in my left hand, and at the moment there came from the depth of my soul an imperative impulse, I was to fling this knife at once into the river. If I saw it fall in, my wish to become an artist would be fulfilled, but if the immersion of the knife in the river should be hidden by the overhanging bush of willows, so should I give up both the desire and the endeavour. No sooner had this fancy arisen in me than it was carried out. For without considering the usefulness of the knife, which combined several instruments in itself, with my left hand, as I held it, I hurled it violently into the river. But here I had to experience the deceptive ambiguity of oracles which was so bitterly complained of in antiquity. The immersion of the knife in the river was hidden from me by the last twigs of the willow, but the water, which rose up from the fall, sprang like a strong fountain upwards, and was fully visible. I did not explain this phenomenon in my favour, and the doubt which it aroused in me was afterwards the cause of my pursuing these exercises more interruptedly and more negligently, and therefore gave occasion for the import of the oracle to be fulfilled.

This passage makes an interesting contrast to Ruskin's encounter with the trees, and the two together give us several insights into

the behavior and attitudes of people in the eighteenth and nineteenth centuries. For our purposes here it is enough to point out that Goethe takes a masterful pose toward nature, whereas Ruskin approaches it in a state of exhaustion and looks to it to supply him with strength. The two tableaux are so characteristic that they look as if they had been stage-managed to illustrate two differing periods of culture: Goethe putting his whole body into the effort to force success; and Ruskin, a passive medium, stretched out on the bed of nature, receiving success as a gift. In any case, from this moment on, drawing became Ruskin's main source of self-assurance, of "self-education through realism." In crises he would always turn to drawing as a cure; and the onset of a crisis was always signaled by a breakdown of his ability to draw.

Ruskin called 1842 the year of his birth, showing that he thought of its events not just as a phase in his intellectual and artistic development but as something that changed his life. In 1842, he seems to have found the first medium by which he could halt the ongoing decay of reality in time which had troubled him so on his travels.

Only a few weeks later that same year, he found a second such medium, the word-painting. This came to him not at Fontainebleau like his drawing, but at Chamonix, when he started to work on *Modern Painters*. But although he had the habit of noting down remarks about the daily progress of his drawing, one searches in vain through his diaries and letters for proud or anxious comments about his prose works. For Ruskin, drawing always came first. If he could have had his way, he would no doubt have liked to go down in history as a fine draftsman and watercolorist. The fact that he was not disappointed in this wish, and that today he is regarded as one of the great realistic draftsmen of the nineteenth century, is due to a group of works, mostly nature studies, which he produced after 1842, after he had overcome the mannered, picturesque drawing style of his instructors.

Nor is it an accident that many of the best-known drawings he made in the early part of this new phase are close studies of trees. Ruskin's tree drawings seem to express best the key feature of his style after Fontainebleau: the play of nervous energy in the

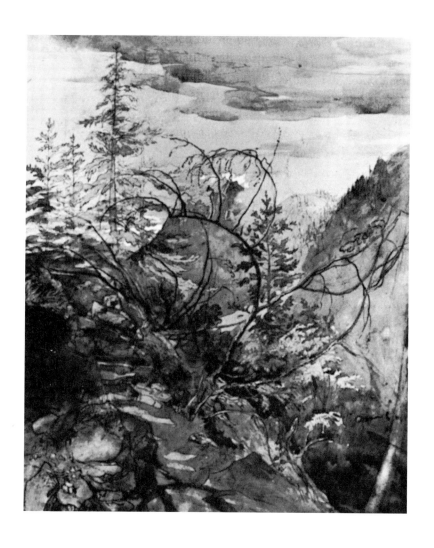

John Ruskin, Trees on Mountain Slope, *1845.*
Pencil, pen-and-ink, and wash.
The Ruskin Galleries, Bembridge School, Isle of Wight

branches, the elastic yet well-defined curve by which they balance their upward drive against the downward pull of their own weight. These branches are the living embodiment of that category of "vital beauty" which Ruskin championed in *Modern Painters*. This term refers to the combination of functionalism and delicacy visible in the forms of natural objects—nature's way of producing a sort of aesthetic surplus out of its sheer superabundance of life.

But this surplus, Ruskin says, can be realized only when it is perceived with sympathy, when the perceiving subject has something comparable to give in exchange. This draftsman who derives his new life from nature feels the urge to restore his life to nature. Like Wordsworth, he abandons "wise passiveness" for the great interchange: "from thyself it is that thou must give, / Else never canst receive."

Our picture of this period in Ruskin's life makes it appear that at Fontainebleau he underwent a conversion to nature as the Everlasting Yea—in contrast to Carlyle's Professor Teufelsdröckh, who, only a few miles away in Paris, had felt enslaved by a nature which he experienced as the Everlasting No, and who rejoiced when he was freed from it. In other words, it may sound as if Ruskin has just completed the typical Victorian conversion, away from introspection, and in the direction of positive achievement— in the way described by Teufelsdröckh, who said that the important thing in life was to transform the precept *Know thyself* into the precept *Know what thou canst work at*. What better larger-than-life profession could there be for a Victorian hero than that of a prophet of nature who would show people "what was really there"?

This is how Ruskin himself saw his situation for some time to come, and the sense that he had found his work in life allowed him to get over his illness, if not his hypersensitivity.

But what he could not foresee was the first thread of tragedy being woven into his life. He had just taken on a project, nature, which seemed to him everlasting. Into the first volume of *Modern Painters* he packed what he could of the truth of trees, of clouds, of water, and so on, each in its own neat chapter. But the subject matter was so rich that each chapter could only outline its topic,

while it was left to later volumes in the series really to do it justice. It would be seventeen years before he finished the last volume. When he did so, he did it in the knowledge that "what was really there" was there no longer. Nature itself had become a thing of the past, and the Everlasting Yea had been perverted by forces of the Everlasting No: and *these* seemed everlasting indeed.

Three
A Mad Man or a Wise
1845–1853

I

We began our first two chapters by looking at painted portraits of John Ruskin. No portrait of him is extant from the years 1845–53, so we must consult a written portrait instead. Or rather a written *self*-portrait.

In February 1852 Ruskin was in Venice, and from there he wrote to his father in London a synopsis of his life since Volume One of *Modern Painters* had been published. This long letter—of which I will quote only the last part—is the earliest autobiographical text we have from Ruskin.

What did he deem worthy of reporting as he looked back on his life of the last decade? Neither his intellectual development nor the story of how he had become an esteemed and successful author, nor even the dramatic shifts of his personal life. The one thing he singled out as worth talking about was the history of his illnesses. He gave his father a medical history as thorough as any that a doctor could have supplied.

Arriving in Venice in 1851,

I found first—that every hour of thought or work of any kind, but especially writing, was just so much acceleration of pulse—with slight flushing of cheeks and restless feeling all over— That I never was healthily sleepy at nights—and often could not sleep more than four or five hours, even if I went to sleep at a proper time. That any violent exercise would make me restless and excited for hours afterwards, instead of wholesomely fatigued—and that the slightest

plague or disagreeable feeling in society would do the same—I got into a little dispute with Mr Cheney about some mosaics one day—and was quite nervous the whole day after—merely a question whether the colours were faded or not— Also—when I first came here, I had not been drawing for some time—and my hand shook so—this sort of way that I could not draw a straight line. You will see, even by the scrawls I have sent you that *this* symptom has disappeared. When I got into this excited state, I found the pulse beating not only quickly and violently but irregularly—three long beats and a short one—three long and a short, and so on—and the short one seemed to be a little freak of the heart itself—and not answered by the pulse—but I could not make this quite out. But it was not so much the quickening of pulse that annoyed me, as its excessive feebleness when *not* quickened: When—in a healthy state—I lay on my right side I could not feel the heart beat at all; and could not feel it strongly whatever way I lay—but to jump—or run a dozen paces, would make it set off at the gallop, still, never so hard as in the old bad time—the morbid pulsation in the back and temples having entirely ceased. The sleepiness and numbness of the foot is also gone—except that it still goes to sleep sooner than the other: at night until within this last month, I used often to wake with one or both hands perfectly dead; especially if they had been thrown back above my head—this symptom has now nearly disappeared, and I have not once had the white chill in the daytime—though my hands have been much swelled and cut by the frost.

So much for the circulation—next for the stomach.

One possible approach to this letter is simply to take it at face value; that is, to accept it as the sort of thing which Ruskin would tend to write to a father who was always concerned about matters of health. Or we could read its minute observation of symptoms as a symptom in itself, and look at its wider implications. Introspection and a serious regard for physical ailments were admittedly

a tradition in the Ruskin household; and John's parents, always anxious for his welfare, were especially eager to know their son's state of health now, because he had spent the winter abroad. Even so, it is amazing that a thirty-three-year-old man should show such rapt absorption in the task.

One cannot help but think of the very different sort of letters written by that other great English author in Venice, Lord Byron, more than thirty years before. Byron's sister, friends, and publisher were as concerned about him during his Venice sojourn of 1816–19 as Ruskin's parents later were about their son. Yet Byron, then about thirty, always returned the same reply to their anxious questions. He told them about his love affairs, only rarely mentioned the poems he was writing, and virtually never referred to his physical condition, which from all indications was far worse than Ruskin's:

> So Lauderdale has been telling a story! . . . Which "piece" does he mean?—since last year I have run the Gauntlet;—is it the Tarruscelli—the Da Mosti—the Spineda—the Lotti—the Rizzato—the Eleanora—the Carlotta—the Giulietta—the Alvisi—the Zambieri—The Eleanora da Bezzi (who was the King of Naples' Gioaschino's mistress—at least one of them)—the Theresina of Mazzurati—the Glettenheimer—& her Sister—the Luigia & her mother—the Fornaretta—the Santa—the Caligari—the Portiera—the Bolognese figurante—the Tentora and her sister—cum multis aliis?—some of them are Countesses—& some of them Cobblers wives—some noble—some middling—some low—& all whores—which does the damned old "Ladro—& porco fottuto" mean?

How very different from Ruskin's self-portrait! Indeed, it does not seem too far-fetched to compare them to two earlier self-portraitists: on the one hand, Dürer, naked and fragile, pointing to the place that hurts; on the other, Rembrandt, in the guise of the Prodigal Son, surrounded by harlots and toasting the viewer.

In Byron and Ruskin we see two fundamentally different tem-

peraments encased in members of two different social classes; more important, we see phenotypes of two strongly contrasting historical epochs. In the one, we have a representative of the great age of revolution and war, prey to a restlessness which enters him from without and then pours outward again, insatiably devouring people, objects, landscapes, themes and forms, and finally the man himself. In the other, we have a child of the mid-century, the Victorian, who cannot say why his heart should pound and his pulse race or threaten to stop altogether. He has burrowed deep into his bodily insides, yet they tell him nothing. Nor can he cope with the outward functions of his body, even though—or because?—he does not consume but is only trying to conserve it. In fact, it may be said of Ruskin in general that he conserved himself emotionally and physically. Granted, he was not a timid stay-at-home but an avid walker, mountain climber, and oarsman, physically fit and able to endure great exertion. Yet his life is marked by a certain balance and economy, an avoidance of giant leaps, shipwrecks, the adventure that risks downfall and death. Byron was only thirty-six when he died in Greece. Ruskin lived to be almost eighty-one—as long as his Queen, like many other heroes of the Victorian Age. His death was as indicative of his character as Byron's was of his, for it was not a sudden but a lingering departure, and more a regression than a progression and completion.

The contrast between Byron and Ruskin during their Venice trips of 1818 and 1852, respectively, is particularly stark in the area of sexuality, a subject on which Byron was so obsessively fixated. The outward circumstances of the two young men were much the same in that Venice, when Ruskin arrived, was still the hotbed of eroticism that it was in Byron's day. A married Venetian woman had an unopposed right to two lovers: one the *cavaliere serviente*, a sort of all-purpose escort who squired his lady love around town, to the theater, parties, and outings, and the other the *cavaliere amante*, whose duties were more or less limited to one thing only. Byron, in many cases, had no trouble availing himself

of the latter function but consistently refused the role of *cavaliere serviente*.

Venice, thus, had a native tradition for the regulation of amorous pursuits and in addition was flooded by non-Venetians who brought their own needs and expectations: young nobles on tour, international adventurers, foreign soldiers, theater troupes, pleasure-seekers of both sexes who washed up in the city of lagoons. Together, they generated the *perpetuum mobile* of Venetian eroticism, a vast love-and-pleasure machine which soon snapped back into running order after every disruption: even so massive a disruption as that of 1848–49, when all of Europe was engulfed in revolutionary tumult. This resilience is evident not least of all from the letters written in Venice between 1849 and 1852 by a young woman named Effie Ruskin.

The idea of Ruskin joining in with the Venetian pleasure-seekers seems as remote as the opposite hypothesis, that Byron could have lived like a monk in Venice so as to devote himself to nothing but writing poetry. Ruskin never availed himself of the traveler's license or enjoyed the city's favors, either before, during, or after his first extended stay. That in itself is hardly disturbing; but what *is* rather disturbing is that he never once asked of himself or of his companion—who was his very own wife—what Byron claims he afforded daily to an ever-changing cast of partners.

To date, five books have been written about Ruskin's marriage, so one feels no need to discuss this point at any length. But the central fact that, by doctors' testimony, Effie Ruskin *née* Gray emerged from her first marriage still a virgin is too glaring and too significant to overlook. Like Ruskin's autobiographical letter, quoted at the start of this chapter, it has symptomatic implications reaching far beyond the individual fates of two people.

John Ruskin and Effie Gray met in the approved way for middle-class men and women of their time. The Grays were old and close friends of the Ruskins from their days in Scotland. Eventually, the Gray family took over the Ruskin home in Perth where John James's parents had spent their declining years. Effie Gray herself—

as if to conform to all the clichés of Victorian melodrama—was begotten in the very room where her future husband's grandfather had committed suicide. Moreover, while still a child, Effie had played muse to the most popular of all John Ruskin's works, *The King of the Golden River*. This was England's very first literary fairy tale—a tale not descended from the folk culture but deliberately composed by a known author. Effie, born in 1828, was only thirteen when she came to visit the Ruskins in London, and John, then a student at Oxford, wrote the story especially for her, at great speed, not intending it as anything more than a minor piece. (A recently compiled bibliography of Ruskin's works lists no fewer than 130 editions of this tale, which Ruskin himself described as completely without value.) When Ruskin met Effie again in 1846, he fell in love with the pretty, vivacious girl. In 1847 they became engaged, and they were married on April 10, 1848, the day of a great demonstration by the Chartist working men's reform movement.

Actually, four parties were involved in the marriage: Effie and the three Ruskins, while Effie's parents chose to stay completely in the background. The attitudes and expectations of these four varied considerably. Effie came from a family of fourteen children, six of whom died young. The Grays lived in the provinces and—it was revealed in the wedding year—were facing imminent financial ruin. Thus, Effie was quite simply dazzled by the social advantages of marriage to someone like John Ruskin, the son of wealthy parents who lived half the year in London and the other half abroad—a well-known writer with a great many interesting acquaintances. Given her youthful insouciance and highly developed sense of intrigue, she may even have been attracted by the idea of shaking up the fossilized trio at Denmark Hill. Her expectations can be summed up by saying that she thought life with John would be a sort of never-ending round of social engagements. Emotional involvement seems to have placed fairly low on her list of priorities.

From all we know, John's attitude seems to have been completely different, and much simpler: he had fallen in love, and he

stayed faithful to that love for some time, immune to all opposition, and no doubt secretly fearing a second disaster like the one with Adèle. Apart from this, he could not afford to bother, because he was totally absorbed in his work. "I find work good for me and when I am busy upon architecture or mathematics I sometimes very nearly forget all about you!—and retain merely a kind of pleasant sense of all's being right," he wrote to Effie during their engagement, when he was most deeply in love with her. If he ever gave any thought to married life, he probably considered that work was the essential thing and that his wife would be there to round out his emotional life. Very likely he also had some thought of getting Effie to help him in his work, but he soon saw that this was out of the question. And he took it as a foregone conclusion that he and his wife would never stray far from his parents' side.

As for the elder Ruskins, they tried at first to block John's relationship with Effie, then gave it their more or less wholehearted support, until after the wedding. The elderly couple—she was sixty-six, he sixty-two—had no objection to John's getting married, but they were aiming for a better match than Effie. They hoped to acquire a daughter-in-law of rank, from a wealthy and distinguished family, rather than a mere lawyer's daughter from Perth. Just such a prize had appeared within their grasp: Charlotte Lockhart, the granddaughter of Sir Walter Scott. The idea appealed to John, too, but Charlotte rejected his proposal and married someone else. After that, John's parents stopped opposing his plan to marry Effie. Like John himself, they feared the effects of a second Adèle episode. They also apparently realized that a daughter-in-law like Charlotte Lockhart, who was a clever, active, and self-assured woman, might lure their son away from their strict supervision in Denmark Hill, whereas the volatile young girl from Perth would more likely prove easy to mold and might take the place of good-tempered Cousin Mary, who had been Mrs. Ruskin's companion and helper for decades and had just left to get married.

But shortly after John and Effie's wedding, when it was revealed that Effie's father, George Gray, had lost all his money speculating in railroad stock and that the young couple would be completely

dependent on the Ruskins' resources, John's parents began to turn against Effie again, and henceforth felt that it was their right and even their duty to intervene directly in the new marriage and in the affairs of the entire Gray family.

Given the true motives of all concerned, there seems no doubt that the marriage was a mistake from the start, as the young couple later admitted and everyone agreed. John explained the failure of his marriage in three sentences which sum up the truth very neatly: "I married her, thinking her so young and affectionate that I might influence her as I chose, and make of her just such a wife as I wanted. It appeared that *she* married *me* thinking she could make of me just the *husband she* wanted. I was grieved and disappointed at finding I could not change her, and she was humiliated and irritated at finding she could not change me."

On the other hand, many couples start out this way, and it does not in the least explain why the marriage was never consummated. The Victorians are renowned for unhappy marriages, but the large numbers of children they produced show that sexual abstinence was not that common. John and Effie's marriage was annulled in 1854. Public and private legal documents relating to the annulment have been widely published, yet we still cannot account satisfactorily for John's puzzling behavior. Actually, there are two unsolved puzzles: first, the reason for John's resistance to consummating the marriage immediately after the wedding; and second, the causes for the ongoing, six-year-long inhibition, which seems to have been nurtured by a large number of rationalizations.

Possibly the real explanation involves not one but several causes. Effie sued for annulment on the grounds that John was impotent. He always denied this, but even if it was true, it would simply substitute one mystery for another. Ruskin testified that on their wedding night he discovered a physical blemish in his wife which made it impossible for him to have sexual intercourse with her. Effie is not known to have been disfigured in any way, so scholars have theorized that Ruskin, who had never seen a naked woman except in paintings, may have been put off by his wife's pubic hair, or by menstrual bleeding.

That Ruskin spent three years at Oxford in close company with worldly young noblemen who, as he himself pointed out, were coarse in their speech and kept pornographic pictures would argue against such theories. Yet there may be some point to his claim. True, his explanation seems a mere pretext, a projection of blame onto someone else; but whatever it was about his wife that disturbed him, the main thing is that he *wanted* to find something wrong with her, and in fact couldn't avoid doing so. For the legal records also contain another statement by him: "My own passion was also much subdued by anxiety."

The fear of the wedding night plays a large role in Victorian marriage guidebooks. Psychologists say that this fear is actually the middle-class male's fear of impotence, and men who are afraid of their own failure typically deal with it by pretending that it is the woman's fault for being so intimidating. Ruskin wrote a remarkable letter to Effie in 1847 which illustrates this point. It reads like a fin-de-siècle piece: "But you know, *now*, my sweet, you are neither more nor less—stay—I don't mean that—for more you are—and a great deal more—but still you are a very sufficient and entire *man-trap*—you are a pitfall—a snare—an ignis—fatuus—a beautiful destruction—a Medusa —I am sorry to think of anything so dreadful in association with such a dear creature—but indeed—people ought to approach Bowers Well [Effie's family home] now as Dante did the Tower at the gate of the city of Dis."

Having worked up his courage after some initial hesitation, and backing up his case with literary allusions, he then continues: "I don't know anything dreadful enough to liken you to— You are like a sweet forest of pleasant glades and whispering branches— where people wander on and on in its playing shadows they know not how far—and when they come near the centre of it, it is all cold and impenetrable—and when they would fain turn, lo—they are hedged with briers and thorns and cannot escape, but all torn and bleeding."

By now Ruskin has written his way to release—by way of captivity—and can finish up with a simile drawn from the world with which he is most familiar: "You are like the bright—soft—swell-

ing—lovely fields of a high glacier covered with fresh morning snow—which is heavenly to the eye—and soft and winning on the foot—but beneath, there are winding clefts and dark places in its cold—cold ice—where men fall, and rise not again."

These elaborate fantasies, which show a relishing of fear, are both embarrassing and exasperating, directed as they are at an essentially normal nineteen-year-old girl. John alludes to the fact that Effie had attracted other suitors besides himself, but though this might serve as the pretext for such a letter, its true motive lies elsewhere: namely, with its author, an almost thirty-year-old bachelor and twice-rejected suitor, weighed down by his own and his parents' emotional problems, compelled to dream up imaginary excuses for the fact that he is still so attached to his mother and father.

His failure on his wedding night also represented a sort of "belated obedience." John had stood up to his parents by marrying Effie, but when the moment came for him to complete this act—when he was called on to join with another person for the first time and thus to release himself from the society of his parents—his fear and his ultimate desire to obey joined forces and gave him a convenient motive for failure.

But there was yet another reason for his failure. As the child of his parents and the child of his times, Ruskin converted all his basic drives into something else: in his case, the "noblest sense," the eye, which he had already made his life's work. As a "pure eye" focused on himself and the object-world, he was unable to penetrate his protective layer of introspection and sensitivity, to risk breach, surrender, self-abandonment. Clinging to what was "heavenly to the eye," he preferred to avoid the peril of the deep "winding clefts and dark places." In the long run, this kind of reserve cries out to be breached by all and sundry, in a sublimated form, that is, through written communications, as Ruskin amply shows.

One of Daumier's caricature drawings shows a man refusing alms to a beggar with the words: "I only give money to aid the poor of Kamchatka!" The Victorian heroes all tended to follow this pattern, in that the exalted sense of responsibility which they derived from their repression of instinct led to defaults in the here

and now, especially where their own lives were concerned. Ruskin later described his own case as follows: "I shall never devote myself to any woman—feeling, whether erringly or not, that my work is useful in the world and supposing myself intended for it."

Ruskin was by no means unique in this peculiarity. Take the case of his revered friend and mentor Thomas Carlyle, for instance. Carlyle's energetically defended claim that he had a right to be nasty, stupid, and disagreeable whenever he chose does not adequately explain the martyrdom he inflicted on his highly gifted wife, Jane Welsh Carlyle. He drove her to the brink of suicide by—among other things—remodeling her little home in Chelsea until the multiple walls surrounding his study screened out every sound of the outside world. Living in monkish seclusion, he then formulated his critique of the world he had shut out, and meanwhile never touched his wife or let her touch him. Carlyle's reliable friend and biographer, James Anthony Froude, claimed that the Carlyles' forty-year marriage also remained unconsummated. Like Ruskin, Thomas Carlyle never broke through the many coats of his own armor.

Froude's description of the Carlyles' marriage makes it sound like something out of Greek tragedy. But, notwithstanding the genius of the spouses, and the serious suffering they endured, theirs and similar marriages do not truly qualify as heroic tragedies. In the Ruskins' case, the fiasco of the wedding night evolved into permanent abstinence, yet the reason for this was no central predicament, no grand trauma, but more a chain of minor difficulties. The inauspicious start was followed by a host of circumstantial obstacles, accidents, egotisms, and rationalizations which maintained and justified the status quo.

Effie, for instance, was often ill, whereas John stayed fit and turned out quantities of work that would have made many another man sick; both John and Effie traveled extensively and were separated for weeks or months at a time; and Effie was frequently under emotional strain because of unhappy events in her family. She said that John did not want children, while he claimed the same of her, and very likely neither was all that eager for offspring:

John because he wanted to work and above all to travel without hindrance; Effie because she had plans to enter London society. On occasion the couple set a deadline by which to end their unnatural behavior, but inevitably something or other came up and the deadline would pass again. External and emotional factors wove an impenetrable thicket of motives which neither John and Effie nor anyone else could cut down. As Victorians, they would have felt it inappropriate to discuss such intimate matters with their parents, relatives, or friends.

One clear-sighted commentator summed up the situation very aptly when he noted that the story of their marriage "is not a subject for judgment and recriminations but for sympathy with two people caught in a tangle of muddled ideas about sex, of frustration and wounded sensibilities and conflicting temperaments." Gladstone, who knew the couple, took the same view: "There was no fault: there was misfortune, even tragedy." "Misfortune" is no doubt the best word for it. The Ruskins' marriage was neither a grim drama nor a flimsy pro-forma arrangement like so many marriages of their day.

Mary Lutyens, the biographer most familiar with all the material relating to their marriage and especially to Effie, summarized their relationship as follows: "Effie, when she left Ruskin, declared that she had never known a moment's happiness with him, yet these letters show beyond all doubt that they had many moments of happiness together, of gaiety even, sympathy, fun and affection . . . and however little either of them was willing to make any real sacrifice to hold their marriage together, they did unwittingly give each other during those first years a great deal for which neither of them afterwards showed the other the slightest gratitude."

2

It was during his years in Venice that Ruskin started to interpret his pet likes and dislikes, his *idées fixes*, as symptoms of "civilization and its discontents," and thus to fortify and entrench them—a strategy which would never have occurred to Byron. Ruskin recorded his opinion of the world at mid-century, and his own place in it, in another of his remarkable letters from Venice, dated January 8, 1850, and addressed to his former tutor, W. L. Brown, now a country parson. Ruskin begins by quoting back at Brown lines from one of Brown's letters which criticized Ruskin for condemning the railroads in Volume Two of *Modern Painters*: " 'I am one of those who always expect to find a reason for whatever *Is.'* . . . *Your* Philosophy is that we have attained this perfection—that things if they are wrong in one way are right in another—that there is a balance here and an equivalent there—that there is a Natural course of things, which has always its purpose and necessity—&c—: Mine is—or has lately begun more distinctly to be— that we are *all wrong* . . . advancing as fast as we can to a condition of misery which may make us a spectacle and a warning to all other Spiritual Creatures looking on. . . . That is what I believe we are doing.— I look upon our engineering and screwing and wedging as just so much Bedlamism— You look upon it as all right and proper." This passage may make us wonder how Ruskin—a man who in 1843, less than a decade earlier, still looked with confidence on a world whose every detail he saw as regulated by the hand of God—could take such a bleak view of it now. His letter now goes on to answer that question:

But consider for a moment how your tranquil position and work in life influences your views of these things. Your theory is true in your own horizon. . . . But now come out of those Wendlebury green fields, and step out into my gondola with me, and let me hear how you like the view from the middle of the lagoon. There is St Mark's place on one side of you; it is full of people, with a band of some 50 soldiers playing

waltzes to them—a great many of them are nearly starving; they are walking up and down in the sun to keep as warm as they can—the others are there because they have nothing to do, or will do nothing—but they would murder all the fifty soldiers who are playing waltzes to them, if they could. On the other side of you there is a church with a Corinthian portico, and in front of it a battery of six guns, bearing on St Mark's place in order to keep the people who have nothing to do from murdering the 50 soldiers who are playing the waltzes.

Given that England was the source from which the "Bedlamism" of the new technology was emanating, it is hard to see why Ruskin should regard as valid "in your own horizon" the quietest views of an Englishman who had elected to stay at home. But, in any case, he was no doubt right that it was the things he saw on his way to Venice, and then in the city itself, which had robbed him of his tranquil attitude to nature and art, and thus of his confident outlook.

The literary product of Ruskin's Venetian sojourns was *The Stones of Venice* (1851–53). These turned out to be not stepping-stones but stumbling blocks in the path of *Modern Painters*. In 1844, the year after Volume One of *Modern Painters* was published, Ruskin went back to Chamonix, the birthplace of that volume. In 1845, he traveled alone for six months through northern Italy and finished Volume Two of *Modern Painters* in the winter of 1845–46. The book reflected an insecurity for which he compensated by an excess of dogma, both aesthetic and religious. This was the one and only time in his writing career when Ruskin completely suppressed his great talent for the close analysis of specific detail and instead evolved an aesthetic and a natural theology to supplement the practical material of Volume One. The result was a purely theoretical text which strikes an alien note in the series, both in subject matter and in methodology.

In 1846, he again traveled in Switzerland and northern Italy. He had a bad year in 1847, a period of self-doubt, illness, and emotional

stress. In 1848 he took his honeymoon trip through Normandy, and in 1849 published the fruits of this journey, *The Seven Lamps of Architecture*. This was the first book to show that the author of *Modern Painters*, while maintaining his interest in the "truth" of clouds, mountains, water, and trees, had added a new theme: the works of man.

It was during his trip through Italy in 1845 that Ruskin first realized how desperately the works of man needed his attention. A publication by the French critic Alexis-François Rio revealed to him how little he knew about Italian art prior to Raphael (the original "Pre-Raphaelite" art). The anonymous frescoes, reliefs, and marble work of the twelfth to the fifteenth centuries, and the works of artists like Gozzoli and Fra Angelico, showed him that his years of criticizing gallery paintings did not necessarily qualify him to discuss on-site murals. He faced the methodological problem of having to set his discussions into a much wider context and, on top of that, the technical problem of how to safeguard the works he wanted to examine, for they were in imminent danger of being destroyed altogether.

Ruskin lived in an age when the monuments of the past were being ravaged simultaneously by three separate forces. Stylistically, the 1840s were heavily influenced by classicism, and anything out of tune with classical ideals was being eradicated. At the same time, the Industrial Age had already started to introduce a new set of values by which old city districts were brutally demolished to make way for railroads and speculative real-estate developments, building ornaments were sacrificed in favor of gas pipes, and everything began to be shrouded in corrosive waste gases and chemical fumes. And finally, the world's first art conservationists and monument preservers were just beginning to "salvage" endangered historical remains by replacing them with supposedly accurate imitations.

The young Ruskin, like many sightseeing travelers, took pleasure in the aesthetic qualities of ruined buildings. But now, in the year 1845, it suddenly struck him like a bolt of lightning that he was going to have to postpone his enjoyment of glaciers and trees, and Turners and Claudes, as long as the great monuments of the

past were being lost every day before anyone even had a chance to make a record of them. This thought was to rob him of his peace for decades. "It is a woeful thing to take interest in anything that man has done," Ruskin wrote to his father in May from the town of Lucca, where he was making the very first exact sketches of the marble work on the façades—not to feature them in the next volume of *Modern Painters* but out of sheer necessity, as he now made clear in the rest of his letter: "Such sorrow as I have had this morning in examining the marble work on the fronts of the churches. Eaten away by the salt winds from the sea, splintered by frost getting under the mosaics, rent open by the roots of weeds (never cleared away), fallen down from the rusting of the iron bolts that hold them, cut open to make room for brick vaultings and modern chapels, plastered over in restorations, fired at by the French, nothing but wrecks remaining—& those wrecks—*so* beautiful."

In Pisa a few days later, he observed that anyone who wanted to install a new tomb in the walls of the Church of Campo Santo was allowed to demolish its frescoes to do so and that plans were being considered to tear down the Church of Santa Maria della Spina to make way for a quay extension. Decades afterward, Ruskin personally witnessed the demolition of this little church, and even went so far as to challenge the workmen on the site physically—to no avail, of course. "I do believe that I shall live to see the ruin of everything good and great in the world. . . . Why wasn't I born 50 years ago[?] I should have saved much, & seen more, & left the world something like faithful reports of the things that have been—but it is too late now."

While searching for traces of early religious painting, Ruskin realized that he now had to see to everything: architecture, sculpture, handicrafts, and resources to help safeguard his discoveries. His once tranquilly planned art trips now were invaded by unrest and dissatisfaction: "I am perpetually torn to bits by conflicting demands upon me, for everything architectural is tumbling to pieces, and everything artistical fading away, & I want to draw all the houses and study all the pictures, & I just can't."

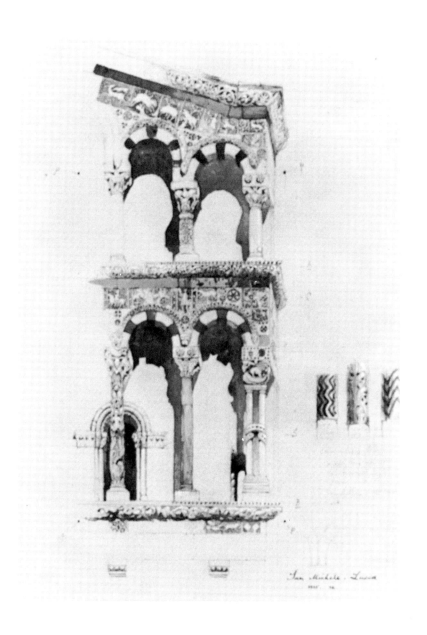

John Ruskin, Detail of San Michele, Lucca, *1845.*
Pencil and watercolor.
The Ashmolean Museum, Oxford

Ruskin's sketching style was changing, too, becoming at once more fragmentary and more precise. The year 1845 marked a general shift in Ruskin's drawing career. The former pupil of Turner, Prout, and Harding had found his own signature now, an exact, closely observed, and sinewy transcription of nature which concentrated on the energetic, animated features of trees, mountains, and sky—what Ruskin would later call "vital lines." In his architectural drawings, the need to keep an accurate record took precedence over the compositional urge to design attractive pictures. It became increasingly rare for Ruskin to produce total images, whole landscapes. Instead, he concentrated on details; but he did these thoroughly, supplying dimensions and cross sections.

J. D. Harding, Ruskin's former drawing master, accompanied him on part of his 1845 trip through Italy, and the two men later compared the sketches from their tour. Ruskin recognized what had happened: "His sketches are always pretty because he balances their parts together, and considers them as pictures; mine are always ugly, for I consider my sketch only as a written note of certain *facts*, and those I put down in the rudest and clearest way as many as possible. Harding's are all for impression; mine all for information."

Ruskin's father, an art collector who appreciated a full-fledged, emotionally charged picture and who thought he knew what the public had come to expect of his son—prose poems, a poetic vesture cast over nature and art—had no sympathy for the recent trend in John's work. While visiting Venice in 1846, Ruskin senior wrote home to a friend: "He is cultivating art at present, searching for real knowledge, but to you and me this is at present a sealed book. It will neither take the shape of picture nor poetry. It is gathered in scraps hardly wrought, for he is drawing perpetually, but no drawing such as in former days you or I might compliment in the usual way by saying it deserved a frame; but fragments of everything from a Cupola to a Cart-wheel, but in such bits that it is to the common eye a mass of Hieroglyphics—all true—truth itself, but Truth in mosaic."

There is much evidence to indicate that, under the stress of his

mission, Ruskin reduced works of art to their separate components; and they in turn fragmented him. Clearly, he went on collecting and amassing data for a long time without any guiding principle to tie it all together: "I have been developing stores upon stores, heaps on heaps of things that I cannot explore nor learn." Yet his sense of the underlying connections continued to grow; or at least he felt a growing need to develop systematic criteria, questions, and concepts which would achieve for art history what the "science of aspects," the study of visual perception in aesthetics, and the principle of infinity had done for his criticism of landscape art.

Two important features of Ruskin's procedural method were laid down in the years before 1850, and he never saw any reason to change them: a preference for sensory data over written information, and a focus on the present moment as a way of looking at the past.

Ruskin had gone to Italy in 1845 with little prior study of research material. Whereas the first generation of German art historians like Rumohr and Förster burrowed through Italian archives, trying to establish a reliable chronology for their studies of Italian art, Ruskin saw the urgent need to preserve the tangible, visible aspect of works of art, rather than background information. He felt that it was imperative to confront history directly. This was not so much a logical decision as a psychological necessity, for he always seemed compelled to prefer what was palpable to the senses.

Until now, Ruskin had given history a wide berth, but suddenly it caught up with him, when he was forced to look at the negative aspects of the present. The older Italian art had been created in what, for him, was a remote and alien past; yet, as far as he could see, this art testified to community spirit, a strong religious identity, and a joyful intimacy with nature. Moreover, he observed that it was still capable of fascinating someone like him, a Protestant Englishman, a man of the Industrial Age, a connoisseur of Turner, panel paintings, and watercolors; and at the same time he could not help seeing that other people, with few exceptions, were indifferent to these relics of history or, worse yet, abandoned them to decay or ruthlessly adapted them to their own needs. All this

brought him face to face with something that he had rigorously ignored up to this point: contemporary Italy.

Ruskin had always viewed Italy with the disdainful eyes of an Englishman, and the English saw Italy as two separate countries. As Shelley put it: "There are two Italies; one composed of the green earth & transparent sea and the mighty ruins of antient times, and aerial mountains, & the warm & radiant atmosphere which is interfused through all things. The other consists of the Italians of the present day, their works & ways. The one is the most sublime & lovely contemplation that can be conceived by the imagination of man; the other the most degraded disgusting & odious."

Ruskin did not actually change his opinion of modern Italy after he found out more about it, but he *did* begin to wonder how a people who at one time were capable of the noblest achievements later became incapable even of appreciating the feats of their fore-bears. He sensed that it was wrong to divorce the past from the present and that he must not allow his detestation of the present to drive him into substituting a dream of the past. He set out to discover history, using the present—with all its negative aspects—as a starting point. In a letter to his father written from Parma on July 10, 1845, he said: "I perceive several singular changes in the way I now view Italy. With much more real interest—I take a far less imaginative or delightful one. I read it as a book to be worked through & enjoyed, but not as a dream to be interpreted. All the romance of it is gone, and nothing that I see ever makes me forget that I am in the 19th century."

It was not Ruskin's way to hide his new attitude from his readers on the grounds that it was too personal and not objective enough for a formal discussion. The outcome of his Italian investigations was not a historical treatise which would transport readers out of the present moment and make them eyewitness participants in major events of Italy's past. Instead, *The Stones of Venice* had the same contemporaneity that distinguished *Modern Painters*.

In it, Ruskin looks at Venice from the vantage point of the nineteenth century, and uses a series of leisurely visual tours to guide the reader into present-day Venetian history. Take, for in-

stance, the way he depicts the approach to the city, compared to Samuel Rogers's version in *Italy*, a book which Turner illustrated and Ruskin treasured.

First, here is Rogers's version:

> The path lies o'er the sea,
> Invisible; and from the land we went,
> As to a floating city—steering in,
> And gliding up her streets as in a dream,
> So smoothly, silently.

(Turner, incidentally, appended these lines to his 1844 painting *Approach to Venice*.) To go from Rogers to Ruskin is to move from the poetry of the sentimental "view-hunter" to the prose of the truly modern traveler. "And now come with me," Ruskin says to his reader at the end of Volume One, "for I have kept you too long from your gondola." He wants to compensate the reader for the exertion of having waded through a 400-page textbook on architecture, so only at the end does he offer the inducement which other authors placed right at the start: a description of the moment when one enters the city of lagoons.

> Another turn, and another perspective of canal; but not in-terminable. The silver beak [of the gondola] cleaves it fast,—it widens: the rank grass of the banks sinks lower, and lower, and at last dies in tawny knots along an expanse of weedy shore. Over it, on the right, but a few years back, we might have seen the lagoon stretching to the horizon, and the warm southern sky bending over Malamocco to the sea. Now we can see nothing but what seems a low and monotonous dock-yard wall, with flat arches to let the tide through it;—this is the railroad bridge, conspicuous above all things. But at the end of those dismal arches there rises, out of the wide water, a straggling line of low and confused brick buildings, which, but for the many towers which are mingled among them, might be the suburbs of an English manufacturing town. Four

or five domes, pale, and apparently at a greater distance, rise over the centre of the line; but the object which first catches the eye is a sullen cloud of black smoke brooding over the northern half of it, and which issues from the belfry of a church.

It is Venice.

3

In Venice, Ruskin found that the two Italys—the Italy of "pale domes" and the Italy of the belfry which has been converted into a smokestack to serve the city's largest steam mill—were engaged in a life-and-death struggle:

And although the last few eventful years, fraught with change to the face of the whole earth, have been more fatal in their influence on Venice than the five hundred that preceded them; though the noble landscape of approach to her can now be seen no more, or seen only by a glance, as the engine slackens its rushing on the iron line; and though many of her palaces are for ever defaced, and many in desecrated ruins, there is still so much of magic in her aspect, that the hurried traveller . . . may still be led . . . to shut his eyes to the depth of her desolation.

Ruskin felt that he could no longer devote himself to the transfiguring work of the imagination "during the task which is before us." "The Venice of modern fiction and drama is a thing of yesterday, a mere efflorescence of decay, a stage dream which the first ray of daylight must dissipate into dust." "The impotent feelings of romance, so singularly characteristic of this century, may indeed gild, but never save, the remains of those mightier ages to which they are attached like climbing flowers; and they must be torn away from the magnificent fragments, if we would see them as they stood in their own strength."

In Venice, past greatness collided with present misery more harshly than in any other place Ruskin knew, and that is why he felt the city was a practical testing ground where it would be decided whether the new Italy could truly preserve the old—not merely protect it, but discern the meaning of its history. Ruskin wanted the remaining witnesses of Venice's past—the solid works its past had produced—to serve as a universal example. "The history of all men, not 'in a nutshell,' but in a nautilus shell"—that is what Venice was for Ruskin.

Venice Serenissima, the Queen of the Seas, had played a far-reaching role in world history, as a great naval power and as a center of culture. Ruskin believed it was therefore uniquely suited to teach the lessons of history to Britain, whose present role closely resembled that of ancient Venice. As Byron wrote in Canto IV of *Childe Harold's Pilgrimage*, "Venice . . . thy lot / Is shameful to the nations,—most of all, / Albion! to thee . . . in the fall / Of Venice think of thine, despite thy watery wall."

Turner visited Venice three times, and when his 1834–35 painting *Venice* (now in the National Gallery in Washington, D.C.) was first exhibited, he chose as its companion piece a London dock scene called *Keelmen Heaving in Coals*—a juxtaposition intended to create pathos by contrasting the morbid charm of decadence with the bloom of rising power.

At the time, comparing Britain to Venice was a standard feature of British political rhetoric, as we see in the following excerpt from a speech delivered by Disraeli in 1849, when he was trying to defend the importance of agriculture against industry: "Although you may for a moment flourish after their destruction [of the principles of native agriculture], although your ports may be filled with shipping, your factories smoke on every plain, and your forges flame in every city, I see no reason why you should form an exception to that which the page of history has mournfully recorded; that you too should not fade like the Tyrian dye and moulder like the Venetian palaces."

But it was Ruskin—no doubt familiar with Disraeli's words—who gave the comparison its classic formulation when he began

The Stones of Venice with these powerful lines: "Since first the dominion of men was asserted over the ocean, three thrones, of mark beyond all others, have been set upon its sands: the thrones of Tyre, Venice, and England. Of the First of these great powers only the memory remains; of the Second, the ruin; the Third, which inherits their greatness, if it forget their example, may be led through prouder eminence to less pitied destruction." The Goncourts described the realistic novels written in the mid-nineteenth century as historical novels about the present. The phrase applies almost equally well to *The Stones of Venice*—Ruskin's desperate last-ditch effort to defend and preserve the past against the destructive tide of the present.

Ruskin made his first trip to Venice in 1835, his second in 1841. He was then still a traveler in search of the picturesque, and both times the city regaled him with iridescent light, one moment the suffused light of Turner and the next the mysterious twilight of Byron. "Thank God I am here! It is the Paradise of cities," he exclaimed in 1841. He was still experiencing Venice as a dream. The "second" Italy hardly existed for him, and its troubling features seemed insignificant and unworthy of notice.

Venice had lost its independence to France in 1797, then fell under Austrian domination. It was conquered anew by France, and then in 1815 became an Austrian colony, which it remained for five decades. Ruskin's contemporaries tended to feel that the former republic had brought its doom on itself, and that the decadence of the Venetian populace had for a long time indicated their wish to be slaves. Shelley was appalled by the modern Venetians: "I had no conception of the excess to which avarice, cowardice, superstition, ignorance, passionless lust, & all the inexpressible brutalities which degrade human nature could be carried, until I had lived a few days among the Venetians." He saw the present fate of Venice as deeply rooted in its remote past and suggested that from the moment the Venetian oligarchy "usurped the rights of the people" at the start of the fourteenth century, they were sowing the deadly seeds of the present. This idea also figures largely in Ruskin's theories about Venice.

Shelley, in his drama *The Cenci* (1819), and Byron, in *Marino Faliero* (1820) and *The Two Foscari* (1821), both took a dim view of the Renaissance, suggesting for the first time that Venice began its decline at that point in its history—in an age when all seemed well on the surface, and when centuries of gaudy splendor still lay ahead.

Apart from the general contempt in which they were held, the mid-nineteenth century Venetians had other, more tangible troubles: decreasing population due to emigration and epidemic disease, and a foundering economy for those who remained, because the Austrian port of Trieste had taken over most of the shipping trade in the Adriatic after Austria regained control of Venice. The production of luxury goods was stagnating, and the city's peculiar geographical situation made it an unsuitable base for new industries. The foreign occupation forces could not and would not make a real effort to improve these conditions, but they did try to keep up appearances, for Venice was always a mecca for the fashionable traveler—though not yet a mass tourist haunt as is frequently claimed. Keeping up appearances meant that they tended the main canals and continued to repair or replace the bridges as needed, while allowing two-thirds of the buildings behind the façades to stand empty and fall into ruin.

When Ruskin returned to Venice for his third visit, in 1845, he had been forewarned by what he saw in Lucca, Pisa, and Florence. He could no longer take the "picturesque point of view," or echo Lady Morgan in her view that decay had enhanced rather than impaired the appearance of Venice. In other cities he had mourned the loss of individual works, but in Venice an entire town was under threat. "Of all the fearful changes I ever saw wrought in a given time, that on Venice since I was last here beats. It amounts to destruction." One year later he repeated this observation, using a dramatic metaphor: "The rate at which Venice is going is about that of a lump of sugar in hot tea."

Ruskin did not know which was worse, the decay stemming from poverty and indifference or the destruction carried out in the name of repair and restoration. The Austrian government was

trying to equip the lagoon city with all the comforts of modern civilization. The year 1846 saw the dedication of the newly built railroad which Ruskin detested so heartily, and gas lamps were installed in the city. "Imagine the new style of serenades—by gas-light." Gondola buses carried traffic, and serious consideration was given to a plan to lay a wide boulevard along the Grand Canal so as to extend the railroad into the city center.

Once again, Ruskin confessed to feeling nervous and restless. He felt he had to work ever faster to keep up with the demolition and new construction. "You cannot imagine," he wrote his father in December 1845, "what an unhappy day I spent yesterday before the Casa d'Oro, vainly attempting to draw it while the workmen were hammering it down before my face. It would have put me to my hardest possible shifts at any rate, for it is intolerably difficult, & the intricacy of it as a study of colour inconceivable—if I had had the whole grand canal to myself to do it, it would have been no more than I wanted—but fancy trying to work while one s[ees] the cursed plasterers hauling up beams & dashing i[n the] old walls & shattering the mouldings."

At around the same time he wrote a similar passage ending with the words "Venice is lost to me"; but in that very moment he made up his mind that he personally would undertake to salvage what could still be salvaged—at least on paper. Henceforth, he never made a drawing without listing the dimensions and showing cross sections. He also discovered the immense usefulness of photography in the recording of architecture. "Well, among all the mechanical poison that this terrible 19th century has poured upon men, it has given us at any rate *one* antidote, the Daguerrotype." But he did not yet have any means of capturing the city as a whole. "There is now *no* pleasure in being in Venice," he complained. Venice had become a chore. He continued his work there in 1846; and then he and Effie spent the winter of 1849–50 in the lagoon city, and wintered there again in 1851–52. Ruskin lived and worked in Venice for a total of fifteen months.

Before he finished, the Serenissima had once again become the focus of attention throughout Europe, and Ruskin's project was

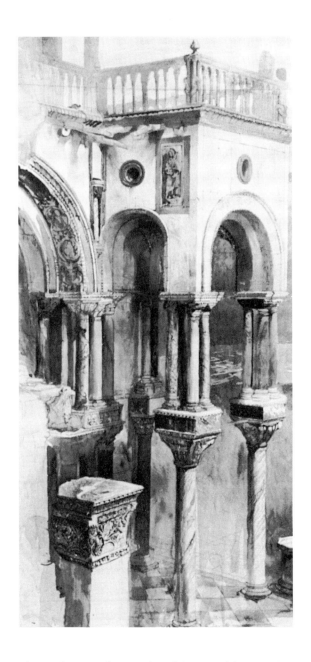

John Ruskin, The South Façade of St. Mark's, Venice, *1851.*
Pen-and-ink and watercolor. Privately owned

suddenly more urgent than ever. Venice was at war. On March 22, 1848, the city had thrown off Austrian rule and declared itself a republic again. The following year, the Austrians launched a military campaign to reconquer it. At last they broke down the violent resistance of the Venetians, but only after five months of siege and a non-stop bombardment whose like had never been seen in the history of warfare. When Venice surrendered on August 22, 1849, its people could feel proud that, of all the nations which had tried to launch revolutions in those troubled years, their city held on to its freedom and national independence the longest. Politicians throughout Europe wondered where the supposedly indolent Venetians had found such energy.

Meanwhile, Ruskin, far away in London, was worrying about the fate of Venice's artworks, which now were exposed to far worse conditions than before. In September 1849—as soon as travel routes were open again—he and Effie hurried back. They were the first and for a few months the only travelers to arrive in the exhausted city, which had been emptied out by cholera, starvation, and military casualties, and was now demoralized by defeat and martial law. Here Ruskin returned to work, in an atmosphere of undiminished hostility, surrounded by bitter poverty, and hampered by the unseasonable cold. He determined at once that the main monuments had come through the bombardment largely unscathed; but they had survived purely by chance, because of their position and engineering, and the threat was by no means over.

A Captain Paulizza soon attached himself to Effie. As commander of the Austrian artillery, he had been responsible for the bombardment. "He did something against Venice very wonderful with Balloons," Effie wrote home—meaning that Paulizza had led the world's first military air raid. But his balloon missiles, while spectacular in their technique, were not very effective; and not even cannon with a range of three miles were able to penetrate the historic and vital heart of Venice. Thus, after the city finally surrendered, the Austrians decided to discourage future rebellions by arming Venice's outer fortifications with very heavy cannon and stationing secured batteries right in the city center, all aimed at St.

Mark's and the area just around it (see Ruskin's letter to Brown, quoted earlier in this chapter). The Austrian forces openly announced their intention to obliterate the cathedral, the square, and the Doge's Palace in the event of any further revolt. The center of Venice, the greatest treasure-house in Europe, was being held hostage. In coming years, Ruskin seized every opportunity to draw public attention to this ongoing threat.

Effie wrote to a friend describing John's work load during the first winter they spent together in Venice: "Mr. Ruskin is busy all day till dinner time and from tea till bed time. We hardly ever see him excepting at dinner, for he has found that the short time we are able to remain is quite insufficient for the quantity of work before him. He sketches and writes notes, takes daguerrotypes and measures of every palace, house, well or any thing else that bears on the subject in hand, so you may fancy how much he has to arrange and think about. I cannot help teasing him now and then about his sixty doors and hundreds of windows, staircases, balconies and other details he is occupied in every day."

Ruskin had in fact set out to draw and measure every single one of the Byzantine and Gothic buildings in the five square miles of the city of lagoons and to make as accurate a record as possible of their every object and feature: "stone by stone, to eat it all up into my mind, touch by touch." This naïve appetite for objects, this need to incorporate them totally, stemmed not only from the desire to protect them from destruction but also from Ruskin's recognition of a fact which no art historian can afford to ignore: when it comes to looking at objects, one cannot assume that anyone has ever really seen them before.

It came as no surprise to Ruskin that his predecessors had misinterpreted what they saw; the culpable thing was that often they had not even bothered to look. This meant that he had to start over from scratch and investigate everything for himself. For example, he once asked the leading authority on the Doge's Palace whether the windows of the Sala dello Scrutinio had ever been lined with tracery on the inside, and was assured that they had not. Ruskin then climbed a ladder and opened the windows one

after another, only to find the bases of the old shafts, with the sockets into which they had fitted, notations of the diameter of the struts, and in one rear window the actual remains of a shaft with its capital—all unnoticed by the supposed expert.

As an Englishman, Ruskin was not afraid to be called an eccentric, and so he was willing to go to any length in his investigations. The team which set out from the Hotel Danieli each morning was a small one. It included Ruskin, his English servant George Hobbs, an Italian manservant called Domenico, their gondolier, and sometimes Effie and her companion Charlotte Ker. They tackled buildings both on water and on land, armed with tape measures, ladders, photographic equipment, architectural drawings, and notebooks. If there was an exceptionally tricky drawing to do—something high up toward the ceiling of St. Mark's, for instance—Ruskin would simply fling himself down on his back next to the high altar for half an hour and sketch away: "John excites the liveliest astonishment to all and sundry in Venice and I do not think they have made up their minds yet whether he is very mad or very wise. Nothing interrupts him and whether the Square is crowded or empty he is either seen with a black cloth over his head taking Daguerrotypes or climbing about the capitals covered with dust, or else with cobwebs exactly as if he had just arrived from taking a voyage with the old woman on her broomstick. Then when he comes down he stands very meekly to be brushed down by Domenico."

By the end of his fifteen months' work in Venice, Ruskin had amassed a vast supply of data: 168 oversize, densely inscribed "work sheets," two big notebooks totaling 454 pages, and eight small notebooks totaling 582 pages. These notebooks and work sheets must contain over three thousand detail studies, floor plans and façade sketches. We can better appreciate the scale of Ruskin's achievement if we reflect that he had to measure a window or a portal an average of twelve times to get an accurate profile. He would later write in *Praeterita*: "six hundred quarto pages of notes for it, fairly and closely written, now useless. Drawings as many . . . useless too." But even while he was still in Venice, Ruskin

John Ruskin, Studies of the Ca d'Oro, Venice, *c. 1849.*
Pen-and-ink and pencil.
The Ruskin Galleries, Bembridge School, Isle of Wight

felt that no one really cared to have such a wealth of specific detail. Nor did he, when it came time for him to write *The Stones of Venice*. Admittedly, he did include drawings of about a thousand objects in the three volumes of *Stones*: most of them diagrams of architectural fragments such as pedestals, moldings, capitals, etc. But the public paid little attention to the factual side of the work, even in this accessible form. Instead, everyone treated it as a piece of literature, a travel guide, an exposition of architectural theory, and a pamphlet on social reform. For the past 130 years, virtually no one has used the book as it was originally meant to be used: as an accurate record of Venice at a time when parts of its past had already been lost. Only now are Ruskin scholars delving into his papers and informing art historians what St. Mark's and other buildings were like before the restorers carried out their unparalleled acts of vandalism in the period between 1850 and the 1870s. If you want to know the original order of the columns on the south façade of St. Mark's, you must turn to Ruskin's drawings and watercolors, which show the veining of the different types of stone so clearly that they reveal not only the former position of the columns but also that the restorers mounted one shaft upside down.

Seeing things clearly does not always bring contentment, however. Ruskin first noticed this, not when he was observing nature, but when he studied the works of man: "I went through so much hard, dry, mechanical toil there, that I quite lost, before I left it, the charm of the place. Analysis is an abominable business," he wrote in May 1859. The passage continues:

One only feels as one should when one doesn't know much about the matter. If I could give you for a few minutes, as you are floating up the canal just now, the kind of feeling I had when I had just done my work, when Venice presented itself to me merely as so many "mouldings," and I had few associations with any building but those of more or less pain and puzzle and provocation;—Pain of frost-bitten finger and chilled throat as I examined or drew the window-sills in the wintry air; Puzzlement from said window-sills which didn't

agree with the doorsteps, or back of house which didn't agree with front; and Provocation from every sort of soul or thing in Venice at once,—from my gondoliers, who were always wanting to go home, and thought it stupid to be tied to a post in the Grand Canal all day long, and disagreeable to have to row to Lido afterwards; from my cook, who was always trying to catch lobsters on the doorsteps, and never caught any; from my valet-de-place, who was always taking me to see nothing, and waiting by appointment at the wrong place; from my English servant, whom I caught smoking genteelly on St. Mark's Place, and expected to bring home to his mother quite an abandoned character; from my tame fish, who splashed the water all over my room and spoiled my drawings; from my little sea-horses, who wouldn't coil their tails about sticks when I asked them; from a fisherman outside my window who used to pound his crabs alive for bait every morning, just when I wanted to study morning light on the Madonna della Salute; from the sacristans of all the churches, who never used to be at home when I wanted them; from the bells of all the churches, which used always to ring most when I was at work in the steeples; from the tides, which were never up, or down, at the hour they ought to have been; from the wind, which used to blow my sketches into the canal, and one day blew my gondolier after them; from the rain, which came through the roof of the Scuola di San Rocco; from the sun, which blistered Tintoret's Bacchus and Ariadne every afternoon at the Ducal Palace; and from the Ducal Palace itself, worst of all, which wouldn't be found out, nor tell one how it was built. (I believe this sentence had a beginning somewhere, which wants an end someotherwhere; but I haven't any end for it, so it must go as it is.)

Could any great scholar of the past have delivered so uncanny a report on the process of academic research? Thomas Carlyle may have been the first to point out that material objects were now in revolt against man—a concept which, on the Continent, is often

referred to by Friedrich Theodor Vischer's phrase "the malice of the object." This idea seems to have been entirely a nineteenth-century invention, and shows that people now had a different attitude toward inanimate objects—or, as Vischer would say, that objects were now behaving differently toward people.

A new but characteristic feature of mid-Victorian psychology emerged at this time: man's insecurity about his role as a rational being. People complained of having lost their emotions in the pursuit of facts, and the striking thing is that they now perceived this as a change for the worse. They were convinced that there were other ways to experience and describe the world, in fact that they themselves once practiced these ways, back when they "didn't know as much as they knew now." Now they feared becoming "Dryasdusts," as Carlyle dubbed mere fact-gatherers. They had expected more of themselves: poetic inspiration, all-embracing syntheses, ingenious reflections. But now the "subject under study" kept recalling them to duty, to the total and systematic registration of data demanded by the new standards of knowledge; and so they oscillated between painstaking diligence and emotional impulsiveness, between obligation and a freedom to which they laid claim but no longer possessed. Black humor—another nineteenth-century invention—was not enough to help them rise above the malice of objects and their insecurities about their chosen role.

As Ruskin pointed out at the end of the above-quoted passage, his sentence—his experience—had a beginning but no real end. Once a person became the target of what Vischer called "the purposeful drive inherent in all objects," the inner and outer worlds became hopelessly muddled, subjective troubles started to look objective and vice versa, and the world became a place of "pain and puzzle and provocation."

4

Ruskin's claim that he had lost "all feeling of Venice" contrasts oddly with his plan to take in the city's architecture "touch by touch." No historian ever learned as much from the tactile qualities of objects as did Ruskin. One word that crops up over and over in his studies of Venice is "mouldings"; that is, the swellings and bottlenecks, bulges, groins, ridges, concavities, and ornamental curves of all kinds, which adorned door and window jambs, stairs, banisters, columns, joints, cornices, and so on. Ruskin offered a systematic description of these abstract curves, and set great store by their implications. They, in fact, gave him the key to his understanding of the entire system of Venetian Gothic. But his technique of basing conclusions on the detailed study of fragments was borrowed from the most advanced architectural analysis of his day.

Probably it was during his trip to Italy in 1846 that Ruskin noticed the writings of Cambridge professors Robert Willis and William Whewell, who at that time were the acknowledged authorities on the English Gothic cathedral. Later, when Ruskin became more generous about admitting the material he borrowed from other scholars, he described Willis's *Remarks on the Architecture of the Middle Ages* (1835) as "my grammar." Whewell and Willis elaborated an approach which had first been put forth in a popular handbook written in 1817, Thomas Rickman's *An Attempt to Discriminate the Styles of Architecture in England*. The fifth edition of this book, printed in 1848, was freshly illustrated with engravings by Le Keux, who later engraved many illustrations for Ruskin.

Rickman's approach was "membrological"; that is, it involved looking at individual architectural "members"—distinctive features such as the capitals of columns—to see how they had changed over a period of time, so as to draw conclusions about the development of architectural styles. The reader was asked to make a practical comparison between, for example, capitals of the Norman period, the early Gothic, and all succeeding stages of style.

Ruskin was so impressed by this straightforward classification that he used it as the basis for Volume One of *The Stones of Venice*,

figure 1

168

called *The Foundations*. In thirty chapters he discussed the most important structural members of Venetian architecture, starting with the foundations and climbing to the roof; and after completing this survey of the functional features, he then made a second round to study successive styles of substructures and decorative forms.

This model actually was based on the concept of a building as an organic whole. The underlying assumption was that all building features dating from the same period would have common characteristics and, as time advanced, all the structural members would be uniformly affected by change. Of course, this approach reflected an ideal more than an actuality. The "membrologists" used the detail to draw inferences about the whole without ever really seeing or understanding the whole. *The Stones of Venice*, for example, never shows us the whole of anything, except for a bird's-eye view of the Doge's Palace. Apart from this, the first volume is, literally, made up of "stones," or individual building blocks.

But perhaps those who stuck with the separate features, and treated the total structure as an idea, were the true realists: for at what point in time was there actually any such thing as a functioning whole, an idea made stone? Buildings had always been something unfinished, patched together out of mismatched bits. Not until the late nineteenth and early twentieth centuries, under the impress of the new purged, reconstructed, textbook style of architecture, did buildings start looking all of a piece.

Moreover, Venetian architecture elevated to a basic principle of style the patchwork structure which elsewhere was just a makeshift solution or resulted naturally from the passing of generations. As Ruskin wrote in his first preface to *Stones*:

> As far as my inquiries have extended, there is not a building in Venice, raised prior to the sixteenth century, which has not sustained essential change in one or more of its most important features. By far the greater number present examples of three or four different styles, it may be successive, it may be accidentally associated; and, in many instances, the restorations or additions have gradually replaced the entire

structure of the ancient fabric, of which nothing but the name remains, together with a kind of identity, exhibited in the anomalous association of the modernised portions: the Will of the old building asserted through them all, stubbornly, though vainly, expressive; superseded by codicils, and falsified by misinterpretation; yet animating what would otherwise be a mere group of fantastic masque, as embarrassing to the antiquary as, to the mineralogist, the epigene crystal, formed by materials of one substance modelled on the perished crystals of another. The church of St. Mark itself, harmonious as its structure may at first sight appear, is an epitome of the changes of Venetian architecture from the tenth to the nineteenth century.

Given the kaleidoscopic quality of the architecture, the only sensible method for dating structures and structural changes was to determine the stylistic period of particular features. The evidence of documents alone could not establish a continuous sequence: judging by the random samples which Ruskin had taken of household records, the documents tended to concentrate on features of interior decoration installed to welcome visiting nobles.

Ruskin's goal was thus to assemble complete developmental sequences of each architectural feature in order to facilitate the dating and classification of baffling structures by reference to some characteristic motif. To make the distinctions more precise, he went a step beyond the traditionally recognized "membra," and started to analyze and classify molding patterns, or profile curves. This brought a methodological advance which, once again, was a logical outgrowth of the special circumstances of Venice. Not only was Venetian architecture a medley of styles, but many of its features were of foreign origin. Sculpture from distant times and places, imported goods, and war spoils were blithely added to existing buildings or incorporated into new ones, giving rise to imitations by generations of Venetian stonemasons, not always at once but decades or even centuries later; and the imitations in turn produced fresh imitations. So how could anyone be sure of the

true age of any feature, when a piece which looked to be ancient Greek might really have been made in the fifteenth century, as the reprise of a reprise? Ruskin's intuitive sense of the importance of moldings stood him in good stead here, for he found that the profile curves were as unmistakable as handwriting.

Ruskin made systematic use of the molding as an investigative tool, but he was not completely original even in this. Rickman's compendium contained a chapter on moldings, along with a series of very exact illustrations which were even more informative than Ruskin's; while Ruskin supplied simple outlines, Rickman gave cross-section views and showed forms in perspective. Willis too, in his monographs on cathedrals, used profile analysis to distinguish architectural phases. And the architect August Welby Pugin, who played a prominent role in the Gothic Revival and whose work Ruskin studied carefully before vilifying it in *The Stones of Venice*, had actually developed a basic theory of moldings in his 1841 book, *True Principles of Pointed or Christian Architecture*—a theory to which Ruskin then adhered fairly closely.

Willis, Pugin, and other architectural historians devoted considerable attention to this simplest form of building sculpture. In one of his prefaces, Willis wrote that he had used a cymagraph to trace the contours of all his moldings, and then reduced their scale and transferred them to paper with the aid of a pantograph and a camera lucida. The "cymagraph for copying mouldings" was Willis's own invention, introduced in 1842. It was a small instrument guaranteed to produce exact profile tracings.

Whereas Willis emphasized the importance of mechanical aids, Ruskin—typically for him—stressed the need for human commitment, without sacrificing accuracy. In his preface to *The Stones of Venice*, he called attention to the difficulties of describing accurately the subtle curvature of natural objects:

Zoologists often disagree in their descriptions of the curve of a shell, or the plumage of a bird, though they may lay their specimen on the table, and examine it at their leisure; how much greater becomes the likelihood of error in the descrip-

tion of things which must be in many parts observed from a
distance, or under unfavourable circumstances of light and
shade; and of which many of the distinctive features have
been worn away by time.

For Ruskin, the subtle curves of stone moldings were like or-
ganic patterns, closely akin to the curves of a shell. Like William
Hogarth a century earlier, he designed a chart of beautiful curves.
But Hogarth looked to artifacts and works of art—man-made ob-
jects—to find the ideal curved line which he described in his *Anal-
ysis of Beauty*; he constructed the line synthetically. Ruskin, who
always looked to nature to supply the model, took all his ideal
curves from the contours of leaves, shells, branches. And the su-
preme example, "Curve a b" in his chart, was the silhouette of a
small glacier on a spur of the Aiguille Blaitière at Chamonix. Rus-
kin described "Curve a b" as "the most beautiful simple curve I
have ever seen in my life." Where Hogarth chose as the ultimate
curve a graceful but sharply defined S-curve, Ruskin preferred long
and gentle curves. He looked, not for enclosed ornamental forms,

figure 2

but for a vital contrast of force and counterforce, for an expression of movement and energy.

To be sure, movement, energy, and balanced force characterized curves in architecture as well as in nature; but Ruskin warned that man's techniques were coarser than nature's and could not reproduce the subtle arcs of nature's loftiest designs. Two simple segments from his curve chart would, he believed, supply architecture with all the basic forms it needed.

But although nature might have a much wider range of forms than art, man-made profiles were still of prime importance to the interpreter: when exploring them, he was closer to the sources of a style and a period than at any other time.

Carlyle, in his 1833 novel *Sartor Resartus*, described a philosophy of clothing and tailoring which showed how the detailed analysis of styles allowed one to reconstruct an entire age, in the manner of Hegel: "For neither in tailoring nor in legislating does man proceed by mere Accident, but the hand is ever guided on by mysterious operations of the mind. In all his Modes, and habilatory endeavours, an Architectural Idea will be found lurking. . . . In all which, among nations as among individuals, there is an incessant, indubitable, though infinitely complex working of Cause and Effect: every snip of the Scissors has been regulated and prescribed by ever-active Influences, which doubtless to Intelligences of a superior order are neither invisible nor illegible."

The "snip of the Scissors" which curves a bodice and the chisel blow which shapes a bulging molding are elementary and mysterious operations that lie beneath the threshold of consciousness, both of their viewer or user and of the tailor or builder: for Carlyle says they are accessible only to "Intelligences of a superior order." But this is just what makes them such a useful period index. The underlying premise is that, spontaneously produced, anonymous material is the most revealing.

The nineteenth century has been credited with developing a process of inductive reasoning, based on circumstantial evidence, which transcends any particular discipline and which uses inanimate remains as a basis for conclusions about the live original.

Giovanni Morelli used the details of paintings and sculpture—ears, fingernails, eyelids, and other features which always automatically stayed the same—as criteria for identifying the artist. Francis Galton helped to classify the fingerprint as an infallible means of identification. The fictional detectives created by Arthur Conan Doyle and Edgar Allan Poe extrapolated from inanimate details. These men were all well-known nineteenth-century symptomatologists, exponents of the "trace paradigm." But Ruskin was a leader in the field of architectural analysis and in his comparison of the patterns of nature and art; and he, in turn, was following in the footsteps of those classical scientific role models, the geologists and paleontologists, who spent their lives gathering mere traces. Buckland had taught him how to reconstruct a long-extinct animal, complete with all its functions, from a petrified footprint or bone fossils. The lesson stood him in good stead when he investigated the abstract lines of natural and man-made works.

5

What was there to discover about these works, once their provenance and dates were established? Ruskin's interest in wealth and abundance was practical as well as theoretical. He extracted a myriad of messages from expressive lines, and thus his methodology is one which might normally be described as pluralistic. But this is not the right word for Ruskin. He is not a man who, having amassed a repertoire of methods, then leans back and masterfully deploys them one by one. Instead, he struggles with his material, and need rather than indecision drives him to grab at any tool which promises aid, even though it usually turns out that such tools are still in need of refinement. His pluralism is unripe, rough and ready, often unscrupulous, sometimes arrogant:

> The labour of seeking must often be methodless, following the veins of the mine as they branch, or trying for them where they are broken. And the mine, which would now open into

the souls of men, as they govern the mysteries of their han-
dicrafts, being rent into many dark and divided ways, it is
not possible to map our work beforehand, or resolve on its
directions. We will not attempt to bind ourselves to any me-
thodical treatment of our subject, but will get at the truths
of it here and there, as they seem extricable.

Ruskin wrote this passage much later, but it appropriately describes
his way of working, ever since he set out to explore "the souls of
men, as they govern the mysteries of their handicrafts."

Which "veins" were they whose "dark and divided ways" he
followed throughout his life? There seem to be three: materials and
technology, the viewer's aesthetic/perceptual involvement, and the
organization of labor within a sociohistorical framework. These
were the factors which determined the final shape of a curve—the
curve of a bridge, for instance:

I ask the reader to admire . . . the choice of the curve, and
the shaping of the numbered stones, and the appointment
of that number; there were many things to be known and
thought upon before these were decided. The man who chose
the curve and numbered the stones, had to know the times
and tides of the river, and the strength of its floods, and the
height and flow of them, and the soil of the banks, and the
endurance of it, and the weight of the stones he had to build
with, and the kind of traffic that day by day would be carried
on over his bridge,—all this especially, and all the great gen-
eral laws of force and weight, and their working.

Let us examine the three "veins" one by one, beginning with
materials and technology. Ruskin's discussion of bridge building
can be extended to all the features of Venetian architecture, both
large and small. Some Ruskin scholars have accused him of having
no grasp of the functional requirements of a building, whereas
others claim that, on the contrary, he was one of the first and most
important theorists of functionalism and materialism in architec-

ture. If we ask whether he understood the connection between the structure of a building and its practical purpose—the connection between a church design and the liturgy, for instance—then the answer is no. For although Ruskin was skilled in defining types, and supplied us with a history of the development of the Venetian palace façade which is still valid today, he was unable—or did not care—to link changes in the outward appearance and structure of buildings with changes in what was going on inside them.

On the other hand, if we ask whether Ruskin understood the functional aspects of buildings in terms of production problems and the laws of physics, then the answer is yes. *The Stones of Venice* is in many ways a ground-breaking work when it comes to the technical aspects of architectural history. Ruskin looks almost like a callous materialist compared to art historians like Lord Lindsay, with their strong leanings to German Idealism. It was Venice itself which made it possible for Ruskin to achieve his scientific perspective. The history of Venice was to him what the Galapagos Islands were to Darwin: an island universe, a self-contained environment subject to extreme pressure from the outside world, a living example of the struggle for survival, of gradual adaptation, and of the effort to capitalize on a limited set of conditions: "It is the history of a people eminently at unity in itself, descendants of Roman race, long disciplined by adversity, and compelled by its position either to live nobly or to perish:—for a thousand years they fought for life; for three hundred they invited death: their battle was rewarded, and their call was heard."

Ruskin plausibly explains many things in terms of the local conditions of Venice: the use of brick and the importation of other building materials resulted from the lack of nearby stone quarries; marble was used extensively because it weighed the same as sandstone and was just as easy to import; stones cannibalized from earlier sites were often used because the Adriatic coast was riddled with ancient cities, all close to ports visited by Venetian ships; the taste for flat marble incrustations in building decoration reflected the desire to conserve the precious material by laying it on in thin slabs, as well as the desire not to overload the structure. Ruskin

even thought that the basic architectural designs of Venice grew out of its geography and early history: "It is with peculiar grace that the majestic form of the Ducal Palace reminds us of the years of fear and endurance when the exiles of the Prima Venetia settled like homeless birds on the sea-sand, and that its quadrangular range of marble wall and painted chamber, raised upon multiplied columns of confused arcade, presents but the exalted image of the first pile-supported hut that rose above the rippling of the lagoons."

figure 3

Ruskin does not so much explain as take for granted that architecture demonstrates "the intelligence and resolution of man in overcoming physical difficulties," as he says in Volume One of *Stones*. But he proves the truth of this claim with his usual painstaking care when he comes to treat individual architectural features. While studying shells in the British Museum in 1848, Ruskin had a theory about the real nature of form which proved useful in his work on Venetian capitals, bases, and cornices. His diary records

it this way: "Now I think that Form, properly so called, may be considered as a function or exponent either of Growth or of Force, inherent or impressed; and that one of the steps to admiring it or understanding it must be a comprehension of the laws of formation and of the forces to be resisted; that all forms are thus either indicative of lines of energy, or pressure, or motion, variously impressed or resisted, and are therefore exquisitely abstract and precise."

figure 4

We have already encountered the echo of this diary entry in what Ruskin wrote about abstract lines being the expression of action or force. This is a genuinely Victorian attitude, which regards form as the product and balance of contesting forces, rather than merely the product of inner growth, as the Romantics did. To see how Ruskin applied this idea to architectural features, we will look at one example: the cornice.

An outer wall needs a ledge or shelf at the top to protect it from rain, or to distribute the weight of the roof beams and other supports (Fig. 3). If a ledge is wanted to extend over the top (b) so

as to distribute pressure more evenly, create a larger support surface, and divert rain from the wall, it makes sense to taper it underneath as shown in (c), to avoid chipping and weather damage; and the ideal way to balance the requirements of support and of rain diversion is shown in (d). The resulting form is the "great root and primal type of all cornices whatsoever," which becomes the basis of both the concave and the convex variants shown in Figure 4. The concave model (b) is used to shield the wall and

figure 5

divert rain; the convex (c), when the need is to carry weight. Allowing the ledge to project a little beyond the lower molding, as in (f) and (g), avoids formation of a corner at the point where the upper vertical line meets the lower sloping line, and so avoids the possibility of rain running down. In a very wet climate, merely tapering the base of the cornice will not prevent water from running down the cornice and the wall underneath, so in this case it is necessary both to deepen the concavity and to extend the projecting ledge.

The result is the Gothic dripstone (Fig. 5), which is deeply incised underneath, and also slopes on top, so that water will not stand on it.

But the essential part of the arrangement is the up and under cutting of the curve. Wherever we find this, we are sure that the climate is wet, or that the builders have been *bred* in a wet country, and that the rest of the building will be prepared

for rough weather. The up cutting of the curve is sometimes all the distinction between the mouldings of far-distant countries and utterly strange nations. Fig. [6] represents a moulding with an outer and inner curve, the latter under-cut. Take the outer line, and this moulding is one constant in Venice, in architecture traceable to Arabian types, and chiefly to the early mosques of Cairo. But take the inner line; it is a drip-stone at Salisbury. In that narrow interval between the curves

figure 6

there is, when we read it rightly, an expression of another and a mightier curve,—the orbed sweep of the earth and sea, between the desert of the Pyramids, and the green and level fields through which the clear streams of Sarum [i.e., Salisbury] wind so slowly.

This "narrow interval" was the field where artisans and architects were free to display their inventiveness and love of decoration, or their confinement and lack of invention, or their pride and caprice. They were free to indulge their fancy in shaping the final outline, as long as they remained within the limits of the basic forms. These basic forms served as "the natural channels by which invention is here to be directed or confined." The materials, together with external forces acting upon them such as weight or

the action of weather, established a sort of standard curve which represented the simplest possible balance of the contesting forces. This basic curve was then elaborated by "an innumerable variety of curves" which could be drawn "from every leaf in the forest, and every shell on the shore, and every movement of the human fingers."

Consequently, an interpreter of moldings must keep in mind the role which necessity plays in shaping the curve of a molding. Venice was itself the product of unique "adaptations," and taught that architecture was born out of the combined effects of adaptation and variation; that is, out of "force" (material conditions) and "action" (human intervention). This brings us to the second of Ruskin's "veins." For adaptation involved more than just what he called the "necessities of practice" and "physical accidents." A building was shaped by people's needs as well as material conditions—but the needs of the *spectator*, not the user. Nowhere in *The Stones of Venice* did Ruskin take seriously the functional purpose of a church layout or of the order of rooms in a palazzo. It is not hard to see the reason for his attitude. Ruskin was a foreigner and a tourist in Venice, and he wrote *Stones* for other foreigners and tourists, so he could not help but stay detached. He was a Protestant writing about a city deeply imbued with Catholicism, and an Englishman looking at two peoples—the Italians and their Austrian masters—both of whom he disliked on political, moral, and religious grounds. Inevitably, he felt outraged by the way that the Venetians, the Austrians, and the Catholic Church were abusing the buildings of Venice's prime, which he considered the period up to about 1418. With lugubrious satisfaction he noted that the Italians were using part of the Doge's Palace as a urinal; the Austrians were using other parts as cannon emplacements; and the Great Entrance to St. Mark's Cathedral had been turned into a bazaar selling toys, books, and caricatures.

One Sunday, February 24, 1850, he painstakingly recorded all the items on sale at St. Mark's, and put the list in an appendix to *Stones*. Among the listed items was a volume of the correspondence of Madame de Pompadour, lying open right next to a book on

the moral education of daughters. Ruskin left no one in doubt as to his conclusions. He called for support of the poverty-stricken Protestant churches of France, Switzerland, and Piedmont, and commented as follows on the contemporary uses of the churches of Venice: "I do not know, as I have repeatedly stated, how far the splendour of architecture, or other art, is compatible with the honesty and usefulness of religious service. The longer I live, the more I incline to severe judgment in this matter, and the less I can trust the sentiments excited by painted glass and coloured tiles. But if there be indeed value in such things, our plain duty is to direct our strength against the superstition which has dishonoured them; since there are thousands to whom they are now merely an offence, owing to their association with absurd or idolatrous ceremonies."

Until the true and enlightened faith gained control of all works of sacred art, the Protestant could legitimately devote himself to the worship of beauty, to the religion of art. Inside St. Mark's, Ruskin observed that the faithful were attracted solely by the trappings of superstition: incense, warmth, the mysterious half-darkness, the gleam of precious materials.

> I never saw one Venetian regard [the cathedral's artwork] for an instant. I never heard from any one the most languid expression of interest in any feature of the church, or perceived the slightest evidence of their understanding the meaning of its architecture; . . . we have in St. Mark's a building apparently still employed in the ceremonies for which it was designed, and yet of which the impressive attributes have altogether ceased to be comprehended by its votaries. The beauty which it possesses is unfelt, the language it uses is forgotten; and in the midst of the city to whose service it has so long been consecrated . . . it stands, in reality, more desolate than the ruins through which the sheep-walk passes unbroken in our English valleys.

Eventually, the Protestant faith would determine the true role of art, but until then, its devotees had to be particularly pure in their perceptions and to keep art free of all religious implications. Ruskin worried that Protestants, due to their underdeveloped sensuality, might easily succumb to the "glitter of [the Catholic Church]" and be "stitched into a new creed by gold threads on priests' petticoats."

Thus, Ruskin's stress on form over function grew out of his Protestant spirit and was intended as a temporary measure which would pave the way for a future faith while warding off the corrupt Catholic faith of the present. It is in this sense that Ruskin can rhapsodize about the visionary experience of looking at St. Mark's: for this is a secularized St. Mark's, which he views purely as architecture. Stripped of its religious associations, the façade appears to him "a precious film," "a confusion of delight." He is ecstatic about an architecture whose "low walls spread before us like the pages of a book, and shafts whose capitals we may touch with our hand," and this same spirit leads him to make the astonishing remark that "it was a wise feeling which made the streets of Venice [i.e., the house fronts lining the canals] so rich in external ornament, for there is no couch of rest like the gondola."

This visionary attitude is what generates Ruskin's "visual functionalism"—his belief that the structure of a building should be adapted to the needs of the spectator. A building was functional if it met two requirements: it was functional in itself if it conformed to the laws of architecture; and it was functional for the spectator if it conformed to the laws of "visibility."

In *The Stones of Venice* Ruskin sharply criticized Pugin for converting to Catholicism (allegedly) for aesthetic reasons. And yet Pugin's views in many respects closely resemble Ruskin's own. In his book on the *True Principles of Pointed or Christian Architecture*, Pugin had said that one of the main factors governing the shape of a profile was the spectator's position in relation to it. Ruskin, who had based Volume One of *Modern Painters* on this same principle—that is, on the need to adapt art to the perception

of the viewer—then carried over the idea into his discussion of
Venetian architecture:

> Next we have to consider that which is required when it is
> referred to the sight, and the various modifications of treat-
> ment which are rendered necessary by the variation of its
> distance from the eye. I say necessary: not merely expedient
> or economical. It is foolish to carve what is to be seen forty
> feet off with the delicacy which the eye demands within two
> yards; not merely because such delicacy is lost in the distance,
> but because it is a great deal worse than lost:—the delicate
> work has actually worse effect in the distance than rough
> work.

The need to keep the viewer's position in mind was yet another
reason for Ruskin to study architectural features close up, to clam-
ber about among the capitals of the columns, to determine the
degree of detail, and then to retreat to a normal distance to test
the overall effect. All this made a useful exercise for the trace
detective, the myopic student of molding outlines.

For example, when Ruskin first looked at the capitals of the
upper arcade of the Doge's Palace, he felt that they were distinctly
inferior to the lower capitals; but then he changed his mind. "It
was not till I discovered that some of those which I thought the
worst above, were the best when seen from below, that I obtained
the key to this marvellous system of adaptation; a system which I
afterwards found carried out in every building of the great times
which I had opportunity of examining."

Venice's fine architecture achieved something which Ruskin felt
should be demanded of all architecture: "The spectator should be
satisfied to stay in his place, feeling the decoration, wherever it
may be, equally rich, full, and lovely: not desiring to climb the
steeples in order to examine it, but sure that he has it all, where
he is." The work of art, in other words, must make an intelligent
appeal to the eye, must involve and stimulate it, without requiring
the eye to see all the details of what it looks at: "The eye is con-

tinually influenced by what it cannot detect; nay, it is not going too far to say, that it is most influenced by what it detects least."

When he says that the eye need not see everything, Ruskin does not mean simply that some subtle details always escape the spectator but that deliberate techniques should be used to adapt architecture to the scale of the viewer. The stonemason can deliberately carve a careful version of a design when it will be seen close up or a rough version of the same design when it will be seen from a distance, emphasizing only its main features.

When Ruskin studied the sculpture of Adam at the corner of the Doge's Palace, on the side facing the Riva dei Schiavoni, he found that the eyes acquired their "anxious and questioning" look only when viewed from at least fifteen feet away: "The expedient can only be discovered by ascending to the level of the head; it is one which would have been quite inadmissible except in distant work, six drill-holes cut into the iris, round a central one for the pupil."

Devices of this kind were not a sign of crude execution but rather were an attempt to supply information whose sole purpose was to benefit "visibility." Ruskin believed that such techniques, far from being mere tricks to defraud the spectator, represented an acknowledgment of his existence and a tribute to his sensory processes. The eye needed to celebrate the mystery of "apparent and actual form," to inhabit the border between conscious and unconscious response, to move back and forth between beholding and insight. The theory of viewer participation which Ruskin had introduced in *Modern Painters* was made more systematic in *The Stones of Venice*:

> The right point of realization, for any given work of art, is that which will enable the spectator to complete it for himself, in the exact way the artist would have him, but not that which will save him the trouble of effecting the completion. So soon as the idea is entirely conveyed, the artist's labour should cease; and every touch which he adds beyond the point when, with the help of the beholder's imagination, the story ought

to have been told, is a degradation to his work. So that the art is wrong which either realizes its subject completely, or fails in giving such definite aid as shall enable it to be realized by the beholding imagination.

The principle that a living work of art demands an active spectator was one factor that lay behind Ruskin's rejection of Renaissance and post-Renaissance art. The Renaissance principle, he believed, was the striving for "universal perfection": it aimed for uniform execution in art, and also for a high level of detail which left little or nothing to the spectator's imagination. In the Renaissance, art and handicrafts began to center on themselves; and, consequently, what Ruskin regarded as the highest concern of all art—a direct exchange between artist and perceiver—gradually fell by the wayside. The end result of this development was the isolated artist-genius, whose great achievements set the pattern to be carried out by the craftsman. The craftsman is no longer free to follow his invention; nor, equally, is the viewer, who is prevented from making his own contribution.

Now we come to the third "vein" which Ruskin pursued, which for him turned out to be a vein of gold: for in exploring it he found his own best formula, his "godterm." In days to come, perhaps there will be no one left who will care to read Ruskin's analysis of the elegant curve of a common spruce branch, or the base of a Venetian column, because by then both branch and column, nature and civilization, will no longer exist as we know it. But even then there will still be people who will quote these lines of his, who will quote them though they fail to take them to heart, the lines which grew out of his study of the work of the Gothic stonemasons of northern France and of the masons of Venice.

The earliest versions went like this: "I believe the right question to ask, respecting all ornament, is simply this: Was it done with enjoyment—was the carver happy while he was about it? It may be the hardest work possible, and the harder because so much pleasure was taken in it; but it must have been happy too, or it will not be living." And: "Things . . . are noble or ignoble in

proportion to the fulness of the life which either they themselves enjoy, or of whose action they bear the evidence."

Ruskin claimed that looking at moldings and observing the quality of the workmanship would tell him the working conditions of the workman, and this in turn would tell him about the entire society in which the work had been produced. It is important to emphasize again why Ruskin consistently concentrated on the simple features of architecture, while supplying no analyses of large structures. Willis comments that the window moldings at Winchester Cathedral "afford a very useful test of the different powers of the artists that designed them." Ruskin would have dismissed as "ungothic" and as typically nineteenth-century the idea that it is "artists" who design carvings while stonemasons merely execute them. It was this cleavage between design and execution which was apparent in the Gothic Revival churches of the nineteenth century. Ruskin, having studied the ornamentation of one such church in Rouen, concluded that it was based on good models, yet he said of its execution: "But it is all as dead as leaves in December; there is not one tender touch, not one warm stroke on the whole façade. The men who did it hated it, and were thankful when it was done."

For Ruskin, the quality of architecture depended on the degree of freedom allowed to the artisan in carrying out the plans. He pleaded the cause of that horde of nameless workers who, in their work, expressed not themselves but only their labor.

Ruskin believed that there were three ways in which the labor of building could be shared out. First, the artist-architect could design everything down to the last detail and then have the artisans copy his designs exactly. This was the system followed by the Egyptians, the Greco-Roman world, during the Baroque period, and at all subsequent times.

Second, the artist-architect could call on artist-sculptors to design and execute ornaments, and could give them independent status equal to his own—the Renaissance system.

Or, third, the role of the artist-architect could be omitted, as in the "mediæval system, in which the mind of the inferior workman

is recognised, and has full room for action, but is guided and ennobled by the ruling mind." This was the system of the Gothic, the only school of architecture which truly deserved the titles Christian and European—Christian because it had regard for even the lowliest workman, and European because it respected individuality, the fundamental principle of the West: "This is the glory of Gothic architecture, that every jot and tittle, every point and niche of it, affords room, fuel, and focus for individual fire."

Ruskin began work on Volume Two of *The Stones of Venice* on May 1, 1851, and made the following solemn entry in his journal: "Denmark Hill. Morning. All London is astir, and some part of all the world. I am sitting in my quiet room, hearing the birds sing, and about to enter on the true beginning of the second part of my Venetian Work. May God help me to finish it to His glory, and man's good."

The reason that "all London was astir" was that this day marked the opening of the world's first international trade exhibition, at the Crystal Palace in London. The Great Exhibition was dedicated to the productive union of art and industry, as allegory stated on the title page of the catalogue, and as rhetoric repeated in the innumerable speeches and prospectuses. Ruskin did not attend, not because contemporary events held no interest for him compared to Venice, but because he was occupied with the second part of *Stones*, in which he meant to talk about the problem underlying the Great Exhibition, and to discuss Venice as an example of what he meant.

The Crystal Palace and the goods displayed there formed the background to Ruskin's reflections on the work of the Gothic stonemasons, and on work in general. The Crystal Palace had been designed by a single individual. His specifications for every part were exact to the last fraction of an inch and required equally exact execution. That is, they demanded the total subjugation of all the workers to the will of the architect, or, rather, their subjugation to a system of architecture divorced from people. Moreover, the building of the Crystal Palace had reintroduced a system of labor apportionment that had not been seen since the days of the Pyr-

amids. All the pieces of the building—both the standardized sheets of glass and the iron frames which were to hold them—were prefabricated. They arrived at the site ready-made and there was nothing left for the workmen to do but assemble them. The workmen who did the prefabricating had no idea of the overall plan of the building and simply manufactured individual sheets of glass with no meaningful shape. The workmen who put the pieces together knew the overall plan but had no say in it.

The Crystal Palace was a functional container. Inside lay hundreds of thousands of objects, the products of a veritable fury of mid-nineteenth-century decorative invention. But we must not imagine that the objects enjoyed any more liberty than their container. The iron law which made it possible to build the Crystal Palace was the same that governed commercial handicrafts. Ornamental devices borrowed from every period and century were distributed with absolute exactness and uniformity over vessels, fabrics, furniture, tools, machinery, and so on.

Ruskin's answer to all this was as follows:

> Wherever the workman is utterly enslaved, the parts of the building must of course be absolutely like each other; for the perfection of his execution can only be reached by exercising him in doing one thing, and giving him nothing else to do. The degree in which the workman is degraded may be thus known at a glance, by observing whether the several parts of the building are similar or not.

"And observe," he says, turning directly to the reader/customer/manufacturer/consumer:

> And observe, you are put to stern choice in this matter. You must either make a tool of the creature, or a man of him. You cannot make both. Men were not intended to work with the accuracy of tools, to be precise and perfect in all their actions. If you will have that precision out of them, and make their fingers measure degrees like cog-wheels, and their arms

strike curves like compasses, you must unhumanize them. All the energy of their spirits must be given to make cogs and compasses of themselves. All their attention and strength must go to the accomplishment of the mean act. The eye of the soul must be bent upon the finger-point, and the soul's force must fill all the invisible nerves that guide it, ten hours a day, that it may not err from its steely precision, and so soul and sight be worn away, and the whole human being be lost at last—a heap of sawdust. . . .

Let me not be thought to speak wildly or extravagantly. It is verily this degradation of the operative into a machine, which, more than any other evil of the times, is leading the mass of the nations everywhere into vain, incoherent, destructive struggling for a freedom of which they cannot explain the nature to themselves. . . . The foundations of society were never yet shaken as they are at this day. It is not that men are ill fed, but that they have no pleasure in the work by which they make their bread.

This is another restatement of Ruskin's basic formula, his assertion of man's supreme right in the golden age of industry: the right to be happy in his work. Ruskin never fought in the struggles for freedom of the press, free trade, equal rights for women and minority races, or for universal suffrage. Born and educated a Tory, he regarded these causes as either noxious or insignificant. A single concern lay at the heart of his social criticism, both theoretical and practical: to create humane working conditions for the worker, and so to make him happy.

Ruskin's intellectual precursor, Carlyle, was largely responsible for identifying the work ethic as the dominant creed of the age; but Ruskin was the first to ask questions about the *quality* of work and thus overcame the unfortunate Victorian tendency to worship work for its own sake and to exalt formalistic behavior.

Carlyle frequently invoked the work principle in *Sartor Resartus*, saying that man's "vocation is to work," and enjoining all to "Toil on, toil on: thou art in thy duty." But it was left to Ruskin to

debate the fundamentals of production. "It may be proved, with much certainty, that God intends no man to live in this world without working: but it seems to me no less evident that He intends every man to be happy in his work. It is written, 'in the sweat of thy brow,' but it was never written, 'in the breaking of thine heart,' thou shalt eat bread."

"Work" has the double meaning of "labor" and "object *made* by labor" (including "artwork"). For Ruskin, the highest-quality art was that produced by the most satisfying labor. His most succinct definition of worthwhile art as the product of worthwhile labor was "art which proceeds from an individual mind, working through instruments which assist, but do not supersede, the muscular action of the human hand, upon the materials which most tenderly receive, and most securely retain, the impressions of such human labour."

Put into slightly more systematic terms, this gives us a brief catalogue of criteria for "good work," the same which Ruskin later applied to his practical experiments in social reform. As we have now repeated more than once, the workman must have scope for individual action, within a prescribed framework. The irregular features of his work should be not only accepted but encouraged, for the absence of uniformity is a characteristic both of nature's production and of man's. An absolute ban is placed on mere copy work and machine labor, because they destroy the workman and make the viewer insensible to "the bright, strange play of the living stroke." All work must use sound, authentic materials and good-quality designs, and must not mislead the viewer, either about the materials or about the amounts of time and skill that have gone into the production.

These main criteria, and a series of secondary criteria, would, if they were met, produce results essential to any healthy exchange between producer and consumer: people would be happy in their work, the product of the work would contribute to the mental well-being, energy, and joy of the viewer, and the work would fulfill its material purpose. All art, all the works of man depend for their existence on the exchange between maker and perceiver.

Only if all the artist's faculties operate in a production can that production in turn affect all the viewer's faculties.

Thus, there are a number of qualities to look for when we examine moldings. The supreme quality a piece of work can reveal is that it is free and not slave. It will also reveal the extent to which understanding of a building's function, and an understanding of the needs of the viewer, entered into its production. All three factors, taken together, give us a molding representative of its time. Then, a knowledge of the specific features of all three elements is required, before we can form an overall judgment of the work's quality and evaluate periods and styles in the light of it.

Ruskin, after examining his Venice material, found that it seemed to fall into three periods. This tripartite scheme was a convention of his day; his analysis and his ranking of the three periods was not. First came Venice's version of Byzantine–Romanesque architecture, a period which Ruskin admired deeply. Other art critics of his century—Jakob Burckhardt among them—considered St. Mark's Cathedral "extremely ugly" or "rather trivial and clumsy," but Ruskin praised its sturdy forms, its honesty and directness, its abstract, flat ornamentation, and especially its feeling for color—for the love of color, he believed, was an essential sign of the vitality of a period in art. In the Byzantine–Romanesque period, the work of stonemasons had been earnest and practical, inventive within the limits permitted by the classical models, reliably and evenly executed. "Faithful energy" was Ruskin's key term for their work.

But his real love went to the second period, the Gothic, to whose qualities he devoted a lengthy catalogue: it had "rudeness or savageness," "changefulness or variety," "naturalism or sympathy with the material universe," a "sense of the grotesque," "rigidity or strength of will." The first two categories were the chief ones and illustrate the essential qualities of work as we just outlined them: the worker is unfettered, free to express what is "changeful and various," according to his own lights.

For historical reasons, and for practical reasons which need not be enumerated here, Ruskin called the Gothic "not only the best,

but the *only rational* architecture." For him, a late Gothic structure like the Doge's Palace was "the central building of the world." He studied the late Gothic very closely and used the principles he had outlined to trace its inevitable decline.

The third period in his tripartite classification was the Renaissance, whose "first assault" against the degraded Gothic, "the requirement of universal perfection," was bound to lead to the piecemeal labor and shackled working conditions of his own time.

> The world could no longer be satisfied with less exquisite execution, or less disciplined knowledge. The first thing that it demanded in all work was, that it should be done in a consummate and learned way. . . . Imperatively requiring dexterity of touch, they gradually forgot to look for tenderness of feeling; imperatively requiring accuracy of knowledge, they gradually forgot to ask for originality of thought. The thought and the feeling which they despised departed from them, and they were left to felicitate themselves on their small science and their neat fingering.

The main quality of Renaissance art was its pride: pride in personal achievement, pride in science, pride in nobleness, pride in system. Renaissance art was self-cultivating and lacked the living exchange with something outside itself, whether God, nature, or man: "There was never in any form of slavery, or of feudal supremacy, a forgetfulness so total of the common majesty of the human soul, and of the brotherly kindness due from man to man, as in the aristocratic follies of the Renaissance."

6

Indisputably, Ruskin's methods of studying and probing Venetian architecture produced very valuable interpretations. He showed how different architectural features were related, he looked at the underlying technical principles and at the aesthetic principles as

they related to the viewer, and searching incessantly for vital expression in stone, he amassed a quantity of subtle and complex analyses of architectural detail, unmatched by any student of architecture before or since.

But it is highly doubtful that his theories unlocked the system of Venetian architecture as he believed. The notion that the medieval building worker was relatively free to design his own work has been harshly but justifiably dismissed as "pure fantasy" and "sentimental nonsense." And the knowledge that one day a critic would describe "rudeness" and "savageness" as the highest qualities of their work would have brought despair, not joy, to the architects and stonemasons of the thirteenth and fourteenth centuries: for, naturally, they must have felt that they were seeking perfection, the rigor of a system, pride in their accomplishments— all the things which Ruskin described as belonging to the "winter blight" of the Renaissance. Moreover, the same architects and stonemasons doubtless behaved far less indulgently toward their less skillful colleagues than their latter-day admirer would one day claim. The masons' guilds may have been social-security organizations, but they were definitely not institutions of progressive education, as Ruskin believed.

That Ruskin was wrong in his proofs but right in his general points is another matter. We may agree with him that the anonymous Gothic sculpture is superior to later work in its lack of constraint, its wealth of invention, and its vitality of line, but we attribute these qualities to different causes than he did: to a relaxed attitude about changing the overall building plan; to the fact that building plans did not exist on paper but were preserved by the guild artisans, who prided themselves on keeping everything in their heads; to the vast dimensions of building projects, which made it hard to keep track of details; to the haphazard organization, which, rather than leaving the workman free to innovate as Ruskin supposed, made innovation compulsory; and so on. But all this lies outside the scope of our discussion. We should concentrate instead on the fact that *The Stones of Venice* was not a straightforward factual history of architecture, nor was it intended as such.

Ruskin was well aware that British historians, influenced by their German colleagues, were changing their methodology and devoting themselves to the study of documents. This was true also for the newborn study of art history. While he was in Venice, he came into almost daily contact with British historian Rawdon Brown, who had dedicated his life to researching Venice's voluminous archives. But, much as Ruskin admired his friend, he feared the effects of Rawdon Brown's non-sensory way of relating to history. So extreme was his fear that he wrote to his father from Venice, asking him to go to the British Museum Library to look up facts which Brown could have supplied him with in a matter of minutes. For Ruskin was unconditionally committed to the works themselves, and to the quality of their carving—not just because he was a visual person but also because he was not in complete agreement with the ideals of the German school of history: research free from value judgments—the negation of personality which rewarded the researcher for his ascetic labor. The time-honored British tradition had been to write about history out of a concern for the present, and Ruskin would not abandon that tradition.

But this did not mean that he had joined the camp of philosophical Idealist historians descended from the Enlightenment and from Hegel. Ruskin was as familiar with this alternative attitude to history as he was with the German school, for he had written equally long reviews of Lord Lindsay's *History of Christian Art* (1847), the main work of Hegelian art history published in Britain, and of Eastlake's *History of Oil Painting* (1847), a major work of the archive-research school. What Ruskin disliked about the Hegelian historians was the primacy they attached to ideas and principles. He saw nothing in them but "metaphysical analogies," feeling that they missed the challenge offered by the individual work and that they failed to take into account the "necessities of practice," the materials and other limiting factors that art had to grapple with. Moreover, he believed that thinkers whose main concern was synthesis—uncovering the grand design—were far too wishy-washy when it came to judging specific artworks. Books

about art have to be practical, he said, and he criticized Lord Lind-say's book for being "too finely woven, to the hard handling of the materialist."

Ruskin had his own idiosyncratic view of the purpose for writing art history. For him, there were two categories: art history as criticism, and art history as a salvage operation. In both cases, the aim was to serve the present. Even when he wrote trying to save ancient artworks, the present was his concern, because the present had showed itself incapable, he said, either of producing great architecture or of preserving the great architecture of the past. Thus, the art historian's task was to safeguard works threatened by neglect or deliberate destruction, and this job could not be done by delving in archives.

Moreover, Ruskin also practiced what E. K. Helsinger calls "history as criticism," by using art history as a critical vehicle so that what had been saved could have a practical influence on present styles. Ruskin's criteria for art were dictated largely by a practical concern for the needs of the present. His position was roughly this: he wanted to transplant the best architectural style he knew, the polychrome Gothic of northern Italy, into nineteenth-century England.

The Stones of Venice begins with the warning that England could suffer the same fate as Tyre and Venice, and the book ends with an expression of hope that it may not yet be too late for London to become a second Venice or Florence, aesthetically though not politically: "as Venice without her despotism, and as Florence with-out her dispeace." Ruskin devoted the entire first volume of *Stones* to the technical details of Venetian architecture, and wanted it to be read as a sort of crash course in the whole field of architecture: "I shall endeavour so to lead the reader forward from the foun-dation upwards, as that he may find out for himself the best way of doing everything, and having so discovered it, never forget it. I shall give him stones, and bricks, and straw, chisels and trowels, and the ground, and then ask him to build; only helping him, as I can, if I find him puzzled."

All three volumes of *Stones* are laid out like a rich sampler of

architectural styles, and yet it is always apparent which styles Ruskin judges to be aesthetically preferable: "I had always, however, a clear conviction that there *was* a law in this matter: that good architecture might be indisputably discerned and divided from the bad."

Ruskin deployed his descriptions of the main criteria of good architecture with great tactical skill to combat the Renaissance tradition which was still so powerful in England. He was fighting to persuade the English to adapt the Italian Gothic to British needs, to incorporate its eclectic and polychrome style into British architecture. Eventually he succeeded: *The Stones of Venice*, with its predecessor *The Seven Lamps of Architecture*, played a crucial role in establishing a type of historicist design known as High Victorian Italian Gothic. Ruskin was not the sole champion of the new style of colorful brick architecture, and even socioeconomic forces seemed to favor it when, for example, the tax on bricks was repealed in 1850. Nevertheless, his personal influence on the trends of architecture greatly exceeded that normally stemming from art historians and critics.

The same can be said of Ruskin's influence in reviving interest in Gothic and Romanesque architecture in Italy. *The Stones of Venice* represented a sort of "Guide to the Enjoyment of Italy's Art Works," to quote the subtitle of Jakob Burckhardt's *Cicerone*, written in this same period (1855). Venice had long been a favorite "watering-place" of the British aristocracy and of British bohemians, but only after the mid-nineteenth century did it also become a focus of organized tourism, a star attraction for the middle-class British traveler; and this was due to the influence of *The Stones of Venice*. The effect on travel, however, was not immediate. Like the spread of Venetian Gothic style in British buildings, it came on slowly and peaked at the end of the century. By that time, so many British tourists were roaming around Venice with specially edited, travel-guide editions of *Stones* tucked under their arms that they had become a frequent subject of caricature. While British foreign policy had failed to bring Italy into Britain's sphere of influence, Ruskin had engineered the total occupation of Italy, with

the aid of two detested allies, the railroad and Cook's Travel Agency.

Ruskin's express aim was to rescue the great art treasures of Italy—especially those born out of good government and unspoiled faith—from the superstitious and indolent Italians and the destructive Austrians, and to make them available for the aesthetic profit of his Protestant countrymen. He did a great deal to preserve Italian buildings and paintings, not only by his writings and drawings but also by his practical activities in societies like the Arundel Society, which made exact reproductions of Italian frescoes, and the Architectural Photographic Association, which promoted photographic records of Italian architecture.

On the other hand, Ruskin showed no scruples about arranging the sale of Italian art to the British National Gallery. His writings, more than those of any other author, reinforced the feeling among his countrymen that Britain was entitled—indeed, duty-bound—to inherit the cultural artifacts of other nations. Admittedly, Ruskin always pointed out that no other nation had such a desperate need to turn to outsiders for quality artwork as did nineteenth-century Britain. But he did not realize the impact British hands had on the stones of Venice until alabaster panels stripped from St. Mark's by vandal-restorers began to arrive in England, where they soon adorned staircases all over London. In later years, he was able to lecture on his favorite theme, incrusted marble work, using original pieces as visual aids.

Certainly, with his two books on architecture, Ruskin was not able to influence manufacturing conditions in his capitalist country or to shift the social policies of his time. And yet his contemporaries did listen to what he said. His chapter on "The Nature of Gothic," in which he praised medieval work methods and denounced modern ones, was printed in a special edition that circulated widely among working-class men. William Morris called it "one of the very few necessary and inevitable utterances of the century." But Ruskin knew that his job was far from done and that he had opened up an important theme which he would return to later. While he was still in Venice, close to finishing *Stones*, he wrote to his father

the following prediction: "I believe I shall some day—if I live—write a great essay on Man's Work, which will be the work of my life. I don't see anything beyond it."

Thus, *The Stones of Venice* planted the seeds of later books, as would each of Ruskin's books from now on. But in addition to new themes, *Stones* also brought him something new in the way of method.

Earlier we mentioned how Ruskin used art history as a vehicle both for salvage work and for criticism; but we did not point out that this two-tiered approach could lead to conflict on the practical level. If you view art history as a salvage operation, you are compelled to catalogue as many works as possible. But if your aim is criticism, you need not analyze all the Byzantine and Gothic buildings in Venice down to the last curve of their moldings. Selected examples are enough to prove your case. Clearly, Ruskin came under both inward and outward stress when he tried to reconcile the two conflicting modes of presentation.

He wanted desperately to preserve as many works as he could, at least on paper, and yet he knew that he could discuss only a limited number in the main text, and moreover that he could fill whole chapters with solid argument, grand descriptions, and fiery expositions, without reference to more than a few objective examples. Thus, when he drew up the final appendix, he unloaded another 219 moldings on the already overburdened reader.

Also, his father in London, who was administering his literary affairs, continually nagged him for sending nothing home from Venice but "small minute grave Business details" when instead he ought to have been writing "Eloquent passages—when you, in fact, retire from Business & get to sea or up in the clouds." In other words, John James wanted more of what had made *Modern Painters* so famous, for, as he put it, "*Modern Painters* is the *selling* book." At first, John tried to placate his father with the same argument he had used in the Preface to *Stones*: "You know I promised them no Romance—I promised them Stones. Not even bread. . . . To give Turneresque descriptions of the thing would not have needed ten days' study—or residence."

But Ruskin was a man who wanted to achieve practical effects, who wanted to hold Venice up as an example to his contemporaries, and he could not afford to alienate his audience. Thus, he had nothing to say in his own defense when his father wrote reproachfully: "You can only be an author of the *present* day by studying public taste." So he chose a compromise. He crammed Volume One of *Stones* with factual details and then decorated the two concluding volumes with "eloquent passages," high-flown descriptions, and weighty analyses of the characteristics of the different period styles. In addition to this organizational scheme, the pressure to use art history as an effective vehicle of criticism produced a second, more important methodological technique: a new way of highlighting details. Ruskin never allowed his father or any other critic to dissuade him from his conviction that no detail is too insignificant to supply important information about high and universal matters: "Greatness of mind is not shown by admitting small things, but by making small things great under its influence. He who can take no interest in what is small, will take false interest in what is great."

In Venice, Ruskin discovered ornamental details which were as apt to go unnoticed as moldings, but which were more appealing and more expressive. Here is one example:

> In the choir of the same church, St. Giov. and Paolo, is another tomb, that of the Doge Andrea Vendramin. . . . It is unanimously declared the *chef d'œuvre* of Renaissance sepulchral work, and pronounced by Cicognara, (also quoted by Selvatico), *"Il vertice a cui l'arti Veneziane si spinsero col ministero del scalpello"* ("The very culminating point to which the Venetian arts attained by ministry of the chisel").
>
> To this culminating point, therefore, covered with dust and cobwebs, I attained, as I did to every tomb of importance in Venice, by the ministry of such ancient ladders as were to be found in the sacristan's keeping. I was struck at first by the excessive awkwardness and want of feeling in the fall of the hand towards the spectator, for it is thrown off the middle

of the body in order to show its fine cutting. . . . The Vendramin hand is . . . laboriously cut, but its blunt and clumsy contour at once makes us feel that all the care has been thrown away, and well it may be, for it has been entirely bestowed in cutting gouty wrinkles about the joints. Such as the hand is, I looked for its fellow. At first I thought it had been broken off, but on clearing away the dust, I saw the wretched effigy had only *one* hand, and was a mere block on the inner side. The face, heavy and disagreeable in its features, is made monstrous by its semi-sculpture. One side of the forehead is wrinkled elaborately, the other left smooth; one side only of the doge's cap is chased; one cheek only is finished, and the other blocked out and distorted besides; finally, the ermine robe, which is elaborately imitated to its utmost lock of hair and of ground hair on the one side, is blocked out only on the other:—it having been supposed throughout the work that the effigy was only to be seen from below, and from one side.

It was indeed to be so seen by nearly every one; and I do not blame—I should, on the contrary, have praised—the sculptor for regulating his treatment of it by its position; if that treatment had not involved, first, dishonesty, in giving only half a face, a monstrous mask, when we demanded true portraiture of the dead; and, secondly, such utter coldness of feeling, as could only consist with an extreme of intellectual and moral degradation: Who, with a heart in his breast, could have stayed his hand as he drew the dim lines of the old man's countenance—unmajestic once, indeed, but at least sanctified by the solemnities of death—could have stayed his hand, as he reached the bend of the grey forehead, and measured out the last veins of it at so much the zecchin?

In a passage that adds nothing to his earlier argument, Ruskin is, once again, discussing the need to adapt ornament to the position of the viewer. He rejects the adaptation made by the sculptor, because he always rejected shortcuts taken simply to save trouble.

He did not see the spectator as someone who, due to the limitations of circumstances, had only a partial insight into a work of art, but rather as what Novalis would call "an extension of the author," as the one who actually completed a work in which there actually was something left to be completed. This was impossible in the present case, where the sculpture is like a Janus head divided into two parts: one so fully formed that it requires no viewer participation, and the other just a rough-hewn block which calls, not for a viewer, but for a sculptor, and thus once again excludes participation.

But Ruskin has told us this sort of thing before. The new element in this passage is the quality of the detail he selects to illustrate his point. Collecting and analyzing every molding in sight is a fundamentally different thing from happening to notice a detail that one had not looked for. In the first case, the detail is significant only in terms of the system of which it forms a part; in the second, the detail is discovered at random and suddenly reveals far-reaching meanings. Vendramin's missing hand resembles the aspen tree which Ruskin found in the woods at Fontainebleau. Like the tree, it has the character of epiphany, it is a "moment of illumination, and visual transvaluation." Thus, the language which describes it also takes on a different quality. To use the phrases of John James Ruskin, the language moves from "minute grave Business details" to "eloquent passages." Ruskin's moldings tell us nothing in themselves and become expressive only if they are incorporated into a dense mental edifice which requires some effort to find your way around.

By contrast, the missing hand is a heavy indictment of Renaissance art which everyone can understand and which must have seemed especially damning to the Victorians, who took a dim view of any breach of the work ethic. The missing hand underlines the same point as the detailed analysis of moldings but frames it all in a single question with a deep moral resonance. Only a man with Ruskin's brilliant eye for detail could have made this discovery and recognized its significance.

Nevertheless, perhaps dangerous temptations lay in the method

of seeking out the "eloquent detail." Ruskin's only two works of original research were *Modern Painters*, which he did not finally complete until 1860, and *The Stones of Venice*. His later works were original in thought and composition and made generous use of original, evocative details—newspaper items, scraps of overheard conversation, observations of daily life, bits and pieces of art. The result was a new directness and incisiveness which should not be underrated. But his future writings—with the sole exception of his third major work, *Fors Clavigera*, the first installments of which were published in 1871—were no longer works of research, inexhaustible reservoirs of data like the earlier masterpieces. They had lost their typically Victorian quality of presumption, their daring attempt actually to *reproduce* the infinity of the finite: not merely to capture it in a single multifaceted gem, but to copy the whole thing "stone by stone, to eat it all up into my mind, touch by touch." Thus, in describing Ruskin's view of history, we would have to add to the ideas of history as salvage and history as criticism a third idea, of history as realism.

However, to quote Ruskin, "I have kept you too long from your gondola." Too many stones and moldings have encumbered the route of this chapter. Let us conclude with a second example of Ruskin's brilliant random discoveries, a second example of the missing-hand motif which highlights even more clearly than the first the charms and the hazards of the evocative detail. The side of the Doge's Palace facing the Piazzetta is lined with ground-floor arches whose capitals Ruskin found to be feeble copies of their counterparts on the seaward side. In these copied capitals, the fifteenth century—the start of the Renaissance—was imitating the work of the fourteenth. Examining them more closely, Ruskin noted the following difference between the model and the imitation of one capital:

> The point I have here to notice is in the copy of the 9th capital,
> which was decorated (being, like the rest, octagonal) with
> figures of the eight Virtues. . . . The virtues of the fourteenth
> century are somewhat hard-featured; with vivid and living

expression, and plain everyday clothes of the time. . . . Hope is praying, while above her hand is seen emerging from sunbeams—the hand of God (according to that of Revelations, "The Lord God giveth them light"); and the inscription above is, "Spes optima in Deo."

This design, then, is, rudely and with imperfect chiselling, imitated by the fifteenth century workmen; the Virtues have lost their hard features and living expression; they have now all got Roman noses, and have had their hair curled. Their actions and emblems are, however, preserved until we come to Hope; she is still praying, but she is praying to the sun only; *The hand of God is gone.*

Four
The Luther of the Arts
1853–1860

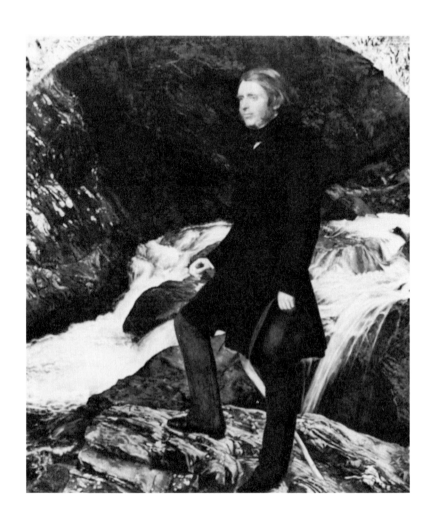

John Everett Millais, John Ruskin, Age 34, *1853–54.*
Oil on canvas. Privately owned

One author has called it *Déjeuner sur l'herbe* in reverse. It is the full-figure portrait of John Ruskin painted by John Everett Millais in 1853–54, ten years before Manet painted his famous version of a country outing. The Ruskin we see in Millais's portrait—the third portrait that we have looked at—is a man who is now thirty-four years old, a man not relaxed and at ease but "dressed up" for Nature, a priestly figure rather than a tourist, a scholar, or an artist. His mobile appearance in the earlier portraits has given way to a stiff pose. The artist has not even tried to pretend that he has captured Ruskin in the act of walking: the only direction these legs could walk is blocked by the foaming mountain stream. In the earlier portraits, the figure was matched to the background, and the props and symbols harmonized with the painting's underlying formula. Here, no attempt is made to maintain any such pardonable fiction; the man and his surroundings have parted company. This is so, despite the fact that Millais, we know, painted the scene directly from nature, unlike Ruskin's earlier portraitists, Northcote and Richmond, who were free to assemble their compositions in the studio. Notwithstanding its realism—or because of it—nothing here seems compatible. The man casts no shadow, nor does he stand in the shadow of anything; and none of the spray from the turbulent water is touching him. Nature and culture are estranged; no trace of the noisy and primeval can break through to the quintessential Victorian. He is reacting to something inside himself. It is as if his eyes are looking inward; as if his ear, behind the thick hair, is listening to an inner sound; as if his tightly pressed

lips and curled fingers are feeling only each other. The man is absorbed in himself, while nature is left to follow its own course.

The portrait is missing not only physical but symbolic correspondences. There is no far-off space, no infinity of landscape, to answer the wayfarer's musings, such as we would find in the works of Caspar David Friedrich; and symbolic emblems would look out of place. The painter is concerned with hard, solid facts, with the circumstantial details of the external world. His vision is uniform at every point: his is the unswerving, sharply defined eye of a camera, set on a long exposure. "Nature in the looking glass" is the term Ruskin used for this photographic recording technique.

Some discussion is required to explain why the "prophet of nature," of all people, should have been the subject of a portrait in which the parting of figure from landscape, culture from nature, is so prominent. This is one of those cases when it may really help us to know the details of how a work was painted.

The biographical details are straightforward enough. By the summer of 1853, Ruskin had virtually completed the second and third volumes of *The Stones of Venice*, and needing rest, he traveled with Effie to the tiny hamlet of Glenfinlas in the Scottish Highlands, in the company of their new friend, the artist John Everett Millais. It is hard to see what drew the threesome to this remote, uncomfortable Highland valley, or why they should have endured several months here in cramped, primitive lodgings, in the perpetual cold and damp, rained on daily or continuously for days on end, always overshadowed by the low-hanging clouds. Admittedly, John had always been attracted to mountains and mountain streams and wanted to study them more closely for his continuation of *Modern Painters*. As for Millais and Effie, the crowded conditions dramatically inflamed the passion they had begun to feel for each other since they had met in London. After this holiday came one last dismal winter of married life back at Herne Hill, riddled with Victorian machinations and malices. Then, on April 26, 1854, Effie left her husband. On July 15, their marriage was annulled on the grounds of John's "incurable impotence." On July 3, 1855, Effie married John Everett Millais.

It was a good thing that the Ruskins' marriage was dissolved. It was a bad thing that news of the affair spread all across London and gave Ruskin's enemies ammunition to sap his life and effectiveness. Sterile the marriage may have been, but the breakup was positively deadly. The most influential figures in the London art world had always been hostile toward Ruskin, and that hostility would bear fruit in a coming moment of crisis.

But dramatic as these developments were, they do not cast any light on the portrait that the one John painted of the other. In this case, the bare facts of time and place tell us more.

While out on a walk with Ruskin during their stay in Scotland, Millais decided to paint his companion standing in front of a certain mountain stream. He may have been encouraged in the idea by Ruskin's friend Henry Acland, who visited them later that month. Millais ordered a special canvas approximately four feet by five. A small dugout shelter was built at the chosen spot and the painter set to work, keeping at it for several hours a day though hampered by rain, cold, wind, and midges, suffering both physical and emotional discomfort—"miserably damped in body and spirit," as he wrote to his friend, the artist William Holman Hunt.

Ruskin, on the other hand, was in ecstasy. It was a new experience for him to observe and even participate in the birth of a major painting. Turner had never allowed him the privilege of watching him work. We know that when Ruskin sat for portraits later in life, he showered his portraitists with helpful suggestions, and presumably he did the same with Millais. He also staged a friendly contest with the artist, by sketching the same large granite boulder that Millais depicted at the left of the portrait. The resultant drawing was one of Ruskin's finest, fanatically detailed yet wiry and energetic rather than cold and dead: a first-rate example of what Ruskin meant by "vital beauty." Ruskin intended it as a concrete example to add to his beautiful-line chart from *The Stones of Venice*. He wanted to use lines which expressed "action or force" to tell the story of the rock, of how it formed out of a liquid mass and then underwent weathering and decomposition. A short time later, he would write in Volume Four of *Modern Painters*: "There

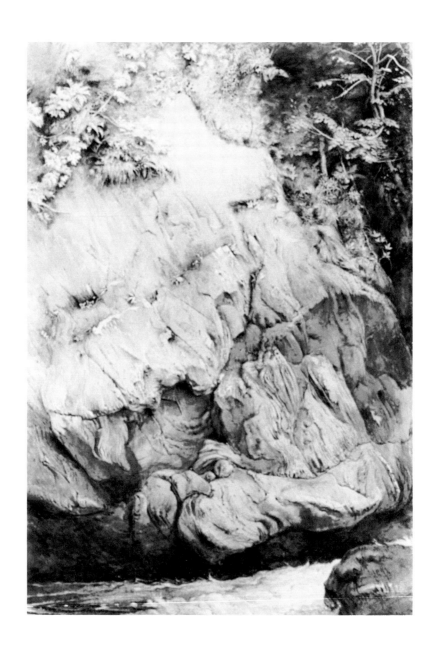

John Ruskin, Gneiss Rock, *1853. Pen-and-ink and wash.*
The Ashmolean Museum, Oxford

are no natural objects out of which more can be thus learned than out of stones." In the end, he produced a drawing of the boulder which was substantially superior to Millais's version in the portrait. Still, it was only a detail sketch, not a whole picture. "I can no more write a story than compose a picture," Ruskin complained.

John Everett Millais was one of the seven founding members of the Pre-Raphaelite Brotherhood which had been formed in 1848 with the aim of creating an anti-academic, that is, anti-Renaissance, school of painting in England. They modeled their art on the vivid color and sharply defined detail of Italian painting before Raphael, believing that early Italian masters had worked directly from nature and avoided adorning it with artificial graces. Their chief defender was John Ruskin, who wrote this encomium in 1851:

> Pre-Raphaelitism has but one principle, that of absolute, un-compromising truth in all that it does, obtained by working everything, down to the most minute detail, from nature, and from nature only. Every Pre-Raphaelite landscape back-ground is painted to the last touch, in the open air, from the thing itself. Every Pre-Raphaelite figure, however studied in expression, is a true portrait of some living person. Every minute accessory is painted in the same manner.

In Ruskin's own portrait, the landscape was painted first, recorded meticulously "inch by inch" at the site itself. The subject of the portrait was drawn in outline and then left to be filled in later. This represented a reversal of the normal sequence in portraiture, and also a reranking of the background in relation to the figure. The earlier portraitists, Northcote and Richmond, brought their clients into the studio to copy facial features, posture, and clothing. Later, they added whatever background they chose, perhaps referring to sketches but not bothering to copy original landscapes. When Ruskin was painted as a child, Northcote allowed him to choose what he wanted in the background, and in his autobiography the aged Ruskin claims that he asked for blue moun-

tains, "a fact sufficiently curious, and not without promise, in a child of that age."

But in 1853 the Pre-Raphaelites considered the background as important as the figure and thought that it deserved to be produced under equally realistic conditions. Like the central subject, the background had to be painted from life. If that overused word "photographic" can justly be applied to Pre-Raphaelite painting, it is with regard to the work technique. All realistic art obeys the basic principle of photography: that objects help bring their own images into being. This principle was adhered to so strictly that a painting had to be discarded, or remain uncompleted, if the object it depicted became unavailable. Even painstaking preliminary studies could not make up for the absence of a primary object. Thus, Millais had to return to the damp wilderness of Glenfinlas in May 1854 in order to finish the landscape, which was still in a fragmentary state despite the months of work he had put into it in the summer and autumn of the previous year. Reaching the site, he was pleased to see that the new plants matched the shape of the previous year's vegetation almost perfectly: "Returning to the place is so wonderfully strange that all the rest of what has happened appears a dream. Scarcely a leaf is out of place for the new ones have taken nearly the same form and position."

As for the portrait of Ruskin, Millais had worked on it over the winter in his London studio. Ruskin refers to the fact that it was a studio portrait in a letter confirming receipt of the finished work: "My Father and mother say the likeness is perfect," he informs the man for whom his wife has deserted him, "but that I look bored—pale—and a little too yellow. Certainly after standing looking at that row of chimnies in Gower Street [where Millais's studio was located] for three hours—on one leg—it was no wonder I looked rather uninterested in the world in general."

And so we see that the urbane individual in the portrait, with his intense inner absorption, is actually a reflection of London's Gower Street and the studio art world—while the crystalline slate rock, mosses and bracken, and the turbulent water belong to the Scottish Highlands. The truth of the portrait derives from the

technique that gave it birth, and behind this truth lies another and greater truth: much of nineteenth-century landscape art was produced, psychologically if not physically, in a state of alienation from nature. Even objects painted out-of-doors could reflect this alienation, and raised questions about human production in general, in an age when nature was dominated by technology. This was the problem that drew Ruskin's attention in the 1850s.

To Ruskin, the name Gower Street was synonymous with the barrenness of modern architecture. The name crops up again in Volume Three of *Modern Painters*, which Ruskin originally planned to give his father as a Christmas present in 1853, but which was not actually published until two years later, along with Volume Four. The passage where he mentions Gower Street is an indirect criticism of Millais's portrait in particular and of modern painting in general. Comparing the landscape art of the ancient world, the Middle Ages, and recent times, Ruskin claims that the first quality to strike the eye in modern paintings is "cloudiness." "And we find that whereas all the pleasure of the mediæval was in *stability, definiteness*, and *luminousness*, we are expected to rejoice in darkness, and triumph in mutability; to lay the foundation of happiness in things which momentarily change or fade; and to expect the utmost satisfaction and instruction from what it is impossible to arrest, and difficult to comprehend."

Of course, Ruskin means more by "cloudiness" than the predilection for depicting clouds that we see in landscape painters like Turner and Constable. Really he is talking about the overall appearance of landscape. In earlier periods of art, all objects were portrayed with uniform distinctness, but now, Ruskin says, you may find a spot of red paint standing for a face. Everything else must give way to the atmosphere, everything is covered by a hazy film. "Our ingenuity is all 'concerning smoke,' " Ruskin says sternly.

Ruskin also detects a second characteristic in the new painting which he calls "love of liberty." The modern painter, he says, shies away from depicting anything that is neat and well ordered: "Never paint anything but free-growing trees, and rivers gliding 'at their

own sweet will'; eschew formality down to the smallest detail; break and displace the brickwork which the mediæval would have carefully cemented; leave unpruned the thickets he would have delicately trimmed; and, carrying the love of liberty even to license, and the love of wildness even to ruin, take pleasure at last in every aspect of age and desolation which emancipates the objects of nature from the government of men." Ruskin considers the special regard that modern painters have for solitary mountains as a prime token of their preference for what is free and uncultivated by man.

The third and last characteristic of modern art in Ruskin's catalogue is its "strong tendency to deny the sacred element of colour."

> Whereas a mediæval paints his sky bright blue and his foreground bright green, gilds the towers of his castles, and clothes his figures with purple and white, we paint our sky grey, our foreground black, and our foliage brown, and think that enough is sacrificed to the sun in admitting the dangerous brightness of a scarlet cloak or a blue jacket.

This trait also informs us about things other than art:

> At first, it is evident that the title "Dark Ages," given to the mediæval centuries, is, respecting art, wholly inapplicable. They were, on the contrary, the bright ages; ours are the dark ones. I do not mean metaphysically, but literally. They were the ages of gold; ours are the ages of umber.
>
> This is partly mere mistake in us; we build brown brick walls, and wear brown coats, because we have been blunderingly taught to do so, and go on doing so mechanically. There is, however, also some cause for the change in our own tempers. On the whole, these are much *sadder* ages than the early ones; not sadder in a noble and deep way, but in a dim wearied way,—the way of ennui, and jaded intellect, and uncomfortableness of soul and body.

These passages show that the attitudes and the writing style which Ruskin had developed for *The Stones of Venice* carried over to the latter volumes of *Modern Painters*. Volume One of *Modern Painters* shifts back and forth between observations of nature and of art; but from the third volume on, the emphasis is not on observation but on criticism of both art and society. Yet the early and the late volumes of the work have a single overriding quality in common, the most basic of all Ruskin's qualities: specificity, concreteness.

There was much to criticize in the England of the 1850s—just how much, Ruskin would learn as time went by—and a series of prominent social critics brought their guns to bear on it: Carlyle, Dickens, and Kingsley, among others. And yet Ruskin alone was capable of fastening on such details as the fact that people's clothing had suddenly become darker.

Alone in Britain, that is, but not in Europe, for we find similar observations being made in Germany and France: in Germany by a socially concerned professor of aesthetics and Hegel disciple with the biting tongue of a Carlyle; and in France by a lyric poet and dandy who had closely studied the relations between fashion and society. Friedrich Theodor Vischer: "But worst of all is what has happened to color. Rich colors have been left to trick riders and tightrope walkers while only drab-and-dung colors are in style. Children chase after anyone who doesn't follow this fashion. The appreciation of color is dead." Charles Baudelaire: "The tailcoat, it seems, is the essential item of clothing for our afflicted age, which wears the symbol of eternal mourning on its thin black shoulders. And note that the black tailcoat and the frock coat have not only their political beauty, in that they are the expression of a universal equality, but also their poetic beauty, as an expression of the public attitude. A vast army of funeral bearers, political funeral bearers, funeral bearers in love, middle-class funeral bearers. Each one of us is carrying something to the grave."

If it is true that art and life are inseparably linked, then painting cannot be blamed for its subdued coloring at a time when somber colors are preferred in clothing, interior decoration, and architec-

ture. We can ask of art only what we ourselves are prepared to give: "It is not so much in *buying* pictures, as in *being* pictures, that you can encourage a noble school," Ruskin proclaims in the autumn of 1853, at the end of a public lecture in Edinburgh. By now, he is convinced that the important thing in the creation of art is people's daily life in the present moment. He is not satisfied with art as mere beautification, a false or edifying appearance, a chimera which diverts attention from an ugly reality. The embodiment of all that is ugly is Gower Street: Gower Street as a symbol of monotonous brick buildings, of the neglect of nearby "personal beauty," of fashionable ugliness in everyday life. It is the reality of Gower Street which makes art and nature necessary as an antidote and at the same time reduces them to a derivative function.

> Accordingly, though still forced, by rule and fashion, to the producing and wearing [of] all that is ugly, men steal out, half-ashamed of themselves for doing so, to the fields and mountains; and, finding among these the colour, and liberty, and variety, and power, which are for ever grateful to them, delight in these to an extent never before known; rejoice in all the wildest shattering of the mountain side, as an opposition to Gower Street, gaze in a rapt manner at sunsets and sunrises, to see there the blue, and gold, and purple, which glow for them no longer on knight's armour or temple porch; and gather with care out of the fields, into their blotted herbaria, the flowers which the five orders of architecture have banished from their doors and casements.

Although for several years Ruskin repeatedly extolled Pre-Raphaelite painting as an exception to the stylistic constraints of the nineteenth century, it is not hard to see that Millais's portrait, to which Ruskin himself made so large a contribution, shows some of the very characteristics that Ruskin deplores. For one thing, the portrait is dark-colored and sunless, confining itself to those gray and brown tones which, in Ruskin's words, please the modern man "by expressing that melancholy peculiar to his more reflective

or sentimental character." In the Millais portrait, Ruskin's blue jacket already constitutes an act of daring, a "dangerous brightness." And yet Ruskin himself, not Millais, was responsible for the choice of color. Having his portrait painted in a blue frock coat and a blue tie that matched the color of his eyes was his modest way of protesting against a clothing style which reveled in black and umber.

The dark tone of Millais's picture is doubly surprising because the Pre-Raphaelites *did* usually cultivate vivid, pure colors, in sharp contrast to the prevailing muted hues; and also because their arch-champion raised no objection to dark colors when it came to his own portrait: "I think the picture will be peculiarly beautiful because there is no *sun* in it," Ruskin wrote in a letter on August 4, 1853. "All dark rocks with plants hanging down over them and the foaming water below—and Everett paints so brightly that he cannot possibly have too quiet a subject."

On the other hand, Millais admittedly laid on his colors in more distinct blocks than many of his painter colleagues and thus avoided shading the colors into each other. In spite of the dark look of the portrait, there is no ground tone to merge everything together—no sign of what Ruskin called "cloudiness."

Yet Millais's portrait is a prime example of what Ruskin called "love of liberty" in modern painting, the preference for nature in its wild state. For, besides the rock and the mountain stream, it also shows us the underlying cause of the cult of the wild: Gower Street. Gower Street is present in the melancholy, studied, reflective figure of Ruskin himself, this wholly alien being who cannot interact with nature. The human body here is a foreign body. "The figure's standing in the way," as Ruskin says—and especially so in the case of his own body. For, in a remarkable piece of self-analysis in Volume Three of *Modern Painters*, Ruskin concludes that even his own love of nature represents not an overcoming of the primal separation from Mother Nature but a compensation for it: "Our love of nature had been partly forced upon us by mistakes in our social economy. . . . I was born in London, and accustomed, for two or three years, to no other prospect than that of the brick

walls over the way; had no brothers nor sisters, nor companions; and though I could always make myself happy in a quiet way, the beauty of the mountains had an additional charm of change and adventure which a country-bred child would not have felt."

Earlier we examined the myth that Ruskin suffered sensory deprivation in childhood and spent his life attempting to compensate. The myth may not be literally true, yet undeniably he felt a primary conflict between life in the city and life in the countryside.

In any case, Millais's painting makes no attempt to join together what civilization has put asunder. Supposing his work to be sincere—and Ruskin had praised sincerity as the chief quality of the early Pre-Raphaelites—then it cannot help but resemble its time: divided and unpredictable.

The elements of progress and decline being thus strangely mingled in the modern mind, we might beforehand anticipate that one of the notable characters of our art would be its inconsistency; that efforts would be made in every direction, and arrested by every conceivable cause and manner of failure; that in all we did, it would become next to impossible to distinguish accurately the grounds for praise or for regret; that all previous canons of practice and methods of thought would be gradually overthrown, and criticism continually defied by successes which no one had expected, and sentiments which no one could define.

Once again, we find similar comments emerging from Ruskin's intellectual kinsman in Germany, F. T. Vischer, who writes—not about painting, but about the inconsistency of his age in general: "Thus the individual has a world within but does not act upon the outside world. Inwardly consumed, he becomes divided, then jaded. Fully without nature, he closes himself off in the very act of communicating. The wealth of appearance is odious to good and evil alike. Sociability turns flat and fake, sensuality becomes lewdness, joy a source of remorse. Premeditation cancels all pleasure. The age of revolution has stripped from our culture even

those [aforementioned] blights, and imposed utter barrenness, pov-
erty, drabness, and intermittent scrounging off the forms of the
past, while at the same time a horde of new inventions in one field
after another, smothers individual vitality."

In a footnote Vischer adds: "Inner conflict is the penultimate,
jadedness the ultimate form." If this is true, then Ruskin never got
beyond the penultimate stage; but he experienced that at its most
extreme. After *The Stones of Venice*, his disillusionment and inse-
curity about the things he loved best—painting, landscape art,
nature study, art criticism—became so intense that it seems a won-
der that he ever completed the last three volumes of *Modern Painters*.
He praises the Pre-Raphaelites, yet writes in a pamphlet about
them: "The painter has no profession, no purpose. He is an idler
on the earth, chasing the shadows of his own fancies." And con-
cerning the social necessity of art he says:

> The fact is, we don't care for pictures: in very deed we don't.
> The Academy exhibition is a thing to talk of and to amuse
> vacant hours; those who are rich amongst us buy a painting
> or two, for mixed reasons, sometimes to fill the corner of a
> passage—sometimes to help the drawing-room talk before
> dinner—sometimes because the painter is fashionable—oc-
> casionally because he is poor—not unfrequently that we may
> have a collection of specimens of painting, as we have spec-
> imens of minerals or butterflies. . . . But as for real love of
> the picture, and joy of it when we have got it, I do not believe
> it is felt by one in a thousand.

In the end he wonders whether, in these times, "Art is a Crime
or only an Absurdity."

Considering the doubts and self-criticisms expressed in these
and many similar passages, we might expect to find the Ruskin of
the 1850s turning into a withdrawn, cautious, discouraged man.
Perhaps this is indeed what he became by the end of the decade,
but in 1853–54 he certainly was not. His appearance in his portrait
tells us so. The very discord between the figure and the background

suggests that the contest between them has not yet been resolved. The man has a positively dogmatic bearing, and his inward absorption testifies less to despondency than to concentration.

Moreover, Ruskin was uniformly positive in everything he had to say about Millais's portrait. He was the first and remained the most significant promoter of the Pre-Raphaelite cause throughout the 1850s. Of the Brotherhood in general he said that these men may "lay in our England the foundations of a school of art nobler than the world has seen for three hundred years." As for Millais and his portrait, Ruskin said that it was "the finest thing I ever saw him do"—a verdict, incidentally, which was shared by Charles Eastlake, director of the National Gallery. Eastlake, who as one of Effie's ardent supporters was actively hostile to Ruskin, called Millais's work "one of the remarkable pictures of the world." And even after his falling out with Millais, Ruskin remained loyal to the Pre-Raphaelites. He took Dante Gabriel Rossetti as his next protegé, and wrote to him: "Amongst all the painters I know, you on the whole have the greatest genius."

None of this suggests that Ruskin was losing hope for contemporary art, or giving way to resignation and ennui. In fact, his output actually increased after 1853. He wrote the last three volumes of *Modern Painters*, which were published in 1856 and 1860. He studied and classified a vast body of never-viewed works— some twenty thousand paintings, drawings, and watercolors— which Turner had bequeathed to the nation at his death, and went on to produce three books about Turner based on these studies. He published annual critiques of art exhibitions between 1856 and 1859. He composed two courses of drawing; and he compiled several books out of his lectures, pamphlets, and small articles on contemporary cultural policies and aesthetic education. The latter included such well-known and important works as *Lectures on Architecture and Painting* (1854), *The Political Economy of Art* (1857, reissued in 1880 as *A Joy for Ever*), and *The Two Paths* (1859), a book about the principles of design.

His literary output was immense; but even more remarkable was the way in which he kept expanding the range of his influence.

Until 1853, he was a writer on art known to only a small public, but in the following years he successfully mastered the roles of teacher, traveling lecturer, and pragmatic reformer. These functions, and the way he interpreted them, are so typically mid-Victorian that Ruskin seems never more a man of his times than in the 1850s. These were his best years, despite the painful breakup of his marriage, despite his fits of despair and his unsettling conversion experiences. He had not yet frozen into a wise man, he had not yet acquired the freedom of the known eccentric, and he had not yet been forced to attack publicly things that were the wellsprings of his own identity. He still had to fight for a public and a position, and he did so by making the most of every opportunity—usually with supreme grace and charm and occasionally with unbearable arrogance—while maintaining his independence as always. He was still living for the future.

2

The Ruskin of the years 1853 to 1860 was an educator—more precisely, an art educator. He began to teach drawing to laborers at the Working Men's College in London, but his real classroom was the lecture hall, for now everyone—industrialists, middle-class art patrons, drawing teachers, working people, designers—wanted to hear him speak. It was in the 1850s that attending lectures first became a favorite British pastime. Carlyle's wife, Jane Welsh Carlyle, alludes in a letter of June 1851 to the fact that it had now become fashionable to think of lectures as a source of entertainment. Noted writers, critics, philosophers, and theologians started going out on annual lecture tours, and the circuit was so well organized that some could even earn their living from lecturing alone.

Ruskin's parents were troubled by the prospect that their son might become a traveling salesman hawking art education, as Ruskin senior did wine, and John was obliged to promise them that "I do not mean at *any* time to take up the trade of a lecturer. All

my real efforts will be made in writing." But he was not completely faithful to his promise. He delivered his first series of lectures in Edinburgh in the fall of 1853, and so dramatic was their success— a thousand people turned up to hear him—that his calendar was soon filled with engagements. In the 1850s, he covered as much ground as his father. In this way he found out what the British industrial cities were really like, which he would probably not have learned otherwise. Now he took a more determined stand when replying to the reproaches of his anxious parents: "You don't like lecturing as a principle; nor do I," he assured his father in 1859, only to continue: "but it does much good. . . . If I wanted to produce immediate effect in any direction, I am quite sure a month or two's course of lectures would do more good than many books."

In the 1850s, Ruskin began to lecture on applied art, about applying aesthetics to general social problems. He refused to limit himself to an assigned topic. For example, when he was invited to talk about iron in Tunbridge Wells, a center of the iron industry, he chose as his theme "The Work of Iron in Nature, Art and Policy." This choice allowed him to hold forth about colors in nature, the proper selection of building materials, metal-smithing in Switzerland, and the tools which typify the political junction of iron: the Plough, the Fetter, and the Sword. And of course it also allowed him to speak against the railroads.

Invited to offer advice on specific problems of design and art education, he preached the "Unity of Art." This is the title of a lecture he gave in 1859, and indeed it was the message of all his lectures. Skills were many, but art was one and its spirit governed them all.

For a time, the whole of the British public were deeply engrossed in the question of art for the masses—how to bring art education and drawing lessons to everyone. In fact, there was as much public concern over this issue as there had been over the repeal of the Corn Laws in the 1840s, and over the struggle, waged from 1830 to 1850, for the ten-hour workday. Today the idea may sound farfetched, but at the time art education took on the status of a critical national problem.

Although Britain had become the world leader in the production of industrial goods and in the techniques of cheap mass manufacture, it was unable to dictate trends in the production of luxury and fashion goods, because of its lack of good design skills. In the field of industrial design, Britain lagged behind the Continental producers. This was clearly revealed at the first world trade exhibition, held at the Crystal Palace in 1851, and as far as Britain was concerned, it was the fair's only negative result.

The British immediately set out to remedy the situation. Their aim was to raise the general level of creativity by specialized training of designers and draftsmen, but also by introducing the teaching of drawing into the regular school curriculum, thus increasing the nation's resources of both talent and taste.

The man called upon to initiate this process was Henry Cole, a jack-of-all-trades who had proved very efficient during the preparations for the Great Exhibition. "If you want steam, you must get Cole," Prince Albert quipped about his most valued assistant. Writers on Ruskin rarely even mention Henry Cole's name, yet Cole, more than anyone else, was Ruskin's great adversary throughout the decade. Whereas Cole was able to put his theories of art education to work in institutions all over the country in his own lifetime, Ruskin's were far ahead of their time, and it was not until 1890 that his ideas and methods found widespread application.

In 1873, the year of his retirement, Cole could feel proud when he looked back at his achievements. Since the year 1852 he had turned twenty ailing schools of design into 120 thriving schools; established five hundred day and evening courses in drawing for craftsmen and laborers; installed drawing instruction as part of the regular elementary-school curriculum for 180,000 young boys and girls; and helped establish the South Kensington Museum—today the Victoria and Albert Museum—as a huge warehouse of the best art and scientific designs from all over the world.

Cole's system rested on three pillars. First, the "schools of art," which were gradually set up in all of Britain's larger towns, equipped with teachers, teaching materials, and lessons by the head

office in London. Second, elementary-school instruction, which was supplied by teachers using London-made lesson plans, after brief training at the London center. And third, the London headquarters itself, based in the South Kensington Museum, which organized traveling exhibitions and so shipped designs, ornamental patterns, and samples of historical and contemporary tools all across the country.

His system of art education—government-run and centrally organized—represented a radical break with the British tradition of private education. The Schools of Design, which had just appeared in 1837 as an initial attempt to improve national skills, were the only state-run schools in the land, except for military academies and the self-supporting Royal Academy. But now more than a hundred new schools sprang into being and were held together by a single, strictly governed school system like those in France and Prussia—nations of a very different political complexion from Britain. In Britain, however, these centrally run schools were art schools, not schools of mechanical engineering, mining, or foreign commerce. The British had managed to develop the machinery of the industrial age without the aid of institutional research—an incomparably more difficult and creative task than the mere production of ingenious or salable designs—and thereby greatly enhanced their production quality. But once the whole process was under way, they realized that it could all come to nothing if no one actually wanted to buy the products emerging from their magnificent machines. What if industrial progress in Britain had already run its course? Faced with this alarming prospect, the government intervened with such determination and pragmatism that principles hallowed for centuries were discarded almost overnight.

It was at this crucial juncture that Britain turned to Ruskin, whose *Stones of Venice* had just been published. People wanted the advice of an author who theorized that art derives from the totality of a society's production, and that even the most hidden ornament reflects underlying social principles. The debate over the art schools and their syllabuses, and over questions of design, formed a sonorous background to Ruskin's activities throughout the decade of

the 1850s. Not only artists and art lovers but the laborers, artisans, and teachers attached to Cole's art schools began to read Ruskin, despite—or because of—the fact that he was a fierce opponent of the new system.

Actually, it was not state-run art education that Ruskin opposed, for he soon grasped that a centrally controlled organization was the ideal vehicle for disseminating teachings about art. In fact, he wrote to his father in 1858 that he wished he could see his own system being taught at Marlborough House, then the address of Cole's head school and museum. But Ruskin openly campaigned against the goals and teaching methods at Marlborough House. He wondered what could really be achieved by a nationalized art education—unlike the utilitarian Cole, who tried to remedy what he saw as merely a flaw in teaching methods, while ignoring the deeper causes and related symptoms. For Ruskin, the question had much broader ramifications. He was not certain that it was even possible to teach art in an industrialized culture, or to promote design skills in isolation from the other aspects of culture which actually produced good design. Could design be taught as a specialized skill?

All over Britain, students and lecturegoers were listening to what Ruskin said, and clamoring to be made into designers. Ruskin's reply to their plea was a question: How do you envision our country's future? For only if the British knew the sort of future they were working toward could they know if it was even possible to produce the right conditions for designers. "As matters stand, all over England, as soon as one mill is at work, occupying two hundred hands, we try, by means of it, to set another mill at work, occupying four hundred. That is all simple and comprehensible enough—but what is it to come to? How many mills do we want? or do we indeed want no end of mills?"

Mills weren't the only thing. How many clay, ore, and coal pits did Britain want? There would be no difficulty "in working the whole of our mountain districts as a gigantic quarry of slate and granite, from which all the rest of the world might be supplied with roofing and building stone."

Last week, I drove from Rochdale to Bolton Abbey; quietly, in order to see the country, and certainly it was well worth while. I never went over a more interesting twenty miles than those between Rochdale and Burnley. Naturally, the valley has been one of the most beautiful in the Lancashire hills; one of the far-away solitudes, full of old shepherd ways of life. At this time there are not,—I speak deliberately, and I believe quite literally,—there are not, I think, more than a thousand yards of road to be traversed anywhere, without passing a furnace or mill.

Now, is that the kind of thing you want to come to everywhere?... How much of it [England] do you seriously intend within the next fifty years to be coal-pit, brick-field, or quarry? For the sake of distinctness of conclusion, I will suppose your success absolute: that from shore to shore the whole of the island is to be set as thick with chimneys as the masts stand in the docks of Liverpool: that there shall be no meadows in it; no trees; no gardens; only a little corn grown upon the housetops, reaped and threshed by steam: that you do not leave even room for roads, but travel either over the roofs of your mills, on viaducts; or under their floors, in tunnels: that, the smoke having rendered the light of the sun unserviceable, you work always by the light of your own gas: that no acre of English ground shall be without its shaft and its engine; and therefore, no spot of English ground left, on which it shall be possible to stand, without a definite and calculable chance of being blown off it, at any moment, into small pieces. Under these circumstances, (if this is to be the future of England,) no designing or any other development of beautiful art will be possible. Do not vex your minds, nor waste your money with any thought or effort in the matter.

Did all this mean that Ruskin felt it was still meaningful to teach design, as long as England had not been totally destroyed? Was it still meaningful, as long as there was a spot left "on which it shall

be possible to stand, without a definite and calculable chance of being blown off it, at any moment, into small pieces"?

No, he was not even as confident as that, for he believed that the real basis of aesthetic education had already been destroyed:

> The changes in the state of this country are now so rapid, that it would be wholly absurd to endeavour to lay down laws of art education for it under its present aspect and circumstances. . . . To men surrounded by the depressing and monotonous circumstances of English manufacturing life, depend upon it, design is simply impossible. This is the most distinct of all the experiences I have had in dealing with the modern workman. He is intelligent and ingenious in the highest degree—subtle in touch and keen in sight: but he is, generally speaking, wholly destitute of designing power. And if you want to give him the power, you must give him the materials, and put him in the circumstances for it. Design is not the offspring of idle fancy: it is the studied result of accumulative observation and delightful habit. Without observation and experience, no design—without peace and pleasurableness in occupation, no design—and all the lecturings, and teachings, and prizes, and principles of art, in the world, are of no use, so long as you don't surround your men with happy influences and beautiful things. It is impossible for them to have right ideas about colour, unless they see the lovely colours of nature unspoiled; impossible for them to supply beautiful incident and action in their ornament, unless they see beautiful incident and action in the world about them.

Design teaching and art education were impossible until working conditions—especially for artists and craftsmen—had changed. At first glance, Ruskin's attitude seems to fit the standard utopian view that the foundations of society must be reformed before a problem can be addressed on a practical level. But in fact Ruskin was not at all averse to pragmatic action. He had already been

teaching drawing to working men for years, with considerable success. Moreover, his position was not as radical as it may appear, thus taken out of context. The theories he voiced in his chapter on "The Nature of Gothic" in *The Stones of Venice* were more extreme in their challenge of modern industrial methods. As mentioned in the previous chapter, a special edition was printed in the latter half of the decade and circulated widely among working men, who were interested in its criticism of mass production: "We have much studied and much perfected, of late, the great civilized invention of the division of labour; only we give it a false name. It is not, truly speaking, the labour that is divided; but the men:— Divided into mere segments of men—broken into small fragments and crumbs of life."

Thus, in 1853, Ruskin had attacked modern labor techniques for turning workers into mere tools; for mechanizing work and therefore making it slavery; and especially for treating the worker as equivalent to what he produced. But in the second half of the decade, instead of moving on to analyze the social conditions underlying the new production methods, he took a *less* radical posture and concentrated on the material conditions of production: the monotony of factory architecture and factory towns; the destruction of the natural environment; and the literal darkening of the physical and mental landscape: "Beautiful art can only be produced by people who have beautiful things about them, and leisure to look at them."

It would be easy to dismiss Ruskin by saying that when an aesthete tries to be a social critic, the first thing that he is bound to take offense at is the unlovely surface of industrial life, and yet there is more to his argument than is apparent to the modern eye. Today we imagine that we are threatened by far worse things, and it hard for us to realize the deep shock which people felt at the destruction wrought by the Industrial Revolution.

In Britain, the change came too fast for most people to assimilate. By 1851, for the first time in the history of England or indeed of any nation, more people were living in the cities than in the coun-

tryside. As a result, more than half of the English people suffered conditions that no modern urban dweller would be expected to put up with. There will be more to say on this topic later, when we come to Ruskin's obsession with the idea that the skies were getting darker.

The 1840s had been a period of political and economic turbulence and ideological soul-searching, during which many people lacked the most basic necessities of food, shelter, and employment. But the comparative political and economic stability of the following decade allowed attention to focus on the more physical aspects of the Industrial Revolution. The 1850s were the age of "systematic sanitary reform . . . (drainage, water-supply, street-cleaning, and so on)" when "affluence produced municipal building and, combined with radical agitation, even managed to save some open spaces and parks for the public in those fortunate areas where they had not already been built up." People also began to think about improved town planning and mass building projects. Once direct political pressure had waned, attention centered on the ethical, educational, ecological, and aesthetic dimensions of public issues.

Ruskin, who had spent the 1840s voluminously mourning the destruction of Italian artworks, without thinking it worthwhile to mention the million Irish dying of famine and epidemics, and who had married Effie in peaceful Scotland on the day the great Chartist demonstration of 1848 took place in the south, now stepped forward as a social critic. He had chosen the right moment, when there was a demand for his analytic techniques and an eager public awaited.

Ruskin first called for an improvement in working conditions—hardly a revolutionary demand. Hand in hand with this went the need to reform the conditions of learning. Ruskin felt that the shabby buildings which housed the evening design schools were as unconducive to learning as were the spartan, stripped-bare classrooms of the ordinary daytime schools. He would have liked all the design schools to look like the classrooms he set up for his own drawing pupils: packed with objects from art and nature.

"Now, my own belief is, that the best study [room] of all is the most beautiful; and that a quiet glade of forest, or the nook of a lake shore, are worth all the schoolrooms in Christendom."

His second demand was for improvement in the quality of goods produced. Here, too, he preferred to go his own way, focusing on practical needs and largely ignoring the abstract concerns of the political economists. Economic thinkers had not considered working conditions, except to note that, at a certain critical point which was hard to define, conditions could become so poor that they were counterproductive—that is, a worker could no longer do work profitable to the capitalist—so in the interests of profit, not of the worker, it was essential to achieve the right balance between factors that helped and hindered work.

But no one had bothered to think about the possible effects that the overall environment might have on the quality of production and of the wares produced. In fact, the whole problem of the quality of goods was of little interest to economists. Their concern was not with quality as such but with the relationship between quality and such factors as sales, profit, and maximizing production capacity.

As Marx had written in Chapter 2 of *Capital* ("Exchange"), "Whether that labour is useful for others and its product consequently capable of satisfying the wants of others, can be proved only by the act of exchange." From an economist's point of view, a good product was one that would sell. This might be a cheap product which would last only a short time; an inferior product which could be passed off as quality work; or a fashionable product whose aesthetic value would wear out before its materials. To the economist, quality was a matter of mathematical calculations and marketing psychology. He ignored the real underlying problem, which, as Ruskin saw it, could be broken down into two questions. First: How do we determine the quality of goods? And second: What quality of goods is best for society? The formal economist simply dismissed the first question with some such evasion as Marx used in Chapter 1 of *Capital* ("Commodities"): "The use-values of commodities furnish the material for a special study, that of the

commercial knowledge of commodities." The second question was
one that economists could not incorporate into their system in any
form at all. Thus, it fell to outsiders like Ruskin to pose these
awkward questions and to look at the specific effects of contem-
porary industrial practice.

The unleashing of giant industry served to undermine the man-
ufacturing and sales organizations of small craftsmen. One result
of this was the deluge of adulterated goods which began to over-
whelm the market in the first half of the nineteenth century. In
the past, such goods were as a rule produced only in times of great
hardship, or as an isolated crime, which as such drew very harsh
punishment. Ruskin quotes Ralph Waldo Emerson, who wrote in
1856, after visiting England: "England is aghast at the disclosure
of her fraud in the adulteration of food, of drugs and of almost
every fabric in her mills and shops; finding that milk will not
nourish, nor sugar sweeten, nor bread satisfy, nor pepper bite the
tongue, nor glue stick. In true England all is fake and forged."

A modern social historian, J.F.C. Harrison, has this to say on
the subject:

> Ale and porter were treated with *cocculus indicus* (a dangerous
> poison) as a cheap substitute for malt and hops, and new beer
> had sulphuric acid added to make it taste mature. Bread con-
> tained a small quantity of alum whose purpose was to whiten
> an inferior grade of flour; and potatoes, chalk and pipe-clay
> were also used in so-called wheaten bread. Tea was adulter-
> ated in several ways, such as mixing with used tea leaves
> which had been treated with gum and dried, or adding 'British
> tea' made from dried and curled local leaves from the hedge-
> rows. It was easy to add floor sweepings to pepper or to
> dilute milk with water.

The adulteration of food was the worst aspect of a trend to
invent more and more synthetic materials. The new technologies
allowed wood to be replaced by metal and brought revolutionary
changes in the dye industry. Other innovations, such as the papier-

mâché and gutta-percha furniture shown at the Great Exhibition, sprang from whim and experiment. Moreover, even traditional materials were now being treated by machinery which transformed their qualities, giving them new textures and finishes, and uniform proportions. Styles and fashions were changing faster than ever and forcing manufactured goods to adopt an endless series of new designs. Thus, the citizens of 1850 were exposed to a vast array of sensations—tastes, textures, sights, and smells—that had not been available fifty years before. This world of novel sensation was the scene of Ruskin's lifelong struggle to improve the quality of goods.

Despite his own interest in religious matters, however, Ruskin managed to overlook one fact preeminently suited to raise the debate about the quality of goods to the very highest level. Catholic theologians had discovered that substances such as bread, wine, oil, wax, and incense, which had been used in administering the sacraments, had been adulterated for decades. Horrified by the thought that God would refuse "to descend into potato flour"— as Huysmans mockingly summed up their doctrine in *A rebours*— well-known theologians voiced their suspicion that the grace of the sacraments had so far been missing from their century; that is, the nineteenth century had failed to receive the blessing of God. Ruskin, had he known of their conclusion, would have agreed with alacrity.

In his lectures, he told his astonished listeners that, in fact, design was secondary; product quality came first. "We require work substantial rather than rich in make; and refined, rather than splendid in design." "We must learn first to make honest English wares, and afterwards to decorate them as may please the then approving Graces." The productivity of giant industry was not real but simulated, and it did not help matters to turn simulation itself into another product. Quality came before quantity, solid construction before "wholesome evanescence"—Ruskin's ironic term for the phenomenon we now know as planned obsolescence. For Ruskin, product design was important not in itself but only indirectly, as a way of protecting products from premature aesthetic decay.

Of course, the production that mattered most to him was art, and this meant good-quality paper and paints. Ruskin proposed new standards for the manufacture of artist's paper and watercolors, and he knew whereof he spoke. Turner had sinned grievously against his own profession all his life by his carelessness in preparing his paints, by his lack of patience when building up the layers of color, and by laying the paint on too thickly. The paint of many of his works was still soft and wet when the Royal Academy opened its doors on the first Turner exhibition. Turner had spent the last few days before the opening giving his paintings a final gloss and touch-up, trying to make his products look good, exactly like a butcher or a brewer. When under pressure he would use temporary bonding agents like glue, water, or beer, and as a result the appearance of his paintings would continue to change for a year or two, until finally the colors turned dark, lifeless, and opaque—not to mention all the splits and cracks.

Ruskin had started complaining about Turner's methods as early as Volume One of *Modern Painters*: "How are we enough to regret that so great a painter should not leave a single work by which in succeeding ages he might be entirely estimated?" Turner was not alone in his carelessness but reflected a trend which had transformed the foundation of art production.

The invention of the solid cake of watercolor at the end of the eighteenth century had relieved painters of the labor of mixing their own watercolors, transferring the task to industry instead. Then the tin paint tube was invented and came into wide use in the second quarter of the nineteenth century. From then on, artists also had fresh, prefabricated oil paints at their disposal. By this time, they had stopped making any of their tools. Brushes, paints, bonding agents, primed canvases, drawing and watercolor equipment—the production of which had once belonged to the secret arts of the studio—was now turned over to unsupervised industries and suppliers. The results were just what might have been expected. Paint colors faded; mixing certain pigments produced unpredictable reactions; and above all, the quality of paper deteriorated dramatically. The hitherto unknown practice of combining

wood pulp with alum-treated resin produced rapid aging and color change in paper, thus damaging watercolors, drawings, graphic works, and fine script. Ruskin commented what a pity it was that, at the very moment when all the techniques for recording nature were at their peak, there was a sharp decline in artists' ability to preserve their work.

A period of approximately eighty years had seen the loss of many of the artist's former domains and prerogatives: control of his materials, specialized technical skills, the ethos of craftsmanship, the reliance on natural products. Important techniques had been lost and forgotten. What effort the British put into their struggle to regain the skills of fresco painting and to apply them to the decoration of the new Parliament buildings, and to so little avail! Most of the fresco paintings had to be done twice, and in the end they had to be painted onto canvas which was then set into the wall.

The same fate befell a project which Ruskin personally had helped to promote. In 1857, the same year he delivered his lectures on the "Political Economy of the Arts" in Manchester, seven Pre-Raphaelite artists met at Oxford—partly in response to Ruskin's urgings—and set out to cover the walls of the newly built Union Hall with paintings from the cycle of Arthurian legends. Both Ruskin and the participating artists felt that their enterprise reflected a genuinely medieval spirit, but its outcome was unexpectedly modern. Only one year later, barely a trace of the paintings was still visible.

Ruskin summed up the whole situation in a bold metaphor. Once, at the command of Pietro di Medici, Michelangelo is said to have formed a statue out of snow; and in just the same way (Ruskin said), the present age was devoting itself to the "service of annihilation," building "a statue in snow . . . to make a cloud of itself, and pass away from the earth." It was actively destroying, or allowing to fall apart, everything that past ages had entrusted to its care, and ensuring that its own productions would not survive to reach future ages, for although "you may still handle an Albert Dürer engraving, two hundred years old [sic!], fearlessly, not one-

half of that time will have passed over your modern water-colours, before most of them will be reduced to mere white or brown rags; and your descendants, twitching them contemptuously into fragments between finger and thumb, will mutter against you, half in scorn and half in anger, 'Those wretched nineteenth century people! they kept vapouring and fuming about the world, doing what they called business, and they couldn't make a sheet of paper that wasn't rotten.' " As usual, Ruskin's predictions are even now being fulfilled, or very nearly. Experts claim that the paper of the "alum age" will deteriorate completely by the next century, unless heroic measures are taken to preserve it. Its life span will thus be 150 years, little more than the hundred that Ruskin supposed.

Labor, skill, and materials were being wasted in the manufacture of inferior products, Ruskin claimed, while solid products were decaying for lack of care. "Here in England, we are making enormous and expensive efforts to produce new art of all kinds, knowing and confessing all the while that the greater part of it is bad, but struggling still to produce new patterns of wall-papers, and new shapes of teapots, and new pictures, and statues, and architecture; and pluming and cackling if ever a teapot or a picture has the least good in it."

Meanwhile, the true principles of economy were being lost— economy, that is, in Ruskin's sense, "the wise management of labour . . . mainly in three senses: namely, first, *applying* your labour rationally; secondly, *preserving* its produce carefully; lastly, *distributing* its produce seasonably." For "artistic produce"—as for the economy as a whole—this meant that the least economical products were those which were cheap and short-wearing; only the best, most durable work really paid; and only work that made the worker happy would make the consumer happy in the long run.

Ruskin was of course reemphasizing the message of *The Stones of Venice*: only work done in freedom could satisfy both the producer and the consumer. Because he embraced this principle, he could not fulfill the expectations of people who asked him for design specifications. And for exactly the same reason, he could

not feel happy that *Stones* had helped bring about a concrete change in English architectural style, causing a swing to the polychrome brick buildings of the Northern Italian Gothic—"streaky bacon style." Clearly, he was working for a national revival of Gothic, but he did not want to patent any particular style. Instead, he meant to create a framework within which the creativity of the artisans could then unfold.

When he and several companions managed to get a Gothic design approved for the new university museum at Oxford, he devoted his financial and other resources to encouraging a group of Irish stonemasons to decorate the structure with capitals of their own design. After some promising starts which are still visible today, the project ended as miserably as the Union Hall frescoes, which were being painted at the same time. The Irish masons developed a bit *too* freely and were dismissed by the university governors, whereupon most of the capitals were left without decoration. Better no decoration at all than to have the masons carve other people's designs or make all the capitals to the same pattern, Ruskin appears to have thought.

His intention was not to feed a never-ending stream of new designs into an industrial machine that could only turn out inauthentic products, but instead to expose and disrupt the machine itself, and so create the practical conditions for a different type of production. His persistent preoccupation was with quality, both of the production process and of the goods produced.

Ruskin hoped that his ideas would find support among three different social groupings: capitalist industrialists, government authorities, and consumers. Yet so discrete, even antagonistic, were these groups that his hope of winning the favor of all three shows how vague he still was on many political points of his "political economy." Middle-class English intellectuals, disillusioned by the aristocracy and insecure and anxious about the proletariat, tried for years to elevate the capitalists, entrepreneurs, and factory owners to the status of a new ruling class. Carlyle was the first to launch this suggestion, in his fantasies about a "chivalry of labour" in

which antagonistic classes would unite to bring progress. In *Past and Present* he drew a parallel between the noble, devout knight of feudal times and the ignoble, godless buccaneer of modern industry who enlists his thousand men, leads them to "Victory over Cotton," leaves the loot at his banker's, and disbands his regiment. The Captains of Industry, Carlyle felt, should imitate the knights of the past by placing the welfare of their men and the good of society above their selfish desires for wealth and success. The author's tendency to hero worship made him see even the crude behavior of these new knights in a positive light.

Like Carlyle, Ruskin, too, regarded the captains of industry as an important group, and conferred on them—less romantically than Carlyle but just as naïvely—the role of educators whose products could serve as "instruments of education" and whose influence might do more good than that of ordinary moral educators. In an 1859 lecture on Manufacture and Design delivered in Bradford, he addressed an audience of these same "enlightened" factory owners and told them:

> And you must remember always that your business, as manufacturers, is to form the market, as much as to supply it. If, in short-sighted and reckless eagerness for wealth, you catch at every humour of the populace as it shapes itself into momentary demand—if, in jealous rivalry with neighbouring States, or with other producers, you try to attract attention by singularities, novelties, and gaudinesses . . . to make every design an advertisement . . . no good design will ever be possible to you, or perceived by you. . . . The whole of your life will have been spent in corrupting public taste and encouraging public extravagance. . . . You all should be, in a certain sense, authors: you must, indeed, first catch the public eye, as an author must the public ear; but once gain your audience, or observance, and as it is in the writer's power thenceforward to publish what will educate as it amuses—so it is in yours to publish what will educate as it adorns. . . .

How many are content to be merely the thriving merchants of a state, when they might be its guides, counsellors, and rulers—wielding powers of subtle but gigantic beneficence.

Ruskin's hope for government support seems commonplace today, but in mid-Victorian times, and especially in a capital of laissez-faire ideology like Manchester, such ideas were practically tantamount to treason. Yet it was here that Ruskin appealed for a "paternal government" that would not only obstruct misdeeds but also support beneficial ones, that would "direct us in our occupations, protect us against our follies, and visit us in our distresses: a government which shall repress dishonesty, as now it punishes theft; which shall show how the discipline of the masses may be brought to aid the toils of peace, as discipline of the masses has hitherto knit the sinews of battle."

Government intervention in the Political Economy of the Arts meant that the government would set up special "trial schools" to foster young design geniuses, commission giant decorating programs, and establish model factories to produce good-quality paper and paints. Of these three proposals, only the third and most modest was Ruskin's own idea. The proposals for government-sponsored art schools and for government-commissioned art projects had already been accepted and were already being acted upon, albeit not in the form that Ruskin had in mind.

Ruskin's idea that the government could serve as a "model employer," as the owner and manager of model firms, was both new and provocative, and, moreover, was not too utopian to be put into practice because it was—just barely—consistent with the traditional English way of doing things. Unlike the nationalized workshops of France, which controlled both the labor market and the products market by siphoning off a huge part of the labor force, Britain's government-run factories would not try to put the capitalist producers out of business with subsidized goods, but would merely serve as an object lesson by acting as one competitor among many, respecting the final authority of the mar-

ketplace, and appealing to the insight and responsibility of the consumer.

And here we have the third, and most important, social group to whom Ruskin appealed for support. For, despite the hopes he placed in the "captains of industry" and the "pilots of government," he ultimately took his stand beside the recipient, the consumer, that same individual to whom formerly he had addressed his theories of art. By now, there had been any number of economic thinkers who focused their attention on money, or capital, or labor; but Ruskin was the first consumer economist, the first to base his theories on the way the consumer consumed: a rare phenomenon, especially in the nation which led the world in industrial manufacturing.

Already, in *The Stones of Venice*, Ruskin had said that the evil of the Industrial Revolution could be averted only by the "determined demand for the products and results of healthy and ennobling labour." He called on the public to follow three simple rules: "1. Never encourage the manufacture of any article not absolutely necessary, in the production of which *Invention* has no share. [This included all goods not essential to life.] 2. Never demand an exact finish for its own sake, but only for some practical or noble end. 3. Never encourage imitation or copying of any kind, except for the sake of preserving records of great works."

These three rules actually were reducible to one injunction: Buy no product that is not original work. In the late 1850s, Ruskin added a second: Buy only durable products.

The consumer and the worker both would benefit if these rules were observed. Once again, Ruskin's concept of the organic, unitary relationship between the creator of an artwork and its perceiver came in handy: this time, in the area of economics. The manufacturer and the consumer were engaged in a permanent dialogue, because all human relationships mediated by a product were governed by one law, which was that, in the work, one soul communicated itself to the other. As Marx had written in a treatise of 1857–58: "Thus production not only produces an object for the

subject, but also a subject for the object"; and both Marx and Ruskin would surely approve if we supplement their arguments with this principle: Consumption produces production.

But, unlike Marx, Ruskin could not understand that a third independent force intervened between production and consumption: the product itself. Nor did he realize the destructive effect that this third force could exert on the vital and vitalizing exchange between producer and consumer.

In the late 1850s, Ruskin instead hypothesized a direct, one-to-one relationship between worker and consumer, when he interpreted the buying process not as the purchase of goods but as the purchase of a portion of the worker's time: "Whenever we spend money, we of course set people to work. . . . By the way in which we spend it, we entirely direct the labour of those people during that given time. We become their masters or mistresses, and we compel them to produce, within a certain period, a certain article." In this way we determine whether the work they do is "useful and lasting" and "useful to the whole community," or is "useless and perishable" and "useful only to ourselves"; and it depends on us, as consumers, whether our workers carry out work that is "healthy and good for them." At this point, Ruskin did not yet have the theoretical and political foundation to attack the actual conditions of production, so all he could do was invoke the power of the consumer and call on the consumer to influence production by buying only what was appropriate and renouncing consumption of the inappropriate.

Admittedly, most British people were living at subsistence level and thus did not have a wide range of choice in what they bought. Moreover, their long workdays, and sometimes the contractual obligations to their employers, forced them to shop at the company stores near where they lived and worked; in the factories' own "tommy shops." Thus, Ruskin's appeals to the "critical consumer" were tailored to the middle and upper classes and had no hope of expanding into a grass-roots campaign to halt the evil of the age. It appears that Marx was right in his claim in Chapter 1 of *Capital*: "In bourgeois societies the economic *fictio juris* prevails, that every

one, as a buyer, possesses an encyclopaedic knowledge of commodities."

Indeed, the bourgeois ideal of the consumer would require that he have not only "knowledge" but also everything else that makes up the middle-class citizen—rationality, freedom, responsibility. Economists—Thorstein Veblen among them—have pointed out that political accounts which assume the consumer's power to effect revolt are bound up with class attitudes, and that even the values recommended to the buyer clearly reflect upper-class tastes. Uniform, machine-produced goods, mass production, the cycles of fashion, are voted down in favor of the traditional values of hand-crafting, individually produced goods, durability, and dateless styling—all values which are neither intrinsically nor socially meaningful and whose main effect has been to serve as a visible reminder of social distinctions.

To be sure, Ruskin could have returned some reply to these charges. If we take the first objection—that he was addressing the middle and upper classes when he ought to have addressed the poor—he might have replied: "I think for the people who hear me, but I do not speak for them." There were few workers' organizations in the England of the 1850s, and no class-conscious proletariat that thought and acted as a political group. When a middle-class intellectual took up the role of social critic for the first time, after taking no part in the political conflicts of 1848, he found no ready-made audience among the working masses. These were the years that Marx spent confined to the Reading Room of the British Museum Library, unable to carry on practical politics except in emigrant circles. Some time would pass before Ruskin began to address his writings to the workers of Britain, before he abandoned his concentration on the consumer and pushed reforms of production instead.

The 1850s were a period of consolidation for the middle class. Social statisticians point out that one especially significant sign of the growing wealth and power of the middle class was the increase in the numbers of servants. In the 1850s the servant population rose by almost 27 percent, to 1.05 million. This was also a decade

of surplus capital, when, despite the gathering pace of industrialization, the sums of available cash outstripped the possibilities of reinvestment and so were converted into luxury goods and into art objects and architecture.

Moreover, the 1850s, which until then had seemed a decade of tranquillity and prosperity, ended in a worldwide economic crisis, the first of its kind, lasting from 1857 to 1859. Many of Ruskin's contemporaries lost their wealth or their jobs; and both they and those who had been spared now had cause to doubt the wisdom of previous management policies, both public and private.

Ruskin's career was closely bound up with the movements of the middle class and of surplus capital, and the economic collapse which struck in 1857—the year of Ruskin's lectures on the Political Economy of the Arts—spurred him on in his new role as a critic of capitalism. In this role, he did not act as aesthetic adviser, investment counselor, or troubleshooter to his own class. Nor did he instruct the buyers and commissioners of goods on how to help regulate the existing range of commodities. Instead, he told people what the existing goods implied about society and then said that these goods must be changed, starting at the production end.

Moreover, despite a stagnating economy, rising unemployment, and the million poor and unemployed who were being supported at community expense, he was bold enough, in March 1858, to reject the call to step up private consumption. The New York common council, in a report on the commercial crisis, had published their opinion that luxury consumption was not sinful but economically desirable, because: "If a man of 1,000,000 dollars spends principal and interest in ten years, and finds himself beggared at the end of that time, he has actually made a hundred who have catered to his extravagance, employers or employed, so much richer by the division of his wealth. He may be ruined, but the nation is better off and richer."

But Ruskin challenged the councilmen's argument in a passage that asked: "Yes, gentlemen of the common council" . . . but "where is the product of that work" for which one million dollars was spent?

By your own statements, wholly consumed; for the man for whom it has been done is now a beggar. You have given therefore, as a nation, 1,000,000 dollars' worth of work, and ten years of time, and you have produced, as ultimate result, one beggar. Excellent economy, gentlemen! and sure to conduce, in due sequence, to the production of *more* than one beggar. Perhaps the matter may be made clearer to you, however, by a more familiar instance. If a schoolboy goes out in the morning with five shillings in his pocket, and comes home penniless, having spent his all in tarts, principal and interest are gone, and fruiterer and baker are enriched. So far so good. But suppose the schoolboy, instead, has bought a book and a knife; principal and interest are gone, and bookseller and cutler are enriched. But the schoolboy is enriched also, and may help his schoolfellows next day with knife and book, instead of lying in bed and incurring a debt to the doctor.

Ruskin's economic theories were designed to support neither over- nor underconsumption. As an economist he was looking for the "right" levels of consumption and production. That is—to quote a previously cited passage—his doctrine was "*applying* your labour rationally . . . *preserving* its produce carefully . . . *distributing* its produce seasonably." Thus, he rejected not only the need for luxury consumption but also another prized tenet of economists: that the only thing which could stimulate and maintain the economy was the steady "invention of new wants." As long as the "old wants" were not yet satisfied—as long as the poor were not comfortably housed and clothed, for instance—then the labor that went into new fancies would be taken away from useful production.

Ruskin was by no means opposed to luxury and affluence, but he wanted luxury for everyone, as the fruit of collective and cooperative management, rather than the privilege of the few, born of their egotistical desires, their oppression of others, and their abuses of the resources of nature. In the 1850s, Ruskin was still

optimistic about the possibility of achieving his aims: "A time will come—I do not think even now it is far from us—when this golden net of the world's wealth will be spread abroad as the flaming meshes of morning cloud are over the sky; bearing with them the joy of light and the dew of the morning, as well as the summons to honourable and peaceful toil."

3

We have seen the Ruskin of the 1850s hovering on the brink of dropping art education altogether and moving completely into the camp of the social critics and economists. Only one thing was still holding him back: he had a promise to keep. He had promised his father that he would finish *Modern Painters*, and time was running out. The years 1853 to 1860, already overcrowded, were the span in which he had somehow to complete Volumes Three to Five. It was, in many senses, a race against the clock: the years of his father's life were ticking away; his own inner development was leading him further and further away from the subject matter of *Modern Painters*; and his times were killing off both nature and art before he could finish writing about them.

This last concern became paramount. As Ruskin composed the final volumes, he found that he now occupied the same position as Turner at the moment when Ruskin took up the painter's cause. Ruskin was now a famous man, the subject of heated debate, and the object of public attack. For example, Lady Eastlake, evaluating *Modern Painters* in the *Quarterly Review*, had censured its "false assumptions, futile speculations, contradictory argument, crotchety views and romantic rubbish." Ruskin was undaunted by public opinion; yet at the same time he feared, and then concluded, that his message would go unheard, that no one wanted to see what, for a little time, was still left to be seen, and that no one *could* see what had already vanished.

At the end of *Modern Painters*, he tried to describe the "condition of mind" in which Turner had done his great work: " 'What I do

must be done rightly; but I know also that no man now living in Europe cares to understand it; and the better I do it, the less he will see the meaning of it.' " Even after Turner was dead, he remained a powerful inspiration to Ruskin, who continued to analyze his work until literally the penultimate page of *Modern Painters*. In the final chapter we read that Ruskin feels "Full of far deeper reverence for Turner's art than I felt when this task of his defence was undertaken."

Ruskin's study and classification of Turner's private collection, undertaken after Turner's death, confirmed his thesis that the painter had always been accurate in his depiction even of the most inconspicuous details of nature. These thousands and thousands of drawings of every conceivable natural phenomenon showed that Turner had made an all-inclusive, if chaotic, study of the behavior of water, clouds, and plants under changing conditions. But, as was the case for Ruskin himself, Turner's urge to amass samples of everything testified to a desperate effort to save it. "There seemed through all his life to be one main sorrow and fear haunting him—a sense of the passing away . . . of beauty," Ruskin wrote after sorting out the Turner Bequest.

In the summer of 1846, Ruskin had begun to collect in diaries, notebooks, and sketchbooks the material which was to fill the final volumes of *Modern Painters*. They contained all the data that he had promised his readers: the "truth" of clouds, rocks, plants, and water, in more detailed form than he had described them in the outlining chapters of Volume One. Gower Street, the symbol of England and of anti-nature, kept driving the priest of nature back to a place where it was still wild and solitary: to Chamonix in the Alps, where his work on Turner began.

Roughly two-thirds of Ruskin's nature studies were carried out in the Alps. One result was that the "Truth of Mountains" eventually occupied an entire volume of *Modern Painters* (Volume Four), while the "Truth of Water"—surely the essential nature element in any study of Turner, who was most noted for his seascapes— was omitted entirely; and the treatment of other natural features was curtailed.

Even before Ruskin came to value the solitude of mountains, he loved them for their solidity and concreteness, and for their dual nature, as objects of both scientific and aesthetic interest. Mountains spoke to Ruskin, the scientist-artist, the "scientist of aspects," as nothing else could. To be in the mountains meant to experience them, simultaneously, as both near and far away.

Here follows Ruskin's diary description of a workday in the high mountains at Chamonix:

It has been a glorious [day]. I was working [on a drawing] from Mont Blanc before breakfast, out immediately afterwards; made some notes of aiguille Bouchard, went on to the Source, beside the Arveron somewhat closer than usual, it having changed its bed entirely within the last three days and running four feet deep where I used to walk. Took slopes of Dru, from just beside the Arveron bridge, then climbed the avalanche with Coutet [his mountain guide] to foot of rocks nearest Montanvert—could not get upon them—awkward chasm between the ice and them—and at the only place where we could get upon them, another at the other side, which made it a risk to pass the ridge. Got on them at last, however, higher up, and took from them specimens 27, 28. [Here he records the geological characteristics of his rock specimens.] After examining the rocks here—note that the one under the cascade is called the *rocher du Chataigne*—we climbed to an almost isolated promontory of pines immediately on the right of the bare rocks. At the top of it the glacier was seen against the sky through the most fantastic pines, and the grand rocks falling to the source, nodding forwards (like "a wave about to break") and the great cascade bounding from its narrow way, with the look of a wildly revolving wheel. . . . There is something in its great weight of water which makes it differ in its fling from all other cascades I have ever seen—its waves bound like masses of stone—and nearly all the way down the solid water is seen yellowish among the small clouds of blue spray which beat

down with it. [Data follows on the diagrammatic curves of the waterfall and the rock silhouettes.] I never saw a more wonderful scene than the glen at this point; with its small but steep torrent, its mighty stones cast down from the moraine above and its vertical walls, shutting us in to the glacier, and the awful cataract beneath it.

Ruskin's geological samples show what the rocks "are," while his innumerable drawings of curves and long-distance profiles show how they "appear." And so, to the very end of *Modern Painters*, Ruskin remains loyal to his initial task: to read the beauty and truth of nature's objects in the "consistency of their curves." His curve chart in *The Stones of Venice* had shown his favorite curve to be the outline of a small glacier in the foothills of Aiguille Blaitière; but now he preferred the more expressive, precipitous outlines of the aiguilles—the "rock needles"—themselves, to which he devoted thirty-six large drawings in the years 1848 and 1849 alone, and to which he gave more space in *Modern Painters* than to the actual central peaks of the Alps.

The aiguilles, with their pared-down structure, served Ruskin as guideline fossils, just like the moldings left by the Venetian stonemasons. Their jagged contours laid no claim to beauty, and for that very reason they were important to the interpreter of curves, because "We could not, from these, have proved any resolved preference, by Nature, of curved lines to others, inasmuch as it might always have been answered that the curves were produced, not for beauty's sake, but infallibly by the laws of vegetable existence." In other words, by Ruskin's new view, "It is therefore, not so much what these forms of the earth actually are, as what they are continually becoming, that we have to observe."

This historical approach to nature study is a fresh element that came into *Modern Painters* in the 1850s, or at least became more pronounced than in the early volumes. Ruskin increasingly read the lines of objects as lines of energy, as a clue to their history, and as the product of conflicting forces. He now transferred to the stones of the Alps knowledge he had gleaned from the stones of

Venice. The critical analysis of lines could be extended to their genetic aspects. Everything, even the extreme and the ugly, became instructive as soon as you could look into its origins. From the analysis of beauty grew the analysis of history, and the change brought a more productive fusion between the close-up study of an object and the distant view of it, between the "science of facts" and the "science of aspects."

Nature's vital lines reflect the same laws laid down, on a smaller scale, in the fine patterning of both organic and inorganic phenomena. Thus, it is useful to examine the earth's anatomy, even though it remains the case that all essential knowledge can be gained "aesthetically," by direct visual perception. Ruskin comments on the role of energetic line in a passage from Volume Four, concluding the discussion of the Aiguille Blaitière. He says not a word about the beautiful curve of the glacier, but this time concentrates exclusively on the jagged needle of rock above the glacier:

> I call these the governing or leading lines, not because they are the first which strike the eye, but because, like those of the grain of the wood in a tree-trunk, they rule the swell and fall and change of all the mass. In Nature, or in a photograph, a careless observer will by no means be struck by them, any more than he would by the curves of the tree; and an ordinary artist would draw rather the cragginess and granulation of the surfaces, just as he would rather draw the bark and moss of the trunk. Nor can any one be more steadfastly averse than I to every substitution of anatomical knowledge for outward and apparent fact; but so it is, that, as an artist increases in acuteness of perception, the facts which *become* outward and apparent to him are those which bear upon the growth or make of the thing. . . . So, in looking at these rocks, the keenness of the artist's eye may almost precisely be tested by the degree in which he perceives the curves that give them their strength and grace, and in harmony with which the flakes of granite are bound together, like the bones of the jaw of a saurian.

This is the chief message of the last volumes of *Modern Painters*, and of all the other writings for nature conservationists, artists, and drawing pupils which Ruskin published at this time. It is a more compact message than he could convey in Volume One, which focused on the "particular, rare and individual truths"; that is, on such problems as how a red sail was reflected in a distant swell. Whether the object of study is a tree, a rock, or a cloud, the aim is to know its lines, as an expression of the laws which govern its life. If we look at a tree, we see that the higher the branches grow on the trunk, the less they curve, and that the tips of all the branches together describe a single giant curve all around the tree. Even inanimate objects have their "vital lines" or "talkative facts." "In an old house roof, a bad observer and bad draughtsman will only see and draw the spotty irregularity of tiles or slates all over; but a good draughtsman will see all the bends of the under timbers, where they are weakest . . . and the tracks of the run of the water in time of rain, where it runs off fastest, and where it lies long and feeds the moss."

The artist must never immobilize what he depicts. Even things which appear inanimate give clues to their past and future: "Try always, whenever you look at a form, to see the lines in it which have had power over its past fate and will have power over its futurity."

The ability to see and reproduce such lines enables a person to grasp the underlying unity of all things, the grammar of their activity. It was in the woods at Fontainebleau that Ruskin had learned that it is "the same laws which guided the clouds, divided the light, and balanced the wave." But he did not actually communicate that lesson until fifteen years later, in the last volume of *Modern Painters*, and in his book of drawing instruction, *The Elements of Drawing*. In these works he lists several laws of composition which "compose" everything: "the law of principality," "the law of repetition," "the law of continuity," "the law of curvature," "the law of radiation," "the law of contrast," "the law of interchange," and "the law of harmony." These can perhaps be reduced to a single common denominator, to a single great rule that Ruskin

called "the law of help." "Thus, intensity of life is also intensity of helpfulness—completeness of depending of each part on all the rest. . . . The highest and first law of the universe—and the other name of life is, therefore, 'help.' The other name of death is 'separation.' Government and co-operation are in all things and eternally the laws of life. Anarchy and competition, eternally, and in all things, the laws of death."

Ruskin had already realized, while drawing in the woods at Fontainebleau, that man, too, was embraced in the great unity of nature. He had also learned that all human faculties were specially fitted to the creation as the creation was to them: "Divine in their nature, they are addressed to the immortal part of men." But only now did he see that this organic unity of man and nature might also prefigure the order of society: only now, that is, did it become important to him to see this, at a time when his personal problems seemed to enhance, and be enhanced by, those of society at large.

The "law of help" was a strange brew, concocted partly of the hope to find some model of wholeness and partly of the urge toward realism: for the law of help, Ruskin says, depends upon the "law of fracture." At the end of his chapter on the aiguilles, he points out that nature is

> bound to produce a form, admirable to human beings, by continual breaking away of substance. And behold—so soon as she is compelled to do this—she changes the law of fracture itself. "Growth," she seems to say, "is not essential to my work, nor concealment, nor softness; but curvature is: and if I must produce my forms by breaking them, the fracture itself shall be in curves. If, instead of dew and sunshine, the only instruments I am to use are the lightning and the frost, then their forked tongues and crystal wedges shall still work out my laws of tender line. Devastation instead of nurture may be the task of all my elements, and age after age may only prolong the unrenovated ruin; but the appointments of typical beauty which have been made over all creatures shall not therefore be abandoned; and the rocks shall be ruled, in

their perpetual perishing, by the same ordinances that direct the bending of the reed and the blush of the rose."

In this passage, faith in nature turns even the "law of fracture" into something positive. But other statements—especially Ruskin's drawings, and the sociopolitical teachings he derives from his experience of the Alps—show that, for him, fracture was a matter of deadly earnest. One of his most dramatic drawings is of a waterfall, the Cascade de la Folie at Chamonix. The work has been variously dated anywhere between the late 1840s and 1856. It gives us that picture of the earth's own inner life which German landscape painters of the time were seeking but never actually found: at least, the efforts of Caspar David Friedrich, Joseph Anton Koch, and Ludwig Adrian Richter look static compared with this drawing by Ruskin. The massive curving slopes of the mountain are split by the cleft which the water has driven into their firm flanks. *Modern Painters* refers to such clefts as scars, wounds, never-healing rifts. Or is it the dark unfolding of sex that we see? Sex as an open wound?

No psychoanalyst is likely to ignore this drawing, once he has read Ruskin's comments about his marriage, and about the anxiety he felt toward the supposed disfigurement of Effie's body. Before he and Effie were married, in 1847, did he not compare his future wife to a field of glaciers that hid "winding clefts" beneath its fresh carpet of snow?

Only one thing is certain: whatever personal barrenness may be laboriously expressed or excused in this drawing, Ruskin has found, in its execution, the means to confer vitality. For no other artist has managed to give nature such tension, always getting her forms to flex their sinews and muscles. The tension here reaches the point of fracture. Or, rather, it reflects the argument between fracture and intense life, between destruction and generation, which characterizes the aiguilles, and mountains generally.

The torrent cuts through the slope like forked lightning. One sees clearly marked the points at which it will continue to carve its way through the mountain, yet the wound looks soft and fertile.

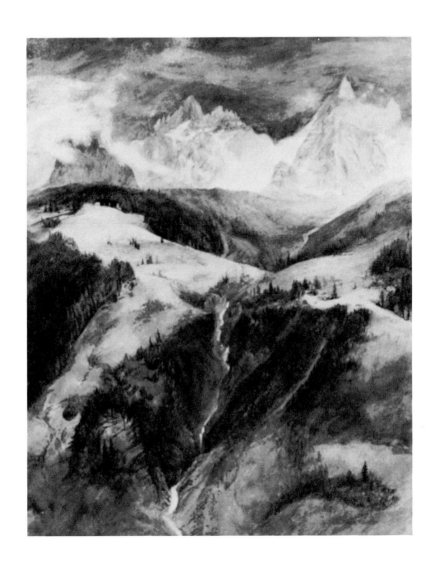

John Ruskin, Cascade de la Folie, Chamonix, *c. 1849–56.*
Pen-and-ink and watercolor.
The City Museum and Art Gallery, Birmingham

Pines and knee timber have sprung up on the earth and stone embankments mounted along the adjoining channels, and they are fed by the water as it splashes up, then runs off. The water, seeming to trickle away only to resurface, gives the dark cleft some of the look of a headstream and so reminds us of the vital role the mountains play in supplying water and soil to the plains below. "That turbid foaming of the angry water,—that tearing down of bank and rock along the flanks of its fury,—are no disturbances of the kind course of nature; they are beneficent operations of laws necessary to the existence of man and to the beauty of the earth."

The lesson the mountains teach is "that no good or lovely thing exists in this world without its correspondent darkness" and "that where the beauty and wisdom of the Divine working are most manifested, there also are manifested most clearly the terror of God's wrath, and inevitableness of His power." This being so, it is logical that the last two chapters of Volume Four of *Modern Painters*—the volume on mountains—are called "The Mountain Gloom" and "The Mountain Glory." Ruskin's own enjoyment of the Alps had not blinded him to the grim living conditions of the people who actually made their homes there and who suffered from the unpredictable workings of nature. The "gloom" of their lives—this mixture of poverty, isolation, inbreeding, superstition, and drudgery—could, Ruskin said, be alleviated for the sum spent annually by the theatergoers of London and Paris, who flocked to see a stage dressed up to look like a pretty Swiss mountain village and actors representing happy Alpine herdsmen and dairymaids.

And yet, having suggested that wealthy urbanites might devote to the Swiss what they now devoted to caricaturing them, Ruskin then advises against it: "But I would that the enlightened population of Paris and London were content with doing nothing;—that they were satisfied with expenditure upon their idle pleasures, in their idle way; and would leave the Swiss to their own mountain gloom of unadvancing independence." For Ruskin had detected, in the leading lines of the mountains, a new dialectic of "gloom and glory," of generation and destruction, which, though manmade, was more terrible in its effects than the violent acts of nature.

Fracture and tone, erosion and the production of new soil, flood and irrigation—the conflict between natural forces was dynamic, but not revolutionary. Ruskin had learned from Lyell that natural history progressed very slowly. But the kind of "progress" now coming into the Alps brought a new, revolutionary rate of change.

> I could say much on this subject if I had any hope of doing good by saying anything. But I have none. The influx of foreigners into Switzerland must necessarily be greater every year, and the greater it is, the larger in the crowd will be the majority of persons whose objects in travelling will be, first, to get as fast as possible from place to place, and, secondly, at every place where they arrive, to obtain the kind of accommodation and amusement to which they are accustomed in Paris, London, Brighton, or Baden. . . . The valley of Chamouni . . . is rapidly being turned into a kind of Cremorne Gardens [a London amusement park]; and I can foresee, within the perspective of but few years, the town of Lucerne consisting of a row of symmetrical hotels round the foot of the lake, its old bridges destroyed, an iron one built over the Reuss, and an acacia promenade carried along the lake-shore, with a German band playing under a Chinese temple at the end of it, and the enlightened travellers, representatives of European civilization, performing before the Alps, in each afternoon summer sunlight, in their modern manner, the Dance of Death.
>
> All this is inevitable; and it has its good as well as its evil side. I can imagine the zealous modernist replying to me that when all this is happily accomplished, my melancholy peasants of the valley of Trient will be turned into thriving shopkeepers, the desolate streets of Sion into glittering thoroughfares, and the marshes of the Valais into prosperous market-gardens. I hope so; and indeed am striving every day to conceive more accurately, and regulate all my efforts by the expectation of, the state of society, not now, I suppose, much more than twenty years in advance of us, when Europe,

having satisfactorily effaced all memorials of the past, [will have] reduced itself to the likeness of America.

Ruskin was quite right: he did no good by saying this. In 1857 an "Alpine Club," the first in the world, was founded in London; and in 1863 Thomas Cook, the British tourist pioneer, organized the first tour of the Alps. In fact, if anything, Ruskin's writings produced just the opposite effect from what he desired. Just as, years earlier, Turner's watercolors had inspired Ruskin and his parents to tour the Alps to view the original scenes of his paintings, so now British tourists, enthralled by Volume Four of *Modern Painters*, trailed around in Ruskin's footsteps with his book in hand. And the founders of the Alpine Club explicitly mentioned its inspiring descriptions of mountains. The only tangible conservation measure which resulted from it was the rescue of the bridge at Lucerne, which was in danger of being torn down until British protesters managed to save it. All Ruskin's other dire predictions came true.

His description of a future world devoid of history and nature alike aimed, on the concrete level, to prevent "the turning of a sweet mountain valley into an abyss of factory-stench and toil, or the carrying of a line of traffic through some green place of shepherd solitude." But there was more to it than that. His critique of civilization expressed the fear that man himself, as an organ created to experience the infinity of creation, might now regress in his development.

In Volume Three of *Modern Painters*, which marked the moment when Ruskin's subject—art and nature—suddenly faced attack from the accelerated world of the 1850s, Ruskin began to talk about the growing enfeeblement of man's perceptual faculties. His discussion of the new technology and its adverse effects on man sounds, quite appropriately, like what today we would call a critique of the media:

No changing of place at a hundred miles an hour, nor making of stuffs a thousand yards a minute, will make us one whit

stronger, happier, or wiser. There was always more in the world than men could see, walked they ever so slowly; they will see it no better for going fast. And they will at last, and soon too, find out that their grand inventions for conquering (as they think) space and time, do, in reality, conquer nothing; for space and time are, in their own essence, unconquerable, and besides did not want any sort of conquering; they wanted *using*. A fool always wants to shorten space and time: a wise man wants to lengthen both. A fool wants to kill space and kill time: a wise man, first to gain them, then to animate them. Your railroad, when you come to understand it, is only a device for making the world smaller: and as for being able to talk from place to place, that is, indeed, well and convenient; but suppose you have, originally, nothing to say.

In this passage, Ruskin is seconding the arguments of the American Transcendentalists, to whom he appealed far too seldom for advice and support, presumably because he expected little good to come out of America. In any case, he acknowledged in a footnote that Emerson had in 1847 expressed the same thought: "The light-outspeeding telegraph / Bears nothing on its beam."

And had he consulted Thoreau's *Walden* (1854), he might have read these words, from the chapter "Economy": "We are in great haste to construct a magnetic telegraph from Maine to Texas; but Maine and Texas, it may be, have nothing important to communicate." And the following Thoreau passage (from the chapter "Where I Lived") could just as easily have been written by Ruskin: "[The nation] lives too fast. Men think that it is essential that the *Nation* have commerce, and export ice, and talk through a telegraph, and ride thirty miles an hour. . . . Why should we live with such hurry and waste of life? . . . All these times and places and occasions are now and here. God himself culminates in the present moment, and will never be more divine in the lapse of all the ages. And we are enabled to apprehend at all what is sublime and noble only by the perpetual instilling and drenching of the reality that surrounds us."

The first people to try out a new technology always find out that the medium is the message. The passengers who took the historic railroad journey from Liverpool to Manchester in 1826 had no particular interest in traveling this route—no more than the first people to look at daguerrotypes especially wanted to know what Paris looked like from the Quai d'Orsay. Nowadays it has become a cliché to point out that all media are self-gratifying, that they are not reducible to their everyday function but rather satisfy needs they themselves create. This insight, though, originated with Ruskin and the American Transcendentalists.

Nor was this all they had to say on the subject. They also expressed their fear that the new self-perpetuating technologies would react adversely upon man, and upon nature, whose resources were thereby put under continual siege. Ruskin went on fighting the railroad designers and builders until well into old age, trying to curb their leveling and destruction of the landscape. But his deepest concern of all was reflected in that famous brief sentence: "There was always more in the world than men could see, walked they ever so slowly." Man's sensory apparatus and his very soul were—in Ruskin's view—a mirror, "dark, distorted, broken," a "dark glass," which only with difficulty could live up to its task of reflecting God's creation.

Yet knowledge did exist, dark though it might be: "Through the glass, darkly. But, except through the glass, in nowise." If man darkened the glass further, by "defiling, despising, and polluting" it, his sensory faculties would be blunted, and he would at the same time rob nature of its infinite diversity. Man's link to the creation meant that if one of the two suffered, both would suffer; or, as in this case, that both the inward and the outward world would be "uncreated" and "unparadised again." This idea of reciprocity between inner and outer is the guiding thread which leads us through all Ruskin's writings, from Volume Three of *Modern Painters* to the very last things he wrote in the 1880s. "Man is the sun of the world; more than the real sun. . . . Where he is, are the tropics; where he is not, the ice-world." Where man "is not"—where he has allowed the glass to turn dark—the result,

Ruskin says, is the neglect first of details and then of larger matters and finally of whole realms of the world.

In the end, it was no longer possible to tell whether the destruction wrought by his age stemmed from policy or indifference, because man had stopped seeing and was no longer aware of the ground he trod upon. While Ruskin was composing *Modern Painters*, a country parson named John Henslow, whose parish was in Hitcham, Suffolk, took a census of all the plant species in the area. With the help of the village schoolchildren, he was able to count 406 separate species. Then, in 1860, the publication year of the last volume of *Modern Painters*—which partly treats of plants—the woodland around Hitcham was cleared for farming. Another plant census taken one hundred years later reported that sixty of the original plant species were now extinct, while many were on the verge of extinction. Year after year since then, the terrifying reports have continued to come in: "No cornflowers seen for a number of years"; "verbena disappeared 1972"; "flax now found only along the road-edge"; "columbine extinct"; and so on.

These are profound and sweeping changes, especially if we consider that they have taken place in a small rural community; and yet, as Richard Mabey, a contemporary "Ruskinian" writer on ecological topics, has pointed out, the changes were spread across four generations and so went virtually unnoticed.

We can only save what we can see. Everything is a question of perception, Ruskin went on stubbornly repeating over and over: "The greatest thing a human soul ever does in this world is to *see* something, and tell what it *saw* in a plain way. Hundreds of people can talk for one who can think, but thousands can think for one who can see. To see clearly is poetry, prophecy, and religion,— all in one."

4

"Seeing clearly" meant two things. It meant seeing the visible world, practicing the "personal observation of fact," which de-

manded patience, discernment, and devotion. It also meant seeing the invisible: vision, divination, sight of what was to come. Volumes Three to Five show the strain of this dual vision, for they are written in two radically different styles, the factual and the prophetic, and they focus on two different time zones, a past which is lost and a future with nothing to look forward to.

For it must not be imagined, from the more didactic tone of passages quoted in this chapter, that Ruskin had now turned into a mere theorist and critic. We still find him writing hundreds of pages about the "truth" of clouds, plants, and mountains. But the method he pursued in Volume One has now been largely discarded: first the raising of certain facts about nature, and then the comparison of what the ancient and modern masters had expressed about them. A gap separates Volumes One and Two from Volumes Three to Five, and in the gap lie the stones of Venice: "touchstones" as Ruskin calls them, because, having once touched them, one can never again look at any stone—even a stone from the Alps—without seeing its historical dimension, without questioning both the genesis of the rock and the genesis of one's present interest in it.

This new historical perspective curtails the witness of art; indeed, renders it suspect. For, although Ruskin as a historian never treats his subject in conventional historical terms, he is well aware that art cannot be understood apart from the time that gave it birth. Accordingly, he must somehow account—in *Modern Painters*—for how a nineteenth-century artist, William Turner, could have become the greatest landscape painter of all time.

In Volume One, we saw Claude Lorrain and Turner starting off under much the same conditions and headed for the same goal: the truth of nature. In Volumes Three to Five, the goal is still the same but the number of competitors has multiplied and their starting handicaps are different. The runners are evaluated one by one, always from the judges' booth of the present. Turner, admittedly, still finishes well ahead, but the meaning of his victory, and of the whole art contest, has changed drastically.

As a young man, Ruskin took for granted the status and value of landscape painting; but in his middle years he viewed artistic

expressions of intense love of nature as symptoms of compensation, displayed by "disembodied spirits" who did not necessarily show "the highest mental powers, or purest moral principles." And he was obliged to include himself among the swollen ranks of those whose "love of nature had been partly forced upon us by mistakes in our social economy": a passage which we already looked at, when we examined Millais's portrait of Ruskin and the modern cult of nature.

To be sure, even now Ruskin was repeating his old admonition: the best course in times like these is the accurate study of nature, and the selfless service of facts. But by now this sounds like advice to shipwrecked sailors. Ruskin, the disciple of Turner, is now painting a different picture of his master, one that reflects his own changed ideals. He no longer sees Turner as a pure eye, a tireless observer and collector, a "scientist of aspects"—but instead as a prophet, a visionary, an inspired seer whose "mighty unconsciousness . . . instinctively seizes the last and finest traces of any visible law." "All these changes come into his head involuntarily; an entirely imperative dream, crying, 'Thus it must be,' has taken possession of him; he can see, and do, no otherwise than as the dream directs."

Turner—Ruskin says—neither chose nor aspired to the role of prophet; it was imposed on him in an age that had gone blind to "the terrible and sad truths which the universe is full of."

Ruskin, the administrator of Turner's estate in both the legal and the metaphorical sense, was prey, like his master, to increasing restlessness and impatience. While writing about Venice, he had searched for key images that would give instant access to truths which otherwise could be grasped only by patient and painstaking assembly. So now, writing *Modern Painters* in a time of crisis, he looked for more highly charged symbols: first, nature itself, unfiltered by art, a realm less of aspects than of significations, a tissue of laws, precepts, and symptoms—and second, allegorical images able to carry large meanings. Thus, the "law of fracture" now came to operate within *Modern Painters* itself. The jagged language of the final chapters juts out of the supple, engaging prose of the

early volumes, the way the precipitous aiguilles jut out from the ideal curves of the glaciers and hill slopes.

The thematic break is equally abrupt. After reading 2,500 pages dedicated to landscape painting and the observation of nature, we come—without warning or explanation—upon two chapters about the painting of historical scenes. They represent neither a logical end to the work nor, in any sense, a conclusion. For, as Ruskin himself admits at the start of the last chapter: "Looking back over what I have written, I find that I have only now the power of ending this work,—it being time that it should end, but not of 'concluding' it."

Ruskin's personal life gives us the best clues to his book's change of theme. He had always had a divided attitude about figure painting. For a long time he believed he had no gift for drawing and painting the human figure, and because he valued firsthand experience above all else, he disqualified himself from criticizing in others skills of which he lacked practical knowledge. Nevertheless, he was fascinated by the work of figure painters like Tintoretto and Veronese. He found it hard to justify this fascination—all the more so because they had painted at a time which, by his reckoning of Venetian history, was a period of decadence.

But the matter was finally cleared up for him one Sunday in July 1858 when he was in Turin. This was the occasion of another conversion episode, or rather of an "unconversion," as Ruskin called it, because it brought a break with his Protestant faith. Later he often referred to the event in his writings. In his autobiography, he described it as "no sudden conversion" but rather the conclusion to "courses of thought which had been leading me to such end through many years." There being no Protestant services to attend that Sunday, he had gone to a Waldensian chapel. Here he grew tired of the preacher's depressing discourse "on the wickedness of the wide world," left the service, and entered the picture gallery, where he found an antidote: the sensual richness of Veronese's great painting *Solomon and the Queen of Sheba*. "The gallery windows being open, there came in with the warm air, floating swells and falls of military music, from the courtyard before the palace. . . .

And as the perfect colour and sound gradually asserted their power on me, they seemed finally to fasten me in the old article of Jewish faith, that things done delightfully and rightly were always done by the help and in the Spirit of God. . . . That day, my evangelical beliefs were put away, to be debated of no more."

Ruskin's climactic experience with the aspen tree in the woods of Fontainebleau and the experience in Turin in 1858 form a frame around the period in which he began and ended *Modern Painters*. The factor common to the two experiences is that Ruskin met their challenge by drawing. In the first, he struggled to master the lines of the aspen tree and thereby to master the formal laws of nature; in the second, he tackled the human figure. He had scaffolding erected in front of Veronese's work and spent several weeks painting and drawing one of the Queen's handmaidens, thus training himself to become a figure painter. So exhilarated was he by his success that he wrote to his father, in the exaggerated language born of the great occasion: "My sketches from Turner & Veronese are valuable—my own sketches from nature never will be good for anything."

And not only had he learned to depict human beings, he had also turned toward them emotionally. He now accepted as truth that God had "made faces beautiful and limbs strong, and created these strange, fiery, fantastic energies." He had decided that, having dealt with the history of the earth's life, he would now devote himself to the histories of men.

At the end of *Modern Painters*, Ruskin analyzed two more of Turner's paintings and gave more space to them than to any of the others: a chapter apiece. Both were mythological subjects: *The Garden of the Hesperides* (1806) and *Apollo Slaying Python* (1811). Showing the same systematic attention to detail that he had devoted to leaf and branch patterns a few chapters earlier, Ruskin set out to unravel the tangled mythologies of the Greeks. Now, at the end of the 1850s, he finally became what many of his readers and critics had considered him to be all along: a creator of myths and interpreter of allegories.

"Everything's got a moral, if only you can find it," the Duchess tells Alice in *Alice in Wonderland*. This line could well serve as a motto for the entire second half of Ruskin's life. Our next chapter will show in context the meaning of myth for Ruskin as a man and as an author. But for now it is perhaps enough to point out that both of Turner's mythological paintings contain a large and threatening dragon, a mythical beast with the very darkest associations. Ruskin's choice to write of these works testifies that he was waiting to be overwhelmed by an irrational power, and it gives us a clue to why he finally felt forced to abandon "the old road." He leaves the last word to myth in a way that suggests a magic spell, a sort of counter-magic, an attempt to fight off his difficulties by extreme means, now that subtlety and patience have brought only frustration.

Ruskin interprets the painting of Apollo and Python as a reflection of Turner's own most intimate struggle. It symbolizes, he says, Turner's solitary fight, the battle of light and color against the darkness of his time and its dark art. But unlike the Greek god Apollo, who successfully defeated the ruin and mortal sin embodied in Python, Turner was not victorious. Turner's public would neither look nor hear but shouted: "Perish Apollo. Bring us back Python." The painting clearly depicts a hollow victory. Out of the body of the dying monster struggles a smaller dragon, newborn: "Alas, for Turner! This smaller serpent-worm, it seemed, he could not conceive to be slain. In the midst of all the power and beauty of nature, he still saw this death-worm writhing among the weeds. . . . He was without hope. . . . He is distinctively . . . the painter of the loveliness of nature, with the worm at its root: Rose and cankerworm,—both with his utmost strength; the one *never* separate from the other."

As for the dragon in the other painting—the beast which Turner shows lording it over the paradisiac Garden of the Hesperides—it is not only unvanquished but unchallenged. Ruskin, after tracing complex mythological affiliations, concludes that this is the "Dragon of Mammon." Thus, the smoke-breathing monster's

sphere of influence reaches beyond the garden in the narrow sense: it is the grotesque symbol of capitalism, darkening and suffocating the garden of England.

Ruskin goes so far as to call this work "our English painter's first great religious picture; and exponent of our English faith."

> A sad-coloured work, not executed in [Fra] Angelico's white and gold; nor in Perugino's crimson and azure; but in a sulphurous hue, as relating to a paradise of smoke. That power, it appears, on the hill-top, is our British Madonna. . . . This is no irony. The fact is verily so. . . . In each city and country of past time, the master-minds had to declare the chief worship which lay at the nation's heart. . . . Thus in Athens, we have the triumph of Pallas; and in Venice the Assumption of the Virgin; here, in England, is our great spiritual fact for ever interpreted to us—the Assumption of the Dragon. No St. George any more to be heard of; no more dragon-slaying possible.

"Without hope," "for ever," "no St. George," "no more dragon-slaying": so, the author concludes, his five volumes on "visible beauty" have no subject in the end, no message, and, in fact, no reader. "I say *you* will find, not knowing to how few I speak; for in order to find what is fairest, you must delight in what is fair; and I know not how few or how many there may be who take such delight. Once I could speak joyfully about beautiful things, thinking to be understood;—now I cannot any more; for it seems to me that no one regards them. Wherever I look or travel in England or abroad, I see that men, wherever they can reach, destroy all beauty."

Ruskin had always been a writer who was trying to reach the public. When treating abstractions, he kept his style discursive and accessible in the best English tradition; and when he turned to images of art and nature, he tried to let the reader participate directly in his experience. Now, when his multivolume book was coming to an end—and with it a phase of his own life—new, less

accessible images flooded his pages, and his dialogue style turned into a monologue. Only a few years earlier, in 1855, he had asked Robert Browning to write less obscurely, to be more responsive to the claims of the reader. Browning's dismissive reply was: "I write in the blind-dark, and bitter cold, and past post-time as I fear." This would not make a bad motto for the final passages of *Modern Painters*, with their novel, unconventional rhythms.

Modern Painters ends with the interior monologue of a prophet without a people. The voice still nominally addresses the reader, but this does not disguise the fact that we are listening to someone talking to himself. His last chapter is called "Peace," but the speaker is not peaceful as, once more, he calls out the roll of all those key figures which entered his text at the last, to its perdition: the images and obsessions—day and night, light and darkness, garden and desert, gardener-God and dragon, life and death. Once the champion of the creative exchange between maker and receiver, he had addressed these words to his reader, near the end of his second major work, *The Stones of Venice*: "You must be all mine, as I am all yours; it is the only condition on which we can meet each other" . . . "face to face, heart to heart." He must have in mind a different model of exchange now, when he calls his readers "the Chaos children" and "the Dragon children." All the faithful readers and collaborators in *Modern Painters* have been preached right out of the church of art:

> Kindreds of the earth, or tribes of it! the "earth-begotten," the Chaos children—children of this present world, with its desolate seas and its Medusa clouds: the Dragon children, merciless: they who dealt as clouds without water: serpent clouds, by whose sight men were turned into stone;—the time must surely come for their wailing.
>
> "Thy kingdom come," we are bid to ask then! But how shall it come? With power and great glory, it is written; and yet not with observation, it is also written. Strange kingdom! Yet its strangeness is renewed to us with every dawn.
>
> When the time comes for us to wake out of the world's

sleep, why should it be otherwise than out of the dreams of the night? Singing of birds, first, broken and low, as, not to dying eyes, but eyes that wake to life, "the casement slowly grows a glimmering square"; and then the gray, and then the rose of dawn; and last the light, whose going forth is to the ends of heaven.

This kingdom it is not in our power to bring; but it is, to receive. Nay, it is come already, in part; but not received, because men love chaos best; and the Night, with her daughters. That is still the only question for us, as in the old Elias days, "If ye will receive it." . . . But it is still at our choice; the simoom-dragon may still be served if we will, in the fiery desert, or else God walking in the garden, at cool of day. . . . The choice is no vague nor doubtful one. High on the desert mountain, full descried, sits throned the tempter, with his old promise—the kingdoms of this world, and the glory of them. He still calls you to your labour, as Christ to your rest;—labour and sorrow, base desire, and cruel hope. So far as you desire to possess, rather than to give; so far as you look for power to command, instead of to bless; so far as your own prosperity seems to you to issue out of contest or rivalry, of any kind, with other men, or other nations; so long as the hope before you is for supremacy instead of love; and your desire is to be greatest, instead of least;—first, instead of last;—so long you are serving the Lord of all that is last, and least;—the last enemy that shall be destroyed—Death; and you shall have death's crown, with the worm coiled in it; and death's wages, with the worm feeding on them; kindred of the earth shall you yourself become; saying to the grave, "Thou art my father"; and to the worm, "Thou art my mother, and my sister."

I leave you to judge, and to choose, between this labour, and the bequeathed peace; these wages, and the gift of the Morning Star; this obedience, and the doing of the will which shall enable you to claim another kindred than of the earth, and to hear another voice than that of the grave, saying, "My brother, and sister, and mother."

Five
Savage Ruskin
1860–1870

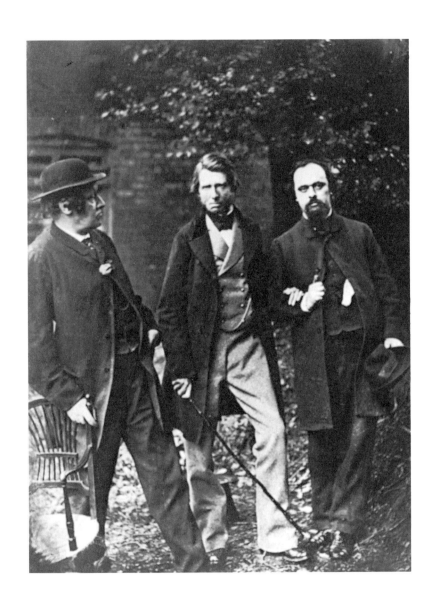

William Downey, William Bell Scott, John Ruskin, and
Dante Gabriel Rossetti, *1863*

I

What is wrong with the three men in this photograph? Isn't one of them capable of standing up straight, or of walking without leaning on someone else? Or of simply letting his hands hang down in a relaxed pose?

The figure in the middle is only forty-four years old, but the hand on the cane is that of an old man. Why is the grip so tense and nervous, as if he wanted to aim a violent blow at the object of his calculating and angry gaze? In fact, why is a man like him clutching a city walking stick at all?

One can't help but wonder who these men are. Three upright citizens caught in shady dealings by the sudden advent of a photographer? Or perhaps an amateur theater group, rehearsing out of costume, awaiting further instructions from the director? Or, more ominously, three asylum inmates walking in the hospital garden, their photograph snapped by a fanatical doctor who wants a visual record of them for his archives?

No, none of these. Two of the men are artists, and in the center is their rather eccentric visitor, who has traveled a long way to see them. The two artists are both dressed in the latest fashion—round soft hats; open, single-breasted coats over single-breasted, tight-fitting waistcoats; and wide, baggy trousers—although neither of them looks terribly comfortable. Their outfits seem to radiate outward from a single center, the top button of the frock coat, and not attune to the body at any point.

But the stranger's clothes have a different cut. They follow the lines of his body; they express it rather than disguise it. And the

body has such energy that it seems to call for this made-to-measure attire, which fits it the way a barrel or cartridge case fits a bullet. If this man stripped off his long coat so that he was perfectly free to maneuver, he would look quite capable of boxing or rowing a boat, or of using his stick to fence with. The other two, once they set aside their hats and coats, might more suitably be seated at a desk or in an armchair. Looking at this photograph as an index to recent changes in the male image, we might say that the Englishman has evolved from a well-bred gentleman whose home is wherever he happens to be, into a clerk who is at home only at home.

This is all the more striking because the two tame-looking characters on the left and right belong to a profession whose members are rarely found in a domestic setting. Both are painters, and the man on the right—the one with the beard and the very pale face—is a writer too, a lyric poet and a full-blown Bohemian, if ever there was such a thing in mid-Victorian England. At the time of the photograph he was living with one of his female models and assorted painter and poet friends in the "Chelsea Menagerie," a house on the Thames named for its colorful human and animal inhabitants. Peacocks lived in the garden where this photograph was taken, along with raccoons, kangaroos, zebus, and armadillos; while marmots, a wombat, and a quantity of ornamental birds occupied the house. Residents at the Menagerie lived up to all the clichés about the weird behavior of artists. People slept in the daytime and stayed up all night; there was a never-ending stream of feasts and drinking bouts; books like the Marquis de Sade's *Justine* and Baudelaire's *Les Fleurs du mal* were read aloud in serial installments, the way Dickens novels were read in other Victorian households. There were violent quarrels, public charges of vice, disastrous love affairs, suicide, and a great deal of hard work. Much money was earned and even more was spent.

But if even this inveterate Bohemian dresses as conservatively as a clerk, then from what liberated sphere must *he* come, the stranger who sports a blue frock coat, a light-colored waistcoat, and trousers of a supple homespun tweed that does not crease— plus a blue neckerchief and a tall top hat (which we see lying in

the grass behind his right leg)? He is a forty-four-year-old mer-chant's son who is living with his parents and at their expense: an author who can afford a distinctly personal style of dress as well as distinctly personal opinions. Judged by his background and life-style, he is no Bohemian, but neither does he belong to the middle class, who might wish to claim him as their own. Does this mean he is a dandy, then—a member of that British "sect" of which Carlyle wrote: "A Dandy is a Clothes-wearing Man, a man whose trade, office, and existence consists in the wearing of Clothes. . . . As others dress to live, he lives to dress. . . . He is inspired with Cloth, a Poet of Cloth"?

The clothing of the man in the photograph is subjectively com-bined from elements which the dandies of twenty or thirty years before would have found fashionable—in other words, they are hopelessly out of date. This man wears clothes more antiquated than his own father's. One might consider him a special type of dandy who ostentatiously harks back to the past, who has made himself a historian of clothing, in order to earn what Carlyle says is the only reward a dandy needs to live: "the glance of your eyes."

But any such creative enthusiast of clothing would have to change his outmoded styles as fast as his own time changed its architectural styles or redesigned objects of everyday use, and that is not the case here. *This* dandy goes in for real provocation: at some point he carefully matched the form, color, and fabric of his attire, and for forty years thereafter he never departed from this combination, until the day when he was no longer able to care for himself. "I am by nature and instinct Conservative, loving old things because they are old, and hating new ones merely because they are new. If, therefore, I bring forward any doctrine of In-novation, assuredly it must be against the grain of me."

A glance at the clothing of the men standing beside him might well confirm him in his view that progress is to be had only at the cost of extravagant aberrations. True, a modest increase of comfort has been derived from the new fashion: the high-buttoning waist-coat and coat make it possible to use stand-up collars, which can be frequently changed. The trouser fly can be buttoned and un-

buttoned, and there are pockets in both the trousers and the coat. These are, in short, the practical details that people loved to concoct in the second half of the nineteenth century. But these minor improvements are outweighed by the loss of overall harmony, and by the modish gimmicks which serve no purpose but to make it necessary to buy new clothes when a new fashion comes into vogue. In this photograph, the gimmicky touch is the single high button on the new coats, to which our eyes are drawn repeatedly.

But the third man, this unusual brand of dandy, has given up his chance to follow the new style, or to set one himself, and thereby has achieved the exalted goal of the "Dandiacal Sect," "*Self-worship,*" in his own special way—a way that leaves him free to pursue all his other aims and interests instead. He allows himself freedom in matters of what he calls "personal beauty," and indeed he regards freedom as the chief law of his existence: "I have perfect leisure for inquiry into whatever I want to know. I am untroubled by any sort of care or anxiety, unconnected with any particular interest or group of persons, unaffected by feelings of Party, of Race, of social partialities, or of early prejudice, having been bred a Tory—and gradually developed myself into an Indescribable thing—certainly *not* a Tory."

This "Indescribable thing" who is so proud of his autonomy longs for friendship, love, and recognition and searches intently for them in the decade 1860–70. He wants to hear that voice that says "My brother, and sister, and mother," and he would like to be able to say these words himself.

In fact, this is the motive that has drawn him to the garden at Cheyne Walk, to stand next to William Bell Scott on the left side of the photograph, and Dante Gabriel Rossetti on the right. In the decade of the 1850s, Ruskin gave art commissions and generous donations to Rossetti, and in effect supported him as well as his "ideal beloved," the unfortunate Elizabeth Siddal, who in 1860 became Rossetti's wife and who only two years later died of an overdose of laudanum in what may have been suicide.

Our photograph was taken in June 1863. By this time, Ruskin no longer needed to help Rossetti financially. Lizzie was dead and

Rossetti was earning more from his painting than Ruskin's total annual income. Now this former art patron and sometimes merciless art critic had more or less the same insecure position in life as all the members of Rossetti's emancipated household on the banks of the Thames. When his enemy Millais painted him in 1853–54, he showed Ruskin standing firmly by the mountain stream, despite the slippery, uneven ground; and in that portrait Ruskin's face wore a calm expression. But now, in this photograph of ten years later, Ruskin looks less serene; and despite his outstretched foot, and the fact that he is holding Rossetti's arm, he looks less steady on his feet. He is propping himself against his neighbor and pulling him so close that Rossetti also looks to be losing his balance, having to support himself against the man he is propping up. It is an oddly rickety arrangement and makes us question the independence of these three men. This is one of those pictures which tell the truth by showing just the opposite of what they pretend. Ruskin himself could not help but be in two minds about it. When Rossetti started circulating the photograph, Ruskin wrote him describing it as the "cause of such a visible libel upon me going about England as I hold worse than all the scandals and lies ever uttered about me." But when he wrote to his father, he described the photo in a far more positive light, and claimed he valued it fifty times more than any previously taken of him.

2

Ruskin and the Bohemians of Chelsea had much in common: neither he nor they were content, and society was beginning to turn against them.

The Victorian society built on the principle of *laissez-faire*—"Let it alone"—was no longer willing to let alone the most violent critic of this principle. In 1860, when Ruskin finally finished the last volume of *Modern Painters*, he was able to carry out his long-delayed plan to "write a great essay on Man's Work," an idea he had first conceived back in Venice.

His work began as a series of articles on political economy written for the *Cornhill* magazine and then published in book form in 1862 under the title *Unto This Last*. Ruskin himself said of it that it was "the only book, properly to be called a book, that I have yet written," although his publisher—his only publisher to date—broke off the articles to appease irate readers, on the grounds that Ruskin's contributions were "too deeply tainted with socialistic heresy."

The same events were repeated in 1862–63, when Ruskin expounded his economic theories in *Fraser's Magazine*. Once again the publisher—a different one this time—stopped his articles. Critics were unanimous in their condemnation: "utter imbecility," "intolerable twaddle"; economic thinkers deserved better than to be "preached to death by a mad governess"; it is "no pleasure to see genius mistaking its power, and rendering itself ridiculous"; "eruptions of windy hysterics." The *Saturday Review* commented: "To English feelings, the most revolting part of Mr. Ruskin's performance is his gross calumny on the nation to which he belongs. Ours is not a country to cry about."

This last sentence would, on its own, justify Ruskin's decision to devote himself entirely to social criticism. It is hardly surprising that his thinking should have taken this direction: after all, he had been laying his plans ever since *The Stones of Venice*, and only the long chore of *Modern Painters* had made him postpone them until now. No, the only remarkable thing is the exclusivity of his dedication to his new theme throughout the decade 1860 to 1870. He has entered a new epoch, indeed. Only a few lectures and articles relating to art education and art history were published during this time, and only in collections, never as independent works. Instead, his major publications lie in other fields: the two series of articles on political economy; another book on the same subject, called *Time and Tide* (1867); a book on the problems of education, *Sesame and Lilies* (1865); a work on mythology, *The Queen of the Air* (1869); a children's introduction to geology, *The Ethics of the Dust* (1866); and an anthology on a variety of sociopolitical topics, *The Crown of Wild Olive* (1866).

Such a radical reorientation by an author is unparalleled in English literature. To equal Ruskin's achievement, a man like Carlyle, after finishing his eight-volume history of Frederick II, would have had to devote his talents to a subject like gardening; or Marx, after finishing *Capital* in 1867, would have had to become a music historian. No wonder that the critics felt overtaxed and reacted with anger and hostility.

Rossetti's household at Cheyne Walk was getting no better reviews than Ruskin. Granted, they had stuck to their own field. And they had avoided offending the cardinal law of a capitalist economy, which was the compulsory freedom of trade and production. On the other hand, they had flagrantly violated the moral code of their time. In the words of Algernon Charles Swinburne, one meteoric member of the Chelsea Menagerie, they wanted to be "as offensive and objectionable as possible." When, after many false starts, Swinburne had his *Poems and Ballads* published (Ruskin had helped by going over the manuscript with him page by page) the critic Robert Buchanan commented that "the glory of our modern poetry is its transcendent purity. Swinburne is unclean for the sake of uncleanness." John Morley, the reviewer for the *Saturday Review*, judged that *Poems and Ballads* was "crammed with pieces which many a professional vendor of filthy prints might blush to sell." "Unspeakable foulnesses" was his concluding verdict. Swinburne's publisher, facing the prospect of being drawn up on charges of obscenity, was forced to withdraw the book. The author then put it in the hands of a publishing house known for dealing in pornography.

Dante Gabriel Rossetti faced problems of a different sort when he wanted to publish his collected poems: he first had to have the manuscript retrieved from his dead wife's grave. Once published, his work earned him the cruelest censure. Robert Buchanan commented: "Here is a full-grown man, presumably intelligent and cultivated, putting on record for other full-grown men to read, the most secret mysteries of sexual connection, and that with so sickening a desire to reproduce the sensual mood, so careful a choice of epithet to convey mere animal sensations, that we merely shud-

der at the shameless nakedness." The avalanche set off by Buchanan went on gathering speed for several months, until finally Rossetti was hit by its full weight when the *Saturday Review*, that same high-principled middle-class periodical which had already condemned Ruskin and Swinburne, devoted its lead article to charging the poet with immorality. The hypersensitive Rossetti, who had felt the target of a critics' conspiracy ever since the start of his career, resorted to the same remedy that had put his wife out of her misery, a drug overdose. Unlike her, he survived, but only to develop increasingly severe symptoms of persecution mania.

The three criticized critics and taboo breakers—Swinburne, Rossetti, and Ruskin—far from feeling that the public's hostility confirmed their views, were all naïve enough to be deeply wounded. Nevertheless, their reactions took a different tone. Swinburne's response was savage vituperation. He wrote of Buchanan: "The little reptile's hide demands the lash—his head the application of a man's heel, his breech of a man's toe." Ruskin merely voiced anxieties about the future: "I do not allow reviewers to disturb me; but I cannot write when I have no audience. Those papers on Political Economy fairly tried 80,000 British public with my best work; they couldn't taste it; and I can give them no more. I could as soon be eloquent in a room full of logs and brickbats."

Of course, Ruskin still had the resources to publish his theories in book form, but he knew that they would not find a wide audience unless they were circulated by the large, highly popular monthly and quarterly magazines. *Cornhill Magazine* estimated its readership at eighty thousand, which, although it was probably an exaggerated figure, greatly exceeded the fewer than one thousand readers who bought copies of *Unto This Last* in the ten years after its publication. Not until much later would editions of Ruskin's books begin to run into the hundreds of thousands. And, unlike many of his fellow authors, Ruskin had virtually never contributed articles to the popular magazines—rather like Rossetti, who had refused to give public exhibitions of his paintings. Now he was punished for his earlier aloofness when he decided that he wanted a wide audience for his work, after all. Once the magazines closed

their pages to him, he had no option except the lecture hall, but by this time there was less demand for his lecturing talents as well. No wonder, considering that he fed his lecture audiences the same type of material he had given the readers of *Cornhill* and *Fraser's*.

For example, when the stalwart but slightly naïve citizens of Bradford invited him to draw up plans for the decoration of their stock exchange, they got the following advice:

> But I can only at present suggest decorating its frieze with pendant purses; and making its pillars broad at the base, for the sticking of bills. And in the innermost chambers of it there might be a statue of Britannia of the Market, who may have, perhaps advisably, a partridge for her crest, typical at once of her courage in fighting for noble ideas, and of her interest in game; and round its neck, the inscription in golden letters, "Perdix fovit quæ non peperit."* Then, for her spear, she might have a weaver's beam; and on her shield, instead of St. George's Cross, the Milanese boar, semi-fleeced, with the town of Gennesaret proper, in the field; and the legend, "In the best market,"† and her corslet, of leather, folded over her heart in the shape of a purse, with thirty slits in it, for a piece of money to go in at, on each day of the month. And I doubt not but that people would come to see your exchange, and its goddess, with applause.

> * *Jerem. xvii. 11, (best in Septuagint and Vulgate). "As the partridge, fostering what she brought not forth, so he that getteth riches, not by right, shall leave them in the midst of his days, and at his end shall be a fool."*

> † *Meaning, fully, "We have brought our pigs to it."*

Carlyle admiringly said that Ruskin was going at society with hammer and tongs. Indeed, it was only proper that "savage Ruskin," society's scourge, should now become the target for a few blows himself. His tactics were simple: he used his reputation

as Britain's reigning art expert as a Trojan horse with which to gain entrance to the citadels of Manchester-style capitalism. Wherever he lectured, he operated basically in the same way as in Bradford:

> My good Yorkshire friends, you asked me down here among your hills that I might talk to you about this Exchange you are going to build: but, earnestly and seriously asking you to pardon me, I am going to do nothing of the kind. . . . I must talk of quite other things, though not willingly. . . . If, however, when you sent me your invitation, I had answered, "I won't come, I don't care about the Exchange of Bradford," you would have been justly offended with me, not knowing the reasons of so blunt a carelessness. So I have come down, hoping that you will patiently let me tell you why, on this, and many other such occasions, I now remain silent, when formerly I should have caught at the opportunity of speaking to a gracious audience.

His new role as social gadfly may have made Ruskin even more welcome inside the gates of the Chelsea Menagerie than his financial donations and critical talents had done in the past. But he now had another attractive feature, too: he had stayed loyal to his experience in Turin and would tell or write anyone who would listen all about his newfound paganism. His parents had to put up with letters in which he wrote them that he was an "iconoclast," "now pretty nearly infidel" and "apostate." While Rossetti was doing his portrait in 1862, Ruskin told him that he had lost his faith in revealed religion. William Rossetti, Dante Gabriel's brother, commented that same year that he found "the whole tone of his [Ruskin's] thought on religious subjects changed, and the ardent, devout Protestant figured as total disbeliever in any form of Christian or other defined faith."

The artists at Cheyne Walk must have been especially delighted to hear that the change in Ruskin's attitude to religion had also changed his judgments of art. At the time he wrote Volume Two

of *Modern Painters*, he was inclined to rank Fra Angelico even above Turner because of his purity, and had claimed as the highest rule of art that good art could come only from good men. Moreover, as recently as 1858, while studying the works which Turner had bequeathed to the nation, he had burned all the artist's pornographic drawings. Now this once scrupulously chaste critic was willing to state openly: "One would have thought purity gave strength, but it doesn't. A good, stout, self-commanding, magnificent Animality is the make for poets and artists, it seems to me." He went even further in another passage, claiming that piety was no fit quality for a great painter, who ought rather to be a bit sinful and "entirely a man of the world."

This pagan attitude not only qualified Ruskin to defend Swinburne's poetry; it even inspired him to consider leaving his fashionable home in Denmark Hill to move down into the Thames valley and join his chaotic friends at Cheyne Walk. Duty, not love, now tied him to his parents. He had in fact decided to make the move—a change which would have been no less dramatic than switching his occupation from art historian to economic critic. Paradoxically, his main reason for not doing so was his father's death, at the age of seventy-eight, in early 1864.

John James Ruskin left his son a fortune of £120,000 to do with as he saw fit, and nothing but a guilty conscience to slow him down. Freud described the death of a man's father as the most significant event and the most far-reaching loss that ever befalls him, referring, of course, to deep-lying conflicts such as the Oedipus complex and "survivor's guilt." In Ruskin's case, the matter was somewhat simpler: in recent years, he and his father had disagreed "about all the Universe"—especially about political and economic questions.

John James would have liked to see his son carry on writing eloquent passages on nature and art. But John, although he always considered his father's business conduct exemplary and acknowledged his charitable enterprises, had become a critic of capitalism and in particular of its monetary system, so he was now attacking the basis of his father's business and thus of John James's whole

existence. This was one of John's techniques of declaring his independence, while becoming independent in name only. Another such technique was to engage in continual self-analysis which never led to any practical conclusion and which surely was inappropriate when addressed to a father already in his late seventies. Indeed, only a few weeks before his death, John James received a letter—the last he would ever get from his son—which said:

> The two terrific mistakes which Mama and you involuntarily fell into were the exact reverse *in both* ways—you fed me effeminately and luxuriously to that extent that I actually now could not travel in rough countries without taking a cook with me!—but you thwarted me in all the earnest fire of passion and life. . . . If I had had courage and knowledge enough to insist on having my own way resolutely, you would now have had me in happy health, loving you twice as much . . . and full of energy for the future—and of power of self-denial: now, my power of *duty* has been exhausted in vain, and I am forced for life's sake to indulge myself in all sorts of selfish ways, just when a man ought to be knit for the duties of middle life by the good success of his youthful life.

We must add that this letter begins with Ruskin's lament that, when he tried to do some live drawing, feelings of exhaustion and disappointment made him break off his effort: "The vital energy fails (after an hour or two) which used to last one all day, and then for the rest of the day one is apt to think of dying, and of the 'days that are no more.' "

We have already noted on several occasions that Ruskin used his drawing performance as a measure of his vitality. He experienced drawing as an intense involvement with reality, in which he sought to receive and to preserve life. This living exchange between himself and nature was always a risky business and was coupled with high expectations—as we see from his "drawing lessons" in the woods at Fontainebleau and the gallery in Turin. So now he claims that the exchange has been interrupted, and accuses his

parents of being to blame for not equipping him for life. This man who learned physical stamina from his parents on their travels, who has and will long retain the energy to row ten miles at a stretch and to climb the highest peaks of the Alps, now presents himself to his family as a mollycoddled, dependent creature who is not long for this world. He paints himself in exaggerated and absolute terms, deriving a painful gratification from the knowledge that nothing can be changed. Finally, he concludes his stringent critique with a line that shows he can see no alternative to business as usual: "Yes, I shall be home (*D.V.*) on Saturday."

There is no longer any possibility of productive results from arguments addressed by a forty-five-year-old son to his seventy-eight-year-old father—not about matters like these. Indeed, the only thing that exists between them, in the father's final years, is late-blooming cruelty and remorse.

In 1862–63, Ruskin pointedly went to spend Christmas at Mornex, near Geneva, where he set up a counter-household and talked about buying land and making plans to settle abroad ("I must find a home"). It was a shock, he told his parents, but he felt happy. Later he wrote the word "cruel" in the margin of the notes he recorded in Mornex.

His father's death, when it came, failed to bring him the only thing he had hoped he might still have in life: "the one only thing I can have is liberty."

This unusually rich and intense father-son relationship—rich in both negative and positive features—came to an unsatisfying end and left a thorn in John's side. The lifelong dialogue the two had shared—they wrote each other, literally, every day when they were apart—broke off with the son's question: "And yet, so long as you think that my present ways and words are things of the surface, not of the deep, how can we in anything understand each other?"

His father's lack of understanding may indeed have disappointed John, but his father's death also meant he had lost the last person in his life who would make uncomfortable demands on him, and from whom he had learned to make uncomfortable demands on others. The elder Ruskin had been blunt and inconsiderate both in

conversation and in letters, and the younger Ruskin tried to emulate this bluntness in his treatment of the public. It was more than filial piety that made him end the laudatory inscription on his father's grave with the words: "His son, whom he loved to the uttermost and taught to speak truth, says this of him."

The virtue of speaking the truth did not desert John now, when face to face with the realities of death. People who offered him conventional expressions of sympathy risked being told that their sympathy was misplaced and would be better directed toward the real misfortunes of their times. His friends, on the other hand, were given a detailed account of his father's death, at which he had been present from start to finish. What he told Henry Acland about his feelings is quite consistent with what he had said in his last, reproachful letter to his father. He had lost, he said, "a father who would have sacrificed his life for his son, and yet forced his son to sacrifice his life to him, and sacrifice it in vain. . . . An exquisite piece of tragedy altogether—very much like Lear, in a ludicrous, commercial way—Cordelia remaining unchanged and her friends writing to her afterwards—wasn't she sorry for the pain she had given her father by not speaking when she should?"

After his father's death, Ruskin felt remorse, but otherwise his feelings were unchanged. He regretted having hurt his father at the end, too late for anything constructive to come of it, and he regretted that he had been incapable of offering criticism *and* love at the same time. But, because death brought no solution, his feelings did not alter. The pain he felt was, he found, not deadly but hard, lucid, and even invigorating, compared with other griefs, "sharp sudden sorrow which in many ways was far more deadly to me than this."

In outward respects, his life stayed the same. If anything, he was now tied more than ever to his parents' home, and to his eighty-three-year-old mother. Two years passed after his father's death before he resumed his former way of life and he began once more to go on long trips abroad. His plans to live in the wilderness enclosure at Cheyne Walk had been shattered.

3

The real entrance ticket to the Chelsea Menagerie was tortured sexuality or a history of long-drawn-out unhappy love affairs. It would take too long to list all the specialized brands of "psychopathia sexualis" we find exhibited in the lives of the Rossettis, Swinburne, Scott, William Morris, and the rest. We have enough on our hands trying to evaluate the contribution of their associate member, John Ruskin.

After the collapse of his marriage, he had grandiosely assured his friends: "My real griefs are about other matters. I could get another wife, if I wanted one, but I cannot get back the north transept of Rouen Cathedral [where restorers had begun work]." Later he took a more realistic view of his chances and abilities: "I shall never devote myself to any woman—feeling, whether erringly or not, that my work is useful in the world and supposing myself intended for it." Once these convictions, too, were taken from him, his tone turned pitiful: "I never think anybody likes me— I fancy the best they can do is to 'put up with me'—somehow I never feel as [if] they *could* like me." Then something happened which he described in these beautiful words: "A little child . . . put her fingers on the helm at the right time; and [chose] to make a pet of herself to me."

The story of John Ruskin and Rose La Touche is one of the great unhappy romances of the Victorian Age. It was unhappy, and it was also typically Victorian, because these two people, already laboring under handicaps, were forced to feel the full weight of the taboos that afflicted their century. The relationship cannot be summarized as briefly as Ruskin's marriage to Effie, despite the fact that it, too, has been the object of extensive study. Rose is far and away the most important person in Ruskin's adult life. His relationship with her shaped much of the work of his later years, and provides the key to many obscure passages. What Ruskin wrote about myths applies equally to Rose, and to her secret presence in his work:

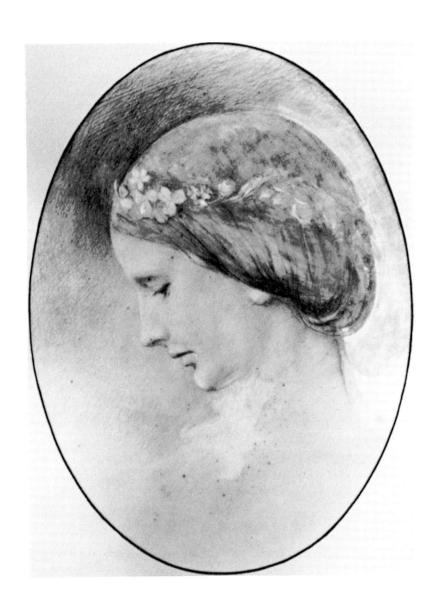

John Ruskin, Rose La Touche, *1874.*
Pencil and black-and-white washes.
The Ruskin Galleries, Bembridge School, Isle of Wight

Now you must always be prepared to read Greek legends as you trace threads through figures on a silken damask: the same thread runs through the web, but it makes part of different figures. Joined with other colours you hardly recognize it, and in different lights it is dark or light. Thus the Greek fables blend and cross curiously in different directions, till they knit themselves into an arabesque where sometimes you cannot tell black from purple, nor blue from emerald—they being all the truer for this, because the truths of emotion they represent are interwoven in the same way, but all the more difficult to read, and to explain in any order.

What began simply enough in 1858 soon turned into a hopeless tangle that lasted seventeen tortured years, until Rose's death in 1875. Indeed, for Ruskin the torment continued long after that. The story is one of psychomachia, of genuine spiritual warfare—the sort of thing Ruskin's Pre-Raphaelite friend Edward Burne-Jones could have used as the subject for a series of tapestries. Four combatants fought for possession of a young girl's soul—Rose herself, John Ruskin, and Rose's parents, Maria and John La Touche. For Ruskin, the struggle was once again for a woman's *soul*: for he did not reach her body.

The La Touches were a noted and wealthy Irish banking family, with homes in Ireland and London. The father's background was unusual in that he had grown up a fine horseman and hunting enthusiast, a perfect cliché of a British country squire, only to convert to the Baptist faith and become a fanatical believer who worked in a London mission leading prostitutes back onto the straight and narrow. His zealous faith had a strong admixture of Calvinism.

Rose's mother did not get along with her husband, in either his first or his second incarnation. Repelled by the lack of cultivation she found among her neighbors, she spent her time writing as an escape. Her cultural ambitions led her to Ruskin, whom she asked for advice about drawing lessons for her children. He was often asked for counsel of this kind, for, after the publication of *The*

Elements of Drawing in 1857, amateur draftsmen of every class, from workers to the nobility, regarded him as a national authority.

No less religious than her husband, Maria La Touche never-theless was more relaxed in her views and followed the more elegant and liberal trends of the Church of Ireland. The La Touches' second daughter, Rose, was born into the tense atmosphere of this marriage in 1848—the same year that Ruskin married Effie. John La Touche, unable to convert his wife, raised Rose in accordance with his newly acquired Calvinist principles. When Rose was nine-teen, she wrote down the history of her faith—in effect, the history of her childhood—in a style which reflected a painstaking exami-nation of conscience:

> I have said that I loved "Religion", and as I grew older I listened and took in all my father's doctrines. I suppose I was "earnest". . . . He taught me that there was but the one thing needful, one subject worthy of thought, one aim worth living for, one rule for conduct, namely, God's Holy Word. So I read and sought and let all things else drop by, with the one aim of being perfect. (I did not do it conceitedly—it is my aim still though I look back now and see the mistakes in those efforts of childhood that have cost (and gained) so much.) I saw and believed how the eternal things passed and surpassed in value all in this mortal life. . . . So I read of fasting and prayer, and I fasted and prayed. Papa said that the Bible was the great, important study, and in my playtime tired with the other studies I sat and read it—(not ostentatiously, no, my innocent delight in it was gone. I used to hide it under the table whenever my brother or sister came in), and I went down to his room and I talked to him of these things. . . . I tried to be good in the schoolroom, and to do my lessons, but the old things had got distasteful to me and the struggling with the two natures (for I was a child still) and the constant thought, I am sure made me irritable and unchildlike too. So I got ill and things used to make my head ache constantly,

and it was a weary period, all that of childhood. I was not often happy.

Quite a tale, coming from a girl of nineteen years! And, given her highly developed taste for introspection, Rose may well have guessed that this history of her past was also a prediction of her future and that the remaining eight years of her life would be no less weary and unhappy, and no less marred by religious crises, illness, and the migraine headaches that were the female plague of the Victorian Age.

If Rose's delicate portrait shows us something beyond a beautiful but bigoted soul, no doubt we owe that to the second of her two natures, the one she called her "Child-nature as well as [her] animal nature," which had given her "a great delight in what was beautiful."

The love of beauty was not all it gave her: she also had a taste for everything wild and untamed—riding, chasing through woods and fields, climbing trees; in short, all untrammeled states of nature. Her intellect, it seems, should be assigned to this side of her character. Rose had a mind that grasped things quickly; she was adept at playing with several trains of thought at a time and could be very witty.

Ruskin met Rose when she was ten and loved her by the time she was thirteen or fourteen. He soon began to idealize her, to make her seem older to himself and to others; and later, when insurmountable obstacles had come between them, he spiritualized her so as to be able to communicate with her via innumerable paintings, people, and objects. But it was her swiftness, her agility, her quick shifts that really attracted him and kept him cruelly enslaved. For a man of Ruskin's temperament, the quality of girlish unpredictability was enormously appealing: seduction and resistance, at this stage, were still a game and posed no threat.

All Ruskin's deep emotional relationships were with young girls, or with slightly older girls whom he had known when they were very young. Adèle was fifteen when he fell in love with her. Effie

had been thirteen when he first met her, and he declared his love for her five years later. He met Rose when she was ten, and proposed to her when she was eighteen—and he almost fifty-seven. None of these three girls was a proud and weary beauty: they were all lively, approachable, full of bounce.

So there is some cause for assigning Ruskin to the ranks of the "nympholeptics," the lovers of little girls. How else can we explain the fact that for years he served loyally as teacher and benefactor to a progressive girls' boarding school, that he wrote hundreds of letters to the school community and to individual girls, and that on his numerous visits he never failed to spend some time romping, dancing, and playing hide-and-seek with the girl pupils? Indeed, these girls, who are the same age as Rose, are the ones he takes into his confidence at the start of his love affair with Rose. They are the ones to whom he complains about what is always the main source of grief to those who love children: the fact that they grow up. In May 1861 he wrote them this plaintive message: "I shan't see her [Rose] again for ever so long—not till winter I fancy—and then she'll be somebody else—Children are as bad as clouds at sunrise—golden change—but change always—I was horribly sad this morning."

Several of Ruskin's biographers feel that his mistake lay in trying to conserve his love for the child Rose and then to transfer it to the grown woman. "If only Ruskin could then have ceased to love her [when she grew up], if only, like Lewis Carroll, he could have then found some new houri of the nursery," writes Quentin Bell, referring to C. L. Dodgson, the most famous of all nympholeptics and an acquaintance of Ruskin's, as was Dodgson's beloved Alice Liddell, the model for Alice in Wonderland.

This accusation may be justified in the case of Ruskin's relationship with Effie, but not in that with Rose. At this stage of his life, Ruskin had much more to lose; his prospects were no longer as favorable as they had been. Moreover, everything he did now, however private, had for him a certain symbolic purpose. He had set out to rescue this girl, his living wild Rose, from the annihilating influences of Calvinism. In trying to save her, he was fighting all

the things which had burdened his own childhood and which even now still had an oppressive effect on him: through her he was also trying to save himself, and he gained a darker view of his own childhood in the process.

All four parties drawn to the combat saw clearly that Ruskin was trying to rescue Rose from her religious upbringing. Her mother went along with his audacious criticisms of religion as long as they supplied her ammunition against her husband's fanaticism, but at a certain point she decided that the whole affair was getting out of hand, and did all she could to frustrate it.

John La Touche must have been suspicious of Ruskin from the start. What good could he expect from a guest and family friend who was known to be an outspoken critic of the nobility and of capitalism, and who confessed in private conversation that he was a convert to irreligion?

Rose, whose parents had warned her that this association was dangerous—her mother showed her letters from Ruskin that were not intended to be read by the child—began to pray for her friend's salvation. This provoked Ruskin to even more vehement declarations of his lack of faith. Rose wrote him that she was "mightily vexed" about his "heathenism," said, "You must not give the one true Good—containing all others, God—up," and asked, "How could one love you, if you were a Pagan?" He, in turn, raved, "I've become a Pagan, too," and "being a heathen is not so bad as all that."

If we consider that at this same time Rose was also the object of a tug-of-war between her parents' opposing orthodoxies, it becomes clear why she experienced such intense emotional conflict. "Heart & desires—head & judgment, my interpretations of right—& my Parents, all pulling different ways, or all mixing to puzzle a brain that cannot bear perplexity" was how she described that time in later years.

When, at nineteen, she wrote down the history of her faith, Rose seems to have taken Ruskin's side rather than her father's, for she says: "One must remember that the Calvinistic doctrine my Father taught me made everything worse for me." And: "The

letters Mr. Ruskin wrote at that time only helped me and did me no harm—whatever others may say.''

And yet she followed her father's lead at many crucial moments—"She's Cordelia—twenty times worse," Ruskin said—or, just as frequently, took refuge in illness. But it is to the discredit of all the adults concerned—including John Ruskin, who had appointed himself her guide in the "land of the living"—that she was so torn by her attempt to live up to everyone's expectations that at a significant point in her spiritual autobiography she felt compelled to write this bitter comment on a line from the 116th Psalm, "I will walk before the Lord in the land of the living": "Only it was not really walking in the Land of the Living."

The main events of the love affair, at least those which fall into the decade 1860–70, can be briefly summarized as follows. In 1861 Ruskin spent happy days vacationing at Harristown, the La Touches' country estate. In 1862 John and Rose saw each other in London, and then were apart for three years, during which time her parents forbade any contact between them, for the reasons already mentioned. Ruskin complained that since the girl had been taken from him in April of 1862 he had not known a happy hour and all his work was ruined.

In 1865 the two met again in London in the winter. Ruskin felt that Rose had grown into "a terribly Irish-Irish girl"—whatever that means. In any case, in one respect she had not changed, as a letter from her mother, written that same year, clearly testifies: "She is perfectly wild & how she is ever to be made a modern 'young lady' of, I can't imagine. She is out from dawn till dark, & it is utterly useless to put on her any raiment that would not suit a peasant, or to expect from her any observance of any of the restraints of civilisation." The reunion was a blessed and blissful time: "Happiest times, for all of us, that ever were to be," Ruskin said. He felt encouraged to propose to Rose, and she replied that he should wait three years. Her parents did not refuse their consent outright but, as soon as the lovers were apart, set out again to undermine the relationship, first forbidding the two to correspond and then refusing to allow any further meetings. Rose and John

communicated through friends who knew them both, but eventually this led to distortions of messages and to disruptions or breakdowns of communication. And Rose's behavior seemed increasingly puzzling to all concerned. When her parents finally allowed her to write Ruskin again, she sent him—even though the prohibition had been lifted—a statement along the same lines: "I am forbidden by my father and mother to write to you, or receive a letter." This enigmatic note was accompanied by two rose petals, for Ruskin to interpret as he chose.

But the years of waiting, with their accumulated uncertainty, obstructions, and setbacks, seemed as nothing compared to the disaster which now befell the lovers, and which unhinged Ruskin more than any event of his past life. The scene of the tragedy was set by Ruskin's ex-wife, Effie Millais, who had taken on the allegorical role of society in general. Enter Effie, exit John and Rose.

Maria La Touche, who had never met Effie, approached her to ask her opinion of Rose's suitor. Over the years, Effie had risen to the peak of the Victorian art world at the side of her extremely successful but by now extremely corrupt husband, Millais, for whom she acted as agent. She was a capable, wealthy, and influential woman, and now she scented the opportunity for delayed revenge. Also, she was afraid of having the past stirred up again, and wanted to forestall any possible misunderstandings as to the circumstances of her first marriage. Her report to Maria was devastating: Ruskin's behavior, she said, could be excused only on the grounds of madness. "He is quite unnatural and in that one thing all the rest is embraced."

Effie's hints about Ruskin's "unnaturalness" were just precise and just vague enough to convince the La Touches that they were right, and to plunge Rose into agonizing doubt. To make matters worse, at Effie's urging, the ever-zealous race of lawyers set a fatal trap for Ruskin. Her attorneys argued that it was illegal for him to contract a second marriage, because if his second union were to produce a child, it would disprove the legal grounds of his 1854 annulment—his impotence—and consequently his first marriage would become valid again, with the result that the marriages be-

tween Effie and Millais and between Ruskin and Rose La Touche would be annulled, and the children of the invalid marriages would be illegitimate. This legal opinion was then countered by a second opinion, but this failed to help Ruskin, because by now Effie had threatened to disclose to the public the grounds for their annulment if he tried to marry again.

As soon as Ruskin learned of these machinations, he concluded that "all is over." And he was right: the longed-for day when Rose would come of age, end his three-year waiting period, and reply to his proposal passed without a word from her. He next saw her on January 7, 1870, when they accidentally ran into each other at an art exhibit. They had by then been separated for four years. Rose ignored him.

He realized, in the light of Effie's intervention, "that this thing, whatever it is, has been openly against me from the year 1854 till now." How could he explain things to Rose, a hypersensitive girl whose brooding imagination, fed on Bible readings and religious tracts, had painted monstrous images of vice and unnaturalness? Should he have said or written to *her* what he told various go-betweens: that in fact he was not impotent, that he had merely been a masturbator, one whose seed begot nothing? In one letter we read these confused sexual confessions of a Victorian man: "Have I not often told you that I was another Rousseau?—except in this—that the end of my life will be the best—has been—already—not best only—but redeemed from the evil that was its death. But, long before I knew her, I was, what she and you always have believed me to be: & I am—and shall be—worthy of her. No man, living, could more purely love—more intensely honour. . . . From Sin I am saved already."

All that Ruskin had asked for himself and Rose was a life independent of both sets of parents and independent of the bonds of conventional religion and morality: a life that would give life, a last chance of fruitfulness. His life was slipping away from him and he fought back, trying to halt time; he fought society too, to gain for himself what he had wanted for everyone: the "extension of life," "immediate life." But he was doomed to suffer in his

private existence the same fate which had dashed his hopes for society and turned him into its critic. The machine of religious and sexual morality, and of work and social morality, that governed his country and his times was, he found, universally constricting and lethal in its effects. He realized that he and Rose were doomed to die that "English death" that he had described in *Modern Painters*: "No decent, calculable, consoled dying. . . . [But the life] rotted down to forgotten graves through years of ignorant patience, and vain seeking for help from man, for hope in God—infirm, imperfect yearning, as of motherless infants starving at the dawn; oppressed royalties of captive thought, vague ague-fits of bleak, amazed despair."

<p style="text-align:center">4</p>

If we turn now to the question of how this emotional disaster affected Ruskin's writing, we find that its influence is expressed on different levels which must be looked at separately.

First, there are the writings in which he speaks directly to and about Rose, or alludes to his relationship with her indirectly. For seven long years he was not allowed to see his beloved, and often he was also banned from writing her. At such times he sought alternative forms of expression by which he might still reach her or her guardians. One example is the book *Sesame and Lilies*, a small tract on education and modern culture and one of Ruskin's most successful works, first published in 1865. Ruskin used the Preface to the second edition (also 1865) to update a theme which he had first treated in Volumes Three and Four of *Modern Painters*: the destruction of the Alps by tourism. This theme was only distantly related to the main subject, but Ruskin felt obligated to keep his readers abreast of new developments in problems which had not been corrected or indeed were growing worse:

Some year or two back, I was staying at the Montanvert to paint Alpine roses, and went every day to watch the budding

<p style="text-align:center">293</p>

of a favourite bed, which was rounding into faultless bloom beneath a cirque of rock, high enough, as I hoped, and close enough, to guard it from rude eyes and plucking hands. But . . . on the day it reached the fulness of its rubied fire, I was standing near when it was discovered by a forager on the flanks of a travelling school of English and German lads. He shouted to his companions, and they swooped down upon it; threw themselves into it, rolled over and over in it, shrieked, hallooed, and fought in it, trampled it down, and tore it up by the roots: breathless at last with rapture of ravage, they fixed the brightest of the remnant blossoms of it in their caps, and went on their way rejoicing.

They left me much to think upon; partly respecting the essential power of the beauty which could so excite them, and partly respecting the character of the youth which could only be excited to destroy.

The experience Ruskin describes here is as suggestive and multifaceted as a dream: the untouched Alpine roses; the protective circle of rock; the favorite bed; the destructive invasion of the strange young boys whom civilization has brought into the solitude of the mountains; the power of beauty and the excitement of destroying it; the "true lover of natural beauty" who watches the scene reflectively but does not intervene. The reader must assemble and reassemble the details, and in all their configurations he will find them a suitable introduction to a book whose author is trying to warn his poor Rose of dangers both from within and from without. He uses the phrase "my poor roses" when referring to this scene of carnage, and in the passage itself counts himself lucky to have seen them while they are still "budding" and still in "faultless bloom." He ends his preface with the words: "And it is one of the few reasons which console me for the advance of life, that I am old enough to remember the time . . . when from the marble roof of the western vault of Milan, I could watch the Rose of Italy [Monte Rosa] flush in the first morning light, before a human foot

had sullied its summit, or the reddening dawn on its rocks taken shadow of sadness."

Once he gets into the main body of the book, Ruskin rapidly switches over from mere allusion to explicit warnings and direct condemnation. Education must be an "advancement of life," he says; it must not serve either the new religion of "getting on" or the old one of "advancement to the next life." And there is no doubt at all to whom he is addressing his warning against "false religious teaching" and fanaticism which "puffs up" its devotees: "Your converted children, who teach their parents [read: male admirerers]; your converted convicts, who teach honest men; your converted dunces, who, having lived in cretinous stupefaction half their lives, suddenly awaking to the fact of there being a God, fancy themselves therefore His peculiar people and messengers [Maria La Touche had called her husband's early life "low and selfish," whereas, after his conversion, his brethren celebrated him as a Baptist missionary in Papist Ireland]; your sectarians of every species, small and great, Catholic or Protestant, of high church or low, in so far as they think themselves exclusively in the right and others wrong [Ruskin wrote in one of his letters about "the accursed sect of religion she has been brought up in"]; and, pre-eminently, in every sect, those who hold that men can be saved by thinking rightly instead of doing rightly, by word instead of act, and wish instead of work [commenting on the La Touches' Irish estate, Ruskin wrote that "A park with no apparent limit, and half the country round paying rent, are curious Paraphernalia of Christianity"];—these are the true fog children—clouds, these, without water; bodies, these, of putrescent vapour and skin, without blood or flesh: blown bagpipes for the fiends to pipe with—corrupt, and corrupting,—'Swollen with wind, and the rank mist they draw.' "

Exaggerated invective often fails to hit its mark. In case any of Ruskin's addressees have failed to recognize themselves in his diatribes, he proceeds with a somewhat calmer exhortation:

There *is* one dangerous science for women—one which they must indeed beware how they profanely touch—that of theology. Strange, and miserably strange, that while they are modest enough to doubt their powers, and pause at the threshold of sciences where every step is demonstrable and sure, they will plunge headlong, and without one thought of incompetency, into that science in which the greatest men have trembled, and the wisest erred. . . . Strange, in creatures born to be Love visible, that where they can know least, they will condemn first. . . . Strangest of all that they should think they were led by the Spirit of the Comforter into habits of mind which have become in them the unmixed elements of home discomfort; and that they dare to turn the Household Gods of Christianity into ugly idols of their own.

At this point all rationality goes out the window again. The paragraph which began on an essayistic note, "There *is* one dangerous science for women," concludes in an outburst of venomous spleen. This is the voice of a preacher who can't refrain from delivering the crowning blow: "into ugly idols of their own;—spiritual dolls, for them to dress according to their caprice; and from which their husbands must turn away in grieved contempt, lest they should be shrieked at for breaking them."

Passages like this are a clear sign of the severe emotional stress which now weighs down all of Ruskin's work. His polemics regularly end on a highly emphatic note, erupt into verbal overreaction. Whether he is speaking or writing, his argument thunders toward its conclusion, delivering crushing blows along the way. This tendency to let language take him over, to publish a stream of consciousness, first showed itself at the end of *Modern Painters*. Now it becomes more frequent, although it still occurs only intermittently.

Ruskin knew that *Sesame and Lilies* made an ideal vehicle by which to communicate with Rose and her family, and, accordingly, he devoted one-third of the book to the question of how to educate young girls, and to the role of women. The whole work is riddled

with allusions and direct references to the La Touches which we have not space enough to list here. But we can show examples of how Ruskin made abstract arguments concrete and adapted them to the events of his own tale of love and grief.

In the draft of his preface to the new 1871 edition of *Sesame and Lilies*—the first published after Effie's intervention in his affairs—Ruskin confessed that, since the last edition was published, he had seen "more of the evil that is in women than good" and that they had taught him "the gloomiest secrets of Greek and Syrian tragedy." Some women suppose that "all will be brought to a good end" because of "the doctrines of shallow religion." "I have seen mothers . . . guard their children as Athaliah did hers; and children obey their parents as the daughter of Herodias."

And Rose? She of course read *Sesame and Lilies*, for Ruskin had inscribed a copy especially for her. We know nothing of her reaction, but we do know from a similar case how well the secret dialogue between the author and his young reader functioned. In 1869 Ruskin published *The Queen of the Air*, an essay on the storm and cloud gods of the Greeks which is lavish in its praise of the beauty and humanity of ancient Greek mythology. He confided to a friend that the text contained things that only Rose would understand—and Rose understood. In one passage, Ruskin speaks of Christianity's corruption of the ancient symbol of the serpent, and the parallel corruption of Christian people: "And truly, it seems to me, as I gather in my mind the evidences of insane religion, degraded art, merciless war, sullen toil, detestable pleasure, and vain or vile hope, in which the nations of the world have lived since first they could bear record of themselves—it seems to me, I say, as if the race itself were still half-serpent, not extricated yet from its clay; a lacertine breed of bitterness." In the margin of her copy, Rose wrote this query beside the passage: "? Poor green lizards! they are not bitter: Why not say serpentine?" And, indeed, we may wonder why Ruskin wrote "lacertine breed" and not "serpentine breed," since, after all, the entire chapter is devoted to serpents.

Ruskin's odd choice of vocabulary, and Rose's query, will make

sense only to those who know that, in Ruskin's circle, Maria La Touche was known as "Lacerta," the Lizard. And only this fact makes clear why the passage then moves on to this malevolent conclusion: "a lacertine breed of bitterness—the glory of it emaciate with cruel hunger, and blotted with venomous stain: and the track of it, on the leaf a glittering slime, and in the sand a useless furrow."

But *The Queen of the Air* does more than merely address the story of John and Rose on the level of little messages to an "implied reader": Rose herself, who then listlessly annuls them with comments in the margins. The turmoil which Rose released in John— the sexual and emotional tangles, distress at aging, the social and religious heresies—covered too much ground to be worked into his writings only in a direct form, or in minute doses of allusion. As a result, Ruskin stepped up his use of symbols, of the storehouse of collective myth, so as to voice his concerns more clearly, yet still covertly. Here we encounter another level on which the love affair entered Ruskin's writing: the symbol. As Carlyle had said in his chapter "Symbols" in *Sartor Resartus*, "In a Symbol there is concealment and yet revelation"—and that just about says it all.

5

We have seen how, at the end of the 1850s when he had finished *Modern Painters*, emotional tensions built up in Ruskin which he transformed into a new language and a new set of themes, infused with powerful allegorical imagery. The causes for this radical transformation that divided his life into two halves lay not so much in his personal life as in his work life and in his clashes with his own times. Given the speed of historical developments, he found "the old road" too slow and introspective, and so grasped at more powerful tools such as Biblical speech and the posture of a prophet.

In the decade of the 1860s, he came under added emotional pressure that reinforced his tendency to invoke a vivid preexisting system of imagery. And this brings us back to the subject of the

Chelsea Menagerie, which can rightly be called the germ cell of the British Symbolist movement.

In the beginning, the Pre-Raphaelites had been uncertain whether they wanted to pursue realism or iconography in their attempts to imitate the early Italians, and they managed to combine the two for a while. By 1855 or so, they were leaning more and more toward a fantasy world made up of historical, mythological, and purely imaginative elements. In his programmatic text *Hand and Soul* (1849–50), Rossetti had interpreted allegorical painting as only one of the three possible approaches to painting, and, even so, not the highest. In his canon, self-expressive art still ranked above allegorical art and art as the imitation of nature.

The second manifesto of the Pre-Raphaelite movement was the short-lived *Oxford and Cambridge Magazine* (1856), in which self-expression blends indistinguishably into symbolism. It is no accident that Rossetti uses the phrase "The Dreamland" to describe the spiritual homeland of the Pre-Raphaelite Brotherhood, for their magazine revels in symbolic visions and somnambulistic fantasies. In 1857–58, James Thomson and William Morris launched their long series of allegorical poems with "The Doom of a City" and "The Defence of Guenevere." The year 1858 also saw the publication of George MacDonald's *Phantastes: A Faerie Romance for Men and Women*. These works signaled the birth of a new literature whose products might be termed "art myths," the ancestors of modern fantasy and science fiction. (MacDonald, by the way, had repeatedly acted as go-between for Rose and John during the long years when they were forbidden to communicate, and served both in the role of father confessor.)

The year 1859 has been called English literature's year of destiny, because it brought the publication of FitzGerald's *Rubáiyát of Omar Khayyám*, George Eliot's *Adam Bede*, John Stuart Mill's *On Liberty*, and Darwin's *Origin of Species*. This year, it has been said, marks a turning point, the start of a late-Victorian period in which skepticism and pessimism become the most prominent features of literature. And yet the years 1856 to 1858 have an equal claim to

be viewed as a watershed, if we consider the vast scope, productivity, and duration of the symbolist movement that began then. Even staunch realists like Ruskin and Dickens did not escape its influence. Mention of the allegorical symbolism of Dickens's novels of the late 1850s has today become a critical cliché, but perhaps nothing testifies so powerfully to the mesmerism and inevitability of symbolism as the fact that Ruskin, the "priest of nature," came to invoke a synthetic reality and, indeed, is now accounted "the major Romantic myth-maker of the Victorian era."

Ruskin's break with his past was profound but not total, however. His recourse to myth was a cry for help, but not a surrender to the irrational. His life, virtually, had split into two halves connected by one thing only now and to the end of his days: his concern to know nature. One could say that after 1860 myth assumed the role in his life which art had occupied previously. Both art and myth filtered the "truth" of nature and made it accessible to human senses.

Now for the second time Ruskin declared war on the "science of facts," but this time he defended not the "science of aspects" but the "science of essence," a science of "eternal facts." Understanding essence required qualities different from those of a scientist of aspects or a scientist of facts. Receptive senses were less important than experience of life:

> The first of requirements, then, for the right reading of myths, is the understanding . . . that [they are] founded on constant laws common to all human nature; that [they perceive], however darkly, things which are for all ages true;—that we can only understand [them] so far as we have some perception of the same truth;—and that [their] fulness is developed and manifested more and more by the reverberation of [them] from minds of the same mirror-temper, in succeeding ages. You will understand Homer better by seeing his reflection in Dante, as you may trace new forms and softer colours in a hillside, redoubled by a lake.

It isn't hard to recognize in this passage Ruskin the theorist of sensory perception and infinite diversity adapting old ideas to a new theme. Myth is a current event: it is a message waiting for someone to hear it, a claim which has still to be settled, and its message actually intensifies each time the myth is reworked. In short, myth is complex.

In our discussion of Rose, we quoted the passage in which Ruskin compares myth-reading to tracking a thread through the rich, variegated pattern of a silk tapestry. In another suggestive passage, he complains of the inability of language to represent a complex of symbolic associations simultaneously in the way that myth can: "I am compelled, for clearness' sake, to mark only one meaning at a time. Athena's helmet is sometimes a mask—sometimes a sign of anger—sometimes of the highest light of æther: but I cannot speak of all this at once." Ruskin attributes to myth the power to convey dual or multiple meanings. He speaks of the "curious reversal or recoil of the meaning which attaches itself to nearly every great myth," and which causes each of its meanings, more or less automatically, to produce its opposite.

The truth myths contain comes from their being personal interpretations of nature. Myths result from instinctive operations of the human mind which make conscious to man facts that affect his fate and happiness; in other words, they are messages for the *individual*. But myths also represent unconscious and accurate interpretations of natural phenomena; that is, they are equally "instinctive" messages about the universal truths, the eternal laws, of nature.

Ruskin had been inspired to the latter conclusion by the Oxford Sanskrit scholar Max Müller, who explained myth as a reflection of the elementary processes of nature. But whereas Müller had merely used this theory as the springboard to his speculations on the origin of language, Ruskin took it very seriously and surprised his readers with repeated hints that certain statements of Greek mythology were the poetic paraphrase and anticipation of some fact of contemporary science.

Ruskin stood alone in his time in this naturalistic interpretation of myth. And yet, objective as the theory may appear, it derives in large part from his wish to keep man's bond with nature intact. If myth always treats of the primordial unity followed by the dissolution of unity, then mythology in general often represents an attempt to restore that unity—and, as we see from Ruskin's case, this attempt is not necessarily equivalent to invoking the irrational. Myth's foundation in nature moved Ruskin so deeply that on occasion he tried to dismiss man's processing of myth, which previously he had said was essential, so as to reach the thing itself, the underlying object in nature:

And, indeed, all guidance to the right sense of the human and variable myths will probably depend on our first getting at the sense of the natural and invariable ones. The dead hieroglyph may have meant this or that—the living hieroglyph means always the same; but remember, it is just as much a hieroglyph as the other; nay, more,—a "sacred or reserved sculpture," a thing with an inner language. The serpent crest of the king's crown, or of the god's, on the pillars of Egypt, is a mystery; but the serpent itself, gliding past the pillar's foot, is it less a mystery?

One wonders what a science of the "living hieroglyph"—a mythology of "natural myths"—could consist of, apart from the ancient myths themselves. Ruskin resolves this dilemma, as he so often does, in literary form, not systematically. His solution consists of brief and playful sketches of objects, evocations of their vital characteristics, which replace the science of aspects with a science of expression. The impromptus spring at us like little ambushes. This technique is responsible for some of the most beautiful passages in English prose. Here is the "living hieroglyph" of the snake:

That rivulet of smooth silver—how does it flow, think you? It literally rows on the earth, with every scale for an oar; it

bites the dust with the ridges of its body. Watch it, when it moves slowly:—A wave, but without wind! a current, but with no fall! all the body moving at the same instant, yet some of it to one side, some to another, or some forward, and the rest of the coil backwards; but all with the same calm will and equal way—no contraction, no extension; one sound- less, causeless march of sequent rings, and spectral procession of spotted dust, with dissolution in its fangs, dislocation in its coils. Startle it;—the winding stream will become a twisted arrow;—the wave of poisoned life will lash through the grass like a cast lance.

A text like this, with its strong reliance on assonance and on- omatopoeia, may be considered a highly mimetic evocation of its subject matter, a renewal of Ruskin's attempt to reproduce life in a living form. And yet this almost magical realism points to some- thing else which Ruskin acknowledges for the first time in his theory of myth: the personal involvement of the interpreter in what he interprets—its connection to his own life history. We must draw some careful distinctions here. The "science of aspects" relied on an archive of authentic personal observations, and it lent range and color to the human senses, but this was not the same as subjectivity. In fact, when it came to the science of aspects, Ruskin expressly demanded the "obliteration of the self before the object." On the other hand, his passage on the snake seems to show secret corre- spondences between "self" and "object." The personal fascination with a living creature coincides so exactly with the collective mem- ory of its traits that we wonder not what *observations* but what *experiences* underlie the serpent's portrait.

Ruskin's explanation of snake symbolism makes it clear why he felt attracted to this myth, with all its variety and contradiction and also its fundamental truth. It also shows why he, a "mind of the same mirror-temper," felt called on to transpose the myth so as to gain a deeper understanding of it. The "divine hieroglyph" of the snake exemplifies the "demoniac power of the earth," which gives life to the fields and likewise ends life with the grave: "Ser-

pents sustain the chariot of the spirit of agriculture." As the insignia of Aesculapius and Hygieia they stand for the power of healing. In its other aspect, the snake "as the worm of corruption . . . is the mightiest of all adversaries of the gods—the special adversary of their light and creative power—Python against Apollo." Serpents symbolize purification and also immortality, as we see from the Egyptian Ouroboros, the snake that bites its own tail. But snakes are the tokens of evil and destruction, too. As such, they are carried in the hands of the Furies, and writhe on Medusa's head.

"The Greeks never have ugly dreams," Ruskin said—but *he* did. It was his recurrent dreams of snakes which drove him to write about the snake myth. One of his snake dreams is described in his diary as taking place on the night of March 9, 1868, a date when he was working on his studies of mythology:

> I took too much wine. Dreamed of walk with Joan and Connie, in which I took all the short cuts over the fields, and sent them round by the road, and then came back with them jumping up and down banks of earth, which I saw at last were washed away below by a stream. Then of showing Joanna a beautiful snake, which I told her was an innocent one; it had a slender neck and a green ring round it, and I made her feel its scales. Then she made me feel it, and it became a fat thing, like a leech, and adhered to my hand, so that I could hardly pull it off—and so I woke.

One doesn't need to be a sophisticated interpreter of dreams to figure out what is going on in the second part of this one. A dream about a snake which first is thin and then, after it is handled by a woman, becomes thick and clings to the dreamer's hand must have been triggered by a powerful physical stimulus. This is a wet dream, or the kind of dream produced by an early-morning erection due to a strong urge to urinate. (Ruskin tells us he "took too much wine.") The snake, of course, is phallic. Ruskin may well have known that snakes are often phallic symbols in mythology,

from the standard work he consulted, James Ferguson's *Tree and Serpent Worship* (1868).

But tracing the dream back to an organic stimulus doesn't really tell us much. More important is that certain values are attached to the symbols and events. The snake in Ruskin's dreams—his private hieroglyph—shares with the "living hieroglyph" evoked by the assonantal portrait the fact that it has a contradictory nature, a "forked tongue." When the snake is left undisturbed, it is "beautiful" and "an innocent one," but when disturbed, it is ugly, evil, and disgusting, as the comparison to a leech makes clear.

Clearly, though, the dreamer feels a powerful temptation to transfer the snake from a harmless state to a dangerous one. There is no doubt about the actual sequence of events. The dreamer awakes from his struggle with the evil snake as from a nightmare, and in this nightmarish state all snake dreams seem to him to be obsessions. He has no doubt that such dreams are "mental evil taking that form" and he is happy to record that for long spells he experiences "no disgusting or serpent dreams." If we read his dream as a fairly transparent paraphrase for masturbation, then the negative emphasis at the end becomes even easier to understand. This was the sin he described as Rousseau's vice, of which he had to confess he was guilty, after Effie's accusation of his "unnaturalness" had poisoned his relationship with Rose. Although at that time he protested that he was cured, this seems doubtful if we consider certain symptoms he lists in his diary, and the increase in his dreams about snakes.

During the years 1865–68, when Ruskin was waiting for Rose to agree to marry him, it was particularly important for him to refrain from "sin." Yet, on the other hand, the only way for him to refute the distressing verdict that he was impotent was by constant masturbation. This created one of those emotional double binds that make obsession permanent and turn symbols into symptoms. Thus, it is relatively unimportant whether we interpret the snake dreams as the guilt-racked experience of wet dreams or the guilt-racked reflection of ongoing masturbation or the guilt-racked resumption of "youthful sins"; the essential thing is that they pro-

voked guilt. And consequently we can understand why Ruskin related the snake symbol to "remorse for sin, or grief in fate."

Something else is obvious, too. Ruskin, who had set himself up as the savior who would rescue Rose from the religious and moral clutches of her parents and her times, was unable to free himself from those same clutches. His battle with the snake—that is, with "sin"—went on until the end of his life. This shows that he had completely accepted the Victorian condemnation of masturbation. The snake which turns into a sucking leech at the end of his dream is a pictorial representation of the view then held by academic medicine and circulated in popular manuals that masturbation drained a man's energy and shortened his life. William Acton, a leading Victorian authority on sexuality, warned: "Such indulgence is *fatal*. . . . From Solomon's time to ours, it is true that it leads to a 'house of death.' . . . Apathy, loss of memory, abeyance of concentrative power and manifestation of mind generally, combined with loss of self-reliance, and indisposition for or impulsiveness of action, irritability of temper, and incoherence of language, are the most characteristic mental phenomena of chronic dementia resulting from masturbation in young men."

The so-called scientific etiology of this grave "syndrome" was very simple, so simple that it was common knowledge. The symptoms resulted because "the large expenditure of semen, has exhausted the vital force."

The dangerous thing about medical opinion of this sort is the effect that it produces—in conjunction with superstition, morality, and religion—on the "sinners" involved. The guilt implanted in them led "self-abusers" (as the contemporary jargon expressed it) to develop precisely those emotional and physical symptoms which doctors had diagnosed would result. Medicine once again displayed its genius in the analysis of secondary symptoms: Acton claimed that the anxiety experienced by the masturbator (which men like him had helped to foster) was often closely tied to feelings about religion, which "forms a noted subject of conversation or delusion" in the illness.

But we have not yet explored the symbolism of Ruskin's dream.

His relationship with Rose not only dominated his waking life but also intensified his dream life during this period and took on a variety of forms at night. In the snake dream we are looking at now, it is important that the dreamer shows the snake to a young girl and the two of them offer it to each other to feel. First he makes her feel it, then she does the same with him—and the snake grows fat. The dream speaks a very artful language. Not only does it speak of a wish for mutuality in love, but it also testifies to the final victory of auto-eroticism: for it is not the woman's touch but his own (directed by her) which makes the snake swell up.

In the first part of the dream, the woman is named Joan, and in the second part, the part dominated by the snake, she is called Joanna. Ruskin's cousin was commonly known as Joan in their household, which she had joined in 1864. (The "Connie" of the dream is Joan's friend Constance Hilliard.) Ruskin says that in his dream he showed the snake to "Joanna." At this point the woman stops being Joan Ruskin and becomes a sort of personification of a virgin, like Jeanne d'Arc. Presumably this maiden represents more than "leftover business" from Ruskin's day and in fact stands for the "wild" virgin he is really thinking about. His inner censor would not allow him to involve Rose directly in an incident which is so transparently sexual, so he substituted a harmless female relative instead.

Even the most skeptical observer must accept that the woman and the snake are the driving elements of the dream and suggest a wider range of meanings. Often, a dream breaks down into separate or opposite components, things which actually are identical or parts of a whole, or at least complementary. Not only Ruskin's personal mythology but the general worlds of myth and imagery show many instances of girls and women with snakelike traits and vice versa. It was changefulness, mobility, continual self-transformation, elusiveness which attracted Ruskin to his child-lovers, and especially to Rose. In 1858 he wrote in a letter to his father from Turin: "One of the finest things I saw at Turin was a group of neglected children at play on a heap of sand—one girl of about ten, with her black hair over her eyes and half-naked, bare-

limbed to above the knees, and beautifully limbed, lying on the sand like a snake."

Ten years later, when he saw a young girl performer dance a grotesque dance accompanied by music, she reminded him of a rattlesnake. And in 1866, when he wrote the lectures of *The Ethics of the Dust* for the young girl pupils of Winnington School, he included in one dialogue the description of a scary Dantesque valley where serpents lived in the trees. One little girl felt frightened, whereupon he consoled her with the dubious reassurance that "The serpents would not bite you; the only fear would be of your turning into one!"

For Ruskin, the union of woman and snake is the embodiment of evil: "half-maiden, half-serpent; . . . she is the spirit of all the fatallest evil, veiled in gentleness: or, in one word, treachery;— having dominion over many gentle things;—and chiefly over a kiss." Obsessive dreams like the following make it easier to understand the obsessive quality of his daytime thoughts: "Got restless—taste in mouth—and had the most horrible serpent dream I ever yet had in my life. The deadliest came out into the room under a door. It rose up like a Cobra—with horrible round eyes, and had woman's, or at least Medusa's, breasts. It was coming after me, out of one room, like our back drawing room at Herne Hill, into another; but I got some pieces of marble off a table and threw at it, and that cowed it and it went back; but another small one fastened on my neck like a leech, and nothing would pull it off."

Dream interpreters no doubt could have a field day with this second snake dream, as with the first. But we must content ourselves with noting the association of ideas within Ruskin's own writings. This second dream is reminiscent of his analysis of Turner's painting *Apollo Slaying Python* at the end of *Modern Painters*. There, too, he observed a second, smaller serpent emerging from the mortal wound that had slain the large serpent. Thus, the battle with the serpent—"the strife of purity with pollution; of life with forgetfulness; of love, with the grave"—is both vain and never-ending.

In this second snake dream, the creature which slides in under

the door and then rises up as it glides into the room takes on the attributes of a woman. The dream thus allows the man to throw off his guilt and to stylize the woman into a temptress; indeed, the very principle of evil. Of course, this tactic doesn't actually free him of his compulsion. This is clear from the "horrible round eyes" of the first snake, and also the successful attack of the second snake. The snake hypnotizes the dreamer with its unwavering gaze and its bizarre movements.

In one letter, Ruskin writes this very direct statement about Rose: "Basilisk or not, I must service her, obey her—live and die for her, now. Suppose she should not be a serpent—but a flower— Or a stone? Women have been changed into flowers. Why not flowers into women?" Of course, Ruskin would not be released from the spell if Rose changed form, because it is her very power to transform which holds him captive. But the point is that, in an apparently unmotivated digression from his snake mythology, he begins to talk about plants which are associated with snakes, including the rose family, to which the apple tree also belongs: "the rose tribe, in which fruit and flower alike have been the types, to the highest races of men, of all passionate temptation, or pure delight, from the coveting of Eve to the crowning of the Madonna."

As a much younger man, Ruskin had written: "Symbolism, although very interesting, and doubtless actual, in creation, is a dangerous plaything; it has wasted the time of the whole of Europe for about two centuries; and should only be pursued when it is either perfectly plain—or as helpful to the feelings at any given moment when it suggests itself—without being insisted upon as more than a fancy." The older Ruskin learned to his sorrow how very true this insight was. Symbolism was not only a dangerous plaything; it was a total labyrinth, for every path one took was both right and wrong.

"For all the greatest myths have been seen, by the men who tell them, involuntarily and passively—seen by them with as great distinctness (and in some respects, though not in all, under conditions as far beyond the control of their will) as a dream sent to

any of us by night when we dream clearest; and it is this veracity of vision that . . . can only be interpreted by those of their race, who themselves in some measure also see visions and dream dreams." Both primary and secondary sources of myth acknowledge the symbolic power and multiple meanings of the serpent. Ruskin "realized" this power and meaning in his dreams of the late 1860s; yet, in his waking life, he treated the snake as one of those myths whose meaning could *not* be interpreted by those who first envisioned them but "which it may be for ages long after them to interpret." But *why*, we may ask. Clearly, many aspects of the snake myth were accessible to him: its changefulness, its polarities—the contrast between good and evil, male and female, fertility and barrenness, life and death—so why couldn't or wouldn't he see the basic meaning of his own dreams, rather than simply enduring them and trying to use them like experiments he conducted on himself which could be incorporated into his mythological exercises?

In *The Queen of the Air*, Ruskin in fact developed a model for the interpretation of myth which would apply equally well to the interpretation of dreams: "You have to discern these three structural parts—the root and the two branches:—the root, in physical existence, sun, or sky, or cloud, or sea; then the personal incarnation of that; becoming a trusted and companionable deity, with whom you may walk hand in hand, as a child with its brother or its sister; and, lastly, the moral significance of the image, which is in all the great myths eternally and beneficently true." To adapt this passage to dreams, we might try substituting for the three "structural parts" of myth the term "dream-triggers" (organic stimuli, the day's impressions, emotional motivations), dream formation (the translation into image and action), and dream censorship (distortion, affect, affect displacement).

Given that Ruskin was capable of such fine insight, why did he never use his diagnostic tools on himself? Actually, the lines we just quoted give us a clue to the reason: he saw myth-making as a positive activity, the positive counterpart of the negative activity of dreaming. Dreaming might have the same function as myth and

might be suitable for the Greeks, who, he said, "never have ugly dreams," but it was unacceptable in him because his dreams were ugly. His diary is filled with repetitive phrases like "disgusting dreams," "horrible dream," "vexatious and ugly dreams." Unlike myths, his dreams afforded him no "trusted and companionable deity" with whom to walk hand in hand, but only snakes that sucked him and wouldn't let go. They gave him no "beneficent" truth, but merely reflected his own "mental evil." Dreams were necessary to understand myth; but understanding myth did nothing to change the dreams. Dreams could not endure the duality of good and evil. Always it was terror that startled the dreamer awake, never a bright sense of happiness: "So you have, on the one side, the winds of prosperity and health, on the other, of ruin and sickness. Understand that, once, deeply—any who have ever known the weariness of vain desires; the pitiful, unconquerable, coiling and recoiling, and self-involved returns of some sickening famine and thirst of heart."

It is this dimension of *suffering* which separates the modern dreamer from the myth-making Greek. The Greeks, Ruskin says, made clear and distinct representations, in full control of their own instruments, and with peaceful hearts: "everlasting calm in the presence of all fate" is his description of the prominent feature of all Greek art and mythology. Modern artists, on the other hand, had not been so blessed. They were characterized by a "wild writhing, and wrestling" and by the "general spinning out of one's soul into fiddlestrings"—unlike the ancient Greek, who never expected "to find the bones of anything in his inner consciousness." In this respect, Ruskin, too, was a modern man. He could not simply accept the material of myth, with all its dualities, as a self-evident part of his existence. He had to experience and suffer through it; he had to be amazed and carried away anew by each shift in polarity.

In other words, the discussion of myth fulfills Ruskin's imperative need to deal publicly with material which troubles him in private, and to confer a pure and lucid form on things which in themselves are confusing and frightening. The examples of myth

which he selects all come from the noblest age of Greek religion, the time of Pindar and Aeschylus, for he regards the later history of mythology, including its confrontation with Christianity, as a period of decadence. The end product of myth—the repetition of myths in his own dreams—is the ultimate proof of that decadence. Consequently, as Ruskin himself acknowledges, his view of myth is actually historical. The solution to present-day problems is thus sought not by facing them directly—which is the recommended approach of the twentieth century—but by drawing a nobler counter-image out of the past.

Thinking back to Ruskin's second snake dream, we are irresistibly tempted to mention one detail which seems to bear on his theory of myth. The dreamer conquers the "deadliest," the first snake, by throwing chunks of marble at it. Is it too farfetched to imagine that this reflects Ruskin's trust in the purifying power of ancient Greek art?

6

In the 1860s, Ruskin's discourse on myth leads into mythic discourse. He adopts mythic language as his chief form of communication. We have already looked at some early examples and made a thumbnail sketch of the development of symbolic language in his work. In *The Stones of Venice*, we found him using symbolic emblems in a localized, strategic way. One such emblem was the "missing hand of God" in a Venetian sculpture, which Ruskin interpreted as a significant symptom of the beginning decline of the city.

In his lectures of the 1850s, Ruskin made frequent allusions to the allegorical world of the Italian fourteenth century and to its most important creations, Giotto's allegorical paintings in Padua, with the result that Proust, who translated Ruskin into French and followed his lead in many things, became devoted to the allegories and in turn handed on his enthusiasm to his own German translator, Walter Benjamin.

In the 1860s, Ruskin designed his own allegories: for instance, the fantastic allegory of capitalism, the goddess "Britannia of the Market," whose image he recommended to the businessmen of Bradford as an appropriate adornment for their new stock exchange. In this same period he also readopted the Biblical-prophetic tone that we heard for the first time in the finale of *Modern Painters*.

Actual paraphrases of prophetic literature are intermittent and not very elaborate in the books written after 1860. Such passages come on like sudden fits, and their chaotic sequence of words and images makes them seem out of control. They always mark moments when the despair of history fuses with the despair of the individual. The same can be said of Ruskin's private mythology, or the mythology of everyday life, which is his special contribution to the symbolist movement.

Ruskin was not alone in his recourse to allegory. The Pre-Raphaelites also drew imagery from the allegorical world of the Middle Ages. Moreover, Ruskin's Biblical language often sounds like a moderated version of "Carlylese," the defiant, invariably strident speech of his friend. But scenes like the destruction of the rose bed in *Sesame and Lilies* are typical only of Ruskin's work, and only in the period after 1860.

When we discussed the rose-bed passage, we suggested the comparison with a dream. We could take this a step further and describe such scenes as complex dream portraits—that is, tableaux in which quantities of realistic details are woven together to give the effect of a unified symbolic message.

These were the language tools which Ruskin had at his disposal when he composed his main works of the 1860s; namely, his tracts on political economy. Not only the theory but the form of these is innovative and unorthodox. In what other treatise on economics and politics could we find, for instance: a mythological study of the sirens in a discussion of the problem of money; a discourse on social justice that uses the proverbs of Solomon; a description of the grotesque acrobatics of Japanese jugglers as an illustration of modern leisure entertainment? What economist would have challenged the Pre-Raphaelite Edward Burne-Jones to produce designs

to illustrate political pamphlets, and to devise initial letters based on mythological and allegorical figures like Ceres, Proserpina, Plutus, Invidia, and Lady Poverty? Who would begin an analysis of property with a passage like this:

> And first of possession. At the crossing of the transepts of Milan Cathedral has lain, for three hundred years, the embalmed body of St. Carlo Borromeo. It holds a golden crosier, and has a cross of emeralds on its breast. Admitting the crosier and emeralds to be useful articles, is the body to be considered as 'having' them? Do they, in the politico-economical sense of property, belong to it? If not, and if we may, therefore, conclude generally that a dead body cannot possess property, what degree and period of animation in the body will render possession possible?
>
> As thus: lately in a wreck of a Californian ship, one of the passengers fastened a belt about him with two hundred pounds of gold in it, with which he was found afterwards at the bottom. Now, as he was sinking—had he the gold? or had the gold him?

Some people may regard this kind of provocative reasoning as a sign of a lack of seriousness. But from such eccentric examples Ruskin developed one of his most significant economic principles: "that possession, or 'having,' is not an absolute, but a gradated, power; and consists not only in the quantity or nature of the thing possessed, but also (and in a greater degree) in its suitableness to the person possessing it and in his vital power to use it."

What other economist, moreover, ever took his basic principles only out of Homer, Plato, Xenophon, Dante, and the Bible, and, when debating the interpretation of central categories, always relied on etymological derivations? For he believed that the political and social sciences were also governed by the truth that the first knowledge was the best and that "the highest truths and usefullest laws must be hunted for through whole picture-galleries of dreams, which to the vulgar seem dreams only."

This brings us to another important feature of Ruskin's "new epoch." His mental attitude and style were one such feature; a second is his method of acquiring knowledge. One way to emphasize this point would be to say something like this: Ruskin wrote *Modern Painters* and *The Stones of Venice*, both groundbreaking works in their field—whereas the equivalent classic in the field of political economy was not written by Ruskin but by Karl Marx. Ruskin's books on political economy—*Unto This Last, Munera Pulveris*, and *Time and Tide*—were based on a thorough reading of the ancient and medieval economists, a cursory acquaintance with contemporary authors, intensive newspaper reading, and a vast knowledge of symbolic configurations. If Ruskin had gone about writing *Modern Painters* and *The Stones of Venice* in the same way, the equivalent method would have been for him to base his knowledge of nature and art on a reading of Lucretius' *On the Nature of Things* and Lyell's *Principles of Geology*, along with Sismondi's history of Italy and Selvatico's history of Venetian architecture. Thus, Ruskin's own principle of firsthand research, the need to drink in the object "touch by touch, stone by stone"—the principle of science as realism—was discarded when he prepared his economic works.

Ruskin wrote his Political Economy as a critique of political economy, which he called a bastard science, and also as a philosophical outline of a utopian economic order. He did *not* write, as Marx did, to produce a genuinely scientific critique of the economy and of economic theory. Marx may well have visited fewer industrial towns than Ruskin and seen the insides of fewer factories, but he had spent years studying the blue books compiled by the government factory inspectors and thus had opened up an infinitely rich vein of original source material.

When Ruskin disputed methodology with the "classical economists" like Smith, Ricardo, Malthus, and Mill, he tended to accuse them of abstract, a priori thinking. Actually, this charge applied equally well to him. Ruskin was a trained empiricist, adept at pointing out the weaknesses of the theoretical method. But once he had finished criticizing its principles, he still had no real alter-

native to offer. He, too, was reduced to arbitrary decisions, with nothing to base them on but creative ideas, subjective speculations, and mythological or etymological derivations.

After his preliminary work for "The Political Economy of the Arts," the lecture series he delivered in Manchester in 1857, one might have expected him to found a new, economic version of the science of aspects, using his economic investigations to criticize the capitalist method of production, basing his argument on the design of its products and the quality of the work environment. "I am forced by precisely the same instinct to the consideration of political questions that urges me to examine the laws of architectural or mountain forms," he wrote as late as 1856.

The reversal of approach which followed had to do with more than merely his change of theme and the emergence of myth as a prime concern. It also involved a complete change in his work method, and in his way of assimilating reality. After 1860, political economy became, like mythology, a "science of eternal facts" which, as such, was "everlastingly and practically true." Consequently, Ruskin now felt entitled to proclaim at frequent intervals that his was the first correct analysis of political economy ever made.

When talking of Ruskin it is always important to point out—as he himself did—the physical location where he wrote, because he always drew inspiration from scenes which were actually present. *Unto This Last*, the series of articles which marks the start of the "new epoch," was written in Chamonix, where everything began for him once before. (This was indeed an experience not just of *déjà-vu* but of *déjà-vécu*, a repetition of past life.) *Munera Pulveris*, the second series of articles, was written in Mornex, near Geneva.

Suitable as these places may have been to inspire a work like *Modern Painters*, they were infinitely far removed from everything to do with the political economy of Britain. This time, Ruskin went there not to be close to his subject but to gain some detachment from it, to avoid the world's suffering. But soon the stillness of nature resounded with this suffering all the same. Ruskin had fallen prey to an affliction which he himself had diagnosed as the

"pathetic fallacy," and to which he had believed the true scientist was immune. In other words, he was projecting all his own emotions onto nature. His descriptions of his feelings while in the Alps are reminiscent of those experienced by Nietzsche or Munch: "The loneliness is very great [and] the peace in which I am at present . . . is only as if I had buried myself in a tuft of grass on a battlefield wet with blood, for the cry of the earth about me is in my ears continually if I do not lay my head to the very ground. The folly and horror of humanity enlarge to my eyes daily." And several months later: "I am still very unwell, and tormented between the longing for rest and lovely life, and the sense of this terrific call of human crime for resistance and of human misery for help, though it seems to me as the voice of a river of blood which can but sweep me down in the midst of its black clots, helpless."

If Ruskin intended mythology as the corrective to his world of private imagery, then he planned his lectures in political economy as a wish fulfillment of his private ideals, raised to a collective scale. For instance, if we look at his use of the key word "life" in this major passage from *Unto This Last*, we see that there is a clear parallel between life in the individual and in the society:

> THERE IS NO WEALTH BUT LIFE. Life, including all its powers of love, of joy, and of admiration. That country is the richest which nourishes the greatest number of noble and happy human beings; that man is richest who, having perfected the functions of his own life to the utmost, has also the widest helpful influence, both personal, and by means of his possessions, over the lives of others.

In effect, Ruskin is defining political economy as the science of life, and its purpose as the safeguarding of a healthy and happy life. The deeply opposed forces which he invokes at the end of *Modern Painters*—the dualism of life and death, day and night, society and solitude, fertility and barrenness—are also basic to the argument of the economic treatises. The discipline commonly referred to as political economy is, Ruskin says, the modern per-

sonification of death, and the most degenerate and paralyzing plague that has befallen human thought.

The counterpart to this corrupt theory is corrupt practice—the actual practice of English capitalism. This practical level produces "bads" instead of "goods," "illth" instead of "wealth." "Illth" is the unproductive deployment of labor and capital so as to produce unnecessary and life-destroying goods ("bads"). "Illth" is the hallmark of a system which destroys life but is incapable of producing life from this destruction, a system which produces progress but can produce no progress from the *results* of progress: "Our cities are a wilderness of spinning wheels instead of palaces; yet the people have not clothes. We have blackened every leaf of English greenwood with ashes, and the people die of cold; our harbours are a forest of merchant ships, and the people die of hunger."

To all this, Ruskin opposes his famous admonition: "There is no Wealth but Life." The science which must act on this principle must determine which goods are useful and life-enhancing, and what type of work is necessary to produce and distribute them. Political economy is not a science of "what will happen if" but a theory of what *ought* to happen: it is an ethic, centered on the concept of value.

Classical economics had drawn a distinction between use-value and exchange-value, although from then on it concerned itself only with the exchange-value. Ruskin wanted to establish use-value as the main economic criterion. Here is his "true definition" of value, *valor*.

> *Valor*, from *valere*, to be well or strong (ὑγιαίνω);—strong, *in* life (if a man), or valiant; strong, *for* life (if a thing), or valuable. To be "valuable," therefore, is to "avail towards life." A truly valuable or availing thing is that which leads to life with its whole strength. In proportion as it does not lead to life, or as its strength is broken, it is less valuable; in proportion as it leads away from life, it is unvaluable or malignant.

Making "life" the criterion underlying the production and consumption of every product also gave guidelines for regulating the other major elements of economics. "Classical economy" had always been confined in its movements, forced to pick its way anxiously among the multiple scarecrows of over- and underconsumption, over- and underpopulation, falling wages and sinking profits.

Moreover, classical economy was deeply imbued with the Protestant virtues of thrift, frugality, and duty. So now, as he moved into the world of economics, Ruskin had yet another score to settle with the evangelical heritage he had recently discarded. The adage "There is no Wealth but Life" also had the meaning that life must be wealthy, abundant, that it should embody the primary Ruskinian virtues of variety and infinity. The tasks of economics, he said, were to save present life, and to gain more. Whereas his adversaries not only wanted the masses kept at subsistence level but, on top of that, wanted to further decimate their numbers through birth control and emigration, Ruskin proposed that:

> In fact, it may be discovered that the true veins of wealth are purple—and not in Rock, but in Flesh—perhaps even that the final outcome and consummation of all wealth is in the producing as many as possible full-breathed, bright-eyed, and happy-hearted human creatures. Our modern wealth, I think, has rather a tendency the other way;—most political economists appearing to consider multitudes of human creatures not conducive to wealth, or at best conducive to it only by remaining in a dim-eyed and narrow-chested state of being.

And whereas the classical economists wanted to administer scarcity for the many and an abstract wealth for the few, Ruskin—in defiance of all English Protestant tradition—evolved the vision of a society of affluence. The words "economy" and "economical" had to be freed from their secondary meaning of frugality and saving. Their true meaning was home management, a regulated

national economy, the wise assignment of labor. "And a nation's labour, well applied, is, in like manner, amply sufficient to provide its whole population with good food and comfortable habitation; and not with those only, but with good education besides, and objects of luxury." "Luxury is indeed possible in the future—innocent and exquisite; luxury for all, and by the help of all." Luxury, thus, was possible and permissible only when it was achieved equally for all—"unto this last, even as unto thee" (Matt. 20:14).

Ruskin's entire reconstruction of economic theory can be understood from his definition of the value of goods as equivalent to "vital value," or vital use. His theory of profit, cost, and capital; his theory of work, wages, and working conditions; his theory of gold and money; his theory of demand and consumption—all these theories, partly revolutionary, partly sophistical, partly pedestrian, and wholly the views of an outsider—are too involved for us to explore here; but the foundation and keystone of them all is the analysis of *quality*, the question of how economic management benefits or harms society.

We will not accompany Ruskin the economist very far on his intricate journey, but only take a sample of how he goes about solving a difficult problem, using a blend of "old epoch" and "new epoch" approaches.

The above passage which gives the etymological derivation of the word "valor" goes on to say that the "vital value" of goods "is independent of opinion, and of quantity." It represents an "intrinsic" and "objective" value which remains fixed, independent of market situations and subjective determinations of value: "Think what you will of it, gain how much you may of it, the value of the thing itself is neither greater nor less."

In taking this stand, Ruskin moved away from all previous economic theory, of the classical and anti-classical schools as well as of the materialist or German-historical, and from the theorists of marginal profit. He chose to regard the use-value of a thing as fixed and objective, as a "power which it holds from the Maker of things and of men." He felt the need to take this position at a

time when almost everything in his life seemed shaky and under threat. At least *things* should keep a clear definition and value, serving as "types" and "words" whose meaning it was the mythologist's job to ransom, while the economist would discharge their life-giving powers.

But this dogmatic stand naturally brought Ruskin into conflict with his own professed views: for "vital value" is a transitive definition which presupposes someone to receive and enjoy the value, who inevitably modifies it. So Ruskin had to revamp his unilateral position and break down the concept of value into two parts. Now he conceived objects as having both an "intrinsic" and an "effectual" value.

> But in order that this value of theirs may become effectual, a certain state is necessary in the recipient of it. The digesting, breathing, and perceiving functions must be perfect in the human creature before the food, air, or flowers can become of their full value to it. *The production of effectual value, therefore, always involves two needs: first, the production of a thing essentially useful; then the production of the capacity to use it.* Where the intrinsic value and acceptant capacity come together there is Effectual value, or wealth. . . . A horse is no wealth to us if we cannot ride, nor a picture if we cannot see, *nor can any noble thing be wealth, except to a noble person.*

Pared down to the basics, Ruskin's main principle is that "Wealth, therefore, is 'THE POSSESSION OF THE VALUABLE BY THE VALIANT.' "

Provided that we understand the concept of "acceptant capacity" correctly, and do not mistakenly associate it with theories of the subjective nature of value, which were being formulated at this same period, we will have found an important key to the whole of Ruskin's work. The text we just quoted speaks not of the recipients' *needs* but of their ability to make use of value. Needs can be manipulated, and produced artificially, independently of what is beneficial for an individual's vital functions, and of the general advantage to the economy. Ruskin was among the first to point

out that the advertising appeal of British goods was beginning to exceed their usefulness, and that the "vital value" of goods—such as food—which resisted the distortions of design was being drastically reduced by adulteration.

Ruskin's economic ethic had nothing in common with theories of the subjectivity and relativity of value. Admittedly, in his concept of "acceptant capacity," he enhances the value of consumption and thus of the consumer:

It is, therefore, the manner and issue of consumption which are the real tests of production. Production does not consist in things laboriously made, but in things serviceably consumable; and the question for the nation is not how much labour it employs, but how much life it produces. For as consumption is the end and aim of production, so life is the end and aim of consumption.

At this point, his economic theory meshes with his theory of art and with his initial digressions into the field of "The Political Economy of the Arts" (see Chap. 4, part 2). Ruskin was incapable of taking an abstract, quantitative view of production and consumption—the view that "the main thing is that the smokestacks go on smoking." Quality goods demanded quality consumers; they must help to develop quality in the consumer. Note that he speaks of "the production of the capacity to use" the goods. His aim was a dialogue, a dynamic exchange between goods and consumer, like that which the Romantics defined for the relationship of man and nature, and which Ruskin envisaged in his theory of the viewer's reception of nature and art.

Once again we are seeing an instance of Ruskin's desire to resist man's growing estrangement from nature, art, and society, and to set up an organic concept which will ensure that the individual continues to be *addressed* by his world, that he continues to be *spoken to*, both by nature's objects and by the artifacts of man.

The American economic historian James Clark Sherburne has sketched a brief and very useful summary of Ruskin's organic view

of economics, based on his theory of value and the category of "acceptant capacity":

> Ruskin's relation of value to living men allows him to unify three counters of economics—production, product, and consumption. Since value or utility "depends on the person, much more than on the article," Ruskin can speak of utility in consumption and in production as well as in the product itself. The development of acceptant capacity or "valiant men" depends on useful consumption. Useful consumption, in turn, is dependent on useful production since the quality of the productive process determines, on the one hand, the value of the product and, on the other, the quality of the worker's life, his habits of consumption, and the quality of the products he demands—in short, his acceptant capacity. Ruskin points to the large consumption of gin among English laborers as evidence of how degrading production lowers the quality of consumption. While useful consumption depends on useful production, the converse is also true, for the quality of consumption determines the type of product demanded, the quality of the consumer's life, and, hence, his "valiant" power as a worker. Production, product, and consumption in Ruskin's vital economics form a triangle of interdependent elements. Man is the center, and the whole structure is potentially infused with utility or value, the life-giving power.

Reading this passage, people are bound to wonder why Ruskin's theories triggered such outright panic among readers, critics, and publishers when he began to make them public. Actually, the panic did not stem from anything we have touched on here. The ideas we have cited could readily be dismissed, as were so many other utopian economic schemes, with the verdict that they were "unrealistic" or "sentimental." What really provoked public outcry was not his theories but the practical measures he wanted to derive from them: his demands for fixed wages, government maintenance of education, government-subsidized industries and shops for the

production of quality goods, state-run industries for the unemployed, state care for the elderly, poor, and unfit. And this catalogue of demands is far from complete, for it represents only the program envisaged by a single book, *Unto This Last*.

At the time when Ruskin proposed these measures, none of them was being even debated or planned, much less carried out. They all violated the ironclad rules of the British economic system; namely, the free-for-all of economic forces, no government intervention, and no law in economic matters except that people are responsible for their own poverty or wealth.

The public was particularly incensed by Ruskin's demand that labor should not be treated as a commodity but rewarded equally and justly by a system of fixed wages. The property-owning class did not want it pointed out to them that the open labor market was a principle they wanted to apply only to the masses who owned nothing, and not to themselves. Why, Ruskin asked, do doctors, lawyers, judges, university teachers, government officials, and clergymen have fixed fees and salaries, when agricultural and factory workers, sailors and miners do not? In reality, he concluded, Britain did not have a pure but a mixed economy. And thus laissez-faire economics was not really a principle so much as a tool of exploitation, "the art of establishing the maximum inequality in our own favour."

It was Ruskin's concrete plans for reform which, at first, earned him direct criticism. That the disciples came only later is not surprising. Even if we assume that he had taken an interest in practical politics, to what constituency could he have appealed for support in his own times? Who was there to follow the lead of a renegade Tory with radical socialist leanings who also despised parliamentary democracy? The official Tories represented landed interests in the area of foreign policy, but in domestic issues were as devoted to the British free-market economy as all the other political parties. The progressives, with their interest in railroads and blast furnaces; the gentry who were mowing down their hedgerows and chopping down their woods; the radical democrats with their campaigns for

universal suffrage; the workers with their increasingly powerful organizations who now were voting for the progress of industry like everyone else: where among them could Ruskin find an ally?

Not until a new generation of politicians and parties came along—the Christian Socialists and the Social Democrats—would there be anyone who could start to make sense of Ruskin's principles of social justice. By then, more than one hundred thousand copies of *Unto This Last* were in print—but Ruskin was dead. Most of the founding fathers of the British Labour Party looked to him as an authority, as did the powerful group of the "Revivalists" who tried to promote a form of guild socialism based on medieval models. Later, Gandhi would describe his first reading of *Unto This Last* in much the same terms that Ruskin used to describe his conversion experiences in the woods at Fontainebleau and the gallery in Turin: "That book marked the turning point in my life." Gandhi resolved to live in accord with "this great book" in which "I discovered some of my deepest convictions . . . and that is why it so captured me and made me transform my life." An ironic highlight is cast on this scene by the fact that Gandhi's Ruskinian conversion occurred, of all places, in a train compartment!

If we consider all the concrete reforms proposed by Ruskin which in fact were finally carried out, we may well feel that he was one of the most successful social theorists of the nineteenth century. Government-run education, vocational-training centers, fixed minimum wages, support and retraining for the unemployed, old-age pensions, government quality controls on goods, work-creation schemes—all these "unrealistic" measures advanced in *Unto This Last* did become reality and in many countries are now as much taken for granted as reforms which Ruskin proposed later, such as government stockpiling; interest and price controls; the nationalization of roads, canals, ports, and railroads; and a European economic community. In fact, all this makes not a bad record of practical achievement for a theorist who, unlike Marx, did not follow up formulation of his ideas by founding a political organization to carry them out.

And yet, at the same time, it makes a tragic record. For all these reforms were achieved without attention to a single one of Ruskin's central concerns. The social and ecological cost-benefit ratio, qualitative and organic management of the economy, "vital use," "extension of life," "immediate life," the conserving of national and foreign resources—all these remain to be acted upon today.

Six
The Professor
1870–1878

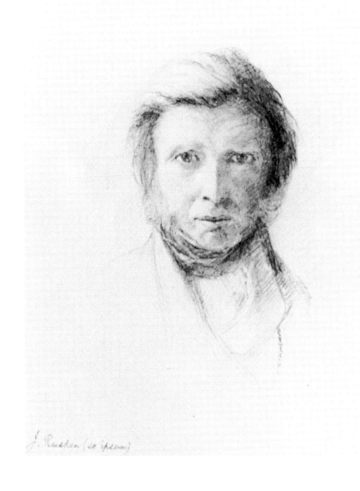

John Ruskin, Self–portrait, *c. 1873. Pencil.*
Education Trust, Brantwood, Coniston

I

In 1873–74, Ruskin did a series of self-portraits, probably at the urging of his American friend Charles Eliot Norton. Norton had appointed himself Ruskin's "emotional dietician," and since it was not Ruskin's normal habit to draw self-portraits, we must suppose that his faithful counselor had recommended the exercise as part of his overall "therapy" for the troubled author.

Norton, who lived far away in Boston, stayed close to his friend through a frequent exchange of letters, and often he knew more about Ruskin's feelings than Ruskin's family and friends in Britain. Ruskin felt free to confide in Norton unreservedly because he knew that in Norton he had found a confidant who could stand up to any amount of strain ("You're always too strong for me," he once said) and who could show concern without getting caught up in Ruskin's feelings. For, with all his readiness to sympathize with his friend's distress, Norton yet remained too "American"—as Ruskin would have put it—to be really stricken or to react with a like emotion.

At bottom, Norton shared the view of his famous New England colleague Ralph Waldo Emerson, who had said, after paying a visit to Ruskin in 1873: "I wonder such a genius can be possessed by so black a devil. . . . I cannot pardon him for a despondency so deep. It is detestable in a man of such powers, in a poet, a seer such as he has been." According to Norton, Emerson thought that Ruskin "was serious enough, but his perversity made you angry, you could not talk with a man who insisted on being hopeless to

the extreme of denial of the progress of the world. He should come to America to be restored to sanity."

Norton had other remedies in mind, equally simple and basically sensible prescriptions, to free his friend from his worst emotional snarls. But he did not share Ruskin's despair at the course of the world, and consequently he regarded Ruskin's personal life and misguided decisions as solely responsible for his unhappiness. Ruskin's biographers are fond of quoting what Norton said of him after his friend's death: "I have never known a life less wisely controlled, or less helped by the wisdom of others than his. The whole retrospect of it is pathetic; waste, confusion, ruin of one of the most gifted and sweetest natures the world ever knew."

These lines testify to the practical mentality of an American who thinks that a little "therapy" and manly determination will get things back on course. But his concentration on Ruskin's psychological makeup did allow him to arrive at a second, profounder insight: "Never was a soul more open and accessible to immediate impressions, never one that responded with more sensitiveness or more instant sympathy to the appeals of nature or of man. It was like an Æolian harp, its springs quivering musically in serene days under the touch of the soft air; but, as the clouds gathered and the winds rose, vibrating in the blast with a tension that might break the sounding-board itself."

By 1873–74, Ruskin had long since reached a stage in which his suffering at his own fate was no longer distinguishable from his suffering at the collective anguish of history. Both sources of depression acted like drainpipes, sucking down everything in nature and society which he had formerly found healing, so that it all mingled at a subterranean level.

Norton, like everyone in Ruskin's circle of friends—with the single important exception of Carlyle—was convinced that Ruskin would be better off dropping the subject of political economy and devoting himself to art and nature again: "Your influence will be made deeper, more permanent, and more helpful by patient work of this kind, than by your impassioned and impatient appeals to men who will scoff at your words." "I am like one of the bells in

the old nursery rhyme, always dinning the same tune in your ear. Stick close to art."

Ruskin was, for various reasons, responsive to Norton's appeals, and sent his drawings away to Boston at regular intervals. Moreover, in the 1870s he wrote remarkably detailed and thorough studies of art, of a kind that he had not produced for three decades. In the period covered by this chapter, he published no less than ten separate books on themes of art and art history.

No one would wish to denigrate these writings, which were innovative in their approach and which, incidentally, were the works that moved Marcel Proust to become Ruskin's disciple and translator. Nor would anyone deny that the work of recording frescoes and glaciers occasionally brought Ruskin peace and contentment, and even gave him the strength to go on. Yet, all the same, one cannot help feeling that there is something uncomfortably regressive here. Once again, his study of art and nature brings him suffering because he cannot keep pace with the destruction that is overtaking them: "My time is passed in a fierce steady struggle to save all I can every day, as a fireman from a smouldering ruin, of history or aspect."

In Chamonix, in the autumn of 1874, he found that the old winding track he had known had been expanded into a spacious paved road: "This enables vast omnibuses, like our tramway ones, to carry the mob up to Chamouni from Geneva in a day. Away they bowl, as if to Epsom; the harder they go the merrier."

Once he had prescribed an antidote for those of his readers who were suffering from either of the extremes, a romantic view of history or a blind faith in progress: they must endure the contrast between Then and Now, nature and culture, positive and negative. But his own remedy was no longer of use to him. He sometimes felt as if inside and outside had become asynchronous, as if the world had turned into a runaway machine, fidgeting and twitching and squeaking shrilly as it ran down. Now the cycle of ecstasy and despair, the interval between highs and lows, was growing shorter all the time.

Psychologists have tended to diagnose Ruskin as manic-

depressive, and in fact the violent mood swings which he records in his diaries make this a predictable conclusion: "*August 6th* [1874]. . . . Fearfully despondent and confused last night." "*August 7th*. . . . Had a glorious day of learning." "*August 9th*. . . . No pleasure in *anything*." Ruskin himself saw and described his total absorption in the current phase of the cycle, and yet was not able to control it: "While I am looking at a sunset, I forget the sunrise; but the next morning sunrise makes me forget the sunset."

But we would do well to pause for a moment before citing evidence of a cyclically recurring mania, or pointing out the compulsive repetitions of Ruskin's dreams, his sexual life, and his relationship with Rose. (Rose's motto, incidentally, was *Je reviendrai*, "I'll come again," which irritated Ruskin, whose motto was "To-day To-day To-day.") We should also keep in mind that Ruskin covered more ground and changed subjects faster than almost any other writer of his day—and he was not just traveling in circles. We must never underestimate the realistic content of his observations, up to the very last things he wrote, which were dictated by delusion and obsession. Perhaps his cycles of mania merely mirrored, in a compulsive but not uninformative way, the larger cycles of his world—not the processes of nature, but the collective cycles of economics, politics, and art.

If there is one infallible guide to Ruskin's increasing emotional instability, it is his drawings. We don't know what psychological considerations led Norton to insist that his friend produce a series of self-portraits, but the results must have shocked him.

Let's take the pencil portrait showing Ruskin at age fifty-four, drawn, we think, in 1873. It seems to be a mood study, a study of expression, in which the draftsman has highlighted the signs of deep despair, melancholy, or, to use the term fashionable at the time, "spleen." Compelling as the expression is, however, at first glance it looks somehow extrinsic to the face, which is not aged or ravaged by wrinkles. The hair and long sideburns grow thick and strong; the posture is steady, unstooped.

But then, after closer study, one becomes aware that the features of despair are not actually laid on but graven in. The brow arches

above the bright eye and lowers above the shaded one. This feature, along with the contrast of light and shadow and other details, divides the face into two halves: one is truly gloomy and self-threatening, while the other merely looks slightly lost or morose. The two halves of the face are linked by the anxiously twitching mouth. Together, they are like the contrast between light and lightning. This is a face with independent epicenters which both seem to be on the verge of an eruption. Perhaps these are the "terrible subtleties" Ruskin was referring to, in a letter he wrote to Norton: "All that is good in me depends on terrible subtleties, which I find will require my very best care and power of completion"—terrible subtleties in the dual sense of "terribly difficult to depict" and "terrifying."

But it would be a mistake to regard the imbalance in the facial features as a mere play of expression, or as a temporary exaggeration brought on by nervous strain. To see that there really is something wrong, all we need do is examine the actual pencil marks that make up the portrait. These marks, which are the most basic level of the drawing, can tell us more reliably than the facial expression that the artist is responding, unconsciously, to new but compelling laws. In the past, this theorist of vital lines and intricate moldings was a monumental draftsman; the lines he drew were strong and energetic. In his drawings, nature was alive and crackled with tension. But now his own drawing lives under the "law of fracture" which *Modern Painters* had to bow to in the end.

Unlike his author's quill, Ruskin's drawing pencil and watercolor brush no longer have the power to produce cohesive images. When he spoke about fracture, it was always in a unified grammar. Now it is as if vocabulary and syntax have traded places. This draftsman works in short sharp bursts, vigorously but without command. His strokes often look as stunted as the tree branches of the Dutch landscape artists he despised. The first layers have been traveled over, indignantly, by second thoughts and retouchings. From up close, the image has a tendency to break down into obsessive detail, a rebellious whirlwind of pencil marks, of hatching that leads nowhere. The crumbling line that leads down from the

right lapel, indicating his watch chain, is downright alarming; it looks patchy, like the spoor left by a sick animal. It is as if the draftsman, at the height of his powers, is deliberately driving his medium to the breaking point. And in the shaded parts of the face, where delicacy is called for, the strokes admittedly are even and expressionless in themselves, but they tend to lump together into an ill-defined mass.

The drawing we have just described still has a finished, carefully wrought look. In contrast, the rough sketches Ruskin produced on trips during the 1870s can only be described as chaotic. We have come to know him as a punctilious draftsman, scrupulously devoted to detail, but now he often works with a thick pencil, in broad sweeping strokes, ignoring details, ornaments, moldings, and perspective. This critic, who has not one kind word for the Impressionists, is an Impressionist himself, interested in nothing but light and shade, disconnected patches, loosely indicated forms, unvariegated backgrounds. Sometimes the sketches are merely erratic, ravaged, and stubborn-looking; but when they are good, they are faintly reminiscent of the pencil drawings which Georges Seurat was producing at the time.

Still, there are always these disturbed areas, full of short, choppy reactions, an angry automatism. These are symptoms of a loss of reality, a severed communication with nature. Yet what looks like deformation is really new information, written in a different script, in a cybernetic language. So Ruskin has, after all, been overtaken by the trends of his time which he described in Volume Three of *Modern Painters*: the tendency of technology to produce and gratify its own needs, of the medium to become the message, the loss of direct contact with nature.

Measured by the goals Ruskin had set for his life, this was a bad development. But there is more to be said before we make up our minds about it, and about whether its causes are wholly external.

For the moment, the self-portrait is truer than the anti-nature studies, because it shows us both sides of the coin. It shows us a man who is still holding on to solid reality, and at the same time it shows a man losing control, becoming obsessive.

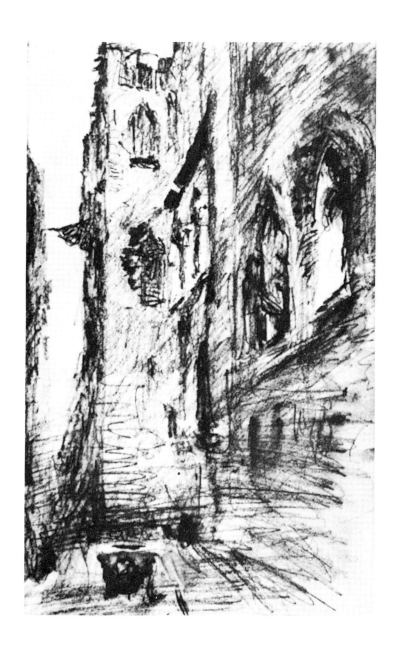

John Ruskin, Street in Venice, *1876–77.*
Pencil and wash.
South London Gallery, Borough of Southwark, London

After a severe illness in 1871 in which he suffered from delirious obsessions, Ruskin wrote that he knew he had been "within an ace of the grave," but had managed to save himself by an instinctive knowledge of what treatment he needed, which surpassed that of the doctors.

Undoubtedly, the ups and downs were following faster and faster on each other's heels now, the dreams were growing more oppressive, the writings more confused, the behavior more abrupt. Yet we still find in these years the Ruskin of former days, courteous and cultivated, charming and helpful, the public speaker who simultaneously provokes and enchants his audience, the family man who is friendly to all children, the confidant of countless friends and of strangers who write asking his advice. And on top of the growing burden of personal obligations, Ruskin now, for the first time, has a regular civilian job.

2

The wealthy attorney and art collector Felix Slade had endowed fine-arts professorships to be set up at the universities of London, Cambridge, and Oxford. John Ruskin was asked to serve as the first Slade Professor of Fine Arts at Oxford. Apart from his popularity on the lecture circuit, this was the first tangible public recognition he had received for his work and fulfilled belatedly what had been his original ambition in coming to study at Oxford: to learn a profession, to become a clergyman, scientist, or university teacher.

But now, as in the past, he again realized that he did not belong at Oxford and that he had been wise not to ally himself with any institution. His student years, 1837 to 1842, had already made clear that he was not suited for an ordinary professorial career. He had never been inclined to become that quintessentially English type of professor who, back in 1840, was molded by the great universities: a man with a traditional view of his discipline, well versed in the classics, and deeply religious—the kind of professor who,

by 1870, was referred to as "pre-scientific." Nor did he fit among the proper scientists, either in 1840 or in 1870. He was neither a specialist nor a proper Oxford don. Despite his flair for the empirical, he did not have the temperateness and patience to devote his life to the positivistic investigation of a single subject.

So, in 1870, thirty years after he left Oxford the first time, he came back, the same man as before: an outsider, his qualifications enhanced only by the fact that now he was also a public eccentric and provocateur. Clearly he enjoyed being at Oxford. He loved his surroundings so much that after a while he took up residence in one of the old colleges, Corpus Christi, where a regular don or a student would normally live. "With all my grumbling over what might have been, or what I crave for, or what I have lost, I am not unconscious of the much good I have, especially in power of giving pleasure and help; and I admit it to be really a very comfortable thing for an old gentleman to be able to sit in a cathedral stall to hear Bach music and to have Ediths to flirt with, Princes to walk with, and Pussies to love." So he wrote in 1873 to "Pussie," his cousin Joan Severn. "I am also to-night in a very comfortable room—all my own; have four wax-candles and a nice fire; a college dinner about to be brought up in state, admirably cooked. A Titian portrait in the corner, Turner's Bolton Abbey over the chimney-piece, fifteen sketches by Mantegna under my table, any book in London that I like to send for, and a balance of about a thousand pounds ready money at my banker's. And I think in claiming, or even expecting, any extraordinary share of pity or condolence from my fellow-mortals, I am perhaps a little exacting."

But Ruskin would not be Ruskin—nor would we have any need to study his life now with rapt attention—if he had really turned his professor's chair into an easy chair and settled happily into the life of an Oxford fellow, feeling that he had finally attained the peace and recognition he craved.

Actually, important as decor always was to Ruskin, there was more to attract him to Oxford than just the beautiful surroundings. The professorship was also precious to him, because, for the first time, he was holding a responsible position and did not have to

create his job and his public himself. "Whatever happens now," he ceremoniously announced in a letter to his mother, "I *have* been permitted by the ordaining Power to begin in Oxford the study of my own art, for others." "I really think the time has come for me to be of some use."

He showed almost an excess of cooperation in the way that he adapted to the ceremony of university life. Upon receiving his appointment, he assured his friend Henry Acland that he would carry out his duties quietly and support no opinion that could offend the university. He also promised the dean of his college that he would adapt his teaching to the university system and not press for a more practical type of instruction. But it wasn't long before a disturbance broke out, and soon people throughout Britain were looking toward Oxford—as they always did to wherever Ruskin was—with amusement or chagrin or delight, or with very mixed feelings.

The reason that Ruskin did not keep his promise to make fire without smoke was not that he "could not do otherwise," nor was it that others provoked him. Like every great teacher, all he did was to take seriously the original purpose of his job and of the institution he served. In the nineteenth century, Cambridge and Oxford had been the targets of innumerable plans for reform. In 1864, after violent struggle, Oxford had taken what at the time was a revolutionary step by allowing science students to drop the study of classics—formerly the mainstay of the curriculum—after one year if they chose. A mathematics fellow who was destined to become famous for something other than his scientific career—C. L. Dodgson—called the reform "a step towards a total surrender, of the principle, hitherto inviolate, that the classics are an *essential* part of an Oxford education." To opponents of the reform, ousting classics from their central position meant giving in to the utilitarian and materialist tendencies of modern England—vocational training rather than education.

Like Dodgson, Ruskin opposed the reform. He fought for "general education" in two senses: first, that it should be for everyone;

and second, that it should educate the whole man. Thus, he assured the deacon, when he accepted his post at Oxford: "There is no modern error in that respect which I more regret than the increasingly prevalent corruption of a University as a place for teaching youth various trades or accomplishments by which they may get their living, instead of what it has been—and must against all vulgar pressure maintain itself in being—a place where the character is to be formed which shall make Life graceful and honourable—after it has been won."

But he did not inquire if his view was shared by the head of the university and by his colleagues. He believed that he was right in his basic view of education, and he *was* right if we consider what an art professorship involved in his day. At the time, comprehensive, concentrated courses of study for specific professions simply did not exist in the form that we know them today. More to the point, there was no way that a Slade Professor of the Theory of Art could have helped prepare students for a professional career. Oxford was the study place of theologians, philologists, and scientists. Consequently, what Ruskin offered could not help but form just one part of a medieval "studium generale," a liberal-arts course which included ancient literature, theology, and geometry—all of which were still a required part of every student's curriculum.

To teach art as part of general humanities at an outstanding institution like Oxford meant, first of all, a chance to reply to the old question of the value of the fine arts. Ruskin's answer was bound to be interesting because, for one thing, his ten-year absence from the whole field of art had raised doubts about the validity of his aesthetic theories and, indeed, about his competence as a thinker on art. During his "sabbatical," a new breed of art theorist had sprung up—at Oxford and elsewhere—whose ideas swiftly won acclaim. In addition, there were also the two traditional approaches to art in Britain to contend with: Ruskin had campaigned against the influence of both from the start of his career, and had not yet met with much success. His Oxford Lectures on Art gave him a perfect opportunity to summarize and test his theories with a view

to exercising some guidance over the old and new trends of thought. And they give us the opportunity to look at Ruskin's mature theory in this summarized form, and in context.

3

There were two established and competing views in Britain about the role of the arts in contemporary society. One was old and venerable. It had grown out of the traditional role of art in polite society and emphasized art's emotionally nourishing, edifying, and relaxing effects. This was how Ruskin's parents had looked at art during his childhood—conversation with amusing artists during dinner, the light diversion of looking at prints and paintings after meals, recreational reading in the evenings. In their household, art was a pleasant enrichment, both financially and figuratively. John James's memorable remark about Turner—"I like him after Roast & pudding & a few Glasses of Sherry"—describes this attitude perfectly. (No wonder that Ruskin wrote, in his last letter to his father: "About Turner you indeed never knew how much you thwarted me.")

This practice of enjoying art on a full stomach was a hallmark of the cultural attitudes of the well-to-do Englishman throughout the nineteenth century and beyond. Moreover, some took it a step further and offered art up as a means to promote social harmony. In 1848, the year of revolutions throughout Europe and of the Chartist demonstrations in England, author Charles Kingsley prescribed that British workers should visit the National Gallery as a way to relax:

> Picture-galleries should be the workman's paradise, a garden of pleasure, to which he goes to refresh his eyes and heart with beautiful shapes and sweet colouring, when they are wearied with dull bricks and mortar, and the ugly colourless things which fill the workshop and the factory. . . . His hard-worn heart wanders out free, beyond the grim city-world of

stone and iron, smoky chimneys, and roaring wheels, into the world of beautiful things—*the world which shall be here-after*—ay, which shall be! Believe it, toil-worn worker, in spite of thy foul alley, thy crowded lodging, thy grimed clothing, thy ill-fed children, thy thin, pale wife—believe it, thou too, and thine, will some day have *your* share of beauty.

A Turner from your own collection after meals; or a Turner in the National Gallery after work as a substitute for a meal. Those two ideas are not so disparate as they might seem, for they both obey the same definition: art relaxes and compensates; it is a counter-world and a higher world.

The second established view that Ruskin was up against was equally English but had developed more recently. In fact, the idea that art would soon be obsolete because it was of no use in the new age was very much a product of those progressive times. Edward Bulwer-Lytton gave a clear account of what was happening and why, as early as 1833: "When Byron passed away, the feeling he had represented craved utterance no more. With a sigh we turned to the actual and practical career of life. . . . We were in the situation of a man who, having run a certain career of dreams and extravagance, begins to be prudent and saving, to calculate his conduct, and to look to his estate."

Thomas Love Peacock may be considered the chief spokesman for this line of thought, because his views, although vehement, were unclouded by philistine and utilitarian considerations. It was only 1820 when he wrote, in his essay "The Four Ages of Poetry":

While the historian and the philosopher [i.e., scientist] are advancing in, and accelerating, the progress of knowledge, the poet is wallowing in the rubbish of departed ignorance, and raking up the ashes of dead savages to find gewgaws and rattles for the grown babies of the age. . . . A poet in our times is a semi-barbarian in a civilized community. . . . [Po-etry] can never make a philosopher, nor a statesman, nor in any class of life an useful or rational man. It cannot claim the

slightest share in any one of the comforts and utilities of life of which we have witnessed so many and so rapid advances.

Peacock took a consistently historical view of his subject. He doesn't ask What is poetry? but rather What can poetry do now? in an age which demanded such different things of people than previous ages did. Art was important as long as it advanced the emancipation of the race, when it was still "the mental rattle that awakened the attention of intellect in the infancy of civil society." But now it was no longer the hub of intellectual progress—not because the quality of intellectual achievement had declined but because, in this century, intellectual energy was flowing into different channels.

The loftiest tenets of German aesthetics would have confirmed such a view. But in England only the crudest philosophical arguments were marshaled in its defense. The new middle class and its ideologues, the "steam-engine intellectuals," especially, found all the ammunition they needed in the formulas of the utilitarian philosopher Jeremy Bentham, who was given to remarks as unfortunate as this one: "Prejudice apart, the game of push-pin is of equal value with the arts and sciences of music and poetry. If the game of push-pin furnish more pleasure, it is more valuable than either. Everybody can play at push-pin: poetry and music are relished only by a few."

The philistines considered push-pin more valuable. All histories of Victorian culture mention how infinitely creative the Victorians were in inventing games and pastimes. Theirs was the first age to have its own large-scale "entertainment industry." Both Ruskin and Matthew Arnold fought this tide of anti-culture and anti-intellectualism, but the strength of the opposition was clear from the fact that they failed to gain the support of the man who was the recognized conscience of their age, the firebrand critic and declared enemy of the utilitarians, Thomas Carlyle. Carlyle never really understood what his friend Ruskin hoped to do with art. Here is just one of his many caustic remarks on the subject, from a conversation that took place in the early 1870s: "How can Ruskin

justify his devotion to Art? Art does nothin' in these days, and is good for nothin'; and of all topics of human concern there's not one in which there's more hypocrisy and vain speakin'. . . . The pictures in our days have seldom any scrap of help or meanin' for any human soul,—mere products of emptiness and idleness, works o' the devil some o' them, but most o' them rather deservin' to be consigned without delay to the *limbo dei bambini.*" No doubt, most British people of his time thought the same.

These two antithetical attitudes—"Art is important because it relaxes" and "Art is unimportant and even harmful"—both implied that there were other, more important things in life than art, and both gained ground relentlessly. But at mid-century a third attitude began to evolve, building from a small to a major force throughout Europe, that in fact there was *nothing* more important than art— that art was all.

When Ruskin came to teach at Oxford, he found the lilies of the "new aesthetics" already blooming there. They were still a local plant but would not remain so for long. Their seeds had blown over from France; they had begun sprouting in the green-house of Cheyne Walk, and grown to maturity in the "cold frame" of Oxford, and from there been transplanted elsewhere. The gardeners who tended them were Baudelaire and Gautier in Paris, Swinburne and Whistler in London, Arnold and Pater at Oxford.

Matthew Arnold, Oxford Professor of Poetry from 1857 to 1859 and again from 1861 to 1865, and Walter Pater, who came to Oxford as a student in 1858 and in 1864 became a junior fellow, embody the two main varieties of the new art theorist: the liberal-humanist and the aesthetic-philosophical. *Culture and Anarchy* (1869), Arnold's main work on the philosophy of culture, was a polemical treatise against polemics, against the incessant uproar over politics and religion, against the Puritan principle of *Porro unum est necessarium* ("But one thing is needful"), against faith in the power of just *one* essential theory or solution.

Culture and Anarchy pleads for more detachment from daily affairs, for an attitude of "disinterestedness" that facilitates "giving

our consciousness free play" and the process of self-perfecting; that is, a form of activity directed inward more than outward. "And the culture we recommend is, above all, an inward operation." "What we want is a fuller harmonious development of our humanity, a free play of thought upon our routine notions, spontaneity of consciousness, sweetness and light; and these are just what culture generates and fosters."

Phrases like this will sound familiar to readers of German Transcendental Idealism, with good reason. Matthew Arnold was, next to Carlyle, the English author most versed in German letters. Through his writings, German Idealist concepts grew popular in England as revolutionary movements drove people to look for alternatives to the turmoil of history:

> The particular "anarchy" confronting Arnold during the composition of this "Essay in Political and Social Criticism" was the anarchy, or the omens of it, associated with "shooting Niagara" [Carlyle's phrase for the British policies leading to expansion of voting rights], the second Reform Bill [which brought the new voting law and a reorganization of voting districts], with trades-union disturbances, Fenian outrages [i.e., of the Irish emancipation movement], Reform League riots in Hyde Park, the campaign of John Bright [who fought for the workingman's right to vote], the Murphy riots at Birmingham and Manchester [1867–68] and the like.

Arnold sought a contemplative retreat in what Disraeli called an "age of shocks." He wanted a place where intellectual and spiritual life could still be free from the nation's established doctrines, from the "hardness and vulgarity of middle-class liberalism" and the "hideous and grotesque illusions of middle-class Protestantism"—and he found that place in Oxford, which he described as a repository of beauty that had not yet been caught up in the modern age and still had the power to communicate the ideal of perfection.

Walter Pater, one of Arnold's students at Oxford, organized a series of "Conferences on the External Improvement of Pater" in which his friends were given the task of discovering how the physically graceful but otherwise unattractive Pater could come closer to the great ideal of his life, beauty. He is quoted as having said, "I would give ten years of my life to be handsome." The result of the conferences was that he grew a full mustache resembling that later worn by Nietzsche.

Pater was the complete opposite of the rowdy masculine types who had always dominated Oxford—the young men whom Arnold called the "barbarians at play"—and he was also totally different from the young man Ruskin had been in his own student years. Ruskin had endured both the barbarians at play and the fossilized curriculum, and learned what he could at Oxford in spite of them. He excelled everyone in curiosity and in his ability to absorb information. Pater, on the other hand, stayed aloof from it all and used the institution as protective cover, choosing to remain in the lowly position of a junior fellow for the next thirty years.

Pater was neither a good student nor a good teacher, by university standards. He preferred to devote himself to refined and exotic studies of his own choosing and to the cultivation of his personality, appearance, and writing style, and was unconcerned with anything that happened outside the walls of Brasenose College. Matthew Arnold had served as a school inspector for some forty years before he called on people to take the path that led inward, and so he had had some direct experience of anarchy and barbarism. Not so Pater, who, rather gratefully, took for granted that times were hard and henceforth confined himself to two themes, "self-indulgence and art."

This last quote comes from the dialogue novel *The New Republic* (1877), written by one of Ruskin's students, William Hurrell Mallock. Pater appears in the book under the pseudonym "Mr. Rose," and functions as an ideological foil to Ruskin, Arnold, and other ideologues of the period. At the time *The New Republic* was written, Pater had published only one slender volume, *Studies in the*

History of the Renaissance (1873), yet he was a choice model for a fictional character because, quite apart from his single piece of exquisite prose, he had created an exquisite life-style all his own, which made the slender, dandyish figure more influential than the austere theorist Arnold, and which turned Pater into Ruskin's secret adversary during the period of Ruskin's stay in Oxford. Pater's distinctive brand of Oxford aestheticism enabled him to bring to life an alternative view of art which could stand up to the dual threat of the jovial art-consumer and of the puritanical utilitarian who felt nothing but contempt for art. Moreover, he managed to achieve this while remaining at the heart of a great English institution, rather than occupying the fringes of society as Ruskin was forced to do.

What Pater had to say about the role of art he had already said by 1868, in one of his earliest essays, and he never really said it better:

> We have an interval, and then our place knows us no more. Some spend this interval in listlessness, some in high passions, the wisest, at least among "the children of this world," in art and song. For our one chance lies in expanding that interval, in getting as many pulsations as possible into the given time. Great passions may give us this quickened sense of life, ecstasy and sorrow of love, the various forms of enthusiastic activity, disinterested or otherwise, which come naturally to many of us. Only be sure it is passion—that it does yield you this fruit of a quickened, multiplied consciousness. Of such wisdom, the poetic passion, the desire of beauty, the love of art for its own sake, has most. For art comes to you proposing frankly to give nothing but the highest quality to your moments as they pass, and simply for those moments' sake.

4

This brings us to Ruskin's inaugural address at Oxford. As the museum lecture hall proved too small, his audience had to move to the Sheldonian Theatre, where, many years before, the student Ruskin had recited his prize-winning poem. Now there were a thousand people waiting to hear him speak.

Those who had expected the first Slade Professor of Fine Art to tackle head-on those rival theories which had risen against him at Oxford during the 1860s came away disappointed. Instead, the speaker took a roundabout route to explain his intentions and what he would require of his listeners.

Loyal to his long-time principle that theory divorced from practice can achieve nothing—especially in the arts—he announced that he would contribute an additional £5,000 to the Felix Slade trust, to be used for the appointment of a university drawing instructor and the foundation of an art school with its own attached instructional gallery. His lectures—so he told the audience—would be supplemented by practical exercises, and eventually the lectures would serve only to prepare and accompany the students' own independent artistic productions.

Politely and patiently, Ruskin pointed out the potential benefits which practical exercises of this kind could bring to every field of knowledge. Reading his temperate words today, one can almost taste the jaded resistance of all those in his audience who had come hoping to get a pleasant thrill from the notorious orator and who were not the slightest bit interested in doing anything practical, especially nothing as tedious and painstaking as learning to draw. But if Ruskin's audience was already groaning at this early stage, how can it possibly have made sense of his next remarks regarding the higher purpose behind the practical studies?

The following passage, which comes at the end of a lengthy, well-camouflaged buildup, takes us with lightning speed into the very heart of Ruskinism:

And the best skill that any teacher of art could spend here in your help, would not end in enabling you even so much as rightly to draw the water-lilies in the Cherwell (and though it did, the work when done would not be worth the lilies themselves) unless both he and you were seeking, as I trust we shall together seek, in the laws which regulate the finest industries, the clue to the laws which regulate *all* industries, and in better obedience to which we shall actually have hence-forward to live: not merely in compliance with our own sense of what is right, but under the weight of quite literal necessity.

This text, put into more systematic terms and expanded by other passages, will serve as the basis for our summary of Ruskin's theory of art.

1. Art is work, and both artists and non-artists can experience it only on the practical level. "The definition of art is 'human labour regulated by human design.' " Ruskin warns his pupils against trying to get by with *only* labor or *only* design—for example, trying to avoid the effort of drawing nature studies, by resorting to photography:

Photographs will give you nothing you do not work for. They are invaluable for record of some kinds of facts, and for giving transcripts of drawings by great masters; but neither in the photographed scene, nor photographed drawing, will you see any true good, more than in the things themselves, until you have given the appointed price in your own attention and toil.

The present age, he says, has tried in every field to "substitute mechanism for skill." "That is your main nineteenth-century faith, or infidelity." The pleasure in skill, and the respect for its innate dignity has disappeared, and in the field of the arts this has produced a schism between theoretical and practical studies, so that people studying the theory of art "have no conception of what the right

costs; so that all the joy and reverence we ought to feel in looking at a strong man's work have ceased in us."

The first goal of Oxford's new art school would be "that you may know truly what other men have felt during their poor span of life." Genuine knowledge of great works of art also represents an authentic form of personal experience, without which there can be no art or experiencing of art. Skill combined with knowledge may then enable individuals to expand their own "brief span of life" and transform the knowledge of others into skill and knowledge of their own:

> Those of you who succeed in learning what painter's work really is, will one day rejoice also, even to laughter—that highest laughter which springs of pure delight, in watching the fortitude and the fire of a hand which strikes forth its will upon the canvas as easily as the wind strikes it on the sea.

2. Art is not the be-all and the end-all. Art "must never exist alone—never for itself." A water lily in a drawing is less valuable than the real water lily. Moreover, the most important thing about the water lily in the drawing is what it says about the *real* water lily, or, rather, what it says about the relationship between nature and art, how it serves its purpose as a means of knowing the original flower. His main quality, Ruskin claims, is his "steady habit of always looking for the subject principally, and for the art, only as the means of expressing it."

This is the starting point for what is probably the single best-known passage in the Oxford Lectures on Art, the one beginning "ALL GREAT ART IS PRAISE":

> The art of man is the expression of his rational and disciplined delight in the forms and laws of the Creation of which he forms a part. . . . Farther to complete the range of our definition, it is to be remembered that we express our delight in a beautiful or lovely thing no less by lament for its loss, than

gladness in its presence, much art is therefore tragic or pensive; but all true art is praise. . . .

Fix, then, this in your mind as the guiding principle of all right practical labour, and source of all healthful life energy,—that your art is to be the praise of something that you love. It may be only the praise of a shell or a stone; it may be the praise of a hero; it may be the praise of God:—your rank as a living creature is determined by the height and breadth of your love; but, be you small or great, what healthy art is possible to you must be the expression of your true delight in a real thing, better than the art. . . . This is the main lesson I have been teaching, so far as I have been able, through my whole life,—Only that picture is noble, which is painted in love of the reality. It is a law which embraces the highest scope of Art; it is one also which guides in security the first steps of it. If you desire to draw, that you may represent something that you care for, you will advance swiftly and safely. If you desire to draw, that you may make a beautiful drawing, you will never make one.

Ruskin is by no means doctoring the facts when he says that this is the main lesson he has taught all his life. In fact, we find the first indications of it in Volume One of *Modern Painters*. But what *has* changed over the past thirty years of his career is the real-life basis of art and nature. In order for art to fulfill its duty to nature, nature has first to exist. It has been Ruskin's sad experience that the existence of nature is no longer something that can be taken for granted.

And remember, were it as patterns only, you cannot, without the realities, have the pictures. *You cannot have a landscape by Turner, without a country for him to paint; you cannot have a portrait by Titian, without a man to be pourtrayed.* I need not prove that to you, I suppose, in these short terms; but in the outcome I can get no soul to believe that the beginning of art *is in getting our country clean, and our people beautiful.*

Thus, it is the task of art to create its own preconditions in nature. This means going far beyond the normal range of artistic activity. It could even mean having to reclaim nature for England, before art will be possible:

> The England who is to be mistress of half the earth, cannot remain herself a heap of cinders, trampled by contending and miserable crowds; she must yet again become the England she was once, and in all beautiful ways,—more: so happy, so secluded, and so pure, that in her sky—polluted by no unholy clouds—she may be able to spell rightly of every star that heaven doth show; and in her fields, ordered and wide and fair, of every herb that sips the dew; and under the green avenues of her enchanted garden, a sacred Circe, true Daughter of the Sun, she must guide the human arts, and gather the divine knowledge, of distant nations, transformed from savageness to manhood, and redeemed from despairing into peace.

3. The work of art must be related to the work of society. Our opening text said that the laws of art give the clue "to the laws which regulate *all* industries." England was facing a fateful decision about how to deploy its industrial labor, the most crucial decision that had ever faced any nation, Ruskin believed.

> The study of the fine arts could not be rightly associated with the grave work of English Universities, without due and clear protest against the misdirection of national energy, which for the present renders all good results of such study on a great scale, impossible. I can easily teach you, as any other moderately good draughtsman could, how to hold your pencils, and how to lay your colours; but it is little use my doing that, while the nation is spending millions of money in the destruction of all that pencil or colour has to represent, and in the promotion of false forms of art, which are only the costliest and the least enjoyable of follies.

The situation was desperate. Britain's "unemployed poor are daily becoming more violently criminal" and economic distress was forcing even the middle classes to recognize the folly of "imagining that they can subsist in idleness upon usury." The real products of the British economy were an abstract wealth, coupled with actual collective impoverishment and destruction. All this was due to the elimination of human skills by mechanical labor devices. Lacking both confidence in themselves and creative imagination, people were now so misguided that they would do away with the whole solar system if they could. Art was not exempt from society's deterioration. "The art of any country *is the exponent of its social and political virtues.* . . . The art, or general productive and formative energy, of any country, is an exact exponent of its ethical life. You can have noble art only from noble persons, associated under laws fitted to their time and circumstances."

If, like Ruskin, one accepts that the age of heavy industry does not represent an advance in human history, then one must be able to specify the stage of development which *would* suit both general and artistic production. Ruskin wanted to establish that the two types of production were inseparably linked. "Now, all the arts are founded on agriculture by the hand, and on the graces and kindness of feeding, and dressing, and lodging your people." He believed that art must begin anew, with fundamental concern for nature; in the provision of healthy, unadulterated foods and good-quality, durable clothing; and in the creation of solid, beautiful, and well-furnished homes in pleasant surroundings, with plenty of bright light and wholesome air. Creating the right conditions for art was a collective enterprise, and this meant, first of all, improving the design of cities and landscape:

> It is not possible to have any right morality, happiness, or art, in any country where the cities are thus built, or thus, let me rather say, clotted and coagulated; spots of a dreadful mildew, spreading by patches and blotches over the country they consume. You must have lovely cities, crystallized, not coagulated, into form; limited in size, and not casting out the

scum and scurf of them into an encircling eruption of shame, but girded each with its sacred pomœrium, and with garlands of gardens full of blossoming trees and softly guided streams.

If the first rule of art is that art is work, then the converse is also true: work must become art again. "Life without industry is guilt, and industry without art is brutality: and for the words 'good' and 'wicked,' used of men, you may almost substitute the words 'Makers' and 'Destroyers.' " Inch by inch the creators wrest order from chaos; all things are preserved and expanded by their attention. Their work is art, and the trail they leave is beauty.

Ruskin's three stipulations for art were interwoven so that at bottom they coincided in a single truth: art was impossible under the present conditions. "Stay in that triumph, if you choose; but be assured of this, it is not one which the fine arts will ever share with you."

What distinguished Ruskin from the Oxford aesthetes was his relentless reflection about the societal factors necessary to the production of art, and his insistence that no man could control those factors by an individual act of will. By continuing to maintain that art was indissolubly linked to the future fate of nature and society, he made clear his intention to remain an old-fashioned and reactionary thinker who would try to preserve the heritage of Romanticism and even of the Enlightenment as the end of the nineteenth century approached. He resisted using—or rather abusing—art by turning it into an individual recreation, and instead defended its power to act together with other social factors to produce a more general good. To refute the new aestheticism, he needed only to repeat and to highlight what he had already said in *The Stones of Venice* and in his lectures of the 1850s: art which has no purpose beyond itself will decay, and art devoted only to the enjoyment of the privileged few has no right to exist.

One critic has said that Ruskin's inaugural lecture at Oxford reads like the work of a gifted disciple trying to summarize in a more orderly and less exciting fashion Ruskin's earlier and more brilliant writings on art. But this view misjudges the strategic

situation in which Ruskin gave his lectures and misjudges Ruskin himself. He was a conservative even with regard to his own work. He frequently offered new themes but not new postulates—so long as the essential conditions he called for had not been met.

It would be wrong to think that Ruskin had nothing in common with his professional rivals. The standard wisdom has tended to earmark him as the true founding father of the aesthetic movement. Granted, put in this form the statement is misleading; and yet it is not false. The change that Pater brought to English art theory, like the change that Nietzsche brought to German art theory, was essentially the emphasis on vitalism—the view of art as an intensification, enlargement, and "vivification" of life: "To burn always with this hard, gem-like flame, to maintain this ecstasy, is success in life," Pater observed in the conclusion to his *Renaissance* studies. Ruskin did not share this attitude, especially where individual life was concerned, or when the aim of effort was to redirect energy inward: life for life's sake, art for art's sake. "Not the fruit of experience, but experience itself, is the end." This line from Pater's *Renaissance* would not have been acceptable to Ruskin, who would rightly have viewed it as a sign of the current trend to create innate values, to produce what fed only on itself. He resented this trend all the more because, as his drawings show, he, too, was not immune from its effects.

And yet Ruskin's work itself is inconceivable if completely divorced from the vitalist philosophy of aesthetics. So many of his phrases—"healthful life-energy," "agency for life," even the central maxim "All great art is praise"—testify to his deep connection with vitalism. His is not a self-centered but a transitive, outgoing vitalism which reflects the expectation that selflessness will be rewarded and the hope that the link between nature and man is still intact.

As we saw in an earlier quote, man's role is to praise a creation "of which he is part." In other words, he praises himself too, but praises what he creates and not, as in Pater and Nietzsche, his status as creator.

Only in Ruskin can we find passages like this:

It is precisely in its expression of this inferiority [of the art-work compared to what it tries to depict], that the drawing itself becomes valuable. It is because a photograph cannot condemn itself, that it is worthless. The glory of a great picture is in its shame; and the charm of it, in expressing the pleasure of a loving heart, that there is something better than picture. Also it speaks with the voices of many: the efforts of thousands dead, and their passions, are in the pictures of their children to-day. Not with the skill of an hour, nor of a life, nor of a century, but with the help of numberless souls, a beautiful thing must be done. And the obedience, and the understanding, and the pure natural passion, and the perseverance, *in secula seculorum*, as they must be given to produce a picture, so they must be recognized, that we may perceive one.

In this attitude of selfless service to art, Ruskin remains incurably an early-nineteenth-century Victorian, as well as a spokesman for religious sentiments he thought he had overcome long ago. To be sure, the Oxford aesthetes also have their cult of service to beauty, and their religion of art, but the cult of personal genius carries equal weight with them. Ruskin largely ignores the cult of genius and continues to think in terms of mediation and of a balancing of forces. In this respect as well, he belongs to an earlier age. What the new aesthetes think to gain in a private intoxication he wants to have by the barter method, in exchange for patient work, active perception, and reciprocal respect and love. He would like human beings to acknowledge that they are a part of nature—not just the makers but the inheritors of art. One last time he develops this same organic concept that had given structure to his early theories of art and then to his economic theory.

In his second Oxford lecture, for example, he explains that landscape painting does its service to nature only if it shows the concrete interest that man has in nature, or, in reverse, the fact that nature is intended for man. "The interest of a landscape consists wholly in its relation either to figures present—or to figures past—

or to human powers conceived." "Landscape painting is the thoughtful and passionate representation of the physical conditions appointed for human existence."

Shortly before he collapsed and became ill, Ruskin said in an Oxford lecture that his course of lectures on himself was necessary because "*Modern Painters* itself is a lecture with no conclusion, and I have now to put the conclusion upon it." In reality, it was in the inaugural lecture that he actually "put the conclusion upon" his past art theories. Nowadays, there is a fashion to value his later, "wilder" lectures more than the first. But I would like instead to maintain that the peculiar achievement of the Lectures on Art is the fact that Ruskin was able, at a time of outer and inner turmoil, to repeat his theories in this clarified form and to record his accumulated reflections. After this, he never again succeeded—except in his autobiography—in avoiding the effects of his violent mood swings, and most of the lectures and writings he produced in the 1870s are caught on the wheel of cyclical mania that now is whirling faster and faster.

5

After several terms at Oxford, Ruskin had to accept that his attempt to integrate practical and theoretical art studies had failed. The university art school so luxuriously equipped by its founder did not flourish. "As for the undergraduates, I never succeeded in getting more than two or three of them into my school, even in its palmiest days." Actually, things were not quite this bad: he usually had around fifteen students taking the practical courses. But comparing this to the several hundred who attended his lectures, it becomes clear why he despaired of changing current attitudes. The students wanted to hear him talk, but not to buckle down and work—the very thing he had described in the inaugural lectures and even more clearly in his letters. They wanted "to be excited for an hour, and, if possible, amused; to get the knowledge it has cost a man half his life to gather, first sweetened up to make

it palatable, and then kneaded into the smallest possible pills—and to swallow it homœopathically and be wise. . . . It is not to be done." "I am resolved now to let the men understand what I mean by useful art. I have waited patiently for five years to see if any good comes of lecturing. None does, and I will go at it now otherwise."

Ruskin now wanted to look around for a different project that would separate the wheat from the chaff and live up to the need to combine theory with practice. Oxford had always been his favorite locale for practical experiments. He had poured ideas and tangible effort into building the natural-history museum there, and even participated in the actual construction work, to the extent of personally erecting one of the columns—although, admittedly, the column had to be dismantled and reinstalled later. And when he and a group of Pre-Raphaelite artists got together to paint the frescoes on Union Hall, everyone involved felt that they were successfully resurrecting an ancient model of group work and group living.

Now he chose a demonstration project which was both very simple and spectacularly dramatic: he built a road near Oxford with his students. Or rather he *re*built it. Originally, it was a neglected little cart track outside town and was in need of redesigning and paving. He and his students did everything themselves: excavated the roadbed, laid drainage ditches, transported stones to the site, broke them up, and arranged them skillfully in layers. It was not long before the sound of pickaxes was heard all over Oxford and then all over England.

None of Ruskin's public performances was as widely talked about as his Hinksey road project, named after the nearby village. For once, the sons of wealthy and noble families exercised their muscles not in rowing, riding, and hitting balls as they usually did, but in a useful cause. Unfortunately, a months-long press campaign, complete with satirical cartoons, and a stream of curious onlookers made it clear that, in the eyes of the public, Ruskin had been guilty of an act of obscenity: he had demanded direct social action from those at the pinnacle of the social hierarchy.

Predictably, not one Oxford don supported Ruskin, and all his colleagues who had been suspicious of the notorious troublemaker's move to Oxford now felt their suspicions were confirmed. Ruskin's friend Acland, who had invited him to teach at Oxford, felt the need to publish a bombastic defense of this simple project in *The Times*.

The effects on Ruskin's students, however, were all he could have wished. The Hinksey Diggers became his elite unit at Oxford, and it was no accident that they included several students who would later help to shape the second Oxford Movement: men who carried on practical social politics, like Arnold Toynbee, Andrew Lang, and Alfred Milner. One would search their ranks in vain for Walter Pater and his imitators—with one exception. And this exception was destined to carry the religion of aestheticism to its greatest extreme and thus, in one sense, to become an obstacle to Ruskin's work. He was the young Oscar Wilde.

Wilde began his first year of study at Oxford in 1874. For a time he remained torn between Ruskin's "gospel of labour" and Pater's "holy writ of beauty"—as he called Pater's *Studies in the History of the Renaissance*, which he was just then reading for the first time. One commentator claimed that "The Oxford Road failed, partly because of the soil, partly because of the laziness of the undergraduates, and partly because Mr. Oscar Wilde would insist on stopping and lecturing upon the beauties of the colour of the soil that turned up."

But this is only one of many versions of the tale of the Hinksey Diggers. Wilde did not impede the road building. In fact, as he describes it, it was due to him and him alone that the project did not break down during one ticklish phase. The road *did* get built. Predictably, it was not an especially good road; but neither was it "probably the worst road in the three kingdoms," as Ruskin later remarked in one of his fits of destructive self-criticism.

Ruskin had taken up the secret challenge of the Oxford aesthetes and showed everyone where aesthetics and life had to join forces—not in the inner life, as Arnold had suggested in the dictum "Culture is an inward operation," or as Mr. Rose, alias Walter Pater, had

claimed in Mallock's *New Republic*, "I . . . look upon life as a chamber, which we decorate"—but in the outside world, where the conditions and the stimuli for culture, the inner life, and art are created: in the humane treatment of nature.

> Let me tell you once more, and if possible, more vehemently, that neither sound art, policy, nor religion, can exist in England, until, neglecting, if it must be, your own pleasure gardens and pleasure chambers, you resolve that the streets which are the habitation of the poor, and the fields which are the playgrounds of their children, shall be again restored to the rule of the spirits, whosoever they are in earth, and heaven, that ordain, and reward, with constant and conscious felicity, all that is decent and orderly, beautiful and pure.

Ruskin had his reasons for choosing a road to be the demonstration piece for this "restoration." Like Wordsworth, Dickens, and many other writers, he had lamented the destruction of the English landscape by industrialization, railroads, and new roads. His most concentrated fury was reserved for the railroads, which he rejected both on the traveler's behalf and on the nature conservationist's. Railroad construction had led to a completely new type of landscape architecture. Now, when new stretches of rail were built, they were straight. According to one historian:

> When the straight new roads were laid across the fields they slashed like a knife through the delicate tissue of a settled rural civilisation. They left their scars on park and copse; they raised high walls of earth across the meadows—"your railroad mounds, vaster than the walls of Babylon," Ruskin called them; they brutally amputated every hill on their way.

The earth mounds erected for the railroads were gigantic. Deep cuttings were made into the mountains and hills. George Stephenson planned a gradient of practically zero on the London–Birmingham line—with the result that eminences had to be deeply

incised, and huge embankments were piled up for crossing the valleys. Sixteen million cubic feet of earth were moved to complete the London–Southampton track. All this produced the type of flat rail line, with few ups and downs, that we still see today.

After a while, road building began to emulate the engineering methods of the rail builders. For the first time, cutting and embanking techniques were adapted for road construction. Apart from the magnificently built Roman roads, the main British road model had been the winding country lane which curved gently around all the natural and man-made obstacles, following the features of the landscape and disclosing them to the traveler from a series of constantly shifting vantage points.

This typically English road was gradually being wiped out by the new engineers with their straightening works, branch roads, and modern building methods. Thus, Ruskin, by choosing to lay a road, was trying to get people to relearn the proper and humane way to build roads and to structure the landscape:

> In the first place, I want to show my Oxford drawing class my notion of what a country road should be. I am always growling and howling about rails, and I want them to see what I would have instead, beginning with a quiet by-road through villages. . . . [I want] a Human Pathway rightly made through a lovely country, and rightly adorned. . . . Now that country road under the slope of the hill with its irregular line of trees, sheltering yet not darkening it, is capable of being made one of the loveliest things in this English world by only a little tenderness and patience in easy labour.

The fact that Ruskin made his gardener the construction boss and assigned him the leveling work is a meaningful symbol of the whole enterprise: a gardener was taking charge of the Garden of England.

His road-building project at Oxford set an example in another respect. The Oxford students who did the heavy labor took on the role of "navvies," the digging workers who in nineteenth-century England were considered the representative type of the

manual worker—more so even than the textile workers, factory
workers, or miners. The English navvy stood for an independent
working class who held on to its regional ties, who were highly
organized and earned relatively high wages. It was for this reason
that the English historical painter Ford Madox Brown, who was
closely affiliated with the Pre-Raphaelites, had placed "navvies" at
the center of his major painting *Work* (1852–63), as representatives
of the manual laborer. In the painting, it is a group of Irish work-
men who are doing excavation work in a middle-class London
suburb, surrounded by members of the upper class, intellectual
workers, and the unemployed. Brown, in his own explanation of
the picture, said that he chose the navvy to represent the worker
who does an "outward and visible type of work."

This is exactly what made digging work ideal for Ruskin's pur-
poses. His students had to show themselves to the public as physical
laborers and put up with comments, even ridicule.

In Brown's painting, two men in frock coats are standing next
to the roped-off building site, apparently with nothing to do. Ac-
tually, Brown says, they are mental workers who are laying the
foundation for the work and happiness of others. To represent this
class, Brown chose to portray the figures of Thomas Carlyle and
Frederick D. Maurice, both friends of Ruskin who, like him, had
pondered the problems of work and society in the industrial age
and had influenced work and society in their writings and their
public activities. All in all, it would not have been a bad choice if
Brown had used Ruskin as the model for his main "intellectual
worker"—especially if we think about the literary model for
Brown's work, which was Carlyle's discussion of the philosophy
of work in *Sartor Resartus*:

> Two men I honour, and no third. First, the toilworn Crafts-
> man that with earth-made Implement laboriously conquers
> the Earth, and makes her man's. . . . A second man I honour,
> and still more highly: Him who is seen toiling for the spir-
> itually indispensable. . . . [Him] who with heaven-made Im-
> plement conquers Heaven for us! If the poor and humble toil

that we may have Food, must not the high and glorious toil for him in return, that he have Light, have Guidance, Freedom, Immortality?

Carlyle—ignoring his assertion that he honors only two men—then goes on to name a third, who combines the vocations of the other two. Ruskin could not have helped feeling spoken to by a passage like this:

Unspeakably touching is it, however, when I find both dignities united; and he that must toil outwardly for the lowest of man's wants, is also toiling inwardly for the highest. Sublimer in this world know I nothing than a Peasant Saint, could such now anywhere be met with. Such a one will take thee back to Nazareth itself; thou wilt see the splendour of Heaven spring forth from depths of Earth, like a light shining in great darkness.

6

Carlyle's gospel in *Past and Present* was that the prophet must work to fulfill his own prophecies. Carlyle rarely did, but Ruskin tried to. This was his goal, of course, when he tackled projects like the Oxford road. But he also knew, or soon learned, not to overestimate his role or his effectiveness when it came to translating ideas into action. Try as he might, he never again wholly rid himself of the doubts about the social significance of art that he had harbored in the 1860s. One day, on his way to deliver a lecture, for instance, he passed a little girl dressed in rags, and the episode led him to make the following characteristic observation: "She was a *very* nice little girl; and rejoiced wholly in her whip, and top; but could not inflict the reviving chastisement with all the activity that was in her, because she had on a large and dilapidated pair of woman's shoes, which projected the full length of her own little foot behind

it and before." Later, while giving his lecture on Italian art, he thought back to the incident:

> But all the time I was speaking, I knew that nothing spoken about art, either by myself or other people, could be of the least use to anybody there. For their primary business, and mine, was with art in Oxford, now; not with art in Florence, then; and art in Oxford now was absolutely dependent on our power of solving the question—which I knew that my audience would not even allow to be proposed for solution— "Why have our little girls large shoes?"

Soon Ruskin started planning further extracurricular schemes and began a parallel project that kept him at least as busy as his teaching duties at Oxford. He single-handedly wrote a monthly newspaper in the form of letters addressed to the "Workmen and Labourers of Great Britain." This newspaper, which bore the odd title *Fors Clavigera*, continued to be published from January 1871 until December 1884, with a break due to Ruskin's illness from 1878 to 1880—a thirteen-year period corresponding more or less to the period of his professorship.

Fors was a success from the beginning. One thousand copies were printed of the first edition of each letter, and reprints would raise the number to approximately four thousand. Starting in 1882, the letters also began appearing in book form, twelve letters to a volume. Thus, we can assume that some five thousand copies of each letter were distributed during Ruskin's lifetime. This was a high circulation for a privately printed newssheet, especially if we consider the staggering competition it faced. There were 25,000 registered newspapers and periodicals in Britain at the time—including several hundred that were classed as "literary"—and editions of the monthlies and quarterlies ran anywhere between a thousand for the *National Review* and seven thousand for the *Edinburgh Review*. This writer whom the monthlies had stopped publishing for fear of losing a few hundred subscribers had now created his own forum.

Next he went on to organize his own production and sales departments. Withdrawing all his books from his former publisher, he turned over sales and production to one of his drawing pupils at the Working Man's College. "George Allen, Sunnyside, Orpington, Kent," was an imprint familiar to all Ruskin readers from the 1870s onward. Allen was a publisher who worked for only one author. Thus, Ruskin became the first British writer with his own private publishing agency. Not only that; he also used his publishing outfit to set an example of Ruskinian economics. George Allen sold Ruskin's books and newspapers at fixed rates, to direct purchasers and booksellers, thus circumventing the system of middlemen, wholesale discounts, and voluntary and indiscriminate price setting.

It goes without saying that Ruskin's publisher settled his firm in an unspoiled country landscape, and that working conditions differed from those in other publishing houses. The story that Ruskin would not let his books and bound newspapers be machine-sewn is quite true; that he would not allow them to be transported by rail is probably apocryphal.

Once he got over the initial hurdles, Ruskin's experiment in alternative economics flourished. In prosperous periods he earned about £4,000 a year from his business—which was more than his father had earned—and it was lucky that he did, because the moment his own income started rising, Ruskin gave away his inheritance.

We should note two other facts about Ruskin's personal life during this period. From 1871 on, he not only had a job, his own newspaper, and his own publishing firm, but also, for the first time, a home of his own. He had bought, sight unseen, a house in the English Lake District north of Coniston Water. This house, called Brantwood, had been offered for sale by a radical-socialist printer and engraver named Linton:

There certainly *is* a special fate in my getting this house. The man from whom I buy it—Linton—wanted to found a "republic," printed a certain number of numbers of the *Republic*

like my *Fors Clavigera*! and his printing-press is still in one of the outhouses, and "God and the People" scratched deep in the whitewash outside. Well, it won't be a "republican centre" now, but whether the landed men round will like my Toryism better than his Republicanism, remains to be seen.

Brantwood remained Ruskin's country home for the rest of his life, from 1872 to 1900.

Buying this property was in fact a repetition of the events of 1863. Ruskin's last letter to his father had been a ruthless squaring of accounts. Now, once again, his last act as a son was a rejection. He bought his own home just before his mother died at the end of 1871, at the age of ninety. Ruskin certainly had a right to criticize his parents and to assert his independence, but unfortunately, in both cases, he did so at ill-timed moments and, indeed, too late to do any good.

Carlyle expressed his sympathy to his friend in a letter: "To all of us the loss of our Mother is a new epoch in our Life-pilgrimage, now fallen lonelier and sterner than it ever seemed before."

Ruskin began this new epoch in the typical Ruskinian way: he went back somewhere he had been before. As a child, he had often spent time in the north of England, where he now had a home. While the boy John had roamed with his geologist's hammer, the mature man now set out to reroute watercourses, build a harbor, and clear his woods. But at the same time he also went on aiming massive ax blows at the rankest growths in British society: "Here is the half-decade of years, past, since I began the writing of *Fors*, as a byework to quiet *my* conscience, that I might be happy in what I supposed to be my own proper life of Art-teaching, at Oxford and elsewhere; and, through my own happiness, rightly help others."

This "byework" ended by towering over all Ruskin's other achievements for the decade to come. The 1,900 pages (650,000 words) of *Fors Clavigera* represent not only his major work of this period but also the most amazing and the most topical work of his career. The publishers of his collected works state in their

introduction to *Fors*: "There is no other book in the world quite like it." Karl Kraus's *Die Fackel*, however, is a German-language cognate to *Fors*: it was a one-man enterprise; unpredictable as the latest headline; disproportionate, in that it enlarged upon seemingly insignificant details; immoderate, because the scale it chose to measure by was the greatest of all monsters, normality. But if *Die Fackel* was the war of one against other men, then *Fors Clavigera* was the war of one against the world. Kraus fought his colleagues, other journalists and writers, and corrupt, incompetent officials. His material was, preeminently, the reality of the news report. But in *Fors* Ruskin fought few personal skirmishes, and although he often responded to news items, he did not become a media critic but remained what he had always been: a critic not of people but of things—of society, of capitalism, of religion, of technology, of the destruction of nature, of art, and, finally, a critic of himself.

Fors Clavigera was the kind of cryptic title that Ruskin was notorious for inventing. The name has no clear-cut meaning. He supplied three alternative translations for the word *Fors*: force (physical strength), fortitudo (mental strength), and fortune (luck, fate, chance); and likewise three for *Clavigera*: clava (the club, the attribute of strength), clavis (the key, the attribute of patience), and clavus (the nail, the attribute of fate). Thus, there is no single correct translation of the title, but only a fluid one that shifts according to circumstances. So the title was not an index to the newspaper's strategy but actually a part of it. "By the adoption of the title 'Fors,' I meant (among other meanings) to indicate this desultory and accidental character of the work." Ruskin wanted, in the name of the goddess of chance, to leave himself the maximum freedom in what he wrote.

Even at Oxford, he did not allow himself a narrow concentration on art history. Besides the eight art-history publications he wrote in the years 1870 to 1878, he also wrote books on the themes of modern science (*The Eagle's Nest*, 1872), ornithology (*Love's Meinie*, 1873 ff), botany (*Deucalion*, 1875 ff), and geology (*Proserpina*, 1875 ff). Lack of time and concentration seduced him into pub-

lishing these works in serialized form. (Some eleven years elapsed between the first and last installments of *Proserpina*.) As a result, he tended to have the manuscripts of four or five books piled on his desk at any one time, and had to keep them all going simultaneously.

But no matter how many book and lecture projects he was involved with, he would still feel the need for a vehicle in which to communicate a recipe for goose pie; to explain what transparent mustard from Bordeaux tells us about the system of modern economics; and to draw up a painstaking list of all the train accidents in September 1873. And when he wrote about the novels of Sir Walter Scott, he had to restrain himself in order not to describe at the same time "how true-love is inconsistent with railways, with joint-stock banks, with the landed interest, with parliamentary interest, with grouse shooting, with lawn tennis, with monthly magazines, spring fashions, and Christmas cards."

Ruskin himself knew that this flight of ideas and wealth of associations bordered on madness: "If I took off the Harlequin's mask for a moment, you would say I was simply mad." Once he asked himself, while speaking to his readers: "Does it never occur to me . . . that I may be mad myself? Well, I am so alone now in my thoughts and ways, that if I am not mad, I should soon become so, from mere solitude, but for my *work*." During a period when he was experiencing a "daily maddening rage," his work on *Fors* gave him the validation he needed. Thus, *Fors* was both a product of delusion and a defense against it. It was a superbly functioning sluice gate between two delusory universes—Ruskin's and the outside world's.

From Ruskin's point of view, predictably, the outside world was madder than he was. After all, who was really deluded: the economists who attributed the 1870s economic crisis to "overproduction," or the author of *Fors*, who fought for a redistribution of society's wealth? the society that fed 700-pound shells into the new giant cannon, the "Woolwich Infant," or the author of *Fors*, who reported to this society news of the starving and dying children of the London slums? "You Fools Everywhere," Ruskin says,

addressing his readers: "For it seems to be the appointed function of the nineteenth century to exhibit in all things the elect pattern of perfect Folly, for a warning to the farthest future."

In preaching to fools, perhaps there is some point in acting the madman. On one occasion, he began by talking about a severe storm on Good Friday, 1876. Then he confessed to the readers of *Fors* that he was not interested in the question of whether the sun had really stood still on the first Good Friday. The real miracle, he said, was that the solar system was still operating today. Moreover, he said, he was astonished that his contemporaries attached no importance to this life-giving miracle:

"Amazed," I say, "almost to helplessness of hand and thought"—quite literally both. I was reading yesterday, by Fors' order, Mr. Edward B. Tylor's idea of the Greek faith in Apollo: "If the sun travels along its course like a glittering chariot, forthwith the wheels, and the driver, and the horses are there;" and Mr. Frederick Harrison's gushing article on Humanity, in the *Contemporary Review*; and a letter about our Cotton Industry (hereafter to be quoted), and this presently following bit of Sir Philip Sidney's 68th Psalm;—and my hands are cold this morning, after the horror, and wonder, and puzzlement of my total Sun-less-day, and my head is now standing still, or at least turning round, giddy, instead of doing its work by Shrewsbury clock; and I don't know where to begin with the quantity I want to say,—all the less that I've said a great deal of it before, if I only knew where to tell you to find it. All up and down my later books, from *Unto This Last* to *Eagle's Nest*, and again and again throughout *Fors*, you will find references to the practical connection between physical and spiritual light—of which now I would fain state, in the most unmistakable terms, this sum: that you cannot love the real sun, that is to say physical light and colour, rightly, unless you love the spiritual sun, that is to say justice and truth, rightly. That for unjust and untrue persons, there is no real joy in physical light, so that they

don't even know what the word means. That the entire system of modern life is so corrupted with the ghastliest forms of injustice and untruth, carried to the point of not recognizing themselves as either—for as long as Bill Sykes knows that he is a robber, and Jeremy Diddler that he is a rascal, there is still some of Heaven's light left for both—but when everybody steals, cheats, and goes to church, complacently, and the light of their whole body is darkness, how great is that darkness! And that the physical result of that mental vileness is a total carelessness of the beauty of sky, or the cleanness of streams, or the life of animals and flowers: and I believe that the powers of Nature are depressed or perverted, together with the Spirit of Man; and therefore that conditions of storm and of physical darkness, such as never were before in Christian times, are developing themselves, in connection also with forms of loathsome insanity, multiplying through the whole genesis of modern brains.

Fors is a work which needs to be personal by its very nature. "*Fors Clavigera* is a series of letters, and intended to be—as letters should be—personal. . . . These letters I write for persons who wish to know something of me, and whom I hope to persuade to work with me, and from beginning to end will be full of all sorts of personality." All he says is perfectly true. Ruskin does not use the letter genre as a vehicle for fiction, like so many other Victorian authors, but publishes a real correspondence, for many readers write him letters, which he includes in his text or reprints in appendices. The newspapers he quotes also respond to his newssheet, and then he in turn quotes their responses. The result is lively communication in which the same correspondents may go on discussing the same topics over many issues. This increases the readers' sense of being part of a group of initiates, and late arrivals, or those who have not done their homework, may feel excluded.

Fors is social criticism, composed of equal parts critique and proposed reform, analysis and satire. *Fors* always keeps pace with current events—the Franco–Prussian War, the Paris Commune,

the measures of the liberal reform cabinet under Gladstone. And the great political issues of the 1870s—the Education Act, the Land Laws, the Housing Question; British imperialism; the cyclical crises of capitalism—all are sensitively recorded in these pages. The replies and analyses which Ruskin inserts are extensions of his theories of the 1850s and 1860s, but now they are more grippingly and didactically expressed.

For example, Ruskin recalls the tale of a picnic party given by members of the Irish upper class, who left the remains of their large picnic lunch to the watching peasant children, "on condition that they should 'pull each other's hair.' " He turns this incident into the letter "The Great Picnic" in which he discusses the Franco–Prussian War and makes the point that "during the last eight hundred years, the upper classes of Europe have been one large Picnic Party" and, by their outlay of capital on war, "have taught the peasants of Europe—to pull each other's hair."

On another occasion, Ruskin went on an art-history outing to Furness Abbey and rode back in a train on which a group of drunk and raggedly dressed rail workers were also traveling. The representatives of two social classes met in a single train compartment, both with their day's work done—one after visiting a ruined fourteenth-century abbey, and the others after back-breaking digging. The author of *Fors* reflects how "Nearly every problem of State policy and economy, as at present understood, and practiced, consists in some device for persuading you labourers to go and dig up dinner for us reflective and aesthetical persons, who like to sit still, and think, or admire." This episode is the basis for the letter "The Abbot's Chapel."

Sometimes in *Fors* Ruskin mentions his political affiliation—but always in contradictory terms: "For, indeed, I am myself a Communist of the old school—reddest also of the red." "I am, and my father was before me, a violent Tory of the old school (Walter Scott's school, that is to say, and Homer's)."

The confusion that he creates by these contradictions is meant to convey that politics, in the classic sense of party politics and foreign policy, is meaningless to him. In this respect, once again,

he is not dissimilar to the Austrian Karl Kraus, who "cheerfully . . . bears the stigma of 'lack of principle' " and "in questions of politics . . . considers non-party politicians the better men." Ruskin considered politics the medium of "daily maddening rage" for people who do not recognize that there is only one real war, a war that transcends the wars of religion and the armed struggles between nations—namely, the war between the capitalists and the workers—and only one real problem: the need for man to restructure his relationship to nature and to his fellowmen.

The author hints that his own political solution to the problem involves a "Communism of the old school"—an agrarian communism of the kind advocated by Thomas More, from whose *Utopia* Ruskin liberally quotes—combined with authoritarian power structures. His economic program can be summed up in two "ordinances": "That every man shall do good work for his bread: and secondly, that every man shall have good bread for his work." And only one ordinance was needed to describe the political policy for carrying out this program: "That land should be given to those who can use *it*, and tools to those that can use *them*."

Fors was also the circular letter of a utopian society, the Guild of St. George, which Ruskin had founded to help him create this ideal system. He hoped that the readers of *Fors* would become members, supporters, and co-workers of the Guild:

We will try to take some small piece of English ground, beautiful, peaceful, and fruitful. We will have no steam-engines upon it, and no railroads; we will have no untended or unthought-of creatures on it; none wretched, but the sick; none idle but the dead. We will have no liberty upon it; but instant obedience to known law, and appointed persons: no equality upon it; but recognition of every betterness that we can find, and reprobation of every worseness. When we want to go anywhere, we will go there quietly and safely, not at forty miles an hour in the risk of our lives; when we want to carry anything anywhere, we will carry it either on the backs of beasts, or on our own, or in carts, or boats; we will

have plenty of flowers and vegetables in our gardens, plenty of corn and grass in our fields,—and few bricks. We will have some music and poetry; the children shall learn to dance to it and sing it;—perhaps some of the old people, in time, may also.

The Guild of St. George, which still survives today, was financed largely by Ruskin, and ran enterprises as varied as the Oxford University drawing school, street-cleaning schemes, and a teashop in London, a museum for workers in Sheffield, and a reference library for Guild members. It supported the revival of the linen industry in Langdale and of handweaving on the Isle of Man; it owned houses, land, and woods in various parts of Britain, and it fulfilled Ruskin's goal of founding agrarian communes. But not even the help of Ruskin's indispensable gardener Downes could get the land projects to flourish. The Guild's schemes must be counted as failures, apart from its encouragement of local industries and the museum which Ruskin built up with great enthusiasm over many years.

A combination of factors served to undermine the Guild's initiatives. First, Ruskin had to wage a grotesque seven-year battle to get the English courts to draw up a legal form for a society which wanted to run businesses on a non-profit basis. Second, by the time the official authorization arrived, Ruskin was a disappointed and sick man who had to conserve his strength, and consequently he was no longer able to devote his personal energy and fighting spirit to the important projects, but only to assist them with money and advice. Together, these two factors may have contributed to a third: relatively few people responded to Ruskin's countless appeals for donations and active assistance. As a penance, the passive readers of *Fors* were regaled with incessant reports of the tragicomic events befalling the Guild.

Fors was not only *by* John Ruskin but *about* him. It was in *Fors* that he first told stories about his childhood. It was for *Fors* that he made his "glass pockets," revealing his financial affairs. It was in *Fors* that he reported his rediscovery of religion. *Fors* was where

he announced that "the woman I hoped would have been my wife is dying," and he informed the readers of *Fors* not only of his emotional upsets but of his particularly deep slumps: "Being in a dream state, and not knowing well what I was doing," he writes shortly before his first major attack of insanity. "I rather enjoy talking about myself, even in my follies."

There is no doubt that this kind of public self-examination derived from the Protestant tradition in which he had been raised. This is why he talks about his childhood, for instance. "It is necessary for many reasons that you should know what influences have brought me into the temper in which I write to you." This is also the reason he explains his finances, including his many charitable enterprises: "I also think it right that, whether people accuse me of boasting or not, they should know that I practise what I preach."

Fors is also a chronicle of ongoing destruction. The skies are getting darker, the glaciers melting, and Scotland's rivers have so much oil in them that they can be set on fire. Italian artworks continue to be demolished and "restored," and the railroad has now reached the last remaining areas of unspoiled countryside in Britain. The readers of *Fors* hear about all these things, and, indeed, they are probably the only people who hear of them in such acute and suggestive terms.

Fors has been called Ruskin's Apocalypse. If we accept this image, then *Fors* is Revelation in the present tense, the revelation of what is happening *now*—"sent and signified" to the prophet John, but not by any angel. *Fors* is Apocalypse in serial form, an entertaining, suspenseful Apocalypse of the nineteenth century.

The form and the content of *Fors* were dictated by the insight that hell is not the end but a perpetuation of the present—combined with the ancient belief that everything on earth is linked to everything else.

7

The best way to say all this is to let *Fors* speak for itself. Here we have a shortened version of Letter 20, "Benediction," dated Venice, July 1872, a letter about blessings and curses and everything under the sun. "My Friends,—You probably thought I had lost my temper, and written inconsiderately, when I called the whistling of the Lido steamer 'accursed.' " This is an allusion to the previous letter, in which he had written:

> I can't write this morning, because of the accursed whistling of the dirty steam-engine of the omnibus for Lido, waiting at the quay of the Ducal Palace for the dirty population of Venice, which is now neither fish nor flesh, neither noble nor fisherman;—cannot afford to be rowed, nor has strength nor sense enough to row itself; but smokes and spits up and down the piazzetta all day, and gets itself dragged by a screaming kettle to Lido next morning, to sea-bathe itself into capacity for more tobacco.

Such raving denunciation from an Englishman who was famous in Venice did not go unnoticed in the city, of course; nor did it remain unanswered. Four Italian newspapers quoted and commented on the passage. The *La Stampa* article appeared under the headline "An Attack of Spleen" and hinted—with reason—that the "dirty population" Ruskin referred to was made up largely of foreigners.

Ruskin loved having to explain in microscopic detail, and with a wealth of allusions and provocative insights, remarks which in fact he had made only in passing. So now he sat down to write half a page on the need for cursing in accursed times—only to be interrupted in his writing once again by the noise of another steamer:

> Now, there is a little screw steamer just passing, with no deck, an omnibus cabin, a flag at both ends, and a single

passenger; she is not twelve yards long, yet the beating of her screw has been so loud across the lagoon for the last five minutes, that I thought it must be a large new steamer coming in from the sea, and left my work to go and look.

Before I had finished writing that last sentence, the cry of a boy selling something black out of a basket on the quay became so sharply distinguished above the voices of the always debating gondoliers, that I must needs stop again, and go down to the quay to see what he had got to sell. They were half-rotten figs, shaken down, untimely, by the midsummer storms: his cry of "Fighiaie" scarcely ceased, being delivered, as I observed, just as clearly between his legs, when he was stooping to find an eatable portion of the black mess to serve a customer with, as when he was standing up. His face brought the tears into my eyes, so open, and sweet, and capable it was; and so sad. I gave him three very small halfpence, but took no figs, to his surprise: he little thought how cheap the sight of him and his basket was to me, at the money; nor what this fruit "that could not be eaten, it was so evil," sold cheap before the palace of the Dukes of Venice, meant, to any one who could read signs, either in earth, or her heaven and sea.

We of today no longer number among the faithful readers of *Fors*, so this allusion to black, inedible figs requires some explanation. These are the figs which the Lord showed to the prophet Jeremiah and symbolize the bad portion of the Israelites, whom God had cursed and driven "into all the kingdoms of the earth," until "they be consumed from off the land" (Jer. 24:1–10). They are also the fig trees of the Book of Revelation which the "mighty wind" of God's wrath causes to drop "untimely" (Rev. 6:13–17). And they are the "summer fruit" which the Lord shows to the prophet Amos, to signify to him that: "The end is come upon my people of Israel. . . . And the songs of the temple shall be howlings in that day." This same passage from the Book of Amos also lists the reason for all these curses, a reason which brings us back to

the figure of the poor boy selling figs: "Hear this, O ye that swallow up the needy, even to make the poor of the land to fail, Saying, When will the new moon be gone, that we may sell corn? and the sabbath, that we may set forth wheat, making the ephah small, and the shekel great, and falsifying the balances by deceit? That we may buy the poor for silver, and the needy for a pair of shoes; *yea*, and sell the refuse of the wheat?" (Amos 8:1–6).

Thus, Ruskin only *appears* to stray from the point when he turns to discussing the fig seller. His digression is purely spatial. In fact, he is still talking about curses, their causes and effects. As his thoughts range freely, he touches on the fact that cursing has become an everyday occurrence, part of the small change of daily conversation, while the Church uses curses less and less, preferring to dispense cheap blessings so as to avoid having to give the poor any material help, and so as to keep the rich under its thumb.

And now we fade back into the basic text again. Ruskin turns to the subject of those special curses and blessings which affect the members of the body and the senses:

Do you suppose that when it is promised that "the lame man shall leap as an hart, and the tongue of the dumb sing"— (Steam-whistle interrupts me from the *Capo d'Istria*, which is lying in front of my window with her black nose pointed at the red nose of another steamer at the next pier. There are nine large ones at this instant,—half-past six, morning, 4th July,—lying between the Church of the Redeemer and the Canal of the Arsenal; one of them an ironclad, five smoking fiercely, and the biggest,—English and half a quarter of a mile long,—blowing steam from all manner of pipes in her sides, and with such a roar through her funnel—whistle number two from *Capo d'Istria*—that I could not make any one hear me speak in this room without an effort),—do you suppose, I say, that such a form of benediction is just the same as saying that the lame man shall leap as a lion, and the tongue of the dumb mourn? Not so, but a special manner of action of the members is meant in both cases: (whistle number three from

Capo d'Istria; I am writing on, steadily, so that you will be able to form an accurate idea, from this page, of the intervals of time in modern music. The roaring from the English boat goes on all the while, for bass to the *Capo d'Istria*'s treble, and a tenth steamer comes in sight round the Armenian Monastery)—a particular kind of activity is meant, I repeat, in both cases. The lame man is to leap, (whistle fourth from *Capo d'Istria*, this time at high pressure, going through my head like a knife) as an innocent and joyful creature leaps, and the lips of the dumb to move melodiously: they are to be blest, so; may not be unblest even in silence; but are the absolute contrary of blest, in evil utterance. (Fifth whistle, a double one, from *Capo d'Istria*, and it is seven o'clock, nearly; and here's my coffee, and I must stop writing. Sixth whistle— the *Capo d'Istria* is off, with her crew of morning bathers. Seventh,—from I don't know which of the boats outside— and I count no more.)

In this passage, Ruskin repeatedly interrupts his reading and interrupts himself, making it clear that all the details of this letter have to do with cyclical repetitions. The "dirty population" of Venice who spend the day in idleness, smoking and spitting, will wake up the following morning and bathe to give themselves the energy to spend another day in idleness, smoking and spitting. This unproductive circular movement is identical to the movement which Ruskin has observed in other social processes, and not only in leisure activities but also in the world of work. He begins by stating facts, but the facts then become incarnate in the form of the steam whistles, and what started as discussion moves onto the level of direct representation. Thought processes run parallel to the concrete events of the outside world and are given equivalent treatment. The original aim of the paragraph—to confirm or, rather, *repeat* the exact meaning of a Biblical blessing—is wrecked by a curse: by the repetitive whistles of the steamer, which harks back to the first repetitive cycle that Ruskin has described. The compulsive repetitions of the outside world win out over the internal

repetitions, and a curse wins out over the attempt at benediction.

No other passage in Ruskin illustrates better than this one the fact that he must have experienced his recurrent cycles of mania not as an affliction but as a *sense organ* finely attuned to the pathology of everyday life. And no passage in Ruskin explains more memorably the way in which his fate obeyed the Darwinian law which he had consciously rejected. He was a man who did not want to adapt to changing living conditions, who chose instead to hold on to all his present sense organs and keep them alive to the lethal manifestations of modern life as long as possible, until his species was wholly destroyed.

Let us now move on to another instance of Ruskin's treatment of repetition in *Fors Clavigera*. This example is wholly different in kind and meaning. Ruskin "reads" the boy fig seller and the fruit he sells as an apocalyptic emblem. Reading—"hard ecclesiastical reading"—is one basic way of approaching the world, but the other is sensory perception of what is immediately there. Ruskin switches rapidly back and forth between the two, and they become indistinguishable at times. He is never able to look at the "visible facts" purely with a view to their abstract meaning. This is why—as we shall now see—he values Carpaccio's art and the hard realism behind its mysteries: "To Carpaccio, whatever he has to represent must be a reality; whether a symbol or not, afterwards, is no matter, the first condition is that it shall be real."

The same can be said of Ruskin: for him, symbol reading and sensory perception remained two quite separate ways of unlocking the world. When he first introduced symbols into his work at the end of the 1850s, in the form of Turner's dragons, he felt compelled to give a long-drawn-out proof of the scientific possibility that real live dragons could exist. And later, as we have seen, he was unwilling to exchange the "living hieroglyph" of the snake for its "dead" image in symbolism. By the same token, when he creates his symbolic tableaux in *Fors Clavigera*—in this case, the tableau of the fig seller—he never lets go of its real flesh-and-blood model. Thus, he mentions that the boy's cry of "Figs for sale!" remains

audible when the boy bends down—even though this detail adds nothing to the symbolic content of the scene.

Another constant factor in Ruskin's writing is the drive with which he shifts from the concrete to the symbolic content of a scene. Each time, this transition is invested with a sensation of hope, of release, and of heightened meaning. We can see this, once again, in Letter 20 of *Fors*. When he deems that his readers have suffered enough from the cacophony of the "steamer music," he leads them out of the sound room of his hotel chamber to the stillest place he has found in all Venice: the bedroom of St. Ursula, as it appears in the famous painting by Vittore Carpaccio.

The painting shows the princess asleep in bed, dreaming of an angel who gives her the message to agree to marry the English prince who has asked for her hand.

Ruskin now offers pages of description in which he gives all the details of the painting. The text is deceptively peaceful and logical— always a rarity in *Fors*. Ruskin approaches each object with a rapt devotion which seems as tranquil and tidy as Ursula's room. Not until the end of the passage does he spell out the message which he has already implied in the preceding luminous description:

> So dreams the princess, with blessed eyes, that need no earthly dawn. It is very pretty of Carpaccio to make her dream out the angel's dress so particularly, and notice the slashed sleeves; and to dream so little an angel—very nearly a doll angel,— bringing her the branch of palm, and message. But the lovely characteristic of all is the evident delight of her continual life. Royal power over herself, and happiness in her flowers, her books, her sleeping, and waking, her prayers, her dreams, her earth, her heaven.

The key words in this passage are "the evident delight of her continual life." Ruskin has always regarded the "continual"—the enduring and constant—as one characteristic of the good life, the other characteristic being "immediacy," or life right now. When

he made us hear the noises of the traffic outside, he made us experience the quality of modern life. In this experience, both the immediacy and the continuity of life were present; but both were imposed from outside and were not transformable into personal life. There was no "happiness in" the things of the world, and thus neither was there "royal power" over oneself. In the modern experience, "continual life" turns into a sensory alertness caused by disruptive stimuli; an ongoing, reflexive response to a recurring event. It is continual but it is not life.

Next, Ruskin hastily plunges the reader into his set of hot and cold baths. He shows us a different image which is the antitype of the painting of St. Ursula. This second image is the type of modern man, the type who is being produced by the new civilization. After spending the morning contemplating Carpaccio, Ruskin writes, he then travels by train from Venice to Verona in the afternoon, and during the journey he encounters two American girls, aged fifteen and eighteen—roughly the same age as Ursula. But these girls are not of royal blood. Instead, they are

> specimens of the utmost which the money and invention of the nineteenth century could produce in maidenhood,—children of its most progressive race,—enjoying the full advantages of political liberty, of enlightened philosophical education, of cheap pilfered literature, and of luxury at any cost. Whatever money, machinery, or freedom of thought could do for these two children, had been done. . . .
>
> And they were travelling through a district which, if any in the world, should touch the hearts and delight the eyes of young girls. Between Venice and Verona! Portia's villa perhaps in sight upon the Brenta, Juliet's tomb to be visited in the evening,—blue against the southern sky, the hills of Petrarch's home. Exquisite midsummer sunshine, with low rays, glanced through the vine-leaves; all the Alps were clear, from the Lake of Garda to Cadore, and to farthest Tyrol. What a princess's chamber, this, if these are princesses, and what dreams might they not dream, therein!

But the two American girls were neither princesses, nor seers, nor dreamers. By infinite self-indulgence, they had reduced themselves simply to two pieces of white putty that could feel pain. The flies and the dust stuck to them as to clay, and they perceived, between Venice and Verona, nothing but the flies and the dust. They pulled down the blinds the moment they entered the carriage, and then sprawled, and writhed, and tossed among the cushions of it, in vain contest, during the whole fifty miles, with every miserable sensation of bodily affliction that could make time intolerable. They were dressed in thin white frocks, coming vaguely open at the backs as they stretched or wriggled; they had French novels, lemons, and lumps of sugar, to beguile their state with; the novels hanging together by the ends of string that had once stitched them, or adhering at the corners in densely bruised dog's-ears, out of which the girls, wetting their fingers, occasionally extricated a gluey leaf. From time to time they cut a lemon open, ground a lump of sugar backwards and forwards over it till every fibre was in a treacly pulp; then sucked the pulp, and gnawed the white skin into leathery strings for the sake of its bitter. Only one sentence was exchanged, in the fifty miles, on the subject of things outside the carriage (the Alps being once visible from a station where they had drawn up the blinds).

"Don't those snow-caps make you cool?"

"No—I wish they did."

And so they went their way, with sealed eyes and tormented limbs, their numbered miles of pain.

Ruskin had, in a single day, seen life in a state of blessing and life under a curse, "in clearest opposition." Ursula was blessed, both in her limbs and in her senses, because in her harmony with herself she saw "things that are not." The American girls were accursed because their "tortured indolence" made them "blind even to the things that are." When one's attitude to nature goes no further than the expectation of being cooled off by its snowfields,

one has lost the great coherence with nature, at which point one really does belong in the new machine age—riding a train—and in the inside world rather than the outside—in a closed rail compartment—and in a world dominated by comfort—novels and refreshments. In short, one belongs to all that we know as civilization and progress.

Ruskin's Venice hotel room, resounding with the noise of the steamers, and the enclosed train compartment with the American girls in it are like a pair of satirical cartoons framing the central image of the triptych: St. Ursula's bedroom. In the hotel room the source of disquiet comes from outside, and in the train compartment it comes from inside the girls. In both cases, the physical and emotional reactions are hyperaesthetic: just as Ruskin registers every whistle from the steamer, the girls yield to every physical irritant, and this hyperaesthesia—this morbidly increased sensitivity—is what prevents them all from regaining their composure and returning to aesthesia or perception of the opposite dimension: the inside or the outside. The overloading of the senses leads them to hypoaesthesia, a feebleness of sensation and denial of perception. The author of *Fors*, when he was still in his state of hyperaesthesia, was able to make these truths visible.

8

Now that we have finished the episode of the American girls, we will leave Letter 20 of *Fors* and return to Carpaccio's *Dream of St. Ursula*, just as Ruskin himself returned to it again and again after he first discovered the painting in 1869. He felt at once that a new world had opened to him—the world of unchanging, intact life—but he took a surprisingly long time to discover its specific personal meaning for his own life. But of course that is the nature of myths, Ruskin writes to the readers of *Fors*, with whom he shares his repeated attempts to approach the painting. Myths reveal themselves only gradually to the imperfect human intelligence, he says. Initially, we have only our "instinctive desires, and figurative per-

ceptions," and only later, as the soul matures and finishes processing these desires and perceptions, does it acquire the "spiritual powers" to read the personal meaning of a myth.

Still, it is no very difficult matter to read the parallel between the legend of St. Ursula and Ruskin's love affair with Rose La Touche. The myth—and Ruskin's detailed version of it in *Fors*—tells us that when Ursula was fifteen an angel commanded her to tell her suitor, the son of the King of England, that she would marry him provided that he met three conditions. He must adopt the Christian faith; he must wait for her for three years; and he must allow her to visit the holy sites in Rome and Jerusalem before their wedding. During the journey, she and her retinue were killed by the pagans, so that Ursula remained forever a bride and a virgin.

In Letter 20 of *Fors*, there is no hint that Ruskin understood the personal implications of this story. But it was during his stay in Venice in 1872 that a certain symbolic pattern formed in his life which later—he confesses—almost proved his undoing.

While he was writing Letter 20, his friends in England informed Ruskin that Rose, after keeping him waiting for six years, now wanted to see him. But Rose being Rose, she could not simply say that she wanted him to come. She demanded that this man who had committed knowing "transgression against God's laws, sins against *knowledge* of God's will & admiration of purity," must alter "utterly & completely & miraculously." "I am not a saint," Ruskin replied in a letter to MacDonald written on July 8, 1872, while he was copying the figure of a bird holding a plant in its beak from a painting by Carpaccio in the Scuola di San Giorgio dei Schiavoni. "Rose is—but a cruel one." But naturally he answered her summons. The two of them met twice that year, experiencing days of grimly determined happiness, for which, Ruskin claimed, he paid for the rest of his life.

He had been drawn back into the old nerve-racking cycle of approach and rejection, ecstasy and despair—"fear mixed with the enchantment," as he wrote, right after the revival of their relationship. Once again they loaded each other with the old burdens, even though they both knew that this time the ground was crum-

bling beneath them and they could not keep up their grotesque ballet much longer. For Rose was dying. She was already gravely ill when Ruskin saw her again in 1872. And she did not recover her health in the next three years, even though—or perhaps *be-cause*—her parents, who in the past had worked so hard to destroy John and Rose's relationship, now looked to John to save their ailing daughter.

Rose La Touche died on May 25, 1875, leaving the tormented Ruskin to try to decide what had killed her. Was it the fact that he had not "let her alone at once—as perhaps I ought"? Was it that "she was killed in youth by religious gloom and folly"? As for himself, he knew that Rose's death had made "much of my past life at once dead weight to me," and for the rest of his days he was left to hope that he was under Rose's protection and guidance. In other words, their relationship continued, in his dreams, drawings, and paintings. "A wreath of wild roses is not so easily disentangled," Rose had predicted in 1862.

Ruskin was studying hawthorn blossoms when Rose died, and later he published his observations of the flower on the anniversary of her death.

> White,—yes, in a high degree; and pure, totally; but not at all dazzling in the white, nor pure in an insultingly rivalless manner, as snow would be; yet pure somehow, certainly; and white, absolutely, in spite of what might be thought failure,—imperfection—nay, even distress and loss in it. For every little rose of it has a green darkness in the centre—not even a pretty green, but a faded, yellowish, glutinous, unaccomplished green; and round that, all over the surface of the blossom, whose shell-like petals are themselves deep sunk, with grey shadows in the hollows of them—all above this already subdued brightness, are strewn the dark points of the dead stamens—manifest more and more, the longer one looks, as a kind of grey sand, sprinkled without sparing over what looked at first unspotted light. And in all the ways of it the

lovely thing is more like the spring frock of some prudent little maid of fourteen, than a flower.

"The longer one looks," indeed, the more one sees Rose in everything that Ruskin wrote. She was a figure who lent herself to endless metamorphosis. In 1875, Rose contacted Ruskin—or so he believed—during spiritualist séances; although again and again he came to doubt the fact.

Then, in 1876–77, she contacted him, clearly and unmistakably, through Carpaccio's painting of St. Ursula. Quite possibly, Ruskin really was unable to decipher the myth until its last part had been fulfilled and the princess had died a virgin before she could marry her heathen Englishman.

In the late fall and winter of that year, Carpaccio's *Dream of St. Ursula* brought Ruskin a third peak experience, a third conversion like those at Fontainebleau and Turin. He experienced and mastered this conversion just as he had the others: through drawing. The painting had been taken down from its high museum wall and placed at his disposal in a special room, where he spent six months—with occasional interruptions—copying it in four separate studies. One copy was of the sleeping girl, drawn to the scale of the original.

On the second day after his private annexation of the painting, he wrote to his cousin Joan that for him it was more than a painting, and Ursula was more than a princess: "There she lies, so real, that when the room's quite quiet, I get afraid of waking her! How little one believes things, really. Suppose there *is* a real St Ursula, di ma [his pet name for his cousin], taking care of somebody else, asleep, for me?"

In this passage, Ursula still appears in the role of Rose's guardian angel. But, in the near future, both girls will change their roles. First, Ursula becomes Rose's preincarnation. Then the two unite and visit their earthly lover as a ghost.

Giving everything he had to his copy work, Ruskin became obsessively absorbed in details of the painting which he had per-

ceived differently in the past, or had not noticed at all. But these "branching details," as he called them, did not lead him—as the details of Venice had done a quarter of a century earlier—to reflect on the relationship between artistic representation and history, between the artist and society. Now he was indeed concerned only with the symbolic content. He had abandoned the attempt he made in his Oxford inaugural to revive his earlier theory of art. His keen perceptual powers were devoted wholly to the hunt for significant details, to what he called "picture reading."

Carpaccio was the ideal artist on whom to exercise this skill: "I might have known Carpaccio never would even *omit* without meaning." Ruskin ranked Carpaccio with Hesiod, Plato, and Dante, among those who "*know* the truths necessary to human life." "He speaks little . . . but his brief book is of extreme value." Carpaccio's work, Ruskin says, is the truest prophecy "of all that Venice was born to utter," it is his "lesson . . . for the creatures of this restless world."

Ruskin's whole interpretation of Carpaccio is too involved to repeat here, but his concluding sentence about the painting of St. Ursula will make clear the method and content of his "picture reading":

> For this is the first lesson which Carpaccio wrote in his Venetian words for the creatures of this restless world,—that Death is better than *their* life; and that not bridegroom rejoices over bride as they rejoice who marry not, nor are given in marriage, but are as the angels of God, in Heaven.

Although we cannot outline in full the path by which Ruskin arrived at this conclusion, it is clear that the theme of death and the motifs of his private life are now dictating his concerns as an art interpreter.

In 1876–77, Ruskin once again experienced Venice as the city of death, or, rather, experienced its life as a particularly inglorious form of dying. "I had never seen Venice look so dead before, or been so dead in it," he wrote in his diary on December 29, 1876.

No wonder that even the most straightforward passages of *Fors* are repeatedly interrupted by fantasies of death. Once, when he is gazing at the Canale Grande and Salute, he observes: "For this green tide that eddies by my threshold is full of floating corpses, and I must leave my dinner to bury them, since I cannot save."

Moreover, even Carpaccio's painting, which once was the promise of undamaged life, now is read as the prefiguration of the saint's martyrdom, down to the most everyday details, which Ruskin composes into allusions to her death.

"The last (probable) additions to our picture reading of the Dream are that the deep crimson rods of the flower-pot are the four nails and lance point of her Lord, and that the singularly open book in her bookcase is the Book of her Life, the black clasp— arrow-head again—marking the place where, in sacred pause, 'Quel giorno non piu leggemmo avanti' ["That day we read no more!"]." Ruskin mentions the arrow-shaped clasp because Ursula was killed by arrows; he discovered the symbol in two other places in her chamber as well.

As we read Ruskin's comments about all these prefigurations of death, we must not forget that the last time he saw Rose La Touche she was lying in her sickbed, and he probably drew pictures of her. Ursula is a more serene but equally doomed version of the dying girl in the bed. Although Ruskin still tempers his personal associations with references to objective features of the painting, so that it is more or less possible for other people to follow his reasoning, his many allusions to brides and bridegrooms never- theless show that he is steadily approaching the same subjective attitude to art that we see in his adversary Walter Pater, who in 1873 had asked the programmatic question: "What is this song or picture . . . to *me?*"

Shortly before Christmas 1876, Ruskin waited for Rose to send him further signs like those which had come to him at the séances a year earlier. The expected series of messages promptly began to arrive in rapid succession; and there could be no doubt that they all came from Ursula-Rose. On December 23, two letters arrived from England. One contained a dried sprig of vervain, the other

a note from Rose's mother. Then, on the 24th, a pot of dianthus flowers was delivered to him, the same type of plant that appears in the right-hand window of Ursula's room in the painting. This was a thoughtful gift from an Irishwoman staying in Venice who knew that Ruskin's work was centering on Carpaccio's *Dream*. "From St. Ursula out of her bedroom window, with love," read the accompanying card. In the hours that followed (Ruskin wrote home to England), everything "went on gradually increasing in distinctness, and consisting of a succession of helpful and sacred suggestions, presented so as to connect themselves with the best feelings and purpose of my life." That night he slept "like a child," and on Christmas morning awoke to receive further gifts, including shells of a kind that he had drawn around the time in 1867 when he had received the message from Rose's father forbidding him to see her again. The shells, Ruskin said, were St. Ursula's way of telling him to forgive John La Touche. He left the house in what he describes as a kind of dream, following the commands of his goddess in "happy effortless obedience."

Christmas Day, 1876, turned into a vast séance, and Venice into a vast theater of mysteries. First, Ursula-Rose sent him to St. Mark's to give thanks. Then, at the home of his gondolier, he found a touching Christmas scene, the gondolier's eighteen-year-old daughter with her baby. From there he went on to the Scuola di San Giorgio dei Schiavoni, to that "cell of sweet mysteries" where, in 1872, he had received Rose's message to come home and see her. "I wondered whether little Bear [Ursula] had anything special to say there—on Christmas day." Approaching Carpaccio's *Baptism of the Sultan*, he looked again at the image of Porphyrio, the bird of chastity, holding a plant in its beak: the same bird which Ruskin had been copying when Rose had summoned him home. "I looked to see what the plant was. . . . It was the vervain *in flower*. 'That's enough, little Bear, for today,' I said—'I can't take any more.' " Ruskin left the church feeling that now his "Christmas day was done, and lesson ended."

But only a few minutes later a second series of messages began in which "there was not a single suggestion made but to what was

wrong, or stupid; Every thing which occurred to my mind was a trap, or a discouragement." The first gondolier who spoke to him was "a horrid monster with inflamed eyes, as red as coals," and in fact was the devil himself, he claimed later. As he turned away, he realized that he must now be prepared "to take any painful or ugly lesson she [Ursula] chooses." The rest of the day passed in false moves and shadowboxing. Twice, when he went out, his boat got lost in the fog; once it misguidedly steered toward the insane asylum of San Clemente. Visits to friends did not go smoothly, and the day ended with severe physical pain. He felt that the "helpful Spirit" had deserted him "and that I was left, unkindly, it seemed, to my own prudence and effort, contending with adverse *chance*." This was the lesson he drew from this "Christmas story": one must obey meekly the dictates of higher powers; but against the confusion and attacks of evil, one must "mobilize the human powers" of resistance. These two powers of acceptance and resistance were both given by God, "but developed, nevertheless, and only to be developed for such contest, by long years of former effort, meditation, and grief." Such is the use of myths when they are living ones, he proclaims at the end, in a tone almost of triumph.

In future issues of *Fors*, he told his readers a great deal (but not all) about these events, and claimed that he had successfully passed his "course of teaching"—but he was deeply troubled. For us today, the refetishizing of pictures—the reexperiencing of their power—is a form of Symbolist spleen which writers like Dante Gabriel Rossetti, Edgar Allan Poe, Oscar Wilde, and J.-K. Huysmans turned into exciting literature. But we should emphasize again that Ruskin turned to the symbolic aspect of painting to compensate for his rapid loss of meaning and of sensory contact with the real world, and to cope with unbearable inner tensions. Back in 1873, he had written in an issue of *Fors* that as long as there were "pictures I could not copy, and stones I could not understand," he would not yet have qualified for the madhouse. That is, he would not go mad, as long as he was still in touch with a healthily demanding reality which had not yet been caught up

in the whirlpool of inner and outer delusion. Now he was forced to learn a lesson which he had failed to learn from his study of ancient myth: that reexperiencing dreams—in this case, St. Ursula's—did not bring about a happy identity with the dreams, and did not bring "continual life." This was the same lesson recorded by Ruskin's student, the myth-maker William Morris, in an 1868 poem: "Dreamer of dreams, born out of my due time . . . I cannot ease the burden of your fears." Nor could Ruskin ease his own, we might add. A universe run by higher powers, in which everything was true, seemed every bit as frightening as a human world where nothing was true anymore.

When he was still very young, Ruskin had described the habit of reading symbols in everything as "a dangerous plaything." At the time, he was in fact resisting the Protestant emphasis on the typological interpretation of the Bible, which had been a dominant force in his own home. In old age, he asked his doctor "whether the peculiar habit of some persons who are for ever striving to find a resemblance, or fancy they do, between what they see and something quite different, which they ought not to be thinking about at all, if they would only rightly understand what they are looking at, can be a variation in a mild form of this disease [i.e., his insanity], or whether it is merely the natural perversity of their foolish dispositions." In any case, his hope of "living happier and more strengthening life with St Ursula's help" was not fulfilled. After the harrowing experience of his first major attack, he wrote Norton a letter in which he said: "*Mere* overwork or worry might have soon ended me, but it would not have driven me crazy. I went crazy about St. Ursula and the other saints,—chiefly young-lady saints."

In the immediate wake of the Christmas messages, he boasted to the readers of *Fors* about his skills in decoding symbols, his new conversion, and his consequent reevaluation of the history of Italian art. Now the "sign painters of God"—Giotto, Cimabue, Fra Angelico, Carpaccio—once again ranked higher for him than the pagan vitalists—Titian, Tintoretto, and Veronese. Meanwhile, he tried to master his obsession by reading "any vicious book I

can find to amuse me—to prevent St. Ursula having it all her own way." But his attempt to emulate Luther, not by throwing an inkpot at the Devil but by throwing an unexpurgated edition of Casanova at a saint, brought him only short-term relief.

After symbolistic excesses of the kind Ruskin had suffered, he would have done better to have sworn off symbols altogether and taken the radical cure that Barbey d'Aurévilly had recommended to the authors of *Les Fleurs du mal* and *À rebours*: either the mouth of a pistol or the foot of the Cross.

Judging by the "more distinctly Christian tone" of Ruskin's writing after his new conversion, one might conclude that he had chosen the second of these alternatives. In fact, he did toy with the notion of becoming a Franciscan in Assisi; but on another occasion he assured his friends in *Fors* that there was no need to fear his imminent conversion to Catholicism.

Ruskin never chose either of Barbey d'Aurévilly's options. After his spiritualistic Christmas adventure, he counted on his own powers of resistance, fortified by suffering, to carry him through. But these were not enough to enable him either to start a new life or to bring his old life to an end. Nor did they allow him to achieve the synthesis he aimed for, the *vita nuova*, the transfigured life in and with Rose. They allowed him to live on; that was all. His solution was not the radical one he would have chosen but the one appointed to his time: repetition.

Concerning the myth of Ursula, he wrote that it was one of those deepest mysteries of life, "which I only can hope to have explained to me when my task of interpretation is ended."

Seven
The Only Real Seer
1878–1890

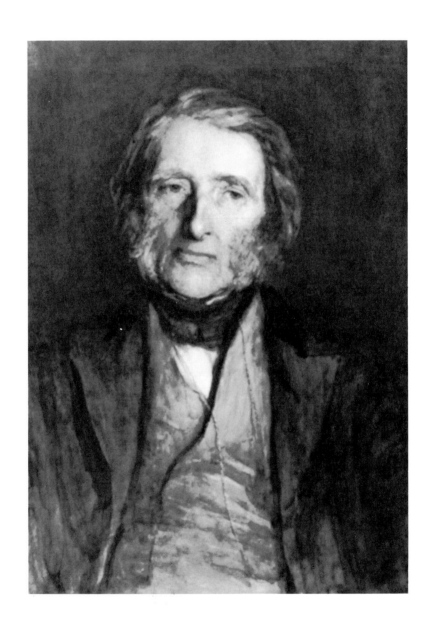

Hubert von Herkomer, John Ruskin, Age 60, *1879. Watercolor.*
National Portrait Gallery, London

I

"I had left him in 1873," Norton wrote, "a man in vigorous middle life, young for his years, erect in figure, alert in action, full of vitality, with smooth face and untired eyes. I found him [ten years later] an old man, with look even older than his years, with bent form, with the beard of a patriarch, with habitual expression of weariness, with the general air and gait of age."

We can confirm Norton's impressions for ourselves by comparing two portraits of Ruskin—his self-portrait of 1873–74, which we looked at in the last chapter—and the portrait which the German-born artist Hubert von Herkomer painted of him in 1879. The only thing missing from Herkomer's portrait is the beard Norton mentions, which Ruskin did not begin to wear until 1881.

The man we see in the self-portrait is still desperately looking himself in the eye, and his body still looks firm, intact. But in the 1879 portrait the expression of strain and effort has yielded to a softness which, on closer inspection, could be interpreted as sluggishness and lack of concentration. His left eyebrow, which in the self-portrait curves down threateningly like an active, independent feature, now is drawn off to the side and looks inexpressive. His mouth—formerly animated by the contrast between the sharply defined upper lip and the full, projecting lower lip—now is simply two parallel strips of flesh. The tense and overwrought expression which we found in the self-portrait has been replaced by shallow furrows, and the formerly taut and rounded flesh has gone slack. The pliable, mobile look has vanished, leaving the bone structure more prominent.

The eyes, Ruskin's special hallmark, which he regarded as the best thing in his face and in his life, have a forlorn look. They see nothing of interest, no infinity; they scan no inner horizon. The mechanism which aligns them appears to be growing limp, like sagging guide ropes. They look as if they are yielding to the force of gravity, and you can hardly imagine their gaze concentrating itself rapidly and becoming focused. Yet there seems to be something evasive in them, something that is looking for a way out. This is not necessarily a contradiction: it is possible that the eyes regard *not* seeing as a way out.

But Ruskin's contemporaries—at least those who were not as close to him as Norton—saw him quite differently. Ruskin was now ripe for canonization. "The fact is that his face *is simply beautiful!*" wrote the painter William Blake Richmond, Ruskin's successor in the Slade Professorship of Fine Art at Oxford. "There is the same calm brow, but that puckering of cynical lines about the nose has gone. The whole face answers now in perfect concord, and a concord of wonderful beauty—strange, very sad, introspective, but saintlike in idealism for search of some thing outside the ordinary ken of humanity."

No doubt, Richmond is right to say that Ruskin's face is now beautiful and harmonious. In his younger days, highly regular features were in conflict with irregular ones, which made his appearance very changeable. By contrast, the worn composure of his old age indeed seems harmonious and beautiful.

But Herkomer's portrait tells us more if we see it as the picture of a man in reverie, lost in thought. After his mother's death in 1871, Ruskin had sold his house in Denmark Hill and moved back to nearby Herne Hill, to the same house where he had lived from 1823 to 1842 and which he had given to his cousin Joan when she married Arthur Severn. He turned his former nursery into a study, and it was here that he wrote all his works of the 1870s and 1880s, except for those that he produced at Brantwood. It was here, for instance, that he wrote the preface to his autobiography. It was here, too, that Herkomer painted his portrait. The sixty-year-old Ruskin, sitting for his portrait in the room he occupied as a child,

is no longer looking for holes in the carpet, as he had done in the studio of James Northcote fifty-six years before; but perhaps he is remembering how he found the holes. A man who returns to his nursery at the age of sixty must be regarded as being absent as much as he is present. That may explain his vapid gaze.

Richmond's description of Ruskin starts out very conventionally, but it gets better as it goes along. In fact, Richmond saw more than he realized:

> It is mad! but the beauty of mad sanity. What a paradox! It is far from the ideal of this century, nor is there the least trace of Self, really—but of a perfect, if hidden, belief, a conviction gained by all manner of roads. There is a sense of strife, inward and outward, revealed, and a dreamland yet unexplored, not burning, but smouldering with the strong sense of a fine fire existing.

<div align="center">2</div>

The enormous changes that we see in Ruskin, the Ruskin of Herkomer's portrait, were caused by events which took place between February 14 and April 23, 1878. It was during this period that he experienced his first bout of full-blown insanity. Five more were to follow.

At the top of a blank page in his diary, Ruskin wrote of this period: "February,—to April—the Dream."

Schopenhauer said that a dream could be defined as a brief madness, and madness as a long dream.

Ruskin always continued to write in his diary until the brink of collapse, up to that point when the distracted mind turns to destroying the body. The evangelical urge to self-exploration sustained him until the very last minute. No doctor, performing an experiment on himself, could have acted with more awareness. Ordinarily, he used to write only two to four lines a day in his diary, and often recorded nothing more than the weather and his

general mood. But, before his breakdown, the entries got longer and longer—as much as four pages each as he neared the crisis. At this point they became shorthand notes reflecting a rapid stream of consciousness that carried away everything it met, whether inside or outside.

In its basic structure, Ruskin's "dream" resembled his Venetian Christmas of 1876, the sole difference being that now all his messages were coming from inside. But the process was the same: Ruskin visited a series of stations, and each station led him on to the next. On February 15, which marked the start of his great associative flight of ideas, he wrote that certain pictures in his room were "giving me no end of practical teaching about the uses of pictures." This brings us very close to what happened in Venice, and in fact to what started happening to Ruskin more and more often from the late 1850s on: the experience of pictures as messages, the creation of connections, the joy in the intermediate link. None of this is really new in his life.

The attack itself began on St. Valentine's Day, 1878, when a number of pictures, all copies of Italian paintings, began communicating to him in Rose's name: "ST VALENTINE — and Ive had the Madonna for a Valentine! — Fors gave me her from the Beata Vigri—the first thing I set eyes on—and all her beauty in the Moon dawned on me as I looked."

Helen Viljoen's meticulous commentary, which makes sense of the diary entries and allows them to speak to us, interprets this entry as follows: Chance (Fors) willed that on St. Valentine's Day Ruskin would receive a gift from a Venetian woman friend: the copy of a painting by a female Bolognese artist, Beata Vigri, who became a canonized saint, known as St. Catherine of Bologna. The painting shows St. Ursula with four other saints, and the nun Catherine at her feet. The diary's reference to the Madonna very likely means simply that Ruskin regarded Ursula as "my lady," who was equivalent to Madonna Rose, and that the holy virgin Catherine, who painted the holy virgin Ursula, had also begun to fuse with the virgin Rose, canonized by Ruskin. Ruskin once told

the MacDonalds that he thought Rose resembled St. Catherine of Bologna in several respects.

Ruskin has fallen into an interpreter's whirlpool, a *symbolisme en abîme*. Each symbol has another tucked inside it. An endless abyss of references opens up which soon makes retreat impossible. Next day the diary reports: "February 15. Friday. My Valentine has been on my chimney piece, with Solomon and the Queen of Sheba,—giving me no end of practical teaching about the uses of pictures, and the—police news—and my lecture—and Miss Edgeworth's Ormond, and the mystery of Morality—Above all—Carlyles lovely moral sense,—and the hymn said in my arms. I *must* get to work,—or I shall get utterly—into dreamland."

Decoded, this extract makes clear the type of conflict which was building for Ruskin. His woman friend in Venice appears to have given him a second copy, which he placed next to the painting by Beata Vigri: a copy of Carpaccio's *Solomon and the Queen of Sheba*—today usually attributed to Bastiani—a work which Ruskin, significantly, had once praised because it shows Carpaccio's habit "of spiritualizing, or reading like a vision, whatever he saw with eyes either of the body or mind."

Naturally, the subject reminds him of Veronese's painting of the same name in Turin, which he had copied and which had led to his "unconversion" in 1858. That event had led to his turning away from the life-inhibiting faith of his mother and toward a paganism which affirmed the senses. As we know, it was this same religious enslavement from which he wanted to rescue Rose, saving himself in the process.

But now the year was 1878, and he had undergone a new conversion after the Christmas story of 1876. Confronting the theme of *Solomon and the Queen of Sheba* again immediately aroused defensive feelings linked to the faith and moral views of his parents and Rose—although, as is frequently the case with references to gods, he does not name them directly. His mother often called on Miss Edgeworth's treatises to inculcate moral values in her son. After the death of Ruskin senior, Carlyle had taken over his paternal

role; and "the hymn said in my arms" refers to a moving episode from the final phase of Rose's illness: when she was violently delirious and unable to sleep, Ruskin was brought in to soothe her, and she found peace and sleep in his arms, while saying over the hymn "Jesus, Lover of My Soul."

Ruskin finished writing the March issue of *Fors* on the same day as he wrote this diary entry. At this point, its technique of free association made it resemble the things which he was writing in his diary. In it he quoted from the Book of Proverbs—purportedly written by Solomon, of course, the same Solomon who appeared in the painting with the Queen of Sheba: "My son, hear the instruction of thy father, and forsake not the law of thy mother. For they shall be an ornament of grace unto thy head and chains about thy neck." This stern injunction to children to obey their parents has applications both to himself and to Rose.

But what kind of temptations is the Bible text warning him against? Why does his diary entry for February 16 say that yesterday had been a day of hard struggle, and of needing patience and cleverness?

"February 17.—Sunday. Stopped upstairs behind Kate to pray, a little—after 'seeing my way' at last at ½ past three this morning—with beata Vigris help—and Ophelias.—Let in—that out—Departed, never more

The devil put a verse into my head just now—'let us not be desirous of *vain* glory.' I am NOT oh Devil. I want useful Glory.—'provoking one another'—Oh Devil—cunning Devil—do you think I want to provoke Beata Vigri and little Ophelia then—?"

The reference to Ophelia ushers in a third prefiguration of Rose, who will often preoccupy Ruskin in his periods of delusion. Even during Rose's lifetime, he had compared her to Shakespeare's tragic heroine, who preferred to obey her parents rather than follow her lover, and went mad because of it. Now, in 1878, he thought

of Ophelia as another Valentine gift because of her mischievous song from Act Four of *Hamlet*:

> To-morrow is Saint Valentine's day,
> All in the morning betime,
> And I a maid at your window,
> To be your Valentine.
> Then up he rose, and donn'd his clothes,
> And dupp'd the chamber door;
> Let in the maid, that out a maid
> Never departed more.

Ruskin abbreviates the last two lines when he quotes them, in a way that makes them completely innocent. To him their meaning was so powerful, like a dangerous spell, that he had to render them harmless in some way. For here we see the real object of Ruskin's struggle: "a steady try if I couldn't get Rosie's ghost at least alive by me, if not the body of her." The maid was to be let in, but not let out again. He repeated the same formula during his second breakdown as well.

On February 20 he had reached such a state that he was fantasizing a mystical wedding to Rose, and wrote to MacDonald: "Dear George, We've got married after all . . . but I'm in an awful hurry, such a lot of things to do." But the wedding was not the end of the dream: the end was a major attack. Once Ophelia-Rose entered the scene, the conflict which at first had stayed general intensified, took a fleshly form, and so became hopeless. For if Ursula and Beata Vigri stood for Rose the saint, Ophelia stood for what Rose herself referred to as her "animal nature."

Despite Ruskin's spiritualization of Rose, she was the last woman he desired, and even after her death she continued to command his desires. Even in her sacred form—the form of her alter ego, Ursula—it was her beauty that fascinated him, not her purity. His first diary entry on St. Valentine's Day speaks of her "beauty in the Moon." Ophelia's plainspoken "love-song" and the refer-

ences to Valentine's Day itself—the day when a man chose a "sweetheart" and when, according to legend, the birds mated—show how Ruskin's wild flight of associations was centering on the sensual world of Turin.

He tried to fight it off with the Cross of St. George, who had defeated the dragon, or serpent, which for Ruskin was the symbol of masturbation. Then he quoted a fragment from Galatians—claiming that the Devil had put it into his head!—which reveals the true meaning he assigned to the Cross. He abbreviated the quotation—as he had done the last lines of Ophelia's song—by cutting out the crucial words, the ones that give him away. Galatians 5:24–26 says: "And they that are Christ's have crucified the flesh with its affections and lusts. If we live in the Spirit, let us also walk in the Spirit. Let us not be desirous of vain glory, provoking one another, envying one another." These lines are a stern warning against the lusts of the flesh, which comes into Ruskin's mind when he falls under the spell of Ophelia-Rose. Later he came to regard this warning against lust as the message of his first three bouts of insanity. He must, he felt, take to heart the precept of Romans 8:13: "For if ye live after the flesh, ye shall die: but if ye through the Spirit do mortify the deeds of the body, ye shall live."

So these are the powers which from now on will resume their old struggle over Rose and John, to claim their lives in the flesh or in the spirit. It is amazing to watch the speed with which they change their disguises and shift their battlefronts, and the variety of material they attract and then repel. Fragments of texts from Pindar, Horace, Dante, Shakespeare, Novalis, Keats, Wordsworth, Flora Shaw, *Punch*, and the *Telegraph Post* all enter the fray. Visual artists get involved too, including Botticelli, Carpaccio, Beata Vigri, Tintoretto, Titian, Burne-Jones, and Richter; and it would take far too much space to list all their collaborators from mythology, history, and religion. Ruskin's stream of consciousness turns into a whirlpool whose swirling waters engulf half of European intellectual history and whose center, rather than remaining still and calm, seems to reverse the flow so as to capture even more. ("I must put it all down as fast as I can.")

The result is a dizzying acceleration in which the symbolism of accelerating time plays an increasingly dominant role. Sometimes it is his mother's watch, sometimes his father's, that speeds him up. A passage like this should be read simply for its effect, without attention to all the details: "Putting it into the drawer I come on my mothers watch in the case I used to be so fond of. What o clock is it? Six minutes to 12—and a few seconds over—as far as I can see with my magnifying glass—my old eyes wont.—Oh yes the second-hand—(Second! life) twenty one seconds.—Time—Twice and a half time or so. Im wasting it—Devil puts me in mind of Iachimo—Imogene dear—& the mole cinq spotted—we'll beat him, wont we?"

By now, Ruskin's symbols are all compressed, abbreviated. What can we make of notations like: "Delphi first. Then Ægina. Behind Carpaccio"? Actually, it is possible to explain it, but it would take several pages. The hectic stream of language is pouring down a cataract, to culminate in a great Venetian fantasy which starts off with the message from Rose that reached him at the Scuola di San Giorgio dei Schiavoni, and moves on to include Titian and Tintoretto, the Doges Gritti, Dandolo, and Selvo, the horses of St. Mark's, his Venetian gondolier Pietro, and the Greek princess, the legendary wife of Doge Selvo, who is yet another mask of Rose: the last such mask to be mentioned in this particular diary entry.

On the morning of Good Friday, 1878, Ruskin was discovered lying unconscious and feverish. His own memory of that time is that he had spent the night walking up and down with no clothes on, awaiting a fight with the Devil. There followed a ten-day struggle to save his life—the sick man refused all nourishment—and then came long phases of milder delirium, endless incomprehensible monologues, sudden violent attacks on his nurses and relatives, paranoid suspicion of everyone and everything around him.

After slightly less than six weeks of the gravest illness, he suddenly took a turn for the better, and on April 8 he was able to leave the house again for the first time. This was roughly the pattern

of all the great "dreams" or bouts of insanity that Ruskin suffered in years to come. He had six major attacks in all, in 1878, 1881, 1882, 1885, 1886, and the last in 1889, which ushered in the longest dream, the one that lasted eleven years until his death.

The material that appears in his "flight of symbols" (as I would like to call what he recorded on paper)—and in the nightmares he experienced during his periods of delirium and later recalled with remarkable clarity—is quite different in each attack. But Rose and his parents are always among the protagonists. The attack of 1886 merits special mention because of the theme that triggered it. Usually Ruskin followed many labyrinthine twists and turns before he ended up in the cul-de-sac of total madness. In 1878, as we have said, it took him some time to fall completely into his Venetian trap. But in the 1886 episode, all it took was an unexpected meeting with a living symbol, a "living hieroglyph," and the dream started up at once. "I had an interesting encounter with a biggish viper, who challenged me at the top of the harbour steps [on the lake below Brantwood] one day before my last fit of craze came on. I looked him in the eyes, or rather nose, for half a minute, when he drew aside into a tuft of grass, on which I summoned our Tommy—a strong lad of 18, who was mowing just above—to come down with his scythe. The moment he struck at the grass tuft, it—the snake—became a glittering coil more wonderful than I could have conceived, clasping the scythe and avoiding its edge. Not till the fifth or sixth blow could Tommy get a disabling cut at it. I finally knelt down and crushed its head flat with a stone,— and hope it meant the last lock of Medusa's hair for me."

Behavior like this must seem incomprehensible to anyone who has not spent night after night being tortured by dreams of snakes, who does not dream of them all day too, during major fits of insanity; and who has not placed himself and his land under the protection of St. George the dragon-slayer. But the remarkable thing is the way Ruskin recounts the event, as if he perceives no relationship between seeing the snake and the insanity that follows. Moreover, even after the next attack, he continues to hope that he has finally destroyed the source of his obsessions, in the form of

the living hieroglyph, and will see no more of "Medusa's hair."

Ruskin pondered the cause and meaning of his attacks. He studied his diaries and gave his friends, doctors, and readers detailed accounts of the chaotic dreams he suffered in his fits of delirium. It was not his way to keep to himself experiences that preoccupied him deeply. Silence and repression would not have preserved his privacy in any case, because Victorian England carried hero worship so far that the newspapers printed daily bulletins about any of its great men whose lives were considered in any way threatened. The meaning of his affliction seemed clear to him; he accepted the conventional view that madness was a punishment, and a message that the afflicted had to decipher: "The two fits of whatever you like to call them are both part of the same course of trial and teaching, and I've been more gently whipped this time and have learned more."

His need for punishment, his desire to atone for real and imagined sins against his parents, God, and Rose, and to atone for his "life in the flesh," was so imperative that his attacks did not hold all the terror for him that one might imagine. Masochistic tendencies and Protestant self-examination encouraged his desire to "define the limits of insanity. My experience is not yet wide enough." They also allowed him to feel a sense of worth and satisfaction: "I am content with so much of Apocalypse as all that I deserve."

But ready as he was to accept an underlying purpose to his illness, Ruskin also knew some of its immediate causes. It is important for us to know what they were, because they are closely bound up with his future strategies of survival, and also with his writings. The fact that he felt a need for punishment should not be interpreted to mean that he enjoyed or sought his breakdowns. From 1878 on, he had two lives, both of which had their rewards and both their punishments. He was not always able to say with certainty which was the real one: "I went wild again for three weeks or so, and have only just come to myself—if this be myself, and not the one that lives in dream." Just as the dream would swallow up elements of the real world, so it would also feed its

own urges and themes back into Ruskin's ordinary waking life, or give him something against which to measure his waking achievements.

Assuming that Ruskin had a subjective hierarchy of causes for his illness, he seems to have accepted one main cause and several more or less equally important secondary causes; and he dismissed outright the cause suggested by his doctors, well-known specialists, who diagnosed brain fever brought on by overwork.

After the first attack, Ruskin said that his life had been saved by a country doctor who recognized that there was something in his soul that needed curing. "The fact is, these illnesses of mine have not been from overwork at all, but from over-excitement in particular directions of work. . . . The first time, it was a piece of long thought about St. Ursula." "*Mere* overwork or worry might have soon ended me, but it would not have driven me crazy. I went crazy about St. Ursula and the other saints,—chiefly young-lady saints. . . . But the doctors know nothing either of St. Ursula or St. Kate, or St. Lachesis—and not much else of anything worth knowing." Ruskin believed—and we must accept—that the main cause and material of his delusion was thinking too much about his dead Rose and the repetition and continuation of his life with other people who had been important to him, all of whom were now dead.

He also assigned three secondary causes, which at the same time were powerful motives for his literary production. In varying contexts, he mentioned compulsive symbolism, compulsive memory, and the compulsive concern with the ills of his time as contributing to his breakdowns. We have already commented on the first of these three at the end of the last chapter, when we quoted Ruskin's self-analytical remark: "I have sometimes wondered whether the peculiar habit of some persons who are for ever striving to find a resemblance, or fancy they do, between what they see and something quite different . . . can be a variation in a mild form of this disease." At certain times, he said, everything began to link up with everything else—"My books always open, perhaps ten times during the day, at passages which strike back into the line of

thought, no matter how apparently foreign to it the book may have been,—Punch, or Dante is all the same, they are sure to open like Sortes [books opened at random to prophesy with]"—and he would be caught in a rapidly closing net of self-activating symbolic allusions. He fought this by trying to construct a counter-network made up of safe, universally recognized symbols. In other words, he tried to use books of conventional symbols to combat books of prophecy, the "Sortes."

In the 1860s, this approach had enabled him to produce his study of mythology, in which he combined the treatment of private and collective symbols. But later he was no longer able to apply this technique successfully. *The Bible of Amiens* (1880–85) and *The Shepherd's Tower* (1881) are inferior to *The Queen of the Air*, because essentially they merely list and break down the allegories, symbols, and religious scenes found in the Cathedral of Amiens or the campanile of the Cathedral of Florence.

Admittedly, headlong flights of symbols appear even in these works. And the famous Ruskinian topos of the spectator making his approach to a monument or artwork never received more fantastical treatment than in the opening pages of *The Bible of Amiens*. But the presence of "purple passages" does not hide the fact that the book consists mainly of dry exegeses of iconography strung together without artistry, as in a dictionary of symbols. Taken as a whole, both *The Bible of Amiens* and *The Shepherd's Tower* aim to be nothing more than sacred texts, expositions of doctrine, based on symbols drawn from monuments of a time which Ruskin considered to be religiously and aesthetically untainted.

The study of iconography had developed in England around 1850 as a means of enabling Protestant travelers to interpret the religious imagery they found when visiting the Continent. Anna Jameson, for instance, claimed this as her motive when she published her *Sacred and Legendary Art* in 1848. In the 1880s, iconographic studies took on fresh meaning as a way to counteract the proliferation of private mythologies in an age when everyone had a mania for symbolism. These studies became a means of reacquainting people with the mainstream symbolic tradition. Ruskin's

decoding of sculpture in Amiens and Florence and his "picture readings" of Carpaccio and Botticelli were published just at the time when public demand for his works reached its peak, and they were advertised by the most eminent of publicists, including Marcel Proust. Ruskin's influence as myth-maker, iconographer, and symbolist began to be felt across Europe.

3

Perhaps Ruskin was not yet aware that the times people live in determine the *manner* in which they go insane. But he did know that the times *could* drive people insane. He saw himself as one in a long line of artists and philosophers who had suffered the same fate: "How many wiser folk than I go mad for good and all, or bad and all, like poor Turner at the last, Blake always, Scott in his pride, Irving in his faith, and Carlyle, because of the poultry next door."

He, as the latest link in the tradition, felt that he had the greatest reason to go mad. Carlyle, for instance, was less entitled to his delusions, because they all centered on his own well-being. Ruskin complained of Carlyle's "perception in all nature of nothing between the stars and his stomach,—his going, for instance, into North Wales for two months, and noting absolutely no Cambrian thing or event, but only increase of Carlylian bile." His own situation was different, he felt: "The illness which all but killed me two years ago [1878] was not brought on by overwork, but by grief at the course of public affairs in England, and of affairs, public and private alike, in Venice."

Once again, it is not hard for us to read between the lines. It seems not too farfetched to suggest that his "interwoven mind" paralleled the movements of the Victorian Age itself, just as his lifespan nearly matched that of Queen Victoria; and that his breakdowns corresponded to negative trends in his troubled society.

The period of Ruskin's depressive illness (1878–1900) was also

the period of the Great Depression in England. During the twenty-year period 1876–96, "Britain fell behind her rivals; and this was all the more striking, not to say painful, when these occupied fields which Britain had herself been the first to plough before abandoning them. . . . Not only did British production fall behind that of Germany and the USA in the early 1890s, but also British productivity." Britain lost its technological lead and its competitive edge as rival colonial powers grew in strength, and it lost in economic strength because restrictions were being placed on the rampant exploitation of domestic workers. Now, for the first time, the capitalist class was in retreat, refeudalizing its assets, as it faced an organized mass movement of workers. At the start of the 1870s, Britain was exporting goods with a value of £256 million, with 1 percent unemployment. But by 1879 the value of exports had dropped to £192 million, and the unemployment rate was 12 percent. As in the economic crisis of the late fifties, doubts arose about the validity of the dominant economic theory.

The most popular economist of the day was not Marx, and neither was he one of the many steadfast ideologues of capitalist expansion. He was Henry George, whose widely read book *Progress and Poverty* (1879)—of which Ruskin made a careful study—was most in tune with the prevailing mood. George proposed the theory that progress creates social misery, so that "Where the conditions to which material progress everywhere tends are most fully realized—that is to say, where population is densest, wealth greatest, and the machinery of production and exchange most highly developed—we find the deepest poverty, the sharpest struggle for existence." Ruskin and Carlyle had both expressed the same idea, but George put it into just the right formula at just the right time.

That the great economic depression was able to affect the individual psyche is clear from the epidemic of neurasthenia that broke out toward the end of the century. This illness was "discovered" and described in 1878 by the American doctor George Miller Beard, and was particularly prevalent among the middle class, those very people who previously had been the most optimistic supporters of progress. The vague clinical description of

neurasthenia included symptoms such as irritability, a mood of depression, the inability to perform work which one had been capable of previously, rapid fatigue, and a tendency toward brooding and self-doubt. These emotional symptoms could appear in conjunction with the most varied physical disorders.

Neurasthenia was a mild version of psychological depression. The depressive atmosphere produced more serious disorders in vulnerable and clairvoyant natures like Ruskin's. In this climate of general hypersensitivity, neuroses and hysterias developed which had never been described before, and in fact had probably never existed before, at least not in a clinically pure form.

Ruskin's case is a good example of the shift from ills of the body to those of the psyche. All the Ruskins were sensitive plants. After the serious illness which John suffered in his youth, he expected for a time that his body might break down in some way, as we saw from the long "health report" he wrote to his father from Venice. When this physical breakdown failed to materialize, his interest then shifted to psychical ailments. As he grew older, the diary notations about his mood swings become increasingly precise, until the time of his actual breakdown, when his disjointed jottings show him descending into the whirlpool. Then, after a certain point, the attacks of insanity undermined his body as well, until it, too, was permanently enmeshed in the ego's disintegration. The confused man exposed himself naked to the winter cold, smashed through glass windows, and tried to hurt himself in other ways. And when he was lying tied down in bed under constant guard, unable to destroy himself, he spent his time dreaming of violent death. He fantasized that he was being riddled with bullets; the Queen cut off his head; he went through some kind of crucifixion; he was poisoned. Yet, although it cannot be said that his attacks of mania left his body unscathed, at the same time they never led to the development of permanent physical symptoms. His body succumbed to a flu epidemic, only long after his mind had been utterly defeated.

Ruskin was not the only one who believed that art—that most sensitive of all the signs of the times—had entered a period of

decline at the end of the 1880s. In 1879 the "picture of the day" (as Ruskin might say) was Millais's sentimental piece *Cherry Ripe*, an enlarged illustration of which 600,000 color reproductions were printed in 1880 and which became the most commercially successful British work of art of the nineteenth century. And Ruskin's fear that art would one day be valued chiefly as an advertising vehicle was fulfilled in his own lifetime: another of Millais's paintings was successfully used as the model for a soap ad.

Thus, the 1870s saw the sad artistic decline of more than one member of the Pre-Raphaelite movement. The times also produced such key paintings as Manet's *Nana* and Whistler's *Nocturne in Black and Gold* (both 1877). In *Nana*, naturalistic painting joined forces with the naturalistic literature of Zola. Ruskin commented as follows on the trend:

> The reactions of moral disease upon itself, and the conditions of languidly monstrous character developed in an atmosphere of low vitality, have become the most valued material of modern fiction, and the most eagerly discussed texts of modern philosophy. . . . The disgrace and grief resulting from the mere trampling pressure and electric friction of town life, become to the sufferers peculiarly mysterious in their undeservedness, and frightful in their inevitableness. The power of all surroundings over them for evil; the incapacity of their own minds to refuse the pollution, and of their own wills to oppose the weight, of the staggering mass that chokes and crushes them into perdition, brings every law of healthy existence into question with them, and every alleged method of help and hope into doubt. . . . A philosophy develops itself, partly satiric, partly consolatory, concerned only with the regenerative vigour of manure, and the necessary obscurities of fimetic Providence; showing how everybody's fault is somebody else's, how infection has no law, digestion no will, and profitable dirt no dishonour.
>
> And thus an elaborate and ingenious scholasticism, in what may be called the Divinity of Decomposition, has established

411

itself in connection with the more recent forms of romance, giving them at once a complacent tone of clerical dignity, and an agreeable dash of heretical impudence; while the inculcated doctrine has the double advantage of needing no laborious scholarship for its foundation, and no painful self-denial for its practice.

This was a crisp early formulation of the arguments against naturalism and later "kitchen-sink" schools of art.

Ruskin's theory of art, which he had reaffirmed in his Oxford lectures at the beginning of the 1870s, did not allow the artist to adapt himself to the conditions of the times. The artist's first duty was to create the conditions which would permit the creation of art. As long as these conditions remained unsuitable, art was neither entitled nor obliged to depict society with the realism which should justly be applied to nature. Art devoted to the depiction of decay was itself doomed to decay.

The chain of reasoning which Ruskin mounts against naturalistic art may have its weak points, just like what it attacks, but he does successfully point out that naturalism is based on a permissive attitude toward pathological phenomena: in other words, on a deep-lying connection between subject and object. For the Victorian art critic, Ruskin included, it was an all-important principle that morbid receptivity did not automatically equal art.

It was this principle which underlay Ruskin's rejection both of naturalism and of Impressionism. In an 1877 issue of *Fors*, he loosed his famous diatribe against Whistler's daring *Nocturne in Black and Gold*, which caused Whistler to bring a lawsuit against him. "I have seen, and heard, much of Cockney impudence before now; but never expected to hear a coxcomb ask two hundred guineas for flinging a pot of paint in the public's face." Whistler won his suit, or at least he won a symbolic victory: Ruskin was ordered to pay him a farthing. The trial itself was well documented but doesn't actually tell us much. Ruskin could and would not accept that the amount of time and effort an artist put into his work was any guide to its value. Whistler, for his part, maintained that his picture

actually represented a whole lifetime's knowledge, not just the two days' labor it had taken to paint it. Ruskin also would not concede that a mere arrangement of line, form, and color—for that was how Whistler described his work—had any title to be called art.

Ruskin, the theorist of the "pure eye" and of the world's "visibility," indeed helped pave the way for Impressionism, but he never became one of its defenders. There were clear points of disagreement between Impressionist theory and his own. Ruskin, for example, had shown the differences between the way the eye perceived a leaf or a rock formation from close up and from distances of ten or a hundred yards. His concentration on the visible aspects of objects emphasized their essential structure, their "governing lines," and thus allowed him to know them better. But it never led to a rapid shorthand—as in Impressionism—which served the interests of the painting, divorced from the object itself. He could not acknowledge that the claims of the medium took precedence over the claims of the objects depicted. When he came to Oxford to teach, he took another look at the art production of his time, but then reverted to the same conclusion he had drawn in the late 1850s, which had made him drop his work as an art historian and art critic: under the present conditions, art was useless and, indeed, impossible.

The natural historian Sir John Lubbock had drawn up a list of the world's hundred most important books, and this moved Ruskin to make up his own list and to put Edward Lear's *Book of Nonsense* right at the top. This fine touch of irony would have made a fitting conclusion to Ruskin's lifetime of attacking the real or perceived decay of art in his times. Unfortunately, if the arts were in decay, so too, it would appear, was art criticism: for Ruskin himself was not exempt from foibles. In one of his Oxford lectures he stated publicly that the sentimental illustrator Kate Greenaway—formerly a greeting-card designer—was one of the greatest artists of all time; and he told her in private that one of her hand-painted Christmas cards was finer than Raphael's painting of St. Cecilia.

But if Ruskin had seen no more in his times than the decay of art and the human spirit, he would not have gone mad over it.

After all, back in the 1850s, a time which everyone else regarded as rosy and prosperous, he had already detected the signature of melancholy and joylessness; and not long after that, he had announced that the whole British economic system was insane. But what finally drove Ruskin over the edge, into obsessional despair about his times, was *nature's* sad fate. He felt that nature itself was getting old and tired, and as reluctant as contemporary humans to rise to its former great achievements. "The 1870s and 1880s were an age of universal catastrophe for agriculture" because cheap imported foods were flooding the market and home-produced foods could no longer compete. In 1879, a failed harvest drastically worsened the effects of the economic recession. A famine broke out in Ireland, worse than any that had been seen since the "hungry forties," and worse indeed than anyone could have imagined was still possible in the enlightened days since the advent of laissez-faire.

"Garden England" had been decimated, first by the Industrial Revolution, when Britain became the factory center of the world, and then by its agricultural decline. These developments seemed to verify a scientific theory which was coming into vogue in the very period when Ruskin had his first breakdown, and when Beard and George were publishing their writings on the psychological and social crises of the times. In 1852, William Thomson (Lord Kelvin) had formulated the second law of thermodynamics, which among other things implies that the exchange of energy between hot and cold heavenly bodies will one day stop, and that "the whole Universe will be one equally heated inert mass, and from which everything like life, or motion, or beauty, will have utterly gone away."

Notably, this prediction that the earth would die in a blaze of heat was largely ignored when it was first published in the 1850s. Not until Balfour Stewart's book *The Conservation of Energy* appeared in 1873 did non-scientists become aware of the theory. After that, it became very popular and was incorporated into all theories which took a pessimistic view of the world, opposed to the aggressive alliance of Darwinism and the ideology of progress.

414

A single example is Tennyson, who in 1850 had hoped for the coming of a "crowning race" "under whose command / Is Earth and Earth's, and in their hand / Is Nature like an open book," and who were approaching ever nearer to God, the great goal of the creation. Later, Tennyson first lost faith in the future of man and then hope for the survival of the creation. The vision of his final years is of God-forsaken creatures wandering through a world that is burning out: "O we poor orphans of nothing—alone on that lonely shore— / Born of the brainless Nature who knew not that which she bore!" In "Locksley Hall Sixty Years After" (1886) he asks how long the earth will continue to nourish its ceaselessly multiplying human beings. How long will it be "till this outworn earth be dead as yon dead world the moon? / Dead the new astronomy calls her."

"Chaos, Cosmos! Cosmos, Chaos! who can tell how all will end?" That was Tennyson's question. The answers given by scientists of various disciplines, among them Henry George, Henry Miller Beard, and Lord Kelvin, all had one thing in common: they had turned away from the faith in evolution and progress then in vogue. Their predecessor on this path was Sir Charles Lyell, who had had a major influence on Ruskin's thinking and whose geological studies had led him to predict a state of entropy similar to that which Lord Kelvin predicted in his general theories of thermodynamics. When the perpetual force of erosion had worn away all the mountains and filled in all the valleys—Lyell said—the earth would be dead, because an earth without mountains is an earth without life: the chapter called "Mountain Glory" in the fifth volume of *Modern Painters* tells us why.

Thus, the anti-evolutionists said that the field of tensions generated by opposites—the field of tensions that produced life and other new states—was not permanent. Instead, the extremes tended to move into a tension-free equilibrium that canceled them out, or into a fruitless stalemate. In fact, this was the same thing that happened to the neurasthenic, who stopped experiencing the wholesome alternation of work and rest and whose nervous state was a combination of restlessness and inactivity. And the same

pattern was repeated again in the economic situation, in which the opposition of wealth and poverty produced only deadlock: the two opposites reinforced each other to no effect.

Ruskin now felt it his duty to add yet another theory of exhaustion and final calamity to all the rest. Apart from professional meteorologists, there can hardly have been a citizen of the nineteenth century who recorded such precise observations of the weather as Ruskin did, over such a long span of time. He had been interested in weather since childhood, but the research results from his "service of clouds" had rarely been put to any use, except as background to his studies of landscape painting.

Now, at the end of his life, Ruskin produced a short work on meteorology which was as self-assured and as fundamental in its approach as the meteorological paper he had written at age eighteen. It was the last work to come out of his "science of aspects," a personal scientific document based on his own incessant observations of his subject. He wanted people to know—not just scientists, but people in general—something which apparently had escaped the notice of everyone, in their collective blindness: the sky was getting darker, and night and day were getting more and more alike.

He knew that people would call him a dreamer or a madman. Even he himself must have thought it was a suspicious coincidence that he had first observed this gradual darkening in 1871, the very year when he suffered a fever that turned into symptoms of delirium, and when various permanent shadows settled over his future.

So he hurriedly set out to explain his meteorological study, *The Storm-Cloud of the Nineteenth Century* (1884), to lecture audiences and readers:

> In many of the reports given by the daily press, my assertion of radical change, during recent years, in weather aspect was scouted as imaginary, or insane. I am indeed, every day of my yet spared life, more and more grateful that my mind is capable of imaginative vision, and liable to the noble dangers of delusion which separate the speculative intellect of hu-

manity from the dreamless instinct of brutes: but I have been able, during all active work, to use or refuse my power of contemplative imagination, with as easy command of it as a physicist's of his telescope: the times of morbid are just as easily distinguished by me from those of healthy vision, as by men of ordinary faculty dream from waking.

And to the ever-skeptical Norton he wrote: "Don't think this is a brain-sick statement—I certify you of the facts as scientifically true."

In fact, he is right; his diaries supply overwhelming proof of the truth of his claim. Down through the years, they report prolonged periods of storm, dark days, and barren wind. These phenomena prove so constant that Ruskin is able to indicate them by abbreviations.

But occasionally he expresses his despair in passages which rival the storms of the weather and which no doubt are unique in the annals of meteorology. Ruskin knew their worth and used their dark glow to enhance his argument. Witness this, written in his diary at Brantwood:

August 13

Wednesday The most terrific and horrible thunderstorm this morning I ever remember It waked me at six, or a little before—then rolling incessantly, like railway luggage trains— quite ghastly in its mockery of them—the air one loathsome mass of sultry and foul fog like smoke—scarcely raining at all,—increasing to heavier rolling with flashes quivering vaguely through all the air—and at last to terrific double streams of reddish violet fire, not forked or zigzag but rippled rivulets—two at the same instant some 20 to 30 degrees apart—and lasting on the eye at least half a second—with grand artillery-peals following; not rattling crashes, or irregular cracklings, but delivered volleys, all the worst of it over towards Seathwaite. It lasted an hour, then past off—clearing a little—without rain to speak of—not a glimpse of blue—

and now ½ past seven seems settling down into Manchester devil's darkness.

¼ to Eight,—morning Thunder returned—all the air collapsed into one black fog, the hills invisible—and scarcely the opposite shore—heavy rain in short fits—and frequent—though less formidable flashes, and shorter thunder

While I have written this sentence it [the cloud] has again dissolved itself, like a nasty solution in a bottle, with miraculous and unnatural rapidity and the hills are in sight again—a double forked flash, rippled I mean, like the others, starts into its frightful ladder of light between me and Wetherlam, as I raise my eyes. All black above—a ragged spray cloud on the Eaglet.

½ past eight—Three times light, and three times dark since I last wrote—the darkness seeming each time as it settles more loathsome, at last stopping my Plato in mere blindness. One lurid gleam of white cumulus in upper lead-blue sky, seen for half a minute through the sulphurous chimney-pot-vomit of blackguardly cloud beneath—where its rags were thinnest.

In the 1840s, Ruskin's descriptive prose had been supple, light, and melodious. From the 1870s on, it became powerful and densely wrought. These lines, with their vigor and onomatopoeia, represent a sort of compressed version of the style of *Fors Clavigera*, and like *Fors*, they are inconceivable without the influence of Carlyle's clotted balls of language. But they go beyond "Carlylese" in their grim, completely unmannered energy. Carlyle is always rhetorical; but Ruskin's diary entries never are—indeed, cannot be, by their very nature. Instead, it is as if they borrow their rhythm and sound from their subject matter. The words shower down like "heavy rain in short fits."

Ruskin himself described this as his third style, the first two being what he called his "affected" style, in which he was always searching for the best words—*Modern Painters* was the main example—and a style which aimed for maximum clarity—meaning the political tracts like *Unto This Last*. This third style was the one

which shaped *Fors Clavigera* and the end of *Modern Painters*. He said of it: "My third way of writing is to say all that comes into my head for my own pleasure, in the first words that come, retouching them afterwards into (approximate) grammar."

Notably, Ruskin transferred the long diary entry quoted above into his public text on weather with only the slightest polishing; and yet one doubts that these words which were dictated to him were really "for my own pleasure," because obviously he finds the storm horrifying, although the text itself does not make it completely clear why.

What really disturbed Ruskin about storms like this one was not their dramatic features but their sterility. He did not claim that the weather had behaved more violently since the 1870s. On the contrary: "In those old days, when weather was fine, it was luxuriously fine; when it was bad—it was often abominably bad, but it had its fit of temper and was done with it—it didn't sulk for three months without letting you see the sun."

Basing his account on diary entries and drawings, Ruskin reconstructs the weather patterns he knew in his youth. These old-fashioned, clear-cut, wholesome types of weather are dying out, he says, or sometimes have disappeared altogether, and have been replaced by what he calls "storm-cloud" or "plague-wind."

In 1875 he wrote about this wind in his diary:

This wind is the plague-wind of the eighth decade of years in the nineteenth century; a period which will assuredly be recognized in future meteorological history as one of phenomena hitherto unrecorded in the courses of nature, and characterized pre-eminently by the almost ceaseless action of this calamitous wind.

But, an hour ago, the leaves at my window first shook slightly. They are now trembling *continuously*, as those of all the trees, under a gradually rising wind, of which the tremulous action scarcely permits the direction to be defined,— but which falls and returns in fits of varying force, like those

which precede a thunderstorm—never wholly ceasing: the direction of its upper current is shown by a few ragged white clouds, moving fast from the north, which rose, at the time of the first leaf-shaking, behind the edge of the moors in the east.

The wind brought clouds in its train, which massed to form a uniform gray layer of cloud: "not rain-cloud, but a dry black veil, which no ray of sunshine can pierce."

Such clouds are barren because they do not discharge rain and because they take away the light, just as the wind is barren because, instead of purifying the atmosphere, it seems only to drive it around in circles. Ruskin never tires of describing the wind as capricious and "malignant." Its arrival is unpredictable and it vanishes just as suddenly; it blows from every direction and always accentuates the worst qualities of winds from each quadrant of the globe. And when it blows, it makes

the leaves of the trees shudder as if they were all aspens, but with a peculiar fitfulness which gives them—and I watch them this moment as I write—an expression of anger as well as of fear and distress. You may see the kind of quivering, and hear the ominous whimpering, in the gusts that precede a great thunderstorm; but plague-wind is more panic-struck, and feverish; and its sound is a hiss instead of a wail.

One striking feature of Ruskin's analysis of this new weather is the way in which he concentrates on the wind rather than on the solid carpet of cloud that follows in its wake, often closing off the sky for weeks on end. Another notable element is the way in which he repeats the same simile over and over: the wind is like the wind that precedes a great rain and thunderstorm. The plague-wind he describes is truly the weather he deems appropriate to his times: it is a mass of exertion and tension which is never relieved and never rewarded. It is a wind that blows only for its own sake, without direction, without goal: not an extreme which generates

an opposite extreme, but a compromise that maintains the status quo. For even when conditions do momentarily intensify into a real thunderstorm of the kind Ruskin described in his diary, it is followed by a return to the same thing, a dense, dark fog. The plague-wind "degrades" all that a storm used to be.

This weather attenuates and degrades all of nature's features, while lacking the power to bring any noticeable meteorological change. It veils the sun and never blows over. One has to observe the sunlight with the naked eye rather than with an instrument, Ruskin says, because just as a wind gauge cannot tell you if it is a steady breeze or a series of fitful gusts that is registering on the gauge, so a photometer cannot tell you if the sun's rays are struggling to penetrate

> a dense *shallow* cloud, or a thin *deep* one. In healthy weather, the sun is hidden behind a cloud, as it is behind a tree; and, when the cloud is past, it comes out again, as bright as before. But in plague-wind, the sun is choked out of the whole heaven, all day long, by a cloud which may be a thousand miles square and five miles deep.

Moreover, a cloud like this is unable to turn the sun red "as a good, business-like fog does with a hundred feet or so of itself." The plague-cloud turns the sun pale. "Blanched Sun,—blighted grass,—blinded man": that is the apocalyptic vision of St. John Ruskin at the end of his life. After a month without an hour of sunshine, the *Pall Mall Gazette* published a witty verse which said that whereas once the sun never set on the British Empire, now it never rises. Ruskin, when he reported the verse, turned it into a solemn prophecy. The process of "uncreation" has begun. "The earth becomes void again; the word goes forth: 'let there be no light.' There is no man, but only dust; and the birds of the heavens are fled."

Coeli Enarrant—"The Heavens Proclaim"—was the title Ruskin gave to an anthology of his writings about clouds. So, "What do the Heavens mean?" his diary asks in the year 1884. Like the other

harbingers of the Apocalypse, Ruskin sees signs of exhaustion and impotence wherever he looks: "But nothing would beat me except the plague of darkness and blighting winds,—perpetual—awful,— crushing me with the sense of Nature and Heaven failing me as well as man." "The deadliest of all things to me is my loss of faith in nature. No spring—no summer. Fog always." But at other times he "reads" the clouds for signs which higher powers may be sending to him and to his generation. For he has always viewed the sky as a medium of communication, a giant writing tablet on which God writes messages—even if most people cannot read what they say.

Ancient peoples would not have failed to notice messages like the ones coming through now. After all, the most terrible prediction of the old prophets was that the sun's light would be extinguished in the sky. In the Bible and among the Greeks, "physical gloom," the darkening of nature, had been interpreted as the result of "moral gloom." So why shouldn't that be so now, after all the sins committed against God and men in the previous twenty years? Science was no help in matters concerning light. Only a "moral Science of Light" could do any good. Even if one could not affect the signs of the sky, one *could* affect the signs of the times, Ruskin said. "Whether you can bring the *sun* back or not, you can assuredly bring back your own cheerfulness, and your own honesty."

It certainly would appear that Ruskin had a startlingly clear vision of the cause-and-effect relationship between the blackness of the soul and the blackness of the sky; or at least he had a clear notion of the intervening steps that connected them. We have already noted that passage from Letter 66 of *Fors* in which he said:

The physical result of that mental vileness is a total carelessness of the beauty of sky, or the cleanness of streams, or the life of animals and flowers: and I believe that the powers of Nature are depressed or perverted, together with the Spirit of Man; and therefore that conditions of storm and of physical darkness, such as never were before in Christian times, are developing themselves, in connection also with forms of

loathsome insanity, multiplying through the whole genesis of modern brains.

These lines implied a causal connection between dark skies and dark souls, at least to the extent that people who have forgotten how to see nature have also stopped seeing what they are doing to harm it. The deterioration of man's senses goes hand-in-hand with the deterioration of what the senses sense. *The Storm-Cloud of the Nineteenth Century* hints at this line of thought several times but never develops it. Ruskin quotes a passage from *The Eagle's Nest* which says that Nature turns into Creation only through the medium of the human eye in its every act of perception. Placed in its new context, the passage suggests that the process of uncreation begins when the light of the eye and the light of nature are extinguished. If "Fiat lux" means "Fiat anima," then "Let there be no light" means that all man's faculties are on the point of extinction.

Storm-Cloud also quotes several passages from *Fors* which speak of man's direct influence on the signs of the heavens. One line, quoted from Letter 8, dated July 1871, Matlock, describes the gray cloud as looking "partly as if it were made of poisonous smoke; very possibly it may be: there are at least two hundred furnace chimneys in a square of two miles on every side of me."

Ruskin also knew that the climate of Lancashire, and especially of the Lake District, where he had his home, had been deeply affected by the blast furnaces which first appeared along the coast fifteen miles away in 1854 and multiplied in the 1870s and 1880s. "A quite black, deadly curtain over sky—in the old way—not fog, but 1000 feet thick of smoke-cloud." "All the Lancashire view utterly lost in black smoke. . . . Evidently no more a breath of pure air to be drawn in England."

But evidently Ruskin was not satisfied to attribute the darkness of the sky to such realistic causes. In one diatribe, for instance, he begins on a concrete note but then turns the culprits into myth: if the law of the Creation is "Fiat Lux," then the united steam, noise, and rust company which has its headquarters in London, Paris, and New York has issued a counter-order: Let there be dark-

ness, and God himself obeys, loosing smoke and plague-wind to take away the light and turn the sky into a dome of ash.

Ruskin prefers interpretations that view gray clouds as dead men's souls, mocking cartoons arranged by the Devil, or signs from God. Images like these may well be projections which reflect his own state of mind. But they also show, in more general terms, the widening gulf between the wealth of empirical data and the diminishing prospects of explaining them. Science no longer even seemed interested in explaining anything but the composition and orbits of the sun and moon, Ruskin said. "And I do not care, for my part, two copper spangles how they move, nor what they are made of. I can't move them any other way than they go, nor make them of anything else, better than they are made. But I would care much and give much, if I could be told where this bitter wind comes from, and what *it* is made of."

If Ruskin could have investigated the wind personally—as once he felt capable of investigating almost any subject under the sun— he might have made a fruitful exchange between "physical" and "moral" science, between "science of facts" and "science of aspects"—and might not only have learned the cause of the wind but also gotten solid proof of the accuracy of all his observations.

Today we know that Ruskin's observations were perfectly correct. Only twenty years after *Storm-Cloud* was published, all his points were generally confirmed; and our more refined methods of looking at past environments have verified his findings many times over—although, even now, little note is taken of his finely tuned weather observations. The 1870s and 1880s form a unique period in the history of environmental and weather study. The skies darkened, the air became thicker and unhealthier, the climate damper and colder. One result was a progressive increase in the numbers of people dying from respiratory ailments. Trees and animals died too, not only in foggy England but also on the Continent. For example, starting in the 1880s, there were widespread reports of damage to forests in Germany. Rosenberg tells us that "From 1869 through 1889 the temperature in London was below average for eighteen of the twenty-one years . . . reliable figures

for sunshine are available only after 1879, but sixteen of the twenty autumns and winters from 1880 through 1889 were below average, and the total sunshine was below average for more than sixty per cent of the decade.''

Thunderstorms steadily became more frequent in the London area, from 1690 into the 1870s. London weather was so bad that at times the mortality rate in a given week could rise by as much as 40 percent.

The darkness and pollution of the atmosphere seemed to culminate in the winter of 1883–84, which was darker and more noxious than any in memory. One week before Ruskin first mentioned the Storm-Cloud—that is, before he published the theories which the newspapers called "fantastic and insane"—the barometer fell to the lowest level ever recorded in London. Modern scientists attribute this effect to the fact that the sulfur-dioxide levels had been rising ever since 1690 and reached their highest level ever in 1880, after which they started falling again. The concentration of smoke and dust in the air also reached its climax in 1880 and then dropped. This description refers to London but could equally well be applied to the whole of Britain and to the industrialized nations of the Continent. Coal consumption, and the resultant contamination of the atmosphere, increased dramatically well into the 1880s. Cities where today the sulfur-dioxide level ranges around 80 milligrams per cubic meter appear to have had levels of 150 milligrams in the 1880s. After that, a combination of factors such as central heating (which reduced the number of fireplaces); better, drier grades of coal; more efficient furnaces; new fuels; and new types of engines which replaced steam engines contributed to an improvement in air quality which even the rapid spread of the automobile could not reverse.

There is no doubt that the gloomy end of Ruskin's own life coincided with a crescendo of gloom in Europe, with unprecedented levels of environmental pollution and climatic deterioration. At the end of the nineteenth century, Ruskin says, the Devil succeeded in perverting the elements themselves: the great fires spread darkness instead of light, because the contaminants they emitted

blackened the skies; and the fires chilled rather than warmed the atmosphere, because the sun could no longer penetrate the dark clouds. At the same time, the glaciers were melting, their ice thawed by the filthy sediments being deposited on them. "The Mont Blanc *we* knew is no more," Ruskin wrote to Norton. "All the snows are wasted, the lower rocks bare, the luxuriance of light, the plenitude of power, the Eternity of Being, are all gone from it—even the purity—for the wasted and thawing snow is grey in comparison to the fresh-frosted wreaths of new-fallen cloud which we saw in that morning light—how many mornings ago?" Ruskin was right about this, too. The melting of the glaciers between 1860 and 1880 exposed large areas which had been covered by ice since the sixteenth century.

But Ruskin had long since arrived at that state when being right no longer makes one happy, and when the hope of finding help where one used to find it is breaking down. What could the countryside communes of the Guild of St. George accomplish in an age in which both town and countryside lay under the same blanket of darkness? What influence lay in moral appeals from England's most prominent environmentalist, when he could not even equal Wordsworth's achievement of preventing a railroad line from being built in the Lake District? Even his pleasure in prophetic rage and shrill denunciation was abandoning him. To be sure, he did still write this kind of note in his diary: "Planned end of 7th lecture [of his Oxford Lectures on the Art of England], how our artists are as bad as Nero in fiddling and painting, not while London is burning, but while it isn't."

But at the same time he openly confessed to Norton:

My own conviction has been these twenty years that when the wicked had destroyed all the work of good people, the good people would get up and destroy theirs; but, though I could bombard Birmingham, and choke the St. Gothard tunnel, and roll Niagara over every hotel and steamer in the States, tomorrow, I still don't see my way to anything farther! and can't lay out my *Nuova Vita* on the new lines!

4

On February 12, 1878, shortly before his stream of associations turned into a torrent, Ruskin wrote in his introduction to a small publication on Turner that now all his thoughts were of those whom he would never meet again. The life he lived in his madness was a life in the past, both private and collective. The more devoid of history the present became, the stronger grew his inner compulsion to repeat the memories of long ago. "*I* call being good, to think of the past—& hope for the future—& then I go mad." "*Both* these illnesses [1879, 1881] have been part of one and the same system of constant thought, far out of sight to the people about me, and of course, getting more and more separated from them as *they* go on in the ways of the modern world, and *I* go *back* to live with my Father and my Mother and my Nurse, and one more,—all waiting for me in the Land of Leal."

The process of recovering his own history was not one he could control. Instead, it consumed him and drove him toward the old fractures, the unsettled accounts, the failures and wounds. It had its moments of fulfillment but in the end, after many collisions, always led to disaster. Both frightened and stimulated by the compulsive memory that took hold of him in his "dreams," Ruskin began, even in his "waking" world, to construct a version of his life with which to control the other, confused and unnaturally magnified one.

This constructed life took the form of a book, Ruskin's last book, his autobiography *Praeterita* ("What is past"). The work has always posed a difficult task for interpreters and biographers, for inevitably they end up competing with Ruskin himself, and that is a competition in which sooner or later they always come out second-best—as Quentin Bell, for one, has testified.

Praeterita was published in installments from 1885 to 1889. It continued to be reprinted and read after Ruskin stopped being a fashionable author, and no doubt it will still be around, and still be worth reading, when the current surge of interest in Ruskin has passed. This is true despite—or because of—the fact that a mere

patchwork survey of his life, pieced together without artistry, would make a more reliable chronicle of the actual events.

The first problem in understanding and interpreting *Praeterita* lies in its author's claim, in its own pages, that he is as incapable of writing a story as of composing a picture; and in its being formed from a life which he describes as formless, inconsistent, and aimless. The second problem is closely related to the first. Writing in difficult circumstances and at a difficult time in his life, Ruskin produced a very simple, one must even say a pure, work. "As, whenever I say anything they don't like, they all immediately declare I must be out of my mind, the game has to be played neatly." He set out, he said, to tell the things in his book as plainly and straightforwardly as possible, and that is just what he does.

Those who read *Praeterita* with no prior knowledge of the real John Ruskin and of his actual life will come away picturing him as a refined, elderly gentleman taking an "old man's recreation in gathering visionary flowers in fields of youth," as he writes in the preface. This autobiography, written during years of dark emotion and in a darkening world, is yet free of visible tensions, of hysteria, agitation, and anger. This remains so, literally up to the last page that Ruskin gave to the printer; and this last page then blends imperceptibly into the text of his final delusion.

Ruskin's description of his life breaks off, had to break off, at the place where his life itself stopped moving forward. The next-to-last chapter tells of his meeting with the child Rose; and the chapter after that ought logically to have been devoted to Rose as a girl and as the woman he loved. But his strength was not equal to this task. The last chapter was composed in the knowledge that he could not continue. It is a terse assemblage of facts and is concerned, above all, with discharging a debt to the female cousin, Joan Severn, who had looked after his mother after his father's death, then became his own friend, mother, and companion, took care of him in his illnesses, and finally became his guardian and heir. This last chapter of *Praeterita* was a thank-you to her and accordingly is called "Joanna's Care." Ruskin was not able actually to write it himself but had to dictate it to Joan.

Only the last page is a vivid re-creation of happier times. It harks back to the year 1872, when for a few brief days Ruskin enjoyed that reunion with Rose for which he paid (he wrote) the rest of his life. Soon after came the violent backlash, the renewed rejection, the words in his diary which he quoted from the dying Christ: "It is finished."

Praeterita has been called Ruskin's "thanatography," the story of a man's death. Engaging as this term is, we must on the other hand acknowledge that the dying process is also life. Moreover, even in a case like this, when such a gap exists between his present reality and what he describes in his writing, we must keep in mind that writing is also life. After the "time of labour," Ruskin wrote, comes "the time of death, which, in happy lives, is very short: but always a *time*. The ceasing to breathe is only the *end* of death." There is a theory of autobiography which says that it is not meant to mirror a life but is itself a part of someone's life; it is not a picture but an ongoing activity. The writer can never pause long enough to view the whole of his life, and he cannot follow it to its final point of rest. So another problem in interpreting *Praeterita* has to do with the sense in which it is simply one part of Ruskin's life.

Every Victorian with the slightest claim to the public's attention took for granted that it was his duty to write an autobiography. But Ruskin's experiment differs radically from the countless other memoirs and life histories produced in the Victorian Age. It does not belong to the familiar "Life and Work" and "Life and Letters" tradition. (Ruskin's "official biography," *The Life and Work of John Ruskin* by W. G. Collingwood, was published only four years after publication of the last installment of *Praeterita*.)

Admittedly, *Praeterita* is arranged in a loosely chronological order; but it never condenses into what Carlyle called "outward biography," which reconstructs a logical sequence of incidents and behaviors. The events that one would expect to find recounted are passed over in silence, as are most of his writings. And *Praeterita* does not fill these gaps with incessant introspection and self-revelation either, as one might have expected of the author of *Fors*

Clavigera, who had supplied such lavish details of his personal circumstances and reflections.

Ruskin once said: "I know no one whom I more entirely resemble than Rousseau." Yet *Praeterita* in no way resembles Rousseau's *Confessions*, which Ruskin found so faithful a mirror of himself that he was tempted to believe he was the author's reincarnation. Those who want to know the sordid truth about Ruskin's marriage, his sexual life, his family relationships, the hidden aspects and secrets of his life, need not bother to read a page of *Praeterita*. It contains not one word of all those events and qualities from which a man might wish to "liberate himself" by confessing his life. Ruskin liberates himself in a different and simpler way, by recording in his memoirs only what he enjoys writing about now, at the end of his days, and only what makes him feel free, at a time when his dreams and fantasies are dominated by uncontrollable flights of ideas and associations: "I have written them therefore, frankly, garrulously, and at ease; speaking, of what it gives me joy to remember, at any length I like—sometimes very carefully of what I think it may be useful for others to know; and passing in total silence things which I have no pleasure in reviewing, and which the reader would find no help in the account of. My described life has thus become more amusing than I expected to myself, as I summoned its long past scenes for present scrutiny."

But if this book is neither ledger-keeping nor self-revelation, then what exactly does it contain and what are its guidelines? Once again—one last time—Ruskin's focus is on *things*, the things perceived: "All I've got to say is: I went there—and saw that. But did nothing."

This is a very accurate characterization, as we can see simply by looking at the table of contents. Of the twenty-eight chapters, twenty-one have the names of places in their titles: "The Springs of Wandel," "Fontainebleau," or "L'Hotel du Mont Blanc." Even the last chapter, the one he gratefully dedicates to his cousin Joan, at one time had several competing titles based on place names like the Salève, Lucerne, and Boulogne.

These chapter titles designate places where some unique event

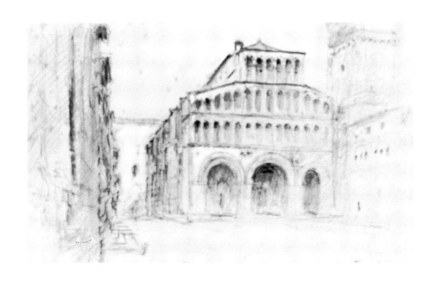

John Ruskin, San Martino in Lucca, *1882. Pencil and wash.*
The Ruskin Galleries, Bembridge School, Isle of Wight

happened (as at Fontainebleau), or places which held a long-time emotional attraction (like the hotel at Mont Blanc). *Praeterita* is first and foremost a book about places and landscapes that lay "On the Old Road," as Ruskin entitled a late collection of short writings. The "old road" was the one that led from London across the Channel to northern France, from there southward, then turned through the Jura Mountains into Switzerland, through Geneva to Mont Blanc, crossed the Alps, and descended to northern Italy, where a large or small circle was described by the traveler before he struck off homeward by the same or a parallel route. As we mentioned earlier, Ruskin made this same journey—with variations and abbreviations—a total of twenty-six times. The last were in 1882 and 1888, and it was between these two dates that he wrote *Praeterita*.

This emphasis on things rather than people is certainly unusual in English autobiographical literature. Only one other nineteenth-century author deliberately selected this same option. Thomas De Quincey, at the start of his *Confessions of an English Opium Eater*, wrote that not he, the opium addict, but opium itself was the true hero of his tale and its true center of interest. Any comparison between De Quincey and Ruskin may seem strained at first, but would it be so far off the mark to subtitle *Praeterita* "Confessions of an English Traveler"?

Of course, the idea of telling the story of one's life in the form of a travelogue was not new. The supreme example of this genre in English literature was Wordsworth's *Prelude*. But there are striking differences between Wordsworth's approach and Ruskin's. Wordsworth uses the medium of travel—the investigation of the unfamiliar—to investigate and to discover himself. Places, areas, countries are means, not ends. They are experienced as specimens of nature, culture, or a blend of the two; but there is no formation of "centers of my life" as in Ruskin. Wordsworth does not need to uproot and recenter himself. Although he may go astray or suffer reverses, he is able to steer toward "home," the sense of self-confidence.

But the author of *Praeterita* claims that he must manage without this fixed abode. His home is in many places and nowhere. *Praeterita* is not really an account of a life's journey but a book about returning home. It describes the search for things which have been repeatedly lost and found again. "Praeterita means merely Past things," the author explained to his friend Kate Greenaway. His past things are past, because they have undergone drastic change over a period of fifty years—not just the cities but, as Ruskin has told us, even the Alps, the glaciers, and the clouds. And yet they are not so lost that he cannot capture them by returning there in the act of writing.

Here lies the difference between Ruskin's book and Proust's *A la recherche du temps perdu*, his "Remembrance of Times Lost." *Perdu*, "lost," is a word as harsh and unyielding as time itself. But the topography of *Praeterita* is not loss. Its aim is to be pleasant, neat and tidy, and so it lives off hope in the local divinities, in the animating power of the spirit of place, in the present moment.

And that is where the difficulty of Ruskin's experiment lies. He is a man who has said: "This is the real state of things with me, of course, in a double sense—People gone—and things. My Father and Mother, and Rosie, and Venice, and Rouen—all gone." So how will he comport himself in this book? If it is true that only the *things* are important, then will he talk about how they used to be, or how they are today; or will he compare the two; or will he be content merely to point out the losses in a tone of grieved emotion but otherwise take care not to disrupt the tranquillity of this, his last book?

Praeterita gives no coherent answer to this question. But it does have a strategy, and the strategy produced celebrated passages which are the book's enduring features. To understand all this better, we must first look more closely at how *Praeterita* was written.

Praeterita was actually Ruskin's second diary and the product of four parallel processes:

1. Ruskin would read his ordinary diaries to prepare for *Praeterita*.

2. As he read, he would write his comments in the margins, thus making editorial notes on his life. It was nothing new for him to add notations to his diary entries. As a rule, he left a margin free for later comment. Nevertheless, it is disconcerting, when one looks at the original manuscript, to see the illegible scrawl of his old age next to the agile, lucid handwriting of the earlier, chronological entries. Moreover, the last marginal notes he made have a conclusive, peremptory ring, which makes them sound like memoranda that an employer might leave for some obliging employee who has done a bit of preliminary research for him. Also notable is the fact that Ruskin both dates and signs his later comments—like a notary public swearing to their authenticity. The autobiographical material expands over time, but in echelons, until its editor-author's thoughts form one last bastion around all the "past things."

Consider an example of this process of accretion. In 1840–41, Ruskin made his grand tour to southern Italy with his parents, and wrote his most detailed travel diary. After returning home, he began in the autumn of 1841—the anniversary of his departure from England—to write a second diary of this trip: a trip on paper, to reconstruct, review, and revise the one on land. On October 23, 1841, he wrote:

> It is odd how completely isolated in time the remembrance of *bits* of a day, however distinct, may get isolated from the general impressions of the day. I have few more distinct impressions than that of the French custom-house near Nice: the long wooden bridge, chattering postilion and place where they went for water along rotten plank, where I got into the mud; and of the wooden guard-house and boasting corporal at Antibes—both these features being totally separated from the general effect of the scenery and emotions of that day.

Two and a half years later, on April 20, 1844, he added a note to this passage: "I have forgotten them now. J.R."

This kind of material—blended with unrecorded memories—is

the stuff of *Praeterita*, a sort of palimpsest covered with superimposed layers of writing—and of life—which are continually being revised, clarified, discarded.

3. Thus, in a sense, writing *Praeterita* meant plagiarizing the diaries. "It is a great bore to keep a diary but a great delight to have kept one," we read in Ruskin's diary entry for December 30, 1840. And forty-five years later we read the same line again in his autobiography. One has the impression that as Ruskin works to capture the various stages of his life and so accomplish the purpose of his review, which is to salvage the past, he calls on the diaries to handle some of the load for him: "I think it, however, quite time to say a little more fully, not only what happened [on the Italian trip of 1840–41] to me, now of age, but what was *in* me: to which end I permit a passage or two out of my diary."

4. As we suggested earlier, *Praeterita* is not just a description of a life but a *part* of a life, life lived in writing and confided in measured portions to the volumes of a diary. "I must try and do a little bit of account of myself every day now," says a diary entry dated January 1, 1885.

This approach had both its advantages and its drawbacks. "I have great pleasure in the thing myself—it is so much easier and simpler to say things face to face like that, than as an author," he wrote to Kate Greenaway. In other words, he intended that *Praeterita*, like his regular diaries, should be a "plain" and "direct telling," and should manage without an omniscient author who knows what will happen from the start. He succeeded, as far as this was possible, but he paid a price for this success. "I think my history will, in the end, be completest if I write as its connected subjects occur to me, and not with formal chronology of plan." This plan—to proceed without a plan—is ambivalent. It can mean a true renunciation of authorial control, allowing things to depict themselves; or it can make their depiction conditional on how the writer feels at the present moment: "as its connected subjects occur to me." This last phrase implies an underlying schism between the two forces, "subjects" and "me," which meet here without either surrendering its claims to the other.

Ruskin wanted to halt the "bitter play" of *Fors* by writing *Praeterita*. (The last issue of *Fors* appeared in 1884 and the first issue of *Praeterita* in 1885.) He wanted to give himself and his readers a rest from being tossed back and forth by every wind of history and emotion, both present and past. And yet *Praeterita*, like *Fors*, and like almost all his works from 1870 onward, was published in serial installments. This both allowed and compelled him to answer arguments and questions from readers as he proceeded, and to take current events into account. In effect, the report of his life became a kind of newspaper. The more of *Praeterita* he completed and the closer he got to the difficult times of his life, the more precarious his state of mind became, and the greater was his temptation to adopt the spontaneous style of *Fors*, thereby allowing the present to triumph over the past.

To relieve some of the strain of his enterprise, Ruskin devised a parallel work, the anthology *Dilecta*, which was also published in installments, starting in 1886. *Dilecta* gave the public many of the scraps which he did not want to include in *Praeterita*: letters, anecdotes, items of information, scenes from the secondary theaters of his life.

But even opening up this archive did not permanently relieve the pressure on *Praeterita*, as Ruskin, in the end, was forced to admit. One of the last fragments he wrote for inclusion in *Praeterita*, dated May 31, 1889, describes this problem as he saw it: "Not only in the order, but a little in the method, of *Praeterita*, the delay of its conclusion has involved changes;—there are so many things now pleading to be told distinctly as soon as possible that I cannot resolutely choose among them, but must let the accidents of each day guide or divert my thoughts as I used to do in *Fors*."

Now his original diary threatened to take over for the autobiography, before the autobiography had caught up to the present moment. Ruskin fought a few rear-guard skirmishes: for example, he dated the penultimate chapter of *Praeterita* as if it were a letter from *Fors*. But he did not actually decide how he would handle the conflicting claims of past and present until he got to the final page. The last words of *Praeterita* were a date, the date of his last

entry, "Brantwood, June 19th, 1889." But this outcome brought neither side a clear-cut victory. The two rival time systems canceled each other out. After this date, there was no more diary and no more autobiography either. Ruskin's life had become both timeless and speechless.

Perhaps the most precise way to characterize the special time structure of *Praeterita* is to say that in its pages a battle is fought to defend the presentness of past things against the presentness of present and future things. For life in the written word is possible only if the most pressing themes of the present moment are set aside. The first part of the book relies on literary forms like the diary and the document, which are the most retentive of present time, and also on the sheer power of memory, which Proust said is the power of bringing the past into the present in unaltered form, as it was in the moment when it was still the present.

But all this could not be achieved while sitting in the comfortable armchair of the storyteller, or at a desk. Life—not the life relived in the mirror of *Praeterita* but the life apart from it—also made its claims on Ruskin. Between the installments of his autobiography come the installments of his madness.

Repeatedly, Ruskin refused to concede methodological advantage either to the retrospective approach or to the up-to-date journalistic style. At some points he explicitly objects to the stance of an old man looking backward. But at others he comes out with passages like this, in which he thinks back to 1856, when he and Norton wandered through Europe together:

> I can see them at this moment, those mountain meadows, if I rise from my writing-table, and open the old barred valves of the corner window of the Hotel Bellevue;—yes, and there is the very path we climbed that day together, apparently unchanged. But on what seemed then the everlasting hills, beyond which the dawn rose cloudless, and on the heaven in which it rose, and on all that we that day knew, of human mind and virtue,—how great the change, and sorrowful, I cannot measure, and, in this place, I will not speak.

This passage is also symptomatic in relation to the theme of homecoming or repetition. This man, who has returned to a scene from his past life to draw strength, like Antaeus, from contact with the earth he trod before, refuses to treat the Now as he does the Here or the Then. This man whom his friend Froude had called "the only real seer we have now left to us" refuses to look too carefully when confronted with the dangerous possibility of change: the path is "apparently unchanged," he says, content with mere appearance. In his earlier writings he had made it his duty to "vex" readers with continual comparisons between Now and Then. Only the deepest of compulsions could bring him so to limit the range of his vision now.

The great achievement of *Praeterita* is that the strain of limiting what he looks at is so rarely visible. And yet, given the tricky nature of the enterprise, there was no possibility of his carrying it off perfectly, throughout. Actually, he is trying to juggle three time zones: the past; the literal present; and a timeless Now created in and by the text itself—a verbal equivalent to the river in which there is "no wasting away of the fallen foam." But the discord between the three zones cuts through even those passages for which *Praeterita* is most famous: those passages in which "past things" have been composed into giant cinematic "close-ups." In itself, this close-up technique seems a reliable method to produce a sense of immediacy, of present time. But just look at how often the verb tense or region of time changes, even in this celebrated sequence about the Rhône River in Geneva:

> With twenty steps you were beside it.
>
> For all other rivers there is a surface, and an underneath, and a vaguely displeasing idea of the bottom. But the Rhone flows like one lambent jewel; its surface is nowhere, its ethereal self is everywhere, the iridescent rush and translucent strength of it blue to the shore, and radiant to the depth.
>
> Fifteen feet thick, of not flowing, but flying water; not water, neither,—melted glacier, rather, one should call it; the

force of the ice is with it, and the wreathing of the clouds, the gladness of the sky, and the continuance of Time.

Waves of clear sea are, indeed, lovely to watch, but they are always coming or gone, never in any taken shape to be seen for a second. But here was one mighty wave that was always itself, and every fluted swirl of it, constant as the wreathing of a shell. No wasting away of the fallen foam, no pause for gathering of power, no helpless ebb of discouraged recoil; but alike through bright day and lulling night, the never-pausing plunge, and never-fading flash, and never-hushing whisper, and, while the sun was up, the ever-answering glow of unearthly aquamarine, ultramarine, violet-blue, gentian-blue, peacock-blue, river-of-paradise blue, glass of a painted window melted in the sun, and the witch of the Alps flinging the spun tresses of it for ever from her snow.

The innocent way, too, in which the river used to stop to look into every little corner. Great torrents always seem an-gry, and great rivers too often sullen; but there is no anger, no disdain, in the Rhone. It seemed as if the mountain stream was in mere bliss at recovering itself again out of the lake-sleep, and raced because it rejoiced in racing, fain yet to return and stay. There were pieces of wave that danced all day as if Perdita were looking on to learn; there were little streams that skipped like lambs and leaped like chamois; there were pools that shook the sunshine all through them, and were rippled in layers of overlaid ripples, like crystal sand; there were currents that twisted the light into golden braids, and inlaid the threads with turquoise enamel; there were strips of stream that had certainly above the lake been millstreams, and were looking busily for mills to turn again; there were shoots of stream that had once shot fearfully into the air, and now sprang up again laughing that they had only fallen a foot or two;—and in the midst of all the gay glittering and eddied lingering, the noble bearing by of the midmost depth, so mighty, yet so terrorless and harmless, with its swallows

skimming instead of petrels, and the dear old decrepit town as safe in the embracing sweep of it as if it were set in a brooch of sapphire.

And the day went on, as the river; but I never felt that I wasted time in watching the Rhone. One used to get giddy sometimes, or discontentedly envious of the fish. Then one went back for a walk in the penthouse street, long ago gone.

This description begins with the past: "you were beside it." The "were" refers to Ruskin's early stays in Geneva in the years 1833, 1835, and 1844: "long ago gone." At the end we are back in the present time of the 1880s. Between the two flows the river Rhône, appearing now in the past, now in the present.

Any ordinary chronicler, even one with a consistent interest in the past, would have put a character piece like this entirely into the present tense. After all, what sense does it make to use the past tense in a sentence like "Here was one mighty wave," if the text nowhere indicates that the Rhône meant something unique to the young Ruskin at a particular moment in his life, and if no indication is given that the Rhône of the past was quite different from the Rhône of the 1880s? Also, what sense does it make to use "was" in a phrase like "that was always itself"?

Ruskin *did* have something to say about the changes in the Rhône, but he didn't do it in *Praeterita*. In 1835, he had devoted one of his first published articles to the color of the Rhône. It was an inquiry more than a discussion as to why the Alpine river, unlike other rivers, was deep blue in color. Ruskin at first called its color indigo, and rejected the popular view that the blue of the Rhône and the green of the Rhine were fed into them from the melting water of the glaciers, whose blue and green tones had purely optical causes.

Already, on his second visit to Geneva, he had found that the color of the Rhône had turned lighter. Disconcerted at hearing people refer to it as sea-green, he suspected that the color might change with the seasons. And so he returned periodically, until his

final visit in 1882, to stand for long periods on the footbridge, gazing into the water.

In *Praeterita*, his description of the Rhône brings together all the shades of color that he ever discovered in the river, the whole spectrum of blue, in fact the entire spectrum of color, for he describes it as "iridescent." At this point he no longer asks the cause of the color; his faith in science disappeared long ago, and the old man reverts to the view, which he had rejected at the age of fifteen, that the river's blue may have something to do with the color of the glaciers, after all. His past experience of the river heightens its immediacy, creates a streaming river of words. What a moment ago was the past, a sum of experience, suddenly adds up to something new, which counts only in the present. The river that *was* becomes a river that *is*, a living river and the river of life. Permanence within change, repetition without change; no essential change but only constant transformation, only a shifting of aspects; "never-pausing," "always itself." These phrases from the passage on the Rhône paraphrase *Praeterita*'s single purpose, which is to keep the past present.

The same end is achieved on the symbolic level. The Rhône, which flows through Geneva, one of the "centers" of Ruskin's life, of course appears to him as a "river of paradise," and as such it is connected with the innumerable other streams and rivers that flow through *Praeterita*. The first chapter is devoted to the "Springs of Wandel": the springs of the little river that flows through Croydon, his mother's birthplace. "The personal feeling and native instinct of me had been fastened, irrevocably, long before, to things modest, humble, and pure in peace, under the low red roofs of Croydon, and by the cress-set rivulets in which the sand danced and minnows darted above the Springs of Wandel."

It happened that as a child Ruskin was able to satisfy his love for flowing water in two places: in the back yard of his mother's sister's home in Croydon, where there was a spring that flowed into the Wandel River, and in Perth, where his father's sister had a rear garden, "full of gooseberry-bushes," which sloped down to

the river Tay. "The water . . . ran past it, clear-brown over the pebbles three or four feet deep; swift-eddying,—an infinite thing for a child to look down into."

In this way, the little boy who at the time was still confined to the house on Hunter Street and had not been released into the Garden of Eden at Herne Hill nevertheless managed to get "occasional glimpses of the rivers of Paradise."

How different was the only water he saw outside the windows of his London home: "The windows of it, fortunately for me, commanded a view of a marvellous iron post, out of which the water-carts were filled through beautiful little trapdoors, by pipes like boa-constrictors; and I was never weary of contemplating that mystery, and the delicious dripping consequent."

Thus, in the very first chapter, he has set up a contrast: on the one hand, the piped water and the shut-in boy, both captive in the big city; on the other, the wild water of the countryside, and the boy whom his relatives allow to roam freely like other children. Already he has introduced flowing water as the symbol of life.

Ruskin hinted only briefly at what eventually happened to the free watercourses of his youth, and what happened to him and to all of living nature in Britain. The spring behind the house in Croydon was incorporated into a "modern canal"; the "laughing" mill stream which had been diverted from the Tay, and where he and his female cousins had built a cozy lair, was filled in or built over. Then, in the 1870s, he learned of the pollution of the Wandel River and had one of its springs, which lay between Croydon and Epsom, cleaned, restored, and lined. He then named the well after his mother and had a tablet erected at the spot which said: "In obedience to the Giver of Life, of the brooks and fruits that feed it, of the peace that ends it, may this Well be kept sacred for the service of men, flocks, and flowers, and be by kindness called MARGARET'S WELL." But eventually this spring which he had dedicated to his mother's memory was polluted again, its waters unusable. A second restoration was planned, but it was never carried out.

These events preoccupied Ruskin deeply. A man who identifies

his two aunts—who were even more motherly than his mother—
with rivers, and who dedicates a well to his mother, is toying with
the weightiest of symbols. We need only examine his dreams dur-
ing this period to see that water now plays as central a role as
snakes do. And we do not need to search long to find a passage
in which he applies the symbol of water to himself. On May 23,
1875, two days before Rose's death, he visited the springs and
pools of Wandel, only to learn that his attempts at restoration had
been in vain. The next day his diary mentions a "nettly island of
mud in the middle of Wandel—like myself—yet sheltering many
creatures—wild ducks and the like."

His own wellspring, the primal landscape of his childhood and—
as we shall soon see—the life source of England and indeed of all
the world, had become tainted and unfit. It was typical of Ruskin
that he always felt things in terms of opposites. So, in the case of
this *paysage moralisé*, he saw himself not really as a purifier of the
springs but as a part of them, and indeed a part that shared in the
blame for their fate: as an island in the foul water, formed of filth
and contributing to filth, yet still serving as a refuge to wildlife.

In the Oxford Lectures on the Art of England, in *Fors Clavigera*,
and in other writings, Ruskin told the story of the Wandel River:

Twenty years ago, there was no lovelier piece of lowland
scenery in South England, nor any more pathetic, in the
world, by its expression of sweet human character and life,
than that immediately bordering on the sources of the Wan-
del. . . . No clearer or diviner waters ever sang with constant
lips of the hand which "giveth rain from heaven"; no pastures
ever lightened in spring-time with more passionate blossom-
ing; no sweeter homes ever hallowed the heart of the passer-
by with their pride of peaceful gladness,—fain-hidden—yet
full-confessed. The place remains (1870) nearly unchanged in
its larger features; but with deliberate mind I say, that I have
never seen anything so ghastly in its inner tragic meaning,
. . . as the slow stealing of aspects of reckless, indolent, animal
neglect, over the delicate sweetness of that English scene.

The water flows "stainless, trembling and pure" for only a short distance before it encounters a rubbish heap placed at the spot by the citizens of Croydon. The townspeople, Ruskin says, are incapable of keeping their river of life clean, or of doing the work necessary to set it free again: "That day's work is never given." Their only achievements these days, he says in one of the typically inventive morality tales that he manages to conjure out of nothing, is a new tavern, whose outside has been lined along its entire length with a six-foot-high iron palisade set only two feet away from the building, to single it out as a place of importance: a fenced-in no-man's-land smothered in refuse. "Now the iron bars which, uselessly . . . enclosed this bit of ground, and made it pestilent, represented a quantity of work which would have cleansed the Carshalton pools three times over."

This is the England of the end of the nineteenth century: iron instead of water, useless labor instead of life-giving work, sharp stakes instead of softness. The analysis of British capitalism which Ruskin spears on the palisade of Croydon is among his most brilliant and impassioned passages. But it is not from *Praeterita*. In any other of his writings, he would have jumped at every chance to speak on this subject. But in his autobiography he skims over places where the ground might give way beneath him, granting them no more than a sentence or two.

The paradise rivers, the Wandel and the Tay, flow at the beginning of *Praeterita*, but a third river flows at the end. It is the one which flows through the garden at Denmark Hill, and this garden in turn has all the attributes of the Garden of Eden that was Herne Hill. The river is an artificial stream created by Ruskin himself—we don't know when—as part of a reconstructed paradise of childhood. At the end of *Praeterita*, the themes of homecoming and the river intertwine, so that the two are virtually identical:

> I draw back to my own home, twenty years ago, permitted to thank Heaven once more for the peace, and hope, and loveliness of it, and the Elysian walks with Joanie, and Paradisiacal with Rosie, under the peach-blossom branches by

the little glittering stream which I had paved with crystal for them. I had built behind the highest cluster of laurels a reservoir, from which, on sunny afternoons, I could let a quite rippling film of water run for a couple of hours down behind the hayfield, where the grass in spring still grew fresh and deep. . . . And the little stream had its falls, and pools, and imaginary lakes. Here and there it laid for itself lines of graceful sand; there and here it lost itself under beads of chalcedony. It wasn't the Liffey, nor the Nith, nor the Wandel; but the two girls were surely a little cruel to call it "The Gutter"! Happiest times, for all of us, that ever were to be; . . . I have been sorrowful enough for myself, since ever I lost sight of that peach-blossom avenue. "Eden-land" Rosie calls it sometimes in her letters. Whether its tiny river were of the waters of Abana, or Euphrates, or Thamesis, I know not, but they were sweeter to my thirst than the fountains of Trevi or Branda.

For Ruskin, paradise is something that can only be constructed artificially, on a child's scale, in his own garden, in the *hortus conclusus*. Meanwhile, the Garden of England is no longer being watered: its wealth, which Ruskin calls "living water," has been exhausted. "The stream which, rightly directed, would have flowed in soft irrigation from field to field—would have purified the air, given food to man and beast, and carried their burdens for them on its bosom—now overwhelms the plain and poisons the wind; its breath pestilence, and its work famine."

There is evidence that, if *Praeterita* had been finished according to the original plan, the description of Geneva, and thus of the Rhône, would have stood at the center of the book. This would have been the appropriate place for a town that Ruskin called "the centre of religious and social thought, and of physical beauty, to all living Europe. . . . And of course, I was going to say, mine."

As it is, the Rhône does not occupy the geometric center of the autobiography. Yet the final tableau, which we quoted above, at least confirms that the great river is its ideal center. Framed on one

side by the wild little rivers of childhood, on the other by the nostalgic adult's mini-river of paradise, the Rhône lies at the heart of Ruskin's "geography of the Self." It is the ideal image of enduring and undamaged life, a pure energy which, though mutable, yet is "always itself," "so mighty, yet so terrorless and harmless," a river to which you can abandon yourself without feeling that you are "wasting time."

In the image of the Rhône, the strategy of *Praeterita* achieves a localized perfection. A symbol is found which realizes the paradox of "the continuance of Time." The primacy of "things" is carried so far that they become interchangeable with the ego, and passing experience blends into life itself. The permanence of things and the recurrence of things is achieved when language confers new life on them in an act of vital transformation.

5

No autobiography can have the factualness of a textbook, but neither can every set of facts be turned into an archetype. Nevertheless, even a life like Ruskin's, which is shown to consist of nearly identical homecomings rather than dramatic turns of events, must have some plan underlying its reconstruction. Ruskin saw his autobiography as being about (1) topography or places and (2) the development of a sensibility. To paraphrase the words we quoted earlier: "I learned to see, I saw, and I did nothing."

The basic movement in *Praeterita* is the movement of traveling. Apart from travel, there are only two other types of activity: seeing and drawing. Writing—an activity with which Ruskin had already filled numerous thick volumes before this one—is hardly mentioned. His innumerable social-reform projects never appear, any more than his scientific, economic, and historical studies. One could argue that *Praeterita* never got past the year 1860, except for the one haphazardly organized chapter at the end. After all, the author of this book has also been a critic, political analyst, lecturer,

teacher, and social politician for a quarter of a century. He has relied on organs other than his eyes, and he should have given at least a general indication of this when he wrote about his life.

Ruskin's stance, to be sure, is that of a man of the 1880s. But from this perspective he gazes backward through the past twenty-five years as if there were nothing there but empty space. He looks not at them but at his *essential* life. He does not claim that it was the right life. Considering all the years he spent developing his sensitivity to phenomena, he might have learned to be sensitive toward himself as well, but one does not get the impression that this old man especially values the man he was in youth or middle age. He seems to believe that his great aptitude was his perceptual ability and that it has been adequately developed and applied— although, admittedly, at the expense of other qualities and abilities. A single quotation will show how clearly he saw it all: "That great part of my acute perception and deep feeling of the beauty of architecture and scenery abroad, was owing to the well-formed habit of narrowing myself to happiness within the four brick walls of our fifty by one hundred yards of garden."

This passage is representative of many in Ruskin. Walter Pater, too, described the development of a young boy, whom he calls Florian, in an "imaginary portrait"—really an autobiographical piece—called *The Child in the House*:

> So the child of whom I am writing lived on there quietly; things without thus ministering to him, as he sat daily at the window with the birdcage hanging below it. . . . The perfume of the little flowers of the lime-tree fell through the air upon them like rain; while time seemed to move ever more slowly to the murmur of the bees in it, till it almost stood still on June afternoons. How insignificant, at the moment, seem the influences of the sensible things which are tossed and fall and lie about us, so, or so, in the environment of early child-hood. How indelibly, as we afterwards discover, they affect us.

In that half-spiritualised house he could watch the better, over again, the gradual expansion of the soul which had come to be there—of which indeed, through the law which makes the material objects about them so large an element in children's lives, it had actually become a part; inward and outward being woven through and through each other into one inextricable texture—half, tint and trace and accident of homely colour and form, from the wood and the bricks; half, mere soul-stuff, floated thither from who knows how far.

The child Florian grows up in a domestic camera obscura in which he is no less protected than the child John.

From this point he could trace two predominant processes of mental change in him—the growth of an almost diseased sensibility to the spectacle of suffering, and, parallel with this, the rapid growth of a certain capacity of fascination by bright colour and choice form—the sweet curvings, for instance, of the lips of those who seemed to him comely persons, mod-ulated in such delicate unison to the things they said or sang,—marking early the activity in him of a more than customary sensuousness, "the lust of the eye," as the Preacher says, which might lead him, one day, how far!

Pater's text was published in 1878, just three years after Ruskin began to tell about his childhood memories in *Fors*. Both autobi-ographies show the lives of their protagonists developing from a very narrow foundation—not much more than a specific sensibil-ity—and as justifiable only on that basis. Both authors take a self-critical view of their one-sided development; but at the same time they compensate both themselves and their readers for their lim-itations by showing all that is woven with this sensibility, and so provide a text rich in descriptions of things and feelings.

But, unlike Pater, Ruskin had many sides to his nature—as many indeed as any man of his century—and yet he places exclusive emphasis on his powers of perception. One reason for this is that,

in writing *Praeterita*, he needed a single orderly principle of composition; he also needed to keep things simple in order to maintain his emotional balance. He always felt he was a victim of the Biblical curse: "Unstable as water, thou shalt not excel." Therefore, he sought continuity in his "aboriginal self, on which a universal reliance may be grounded," as Emerson expressed it. The attentiveness with which the young Ruskin drew snowdrops in Scotland, combining "Wordsworth's reverence, Shelley's sensitiveness, Turner's accuracy," is still familiar to Ruskin the old man, as he looks at how he has become in the 1880s:

> But so stubborn and chemically inalterable the laws of the prescription were, that now, looking back from 1886 to that brook shore of 1837, whence I could see the whole of my youth, I find myself in nothing whatsoever *changed*. Some of me is dead, more of me stronger. I have learned a few things, forgotten many; in the total of me, I am but the same youth, disappointed and rheumatic.

It is not by chance that these lines were first written for a passage—later rejected by Ruskin—which had to do with the theme of homecoming. After four years of living in Oxford and abroad, Ruskin's return to North Britain to study untamed nature really seemed to him like "coming home." In the discarded passage he goes on to say: "In this pleasure in returning to my old thoughts and ways, let me note a point in my character which might easily be lost sight of, or even quite misinterpreted—by the tenor of my life—its pervicacity and unchangeableness."

He tried to give evidence to support this claim but soon became entangled in contradictions. For the idea of his unchangeableness looked more and more improbable the farther away he moved from the starting point of his argument, which was his way of sealing off bits of reality. In the end, he cut out the passage completely.

And yet, in terms of the logic of *Praeterita*, Ruskin was right: the movement of his life was non-progressive; he kept coming

home. He came home everywhere, and everywhere was at home. This kind of movement demands a particular kind of sensibility which can be extravagant within familiar limits; a perception that concentrates on depth not breadth.

Ruskin did not view this sensibility as innate but as a product of the circumstances of his childhood. On the other hand, he did not try to dramatize the story of his seeing eye, in the form of a *Bildungsroman*. It is virtually impossible to keep learning to see better and better and more and more, the whole of one's life. Indeed, it is hard enough even to understand that any deep revolution befell him in the woods at Fontainebleau. What he began when young stayed with him throughout his life.

At times, Ruskin experienced his domination by the eye as a genuine burden: "The worst of me is that the Desire of my *Eyes* is so much to me! Ever so much more than the desire of my mind" (see Pater, above, and I John: 2, 16). But he seemed to feel far more threatened by the danger that the desire of his eyes might diminish. His diaries in the 1880s speak incessantly about doubts and reassurances concerning his eyesight. "Sense of failing eyes always oppressing," he writes at one point; elsewhere he announces triumphantly: "Then I saw rosy dawn, and now the 'white mountain' [Mont Blanc], above long-laid calm morning mist, as clearly with my old eyes as when I was twenty-one." "I see everything far and near, down to the blue lines on this paper and up to the snow lines on the Old man [a mountain near Brantwood] . . . as few men at my age."

Thus, in *Praeterita*, Ruskin's "pure eye" has an origin but no real history, no ongoing development. Once the eye is there, the rest of his life is simply the operation of this sense; it is "seeing clearly and telling what he saw." The desire to see links the inner world to the outer world, makes possible that state of permanence in change which *Praeterita* set out to create. This elixir of permanence could be produced only by the extreme compression of the facts of Ruskin's life. He made his foremost gift occupy the center stage of *Praeterita*. But how much more was his life—is any man's life—than its foremost gift? In one passage he admits

his life's lack of homogeneity—but having admitted it, he then feels obliged to suppress it:

> The aspect of my life to its outward beholder is of an extremely desultory force—at its best—confusedly iridescent— unexpectedly and wanderingly sparkling or extinct like a ragged bit of tinder. Only by much attention—if anyone cares to give it,—nor then without some clue of personal word, like this I am writing,—could the spectator of me at all imagine what an obstinate little black powder of adamant the faltering sparks glowed through the grain of.

Florian Deleal, alias Walter Pater, also faced a world in which he was concerned with "impressions of eye":

> As he felt this pressure upon him of the sensible world, then, as often afterwards, there would come another sort of curious questioning how the last impressions of eye and ear might happen to him, how they would find him—the scent of the last flower, the soft yellowness of the last morning, the last recognition of some object of affection, hand or voice; it could not be but that the latest look of the eyes, before their final closing, would be strangely vivid; one would go with the hot tears, the cry, the touch of the wistful bystander, impressed how deeply on one! or would it be, perhaps, a mere frail retiring of all things, great or little, away from one, into a level distance?

A fitting speculation, for people ruled by the "tyranny of the senses," like Deleal-Pater and Ruskin.

In Ruskin's case, we have no direct answer to the question of how the world looked to him toward the close of his life, but we do have a couple of clues. At the time of his first attack of insanity, and later, during the eleven-year mental twilight that ended his days, we know that he repeated the same words over and over: "E-verything white, E-verything black, E-verything white,

E-verything black." This suggests that the great pairs of opposites he first conjured at the end of *Modern Painters* kept hold of him until the last. Nothing was left of what his life had stood for: no mediations, no diversity, no multiplicity of aspects, and above all no more color—color, which he had called "the great sanctifying element of visible beauty, inseparably connected with purity and life" and "the type of love."

"E-verything white, E-verything black" also means there is no longer any meaningful perceptual activity: neither a motley finale of impressions nor a slow dimming into ashy gray, but only schematic reflexes, the decay of objects, and the decay of the living relationship to objects.

What a different view we get from the last sentences that Ruskin ever published, the closing vision of *Praeterita*. Here we find that synaesthetic explosion which Pater hoped to experience at his death. We have already quoted one passage near the end of *Praeterita* which describes the artificial river-of-paradise that Ruskin placed in the garden of Denmark Hill, whose waters were sweeter to him than those of the Trevi Fountain in Rome and the Fonte Branda in Siena. The names of these fountains then trigger further memories, of his last trips to Rome and Siena. "How things bind and blend themselves together!" he exclaims, once again invoking "things." Here, at the very end, he looses the reins and lets his life run where it will: "as its connected subjects occur to me." The symbolic rivers and the river of words yield to the flowing river of thought:

> How things bind and blend themselves together! The last time I saw the Fountain of Trevi, it was from Arthur's father's room—Joseph Severn's, where we both took Joanie to see him in 1872, and the old man made a sweet drawing of his pretty daughter-in-law, now in her schoolroom; he himself then eager in finishing his last picture of the Marriage in Cana, which he had caused to take place under a vine trellis, and delighted himself by painting the crystal and ruby glittering of the changing rivulet of water out of the Greek vase, glow-

ing into wine. Fonte Branda I last saw with Charles Norton, under the same arches where Dante saw it. We drank of it together, and walked together that evening on the hills above, where the fireflies among the scented thickets shone fitfully in the still undarkened air. *How* they shone! moving like fine-broken starlight through the purple leaves. How they shone! through the sunset that faded into thunderous night as I entered Siena three days before, the white edges of the mountainous clouds still lighted from the west, and the openly golden sky calm behind the Gate of Siena's heart, with its still golden words, "Cor magis tibi Sena pandit," and the fireflies everywhere in sky and cloud rising and falling, mixed with the lightning, and more intense than the stars.

6

"*September 13th* [1888]. *Thursday. . . . To-day* [Ruskin's motto]— I trust—I get up to Chamouni! Yet again. The last time was 1874."

"*September 14th. Friday.* I made no entry, being too much excited and amazed to be in Chamouni again, after quite glorious ascent by the old road, and coffee at Servoz."

"*September 15th, 1888. Saturday.* CHAMOUNI. . . . In my old place, looking down the valley. Stars all night after pure moonlight kept me awake, but blessedly. Then I saw rosy dawn, and now the 'white mountain', above long-laid calm morning mist, as clearly with my old eyes as when I was twenty-one. D.G.—how much!"

"*September 16th, 88. Sunday.* CHAMOUNI. Y[esterday] in the evening, K[athleen]'s lovely letter—after a day of feverish heat and rather failure—gave me a night of perfect rest; and I ans[were]d it this morning, and have just written the last clause of the epilogue to *Mod[er]n Painters*, in the perfectest light of Mont Blanc, after being at mass, and a little walk on fresh grass towards source of Arveron."

These diary entries record Ruskin's last great homecoming and repetition. In them we find richness—layers of life superimposed

one upon the other—and a schematic repetition of past experience. Ruskin goes to Chamonix to recover his health, as he did so often in the past. As always, he comes to the place in order to write about the place. He is no longer able to draw; this umbilical cord connecting him to nature has already been cut: "I . . . feel I could paint it all *now* if I had life."

But although his drawing has gone, writing has turned into a form of self-consumption. He had started off Volume Three of *Modern Painters* with an apology because "this preface is nearly all about myself." But now his preface, main text, and epilogue are all about himself. He travels into the Alps in order to write about how he climbed the mountains with Charles Norton at the same spot long ago, and in order to write an epilogue for the new, unabridged edition of *Modern Painters*.

"How things bind and blend themselves together!" he said at the end of *Praeterita*. In this autumn of 1888, Ruskin lived and wrote in layers. The year 1842, when he first came to Chamonix and began *Modern Painters*, blended with 1888, the year of his final return there, when he at last completed *Modern Painters* with an epilogue. Both, in turn, blended with 1858, the year he was just about to describe in *Praeterita*: the year when he made friends with Norton in the Valley of Chamonix, finished the main text of *Modern Painters*, thus bringing the "old epoch" to a close, and then returned to London, where he met Rose for the first time.

"Some wise, and prettily mannered, people have told me I shouldn't say anything about Rosie at all," Ruskin notes in the penultimate chapter of *Praeterita*, the chapter which he dates at the beginning: "Sallenches, Savoy, 9th September, 1888." But knowing all it had cost him to lose and regain Rose so many times over, he went ahead and wrote about her anyhow. Probably, after all their mystical unions, he must have felt he was now on more solid footing.

As if to make 1888 a perfect duplicate of many years in his past, Rose had recently "sent" him a messenger: "one of Perugino's angels had walked out of the frame." The "angel" was Kathleen Olander, a young art student whom he had met for the first time

in 1887 at the National Gallery in London, where she was copying a Turner painting. He encouraged her work with advice and praise, and soon she became his drawing pupil, like Rose before her, and then his intimate correspondent. The endearments he addressed to her could pass at first as signs of a fatherly affection, but soon it became clear that he meant them more seriously. Ruskin followed them up with an offer of marriage.

The collapsible theater was brought out again, the curtain rose on the familiar plot: Kathleen's parents and Ruskin's surrogate "mother," Joan Severn, trying to drive the couple apart, and at the center of the tug-of-war the indecisive Kathleen, vacillating between her veneration for Ruskin and her religious doubts—for, like Rose, she was deeply religious. John Ruskin, meanwhile, played all the roles available to his sex, being by turns mad with passion, humbly imploring, and imperious in his demands for submission.

Above all, he accompanied all his advances with self-deprecation, thus neutralizing them. For instance, he posed as the great infidel, just as he had done with Rose, and as an incurable ladykiller: "I put this darkness of my creed before you at once—briefly—in the terror and wide range of it." "You've never—seen me flirting with a Parisian shopgirl—or a Jura shepherdess,—I kissed my hand to one only the other day." (The shepherdess was only seven, we learn later.) He also described himself as a man with a problematic past. This time *he* was the one who revealed to the "pure" girl he was courting the story of his marriage to Effie: "I know that you love, your imagination of me—but how far the imagination is true,—is the first question!"

We see again, as in the history of John and Rose, that the desire to "be true" can be a particularly refined obstacle to true love. Long before the outward facts clearly vetoed the romance, Ruskin's last attempt to reach Kate had failed.

The clearest illustration of how truth and the desire to be true may interpenetrate and yet disintegrate each other within a single utterance comes in Ruskin's letter to Kathleen Olander dated September 25, 1888. It could equally well have been written to Rose,

and it serves as a model of the confused logic of Victorian love: "And you *will* be happy with me, while yet I live—for it was only love that I wanted to keep me sane—in all things—I am as pure— except in thought—as you are—but it is *terrible* for any creature of my temper to have no wife—one cannot but go mad."

Barely one year later, this prediction had come true, once and for all.

Eight
The Old Man of Coniston
1889–1900

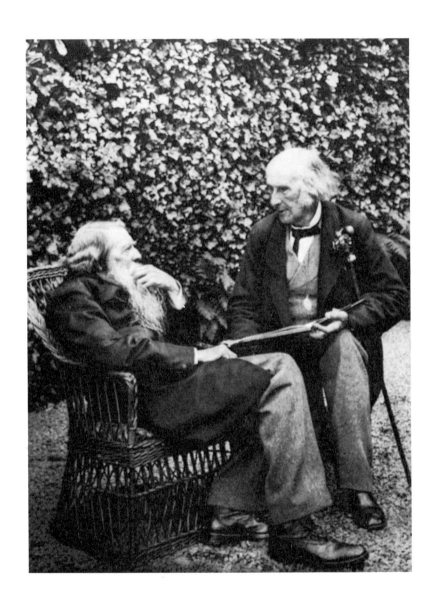

Angie Acland, John Ruskin and Henry Acland, *1893*

Everything in this photograph is Ruskinian, except Ruskin himself. It shows a clear-cut, Pre-Raphaelite image, at a time when the new fashion is for soft focus. "Crisp" is a word you could use to describe its firm, defined texture. We are left in no doubt about what kind of leaves we are looking at, what the ground is like, or the fabrics. Ruskin's old friend Henry Acland is wearing trousers and a waistcoat of machine-woven thread. Ruskin's trousers are of the same heavy, baggy homespun tweed as always. Acland is wearing elegant Oxford shoes; Ruskin, heavy high boots. Acland is altogether more refined, more urbane, more mobile: he is the one who has seated himself politely, to pay a call on his friend.

This physician, Dr. Acland, Regius Professor of Medicine at Oxford, cannot help sitting there like a doctor at a patient's bedside, even though he is in the garden at Brantwood. There is something distinctly patronizing in his attitude, but this is inevitable because Ruskin is no longer Ruskin. You might almost say that he looks like a perfectly costumed marionette lacking only the strings to hold him up or to set him in motion. The truth is that the whole scene is staged. Ruskin has been placed here so that he can be photographed, the way a dying man's heirs may prop him up when the notary comes, in order that he can make a valid will. "Ruskin Lives" was the message of this widely distributed collector's photograph, which Acland's daughter took in the summer of 1893. The "old man" of Brantwood, Coniston, has turned as silent as the high mountain known as the "Old Man," which is visible from Ruskin's estate. The silence is temporary, this period of seclusion

will do him good, his friends report: they are looking after him.

W. G. Collingwood, in his official biography of Ruskin which was published at the same time as the photograph, wrote: "Nowadays he seems, in all but the power of resuming work, himself again, though aged and feeble. . . . There are not wanting signs of reserve power which encourage the hope that many years are in store for him of rest after toil, and tranquil light at evening time."

No one would or could tell the truth about what had happened to Ruskin in the previous four years. Despite all the vagaries of his public career, he had become a British institution. In fact, now he was even becoming popular on the Continent, which had ignored him for half a century. People would happily have flocked on pilgrimage to see the grand old man, as once they did to see the elderly Goethe. But, unfortunately, all the people who expressed the wish to visit him had to be tactfully turned away.

Ruskin had become not only an institution but an industry. Never had his books sold as well as in the last, silent decade of his life. In addition, there were Ruskin ceramics, Ruskin linen, and, of all things, Ruskin cigars for sale. Ruskin societies had formed in many British cities, and members now looked expectantly toward Brantwood, hoping that he would in time resume his many discarded projects and that they might even have a chance of seeing him.

His guardians encouraged the harmless legend of the prophet who had withdrawn into his mountains, distancing himself from daily affairs for a while. And they took care to supply the appropriate details, like a flowing beard and striking views of his profile. When one artist was actually admitted to his presence, this was what he saw:

Ruskin looked the shadow of his former self—the real living man with all his energy and force had gone, and only the shadow remained. He was carefully dressed and scrupulously neat, having gloves on, which, seeing a visitor approach, he began to pull off rather absently, when Mrs. Severn said,

"Never mind the gloves," and I took his hand, but, alas! he had nothing but monosyllables, and soon went away supported on the arm of his constant attendant.

Another time Mrs. Severn brought me into his room, a library, where Ruskin sat in his arm-chair. He had a benign expression, and looked venerable and prophetic, with a long flowing beard, but he seemed disinclined to talk, and when I spoke of things which might have interested him he only said "yes" or "no," or smiled or bowed his head. I did not feel at all sure from his manner whether he identified me at all distinctly. . . . It seemed a sad ending to such a life as Ruskin's had been.

Another visitor, who had just had his last meeting with Ruskin, said that it had been like trying to talk to a ghost.

Ruskin spent the eleven years of his "long death" at Brantwood. His final bout of insanity lasted for almost a year, but after that, no more major attacks came to torment him. He had not yet entered the "Land of Leal," but only a sort of limbo or anteroom of Paradise; he had reverted to early childhood. He let Joan Severn and her family take care of him, played with the children, went for walks now and then, did a little gardening, listened as people read to him, was sometimes cooperative, sometimes obstinate. He shied away from paper and pen like a once-burned child shying away from the fire.

Only five letters written in Ruskin's own hand are known to exist from the period 1889 to 1900, and of these only one, which did not surface until recently, can be called a Ruskin letter in the true sense. It proves that his old themes and interests were still very much on his mind—indeed, that he was capable of treating even the weightiest preoccupations with calm, meticulousness, and, ultimately, with assurance. The letter is appended as a commentary to Dürer's master engraving *Knight, Death and the Devil*, which Ruskin was presenting to a young admirer. He says of Dürer's knight that he "has been a friend to me through life, as Dürer's word of encouragement." "He rides quietly, his bridle

461

firm in his hand, and his lips set close in a slight, sorrowful smile, for he hears what Death is saying; and he hears it as the word of a messenger who brings pleasant tidings, thinking to bring evil ones."

His was no chic madness, or one with a secret reserve. He may have gone mad from the overproduction of myths; but his madness itself did not make a myth. Nor did it make the Victorian Gothic novel that some have thought it resembled. That is, relatives and friends did not wall him up in any dungeon. Undoubtedly, their care was a little constricting, but his willingness to be cared for was greater. There was no longer anything left of the man he had been, so there could not be any injustice in declaring him incompetent. He had achieved the very goal he had recommended to others who accused him of backsliding when he challenged the notion of progress: "Backsliding, indeed! I can tell you, on the ways most of us go, the faster we slide back the better. Slide back into the cradle, if going on is into the grave:—back, I tell you; back—out of your long faces, and into your long [children's] clothes."

And these were the words he bequeathed to his readers and to the members of the Guild of St. George, shortly after his first attack:

> Unable therefore now to carry forward my political work, I yet pray my friends to understand that I do not quit it as doubting anything that I have said, or willingly ceasing from anything that I proposed: but because the warning I have received amounts to a direct message from the Fates that the time has come for me to think no more of any Masterhood; but only of the Second Childhood which has to learn its way towards the other world.

Praeterita was the product of this "way," which reached the other world by going backward. But, in the domain of personal relationships, he had been working toward this second childhood for a long time. After the deaths of his parents, he had transferred the

role of mother to Joan Severn and of father to Carlyle, while assigning himself the role of the "little donkey boy." Since the 1870s, his letters to Joan Severn had all been written in a form of baby talk. This soon turned into a private language between him and the Severns, which disconcerted or worried outsiders.

When Rose lay dying, Ruskin wrote to Joan Severn: "Di Ma, if me fall ill, and give up Felyship and come away to live in the nursery and be nursed out of people's way, won't Arfie and you tire of me?" In other words, he is asking whether he can return to his childhood nursery in Herne Hill where Joan and Arthur (Arfie) Severn are living and be tended by them. And this is what actually happened a few years later, and continued until his death. He was cared for, not in his old nursery but in a landscape he had loved as a child.

On January 20, 1900, only a year before the death of Queen Victoria and of the era he had shared with her, Ruskin died of a brief attack of influenza. He had survived them all, all his companions and his rivals: his parents, Effie and Rose, Rossetti and Millais, Carlyle and Arnold, Morris and Pater, Mill, Tennyson, and the Brownings. The only one he seemed not to have survived was himself.

Upon hearing the news of Ruskin's death, Marcel Proust wrote to Marie Nordlinger, who was helping him to translate Ruskin's works into French: "When I learned of Ruskin's death, I wanted to express my grief to you more than to anyone. No bitter grief, by the way, but full of comfort. After all, I know how insignificant death is, when I see how vitally alive this dead man is, how much I admire him, hang on his words, try to understand and heed him: him more than many another, living man."

The appreciation of Ruskin which Proust wrote soon after is important not only because Proust wrote it but because it reveals so clearly—in the very act of refuting it—the dominant trend of Ruskin criticism around 1900. Proust's attention had first been drawn to Ruskin by a book of criticism, Robert de la Sizeranne's *Ruskin et la religion de la beauté* (1897). Proust courteously but forcefully rejected this popular view of Ruskin as a devotee of the

religion of beauty. He rightly said that Ruskin's religion was re-
ligion; whereas the principle of beauty, in art and in nature, was
never an end in itself but rather a medium of knowledge. Ulti-
mately, Ruskin revered not art but creation. As Proust said, "Those
who regard him as an apostle and a moralist who sees in art only
what it is not, have mistaken their man; as, equally, have those
who neglect the deep [religious] foundation of his view of art, and
confuse it with the sensuality of the 'aesthete.' " Ruskin's work,
Proust said, had been a service to art which he never meant to
assume cult status; nor had he wished art to become an absolute.

Thus, Proust accurately defined Ruskin's intentions, and at the
end of his obituary review he set—as a kind of headstone inscrip-
tion—the words which Ruskin had written about Turner when the
painter died: "And through those eyes, now filled with dust, gen-
erations yet unborn will learn to behold the light of nature."

But then, when his note was reprinted three years later, Proust
did a sudden about-face, when he appended the following words:
"He exhibits a kind of idolatry which no one has defined better
than he":

> Such I conceive to have been the deadly function of art in its
> ministry to what, whether in heathen or Christian lands, and
> whether in the pageantry of words, or colours, or fair forms,
> is truly, and in the deep sense, to be called idolatry—the
> serving with the best of our hearts and minds, some dear or
> sad fantasy which we have made for ourselves, while we
> disobey the present call of the Master, who is not dead, and
> who is not now fainting under His cross, but requiring us to
> take up ours.

"Yet it would appear," Proust goes on, "that this very 'idolatry'
lies at the root of Ruskin's talent. . . . The decisive struggle between
idolatry and sincerity took place not in critical moments of his life,
not on pages of his works reserved especially for that purpose, but
it took place at every moment and was waged in those deep, secret

recesses, scarcely accessible to ourselves, where our ego receives images from the imagination, ideas from the intellect, words from the memory. . . . In these deep regions, Ruskin unceasingly committed the sin of idolatry—so I believe. Yes, in the very moment when he was preaching sincerity, he was sinning against it, not in what he said but in the way he said it. The teachings he stood for were moral rather than aesthetic in character; and yet it was for their beauty that he chose them."

After the blows which he has just rained down on the dead man he had claimed to revere and had called the "conscience of our time," it comes as no surprise when Proust then goes on to say that he detects a "hypocritical, deceitful attitude" in Ruskin. He has now reached a level of argument familiar to every Frenchman of his day, whether he had read Ruskin or not. He has invoked the cliché of the "two-faced Englishman" who does not practice what he preaches or—in this case—does not write as he preaches.

Several theories have been advanced to explain Proust's striking change of view, but this problem lies beyond our scope. We need concentrate only on the fact that, in his second appraisal of Ruskin, Proust emphasized what previously he had denied: that Ruskin had turned beauty into a religion. Whether an overt or a covert aesthete, a man divided or a man at peace with himself, now seemed a moot point. The important thing was that Ruskin's audience accepted the judgment of his early French apostles, who classified him, in broad terms, as part of the European aesthetic movement—a Pater before Pater, a Wilde without his malice, a Huysmans without his voluptuous poison.

It helped not a whit that Proust described Ruskin as "all the same . . . one of the greatest writers of all time and all nations"; or that he claimed that Ruskin's "weakness" was a "universal human foible" rather than a personal one, and that the same weakness had often afflicted Proust himself. The important thing is not how highly Proust ranked Ruskin as a writer, but rather the *kind* of writer he thought him: for this is the factor which determines how a writer lives on in people's minds. In this case, Ruskin came to

be regarded as a member of the Symbolist and fin-de-siècle culture and was therefore discarded along with this culture during World War I—apparently without hope of revival.

One question we must address is whether Proust may not have been at least partly right in his second appraisal of Ruskin. It is a question with no definite answer. To start with, Proust's interpretation sprang from too narrow a perspective. The French secondary literature on Ruskin had assigned to him the role of a writer on art, and Proust, in his own reading of Ruskin, did little to expand that view. For Proust, too, confined himself to Ruskin's early and late writings on aesthetics. Probably his only contact with Ruskin as a cultural critic came from reading *The Stones of Venice* and from translating *Sesame and Lilies*. Both books were still fairly remote from the interests of the "savage" Ruskin of the 1860s and 1870s. No one unfamiliar with the three treatises on political economy, and *Fors Clavigera*, is equipped to offer a conclusive evaluation of Ruskin.

(Incidentally, much the same fate befell Ruskin in other areas of Europe. The majority of his German readers knew no more of him than Proust did, for the beautiful fifteen-volume translated edition of his works published in German by Diederichs in 1903 contained only one volume that dealt with non-aesthetic topics—*Unto This Last*.)

Proust seems also to have known nothing more of Ruskin's life than what was in *Praeterita*, a book which deeply influenced Proust's own work but was an inadequate basis for understanding Ruskin. Consequently, Proust and most of Ruskin's later disciples remained unaware that Ruskin had been fully conscious of the conflict between *sincérité* and *idolâtrie*, that he had lived it out and in living had corrected and repaired it, that he had kept it always in his mind, in both his public and his private life. Proust—so as to avoid accusing Ruskin of a premeditated sin—had supposed the conflict to be deeply buried and concealed; whereas actually it was an open wound which Ruskin had exposed for all to see.

Ruskin's whole theoretical output—from the early *Letters to a College Friend* to Volume Three of *Modern Painters*, and from there

to the writings on political economy, the Oxford lectures, and *Fors Clavigera*—was concerned with the one great question: What can the devoted study of art and nature achieve in and for these times? The fractures and transformations of his life, his spectacular projects, his swift disposal of his father's fortune, and so much else: his whole life reflects that one and only concern.

Why did Ruskin wait for years before granting permission for his early writings to be reprinted, even though there was great demand for them? And why, each time a new edition came out, did he take pains to add prefaces and notes, continually expanding his comments and his ambiguity?

Ruskin carried on a dialogue with his readers, a dialogue in words and in actions. Its course was as unpredictable as that of every genuine dialogue. Moreover, it was always conducted on a number of levels, and via layer upon layer of texts: old and new, his own and other people's, completed and discarded. This form of communication demanded that he be an editor as well as a writer, and required a supreme mastery of the diverse media of the Victorian Age. We who read Ruskin today have at our disposal thirty-eight well-organized volumes—the Library Edition—which rank among the most beautiful and best-edited collected works in the English language. But Ruskin's own contemporaries knew him in the form of:

Heaps of pamphlets, unfinished projects, essays in popular genres, part issues and lecture texts. It must have been immediately apparent to any mid-Victorian reader that he was above all an *occasional* writer, and that the occasions of his writing were not to be predicted. Indeed, of all his works, only the three early art books, *Modern Painters, The Seven Lamps of Architecture* and *The Stones of Venice*, were written deliberately in *volume* format without Ruskin having any distinct sense of a particular readership. The vast bulk of his work comprises lecture texts published in a wide variety of formats (at least fifteen volumes), series of periodical articles, single articles, letters to the press, educational textbooks, pop-

ular guidebooks, books of popular science, exhibition cata-
logues, extended didactic dialogues, and a fairy tale [one
might add: anthologies and selections from his work]. It may
be possible to find an intellectual coherence or emotional unity
in such works, but more immediately striking is the vast
variety and self-consciousness of the literary and social dis-
courses in which Ruskin engaged.

We should perhaps amend Brian Maidment's last sentence to
read that the unity of Ruskin's work *is* a variety which allows him
to be continually present in many places at once, although in each
place he continues to ask his central question: How does the study
of nature and art relate to our times?

In our discussion of the early works, we already suggested that
Ruskin never treats this question in isolation but always in terms
of present conditions, the contemporary packaging and use of art-
works as well as the innate conditionality of art.

Again and again, we see him making an approach to a work of
art, and continually varying the theme of approach in a way that
would stimulate the work of Proust. By the same token, his own
work, too, lies in the staging or the setting of a work, and not
merely in the work as such. Today, what we experience in Ruskin
is merely the especially active presence of the author in his own
writings. But once upon a time he ruled a whole system—the
Present—of concrete reference points in the lives and events and
communication problems of his day. A system indeed that aimed
to do more than advertise or stimulate or coordinate. As Proust
rightly saw, Ruskin was still one of the "pre-scientific men" who
viewed nature and history—and history was just nature, man's
nature unfurled—as a giant message addressed to the present age.
He could not simply write down this message which came to him,
as it were, from above: not after he realized that both the sources
of the message and people's ability to hear it were under threat.
Thus, he received the message and tried to communicate it and at
the same time continually interrupted and recalibrated it, so that
in effect he communicated not so much the message as the pos-

sibilities of the message, and the whole question of what had to be dealt with first, in order to make the message possible. His work became a discussion of whether it was justified to talk about trees and pictures in times like these, and of what entitled a man like himself, with his background and credentials, to join in the talk.

But to return to Proust's evaluation, it was wrong to describe Ruskin—either in praise or in blame—as a "priest of beauty." It is not asking too much to expect his critics to find out something about the "other" Ruskin. Without knowing his other side, it was unfair of them to dismiss Ruskin's activities as social critic and social reformer with the phrase *dilettantisme de l'action*, as Proust does.

Proust appears to have turned into an absolute the view he expressed in *Contre Sainte-Beuve* that there is a gulf between work and life and that "a book is the production of a different self than the one we reveal in our habits, our social relations and our vices." But if the work is really to have precedence and is to count as a man's "real life," then it would have made more sense for Proust to have tried to understand Ruskin's discursive strategy in his work, rather than attacking him in an area where in fact it was hard for Proust to prove his point—for Ruskin himself treated the aesthetic ideal as a never-ending source of questioning, self-doubt, and attempted justifications. Indeed, we might speak of this questioning and doubt as itself constituting his work, if instead of Proust we quote Sainte-Beuve—one of the few French critics who actually read Ruskin—and say that in Ruskin "The commentary has taken over the text."

> I have not written about clouds and flowers because I love them myself, but because the energies of mankind are devoted all around me to the pollution of skies and desolation of fields; and I have not written of pictures because I loved pictures, but because the streets of London were posted over with handbills, and caricatures, and had become consistent and perpetual lessons in abomination and abortion to every soul that traversed them, so far as it used its sight.

These lines, written late in Ruskin's life, are far from being his only reply to the charge of idolatry. We can expand them with another remark from the same passage, which is ideally suited to amend Proust's critique. Ruskin says: "I claimed for myself a peculiar fineness in the pleasures of sight, such as had been possessed in the same degree only by four other men in the last century [Rousseau, Shelley, Byron, and Turner]." Thus, what Proust called the root of Ruskin's talent was not idolatry, not the "religion of beauty," but what the Symbolist Arthur Symons called the "religion of the eyes," or, to use Ruskin's own phrase, "the desire of the eyes"—his drive and craving to see, to be a supreme spectator. In other words, there is not much we can say on the subject beyond what Ruskin himself said in *Praeterita*.

Ruskin's career led him along the path from being a "sightseer" to a "see-er" to a "seer" in the figurative sense, a clairvoyant. This path is also a path of suffering, the suffering from a great gift. Ruskin himself said his gift of seeing was "too great" for him. He gave a consistent account of the causes and the personal costs of the heightened desire of his eyes. Many factors combined to produce it, things which made his life unhappy or out of the ordinary: his withdrawn early childhood, his long-time domination by his parents (which psychologists claim often leads to voyeurism), his problems with women, his desire to see without being seen, and the intensity and inescapability of his late visions. And yet, sad to say, though all this may add up to a case study, it does not add up to a Ruskin. It was Ruskin's peculiar fate to be the seer for an age which no longer wanted to see so much, or which wanted to see differently, and which then went blind and destroyed what there was in the world to see.

But it has been my fate to live and work in direct antagonism to the instincts, and yet more to the interests, of the age; since I wrote that chapter ["The Open Sky," in Vol. One of *Modern Painters*] on the pure traceries of the vault of morning, the fury of useless traffic has shut the sight, whether of morning or evening, from more than the third part of England; and

the foulness of sensual fantasy has infected the bright benef-
icence of the life-giving sky with the dull horrors of disease,
and the feeble falsehoods of insanity.

The tragic undertow of Ruskin's life lies in the facts just de-
scribed and in his lifelong, wide-awake visualization of them. They
are also the "root cause" of his "sins" and his "acts of salvation"—
to stay with Proust's terminology. If for the word "idolatry" we
substitute the words "arrogance" (as in a sense of infallibility) and
"verbiage," we get a better idea of what were really his besetting
sins.

All his major writings, from Volume One of *Modern Painters*
onward, express his basic conviction that he is called upon to see
in a representative and authoritative way at a time when no one
else is any longer seeing.

Who, among the whole chattering crowd, can tell me of the
forms and the precipices of the chain of tall white mountains
that girded the horizon at noon yesterday? Who saw the nar-
row sunbeam? . . . Who saw the dance of the dead clouds?
[1843]

Hundreds of people can talk for one who can think, but
thousands can think for one who can see. [1856]

And I felt also, with increasing amazement, the unconquer-
able apathy in ourselves and hearers, no less than in these the
teachers . . . our hearts fat, and our eyes heavy, and our ears
closed, lest the inspiration of hand or voice should reach us—
lest we should see with our eyes, and understand with our
hearts, and be healed. [1868]

And every man in England now is to do and to learn what
is right in his own eyes. How much need, therefore, that we
should learn first of all what eyes are; and what vision they
ought to possess. [1872]

471

To teach people to see, Ruskin expanded the linguistic techniques for conveying visual facts to such a significant degree that he is credited with having created a new literary form, the visual tone poem. He cannot be described as, by definition, a difficult author or one who is scornful of readers; and yet he often becomes indignant and fretful. At the end of Turner's life, Ruskin believed, the painter was overwhelmed by anxiety that after he was gone there would be no one who would know what was there or what it was possible to see and to show. Ruskin, feeling this same anxiety in himself, tried to compensate for it by posing exaggerated and absolute claims which are symptoms as much of solitude as of arrogance. Again and again he would invent temporary theories just to provoke responses, to challenge his audience to contradict him; and then he himself would adopt that contradictory view. Baudelaire claimed that to contradict oneself was a basic right of the nineteenth-century writer, and Ruskin certainly made liberal use of it. But that is really beside the point, the point being that when Ruskin changed his mind, he did it in the same authoritarian tones with which he had broached his original thesis.

It is hard to decide if he was really moved by pride. Everyone who met him was surprised at the difference between the self-assured voice of his writings and the gentle and sensitive nature of the man himself.

Like the other Victorian prophets, Ruskin would let no one chasten his view of his self-appointed task: "It is quite true, that preface reads haughty enough; but . . . I cannot write with a modesty I do not feel. In speaking of art I shall never be modest any more." In another passage treating a different subject, he tells the reader: "This is so; you may find it out for yourselves, if you choose; but, however little you may choose it, the thing is still so."

Ruskin felt that his authority was confirmed by the very fact that he was the last man fit to wield it. Precisely because he was not suited by nature to the prophet's role, God *must* have called and chosen him to fill it:

And what am I, myself then, infirm and old, who take, or claim, leadership even of these lords? God forbid that I should claim it; it is thrust and compelled on me—utterly against my will. . . . Such as I am, to my own amazement, I stand—so far as I can discern—alone in conviction, in hope, and in resolution, in the wilderness of this modern world. Bred in luxury, which I perceive to have been unjust to others, and destructive to myself; vacillating, foolish, and miserably failing in all my own conduct in life—and blown about hopelessly by storms of passion—I, a man clothed in soft raiment,—I, a reed shaken with the wind, have yet this Message to all men again entrusted to me.

Ruskin describes his "tendency to moralise or sermonise" as both instinctive and vain, both vice and nature. He had done his educating "often with no more sense of duty than the tide has in filling sandpits, or a stone in rolling down hill." The Victorians' sense of mission is bound to go against the grain in an age like the present, which has given words like "somehow" and "maybe" the status of ultimate answers. We might get used to their doctrinaire tone if we could simply view it as a historical eccentricity, and if their style did not keep turning into content. Ruskin, who in the 1840s and 1850s had envisaged a model society built on the kind of "freedom" he supposed had been possessed by the Gothic stonemasons, sharply condemned trends to democracy, in the 1860s and 1870s. In the political sphere, he valued strong leadership, authority, "mastership," and he regarded the desire for free choice and participation in power as one of the basic ills of his time. The test of a political order was not whether it allowed a man to determine his own actions personally; the only thing that counted was whether he had done the right or the wrong thing. And right and wrong had been laid down, Ruskin felt, in the divine and eternal laws which could be interpreted by the "true superiors," the "aristocracy of talent"—Ruskin himself being one of these, we may safely assume. As was recently said by a German historian

473

commenting on the Victorian era in Europe: "This too belongs
ultimately to the character of the nineteenth century: that a man
wants to be both the first and the last. Behind it we feel a driving
will that pushes to the limit, an ambition whose force and vitality
are bound to impress us again and again. But something tells us
not to be overly impressed by them. For the spirit of this ambition
is, as it were, that of Babel: inordinate, condemned to incomple-
tion, and ending in a boundless confusion of tongues. We today
are confronted with the consequences."

Ruskin not only took his readers imperiously to task, or con-
ducted them on long didactic tours of investigation; but he also
rewarded them with linguistic gems, courted them, and—some
claim—hoodwinked them. The "confusion of tongues" he caused
was of a special type, always programmatic. It is when we look
at his verbiage that we must come closest to agreeing with Proust's
accusation of idolatry. For there is no doubt that both the young
and the old Ruskin were often infatuated with their visual and
verbal powers. Once arrived at a suitable subject, they could lose
themselves in grand descriptions and magnificent invectives. Rus-
kin's early style is underlaid by mischievousness, ostentation, play-
fulness, and competitiveness. Later, there is both a lack of control
and a forcing of opportunities to prove his old powers again.

No doubt, it would be inhumane to expect permanent restraint
from a writer who, as John Rosenberg says, did for English prose
what Shakespeare had done for English verse. Ruskin himself stated
clearly his own views on the question of passion versus restraint:
"A poet is great, first in proportion to the strength of his passion,
and then, that strength being granted, in proportion to his gov-
ernment of it."

All the same, he did demand "government" in himself, and got
it. He adopted a curt, robust language for his treatises on political
economy, and the abruptness of this shift testifies to a mastery of
the medium, bordering on self-effacement, which we would seek
in vain among his contemporaries.

But even the pomp of his early prose is not merely a flexing of
muscles or a service to beauty for beauty's sake. In Volume One

of *Modern Painters* Ruskin had said that his interest was not in the aesthetic qualities of the beautiful, the sublime, or the picturesque, but solely in the expression of truth. In his exposition, "truth" becomes increasingly identified with beauty. But, even so, he is not contradicting himself, because to him the beauty of truth or the truth of beauty meant something quite different from the notions that were dear to classical and fin-de-siècle aesthetics. He never spoke of the perfect, the choice, the exquisite, the intense. He equated the beautiful-true with the variety of nature in all its functions and products; with the wealth of its phenomena, the abundance of its structures. The basis of nature is infinity. Man, as the "seeing creature," has the vocation to open his senses to this infinity, and to reproduce an approximate version of it, using his own media of expression. Since there is so much to see, it is permissible that there also be many words; since all nature coheres in long curving lines, language, too, may be organized in garland shapes, arches, and winding festoons; and so on.

Art and the art of language, insofar as they are a function of nature's diversity, cannot be guilty of what Ruskin described as the capital crime in any art form: "haughty self-sufficiency," "pride of system," "demand for perfection." The gorgeous display of his language is intended, first of all, as praise of the world's rich detail ("All great art is praise"). In this case, its mischief becomes a necessary play, a stretching of the limbs, a delight in skill that reaches the point of laughter, "that highest laughter which springs of pure delight, in watching the fortitude and the fire of a hand which strikes forth its will upon the canvas as easily as the wind strikes it on the sea." Such art cannot be haughty, precisely because it is excessive and overwhelming:

> The richness of the work is, paradoxical as the statement may appear, a part of its humility. No architecture is so haughty as that which is simple: which refuses to address the eye, except in a few clear and forceful lines; which implies, in offering so little to our regards, that all it has offered is perfect. . . . There are, however, far nobler interests mingling, in the

Gothic heart, with the rude love of decorative accumulation: a magnificent enthusiasm, which feels as if it never could do enough to reach the fulness of its ideal; an unselfishness of sacrifice, which would rather cast fruitless labour before the altar than stand idle in the market; and, finally, a profound sympathy with the fulness and wealth of the material universe.

Ruskin wrote this about the Gothic workmen. Indications are that he considered himself to be following in their tradition in his work as a writer and draftsman.

But if Ruskin can justify, even prove the need for, wealth in language, how could he have broken with it and withdrawn this appropriate wealth? How did he arrive at insights like the following, which anticipates Proust's critique, and which Proust himself had read?

The more beautiful the art, the more it is essentially the work of people who *feel themselves wrong*;—who are striving for the fulfilment of a law, and the grasp of a loveliness, which they have not yet attained, which they feel even farther and farther from attaining the more they strive for it.

How did the study of nature's superabundant beauty/truth become linked with a sense of wrong? And how did Ruskin allow *history* to define it as a utopia? In the past, it was *nature* that said "impossible" when man tried to grasp it, yet still let him feel that nature addressed him, was meant for him. But now it was history that said "impossible" and, at best, compensated the striver with the conviction that he was right on some deeper level: "And yet, in still deeper sense, it is the work of people who know also that they are right," the last-quoted passage continues.

So Ruskin felt he was right "in still deeper sense"; that is, under a different set of conditions. Actually, we already know the story of how Ruskin's perspective on art, nature, and history shifted with time; and there is no need to recapitulate the process in detail

but only to outline it once more. His early work in Venice led him away from mere observation of phenomena toward a genetic perspective, and led him to study the larger relationships between art history and social history, and between aesthetic and other types of production. From this, there followed an insight into the "impossibility" of art and into the "impossibility" of his own early efforts.

In this book, I have tried to expand Ruskin's own interpretation of his mental shift, and would now like to highlight certain features as we continue our search for those "sins" which Proust alleges he found in Ruskin.

Proust describes Ruskin's "besetting sin" as that of allowing the beauty of his words to belie the sincerity of his message. One piece of evidence he cites to support this claim is a passage from *The Stones of Venice* which comes at the end of Ruskin's detailed analysis of St. Mark's. The fact that Proust chose this particular text gives us a major clue as to why he arrived at the conclusion he did. Let us first look at the whole of the passage quoted by Proust, for we need to see *which* Ruskin it is whose beauty looked "dangerous" at the turn of the century:

> Not in the wantonness of wealth, not in vain ministry to the desire of the eyes or the pride of life, were those marbles hewn into transparent strength, and those arches arrayed in the colours of the iris. There is a message written in the dyes of them, that once was written in blood; and a sound in the echoes of their vaults, that one day shall fill the vault of heaven,—"He shall return to do judgment and justice." The strength of Venice was given her, so long as she remembered this: her destruction found her when she had forgotten this; and it found her irrevocably, because she forgot it without excuse. Never had city a more glorious Bible. Among the nations of the North, a rude and shadowy sculpture filled their temples with confused and hardly legible imagery; but, for her, the skill and the treasures of the East had gilded every letter, and illumined every page, till the Book-Temple shone

from afar off like the star of the Magi. In other cities, the meetings of the people were often in places withdrawn from religious association, subject to violence and to change; and on the grass of the dangerous rampart, and in the dust of the troubled street, there were deeds done and counsels taken, which, if we cannot justify, we may sometimes forgive. But the sins of Venice, whether in her palace or in her piazza, were done with the Bible at her right hand. The walls on which its testimony was written were separated but by a few inches of marble from those which guarded the secrets of her councils, or confined the victims of her policy. And when in her last hours she threw off all shame and all restraint, and the great square of the city became filled with the madness of the whole earth, be it remembered how much her sin was greater, because it was done in the face of the House of God, burning with the letters of His Law. Mountebank and masquer laughed their laugh and went their way; and a silence has followed them, not unforetold; for amidst them all, through century after century of gathering vanity and festering guilt, that white dome of St. Mark's had uttered in the dead ear of Venice, "Know thou, that for all these things God will bring thee into judgment."

In this passage we already see Ruskin the perorating preacher, the prophet who prophesies the future by looking at the past. We also see him touching again on the theme of the refusal of perception. At the start of his discourse on St. Mark's, he makes the point: "I never saw one Venetian regard for an instant" any of the features of the church; "you will not see an eye lifted to it," and "the language it uses is forgotten." Quite literally, people are no longer capable of seeing or hearing St. Mark's.

But Proust chose to quote a passage at the end of the chapter— a point where Ruskin always tended to go "up in the clouds," as his father put it. He did not, for instance, choose one of the earlier descriptive passages—the famous approach to St. Mark's, or the initial description of the interior—which figure with equal prom-

inence in this section. Nor did he point out that the passage he selected follows on as a "reward" after many pages of intricate decoding of the cathedral or, as Ruskin calls it, the "book temple."

The problem with Ruskin's purple passages, in fact, is not intrinsic, is not connected with their treacherous beauty as Proust suggests, as much as with their external aspect, their positioning in the text, the need for them to be there at all. We know that Ruskin often injected purple passages after a piece was completed, simply to add a few highlights—rather the way his master Turner would touch up his paintings just before an exhibition.

However, when he was working on *The Stones of Venice*, he began to do this kind of "touch-up" only after he came under pressure from several sources. First, he was desperate to salvage for the future the wealth of historical detail he had uncovered; second, he felt that the lesson he now had to convey was more urgent than that of *Modern Painters*. For both these reasons, he had to make what he wrote palatable to the public. Added to these factors was the pressure from his father, who personified the attitude of his growing public, and, who like them, demanded *beautiful* books, "eloquent passages."

Once he had finished *The Stones of Venice* and the last three volumes of *Modern Painters*, Ruskin gave up trying to write books that were beautiful as well as communicative. Not until *Praeterita* would he again attempt to respond to all his imperatives at once. In fact, he was never able to achieve this without visible strain, makeshift devices, and fractures. And at the end of the last volume of *Modern Painters*, he had to admit that he had not really reached the end but simply could not continue.

Ruskin began *Stones* with the intention to "eat it all up in my mind" and to reproduce everything in the city of Venice. But by the end of this and his other early works, he still stood as he had at the beginning, his arms loaded down with portfolios of drawings and densely inscribed notebooks, and had to give up the attempt to show all the important medieval portals and windows; just as he had to give up the plan to devote a separate volume of *Modern Painters* to the "truth of water." He had used up all the space

available for such projects, filling it with grand descriptions, long chains of reasoning, background material and evidence.

Many factors could divert Ruskin from what his father had called the "business details" of his books, and in each case these factors must be looked at separately. Sometimes his decisions were based simply on considerations of available time and space. But also the feeling grew in him that the really important questions could, even *must*, be discussed without empirical evidence to back him up. By the end of the "old" and the start of the "new" epoch, we find him not only articulating new themes and using a different type of language but also relying on different devices to win his points. Now he no longer presents data but lines of argument. He no longer writes all-inclusive compendia but instrumental prose. His remarks become shorter, more concrete, more connected to an immediate motive. Nor does he store up new supplies of information: he lives off his existing store, works purposefully toward the next use of it, trusts in the inspiration of the moment to tell him what and when.

And he now has a new imperative: myths, as the formulation of what is eternally true. It is by their model that he now measures his style and behavior, both of which are growing weightier and more authoritarian. He develops two new categories of evidence for those occasions when he feels the need for external supports: etymological derivations, and his own special brand of "telling details," which range from the missing hand of God, and of the Doge in Venice, to the sharp pointed fence outside the tavern in Croydon to the scattered fireflies at the end of *Praeterita*.

We can summarize this whole transition by saying that, at the end of the 1860s, social criticism replaced art criticism as the focus of Ruskin's interest, and, equally, myth replaced nature and art, mythology replaced the "science of aspects," and mythic language replaced explicative prose.

Admittedly, some of Ruskin's basic ideas continue to be important to him: his discursive strategy, the organic interpretation of cultural processes, the emphasis on the role of perception. Nevertheless, he has taken a new direction. He initially concen-

trated on man's perception of natural and aesthetic phenomena; now he turns to a new project: The Nineteenth Century as Myth (subtitled, The Revelation of John Ruskin). In the past, he primarily followed the dictates of the "pure eye," but by the late 1860s he has more at stake and is more concerned with liberating himself from certain aspects of the world. This became clear when we looked at the relationship between his studies of mythology and his need to free himself of his own psychologically generated dreams and myths. Now, whether he looks inward or outward, he keeps beholding the mask of Medusa and cannot get rid of her, no matter how many snakes he lops off her head, either by killing real vipers or by invoking effective counter-myths. For the master of St. George's Guild has truly become a second St. George, a slayer of dragons.

Ruskin has determined to fight the snakes on their own level, to fight fire with fire, to fight the nineteenth century's myths with his own myths, and Apocalypse with his own Revelations. His discovery that the word "dragon" originally meant "the seeing creature," that the primary Greek word for snake, *ophis*, also has basically the same meaning, and the fact that "George" and "Gorgon" came from the same root, proved to him that pairs of opposites were related on an absolute level, and thus that his own personal-battle-with-the-dragon was actually taking place inside a hall of mirrors.

The recent burgeoning of interest in Ruskin is perhaps largely attributable to his "mirror-temper"—the fact that his later life is inextricably bound up with the temporal and psychic history of his age—and to the resultant symbolism of his writings. This theme of the production of myth as a response to crisis is one that speaks to many people in our century. For instance, we read this passage in a 1936 lecture by Thomas Mann:

Myth represents an early and primitive stage in the life of mankind; but in the life of the individual, it is a late and mature stage. Myth shows us the higher truth embodied in reality, the smiling knowledge of the eternal, the everlasting,

the universally valid: the pattern in and *by* which the indi-
vidual lives—though all the while thinking himself wholly
individual and not suspecting, in his naive deceit that he is
one and only, the extent to which his life is a formula and a
repetition, a walking in a path deeply trodden by others.

Mann's words roughly define the zone of interest which attracts
many people to Ruskin today. Ruskin evolved from a seer of
"individual truths" into a prophet of "eternally true facts."
Granted, no Mannesque smiling wise man stands at the end of his
course, but nevertheless he showed that involvement with myth-
ology could be more than an intellectual discipline and that under
certain conditions in the private and public spheres it could lead
to a remythification both of personal life and of the life of an age.
Mann used the same thesis as a means to legitimize his life and
work in the 1930s; today it supplies us with an explanatory frame-
work within which to look at the late Ruskin. Thus, our "priest
of beauty" is resurrected in the guise of a "myth-maker."

One recent investigator who has published a 700-page book on
the role of myth in Ruskin calls him "the major Romantic myth-
maker of the Victorian era." In the days when formalist criticism
was still in vogue, Ruskin was valued by the few scholars who
viewed him as a restorer of the centuries-old allegorical tradition,
and as a well-informed expert on allegory, amid a horde of ill-
informed parvenus. But today he is eagerly studied by all inter-
preters and readers of imagery, signs, and symbols, regardless of
whether their commitment is to Jung, or Freud, or Freud's French
disciples, or to typological, iconographic, or semiotic models. And
they are all the more devoted to him because he took on himself
the risk of living his teaching to the hilt and proved himself willing
to pay whatever price was necessary, to follow wherever the sym-
bols led. Symbolism *was* a dangerous plaything and thus Ruskin
is no longer what Proust found him, dangerously beautiful, but
rather beautifully dangerous. If Proust had foreseen this develop-
ment, he would have formulated his central charge rather differ-
ently. In fact, he would have stuck to the line he broached briefly

and covertly in his first appreciation of Ruskin, when he spoke of the late writings like *The Bible of Amiens*. He recognized in them a "certain fetishism," a tendency to worship symbols for their own sake. Proust interpreted this tendency as a Symbolist variant of idolatry which he called "iconolatry"—and which, in his view, made Ruskin secretly akin to Gustave Moreau! With an eye on the related tendencies of our own day, we ought perhaps to translate the term "iconolatry" as "sign fetishism."

I am myself dissatisfied with this recent fashion in Ruskin criticism. But the blame for it can only partly be laid at the feet of Ruskin's new breed of admirers. Some of it must be kept for Ruskin himself. We cannot turn him into an absolute mythologist or a mythical absolute, for then we have only half of him. Nor should we try—as is commonly done at present—to apply to the younger Ruskin all that was true at the end, for then we would suppress or falsify what is best in him. Those who want their social criticism swallowed up in mythic declamation, or who are looking for poltergeists in mythopoet form, should stick to the real article, like Carlyle or Nietzsche. Admittedly, Ruskin functioned successfully on this level, but that is due to abilities and techniques which he acquired early on and which do not properly belong to the mythic sphere. If *Praeterita* is Ruskin's greatest work, it is because he wrote it in the name and in the spirit of the Old Epoch, with his eye on the things themselves, and not because he based it on a substructure of archetypal images. And if *Fors Clavigera* may be called the most important piece of social criticism to come out of nineteenth-century Britain, it is not because it is driven by the engine of vast mythological speculations, but because, in addition to the myths, each letter contains crisp fragments of reality, banal details of everyday life, which reveal to us the pathology of the age.

In short, the "siren whistles" of the streamer *Capo d'Istria* outside Ruskin's hotel room contain more truth than the alluring symbols in Carpaccio's St. Ursula paintings—although, naturally, Ruskin would not have agreed.

And this takes us away from Ruskin's present-day admirers and brings us back to the man himself. There are many definitions of

myth, but for our purposes we must be satisfied with Nietzsche's idea that it is an abbreviation of reality, a "concentrated picture of the world." Ruskin did not want to accept this idea of it, because when he worked on myths, he did not want to give up qualities like depth, diversity, and incomprehensibility, which had characterized his earlier subjects of study. However, in his study of mythology, he confused the diverse treatment and meanings of myth with its essentials, whose hallmark is a monolithic terseness. When, in his state of "dream," he wrote the compressed notations: "Delphi first. Then Ægina. Behind Carpaccio"—*that* was the language of myth in its pure form. The authority of myth stems from etymologies and genealogies; it is the depiction of causality by the simplest possible means. In this it stands closer to generalized explanations of the world—the explanations of modern science, for instance—than it does to the science which Ruskin helped to found by imitating his master, J.M.W. Turner: the science of aspects. The science of aspects was programmatically indifferent to everything which is integral to myth: the "eternal, everlasting, universally valid," the "pattern" and the "type." The science of aspects always had to do with the "one and only," the "wholly individual," the contextual and transitional, the truth of phenomenal forms. It never involved etymology, or the truths of types or essential categories.

I have often wondered if Ruskin ever fully came to terms with the main conversion experience in his life, his conversion from a particularist to an essentialist. He—and all his biographers along with him—have interpreted this change as an *inevitable* result of both internal and external causes. He had started out by showing what *is*, or, rather, how it *appears*. Later he claimed that it was no longer possible to show what *is* and that instead one had to criticize the fact that what is is being destroyed. Reminiscing about the work he had done for *Modern Painters*, he emphasized the inevitability of his new orientation:

Now, no book such as *Modern Painters* ever would or *could* have been written; for every argument, and every sentiment

in that book, was founded on the personal experience of the beauty and blessing of nature, all spring and summer long; and on the then demonstrable fact that over a great portion of the world's surface the air and the earth were fitted to the education of the spirit of man as closely as a schoolboy's primer is to his labour, and as gloriously as a lover's mistress is to his eyes.

That harmony is now broken, and broken the world round: fragments, indeed, of what existed still exist, and hours of what is past still return; but month by month the darkness gains upon the day, and the ashes of the Antipodes glare through the night.

In the 1850s the conclusion Ruskin drew from this state of affairs was that he could not go on collecting the fragments of the world, nor could he maintain its harmony vicariously or by force. Instead, he had to take fragmentation and its causes as his theme *and* to adopt fragmentation as his form. That is, he had to be unharmonious himself. The jagged mountain crags of the Alps, the aiguilles, are the symbol of this change in him. By returning like for like—by ceasing to reproduce detail and reproducing only the basic structure—he in fact opted for the modern way, and thus allied himself with the underlying movement of the century he claimed he was fighting.

For us today this decision seems to be the only right one. *Fors Clavigera* fascinates us now because of its modern intention to be as brutal (clavigera equals club-carrying) and as chaotic (fors equals accident) as the brutality and chaos of the nineteenth century. It is modern, too, in its uncompromising view that now destruction and the destroyers warrant more attention than what has been, or still remains to be, destroyed. But what seems necessary and inevitable to us today was not yet so in the nineteenth century. And perhaps it only became so because of men like Ruskin and Nietzsche.

If we look at a book like Matthew Arnold's *Culture and Anarchy*, for instance, we see that it is in many ways a parallel enterprise to

Fors. And yet it is exclusively "cultural" and not "anarchic" at all. It was deliberately written in a classic style. I am not suggesting that it ought or ought not to have been written that way, but merely asking that we keep open the question of whether it was salutary or inevitable for Ruskin to make the choice he did.

Admittedly, he had reasons for his uncompromising posture. For a time he still hoped that mankind, once it had arrived "at its wits' end," would find that there was only one option open; namely "to understand that God paints the clouds and shapes the moss-fibres, that men may be happy in seeing Him at His work, and that . . . resting quietly beside Him, and watching His working . . . are the only real happinesses that ever were, or will be, possible to mankind."

Later it became clear to him—clearer than to any other philosopher of history in his time—that, once mankind had arrived "at its wits' end," it was then quite capable of "unparadising" the creation again. This possibility was the cause for the absolutist stance of his late work. Nevertheless, we may be pardoned for suspecting that more "sins" have been committed, more contradictions produced, and more suffering created in the name of this "necessary" absoluteness than under the rubrics of idolatry, iconolatry, arrogance, and verbiage all put together.

In other words, our study of Ruskin does have something to do with arrogance and idolatry, after all. Between them, they explain why he has frequently been described as not believable. George Bernard Shaw's response to this charge was to say: "The reason why the educated and cultured classes in this country found Ruskin incredible was that they could not bring themselves to believe that he meant what he was saying, and indeed shouting." But my own belief is that the reason also lay in Ruskin himself.

From the 1850s on, Ruskin demanded belief while provoking disbelief—when all the time he might instead have continued on his earlier course, making visible to others what it *was* possible for them to know. Believers and unbelievers are not necessarily seeing people, and he might have taken that into account. Ruskin, who never actually joined a profession, nevertheless latched on to his

prophetic vocation as if he had been trained for the role. He leaped too eagerly onto that well-trodden trail, and he deserves the charge of idolatry where his reverence for his own role is concerned. Or at least he deserves it for his unthinking readiness to don the mantle that was offered him by an age which loved to be upbraided for its laissez-faire policies and loved to go on practicing them all the same. As Virginia Woolf said:

> Our fathers were a good deal responsible for the tone which their teachers adopted towards them. There can be no doubt that they liked their great men to be isolated from the rest of the world. Genius was nearly as antisocial and demanded almost as drastic a separation from the ordinary works and duties of mankind as insanity. Accordingly, the great man of that age had much temptation to withdraw to his pinnacle and become a prophet, denouncing a generation from whose normal activities he was secluded. . . . It is hard too not to wish that he [Ruskin] had lived in an age which did not isolate its great men with adulation, but encouraged them to use the best of their powers.

Ruskin, of course, did not lose sight of the real afflictions of his age. The charge of isolation and indifference does not apply to this man who could read the signs of the times in the most banal and everyday facts. But being a prophet means producing brief and absolute proofs, displaying evidence the way you display stigmata or holy relics. Ruskin's great strength was his patient deciphering of reality, and there was no call for that in the world of prophecy.

Let us look at one more concrete example of how Ruskin abandoned his former habits and convictions, and at what was lost in the process. Our example is from his preface to *The Queen of the Air*, which, as we have noted, discusses Greek myths as a form of eternally valid knowledge about nature in general, and about the nature of John Ruskin in particular. In this passage we see the science of aspects definitively replaced by the science of essences.

The preface, dated Vevay, May 1, 1869, touches on Ruskin's

earlier themes and methods, only to say that the ground has now been pulled out from under them:

This first day of May, 1869, I am writing where my work was begun thirty-five years ago, within sight of the snows of the higher Alps. In that half of the permitted life of man, I have seen strange evil brought upon every scene that I best loved, or tried to make beloved by others. The light which once flushed those pale summits with its rose at dawn, and purple at sunset, is now umbered and faint; the air which once inlaid the clefts of all their golden crags with azure is now defiled with languid coils of smoke, belched from worse than volcanic fires; their very glacier waves are ebbing, and their snows fading, as if Hell had breathed on them; the waters that once sank at their feet into crystalline rest are now dimmed and foul, from deep to deep, and shore to shore. These are no careless words—they are accurately—horribly— true.

What proof does he offer? None. We have no choice but to take the word of a man who tells us: "I know what the Swiss lakes were; no pool of Alpine fountain at its source was clearer. This morning, on the Lake of Geneva, at half a mile from the beach, I could scarcely see my oar-blade a fathom deep."

But wait. He does cite one piece of evidence, after all:

Take this one fact for type of honour done by the modern Swiss to the earth of his native land. There used to be a little rock at the end of the avenue by the port of Neuchâtel; there, the last marble of the foot of Jura, sloping to the blue water, and (at this time of year) covered with bright pink tufts of Saponaria. I went, three days since, to gather a blossom at the place. The goodly native rock and its flowers were covered with the dust and refuse of the town; but, in the middle of the avenue, was a newly-constructed artificial rockery, with

a fountain twisted through a spinning spout, and an inscription on one of its loose-tumbled stones,—

> "Aux Botanistes,
> Le club Jurassique."

"Take this one fact," he says. Of course, we would not willingly renounce this malicious and highly meaningful fact. But is that enough? Can he, *must* he, now turn his back on a scene that has been abandoned by all good spirits and start work on the Greek nature divinities? Is this one savage dig a sufficient reply to the cynicism of his times? Would not this in fact be the moment for him to produce an interpretation of nature that would combine his lifelong observation of aspects with critical penetration of the forces now threatening them?

After all, it was Ruskin who had prescribed for the nineteenth century the task of realizing diversity and who had showed that the refusal of perception leads to the progressive disintegration of reality. Emerson had said: "The ruin or the blank, that we see when we look at nature, is in our own eye." But Ruskin's view was that the decay of our perception and the decay of our environment—the blind spots we create inside and outside us—each determines the other. He had already established the need to go on working to keep visible both the forces of destruction and those remnants of nature and culture which still resisted it. For remnants there were, enough to last another hundred years.

Only toward the very end of his career did Ruskin once again try to carry out a combined enterprise: criticism plus salvage—namely, in *The Storm-Cloud of the Nineteenth Century* (1884). Until then, he confined himself to the critique of social ignorance and abandoned his first enterprise, undertaken within sight of the high Alps, to use criticism as a vehicle for rescuing reality: as a synthetic reality, as realism, as the expression of the living presence of images and the unity and compellingness of their content.

But I do not wish to be misunderstood. I am not recommending the advice which his concerned or disgruntled friends and contemporaries used to offer Ruskin, that he should stick to his last and

write of nothing but his observations of art and nature. By the 1850s, he had already turned these genres into vehicles of social criticism, in *The Stones of Venice* and in Volumes Three to Five of *Modern Painters*. In fact, he had created a whole new field of activity, which has continued to grow in importance ever since, and which lay somewhere between the zones of nature, science, and art, combining the generalizing and functionalist concerns of science with aesthetic interest and minute observation—a blend, one could say, of the work of Charles Darwin, Ralph Waldo Emerson, and the entomologist Jean-Henri Fabre.

Henry David Thoreau resembled Ruskin more closely than any other writer, but had discovered his own style and method independently of Ruskin. Others who wrote in a similar vein were incapable of relating descriptions of nature to the critique of society. Richard Jefferies, Edward Thomas, John Muir, W. H. Hudson, Alice Meynell, H. J. Massingham—to name only a few among the horde of British and American "naturalists"—proceeded to rewrite Volume One of *Modern Painters* and adopted Ruskin's anticapitalist, anti-industrial attitude like an article of faith rather than a tool.

Brecht's poem *"An die Nachgeborenen"* ("To Future Generations") contains these famous lines: "Oh what times are these, when talking about trees nearly amounts to a sacrilege, as it implies a silence about so many crimes!"

After 1860, Ruskin concluded that it was both sacrilegious and impossible to go on writing about trees and pictures of trees. The writers just named proved that it at least *was* possible. Ruskin could, if he had chosen, have gone on teaching people like them. He could have shown them that, at the proper time, talking about trees can be more than just talking about trees, and thus was not necessarily sacrilege. And he could have shown *us* that talking about trees involves more than just denouncing their destroyers. It also means finding out about—seeing—the trees themselves.

Notes

Abbreviations of books by and about Ruskin:

34, 136	*The Works of John Ruskin* (The Library Edition), ed. E. T. Cook and A. Wedderburn, 39 vols. (London and New York, 1903–12), Vol. 34, p. 136
BD	*The Brantwood Diary of John Ruskin*, ed. H. G. Viljoen (New Haven and London, 1971)
Bradley	*Ruskin's Letters from Venice, 1851–52*, ed. J. L. Bradley (New Haven, 1955; London, 1956)
Diaries	*The Diaries of John Ruskin*, ed. J. Evans and J. H. Whitehouse, 3 vols. (Oxford, 1956–59)
FL	*The Ruskin Family Letters, 1801–45*, ed. Van Akin Burd, 2 vols. (Ithaca and London, 1973)
Hunt	John Dixon Hunt, *The Wider Sea: A Life of John Ruskin* (London and New York, 1982)
Lutyens 1	Mary Lutyens, *The Ruskins and the Grays* (London, 1972; New York, 1974)
Lutyens 2	Mary Lutyens, *Effie in Venice* (London, 1965). American edition: *Young Mrs. Ruskin in Venice* (New York, 1966)
Lutyens 3	Mary Lutyens, *Millais and the Ruskins* (London, 1967; New York, 1968)
New Approaches	*New Approaches to Ruskin: Thirteen Essays*, ed. R. Hewison (London, Boston, and Henley, 1981)
Norton	*Letters of John Ruskin to Charles Eliot Norton*, ed. Charles Eliot Norton, 2 vols. (Boston and New York, 1904)

Polygon	*The Ruskin Polygon: Essays on the Imagination of John Ruskin*, ed. J. D. Hunt and F. M. Holland (Manchester, 1982)
RD	*Introduction to John Ruskin and Rose La Touche: Her Unpublished Diaries of 1861 and 1867*, ed. Van Akin Burd (Oxford, 1979)
Rosenberg	John D. Rosenberg, *The Darkening Glass: A Portrait of Ruskin's Genius* (New York and London, 1961)
Shapiro	*Ruskin in Italy: Letters to His Parents, 1845*, ed. H. I. Shapiro (Oxford, 1972)
Studies	*Studies in Ruskin: Essays in Honor of Van Akin Burd*, ed. R. Rhodes and D. I. Janik (Athens, Ohio, 1982)
Viljoen	Helen G. Viljoen, *Ruskin's Scottish Heritage: A Prelude* (Urbana, Ill., 1956)
WL	*The Winnington Letters of John Ruskin*, ed. Van Akin Burd (London, and Cambridge, Mass., 1969)

Source information already in the text has not been duplicated. If no listing is given, the quote is from the same source as the previous quote.

One / The Little Phenomenon

Page 3 "I am represented": 35, 21. / 4 "My formed habit": 35, 22. / 4 a second, privately designed work: Present whereabouts unknown. / 5 Ruskin's mother and father: For background on Ruskin's parents, see Viljoen and *FL*. / 6 "There must be brought": Viljoen, 144. / 7 "the half of myself": Ibid., 94. / 8 "We find there [in Britain]": H. von Treitschke, *Historische und politische Aufsätze* (Leipzig, 1967), 318 f. / 9 "Very certainly, had there been": Viljoen, 147. / 13 "We are a King & Queen loving": *FL*, 640. / 13 They lived here for nineteen years: For background on Herne Hill and Denmark Hill, see J. S. Dearden, "Two Ruskin Homes in London" in *Facets of Ruskin* (London and Edinburgh, 1970), 33 ff. / 14 "I am, and my father was": 35, 13. / 15 "These Railroads are": *FL*, 573. / 16 "I

know my utter Selfishness": Ibid., 130. / 16 "I have a sort of a Schoolmaster within": Ibid., 559. / 17 "I was a mere piece": 35, 618. / 18 "the ordinary Victorian Family": J.F.C. Harrison, *Early Victorian Britain: 1832–51* (Harmondsworth, 1979), 25. / 19 "I should have to accuse": *Norton*, Vol. 1, 183–84. / 19 "In all these particulars": 35, 22–23. / 19 "children were much favored": L. Walther, "Invention of Childhood" in *Approaches to Victorian Autobiography*, ed. G. P. Landow (Athens, Ohio, 1979), 67. / 20 "I have not one pleasing": Viljoen, 103. / 20 "My mother's general principles": 35, 20. / 20 "nothing to love": Ibid., 44–46. / 21 "John never spent": *FL*, 116. / 23 "an Idol in a niche": 35, 39. / 24 "Born half-way between": 7, 374–76. / 25 "I took a good deal": Charles Dickens, *The Pickwick Papers*, Vol. 1, Chap. 20. / 25 "It is not the going without": 27, 61. / 26 "that it was at once": 35, 46. / 26 "I never had heard": Ibid., 43. / 27 "He has commenced": *FL*, 185. / 27 "Well Mamma as you think": Ibid., 224–25. / 28 His first poem: 2, 254. / 29 *Harry and Lucy*, as Ruskin himself published it: 35, 52–55. / 31 "That the adaptation of materials": Ibid. 56. / 32 "It low'red upon the earth": 2, 272. / 32 "I determined that": 35, 152. / 33 "In the olden days of travelling": 10, 3. / 34 "To all these conditions": 35, 111. / 34 "Going by railroad": 5, 370. / 37 "entire delight": 35, 166. / 38 "My father liked": Ibid., 110. / 38 "About the moment": Ibid., 153. / 39 "The reader must pardon": Ibid., 158. / 40 Byron had described: See Byron's added note to Preface of *Childe Harold's Pilgrimage* (1812 ff). / 40 "I have been very happy": *Diaries*, Vol. 1, 198. / 40 "I never can enjoy": Ibid., 165. / 40 "I believe the only part": Ibid., 130. / 41 "I was tormented": Ibid. / 41 "There was always more": 5, 380–81. / 41 "such a fine day": Quoted in Hunt, 34. / 42 "A very few years": 35, 115. / 42 "in a completely picturesque object": 6, 15. / 42 "interesting only by the force": Hazlitt, quoted in M. H. Law, *The English Familiar Essay in the Early Nineteenth Century* (Philadelphia, 1934) 132. / 43 "Give me a broken rock": 2, 411. / 43 In his drawings: For background on Ruskin's development as a draftsman, see P. H. Walton, *The Drawings of John Ruskin* (Oxford, 1972; New York, 1985). / 43 "You are in a dream": Law, *English Familiar Essay*, 151. / 44 "proceeded to sketch": 35, 276. / 44 "So completely is this place": *Diaries*, Vol. 1, 118. / 45 "ideal appreciation": 3, 218. / 45 "lower picturesque ideal": 6, 19. / 46 "to me / High mountains": Byron, *Childe Harold's*

Pilgrimage, Canto III, LXXII. / 47 "a soulless image on the eye": Wordsworth, *The Prelude* (1805), Book VI, lines 454–56. / 47 "Characters of the great Apocalypse": Ibid., lines 570–71. / 47 "You stand, as it were": Law, *English Familiar Essay*, 150. / 47 "That burning altar": 2, 237. / 47 "Let us leave the realities": Law, *English Familiar Essay*, 152. / 48 "*July 14th.* MARTIGNY": *Diaries*, Vol. 1, 21. / 49 promised readers that: R. Jameson, *System of Mineralogy* (Edinburgh, 1820), iii. / 49 "I found Saussure": 6, 476. / 49 "I have determined": *Diaries*, Vol. 1, 74. / 50 "They were the first": 35, 178. / 50 "How my parents": Ibid., 179–80. / 51 "I had neither the resolution": Ibid., 183. / 52 "Nature has lost": 2, 466. / 52 "Our child has entered": *FL*, 426. / 53 "You hinted a probability": Byron, letter to John Hanson, Nov. 30, 1805. / 53 "College improves in every thing": Byron, letter to Hargreaves Hanson, Nov. 12, 1805. / 55 "You and my mother": *WL*, 369–70. / 57 "As we can no longer": *FL*, 618. / 58 "I had melancholy thoughts": Wordsworth, *The Prelude* (1805), Book III, lines 75–81. / 59 "The question is a very puzzling one": *FL*, 584. / 59 "The monsters": Ibid., 576. / 61 "Today it suffices": G. Cuvier, *Recherches sur les ossements fossiles de quadrupèdes* (Paris, 1834), Vol. 1, 185. / 63 "I should enter": 35, 185.

Two / The Graduate of Oxford

67 "He painted a charming water-colour": 35, 398. / 68 "What should I be": Ibid., 312. / 69 "Whatever I have asserted": 3, 5. / 71 " 'Soapsuds and whitewash' ": Jack Lindsay, *Turner* (Frogmore, 1973), 253. / 72 "Awful ideas": *FL*, 725. / 72 "This gentleman": 3, xxiv. / 72 "It put me in a rage": Ibid., 666. / 73 "In at Richmond's": *Diaries*, Vol. 1, 245. / 73 "No *picture* of Turner's": 3, 249. / 74 "For many a year": Ibid., 51–52. / 74 "I shall endeavour": Ibid., 138–39. / 75 "For the labour of a critic": 5, 6. / 75 "Ask a connoisseur": 3, 146. / 76 "I should not have spoken": Ibid., xxii. / 76 "The noblest scenes": Ibid., 344–45. / 77 "If we could examine": Ibid., 345–46. / 78 The idea of *plenitudo*: See A. D. Lovejoy, *The Great Chain of Being* (New York, 1960); G. P. Landow, "J. D. Harding and John Ruskin on Nature's Infinite Variety" in *Journal of Aesthetics and Criticism* 27 (1970), 369 ff. / 79 "science of aspects": See P. M. Ball, *The Science of Aspects* (London, 1971). / 79 "For there is a

science of the aspects of things": 5, 387. / 80 "Thus my studies of nature": Goethe, *Hamburger Ausgabe*, Vol. 17, 14. / 80 "I see everything": *Diaries*, Vol. 3, 1128. / 80 "distinction without division": Quoted in M. H. Abrams, *Natural Supernaturalism* (New York, 1971), 279. / 80 "For was it meant": Ibid. / 81 "I will content myself": Wordsworth, *A Guide through the District of the Lakes in the North of England*, Part I. / 83 "a reverie on the indefinite": L. Gowing, *Turner* (New York, 1966), 21. / 83 "evade every attempt": Quoted in A. Wilton, *J.M.W. Turner* (London, 1979), 107. / 83 "Thousands of exquisite effects": 3, 508. / 84 "a surface whose reflective power": Ibid., 499. / 84 " 'a white body floating down' ": Lindsay, *Turner*, 133. / 84 "[May 17th, 1846. 4 P.M.]": *Diaries*, Vol. 1, 337–38; quoted in *Modern Painters*, 3, 501. / 85 "Rippled water": 3, 507. / 86 Like Ruskin, he despised: C. R. Leslie, *Memoirs of the Life of John Constable* (Oxford, 1951), 273. / 86 "The world is wide": Ibid. / 87 "Science deals exclusively": 11, 47–48. / 87 "Go to Nature": 3, 624. / 88 "This imitation": 5, 21. / 88 "It is not within": Harding, *The Principles and Practice of Art* (London, 1845), 17. / 88 "To form a judgment": 3, 387–88. / 91 "Stand upon the peak": Ibid., 415–17. / 93 "Take, for instance": Ibid., 330–31. / 93 "And thus nature is never distinct": Ibid., 329. / 94 "The painter . . . places": Ibid., 133. / 94 "There is, in the first room": Ibid., 277–80. / 99 "Modern thought": Pater, *Appreciations* (London, 1889), 66. / 99 "guide the spectator's mind": 3, 133–34. / 100 "It is a sunset": Ibid., 571–72. For an interpretation of this passage and a commentary on the ensuing discussion, see R. Stein, *The Ritual of Interpretation* (Cambridge, Mass., 1975), 12 ff. / 101 based on the study of types: On typology, see Landow, "J. D. Harding and John Ruskin"; *Victorian Types, Victorian Shadows* (Boston and London, 1980); *W. H. Hunt and Typological Symbolism* (New Haven, 1979); L. Hönnighausen, *Präraffeliten und Fin de Siècle* (Munich, 1971). / 102 "The ruined house": 4, 265. / 102 "I feel now": Quoted in W. G. Collingwood, *The Life and Work of John Ruskin* (London, 1893), Vol. 1, 140. / 102 "the whole body": *Britannia*, Dec. 9, 1843, 778; quoted in 3, xxxvii. / 103 "the light of": Lindsay, *Turner*, 183. / 103 "Aloft all hands": Ibid., 249. / 104 "a mingled mass": Ibid., 250. / 105 "the perfect system": 3, 573. / 105 "its daring conception": Ibid., 572. / 106 "worked entirely on": Ibid., 309. / 108 "The laws of nature": 4, 239. / 108 "But if a painter": 6, 32. / 108 "The

appropriate business of poetry": Quoted in G. P. Landow, *The Aesthetic and Critical Theories of John Ruskin* (Princeton, 1971), 64. / 108 "Science deals exclusively": Quoted in Landow, *Aesthetic and Critical Theories*, 63–64. / 109 "the mediatress": Quoted in Abrams, *Natural Supernaturalism*, 316. / 109 "a man speaking to men": Wordsworth, Preface to the second edition of *Lyrical Ballads* (1800). / 109 "Go to the edge": 3, 537. / 110 "The consequence": Ibid., 320–21. / 112 "The eye must": Lindsay, *Turner*, 150. / 112 "Turner introduced": 3, 322–23. / 114 "The truth is": See 1, 235–45. / 115 "determined the main tenor": 35, 79. / 116 "A balance": Wordsworth, *The Prelude* (1805), Book XII, lines 376–79. / 116 "essentially adapted": Wordsworth, Preface to the second edition of *Lyrical Ballads*. / 116 "despotism of the eye": For this and preceding discussion, see Abrams, *Natural Supernaturalism*, 366 and Chap. 7. / 116 "The most despotic": Wordsworth, *The Prelude* (1805), Book XI, lines 174–76. / 117 "triumph of vision over optics": Abrams, *Natural Supernaturalism*, 377. / 117 "more than delighted": 3, 134. / 117 "Nothing must come between": 11, 49. / 117 Knowing the limitations both of art and of human perception: Cf. P. Junod, *Transparence et opacité* (Lausanne, 1976), Chap. 4. / 118 "Everything that you can see": 15, 27. / 119 The Victorians, when reviewing their lives: On conversion episodes, see J. H. Buckley, *The Triumph of Time* (Cambridge, 1966), 146 ff; *The Victorian Temper* (Cambridge, 1951), Chap. 5. / 120 "all that the young heart": Carlyle, *Sartor Resartus*, Book II, Chap. 7. / 121 "among some young trees": 35, 313–15. So much secondary literature has been written on the subject of Ruskin's conversion episode that it is hard to keep track of it all. Among the more important contributions: Van Akin Burd, "Another Light on the Writing of *Modern Painters*" in *PMLA* 68 (1953), 755 ff (which challenges the authenticity of the event, although the argument cannot be explained in detail here); R. Hewison, *The Argument of the Eye* (London, 1976), 41 f; A. Stokes, *Critical Writings*, ed. L. Gowing (London, 1978), Vol. 3, 173; G. P. Landow, "Ruskin, Holman Hunt, and Going to Nature to See for Oneself" in *Studies*, 68 ff. / 122 "I recollect distinctly": Quoted in C. Salvesen, *The Landscape of Memory: A Study of Wordsworth's Poetry* (London, 1970), 46. / 122 "spots of time": Quoted in Buckley, *Triumph*, 146. / 123 "Our destiny": Wordsworth, *The Prelude* (1805), Book VI, lines 538–39. / 124 "the moment's monument": Buckley, *Triumph*, 148.

/ 124 "wise passiveness": Salvesen, *Landscape of Memory*, 75. / 124
"I had virtually lost": 35, 311. / 124 "my little aspen": Ibid., 315.
/ 124 "a bit of ivy": Ibid., 311. / 125 "I wandered on the right
bank": Goethe, *Poetry and Truth from My Life* (London, 1932), Book
XIII, 490–91. / 126 "self-education through realism": See Landow,
"Going to Nature," 70. / 126 group of works: Compare Walton,
The Drawings of John Ruskin, Chap. 3. / 128 "vital beauty": 4,
146 ff. / 128 "from thyself it is": Wordsworth, *The Prelude* (1805),
Book XI, lines 333–34.

Three / A Mad Man or a Wise

133 "I found first": Bradley, 171–72. / 135 "So Lauderdale has been
telling": Byron, letter to J. C. Hobhouse and D. Kinnaird, Jan. 19,
1819. / 137 To date, five books have been written: For background
on Ruskin's marriage and its consequences, see W. James, *The Order
of Release* (London, 1947; Philadelphia, 1973); J. H. Whitehouse,
Vindication of Ruskin (London, 1950; Philadelphia, 1974); Lutyens 1,
2, and 3; F. Townsend, "The Courtship of John Ruskin" in *Studies*,
1 ff. / 138 the most popular of all John Ruskin's works: For back-
ground, see J. S. Dearden, "The King of the Golden River" in
Studies, 32 ff. / 139 "I find work good": Lutyens 3, 2–3. / 140 "I
married her": Whitehouse, *Vindication*, 15. / 141 "My own passion":
Lutyens 2, 20. / 141 The fear of the wedding night: See S. Marcus,
*The Other Victorians: A Study of Sexuality and Pornography in Mid-
Nineteenth Century England* (New York, 1966), 31. / 141 "But you
know, *now*": James, *Order of Release*, 67–68. / 143 "I shall never
devote myself": *RD*, 44. / 143 Take the case of his revered friend:
Carlyle's biographer, J. A. Froude, told Ruskin about the Carlyles'
marriage many years later. See *The Froude–Ruskin Friendship*, ed.
H. G. Viljoen (New York, 1966), 67. / 144 "is not a subject":
Whitehouse, *Vindication*, 54. / 144 "There was no fault": Ibid., 53.
/ 144 "Effie, when she left Ruskin": Lutyens 2, 4. / 145 "I am one
of those": J. Clegg, *Ruskin and Venice* (London, 1981), 81–82. / 148
"It is a woeful thing": Shapiro, 52. / 148 "I do believe": Ibid., 61–
62. / 148 "I am perpetually torn": Ibid., 71. / 150 "His sketches
are always": 3, 200–1. / 150 "He is cultivating": 8, xxiii. / 151 "I
have been developing": Shapiro, 128. / 152 "There are two Italies":

Shelley, letter to Leigh Hunt, Dec. 20[?], 1818. / 152 "I perceive":
Clegg, *Ruskin and Venice*, 54. / 153 "The path lies o'er": S. Rogers,
"Venice," from *Italy: A Poem* (1823). / 153 "Another turn": 9, 415.
/ 154 "And although the last few eventful years": 10, 7. / 154 "The
Venice of modern fiction": Ibid., 8. / 154 "The impotent feelings":
Ibid., 7–8. / 155 "The history of all men": 19, liv. / 155 "Although
you may for a moment": Robert Blake, *Disraeli* (London, 1966),
288. / 156 "Thank God I am here": *Diaries*, Vol. 1, 183. / 156 "I
had no conception": Shelley, letter to Thomas Love Peacock, Oct.
8, 1818. / 157 "Of all the fearful changes": Shapiro, 199. / 157 "The
rate at which": 36, 63. / 158 "Imagine the new style": Shapiro, 199.
/ 158 "You cannot imagine": Ibid., 209. / 158 "Venice is lost to
me": Ibid., 201. / 158 "Well, among all": Ibid., 225. / 158 "There
is now *no* pleasure": Ibid., 200. / 160 "He did something": Lutyens
2, 133. / 161 "Mr. Ruskin is busy all day": Raleigh Trevelyan, *A
Pre-Raphaelite Circle* (London, 1978), 49. / 161 "stone by stone":
10, xxvi. / 162 "John excites": Lutyens 2, 146. / 162 "six hundred
quarto pages": 35, 483. / 164 "One only feels": 9, xxvii–xxviii. /
165 Thomas Carlyle may have been: See Carlyle, *Past and Present*.
/ 167 "my grammar": 8, 95. / 169 "As far as my inquiries": 9, 5–
6. / 171 "Zoologists often disagree": Ibid., 4–5. / 172 "the most
beautiful simple curve": Ibid., 267. / 173 "For neither in tailoring":
Carlyle, *Sartor Resartus*, Book I, Chap. 5. / 175 "I ask the reader":
9, 66. / 175 Some Ruskin scholars: For background on nineteenth-
century architectural theory, and on Ruskin's theories, see P. Frankl,
The Gothic (Princeton, 1960), 506 ff; K. O. Garrigan, *Ruskin on
Architecture* (Madison, 1973), 59 ff; J. Unrau, *Looking at Architecture
with Ruskin* (London and Toronto, 1978), 13 ff. / 176 "It is the
history": 9, 22–23. / 177 "It is with peculiar grace": 12, 186. / 178
"Now I think that": *Diaries*, Vol. 2, 370–71. / 179 "great root and
primal type": 9, 93. / 179 "But the essential part": Ibid., 97. / 180
"the natural channels": Ibid., 359. / 181 "an innumerable variety":
Ibid., 360. / 181 appendix to *Stones*: Ibid., 471 f. / 182 "I do not
know": Ibid. 439–40. / 182 "I never saw": 10, 91–92. / 183 "stitched
into a new creed": 9, 437. / 183 "a precious film": Quoted in
K. O. Garrigan, "Visions and Verities: Ruskin on Venetian Archi-
tecture," *Studies*, 153 ff. / 184 "it was a wise feeling": 8, 161. / 184
"Next we have to consider": 9, 292. / 184 "It was not till": Ibid.,
292–93. / 184 "The spectator": Ibid., 298. / 184 "The eye": 10,

154. / 185 "anxious and questioning" look: 9, 297. / 185 "The right point of realization": 11, 214. / 186 "I believe the right question": 8, 218. / 186 "Things . . . are noble": Ibid., 190. / 187 "afford a very useful test": R. Willis, *Architectural History of Some English Cathedrals* (1846; Chicheley, 1972), Vol. 1, 60. / 187 "But it is all as dead": 8, 218. / 187 the "mediæval system": 9, 291. / 188 "Denmark Hill": *Diaries*, Vol. 2, 468. / 189 "Wherever the workman": 10, 204. / 189 "And observe": Ibid., 192, 194. / 190 "vocation is to work": On the "gospel of work," compare W. E. Houghton, *The Victorian Frame of Mind 1830–1870* (New Haven, 1957), 242 ff. / 191 "It may be proved": 12, 341. / 191 "art which proceeds": 9, 456. / 191 "the bright, strange play": 12, 173. / 192 "extremely ugly" or "rather trivial": 10, 97, and J. Burckhardt, *Der Cicerone* (Stuttgart, 1964), 112. / 192 a lengthy catalogue: 10, 184 ff. / 192 "not only the best": Ibid., 212. / 193 "the central building": 9, 38. / 193 "The world could no longer": 11, 14–15. / 193 "There was never": Ibid., 78. / 194 harshly but justifiably dismissed: See John Unrau, "Ruskin, the Workman and the Savageness of Gothic" in *New Approaches*, 33 ff. / 196 "too finely woven": 12, 181. / 196 Moreover, Ruskin also practiced: E. K. Helsinger, "History as Criticism: *The Stones of Venice*" in *Studies*, 173 ff. / 196 "as Venice without": 11, 230. / 196 "I shall endeavour": 9, 73. / 197 "I had always": Ibid., 56. / 197 Eventually he succeeded: See J. M. Crook, "Ruskinian Gothic" in *Polygon*, 65 ff. / 198 "one of the very few": Quoted in Rosenberg, 101. / 199 "I believe I shall": Bradley, 177. / 199 "small minute grave": Quoted in R. Hewison, "Notes on the Construction of *The Stones of Venice*" in *Studies*, 143. / 199 "Eloquent passages": Ibid., 142. / 199 "You know I promised": Bradley, 185. / 200 "You can only be an author": Hewison, "Notes on the Construction of *The Stones of Venice*," 142. / 200 "Greatness of mind": 3, 491. / 200 "In the choir": 9, 49–52. / 202 "moment of illumination": Abrams, *Natural Supernaturalism*, 377. / 203 "The point I have here": 9, 54–55.

Four / The Luther of the Arts

205 Title: A phrase used by Pre-Raphaelite artist Edward Burne-Jones about his energetic reformer friend (13, xxi). / 207 One author has called it: Raleigh Trevelyan, *A Pre-Raphaelite Circle* (London, 1978), 83. / 209 "miserably damped": Lutyens 3, 75. / 209–11 "There are no natural objects": 6, 368. / 211 "I can no more write": 35, 304. / 211 "Pre-Raphaelitism": 12, 157–58. / 212 "a fact sufficiently curious": 35, 22. / 212 "Returning to the place": Lutyens 3, 216. / 212 "My Father and mother": Ibid., 247. / 213 "And we find": 5, 317. / 213 "Our ingenuity": Ibid., 319. / 213 "Never paint anything but": Ibid. 319–20. / 214 "Whereas a mediæval": Ibid., 321. / 215 "But worst of all": F. T. Vischer, *Ästhetik oder Wissenschaft des Schönen* (Munich, 1922), Vol. 2, 351. / 215 "The tailcoat, it seems": Baudelaire, *Oeuvres*, Edition de la Pléiade, ed. Le Dantec (Paris, 1931–32), Vol. 2, 134. / 216 "It is not so much": 12, 160. / 216 "Accordingly, though still forced": 5, 324–25. / 216 "by expressing": Ibid., 328. / 217 "I think the picture": Lutyens 3, 77. / 217 "The figure's": Ibid., 247. / 217 "Our love of nature": 5, 354, 366. / 218 "The elements of progress": Ibid., 327. / 218 "Thus the individual": Vischer, *Ästhetik*, 348. / 219 "The painter": 12, 348. / 219 "The fact is": 16, 187. / 219 "Art is a Crime": 36, 313. / 220 "lay in our England": 12, 327. / 220 "the finest thing": Lutyens 3, 75. / 220 "one of the remarkable pictures": Ibid., 246. / 220 "Amongst all the painters": 5, xliv. / 221 "I do not mean": Lutyens 3, 85. / 222 "You don't like lecturing": 16, xxi. / 223 "If you want steam": S. MacDonald, *The History and Philosophy of Art Education* (London, 1970), 157. / 223 drawing instruction: Wolfgang Kemp, *Zeichnen und Zeichenunterricht der Laien 1500–1870* (Frankfurt, 1979), 215 f, 207 ff. / 225 "As matters stand": 16, 335–36. / 226 "Last week, I drove": Ibid., 336–38. / 227 "The changes in the state": Ibid., 337, 340–41. / 228 "We have much studied": 10, 196. / 228 "Beautiful art": 16, 338. / 229 "systematic sanitary reform": E. J. Hobsbawm, *Industry and Empire* (Harmondsworth, 1969), 158. / 230 "Now, my own belief": 16, 90. / 231 "England is aghast": Emerson, *English Traits*, Chap. 10 ("Wealth"). / 231 "Ale and porter": J.F.C. Harrison, *Early Victorian Britain*, 93. / 232 "We require work": 16, 343. / 232 "We must learn first": 20, 29. / 232 "wholesome evanescence": 16, 40. / 233 "How are we enough": 3, 249. / 234 What

effort: For background on the new Parliament buildings, see D. Robertson, *Sir Charles Eastlake and the Victorian Art World* (Princeton, 1978), 324 ff. / 234 The same fate befell: On the Union Hall project, see P. Henderson, *William Morris* (Harmondsworth, 1967), 63 ff. / 234 "service of annihilation": 16, 39. / 234 "you may still handle": Ibid., 43–44. / 235 "Here in England": Ibid., 75. / 235 "the wise management": Ibid., 19. / 236 When he and several companions: On the university museum, see Crook, "Ruskinian Gothic." / 237 In *Past and Present*: See paraphrase of Carlyle's ideas in W. E. Houghton, *The Victorian Frame of Mind*, 319. / 237 "And you must remember": 16, 343–45. / 238 "paternal government": Ibid., 26. / 239 "determined demand": 10, 196–97. / 239 "Thus production not only": Marx, *Texte zu Methode und Praxis* (Reinbek, 1967), Vol. 3, 17. / 240 "Whenever we spend": 16, 48–49. / 241 Thorstein Veblen among them: See R. S. McLean, "Altruistic Ideals versus Leisure Class Values" in *Journal of Aesthetics and Art Criticism* 31 (1973), 347 ff. / 241 There were few workers' organizations: On the 1850s, see D. Thomson, *England in the Nineteenth Century* (Harmondsworth, 1950), 43; A. Briggs, *Victorian People* (Harmondsworth, 1965), 10 ff; E. J. Hobsbawm, *Industry and Empire*, 112. / 242 "If a man": 16, 123–24. / 243 "invention of new wants": Ibid., 48, 123–25. / 244 "A time will come": Ibid., 103. / 244 "false assumptions": Anonymous criticism by Lady Eastlake, *Quarterly Review*, 1856; quoted in Trevelyan, *Pre-Raphaelite Circle*, 121. / 244 the "condition of mind": 7, 452. / 245 "Full of far deeper": Ibid., 441. / 245 "There seemed": 13, 159. / 246 "It had been a glorious [day]": *Diaries*, Vol. 2, 406–7. / 247 "We could not": 6, 240. / 247 "It is therefore": Ibid., 179. / 248 "I call these the governing": Ibid., 231–33. / 249 "In an old house roof": 15, 96. / 249 "Try always": Ibid., 91. / 249 "the same laws": 35, 315. / 250 "Thus, intensity of life": 7, 205, 207. / 250 "Divine in their nature": 4, 210. / 250 "bound to produce a form": 6, 240. / 253 "That turbid foaming": Ibid., 125–26. / 253 "that no good or lovely thing": Ibid., 416. / 253 "But I would that": Ibid., 454. / 254 "I could say much": Ibid., 455–57. / 255 "No changing of place": 5, 380–81. / 256 "The light-out-speeding telegraph": Emerson, "The World-Soul." / 257 "dark, distorted, broken": 7, 260. / 257 "Through the glass, darkly": Ibid., 262. / 258 While Ruskin was composing: On John Henslaw, see Richard Mabey, *The Common Ground* (London, 1981), 40. / 258

"The greatest thing": 5, 333. / 260 "disembodied spirits": Ibid., 367. / 260 "the highest mental powers": Ibid., 361. / 260 as a prophet: On Turner as prophet, see D. Sonstroem, "Prophet and Peripatetic in *Modern Painters* III and IV" in *Studies*, 85 ff. / 260 "mighty unconsciousness": 6, 276–77. / 260 "All these changes": Ibid., 38. / 260 "the terrible and sad truths": Ibid., 297. / 261 "Looking back": 7, 441. / 261 another conversion episode: See Ruskin, *Letters from the Continent, 1858*, ed. J. Hayman (Toronto, Buffalo, and London, 1982), xxi f. / 261 "no sudden conversion": 35, 495–96. / 262 "My sketches": *Letters from the Continent*, 107. / 262 "made faces beautiful": 7, xli. / 263 "Perish Apollo": Ibid., 412. For Ruskin's interpretation of these paintings, see M. Simpson, "The Dream of the Dragon: Ruskin's Serpent Imagery" in *Polygon*, 21 ff. / 263 "Alas, for Turner": 7, 420–22. / 264 "A sad-coloured work": Ibid., 407–8. / 264 "I say *you* will find": Ibid., 422–23. / 265 "I write in the blind-dark": Quoted in Collingwood, *John Ruskin*, Vol. 1, 202. / 265 "You must be all mine": 11, 213. / 265 "Kindreds of the earth": 7, 458–60.

Five / Savage Ruskin

267 Title: The phrase appeared in a poem published in *Punch* on May 24, 1856. / 270 the "Chelsea Menagerie": For background, see William Gaunt, *The Aesthetic Adventure* (London, 1945); B. and J. Dobbs, *Dante Gabriel Rossetti* (London, 1977), 133 ff. / 271 "A Dandy is": Carlyle, *Sartor Resartus*, Book III, Chap. 10. / 271 "I am by nature": 36, 239. / 272 "Dandiacal Sect": Carlyle, *Sartor Resartus*, Book III, Chap. 10. / 272 "I have perfect leisure": 36, 239. / 273 "cause of such a visible": Ibid., 491. Concerning the photo, see also Van Akin Burd, "Ruskin, Rossetti and William Bell Scott: A Second Arrangement" in *Philological Quarterly* 48 (1969), 102 ff. / 273 "write a great essay": Bradley, 177. / 274 "the only book": 18, 103. / 274 "too deeply tainted": 17, xxviii. / 274 "utter imbecility": Ibid. And quoted from *Unto This Last*, ed. P. M. Yarker (London and Glasgow, 1970), 10, 12 et al. / 274 "To English feelings": Quoted in Quentin Bell, *Ruskin* (London and Edinburgh, 1963; New York, 1978), 64. / 275 "as offensive and objectionable": Quoted in Gaunt, *Aesthetic Adventure*, 46. / 275 "the glory of": Quoted in P. Hen-

derson, *Swinburne* (London, 1974), 118. / 275 "crammed with pieces": Ibid., 119. / 275 "Here is a full-grown man": Quoted in Dobbs, *Rossetti*, 181. / 276 "The little reptile's hide": Henderson, *Swinburne*, 173. / 276 "I do not allow": 17, l. / 277 "But I can only at present": 18, 450–51. / 278 "My good Yorkshire friends": Ibid., 433. / 278 "now pretty nearly": *RD*, 60. / 278 "the whole tone": Ibid. / 279 "One would have thought": 7, xl. / 279 "about all the Universe": 36, 414. / 280 "The two terrific mistakes": Ibid., 461. / 281 "the one only thing": Ibid., 415. / 281 "And yet, so long as": Ibid., 460. / 282 "His son, whom": 17, lxxvii. / 282 "a father who": 36, 471. / 282 "sharp sudden sorrow": Ibid., 472. / 283 "My real griefs": Quoted in Trevelyan, *Pre-Raphaelite Circle*, 101. / 283 "I shall never devote": *RD*, 44. / 283 "I never think anybody": 36, 473. / 283 "A little child": *RD*, 42. / 285 "Now you must always": 19, 315. / 285 The La Touches: On Marie and John La Touche, see *RD*, 26 ff. / 286 "I have said that": Ibid., 158–59. / 287 "Child-nature": Ibid., 164. / 288 progressive girls' boarding school: On the Winnington School, see *WL.* / 288 "I shan't see her": Ibid., 312. / 288 "If only Ruskin": Bell, *Ruskin*, 83. / 289 "mightily vexed": *RD*, 83. / 289 "Heart & desires": Ibid., 87. / 289 "One must remember": Ibid., 163. / 289–90 "The letters Mr. Ruskin wrote": Ibid., 164. / 290 "She's Cordelia": Ibid., 110. / 290 "Only it was not really walking": Ibid. 168. / 290 "a terribly Irish-Irish girl": Ibid., 95. / 290 "She is perfectly wild": Ibid., 93. / 290 "Happiest times": 35, 561. / 291 "I am forbidden": *RD*, 114. / 291 The scene of the tragedy: For background on Effie's interventions, see ibid., 20 f, 112 ff, 122 f. / 291 "He is quite unnatural": Mary Lutyens, "The Millais-La Touche Correspondence" in *Cornhill* 1051 (1967), 1 ff. / 292 "all is over": *RD*, 115. / 292 "Have I not often told you": John Ruskin, *Letters to Lord and Lady Mount-Temple*, ed. J. L. Bradley (Columbus, Ohio, 1964), 167. / 292 "immediate life": 19, 229. / 293 "No decent, calculable": 7, 387. / 293 "Some year or two back": 18, 26–27. / 295 "Your converted children": Ibid., 74. / 295 "the accursed sect": Ruskin, *Letters to Lord and Lady Mount-Temple*, 310. / 295 "A park with no apparent": *RD*, 59. / 296 "There *is* one dangerous science": 18, 127–28. / 297 "more of the evil": *RD*, 122–23. / 297 "And truly, it seems": 19, 365. / 297 "? Poor green lizards": *RD*, 118. / 298 "a lacertine breed": 19, 365. / 300 "the major Romantic myth-maker": Harold Bloom, quoted in R. E.

Fitch, *The Poison Sky: Myth and Apocalypse in Ruskin* (Athens, Ohio, and London, 1982), 1. See J. Kissane, "Victorian Mythology," in *Victorian Studies* 6 (1962–63), 5 ff; J. Hayman, "Ruskin's *The Queen of the Air* and the Appeal of Mythology" in *Philological Quarterly* 57 (1978), 104 ff; J. Burnstein, "Victorian Mythology" in *Victorian Studies* 18 (1974–75), 309 ff. On Ruskin's snake symbolism, see Simpson, "The Dream of the Dragon." / 300 "The first of requirements": 19, 310. / 301 "I am compelled": Ibid., 307. / 301 "curious reversal": Ibid., 317. / 302 "And, indeed, all guidance": Ibid., 361. / 302 "That rivulet of smooth silver": Ibid., 362–63. / 303 "divine hieroglyph": Ibid., 363. / 304 "The Greeks": Ibid., 418. / 304 "I took too much wine": *Diaries*, Vol. 2, 644. / 305 "mental evil": Ibid., 685. / 305 "no disgusting or serpent dreams": Ibid., 661. / 306 "Such indulgence is *fatal*": Quoted in S. Marcus, *The Other Victorians: A Study of Sexuality and Pornography in Mid-Nineteenth Century England* (New York, 1966), 18, 21. See also R. Pearsall, *The Worm in the Bud: The World of Victorian Sexuality* (1969), 418. / 307 "One of the finest things": 36, 291. Compare Pearsall, *Worm in the Bud*, 146. / 308 "The serpents would not bite you": 18, 214. / 308 "half-maiden, half-serpent": 7, 399. / 308 "Got restless": *Diaries*, Vol. 2, 685. / 308 "the strife of purity": 7, 420. / 309 "Basilisk or not": Ruskin, *Letters to Lord and Lady Mount-Temple*, 332. / 309 "the rose tribe": 19, 370. / 309 "Symbolism, although very interesting": 1, 501. / 309 "For all the greatest myths": 19, 309. / 310 "You have to discern": Ibid., 300. / 311 "So you have": Ibid., 314. / 311 "everlasting calm": Ibid., 418. / 311 "wild writhing": Ibid., 414. / 314 "And first of possession": Ibid., 86. / 314 "that possession or 'having'": Ibid., 87. / 314 "the highest truths": 17, 208. / 316 "I am forced": 36, 238. / 317 "The loneliness is very great": *Norton*, Vol. 1, 139. / 317 "I am still very unwell": Collingwood, *John Ruskin*, Vol. 2, 192. / 317 "THERE IS NO WEALTH BUT LIFE": 17, 105. / 318 "Our cities": 18, 502. / 318 "*Valor*, from *valere*": 17, 84. / 319 "In fact, it may be discovered": Ibid., 55–56. / 320 "And a nation's labour": 16, 18. / 320 "Luxury is indeed possible": 17, 114. / 320 "Think what you will": Ibid., 85. / 321 "But in order that": Ibid., 154. / 321 "Wealth, therefore": Ibid., 88. / 322 "It is, therefore, the manner": Ibid., 104. / 323 "Ruskin's relation of value": J. Sherburne, *John Ruskin or the Ambiguities of Abundance* (Cambridge, 1972), 129.

/ 324 "the art of establishing": 17, 46. / 325 "I discovered": Rosenberg, 132.

Six / The Professor

329 "You're always too strong": *Norton*, Vol. 2, 54. / 329 "I wonder such a genius": *The Letters of Charles Eliot Norton*, ed. S. Norton and M. A. DeWolf Howe (Boston, 1913), Vol. 1, 507. / 329 "was serious enough": Ibid., 513. / 330 "I have never known": Ibid., 291–92. / 330 "Never was a soul": 27, xxv–xxvi. / 330 "Your influence": *Letters of Charles Eliot Norton*, Vol. 2, 46. / 330 "I am like": Ibid., 16. / 331 "My time is passed": 23, xli. / 331 "This enables": Ibid., li. / 332 "*August 6th* [1874]": *Diaries*, Vol. 3, 803. / 332 "While I am looking": 27, xxvi. / 333 "All that is good": *Norton*, Vol. 2, 73. / 333 But now his own drawing: See Walton, *The Drawings of John Ruskin*, 98 ff. / 336 "within an ace": 37, 34. / 337 "With all my grumbling": 20, xxxii–xxxiii. / 338 "Whatever happens now": Ibid., xxi. / 338 "I really think": Ibid., xlviii. / 338 innumerable plans for reform: On university reform, see B. Simon, *Studies in the History of Education, 1780–1870* (London, 1960). / 338 "a step towards": J. Gattegno, *Lewis Carroll* (New York, 1976), 167. / 339 "There is no modern error": 20, xx–xxi. / 340 "About Turner": 36, 461. / 340 "Picture-galleries should be": Kingsley, *His Letters and Memories of His Life* (London, 1877), Vol. 1, 168. / 341 "When Byron passed away": Quoted in R. Park, *Hazlitt and the Spirit of the Age* (Oxford, 1971), 210–11. / 342 "Prejudice apart": Bentham, *Works*, ed. J. Bowring (Edinburgh, 1838 ff), Vol. 2, 253 f. / 342 "How can Ruskin": *Norton*, Vol. 1, 442–43. / 343 the lillies of the "new aesthetics": On the new aesthetics, see W. Gaunt, *Aesthetic Adventure*; G. Hough, *The Last Romantics* (London, 1949), and Hough's monographs on Swinburne, Pater, Whistler, Arnold, etc. / 343–44 "giving our consciousness": Arnold, *Culture and Anarchy*, Chap. 5. / 344 "And the culture": Ibid., Preface. / 344 "What we want": Ibid., Chap. 5. / 344 "The particular 'anarchy' ": Basil Willey, *Nineteenth-Century Studies* (Harmondsworth, 1973), 264. / 344 "hardness and vulgarity": Arnold, *Culture and Anarchy*, Chap. 1. / 345 "I would give": Gaunt, *Aesthetic Adventure*, 58. / 346 "We

have an interval": Pater, *The Renaissance: Studies in Art and Poetry*, "Conclusion." / 348 "And the best skill": 20, 39–40. / 348 "The definition of art": Ibid., 165. / 348 "substitute mechanism for skill": Ibid., 96. / 348 "have no conception": Ibid., 97. / 349 "that you may know": Ibid., 178. / 349 "Those of you who": Ibid., 98. / 349 "must never exist alone": Ibid., 96. / 349 "steady habit": 22, 153. / 349 "ALL GREAT ART IS PRAISE": 15, 351–54. / 350 "And remember": 20, 107. / 351 "The England who is to be": Ibid., 43. / 351 "to the laws which": Ibid., 39. / 351 "The study of the fine arts": Ibid., 114. / 352 "unemployed poor": Ibid., 40. / 352 "The art of any country": Ibid., 39. / 352 "Now, all the arts": Ibid., 108. / 352 "It is not possible": Ibid., 113. / 353 "Life without industry": Ibid., 93. / 353 "Stay in that triumph": Ibid., 114. / 353 One critic has said: Rosenberg, 177. / 354 "To burn always": Pater, *The Renaissance*, "Conclusion." / 355 "It is precisely": 15, 353–54. / 355 "The interest of a landscape": 22, 14. / 356 "Landscape painting": Ibid., 12. / 356 "*Modern Painters* itself": Ibid., 511. / 356 Nowadays, there is a fashion: On the other side of the Oxford lectures, see J. Hayman, "Towards the Labyrinth: Ruskin's Lectures as Slade Professor of Art" and D. Birch, "Ruskin and the Science of *Proserpina*" in *New Approaches*, 111 ff, 142 ff. / 356 "As for the undergraduates": 21, xxvii. / 356 "to be excited": Collingwood, *John Ruskin*, Vol. 2, 149. / 357 "I am resolved": Quoted in Hayman, "Towards the Labyrinth," 112. / 357 his Hinksey road project: See 20, xxxix, and T. Hilton, "Road Digging and Aestheticism: Oxford, 1875" in *Studio International* 188 (1974), 226 ff. / 358 "The Oxford Road failed": Quoted in Bell, *Ruskin*, 74. / 358 Wilde did not impede: Wilde's own account; see his *Works*, ed. R. Ross (London, 1908 ff), Vol. 15, 306 ff. / 358 "probably the worst": Quoted in Bell, *Ruskin*, 74. / 359 "Let me tell you": 33, 349. / 359 "When the straight new roads": C. Barman, *Early British Railways* (Harmondsworth, 1950), 25. / 360 "In the first place": 20, xli–xlii. / 361 his major painting *Work*: On Brown's painting, see A. Boime, "Ford Maddox Brown, Thomas Carlyle and Karl Marx" in *Arts Magazine* 56 (1981), 116 ff. / 361 "Two men I honour": Carlyle, *Sartor Resartus*, Book III, Chap. 4. / 362 "She was a *very* nice": 28, 14. / 364 an imprint familiar: On George Allen, see Brian Maidment, "Interpreting Ruskin 1870–1914" in *Polygon*, 159 ff. / 364 "There certainly *is*": 22, xxi–xxii. / 365 "To all of us": 36, xxiii. / 365 "Here is the half-

decade": 28, 485. / 366 "There is no other book": 27, xxiii. / 366 He supplied three alternative translations: Ibid., 27–29. / 366 "By the adoption of": 29, 315. / 367 "how true-love": Ibid., 445. / 367 "If I took off": 28, 513. / 367 "Does it never occur to me": Ibid., 206. / 367 "daily maddening rage": *Norton*, Vol. 2, 78. / 367 "You Fools Everywhere": 27, 86, 80. / 368 " 'Amazed,' I say": 28, 613–15. / 369 *Fors Clavigera* is": 37, 48. / 370 "on condition that": 27, 38. / 370 "have taught the peasants": Ibid., 41. / 370 "Nearly every problem": Ibid., 184. / 370 "For, indeed, I am": Ibid., 116. / 370 "I am, and my father was": Ibid., 167. / 371 "cheerfully . . . bears": Kraus, *Die Fackel* 1 (1899), 1. / 371 "That every man": 27, 180. / 371 "That land should be": Ibid., 191. / 371 the Guild of St. George: See M. E. Spence, "The Guild of Saint George" in *Bulletin of the John Rylands Library* 40 (1957), 147 ff. / 371 "We will try": 27, 96. / 373 "the woman I hoped": 28, 246. / 373 "Being in a dream state": 29, 374. / 373 "I rather enjoy": Ibid., 74. / 373 "It is necessary": 27, 167. / 373 "I also think it right": 17, 412. / 374 "My Friends": 27, 334. / 374 "I can't write": Ibid., 328. / 378 the boy fig seller: Ruskin returns to the subject again in *Fors*, Letter 74 (29, 33), to draw a connection between the boy and the Doge's Palace. / 378 "To Carpaccio": 24, 362. / 379 "So dreams the princess": 27, 344–45. / 380 the antitype of the painting of St. Ursula: There is a remarkable parallel to Ruskin's tableau in the train going from Venice to Verona. Augustus Egg's painting *The Traveling Companions* (1862), in the City Museum and Art Gallery in Birmingham, shows two wealthy young Englishwomen in a train compartment, one reading, the other sleeping, with the landscape of Mentone seen through the window; here, too, there are oranges for refreshment. A letter from Ruskin to Norton, written right after the train ride, shows that Ruskin's description was not just a literary transcription of Egg's painting. See 36, 577–78. / 382 "instinctive desires": 29, 54. / 383 "transgression against": *RD*, 125. / 383 "utterly & completely": Ibid., 124. / 383 "I am not a saint": Ibid., 125. / 383 "fear mixed with the enchantment": Quoted in Hunt, 346. / 384 "let her alone": Ibid., 352. / 384 "much of my past life": Ibid., 353. / 384 "A wreath of wild roses": Ibid., 354. / 384 "White,—yes": 25, 301. / 385 a third peak experience: On Ruskin's copying of the Carpaccio, see R. Hewison, *Ruskin and Venice* (London, 1978), 92 f. / 385 "There she lies": Quoted in Hunt, 365. / 386 "I might have known": 28,

761. / 386 "*know* the truths": Ibid., 732. / 386 "lesson . . . for the creatures": Ibid., 746. / 386 "I had never seen": *Diaries*, Vol. 3, 924. / 387 "For this green tide": 28, 757. / 387 "The last (probable) additions": Ibid., 760. / 387 "What is this song": Pater, *The Renaissance*, Preface. / 388 "From St. Ursula": *RD*, 137. / 388 "went on gradually": Ibid., 138. / 388 "I wondered": Ibid., 139. / 389 "helpful Spirit": Ibid., 140. / 389 "pictures I could not copy": 28, 203. / 390 "Dreamer of dreams": "The Earthly Paradise," Apology. / 390 "a dangerous plaything": 1, 501. / 390 "whether the peculiar habit": 38, 173. / 390 "living happier": *BD*, 46. / 390 "*Mere* overwork": 37, 252. / 390 "any vicious book": J. Clegg, *Ruskin and Venice*, 153. / 391 "more distinctly Christian tone": 29, 86. / 391 "which I only can hope": 24, 367.

Seven / The Only Real Seer

395 "I had left him": 33, xlvii. / 396 "The fact is": A. M. W. Stirling, *The Richmond Papers* (London, 1926), 293–94. / 397 "February,— to April": *BD*, 102. / 398 "giving me no end": Ibid., 91. / 398 "ST VALENTINE": Ibid. / 399 "February 15": Ibid., 91–92. / 399 "of spiritualizing": 24, 363. / 400 "February 17": *BD*, 92–93. / 401 "a steady try": 37, 355. / 401 "Dear George": Quoted in Joan Abse, *John Ruskin: The Passionate Moralist* (London and Melbourne, 1980; New York, 1981), 284. / 402 "I must put it": *BD*, 97. / 403 "Putting it into": Ibid., 94. / 403 "Delphi first": Ibid., 100. / 404 "I had an interesting": *Norton*, Vol. 2, 219. / 405 "The two fits": Ibid., 167. / 405 "define the limits": Quoted in Rosenberg, 179. / 405 "I am content": *Norton*, Vol. 2, 158. / 405 "I went wild": Ibid., 167. / 406 "The fact is": 37, 355. / 406 "*Mere* overwork": Ibid., 252. / 406 "My books always open": *BD*, 77. / 408 "How many wiser folk": *Norton*, Vol. 2, 216. / 408 "perception in all nature": Ibid., 190. / 408 "The illness which": 24, 412. / 409 "Britain fell behind": Hobsbawm, *Industry and Empire*, 178. / 409 "Where the conditions": Buckley, *Triumph*, 55. / 411 "The reactions of": 34, 268–70. According to Cook and Wedderburn, the term "fimetic" is "a coinage of Ruskin's; from the obsolete 'fime,' or dung" (27, 630). / 412 "I have seen": 25, 160; quoted in Gaunt, *Aesthetic Adventure*, 94. / 414 "The 1870s and 1880s": Hobsbawm, *Industry and Empire*, 198. / 414

"the whole Universe": Ruskin quoting Balfour Stewart (34, 76). Compare Buckley, *Triumph*, 67. Ruskin's attitude to Thomson and Stewart's theory was ambivalent. On the one hand, he regarded their apocalyptic predictions as well founded; on the other, he was repelled by their purely scientific reasoning, which omitted the idea of the Creation and thus ruled out the possibility of reading nature's phenomena as messages or warnings. / 415 "crowning race": Epilogue to Tennyson's *In Memoriam*; quoted in Houghton, *Victorian Frame of Mind*, 36. / 415 "O we poor orphans": Tennyson, "Despair" (1881). / 416 "In many of the reports": 34, 7–8. / 417 "Don't think": *Norton*, Vol. 2, 179. / 417 "August 13": *BD*, 191–92. / 419 "My third way": 19, 408. / 419 "In those old days": 34, 10. / 419 "This wind": Ibid., 31. / 420 "not rain-cloud": Ibid., 32. / 420 "the leaves of the trees": Ibid., 34. / 421 "a dense *shallow* cloud": Ibid., 39. / 421 "Blanched Sun": Ibid., 40. / 421 a witty verse: Quoted, ibid., 41. / 421 "The earth becomes": *Diaries*, Vol. 3, 796. / 421 "What do the Heavens mean": Ibid., 1026. / 422 "But nothing": *Norton*, Vol. 2, 115. / 422 "The deadliest of all": Ibid., 113. / 422 "Whether you can bring": 34, 41. / 422 "The physical result": 28, 615. / 423 "partly as if it": 27, 133; 34, 33. / 423 "A quite black": *BD*, 157. / 423 "All the Lancashire view": Ibid., 199. / 424 "And I do not care": 27, 133. / 424 Today we know: For background on atmospheric conditions of the time, see 34, xxvi; Rosenberg, 209 ff; P. Brimblecombe, "London Air Pollution 1500–1900" in *Atmospheric Environment* 11 (1977), 1157; D. Cosgrove and J. E. Thomas, "Of Truths of Clouds" in *Human Geography and Literature*, ed. D.C.O. Peacock (London, 1980), 20 ff. / 424 "From 1869": Rosenberg, 214. / 425 Modern scientists attribute this effect: On sulfur dioxide levels, see Brimblecombe, "London Air Pollution," 1160. / 426 "The Mont Blanc": 37, 408. / 426 "Planned end of 7th": *Diaries*, Vol. 3, 1067. / 426 "My own conviction": *Norton*, Vol. 2, 184–85. / 427 "*I call being good*": *BD*, 262. / 427 "*Both* these illnesses": 37, 348. / 428 "As, whenever": 35, xxxix. For background on *Praeterita*, see the various contributions to *Approaches to Victorian Autobiography*, especially that of E. K. Helsinger, 87 ff. / 428 "old man's recreation": 35, 11–12. / 429 "It is finished": *Diaries*, Vol. 2, 732. / 429 "time of labour": 27, 584. / 430 "I know no one": 18, lxii. / 430 "I have written": 35, 11. / 430 "All I've got to say": Ibid., lii. / 433 "Praeterita means": Quoted in Hunt, 394. / 433

"This is the real": 37, 183. / 434 "It is odd how": *Diaries*, Vol. 1, 219. / 435 "It is a great bore": Ibid., 129. / 435 "I think it": 35, 281. / 435 "I must try": *Diaries*, Vol. 3, 1091. / 435 "I have great pleasure": 35, lii. / 435 "I think my history": Ibid., 128. / 436 "Not only in the order": Ibid., 636. / 437 "I can see them": Ibid., 522. / 438 "the only real seer": Quoted in *The Froude-Ruskin Friendship*, 58. / 438 "With twenty steps": 35, 326–28. / 441 innumerable other streams and rivers: On the theme of rivers and waters, see B. B. Redford, "Ruskin Unparadized: Emblems of Eden in *Praeterita*" in *Studies in English Literature* 22 (1982), 675 ff. / 441 "The personal feeling": 35, 33. / 442 "The water": Ibid., 15. / 442 "occasional glimpses": Ibid., 20. / 442 "The windows of it": Ibid., 15–16. / 442 "In obedience to": 22, xxiv. / 443 "nettly island": *RD*, 132. / 443 "Twenty years ago": 18, 385–86. / 444 "That day's work": Ibid., 387. / 444 "I draw back": 35, 560–61. / 445 "The stream which": 17, 61. / 445 "the centre of": 35, 321. / 447 "That great part": Ibid., 132. / 449 "Wordsworth's reverence": Ibid., 220. / 449 "In this pleasure": Ibid., 608. / 450 "The worst of me": 37, 153. / 450 "Then I saw rosy dawn": *Diaries*, Vol. 3, 1149. / 450 "I see everything": Ibid., 1128. / 451 "The aspect of my life": 35, 608–9. / 451 "E-verything white": See L. Schneider, "Everything Black, Everything White" in *Art History* 5 (1982), 166 ff. / 452 "the great sanctifying element": 7, 415. / 452 "the type of love": Ibid., 419. / 452 "How things bind": 35, 561–62. / 453 "*September 13th*": *Diaries*, Vol. 3, 1148–49. / 454 "I . . . feel I could": Ibid., 1150. / 454 "Some wise": 35, 529. / 454 "one of Perugino's angels": Quoted in Hunt, 401. On Ruskin and Kate Olander, see *The Gulf of Years: Letters from John Ruskin to Kate Olander*, ed. R. Unwin (London, 1953). / 455 "I put this darkness": *The Gulf of Years*, 33. / 455 "You've never": Ibid., 69. / 456 "And you *will* be": Ibid., 78.

Eight / The Old Man of Coniston

460 "Nowadays he seems": Collingwood, *John Ruskin*, Vol. 2, 243–44. / 460 he had become a British institution: On Ruskin's growing popularity, see Dearden, *Facets of Ruskin*, 125 ff; Maidment, "Interpreting Ruskin." / 460 "Ruskin looked the shadow": Walter Crane, *An Artist's Reminiscences* (London, 1907), 447 f. / 461

"has been a friend to me": Matthew Levinger, " 'No old man's sorrow': A New Ruskin Letter" in *The Burlington Magazine* 125 (1983), 158 f. / 462 "Backsliding, indeed": 18, 431. / 462 "Unable therefore now": 13, 528. / 463 "Di Ma, if me fall": Quoted in Sheila Birkenhead, *Illustrious Friends* (London, 1965), 276. / 463 "When I learned": On Proust and Ruskin, see R. A. Macksay, "Proust on the Margins of Ruskin" in *Polygon*, 172 ff. / 464 "Those who regard him": Proust, *Oeuvres complètes* (Paris, 1933), Vol. 8, 161. / 464 "And through those eyes": 12, 128. / 464 "He exhibits": Proust, *Oeuvres*, Vol. 8, 182 f. / 464 "Such I conceive": 20, 66. / 467 "Heaps of pamphlets": Maidment, "Interpreting Ruskin," 161–62. / 469 "I have not written": 35, 628. / 470 "But it has been my fate": 33, 388. / 471 "Who, among": 3, 344–45. / 471 "Hundreds of people": 5, 333. / 471 "And I felt also": 18, 153. / 471 "And every man": 22, 207. / 472 "It is quite true": 12, lii. / 472 "This is so": Quoted in Houghton, *Victorian Frame of Mind*, 144. / 473 "And what am I": 28, 425. / 473 "tendency to moralise": 35, 629. / 474 "This too belongs": J. Fest, *"Theodor Mommsen, Zwei Wege zur Geschichte"* in *Frankfurter Allgemeine Zeitung*, July 31, 1982. / 474 "A poet is great": 5, 215. / 475 "that highest laughter": 20, 98. / 475 "The richness of the work": 10, 243–44. / 476 following in their tradition: On Ruskin's style, see N. N. Feltes, "The Quickset Hedge: Ruskin's Early Prose" in *Victorian Newsletter* 34 (1968), 18 ff. / 476 "The more beautiful": 18, 174. / 477 "Not in the wantonness": 10, 141–42. / 478 "I never saw": Ibid., 91, 84, 92. / 481 "Myth represents": Thomas Mann, *Gesammelte Werke* (Frankfurt, 1974), Vol. 9, 493 f. / 482 "the major Romantic myth-maker": Raymond Fitch, quoting Harold Bloom, in *The Poison Sky*, 1. Other discussions of the subject in *Polygon*; and for the most extreme view, see J. Fellows, *Ruskin's Maze: Mastery and Madness in His Art* (Princeton, 1981). / 483 "certain fetishism": Proust, *Oeuvres*, Vol. 8, 166. / 484 "Delphi first": *BD*, 100. / 484 "Now, no book": 34, 78. / 486 "at its wits' end": 5, 384. / 486 "The reason why": Shaw, *Ruskin's Politics* (London, 1921), 9. / 487 "Our fathers were": Woolf, *The Captain's Death Bed* (London, 1950), 49, 52. / 488 "This first day of May": 19, 293–94. / 489 "The ruin or the blank": Quoted in Hunt, 390. / 490 "Oh what times": *Was sind das für Zeiten, / wo ein Gespräch über Bäume fast ein Verbrechen ist / Weil es ein Schweigen über so viele Untaten einschliesst!*

Index

Figures in italics refer to illustrations

Acland, Angie *458*, 459
Acland, Dr Henry 209, 282, 338,
 358, *458*, 459
Acton, William 306
Albert, Prince 13, 104, 223
Allen, George 364
Alpine Club 254, 255
Anti-Slavery League 104
Architectural Magazine 57, 114
Architectural Photographic
 Association 198
Arnold, Matthew 342, 345
 Culture and Anarchy 343–4, 483
Arundel Society 198

Barbey d'Aurévilly 391
Bastiani 399
Baudelaire, Charles 215, 343, 472
Beard, George Miller 409, 414,
 415
Bell, Quentin 288, 427
Benjamin, Walter 312
Bentham, Jeremy 342
Blake, William 72, 78, 98, 116,
 408
 Milton 14
Botticelli 408
Brantwood (house) 364–5, 459–60
Brecht, Bertolt 490
Brewster, David 111
Bright, John 344
Britannia 102

Brockendon, William
 Illustrations of the Passes of the Alps
 32
Brontë, Charlotte 102
Brown, Ford Maddox
 Work 361
Brown, Rawdon 195
Brown, W. L. 145
Browning, Robert 264
Buchanan, Robert 275–6
Buckland, William 58–62, 174
Bulwer-Lytton, Edward 341
Burckhardt, Jakob 107, 192
Burne-Jones, Edward 285, 313
Byron, Lord 32, 33, 135–6, 341, 470
 at Cambridge University 53
 sexuality 136–7
 travels 39–40, 46, 48, 135
 writings 43
 Childe Harold's Pilgrimage 155
 Corsair 8–9
 Marino Faliero 156
 The Two Foscari 156

Carlyle, Jane Welsh 143, 221
Carlyle, Thomas 60, 79, 165–6, 271,
 275, 313, 361, 365, 408
 as father figure to Ruskin 399–400,
 462
 German studies 344
 marriage 143
 Past and Present 236–7, 362

Carlyle, Thomas – *cont'd.*
 Sartor Resartus 120, 128, 173, 190,
 298, 361–2
 on Ruskin 277, 330, 342–3, 429
 on society 190, 215, 236–7, 409
 writing style 418
Carpaccio, Vittore 390, 408, 484
 Baptism of the Sultan 388
 Dream of St Ursula 378–91
 Solomon and the Queen of Sheba
 399, 400
Carroll, Lewis 288, 338
'Chelsea Menagerie' 270, 275, 278,
 279, 283, 299
Cicero 44
Cimabue, Giovanni 390
Claudet 115
Cobbett, William 14–15
Cole, Henry 223–5
Coleridge, Samuel Taylor 32, 46, 80,
 109, 116
Collingwood, W. G.
 The Life and Work of John Ruskin
 429, 460
Constable, John 80, 86, 95, 213
Contemporary Review 368
Cook, Thomas 254
Cornhill Magazine 274, 276, 277
Cuvier, Georges 58, 61

Dante 386, 389
Darwin, Charles 414, 490
Darwin, Erasmus 28
Daumier, Honoré 142
De Quincey, Thomas
 *Confessions of an English Opium
 Eater* 432
Dickens, Charles 215, 359
Disraeli, Benjamin 155, 344
Dodgson, C. L. *see* Carroll, Lewis
Domecq, Adèle Clotilde 51–2, 62–3,
 121, 139, 287
Domecq, Pedro 50
Domenico 162
Downes, Mr 372
Doyle, Arthur Conan 173
Dürer, Albert 135, 234
 Knight, Death and the Devil 461–2

Eastlake, Charles 220
 History of Oil Painting 195
Eastlake, Lady 244
Edgeworth, Maria 29, 399
Edinburgh Review 363
Emerson, Ralph Waldo 231, 256,
 329, 449, 490

Fabre, Jean-Henri 490
Fechner, Gustav 115
Fenwick, Miss 122
Ferguson, James
 Tree and Serpent Worship 305
Feuerbach, Ludwig 118
Förster 151
Fra Angelico 147, 278, 390
Fraser's Magazine 274, 277
Freud, Sigmund 279, 482
Friedrich, Casper David 208, 251
Friendship's Offering 57
Froude, James Anthony 143, 438

Galton, Francis 173
Gandhi, Mahatma 325
Gautier, Théophile 343
George, Henry 414, 415
 Progress and Poverty 409
Gilpin, William 42
Giorgione 23–5
Giotto 312, 390
Gladstone, W. E. 144, 370
Goethe 79–80, 460
 Poetry and Truth 125–6
 Theory of Colors 28
Gower Street, London 212–13,
 216–17, 245
Gozzoli, Benozzo 147
Gray, Effie (later Ruskin)
 contact with La Touche family
 291–2, 297, 305
 correspondence 160, 161
 family background 137–8
 health 143
 marriage to Ruskin 9, 137–44,
 208–9, 220, 251, 283, 287,
 291–2
 marriage to Millais 208
 in Venice 158, 160, 162

Gray, George and Mrs 137–8,
 139–40
Great Exhibition, Crystal Palace
 (1851) 188–9, 223, 231
Greenaway, Kate 413, 433, 435
Guild of St George 371–2, 426, 462,
 481

Hamerton, Philip 102
Harding, J. D. 149, 150
 The Principles and Practice of Art 88
Harrison, Frederick 368
Harrison, J. F. C. 231
 Early Victorian Britain 18
Harrison, William Henry 57
Hazlitt, William 43, 45, 47
Hegel, Georg 173, 195
Helmholtz 115
Helsinger, E. K. 196
Henslow, John 257–8
Herkomer, Hubert von
 John Ruskin (portrait) 394, 395–7
Herne Hill 13–14, 396
Herschel family 111
Hesiod 386
Hilliard, Constance 304, 307
Hincksey Diggers 358
Hobbs, George 162
Hogarth, William
 Analysis of Beauty 172
Hooker, Richard 78
Hudson, W. H. 490
Hughes, Thomas
 Tom Brown's Schooldays 26
Hunt, William Holman 209
Huysmans, J.-K. 389
 A rebours 232, 391

Impressionist Movement 119, 334,
 412–13
Industrial Revolution 228–9, 239,
 414

Jameson, Anna 102
 Sacred and Legendary Art 407
Jameson, Robert
 Systems of Mineralogy 32, 49
Jefferies, Richard 490

Joyce, Jeremiah 29, 31
Jung, Carl 482

Kelvin, Lord 414, 415
Ker, Charlotte 162
Kingsley, Charles 215, 340
Koch, Joseph Anton 251
Kraus, Karl 371
 Die Fackel 366

La Touche, John 285–6, 289–92,
 297, 388
La Touche, Maria 285–6, 289–92,
 295, 297, 298
La Touche, Rose
 appearance in Ruskin's dreams and
 fantasies 383–5, 387–8,
 398–402, 404–5, 406, 428–9
 birth 286
 character 287
 death 384–5, 387, 400, 443, 463
 influence in Ruskin's writing 283,
 293–8, 301, 383–91, 398–9,
 444–5
 portrait by Ruskin *284*, 287
 relationship with Ruskin 283–93,
 299, 305–7, 309, 332, 383–5,
 454, 455
 religion 286–7, 288–90, 295
Labour Party 325
Lang, Andrew 358
Le Keux 167
Lear, Edward
 Book of Nonsense 413
Liddell, Alice 288
Lindsay, Jack 84
Lindsay, Lord 176
 History of Christian Art 195
Linton, Mr 364
Lockhart, Charlotte 139
Lorrain, Claude 91–3, 107, 113, 259
Lubbock, Sir John 413
Lutyens, Mary 144
Lyell, Sir Charles 61, 253, 415

Mabey, Richard 258
MacDonald, George 383, 399, 401
 Phantastes 299

Magazine of Natural History 40
Maidment, Brian 468
Mallock, William Hurrell
 The New Republic 345, 358
Malthus, Thomas 315
Manet, Edouard 207
 Nana 411
Mann, Thomas 481–2
Marlborough House 225
Marx, Karl 239, 241, 315, 325, 409
 Capital 230, 240, 275
Mary (cousin) 56, 139
Massingham, H. J. 490
Maurice, Frederick D. 361
Meynell, Alice 490
Michelangelo 234
Mill, John Stuart 315
Millais, John Everett
 Cherry Ripe 411
 John Ruskin (portrait) *206*, 207–12,
 216–20, 259, 273
 marriage to Effie Ruskin 208–9,
 291–2
 Pre-Raphaelite Brotherhood 211,
 216–18
Milner, Alfred 358
Moore, George 102
More, Thomas
 Utopia 371
Moreau, Gustave 483
Morelli, Giovanni 173
Morgan, Lady 157
Morley, John 275
Morris, William 198, 283, 299, 390
Muir, John 490
Müller, Max 301
Munch, Edward 317
John Murray (publishers) 9, 74

National Gallery (of Britain) 198,
 220, 340–1, 454
National Review 363
New York Common Council 242
Niepce, Joseph Nicèphore 28
Nietzsche, Friedrich 317, 345, 354,
 483, 484, 485
Nordlinger, Marie 463
Northcote, James

John Ruskin (portrait) *2*, 3–5, 21,
 207, 211, 397
Norton, Charles Eliot 395, 396
 correspondence with Ruskin
 329–33, 390, 417, 426
 travels with Ruskin 437, 452,
 454

Olander, Kathleen 454–5
Oxford and Cambridge Magazine 299
Oxford Movement 358
Oxford University 52–63, 336–9,
 343, 347, 356, 372

Pall Mall Gazette 421
Pater, Walter 99, 102, 452
 The Child in the House 447–8, 451
 at Oxford University 343, 344–6,
 358
 on role of art 346, 354, 387
 *Studies in the History of the
 Renaissance* 102, 345, 354,
 358
Paulizza, Captain 160
Peacock, Thomas Love
 'The Four Ages of Poetry' 341–2
Pestalozzi, Johann 26
Peterloo massacre 11–12
Phusin, Kata (pseudonym) 114
Plato 108, 386
Poe, Edgar Allan 174, 389
Poussin, Gaspar 92–3
 Aricia (Le Riccia) 94–8
Pre-Raphaelite Brotherhood 211,
 212, 216–20, 234, 299, 313,
 357, 361, 411
Proust, Marcel 39, 102, 123
 admiration of Ruskin 312, 331,
 408, 463, 464
 A la recherche du temps perdu 433
 Contre Sainte-Beuve 469
 criticism of Ruskin 464–6, 469–71,
 476–9, 482–3
Prout, Samuel 43, 45, 52, 149
 Sketches in Flanders and Germany 32
Pugin, August Welby
 *True Principles of Pointed or Christian
 Architecture* 171, 183

Quarterly Review 244

Raphael 110, 211, 413
Reid, Thomas 7
Rembrandt 135
Republic 364
Reynolds, Sir Joshua 3, 87–8
Rhône River 40, 438–41, 445–6
Ricardo, David 315
Richmond, George
 John Ruskin (portrait) 66, 67–70,
 72–3, 207, 211
Richmond, William Blake 396, 397
Richter, Ludwig Adrian 251
Rickman, Thomas
 An Attempt to Discriminate the Styles
 of English Architecture 167,
 171
Rio, Alexis-François 147
Rogers, Samuel 33
 Italy 32, 115, 152–3
Rosa, Salvatore 89, 93
Rosenberg, John 424, 474
Rossetti, Dante Gabriel 123, 220, 283
 'Chelsea Menagerie' 270, 275
 photograph with Scott and Ruskin
 268, 269–73
 portrait of Ruskin 278
 writings 389
 collected poems 275–6
 Hand and Soul 299
Rossetti, William 278
Rousseau, Jean-Jacques 42, 305, 430,
 470
Royal Academy 224, 233
Rumford, Count 111
Rumohr 151
Ruskin, Jessie (aunt) 18–19
Ruskin, John
 biography 429, 460
 birth 10–13
 and 'Chelsea Menagerie' 270–82
 childhood 19–26, 218, 289, 373,
 447–8
 choice of career 63
 conversion experiences
 at Fontainebleau 119–29, 249,
 261

 at Turin 261–2, 278, 399
 through Carpaccio's *Dream of St*
 Ursula 385–7, 399
 correspondence 461
 with W. L. Brown 145–6, 160
 with Effie Gray 141–2
 with G. MacDonald 383, 401
 with C. E. Norton 329–33, 390,
 417, 426
 with K. Olander 455
 with parents 133–4, 147, 152,
 278, 280–1, 307–8, 338, 340,
 365
 with Joan Severn 337, 387, 463
 death 463
 death of parents 279–82, 365, 396,
 399, 462
 diary 397–8, 400, 410, 417–19,
 426, 433–6, 453
 drawings and paintings 43–5, 69,
 124–6, 149–50, 220, 280,
 446
 Cascade de la Folie, Chamonix
 251, *252*
 Detail of San Michele, Lucca 148,
 149
 Gneiss Rock 209, *210*
 Merton College 54
 San Martino in Lucca 431
 Self-portrait 328, 329, 332–4,
 395
 The South Facade of St Mark's,
 Venice 159
 Street in Venice 335
 Studies of the Ca d'Oro, Venice
 158, *163*
 Trees on Mountain Slope 127
 of Venetian architecture 158–74
 dreams 304–12, 314, 336, 397–8,
 404–6
 dress, style of 67, 269–72,
 459
 education 27, 52
 family background 5–10
 father *see* Ruskin, John James
 fears about eyesight 80
 founding of 'literature of art'
 101–5

geological studies 32, 48–9, 58–62, 246

Guild of St George 371–2, 481

health 62–3, 121, 133–5, 356, 363

Hincksey road project 357–62

homecomings 444, 446, 449, 453

homes 13–14, 364–5, 396

lectures 277
 on art 221–2
 on manufacture and design 237
 on Political Economy of the Arts 242, 316, 317, 322
 Oxford Lectures on Art 339–40, 346–50, 353, 355–7, 363, 426, 443, 466

marriage to Effie Gray 9, 137–44, 208–9, 221, 251, 283, 287, 288, 291–2

mental health 329–35, 367–8, 404–6, 408–10, 427
 first attack (1878) 397–402, 451
 final attack 404, 428, 456, 461–2

meteorological studies 49, 74, 416–26

mother see Ruskin, Margaret

mythology, interest in 262–3, 298, 300–2, 307, 309–13, 317, 382–3, 407–8, 480–4

Newdigate Prize 57

old age 459–63

paganism 278–9, 289

photographs
 with H. Acland (1893) 458, 459–60
 with Scott and Rossetti (1863) 268, 269–73

politics 13, 14, 370–1

portraits
 by Herkomer (1879) 394, 395–7
 by Millais (1853–4) 206, 207–13, 216–20, 259, 273
 by Northcote (1822) 2, 3–5, 21, 207, 211, 397
 by Richmond (1843) 66, 67–70, 72–3, 207, 211
 by Rossetti (1862) 278
 self-portrait (1852) 133–5

self-portrait (1873) 328, 329, 332–4, 395

publishing agency 364

relationships
 with Adèle Domecq 50–2, 62–3, 121, 139, 287
 with Effie Gray see marriage
 with Rose La Touche 283–93, 299, 305–7, 309, 332, 383–5, 454, 455
 with parents 18, 19, 21–2, 26–7, 53, 63, 135, 139–40, 279–82, 399
 with Kathleen Olander 454–5
 with young girls 287–9, 307–8

religious beliefs 261–2, 278, 391, 399

sexuality 136–7, 140–4, 208, 251, 305–7

as Slade Professor of Fine Arts, Oxford 336–9, 343, 346–7, 353, 356, 396

snake symbol, use of 302–12, 404–5

studies at Oxford University 52–63

symbolism, use of 298–313, 378–9, 389–91, 403–4, 406–8, 481–3

travels, 32–41, 432, 446
 Alps 46–8, 71, 245–55, 453–4
 European tour (1835) 32–40, 47–8
 (1842) 63, 71
 (1846) 146
 (1856) 437–8
 Geneva 40, 440, 441
 Italian tour (1841) 434
 (1845) 147–58
 Lake District 82
 Normandy 146
 Rome 44
 Scotland 208
 Venice 136–7, 144, 154–70, 374–89

Turner bequest, work on 220, 245, 278–9

views
 on American girls in Italy 380–2
 on architecture 56–7, 175–94,
 196–9, 212–13
 on art (summary of views)
 348–55, 412
 on art and design education
 221–7, 229, 238, 274, 347–8
 on art criticism 74–6, 94–6,
 98–9
 on art history 194–6, 199
 on art theory 87–90
 on artistic decline 410–13
 on artist's materials 232–5
 on blessing and curses 374–8
 on Bradford stock exchange
 277–8, 313
 on captains of industry 237–8
 on Carpaccio's *Dream of St*
 Ursula 378–91
 on colour 214–16
 on concept of value 318, 320–3
 on curves 172–3, 175, 180–1,
 246–7
 on economics 236–43, 274, 276,
 313–26
 on education 23–6, 295, 296,
 338–9 *see also* views: on art
 and design education
 on figure painting 261–2
 on flowing water 441–6
 on the future 255–8, 414–16
 on Gower Street 212–13, 216–17
 on Impressionism 119, 334,
 412–13
 on infinity 78–9, 88–9, 90
 on Italian art 147–52 *see also*
 views: on architecture
 on landscape painting 74–7,
 89–99, 106, 213, 259–60,
 355
law of fracture 250, 333
 on laws of composition 249–50
 on light 83–5
 on Lorrain 91–3
 on materials and technology
 16–17, 175–85, 255–7
 on modern art 212–16

 on moldings 167–72, 181, 200–2
 on mountains 47–8, 245–55
 on naturalism 411–12
 on nature 76–80, 87, 93–4,
 107–9, 116–19, 217, 245–50,
 414
 on organization of labour 175,
 186–91, 228, 235
 on ornament 186–7, 200–2
 on the picturesque 44–6, 77–8,
 157
 on pollution 423–6
 on Poussin 93, 94–8
 on Pre-Raphaelite art 211–12,
 216–20
 on quality of goods 230–6
 on railroads 34, 359–60
 on religion 36, 295–7
 on religion and art 181–3
 on Rhône River, Geneva 40,
 438–41, 445–6
 on science and art 75–6, 108–9
 on 'science of aspects' 79, 82,
 87, 108, 116, 123, 303, 316,
 416, 484
 on science of essences 300, 487
 on shapes of pictures 114–15
 on Turner 71–4, 76, 86–7, 92,
 93–4, 95, 98, 100–5,
 112–13, 115, 244–5, 255,
 259–60, 262–3, 278, 340,
 427, 472, 484
 on Vendramin's 'missing hand'
 200–4, 312
 on Venice 145–6, 152–70,
 175–85, 192–204, 374–7,
 386–7
 on viewer participation 175,
 185–6, 191
 on working conditions 227–9
writings 73, 264, 274, 418–19,
 446, 467–8, 471–2
 The Bible of Amiens 33, 407
 as child author 27–32
 Coeli Enarrant (The Heavens
 Tell) 31, 421
 The Crown of Wild Olive 274
 Deucalion 366

Dilecta 436
The Eagle's Nest 366, 368, 423
The Elements of Drawing 118,
 249, 286
The Ethics of Dust 274, 308
Fors Clavigera 33, 203, 363,
 365–79, 383, 389, 391, 400,
 412, 418, 419, 422, 423, 429,
 435–6, 448, 466, 483, 485
Harry and Lucy 29–31, 41
The King of the Golden River 138
*Lectures on Architecture and
 Painting* 220
Letters to a College Friend 466
Love's Meinie 366
Modern Painters 33, 78, 80, 105,
 106, 109, 116, 123, 126, 128,
 146, 149, 152, 185, 199, 203,
 208, 215, 219, 220, 244, 247,
 251, 258–9, 260, 261, 262,
 264–6, 273, 274, 293, 296,
 313, 315, 316, 317, 333, 356,
 418, 419, 451, 453, 467, 479,
 484–5, 490
 Volume 1 69, 73–5, 85,
 87–95, 102, 103, 119, 133,
 183, 215, 233, 245, 350,
 470–2, 474–5, 490
 Volume 2 102, 145, 278
 Volume 3 75, 79, 213, 217,
 255, 257, 293, 334, 454, 466
 Volume 4 209, 214, 245, 248,
 253, 255, 293
 Volume 5 23–5, 249, 258, 415
Mornings in Florence 33
Munera Pulveris 315, 316
On the Old Road 33
The Poetry of Architecture 56–7
*The Political Economy of Art (A
 Joy for Ever)* 220
Praeterita (autobiography) 17,
 21, 29, 30, 53, 63, 69, 119,
 122, 162, 427–41, 444–6,
 448–54, 462, 466, 470, 479,
 480, 483
Proserpina 366–7
The Queen of the Air 274, 297–8,
 310, 407, 487

Sesame and Lilies 274, 293,
 296–7, 313, 466
The Seven Lamps of Architecture
 146–7, 197, 467
The Shepherd's Tower 407
The Stones of Venice 33, 108,
 146, 152–4, 155–6, 164–5,
 167–71, 176–85, 188,
 194–204, 208, 209, 215, 219,
 224, 228, 235, 239, 247, 265,
 274, 312, 315, 353, 466, 467,
 477, 479, 490
*The Storm-Cloud of the Nineteenth
 Century* 31, 416–17, 423–5,
 489
Time and Tide 274, 315
The Two Paths 220
Unto This Last 274, 276, 315,
 316, 317, 324, 325, 368, 418,
 466
Verona and Its Rivers 33
Ruskin, John James (father)
 career 5–6, 12, 50
 character 16–17, 18
 childhood 20
 correspondence with wife 18, 27–8
 death 13, 279–82, 399
 expectations of John at Oxford 53,
 63
 family background 5
 family life 13–14, 21–2, 26–7
 family tours 32–40, 48, 71
 health 16
 marriage 7, 9–10
 marriage of John and Effie 139–40
 overprotectiveness 18–19, 135
 paintings, purchase of 71, 72, 150
 politics 14, 15
 religion 7–8
 symbolized in Ruskin's dreams
 404–5
 views
 on art 71–2, 340
 on Genesis and geology 59
 on John's work 150, 199, 200,
 221–2, 279
 on poets 57
 on Queen Victoria 13

on railroads 15
Ruskin, John Thomas (grandfather)
 5
Ruskin, Margaret (mother)
 correspondence with husband 18,
 27–8
 death 13, 365, 396
 family background 5
 family life 13–14, 21–2, 26–7
 family tours 32–40, 48, 71
 health 16
 marriage 7, 9–10
 marriage of John and Effie 139–40
 move to Oxford 53, 56
 overprotectiveness 17–18, 135
 religion 7–8
 symbolized in Ruskin's dreams
 404–5
 views
 on art 340
 on Genesis and geology 59
Ruskin, Telford and Domecq 6, 50

Sainte-Beuve, Charles 469
St Catherine of Bologna (Beata
 Vigri) 398–9, 400, 401
St Ursula 378–91, 398, 401, 406
Saturday Review 274, 275, 276
Saussure, H. B. de 48, 49
 Voyages dans les Alpes 32
Schools of Design 224
Schopenhauer, Arthur 397
Scott, Sir Walter 14, 42, 139, 367,
 370, 408
Scott, William Bell 268, 269–73, 283
Seurat, Georges 334
Severn, Arthur 396, 452, 463
Severn, Joan (cousin) 304, 307, 385,
 396, 428, 430, 452, 455
 as mother figure 462
 care of Ruskin in old age 460–1,
 462–3
 correspondence with Ruskin 337,
 387, 463
Severn, Joseph 452
Shaw, George Bernard 486
Shelley, P. B. 32, 33, 152, 156, 449,
 470

The Cenci 156
England in 1819 11–12
Sherburne, James Clark 322
Siddal, Elizabeth 272
Sidney, Sir Philip 368
Sizeranne, Robert de la
 Ruskin et la religion de la beauté 463
Slade, Felix 336, 347
Smith, Adam 7, 315
South Kensington Museum (Victoria
 and Albert Museum) 223,
 224
Southey, Robert 82
Stephenson, George 359
Stewart, Balfour
 The Conservation of Energy 414
Stewart, Dugald 7
Swinburne, Algernon Charles 102,
 275, 276, 279, 283, 343
 Poems and Ballads 275
Symbolist Movement 299–300
Symons, Arthur 470

Talbot, Henry Fox 28, 111
Tay River 441, 442, 444
Tennyson, Alfred, Lord 43, 415
Thomas, Edward 490
Thompson, James 299
Thomson, Scot James 104
Thomson, Walter see Kelvin, Lord
Thoreau, Henry David 490
 Walden 256
Tintoretto 261, 390
Titian 390
Toynbee, Arnold 358
Treitschke, Heinrich von 8
Turner, J. M. W. 52, 149, 209, 213,
 408, 449, 470
 acquaintance with Ruskins 71
 bequest 220, 245
 childhood 23, 25
 criticism of works 71–4, 90, 340
 travels to Venice 155
 use of materials 233
 views
 on light 83–4
 on nature 80, 82–7
 on optics 111–13

works
 Apollo Slaying Python 262–3,
 308
 Approach to Venice 153
 The Garden of the Hesperides
 262–3
 *Hannibal and His Army Crossing
 the Alps* 113
 Italy (illustrator) 155
 Keelmen Heaving in Coals 155
 *Light and Colour (Goethe's
 Theory)* 113
 Petworth landscapes 113
 The Slave Ship 100–5
 Venice 155
 see also Ruskin, John: views on
 Turner
Tylor, Edward B. 368

Union Hall frescoes, Oxford 234,
 236, 357

Veblen, Thorstein 240
Veronese 261, 390
 Solomon and the Queen of Sheba
 261–2, 399
Victoria, Queen 11, 13, 463
Vigri, Beata *see* St Catherine of
 Bologna
Viljoen, Helen 398
Viollet-le-Duc, Eugène 107
Vischer, Friedrich Theodor 165–6,
 215, 218–19

Walther, L. 19
Wandel River 441–4
Wedgwood family 111

Whewell, William 167
Whistler, James 119, 343
 Nocturne in Black and Gold 411,
 412–13
White, Gilbert
 *The Natural History and Antiquities
 of Selborne* 86
Wilde, Oscar 358, 389
Willis, Robert 171, 187
 *Remarks on the Architecture of the
 Middle Ages* 167
Winnington School 308
Wollaston, William Hyde 111
Woolf, Virginia 487
Wordsworth, Dorothy 81
Wordsworth, William 43, 57, 128,
 449
 travels 32, 33, 432
 views
 on industrialization 359, 426
 on nature 47, 76, 80–2, 109,
 116, 122–4
 writings 108
 'An Evening Walk' 122
 The Excursion 80
 Guide to the Lake District
 81–2
 The Prelude 123, 432
 'Tintern Abbey' 123
Working Men's College, London
 221, 364

Young, Thomas 111
 Mechanism of the Eye 111
 Observations on Vision 111

Zola, Emile 411